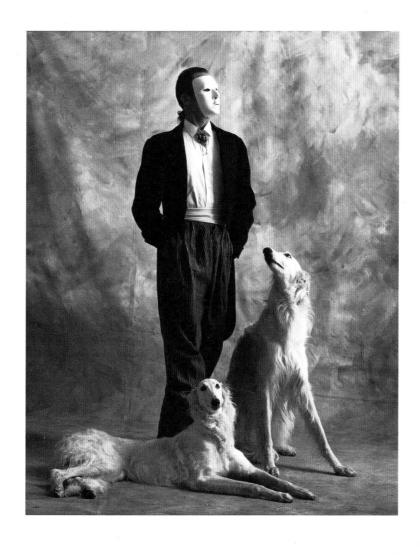

President and Publisher
Ira Shapiro

Senior Vice President
Wendl Kornfeld

Vice President Sales and Marketing
Marie-Christine Matter

Production Director
Karen M. Bochow

Marketing Director
Ann Middlebrook

Data Systems Manager/
Distribution/Grey Pages
Scott Holden

Marketing
Promotion/Editorial Manager
Mitchell Hinz
Marketing Coordinator
Lisa Wilker
Book Sales Coordinator
Cynthia Breneman

Advertising Sales
Advertising Coordinator
Shana Ovitz
Sales Representatives:
John Bergstrom
Kate Hoffman
Ellen Kasemeier
Barbara Preminger
Joe Safferson
Dave Tabler

Administration
Controller
Joel Kopel
Office Manager
Elaine Morrell
Accounts Manager
Connie Malloy
Accounting Assistants
Myron Yang
Mila Livshits
Administrative Assistant
Paula Cohen

Published by:
American Showcase, Inc.
915 Broadway, 14th Floor
New York, New York 10010
(212) 673-6600
FAX: (212) 673-9795

American Photography
Showcase 15
ISBN 0-931144-72-8
ISSN 0278-8128

Cover Credits:
Front Cover Photo:
Hans Neleman
Lead Page Photo:
Susan Segal

Production
Production Manager
Chuck Rosenow
Art Director/Studio Manager
Marjorie Finer
Production Coordinators
Zulema Rodriguez
Tracy Russek
Production Administrator
Pamela Schechter
Traffic Coordinator
Sandra Sierra

Grey Pages
Data Systems Assistant
Julia Curry

Special Thanks to:
Elizabeth Atkeson
Ron Canagata
Ken Crouch
Jeffrey Gorney
Hardy Hyppolite
Amir Iravani
Rita Muncie
Anne Newhall
George Phillips
Tina Sher

U.S. Book Trade Distribution:
Watson-Guptill Publications
1515 Broadway
New York, New York 10036
(212) 764-7300

For Sales outside the U.S.:
Rotovision S.A.
9 Route Suisse
1295 Mies, Switzerland
Telephone: 022-755-3055
Telex: 419246 ROVI
FAX: 022-755-4072

Mechanical Production:
American Showcase, Inc.

Typesetting:
The Ace Group, Inc.

Color Separation:
Universal Colour Scanning Ltd.

Printing and Binding:
Everbest Printing Co., Ltd.

PHOTOGRAPHY

AMERICAN
SHOWCASE

C O N T E N T S

V I E W P O I N T S

G R A P H I C A R T S
O R G A N I Z A T I O N S

L I S T I N G S

A

Abraham, Russell 272,273
Accornero, Franco 44,45
Alejandro, Carlos 73
Amberg, Jeff 183
Anderson, Randy 255
Andris·Hendrickson 74,75
Arruza, Tony 173

B

Bachmann, Bill 184
Baker, I. Wilson 177
Barnhurst, Noel 304,305
Barreras, Anthony 156,157
Barrow Inc., Scott 35-37
Barrows, Wendy 76
Bean, Bobby 171
Bekker, Philip 185
Berinstein, Martin 77
Blankenship, Bob 186
Boas, Christopher 20,21
Bolster, Mark 78,79
Borges, Phil 306,307
Bossert, Bill 308
Bozman, James 80
Brooks, Charles 168
Bubbenmoyer, Kevin 81
Buchanan, Craig 280,281
Buchanan, Robert 82,83
Burke, John 85
Burke/Triolo 291

C

Caldwell, Jim 256,257
Callis, Chris 16,17
Campos, John 86,87
Charles, Cindy 309
Cobos, Lucy 62
Colabella, Vincent 66
Conison, Joel 226
Cook, Kathleen Norris 310
Cosby Bowyer, Inc. 187
Coughlin, Suki 89
Crowley, Eliot 287
Cruff, Kevin 253
Curtis, Lucky 229
Curtis, Mel 311

D

de Wys, Leo 354
deGennaro Associates 276,277
Dickinson, Dick 188
Dietrich, David 174
Domenech, Carlos M. 189
Dorf, Myron Jay 46,47
Douglas, Keith 167
Douglass, Jim 274,275
Dunwell, Steve 54,55

E

Eliasen, Steve 222,223
Elson, Paul 90,91
Ergenbright, Ric 289

F

Farrell, Bill 93
Fatta, Carol 94,95
Feldman, Simon 96
Firebaugh, Steve 312,313
Fisher, Jon 97
Flatow, Carl 99
Fox, Martin 172
FPG 352,353
Francekevich, Al 100,101
Freedman, Holly 303
Frick, Ken 230
Fritz, Michael 315
Funk, Mitchell 102,103

G

Garber, Bette S. 356
Gendreau, Raymond 337
Generico, Tony 104
Gerczynski, Tom 248
Gillis, Greg 218,219
Glaser & Associates, Ken 191
Glassman, Keith 67
Goff, D.R. 225
Golfoto, Inc. 357
Goodman, Howard 105
Grant, Robert 52,53
Green, Mark 236-243
Green-Armytage, Stephen 106,107
Gregg, Barry 297

6

And then the fish said to himself, "Boy, I wish I had arms."

No wonder. Our professional divers' series is accurate down to 200 meters. And features a functional diver's bezel and authentic Swiss movement. So if you're ready to take the plunge, a Scuba 200 will attract all kinds of admirers. Available in deep black, aquamarine, sunsplash yellow and ocean blue. **There's a time and a Swatch for everything.**

swatch+ SCUBA 200

© 1990 Swatch,® a division of SMH (US) Inc. For a free brochure, please write to SWATCH Brochure, P.O. Box 6066, Dept. SI 70, Ranks, PA 17573.

It's also an ad for The Image Bank.

As the creative directors at Weiss, Whitten know, there are two ways to produce a memorable ad. 1) Spend countless days and tons of money shooting it yourself. 2) Take advantage of The Image Bank's incomparable library of stock photography, film, and illustration.

For Swatch, Weiss, Whitten combined a product shot with two Image Bank photos to create the visual you see above. But they're not the only ones. For a list of the print and TV ads currently featuring our work, call or write The Image Bank office near you.

Over 50 offices worldwide, including: Atlanta 404 233 9920, Boston 617 267 8866, Chicago 312 329 1817, Dallas 214 528 3888 Detroit 313 524 1850, Houston 713 668 0066, Los Angeles 213 930 0797, Minneapolis 612 332 8935, Naples FL 813 566 3444, San Francisco 415 788 2208, Seattle 206 343 9319. Headquarters: 111 Fifth Ave. NYC 10003 Tel: 212 529 6700 Fax: 212 529 8886

THE **IMAGE** BANK®

THE IMAGE BANK, TIB, and TIB THE IMAGE BANK are trademarks of The Image Bank, Inc. New York, NY © 1991 THE IMAGE BANK, INC. All Rights Reserved.

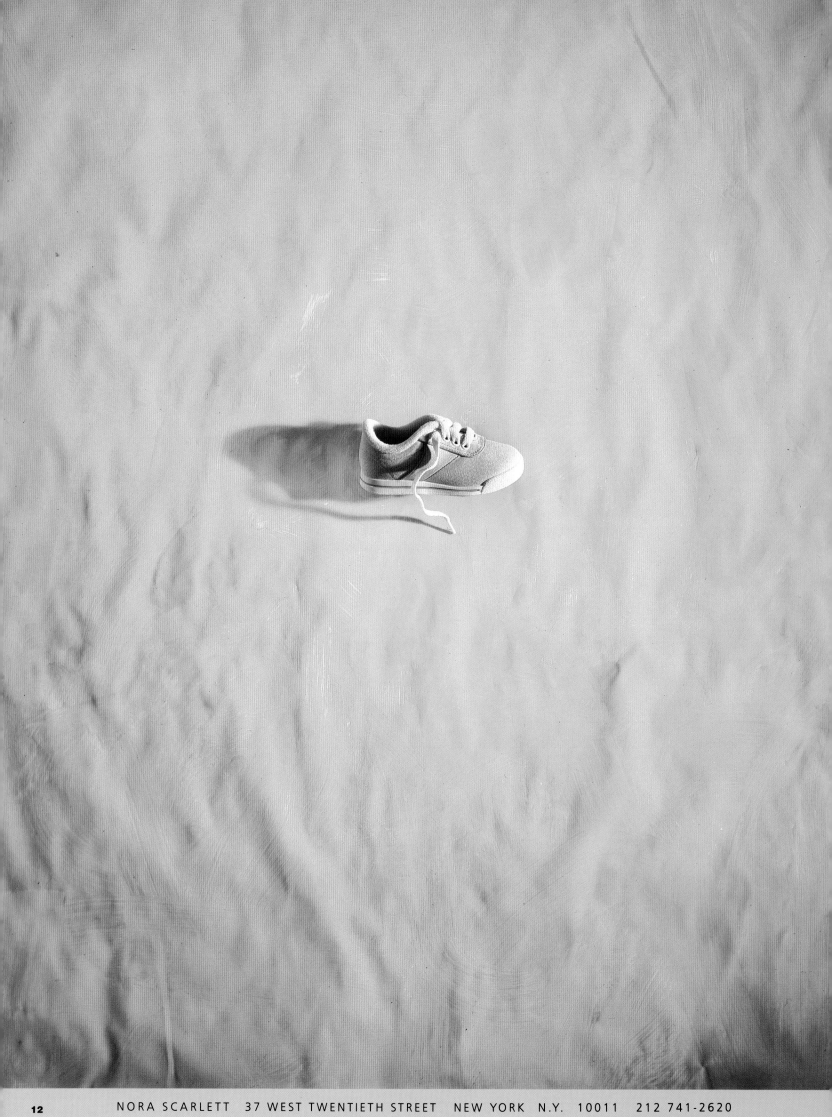

13

108 East 35 St.
New York 10016
Phone: (212) 889-3337
Fax: (212) 889-3341

GERALD & CULLEN RAPP, INC.

DEBORAH *Roundtree*

SPEL·MAN

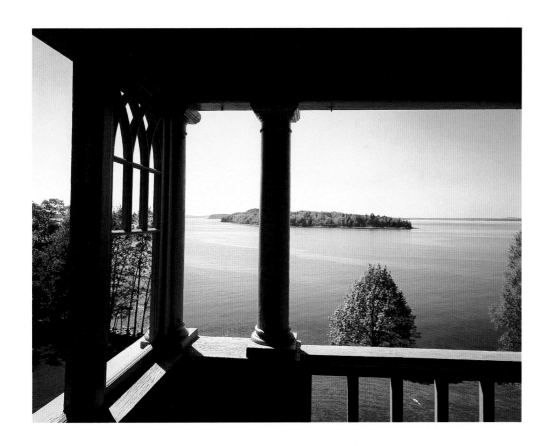

STUDIO

16 EAST 23RD STREET

NEW YORK, NEW YORK 10010

212-228-2288

SELECTED CLIENT LIST

MERCEDES BENZ OF NORTH AMERICA

PRUDENTIAL BACHE

CHRYSLER CORPORATION

KENTUCKY BOARD OF TOURISM

CHEMICAL BANK

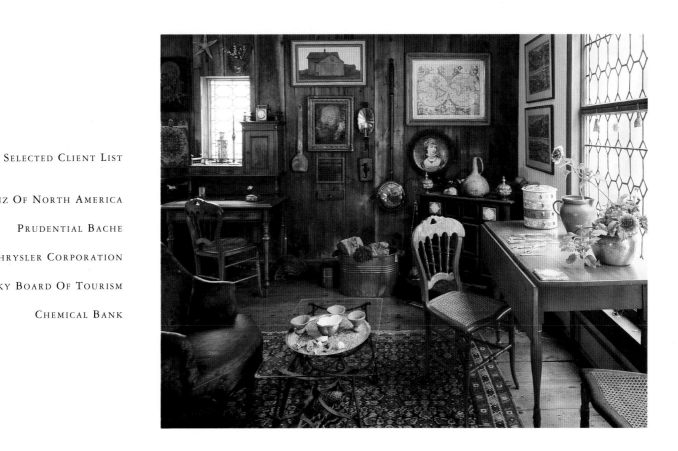

DAVID MAISEL | PHOTOGRAPHY

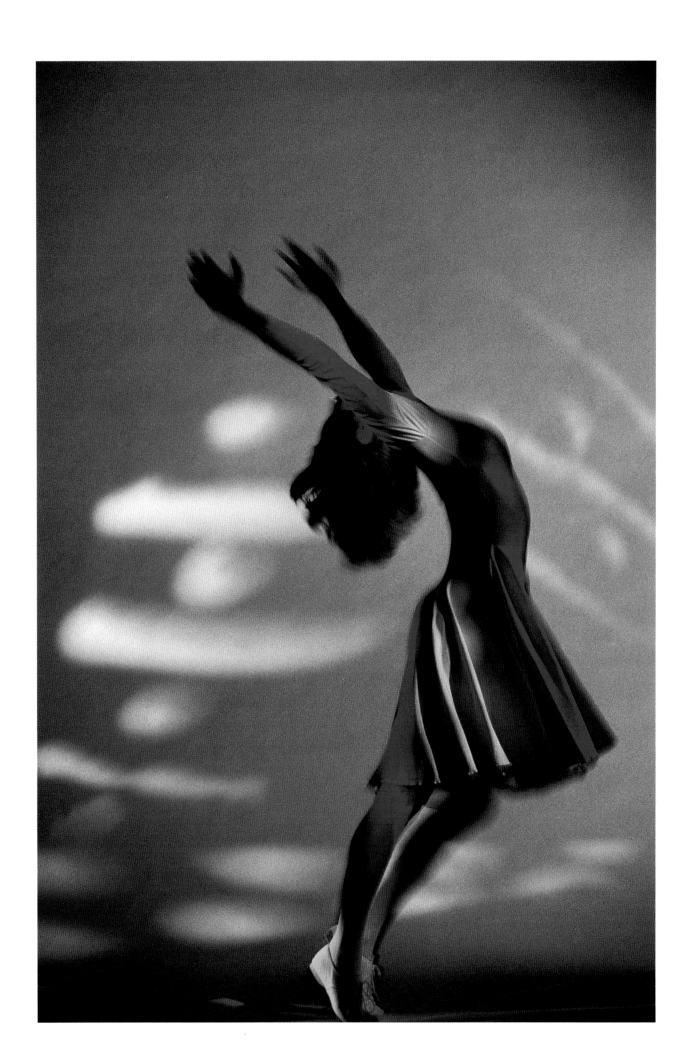

KATVAN

40 W 17 ST
NEW YORK CITY
212 • 242 • 4895

CHRISTOPHER BOAS

20 Bond Street New York City 10012

Telephone + Facsimile 212 982 8576

CHRISTOPHER BOAS

20 Bond Street New York City 10012

Telephone + Facsimile 212 982 8576

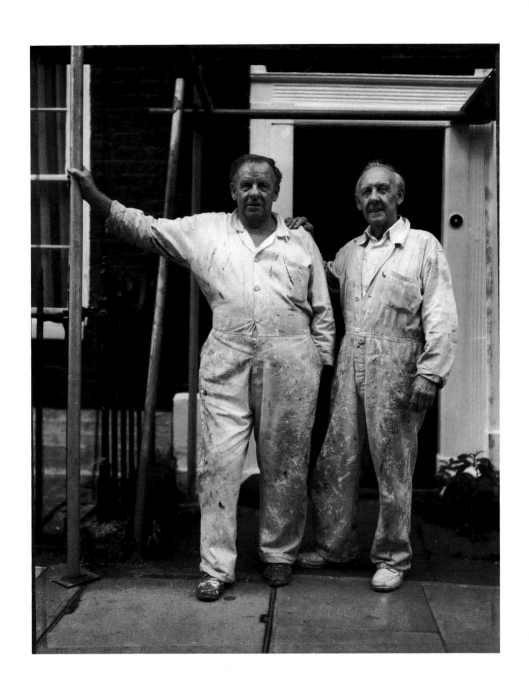

CHRISTOPHER BOAS

20 Bond Street New York City 10012

Telephone + Facsimile 212 982 8576

MICHEL TCHEREVKOFF

15 West 24 Street New York, New York 10010 212.228.0540
Represented by Madeleine Robinson 212.243.3138

Represented by
Madeleine
Robinson
212.243.3138

SHEL SECUNDA

112 Fourth Avenue • 3rd Floor • New York, N.Y. 10003 • 212-477-0241

HITOSHI KIMOTO

HITOSHI KIMOTO

GILLES LARRAIN INC. 95 Grand St. New York NY 10013 (212) 925-8494 (FAX) 925-8747

POW

MERCHANDISE
PROTECTION

CHASE BETTER BANKING

SMIRNOFF®

ERS

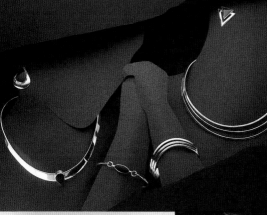

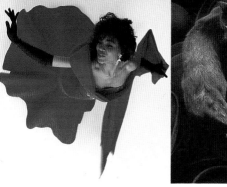

Represented by
CHARLES J. PINTO
(212) 563-3177

spencer jones
PHOTOGRAPHY

· 23 Leonard Street

· Studio 5

· New York, N.Y.

· 10013

· 212.941.8165

· fax 212.941.1699

Aeromexico

Alitalia

Continental Airlines

French Tourist Board

Hilton International

Northwest Airlines

Port Authority of NY / NJ

TWA

Stock Available

44 Market Street

Cold Spring

New York 10516

914-265-4242

FAX 914-265-2046

© Copyright 1992

BARROW

Scott Barrow Inc.

Scott

Barrow

Inc.

914-265-4242

BARROW

44 Market Street

Cold Spring

New York 10516

FAX 914-265-2046

American Express

AT&T

General Motors

IBM

Mastercard

Mexico

James River Corp.

Stock Available

"Life

is

what

happens

while

you

are

making

other

plans".

– John

Lennon

914-265-4242

FAX 914-265-2046

© Copyright 1992

BARROW

Scott Barrow Inc.

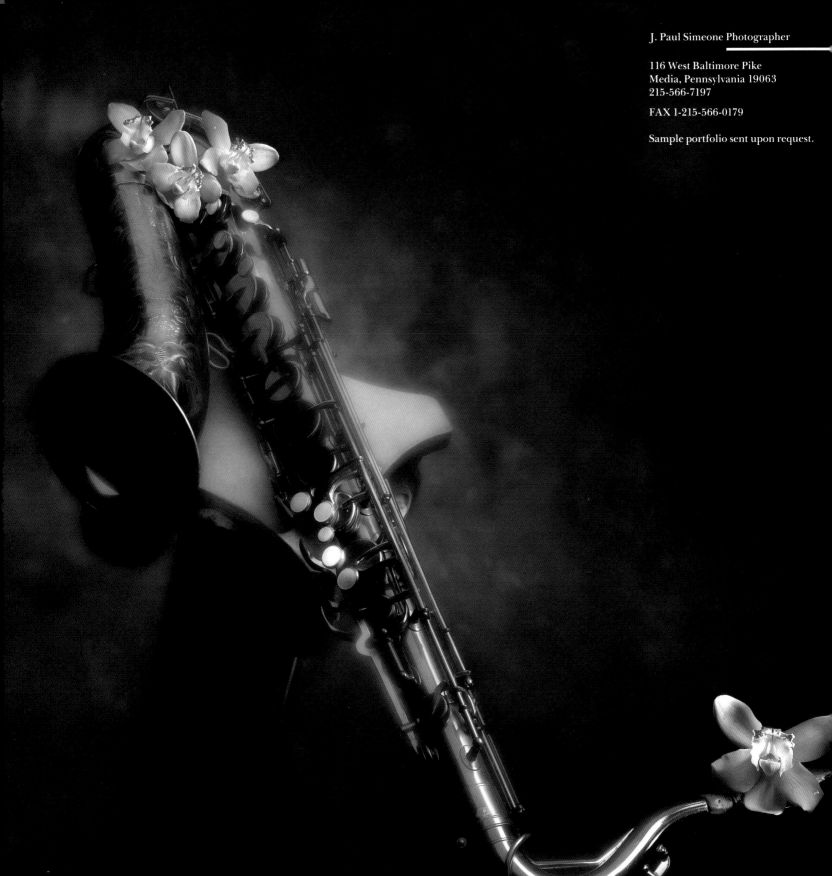

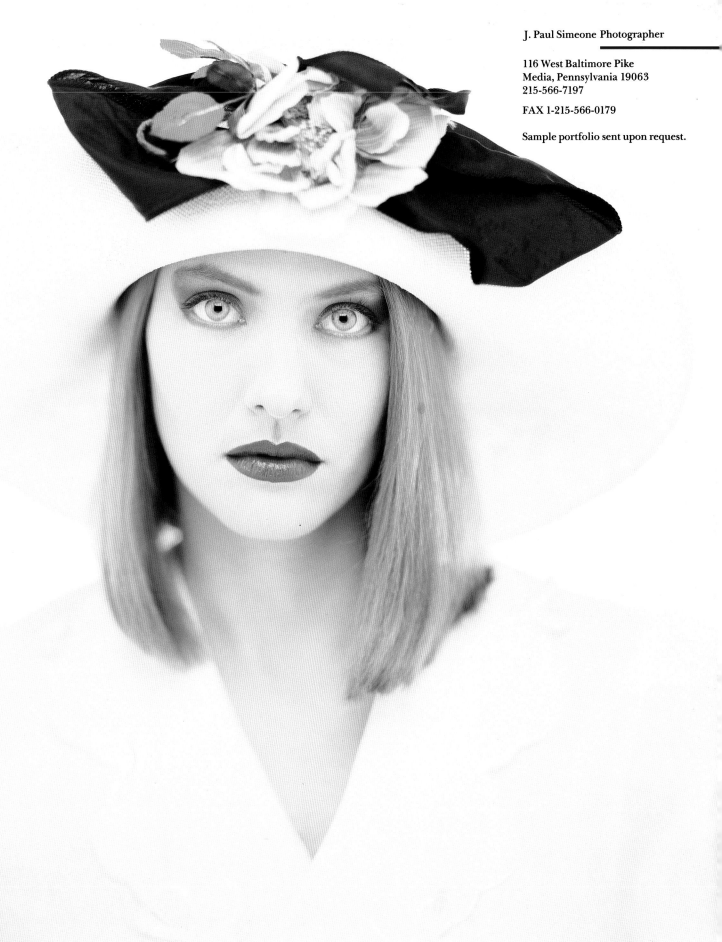

J. Paul Simeone Photographer

116 West Baltimore Pike
Media, Pennsylvania 19063
215-566-7197

FAX 1-215-566-0179

Sample portfolio sent upon request.

**J. PAUL SIMEONE
PHOTOGRAPHER**
215 · 566 · 7197

lou jones
22 randolph street
boston, ma 02118 usa
617/426 6335
212/463 8971

© jones

© jones

clients:
new england telephone
genentech
baxter
bank of boston
business week
bozell
harvard university
rizzoli
financial world
chrysler

international
representation by
the image bank

41

RICKYOUNG
PHOTOGRAPHY, INC.

☎

212.929.5701

FAX:

212.929.5303

✉ 27 WEST 20TH STREET

NEW, NY 10011

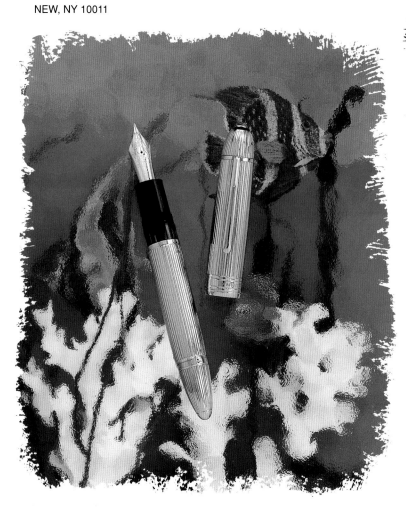

PAMELA BLACK

212.979.2636

42

 20 WEST 27TH STREET
NEW YORK, NY 10011

PAMELA BLACK
212.979.2636

212.929.5701

FAX:

212.929.5303

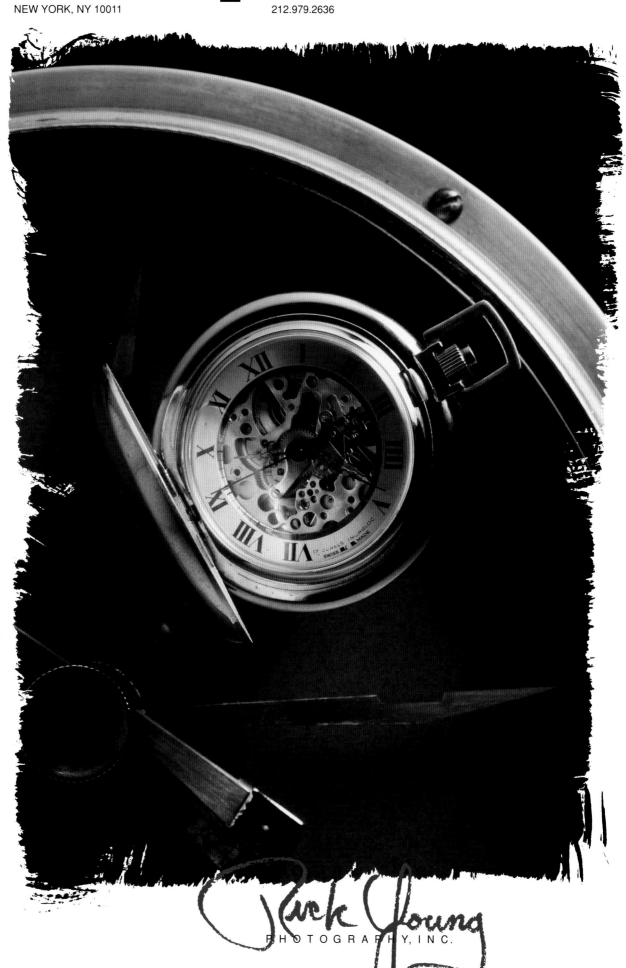

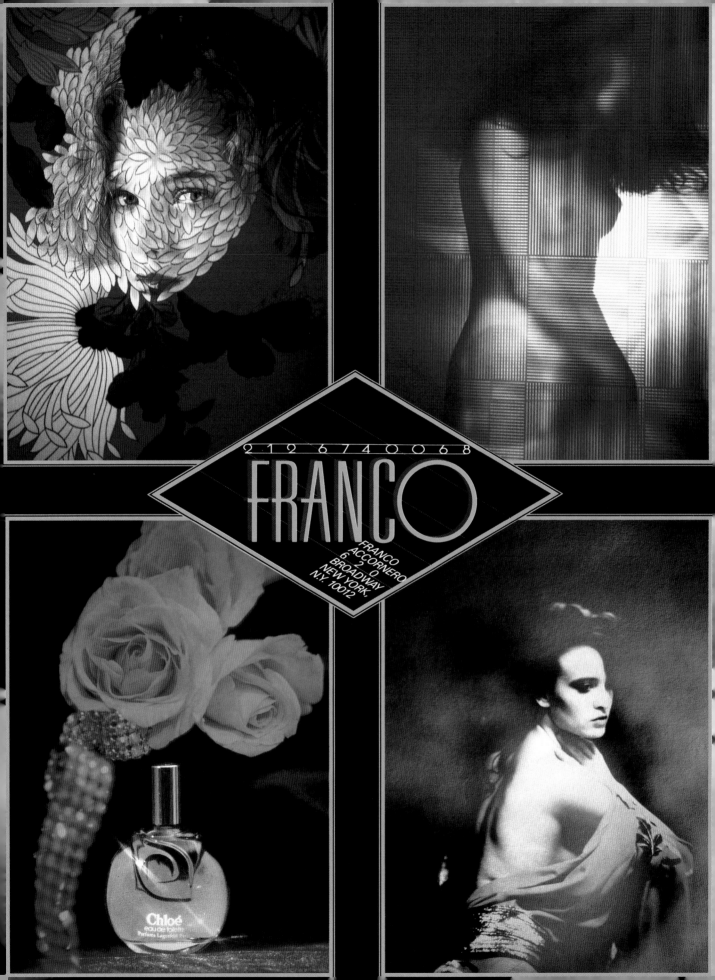

2 1 2 6 7 4 0 0 6 8

FRANCO

FRANCO
ACCORNERO
6 2 0
BROADWAY
NEW YORK,
N.Y. 10012

Chloé
eau de toilette
Parfums Lagerfeld Paris

MYRON JAY
Dorf
ILLUSIONIST

Don't limit your
imagination.

Illusions by Myron Jay Dorf
let you express the
inexpressible.

**205 West 19th Street
New York, New York 10011
(212) 255-2020**

·J·A·C·O·B·Y·

P H O T O G R A P H Y

Graphic Design & Typography by G. Steven Martin

Clients

Caesars Palace

General Cinema

Hilton Hotels

Holiday Inn Crown Plaza

Ken Hurd & Associates

Sun Microsystems, Inc.

The Stubbins Associates

The Waldorf Astoria

© *Edward Jacoby 1991* 108 Mt. Vernon Street • Boston • Massachusetts • 02108 • (617) 723-4896

·J·A·C·O·B·Y·

P H O T O G R A P H Y

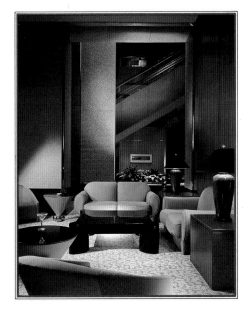

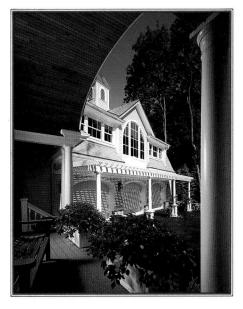

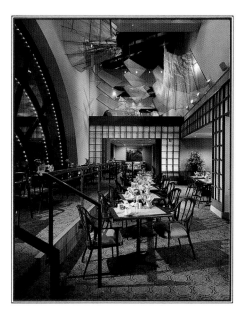

Graphic Design & Typography by G. Steven Martin

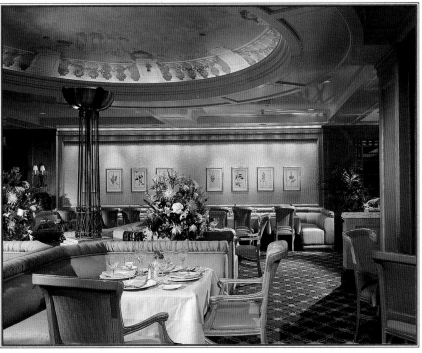

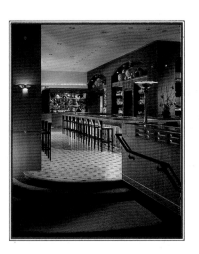

Clients

Caesars Palace

General Cinema

Hilton Hotels

Holiday Inn Crown Plaza

Ken Hurd & Associates

Sun Microsystems, Inc.

The Stubbins Associates

The Waldorf Astoria

108 Mt. Vernon Street • Boston • Massachusetts • 02108 • (617) 723-4896

© Edward Jacoby 1991

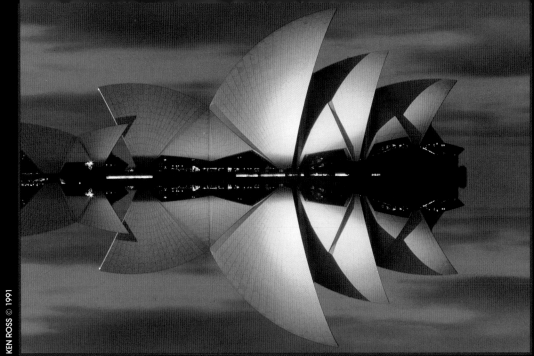

KEN
ROSS

LOCATION PHOTOGRAPHY

80 MADISON AVENUE
NEW YORK CITY 10016
(212) 213-9205
FAX: (212) 686-1527

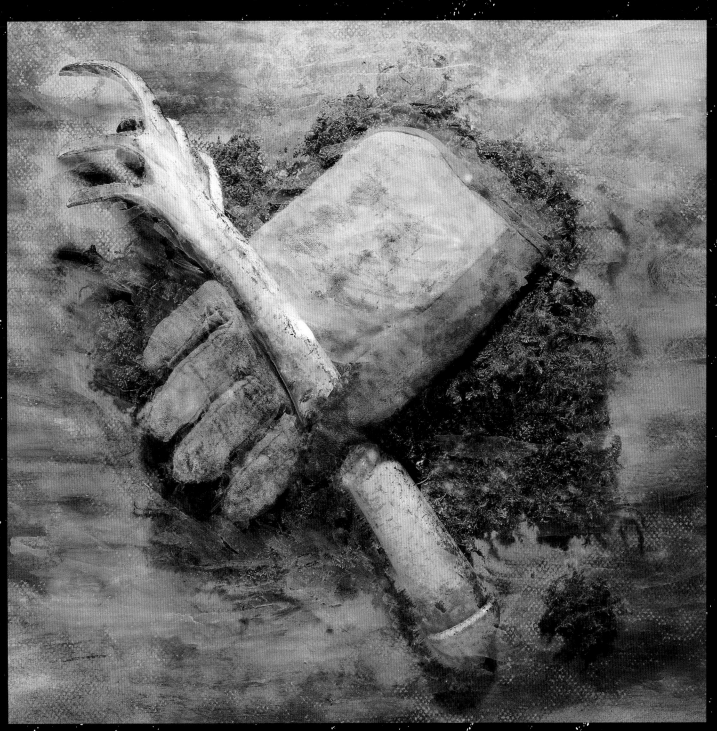

"HandTool"

Robert Grant • (212) 925-1121 Fax • (212) 431-5280 Agent • Ellen Cullom • (212) 777-1749

From Main Street...

DUNWELL

Steve Dunwell Photography
20 Winchester Street, Boston, Massachusetts 02116
Tel: 617.423.4916 Fax: 617.695.0059

STOCK AT THE IMAGE BANK

...to San Marco.

DUNWELL

Steve Dunwell Photography
20 Winchester Street, Boston, Massachusetts 02116
Tel: 617.423.4916 Fax: 617.695.0059

ANDY WASHNIK STUDIO, 145 WOODLAND AVE, WESTWOOD, NJ 07675 • 201-664-0441

WASHNIK

WASHNIK

ANDY WASHNIK STUDIO, 145 WOODLAND AVE, WESTWOOD, NJ 07675 • 201-664-0441

Mark Homan Photography
1916 Old Cuthbert Rd.
Cherry Hill, NJ 08034
(609) 795-6763 • **FAX** (609) 795-8139

Corporate reports, commercial, industrial, portraiture, and photo illustration.

Partial client list includes: Westinghouse, Dun & Bradstreet, Southwest Bell, Bantam Books,RCA,Ducati, Mazda of America, Penn State University, Independence Blue Cross, ARA, Resorts International, Wheaton Glass, Weyerhauser,GE, Sealy Serta, Regina, Inc., J.C. Penney, Dodge Chrysler.

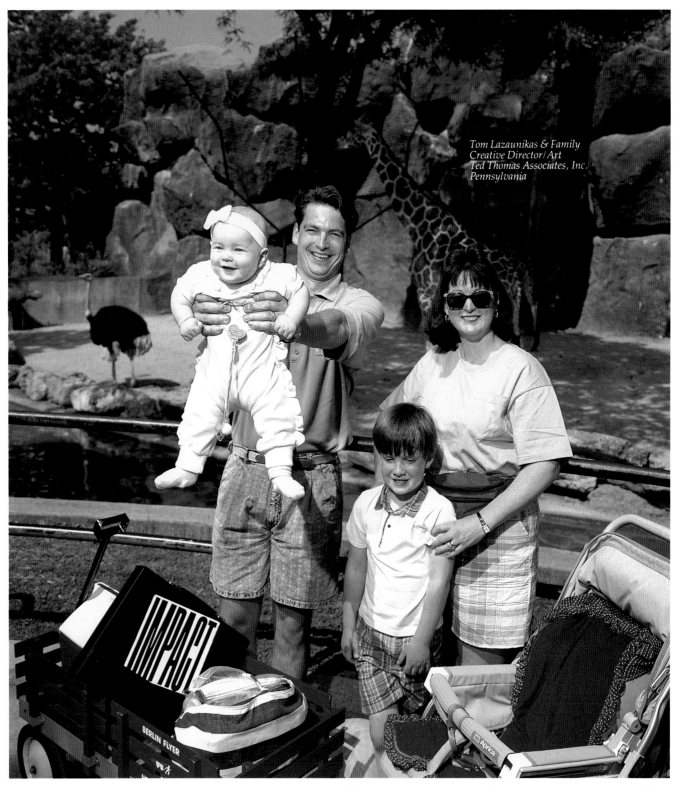

*Tom Lazaunikas & Family
Creative Director/Art
Ted Thomas Associates, Inc.
Pennsylvania*

Touching and Compelling...I almost cried!

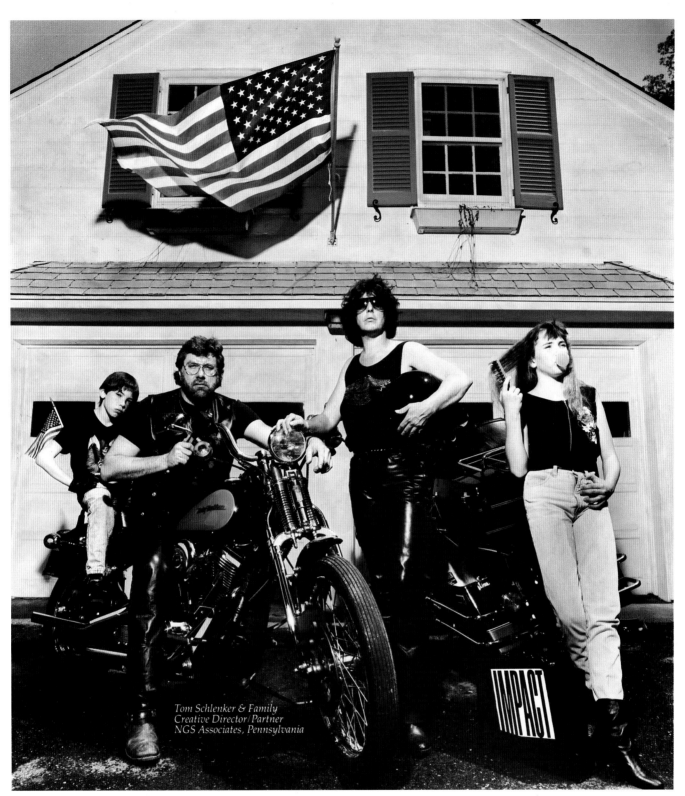

Tom Schlenker & Family
Creative Director/Partner
NGS Associates, Pennsylvania

Wonderfully Twisted…Original & Satisfying.

So what are you waiting for, Book the Book
Call 1-800-726-3988 It will be there tomorrow.

Impact Studios, Ltd.
Photography
Film and Video Production
1084 North Delaware Avenue
Philadelphia, PA 19125

LUCY**COBOS**PHOTOGRAPHY

P.O. BOX 8491
BOSTON, MASSACHUSETTS 02114
617 • 876 • 9537

PORTFOLIO SENT UPON REQUEST.

MARK LYON 145 WEST 58TH STREET NYC 10019 212.333.2631

HAMISH MAXWELL, CORPORATE GIANT & FORMER CEO OF PHILIP MORRIS.

BRUCE CUTLER, LEGAL WIZARD & DEFENSE ATTORNEY.

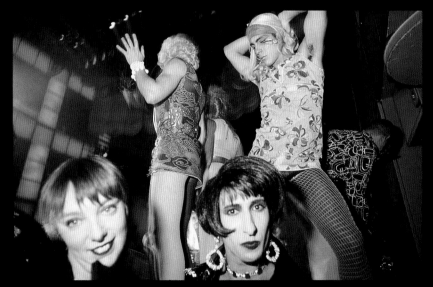

BOYS AT THE PALLADIUM HALLOWEEN BASH.

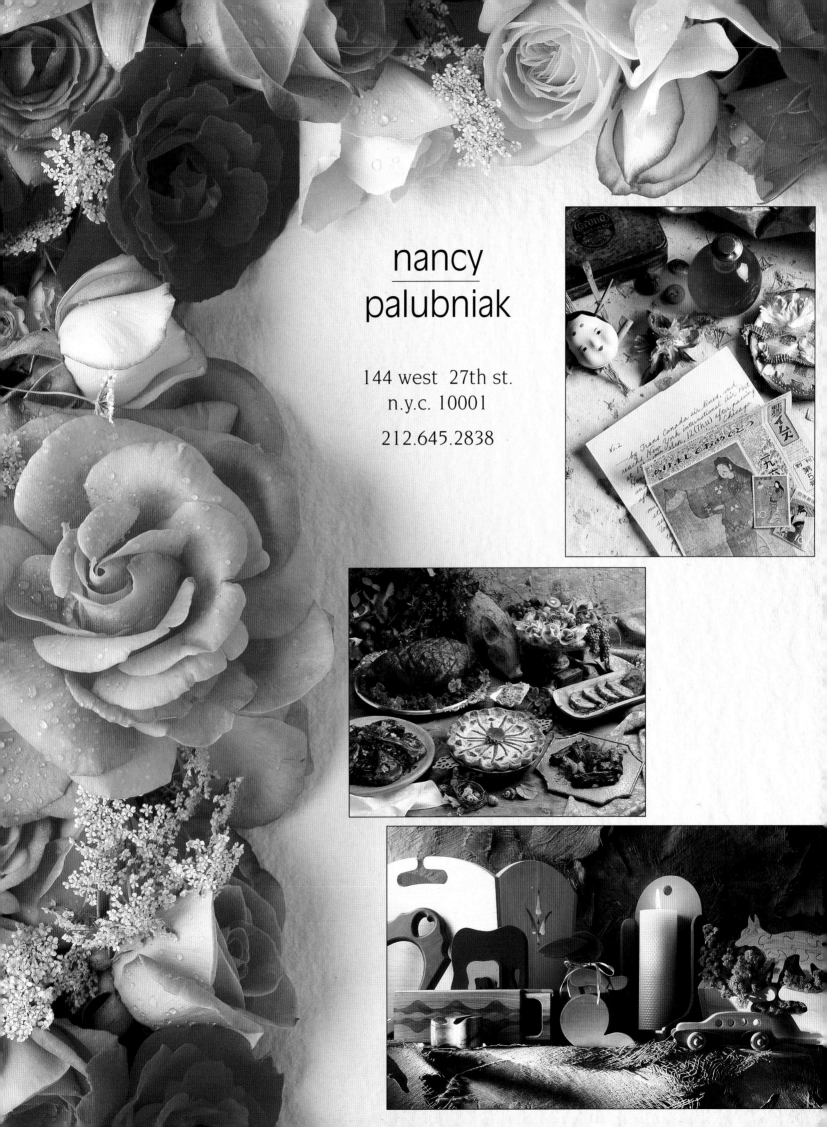

nancy
palubniak

144 west 27th st.
n.y.c. 10001

212.645.2838

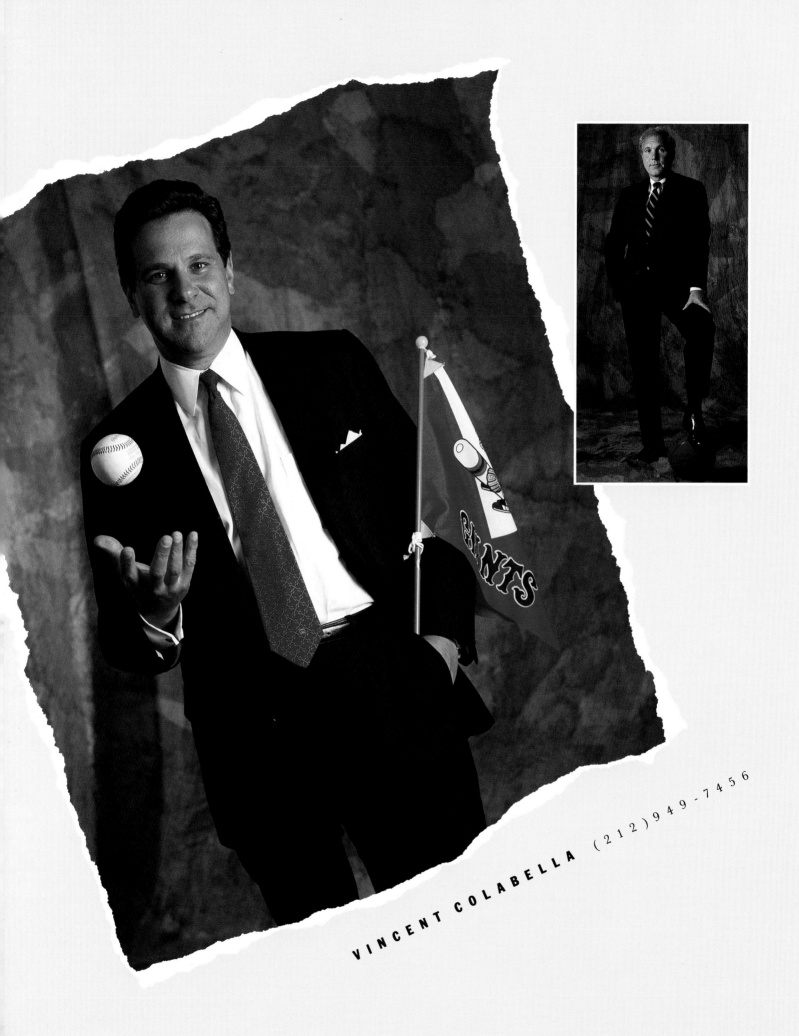

VINCENT COLABELLA (212) 949-7456

KEITH GLASSMAN

365 FIRST AVENUE NEW YORK N.Y. 10010 (212) 353·1214 FAX (212) 353·1675

DICK VAN PATTEN

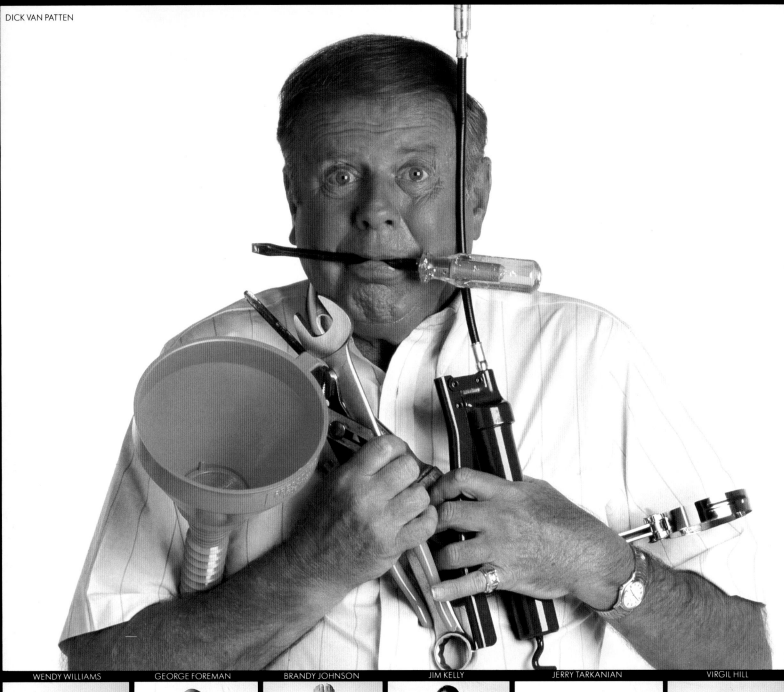

WENDY WILLIAMS

GEORGE FOREMAN

BRANDY JOHNSON

JIM KELLY

JERRY TARKANIAN

VIRGIL HILL

© Copyright John Kane

Decorating and Remodeling—NY Times

JOHN KANE

PHOTOGRAPHER
Studio • Location • Stock
Phone 203•354•7651

SILVER SUN STUDIO
55 WEST ST PO BOX 731
NEW MILFORD, CT 06776

Victoria 1991

Crabtree & Evelyn

Landwehrle

DON LANDWEHRLE
9 HOTHER LANE, BAY SHORE, N.Y. 11706
PHONE/FAX (516) 665-8221

ADVERTISING • CORPORATE • EDITORIAL

W A N G

TONY WANG STUDIO, INC.

118 EAST 28 STREET NEW YORK NY 10016

PHONE 212.213.4433

FAX 212.213.4547

REPRESENTED BY: MAY LEE

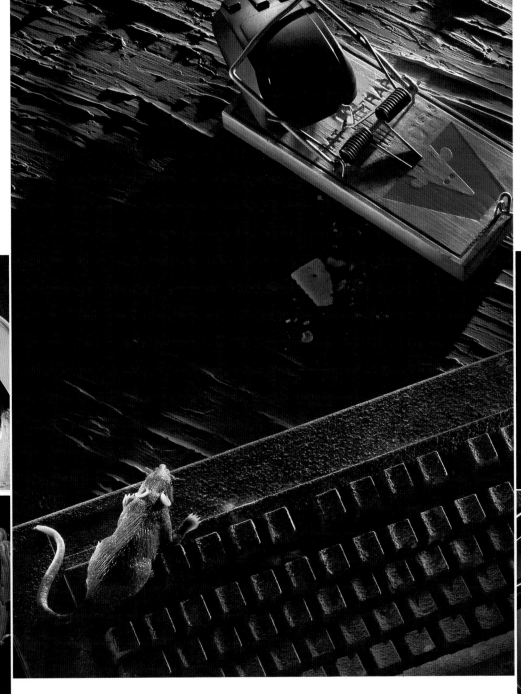

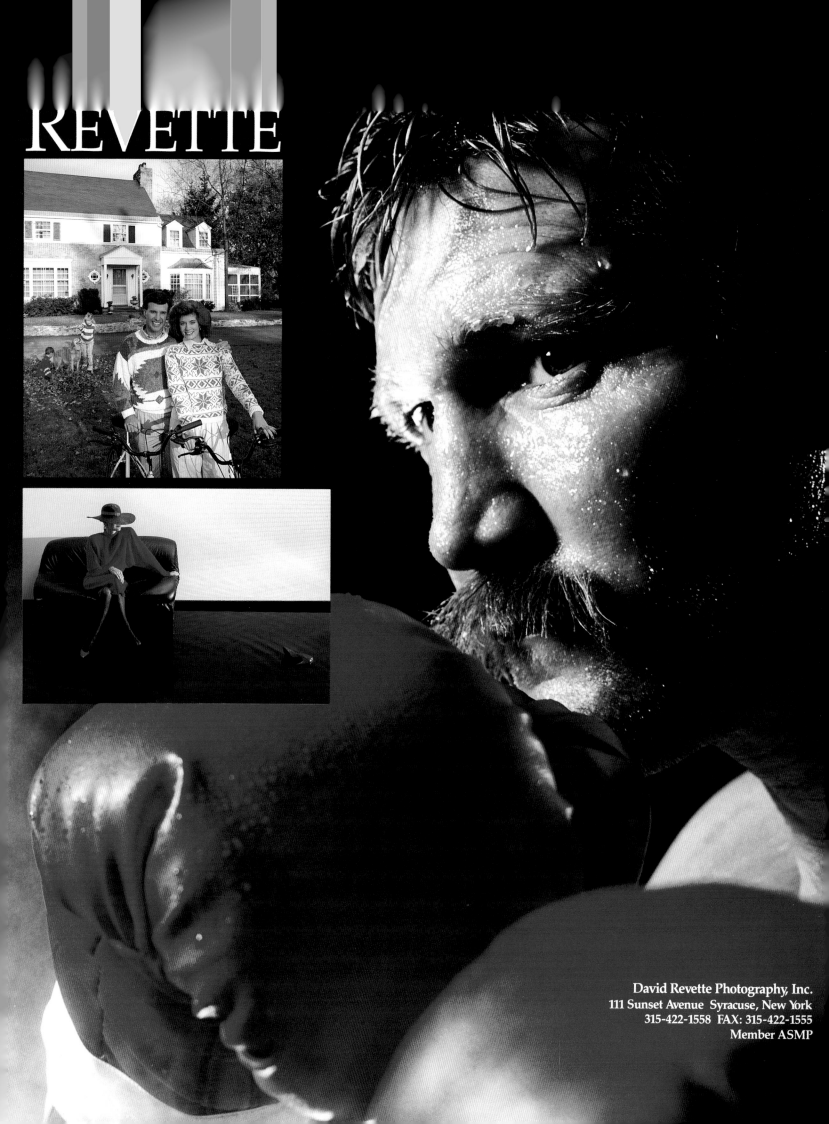

REVETTE

David Revette Photography, Inc.
111 Sunset Avenue Syracuse, New York
315-422-1558 FAX: 315-422-1555
Member ASMP

**Carlos Alejandro
Photography**
8 East 37th Street
Wilmington, Delaware 19802-2321
(302) 762-8220

**Andris · Hendrickson
Photography**
408 Vine Street
Philadelphia, Pennsylvania 19106
(215) 925-2630
FAX: (215) 925-2653

Andris · Hendrickson
Photography
408 Vine Street
Philadelphia, Pennsylvania 19106
(215) 925-2630
FAX: (215) 925-2653

**Wendy Barrows
Photography**
175 Fifth Avenue
suite 2508
New York, New York 10010
(212) 685-0799
(203) 254-0685 in Connecticut

See my work in American Showcase
volumes 8-15.

CAROLYNE ROEHM, PRESIDENT & DESIGNER, CAROLYNE ROEHM INC.

SCIENTIST, IBM

JOSEPH DiMARTINO, PRESIDENT, THE DREYFUS CORP.

Martin Berinstein
Photography
215 A Street, 6th Floor
Boston, Massachusetts 02210
(617) 268-4117
FAX: (617) 268-2829

ASMP Member

MARTIN BERINSTEIN

photography

Mark Bolster/Pittsburgh
(412) 231-3757
FAX: (412) 231-0930

Real life specialist. On location.
All photos © 1992 Mark Bolster

PEOPLE AND LIFESTYLES.

ON LOCATION. ORDINARY EVENTS.

PRODUCED AND PHOTOGRAPHED

WITH EXTRAORDINARY STYLE

AND ENTHUSIASM.

Mark Bolster

412 . 231 . 3757

James Bozman
(212) 889-8319

Kevin Bubbenmoyer
RD #2 Box 110
Orefield, Pennsylvania 18069
(215) 395-3052
FAX: (215) 395-3236

The most common question I'm asked is "where in the hell is Orefield." Actually it's about as far from hell as you could get. Just outside of Allentown, PA it's as close as a phone.

We shoot everything from people to food to cars. Occasionally, even the breeze. You'd be amazed at what you can find in the country.

DESKTOP TECHNOLOGIES, INC.

BOSE CORP.

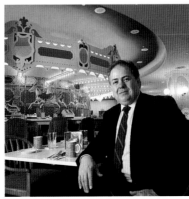

BOSE CORP.

BOSE CORP.

**Robert Buchanan
Photography**
56 Lafayette Avenue
White Plains, New York 10603
(914) 948-9260
FAX: (914) 948-9266

Represented by:
Connections Unlimited
37 E. 29th Street, Suite 506
New York, NY 10016
(212) 696-4120

914/948-9260

Robert Buchanan
PHOTOGRAPHY

914/948-9260

83

COMMON SENSE AND PLAIN DEALING

"Nothing astonishes men so much as common sense and plain dealing"
-Ralph Waldo Emerson

Professional photographers and their clients share at least one common trait: They own businesses which have to be run like businesses if they are to succeed.

Every business has needs and the right to fulfill them. Consequently, many business owners appreciate that a mutual concern for each other's needs is simply common sense. And plain dealing, through negotiations aimed at meeting each other's needs, is the way to a fair deal.

There has been a storm brewing for years in the communication arts industry, and at the center of that storm is: copyright ownership. It has taken on greater proportions than almost any other issue in the industry's history, as copyright ownership and "work for hire" seem to be catalysts in the never-ending battle of demands and claims between the photographer and client. This storm must blow itself out. The alternative, to carry out the analogy, is unending storm damage. With so much at stake for both sides, this conflict must be resolved.

People fight out of need more than greed, and the key to resolving any conflict is to meet the needs of both parties. Hence, the first step requires an acknowledgment of these needs by the parties involved.

Let's look at the needs of the typical client being serviced by the typical photographer. Clients need to:

• Exploit every dollar they expend to the maximum.

• Maximize their income to assure their future profits.

• Protect their image and name from harm.

• Avoid disadvantaging themselves in future dealings.

• Avoid liability and damage from unforeseen circumstances.

Now, when a client makes a demand that a photographer sign over his or her copyright, it is usually for one of these underlying, abstract, but understandable reasons.

However, what the photographer hears from the client is something quite different: Clients say that a copyright must be transferred to protect a proprietary process, or corporate identity; they say that they do not want to have to renegotiate additional use; they say that they must have it because their legal departments have told them that this is the way to do it.

All of these arguments are understandable, but unconvincing to the majority of photographers who put their hearts and souls into their work. Photographers, like their clients, are businesses, and in fact, share many of the same needs. And, when working together, clients and photographers also have similar interests: Both desire a quality job, which they can exploit, and from which they can obtain future value, and for which they will exchange fair value. This makes perfect sense. Now let's get to plain dealing .

Photographers have to recognize that their clients have the right to fulfill their needs. Supporting that right and fulfilling those needs is good business. Clients must also recognize that photographers have the right to fulfill their own needs and recognize and support that right.

However, many businesses fail to see the needs of their photographers. They take a shortsighted view of the business relationship, and try to "win it all" in their negotiations, under the assumption that the supply of talented photographers will never shrink. In other words, they put copyright control as their "bottom line," and tell photographers to "take it or leave it."

continued on page 88

John Burke Photography
60 K Street
Boston, Massachusetts 02127
(617) 269-6677
FAX: (617) 269-0713

Real life scenarios made to order.
Believable lifestyle photography on
location.

Client shown below: Dalzell and
Company for Nurse Mates.

Additional work can be seen in
American Showcase 13 & 14.

John Campos Studio Inc.
411 West 14th Street
New York, New York 10014
(212) 675-0601
FAX: (212) 242-5209

John Campos Studio Inc.
411 West 14th Street
New York, New York 10014
(212) 675-0601
FAX: (212) 242-5209

continued from page 84

No one can see far enough into the future to determine if the ranks of qualified photographers will totally dry up as a result of battles over copyright. However, copyright transfer demands can be a death blow to a photographer's business, and the pool of photographic talent working right now is being affected, and will continue to be affected.

"Take it or leave it" copyright demands bring to mind the story of the shortsighted businessman who made such a good deal with a critical supplier that it put the supplier out of business, which in turn crippled the buyer's business when other suppliers could not meet his demands. So let's examine the other side of the story: Why should a photographer need to retain the copyright to his or her work? The answers are simple. His or her business needs are:

• To establish a body of work that serves as asset and identity.

• To have the right to promote themselves by showing the fruits of their labors .

• To increase future income and profitability to assure future stability and growth .

• To guard against improper exploitation of creative efforts.

Like the business's needs, these are logical. But now let's look at a list of specific needs of the client with regards to a photography assignment. From each job, the client needs:

• The right to increase usage and expand to other media.

• To control and maximize the benefit from expense.

• To maintain necessary confidentiality and exclusivity of use.

• To have predictable costs and avoid uncertain future pricing.

• To profit from commissioned creative work.

Interestingly enough, this set of needs is not irreconcilable with those of a photographer. In fact, it is competitive and complementary at the same time .

The competitive aspect rests solely in the price to be negotiated. Each party wants the most they can get from their time and for their money. This kind of competitive interest is good for the relationship and is usually easily negotiated. The interests of each party are complimentary in that neither side is in conflict with the other. The needs of each can be met with simple understanding based on common sense and plain dealing. Here's how:

First, it should be stated that copyright can be bought or sold when deemed appropriate by both the client and the photographer (anyone can sell an asset if he or she chooses). However, it usually isn't necessary.

Realistically, there is no client need or interest regarding copyrightable work that can not be licensed or contractually provided for by the photographer/copyright owner. For example, pricing of future uses, expanded circulation, re-uses, etc., can all be agreed to in the early stages of a negotiation. Whether by fixed fee, percentage of original fee, or by no increase in fee at all, both the financial interest of the client, as well as the right to exercise such future uses at will, absolutely can and should be protected .

continued on page 92

Suki Coughlin
Photography
Main Street Box 1498
New London, New Hampshire 03257
(603) 526-4645
FAX: (603) 526-4645

Advertising
Architectural Interiors
Corporate
Editorial
People
Location
Travel

Clients Include:
• AT&T Bell laboratories
• CVS
• Family Media, Inc.
• Greater Boston Publishing, Inc.
• Long Island Publishing, Inc.
• Meredith Corporation
• Omni Hotels

• The New York Times
• Sotheby's
• Time, Inc.

See American Showcase 14
Member ASMP
© 1991 Suki Coughlin
Stylist: Paula McFarland

Paul Elson
(212) 744-6690
FAX: (201) 662-7993

Clients:
• Hotels: Hilton International, 31 properties; Marriott, 27 properties; Hyatt, 16 properties; Sheraton, 7 properties; Trust Houses Forte, 5 properties; Conrad International; Omni; Ritz Carleton; RockeResorts; Helmsley Hotels; Intercontinental; Regent; Boca Raton Resort & Tennis Club; Westin; Hilton.
• Airlines: American; TWA; TAP; Alitalia; Pan Am.
• Government Tourist Boards: Mexico; Puerto Rico; Curaçao; Bermuda.
• Cruise Lines: Holland America; Cunard; Royal Viking; Costa; Chandris.
• Magazines: Travel & Leisure; Bon Appetit; Food & Wine; New York Magazine; Money; GQ; Fortune.

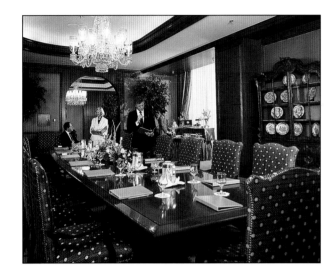

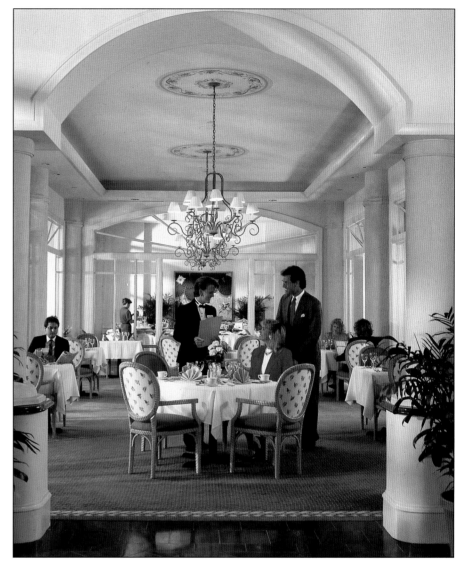

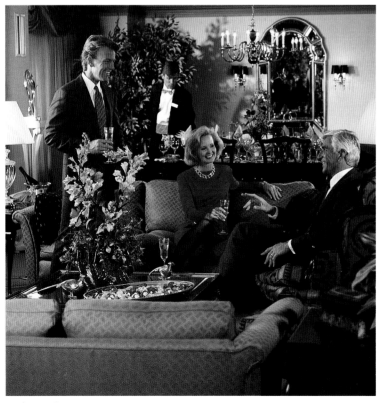

Paul Elson
(212) 744-6690
FAX: (201) 662-7993

Clients:
• Hotels: Hilton International, 31 properties; Marriott, 27 properties; Hyatt, 16 properties; Sheraton, 7 properties; Trust Houses Forte, 5 properties; Conrad International; Omni; Ritz Carleton; RockeResorts;

Helmsley Hotels; Intercontinental; Regent; Boca Raton Resort & Tennis Club; Westin; Hilton.
• Airlines: American; TWA; TAP; Alitalia; Pan Am.
• Government Tourist Boards: Mexico; Puerto Rico; Curaçao; Bermuda.

• Cruise Lines: Holland America; Cunard; Royal Viking; Costa; Chandris.
• Magazines: Travel & Leisure; Bon Appetit; Food & Wine; New York Magazine; Money; GQ; Fortune.

continued from page 88

Clients often have a need to protect certain assets, their image, processes, executives and employees from undesired exposure. This proprietary interest can and must be protected. Again, this can be done by guarantee of the photographer, who as copyright owner should agree to not license such images for any other use by anyone except the original client. When clients protect their needs and secure their interests in such a manner, it allows the photographer to exploit the value of the non-proprietary images for his or her future gain, whether it is from the promotional value of the work or from the residual value in the rights not granted to the original client.

From the photographer's side, the majority of photographers make some share of their revenues from the sale of such residual rights. These revenues contribute to the profitability of the business, which in turn keeps the general cost of assignment photography lower. It is simple mathematics. If a photographer cannot use a commissioned work to obtain residual rights, it will simply drive the price of commissioned work up and up. If you take away that right, you must pay the price to cover the loss of that right.

Hence, a simple understanding of the needs of the client and photographer can lead to a dramatically improved working relationship: one in which the photographer and the client work together to produce the finest possible result and the best possible price; one in which the photographer and the client get all the value to which they are entitled by their needs, not their wants; one in which the mutual dependency of both is recognized and provided for. The simple fact is that all of this conflict over copyright ownership could be put to rest with common sense and plain dealing.

Creative photography is not a commodity. The "I paid for it; I own it" attitude simply isn't in the best interests of the business relationship. Unlike a commodity, a photograph can be used over and over again. It can be everlasting. No stationer would sell a box of envelopes if the box never ran out. That stationer would soon learn that the only way to stay in business would be to lease the use of the endless supply of envelopes.

The interests of photographers and clients are not irreconcilable. These interests can easily be accommodated by simple negotiations aimed at meeting the needs of both the client and the photographer.

Let's hope that common sense and plain dealing soon eliminate the current trend of "take it or leave it."

Richard Weisgrau
Executive Director
ASMP-American Society of Magazine Photographers, Inc.
©1991, ASMP

Bill Farrell
(212) 683-1425

Rep: **Ursula Kreis**
(212) 562-8931
FAX: (212) 562-7959

I work hard to make my photographs of
people look as spontaneous, as natural
and as full of life as possible.

Bill Farrell

617 423 6638

C. Fatta Studio

Carol Fatta
25 Dry Dock Avenue
Boston, Massachusetts 02210
(617) 423-6638

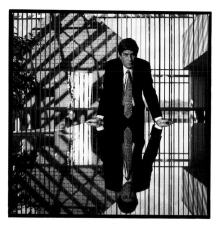

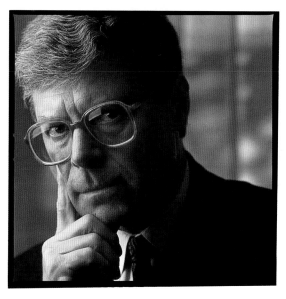

617 423 6638

Simon Feldman Studio
39 West 29th Street
New York, New York 10001
(212) 213-1397
FAX: (212) 683-1657

Clients include
Age International
Austin Nichols
American Express
Bulova Watches
Colours/Alexander Julian
Gear Inc.

Konica Copiers
Lever Bros.
Nautica Fashions
Parker Bros.
Peugeot Cycles
Remco Toys

Remy Martin
Stetson Eyeware
United Way of America

Member ASMP
Stock Available

Jon Fisher
236 West 27th Street
New York, New York 10001
(212) 206-6311
FAX: (212) 627-3136

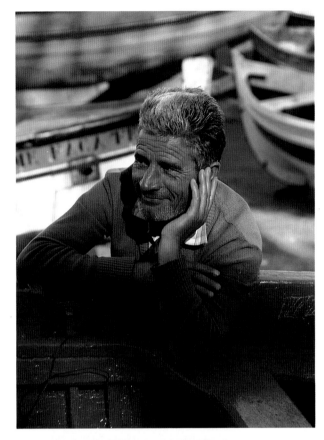

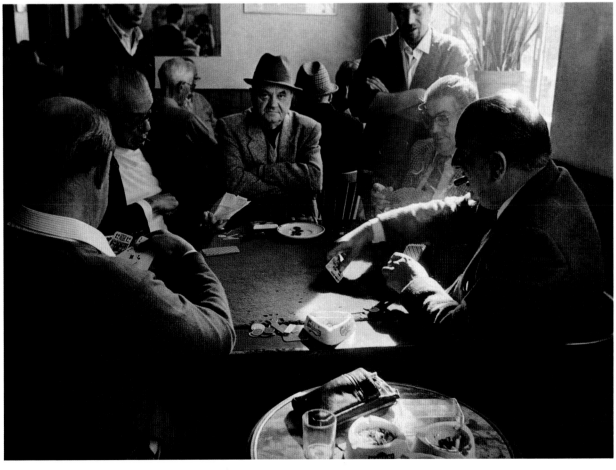

Stock Photography Handbook

A must if you intend to:
- Start a stock business
- Find a stock agency
- Increase your income
- Learn to price stock
- Create an estate
- Produce stock photos
- Sell your own stock
- Become computerized
- Profit from new technology
- Improve negotiating skills
- Protect yourself legally

Ordering Information
Single Copy $29.95
+ 3.00 (U.S. Delivery)

Available Discounts:
ASMP Chapters, 40%; ASMP Members & Affiliates, 20%; Academic Institutions, 40%; Photography Workshops, 40%.

Payment must accompany order. N.Y. City and State residents add appropriate sales tax. Distributors, retailers, book stores, and high volume purchasers—discounts negotiated on basis of quantity. Discounts subject to a minimum order of ten (10) books.

Order from:
ASMP (The American Society of Magazine Photographers, Inc.), 419 Park Ave. South, Suite 1407, New York, N.Y. 10016. Telephone (212) 889 9144.

SOFT MATE®
WEEKLY CLEANING SYSTEM
removes everything*...including the risk of enzyme reaction

The intensive enzyme-free cleaning system for all soft lenses... including all extended-wear

☐ Unlike enzymatic cleaners, rapidly removes protein and nonprotein buildup without leaving irritating enzyme residues

☐ Safely cleans away other naturally occurring residues such as lipids, oils, and mucus

☐ Removes enzyme-resistant soilants such as mascara, nicotine, lipstick, hand lotion, and petroleum jelly

☐ Offers the ease of a ready-to-use solution—to users of either chemical or thermal disinfection systems

With the hydrodynamic cleaning action of the HYDRA-MAT® II, featuring the easy-to-open top.

SOFT MATE®
WEEKLY CLEANING SYSTEM
The intensive enzyme-free cleaner

BARNES·HIND HYDROCURVE INC.
◆A Revlon Vision Care Company

Triple Protection
Aqua-fresh
Reduces caries, freshens breath, and removes extrinsic stains

YOU ASKED FOR IT!
Easy-to-read, color-coded labels for fast, error-resistant product identification

world leader in pharmaceutical research

JANSSEN PHARMACEUTICA
Janssen Pharmaceutica Inc.
Piscataway, NJ 08854

Squish!
A good habit that's good for your teeth.

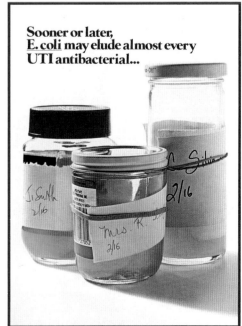

Sooner or later, E. coli may elude almost every UTI antibacterial...

Al Francekevich
73 Fifth Avenue
New York, New York 10003
(212) 691-7456
FAX: (212) 727-9617

Specializing in conceptual photography. © 1992 Al Francekevich
Assignments and stock.

Al Francekevich
73 Fifth Avenue
New York, New York 10003
(212) 691-7456
FAX: (212) 727-9617

Specializing in conceptual photography. © 1992 Al Francekevich
Assignments and stock.

Mitchell Funk
500 East 77th Street
New York, New York 10162
(212) 988-2886

Large stock file available.

Partial list of clients includes: IBM,
AT&T, TWA, Nikon, Newmont Mining,
Inmont, Litton Industries, Life, Fortune,
Newsweek, New York Magazine,

Polaroid, Western Electric, Science
Digest, J&B Scotch, Fuji, Omni,
Johnnie Walker Red, ABC.

Mitchell Funk
500 East 77th Street
New York, New York 10162
(212) 988-2886

Large stock file available.

Tony Generico
130 West 25th Street
New York, New York 10001
(212) 627- 9755
FAX: (212) 727-2856

Clients Include: AT&T, American Express, Master Card, Chase Manhattan, R.J. Reynolds, The Gillette Company, CBS, Lancome, Guerlain, Western Union, Hasbro, Tyco, McGraw Hill, Britannica, The Conde Nast Publications.

Additional Work Can Be Seen In American Showcase 13 & 14

Selected Stock Available

Member of APA & ASMP

Howard Goodman
New York
(914) 737-1162 Studio
FAX: (914) 737-6995

Represented by Lisa Breznak
(914) 737-1162

Clients: General Foods, IBM,
Dictaphone, Fuji, Burger King, Chase
Manhattan Bank, Microsoft, Gannett.

Collections:
Whitney Museum of American Art,
International Museum of Photography
at George Eastman House.

Studio and Location
Product Photography

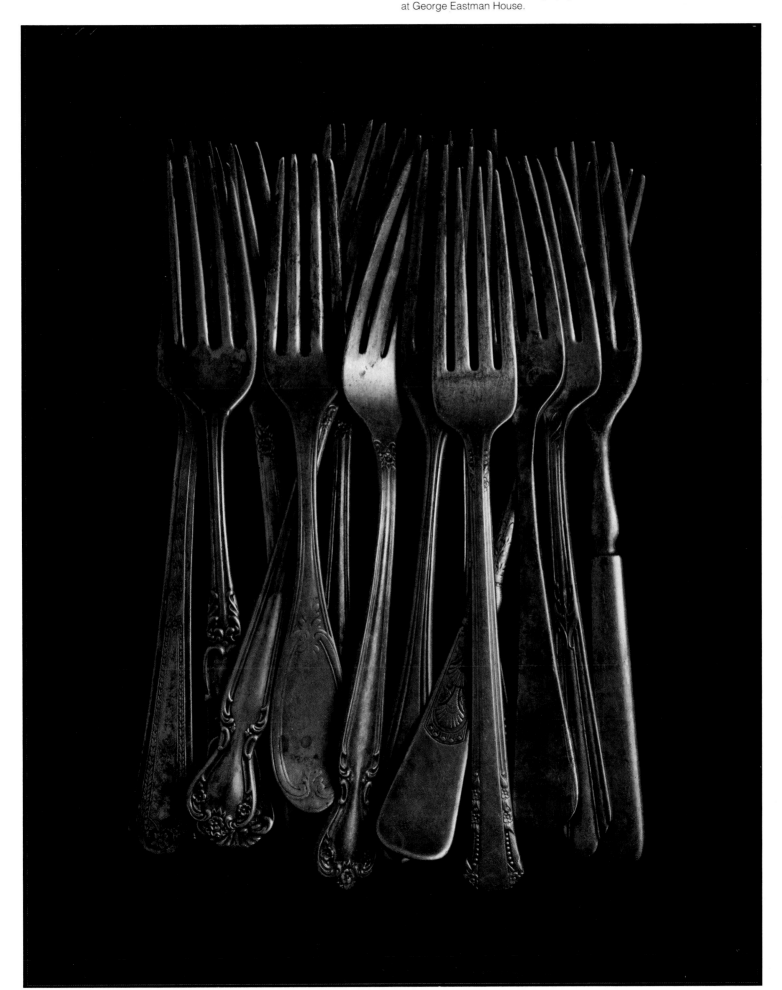

Stephen Green-Armytage Member APA & ASMP
171 West 57th Street
New York, New York 10019
(212) 247-6314
FAX available

Stephen Green-Armytage Member APA & ASMP
171 West 57th Street
New York, New York 10019
(212) 247-6314
FAX available

*Advertising
Photographers
of America Inc.*

apa

Advertising Photographers
Any Street
Anywhere, USA

Dear Advertising Photographer:

In May, 1981, a group of advertising photographers met to address some of the problems dealing with our specialty. Before long, we formed the **Advertising Photographers of America**. And today, we have more than 2,000 members in eight chapters—and we're growing.

Here's the point. If you're an advertising photographer, by God, you should be a member of **APA**!

Why? Because we know it's a tough world out there. And we're dealing every day with the problems, joys, legalities, tax ramifications, technologies, trends, negotiating skills, personalities and opportunities of our professional niche called advertising photography.

And we've got the muscle and knowledge to make a difference in your business.

So, if you're an ad photographer and you're not an **APA** member, you're missing the boat. We talk your language. We understand. And we help.

Call the regional office nearest you...and get the scoop.

Happy Decade,

Mickey McGuire

Mickey McGuire
President, APA National

APA/Atlanta
Jamie Cook
1740 Defoor St.
Atlanta, GA 30318
(404) 351-1883

APA/Chicago
Angela West-Blank
1725 West North Ave. Ste. 202
Chicago, IL 60622
(312) 342-1717

APA/Detroit
Anne Marie Harris
32588 Dequindre
Warren, MI 48092
(313) 978-8932

APA/Florida
Rick Gomez
2545 Tiger Tail Ave.
Coconut Grove, FL 33033
(305) 856-8338

APA/Hawaii
Ric Noyle
733 Auahi Street
Honolulu, HI 96813
(808) 524-8269

APA/Las Vegas
Larry Hanna
3347 South Highland Ste. 304
Las Vegas, NV 89109
(702) 737-1103

APA/Los Angeles
Dorie Loughlin
7201 Melrose Avenue
Los Angeles, CA 90046
(213) 935-7283

APA/Maine
Warren Roos
135 Somerset Street
Portland, ME 04101
(207) 773-3771

APA/New York
Marilyn Wallen
27 West 20th St.
New York, NY 10011
(212) 807-0399

APA/San Francisco
Patricia O'Brien
22 Cleveland Street
San Francisco, CA 94103
(415) 621-3915

H/O Photographers, Inc.

John S. Sheldon
John Sherman
197 Main Street, PO Box 548
Hartford, Vermont 05047
(802) 295-6321
FAX: (802) 295-6324

Photography for advertising, industry
and corporate communications.

Ronald G. Harris
119 West 22nd Street
New York, New York 10011
(212) 255-2330

Represented by:
Katherine Moreno-Sanchez

Ronald G. Harris
119 West 22nd Street
New York, New York 10011
(212) 255-2330

Represented by:
Katherine Moreno-Sanchez

Ron Holtz
Washington, DC
(301) 589-7900

•••••

Ron Holtz
Washington, DC
(301) 589-7900

• • • • •

Eric Jacobson Studio
(212) 696-4279

PRESSURE

BALANCE

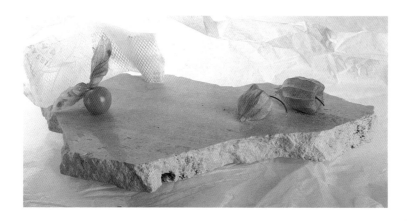

ERIC JACOBSON

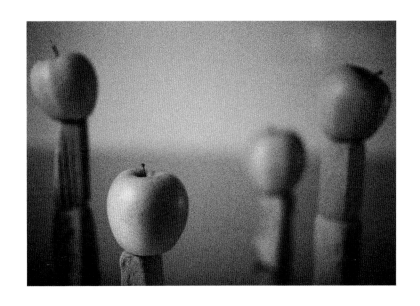

39 W 29 STREET

NEW YORK CITY

212.696.4279

REPRESENTED BY

JOHN HENRY

212.686.6883

George Kamper
15 West 24th Street
New York, New York 10010
(212) 627-7171
FAX: (716) 454-4737

Ursula G. Kreis
(212) 562-8931
FAX: (212) 562-7959

In Michigan: Stage III Productions
(313) 978-7373
FAX: (313) 978-9085

I was given a terrific opportunity to develop a new technique for an ad campaign for the Eastman Kodak Company. The art director and I developed a way of shooting and transferring images to various paper stocks with conventional film. The technique offers a tremendous amount of flexibility, resulting in a very artful final image.

George Kamper
15 West 24th Street
New York, New York 10010
(212) 627-7171
FAX: (716) 454-4737

Ursula G. Kreis
(212) 562-8931
FAX: (212) 562-7959

In Michigan: Stage III Productions
(313) 978-7373
FAX: (313) 978-9085

I was given a terrific opportunity to develop a new technique for an ad campaign for the Eastman Kodak Company. The art director and I developed a way of shooting and transferring images to various paper stocks with conventional film. The technique offers a tremendous amount of flexibility, resulting in a very artful final image.

Catherine Karnow
1707 Columbia Road NW #518
Washington, DC 20009
(202) 332-5656

Represented by
Woodfin Camp:
New York (212) 481-6900

Pacific Press Services:
Tokyo (03) 264-3821

Location photography:
Advertising, people, travel, stock.

Photographs on this page taken
in Scotland for Seagram, Inc.

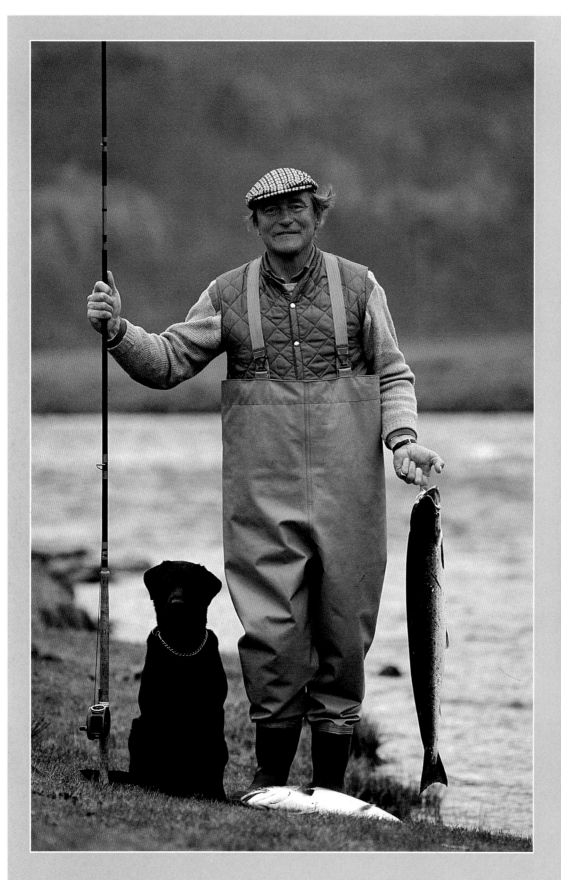

K A R N O W

Reuven Kopitchinski
98 Riverside Drive
New York, New York 10024
(212) 724-1252
(212) 362-0889

Represented by
Cyd Sherman
(212) 724-1252

K O P I T C H I N S K I

BOB REITFELD / ALTSCHILLER REITFELD DAVIS

MIKE HUGHES / MARTIN AGENCY, VIRGINIA

SATCHI & SATCHI AGENCY AD

119

Frank LaBua Photography
377 Hil-Ray Avenue
Wyckoff, New Jersey 07481
(201) 783-6318

Assignments
Fine Art Prints
Stock Images

Frank LaBua

Frank LaBua Photography
377 Hil-Ray Avenue
Wyckoff, New Jersey 07481
(201) 783-6318

Advertising
Corporate
Editorial

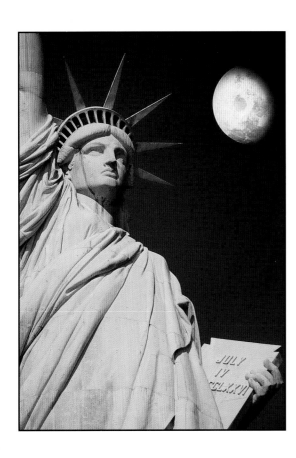

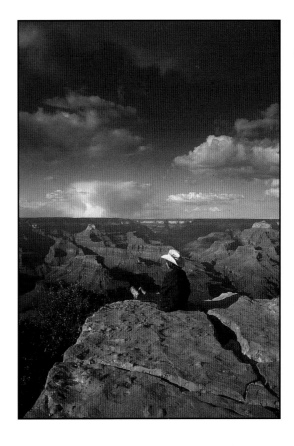

Frank LaBua

**Michel Legrand
John Neitzel**
Skylite Photo Productions, Inc.
152 West 25th Street
New York, New York 10001
(212) 807-9754
FAX: (212) 627-5181

Represented by
Valerie Baker
(212) 807-7113

Thomas K. Leighton
321 East 43rd Street
Penthouse 12
New York, New York 10017
(212) 370-1835

Architectural, Interior, and structural photography: Stock photography and portfolio available upon request.
For additional images see American Showcase Volumes 7-14.

Clients Include: Honeywell, Standard & Poor's, Merrill Lynch, Morgan Stanley, May Centers, Coldwell Banker, John Hancock Properties, Helmsley Spear, Edward S. Gordon, The Spector Group, Gruzen Samton Steinglass, McGraw Hill, Italian Trade Commission, Toys R Us, Long Island Savings Bank

**Paul Loven
Photography, Inc.**
(212) 779-0229 New York City
(602) 253-0335 West Coast
(602) 531-2548 Mobile
FAX: (602) 253-0335

Worldwide location specialist. Creator of award winning (Graphis '91; Photo Design '89) Passport Folio. Fourteen years in business. See Am. Showcase #10 and Black Book 1989 and 1990 for more of my work. If my new style moves you, call for the book.

Partial client list; Northwest Airlines, Windjammer Barefoot Cruises, America West Airlines, Continental Airlines, Best Western, National Geographic Traveler, U.S. Humane Society, Hilton Hotels, Princess Hotels International, Cushman, Ritz Carlton Hotels, Iberia Airlines, Vogue, Travel Holiday.

**Paul Loven
Photography, Inc.**
(212) 779-0229 New York City
(602) 253-0335 West Coast
(602) 531-2548 Mobile
FAX: (602) 253-0335

Worldwide location specialist. Creator of award winning (Graphis '91; Photo Design '89) Passport Folio. Fourteen years in business. See Am. Showcase #10 and Black Book 1989 and 1990 for more of my work. If my new style moves you, call for the book.

Partial client list; Northwest Airlines, Windjammer Barefoot Cruises, America West Airlines, Continental Airlines, Best Western, National Geographic Traveler, U.S. Humane Society, Hilton Hotels, Princess Hotels International, Cushman, Ritz Carlton Hotels, Iberia Airlines, Vogue, Travel Holiday.

Jerry Margolycz Photography
Boston, Massachusetts
(617) 965-6213

People • Portraits
Studio • Location
Advertising • Corporate
Editorial

PHOTOGRAPHY

Margolycz

Phil Matt
PO Box 10406
Rochester, New York 14610
(716) 461-5977
Studio:
1237 East Main Street
Rochester, New York 14609

Stock available directly and through:
Gamma/Liaison (New York and Paris)
Tony Stone Worldwide (London)
Photographic Resources (St. Louis)

See our ads in American Showcase
Vols. 8, 9, 10, 11, 12, 13, 14 and
in Corporate Showcase Vols. 7, 8.

Phil's experience in creating imaginative, well-designed photographs on location has made him a frequent contributor to dozens of major magazines, national newspapers, and specialty publications in many different fields. Art directors and corporate designers bank on his skill in working with people from all walks of life to produce technically precise images that reveal the special dignity and character of his subjects.

Wide-ranging color & B/W stock.
Member, ASMP

1.

2.

3.

Some clients:
(Editorial)

American Way
Barron's
Black Enterprise
Business Week
Business Month
Cahners Publishing
CFO
Changing Times
Computerworld
Connoisseur
Datamation
Entrepreneur
Essence
Farm Journal
Financial World
First
Forbes
Industry Week
Fortune
GEO
Inc.
Information Week
Infoworld
Lotus
MacWeek
Medical Economics

Medical Tribune
Newsweek
New Choices
The New York Times
PC Week
Redbook
Time
U.P.I.
USA Today
U.S. News & World Report

(Corporate & other)

Aetna
Charles Stewart Mott Foundation
The Cleveland Quartet
Columbia Records
Corning
Delos International
Eastman Kodak
Federal Express
Grolier's
Harper Collins
I.B.M.
McGraw-Hill
McKesson
MacMillan
Mead Johnson

Monsanto
N.Y. Stock Exchange
Nutri/System
Nynex
Pillsbury
Prentice Hall
Price Waterhouse
Prudential
Scholastic Publishing
Ken Silvia Design
U.S.I.A.
Xerox

Key to photographs:

1. VALVE & FITTING
 TECHNOLOGIES

2. THE CHARLES STEWART
 MOTT FOUNDATION

3. THE FARM JOURNAL

ALL PHOTOS
©PHIL MATT

THE OLDEST ESTABLISHED PERMANENT FLOATIG CRAP GAME IN NEW YORK

If life were a Hollywood extravaganza, then advertising photography in the last 40 years could be described with a line from the wonderful musical "Guys and Dolls." That is, "it's the oldest established permanent floating crap game in New York."

If you substitute the word "country" for "New York," you'd have an idea of my life as a photographer in the last four decades.

Is this my testimonial letter thanking the industry for a great career? Hardly. Am I going to talk about how great it used to be? Not on your life, since I'll try to make it greater both for myself and all the other shooters out there- no matter which organization they belong to, or what they shoot...

And as long as there's another automobile to be photographed, I might just squeeze in another decade.

Along with sweating out the magic moment for just the right light, I've been actively involved in the past 10 years with the Advertising Photographers of America. Currently, I'm in my third year as national president.

During this 10-year period (which just about spans the short history of the APA), I've seen dramatic changes in the relationship between buyers and creators of advertising photography.

The late 1970's brought about a hard-won victory in the structure of the copyright law. And it wasn't just a victory for photographers, either. It was a victory for any "author" of an original work- writers, artists, composers, illustrators, photographers, etc., etc.

I believe the change took 28 years to get through Congress! Did it destroy publishing? Naw. Did it put magazines out of business? Nope. Does it cost more to produce an ad? Well, not really.

All it did was define who owned the work, who had a right to use it and for how long and in what media. In other words, we gradually began to treat this business like a business- and less like a "floating crap game."

In some ways, however, it's still like a crap shoot. Did I bid too high? Were my expenses too low? What source book should I buy space in? Should I move to a larger studio and double my overhead, or drop the studio and rent as needed?

What if....? How come....? etc., etc. But these are the questions any business person must answer.

That, too, is where the APA came in, offering evenings with art buyers and art directors, meetings with contemporaries, weekend seminars on business and, best of all, dialogue with competitors!

During my first 30 years, photographers avoided each other like the plague. We all thought we were unique, but now we gather and work out mutual problems- namely, how to run a profitable business in this industry.

continued on page 132

Abraham Menashe
Humanistic Photography
LifeStock Images
306 East 5th Street
New York, New York 10003
(212) 254-2754
FAX: (212) 505-6857

Honest, sensitive, emotional, caring.
Photographs made with real people or
models. On location worldwide for the
advertising, corporate & editorial client.

LifeStock Images: Health Care. Nursing.
Rehab. Neonatal. Children. Old People.
Homeless. Handicapped. Prayer. And
much more...all are model released.

Member ASMP, APA.

Donald L. Miller
295 Central Park West
New York, New York 10024
(212) 496-2830

Specializing in C.E.O.'s, Chairmen,
Presidents, Directors, and top
management.

Donald L. Miller
295 Central Park West
New York, New York 10024
(212) 496-2830

Specializing in C.E.O.'s, Chairmen,
Presidents, Directors, and top
management.

continued from page 128

And so it has come to pass- we started communicating. What a novel idea: communicators communicating with each other! After a while, we weren't adversaries anymore, but creators with a common goal: to do good work and get a fair shake.

Now we hear, "Sure, I can give you exclusive rights"... "You can only buy usage in regional issues"... "Hey, you know that art buyer over at ABC&D is all right in my book, very fair"... "Don't worry, we'll work out the copyright problems; I'd really like to shoot this job."

The APA, with the help of art buyers throughout the country, strengthened important professional relationships by creating useful guidelines and scorecards. So instead of being shooters in the oldest established permanent floating crap game, we are professional photographers who are also businessmen and women.

Now we get the business part all agreed to before the shoot, so we can get on with the assignment at hand- creating photographs- which is all we ever wanted to do in the first place.

APA's influence has spread well beyond its membership, and we continue to encourage this influence with our sponsorship of many seminars and meetings that are open to all shooters around the country. With many problems behind us, the challenge this past year was just getting into the game. The attrition rate on both sides of the business has been pretty brutal, but perspective helps. I'm looking forward to my fifth decade in the business.

It should be an exciting time, especially with all the electronic wizardry that's now available. Meanwhile, we may have to fight the good fight all over again, since theft of an image is becoming easier; at least that's what the scare articles in the trade press are saying.

Am I worried? Naw. Concerned? Absolutely. But I still have faith in the people of this business. The same people with whom I've negotiated in the past will still be at the table in the '90's, and the people they teach will just carry it further along.

After all, computers can't steal my images, only the operators can, and I have dealt with too many good people to worry now.

Oh, a handful of people will always try to beat the system. They exist in every business. But 40 years of experience tells me that most people are still imbued with a sense of morality and integrity- people who would be outraged at the thought of copying or stealing another person's work.

People with hearts and souls will still be making the decisions, and until I run into a more advanced species, I'll still maintain my faith in them.

Mickey McGuire
President
Advertising Photographers of America

Hans Neleman
77 Mercer Street
New York, New York 10012
(212) 274-1000

London/Hamiltons
071 259 2106

Paris/Daniele de Lavalette
01 43 80 92 40

Germany/Art Production Team
0211 890 3444

Amsterdam/Lenz
020 625 3333

Neleman Film/Colossal
415 550 8772

Dan Nelken Studio, Inc.
43 West 27th Street
New York, New York 10001

Represented by:
Adele Q. Brown
(212) 532-7471
FAX: (212) 532-9381

Refer to American Showcase 10-14
to view more of our work.

DAN NELKEN STUDIO INC

Dan Nelken Studio, Inc.
43 West 27th Street
New York, New York 10001

Represented by:
Adele Q. Brown
(212) 532-7471
FAX: (212) 532-9381

Stock Available
©1991 Dan Nelken

Refer to American Showcase 10-14
to view more of our work.

DAN NELKEN STUDIO INC

Greg Pease
Greg Pease & Associates, Inc.
23 East 22nd Street
Baltimore, Maryland 21218
(410) 332-0583
FAX: (410) 332-1797

Stock photography available
Studio Manager: Kelly Baumgartner

Also see: American Showcase 4
through 14; Corporate Showcase
1, 4 through 10 and Stock Direct

International Paper capabilities
brochure

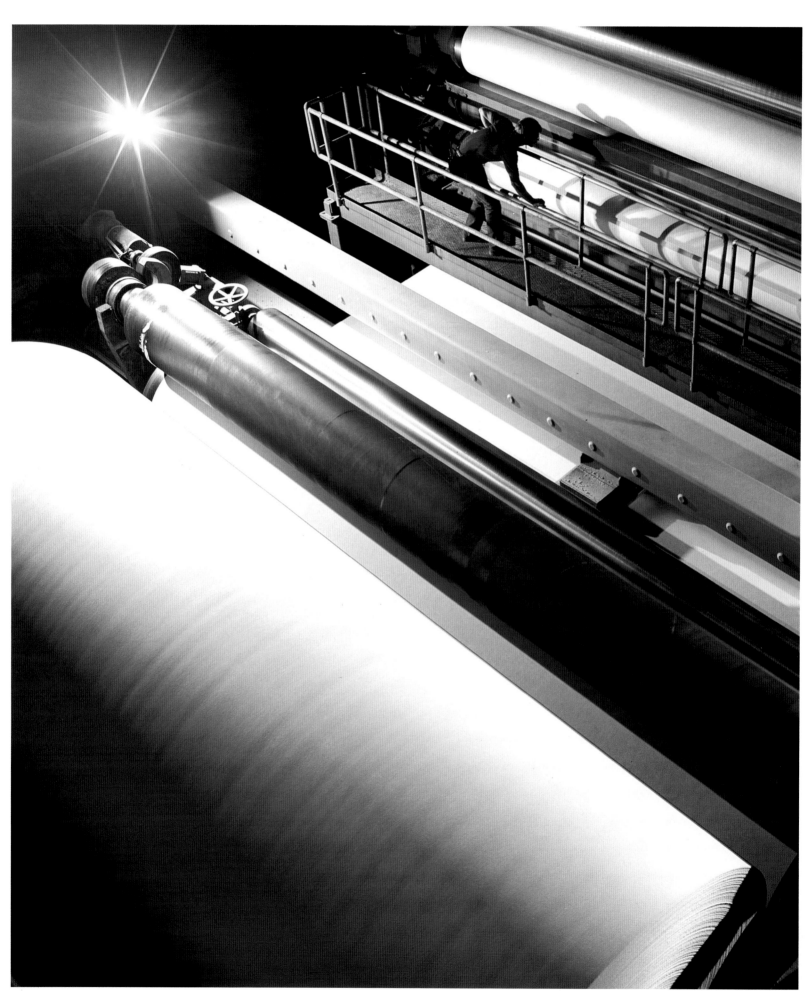

Greg Pease
Greg Pease & Associates, Inc.
23 East 22nd Street
Baltimore, Maryland 21218
(410) 332-0583
FAX: (410) 332-1797

Stock photography available
Studio Manager: Kelly Baumgartner

Also see: American Showcase 4
through 14; Corporate Showcase
1, 4 through 10 and Stock Direct

Maryland Institute, Fudo Myoh-oh
Japanese sculptural project

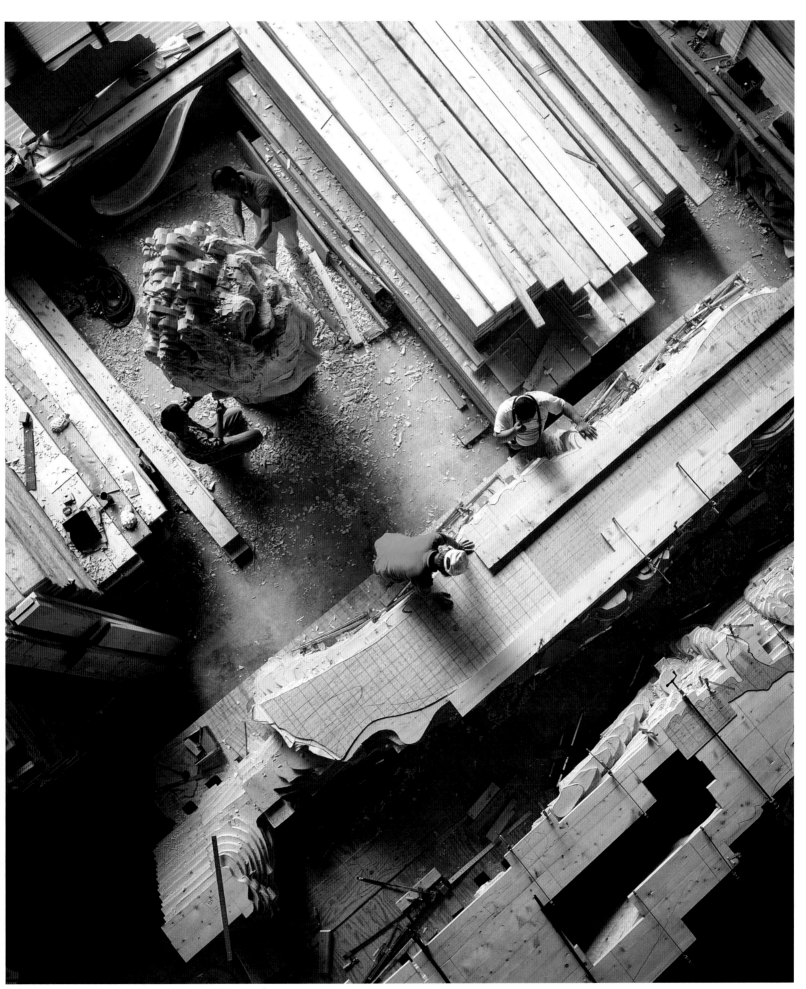

José Luis Peláez
126 11th Avenue
New York, New York 10011
(212) 995-2283

Partial client list includes:
American Express
Barclays Bank
Beth Israel Medical Center
IBM
JP Morgan
JVC Corporation
Lincoln Center for Performing Arts

Bankers Trust
Maxell Corporation
MCI
New York University
Scholastic Inc.

Location and studio photography for annual reports, advertising, editorial and corporate communications.

Stock available. For additional images see Corporate Showcase #7 and #8.

José Luis Peláez
126 11th Avenue
New York, New York 10011
(212) 995-2283

Partial client list includes:
American Express
Barclays Bank
Beth Israel Medical Center
IBM
JP Morgan
JVC Corporation
Lincoln Center for Performing Arts

Bankers Trust
Maxell Corporation
MCI
New York University
Scholastic Inc.

Location and studio photography for annual reports, advertising, editorial and corporate communications.

Stock available. For additional images see Corporate Showcase #7 and #8.

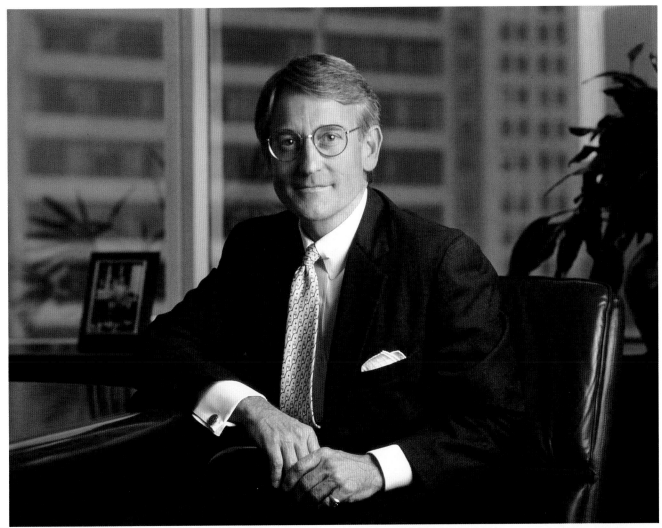

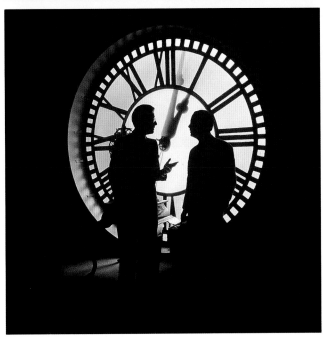

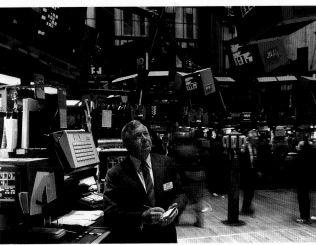

Joe Peoples
11 West 20th street
New York, New York 10011
(212) 633-0026

Joe knows people.

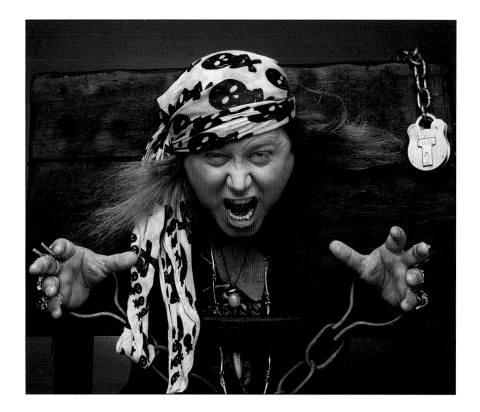

Lynn Saville
440 Riverside Drive #45
New York, New York 10027
(212) 932-1854

Saville

Ron Solomon
149 West Montgomery Street
Baltimore, Maryland 21230
(410) 539-0403
FAX: (410) 539-4343

Represented by:
Timmi Wolff & Co.
(410) 665-8386

Client's Include:
Great Scott Advertising
Trahan, Burden & Charles
Grey Kirk & Evans
Creative Team
Catling & Co.
Merry-Go-Round
The Rouse Corp.

The National Trust
Campbell-Ginn
The Sheraton Corp.

Please see Showcase 13, page 209,
Showcase 14, page 155, ADC Book 1
page 217, Book 2 page 273

solomon
PHOTOGRAPHY

Steven Speliotis
Speliotis Photography
114 East 13 Street, #5D
New York, New York 10003
(212) 529-4765

Much of my work has appeared in
numerous publications including
The New York Times, Vanity Fair,
Art in America, Dance Magazine and
Time Magazine.

TOM CORA (CELLIST)

DAVID SKALL (AUTHOR)

KATHRYN K. SEGAL (AUTHOR)

HANS APPANZELLER (JEWELRY DESIGNER)

ALWIN NIKOLAIS (CHOREOGRAPHER)

SPELIOTIS
PHOTOGRAPHY
N E W Y O R K

We mean business.

The business of commercial art and photography.

The more than 300 SPAR members nationwide represent the best talent in the business.

For over 20 years, while we've been bringing talent and client together, SPAR members also have been working to promote high professional standards and to foster cooperation and understanding.

Our members today are not just salespeople but marketing specialists with a wide range of capabilities.

We are truly professionals doing business with professionals.

SOCIETY OF PHOTOGRAPHER AND ARTIST REPRESENTATIVES, INC.
1123 Broadway, Room 914 New York, New York 10010 212-924-6023

Sylvia Stagg-Giuliano
Boston
(617) 395-4036

Advertising, Corporate and Editorial
Studio and Location

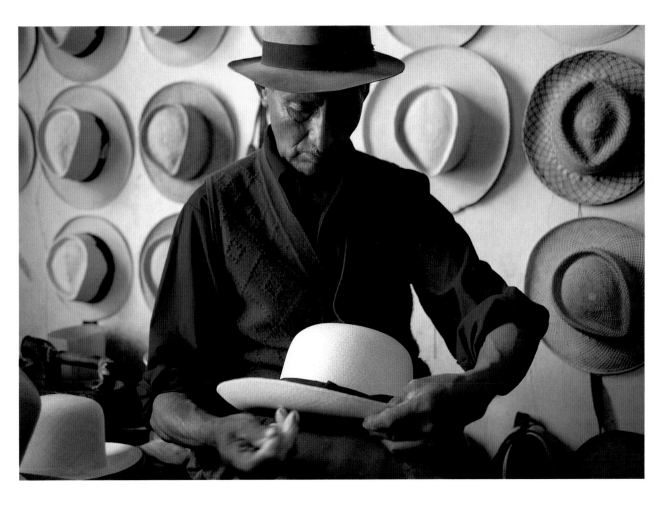

Sylvia Stagg-Giuliano

145

Gary Tardiff Studio
451 D Street, Suite 806
Boston, Massachusetts 02210
(617) 439-9180
FAX: (617) 439-9181

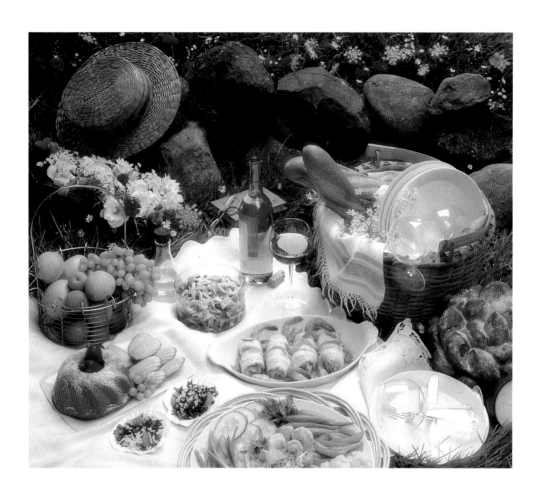

Gary Tardiff Studio

451 D Street

Suite 806

Boston, MA 02210

TEL. 617.439.9180
FAX. 617.439.9181

Gary Tardiff Studio
451 D Street, Suite 806
Boston, Massachusetts 02210
(617) 439-9180
FAX: (617) 439-9181

Tardiff

Gary Tardiff Studio

451 D Street

Suite 806

Boston, MA 02210

TEL. 617.439.9180
FAX. 617.439.9181

Vic Tartaglia
42 Dodd Street
Bloomfield, New Jersey 07003
(201) 429-4983
FAX: (201) 429-7158

What's A Nice Italian Boy From Jersey Know About Food?

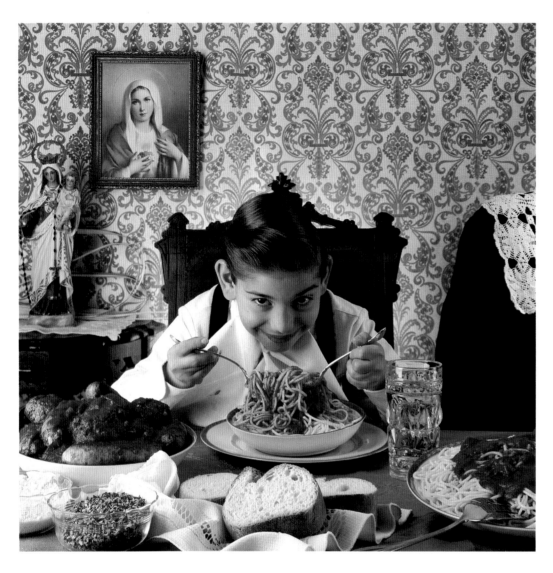

From Antipasto to Zucchini, Vic Tartaglia can even make Chinese food look good.

Tartaglia Photographic is some operation. A 4,500 square ft. studio so you're not tripping all over each other. Two fully equipped shooting spaces, full kitchen, workshop…you name it, he's got it.

The staff? Real pros. They'll make you feel like part of the family.

And stylists? It's like their hands were blessed. Tell them what you need. Badda bing. Badda boom. A work of art.

So you want to see the portfolio, eh? Just call. Trust me, Tartaglia will make your next shoot a piece of cake. Capiche?

Tartaglia Photographic
42 Dodd Street Bloomfield, NJ 07003
(201) 429-4983 Fax: (201) 429-7158

Michael Waine
1923 East Franklin Street
Richmond, Virginia 23223
(804) 644-0164
FAX: (804) 644-0166

Clients include:
• AT&T
• Coca Cola
• U.S. Army
• U.S. Post Office
• Seagrams
• Revlon

• DuPont
• Gillette
• Burger King
• G.E.
• Kodak
• Pepsi
• Wranglers

• Reynolds
• AH Robins
• IBM
• Crestar Bank

© Michael Waine 1991

*Dreams Into Reality. From a fleeting feeling to a riveting image,
capture the magic of dreams. Wake up to Michael Waine.*

Do it by the book.

How do you decide on an appropriate fee for artwork you sell or buy? How do you write a contract that's fair to both artist and buyer? What are the implications of new technologies in the art marketplace? If you're an artist, what business practices should you expect from your clients? And if you're a buyer, what should you expect from a professional artist?

Artists and buyers alike will find good answers to questions like these in *Pricing and Ethical Guidelines,* 7th Edition. Published by The Graphic Artists Guild, the *Guidelines* contains the result of the Guild's extensive survey of pricing levels in every branch of the graphic arts, as well as a wealth of information on estimates, proposals, contracts, copyrights, and many other aspects of the business relationship between artist and buyer.

To order your copy of this indispensable reference, send $22.95 plus $3.50 shipping and handling, along with your name and address, to the **Graphic Artists Guild, 11 West 20th St., New York, NY 10011.** New York residents please add 8¼% sales tax (total $28.63).

Mark Whalen Photography
PO Box 455
Baldwinsville, New York 13027
(315) 635-2870
FAX: (315) 635-1134

Member ASMP

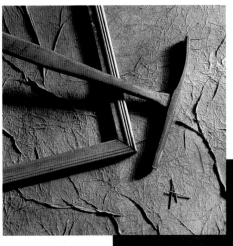

MARK WHALEN

PHOTOGRAPHY

Walter Wick
560 Broadway
New York, New York 10012
(212) 966-8770
FAX: (212) 941-7597

Superbly crafted conceptual
photography available as stock or by
assignment

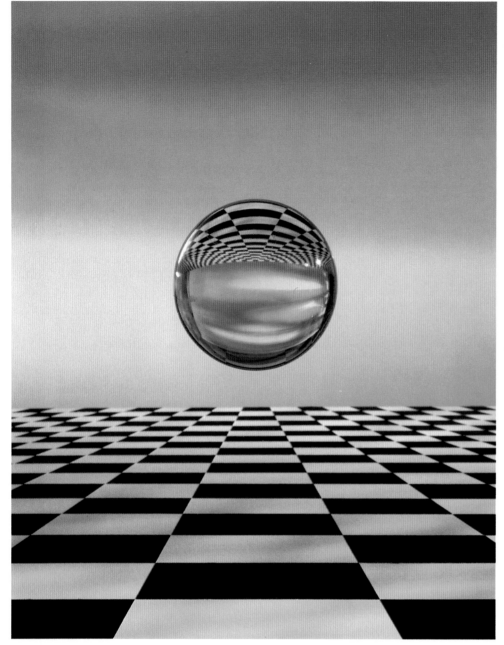

Walter Wick
560 Broadway
New York, New York 10012
(212) 966-8770
FAX: (212) 941-7597

Superbly crafted conceptual
photography available as stock or by
assignment

Illustrators &
Photographers at Work

SHARP WORK AHEAD.

To find the right creative solutions, you've got to know where to look.

And when you own Corporate Showcase 10 you'll have access to the best photographers and illustrators working in America's corporate arena.

Not only that, you'll have a rich creative source-book for ideas and inspiration, offering the widest selections of styles and talent appropriate to every type of corporate communications.

And because Corporate Showcase 10 is a handy one-volume book, you'll slow down the traffic jam of portfolios and briefcases in your office.

So order Corporate Showcase 10 today. Send a check for $37.50 + $4.00 postage and handling for your paperback copy. Or call 212-673-6600.

And enter the fast lane of corporate work.

CORPORATE
SHOWCASE 10
The Work's Great

Published by American Showcase, 915 Broadway, New York, NY 10010 212-673-6600.

ANTHONY BARRERAS

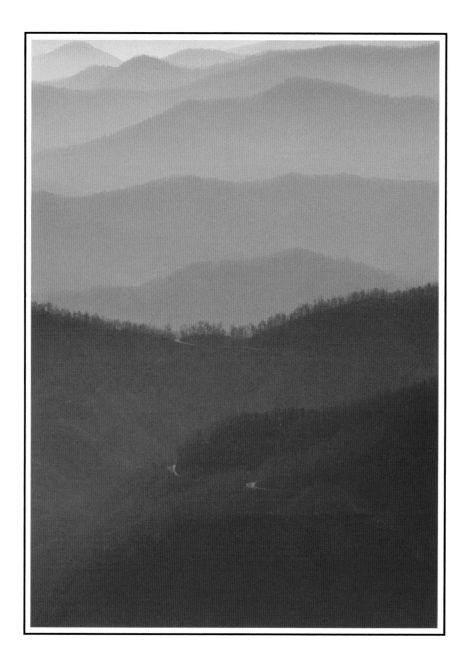

1231-C BOOTH STREET ATLANTA, GEORGIA 30318 (404) 352-0511

ANTHONY BARRERAS

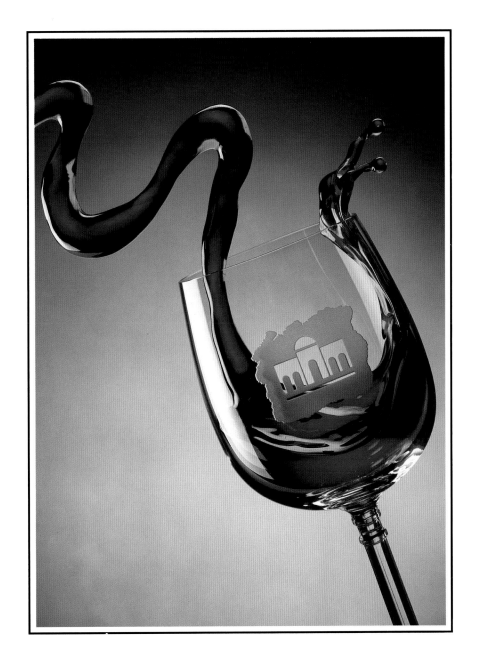

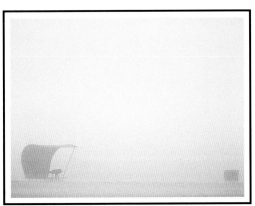
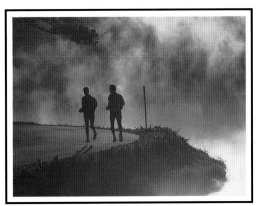
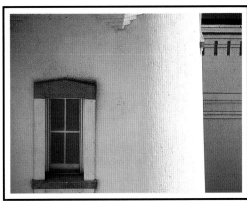

1231-C BOOTH STREET ATLANTA, GEORGIA 30318 (404) 352-0511

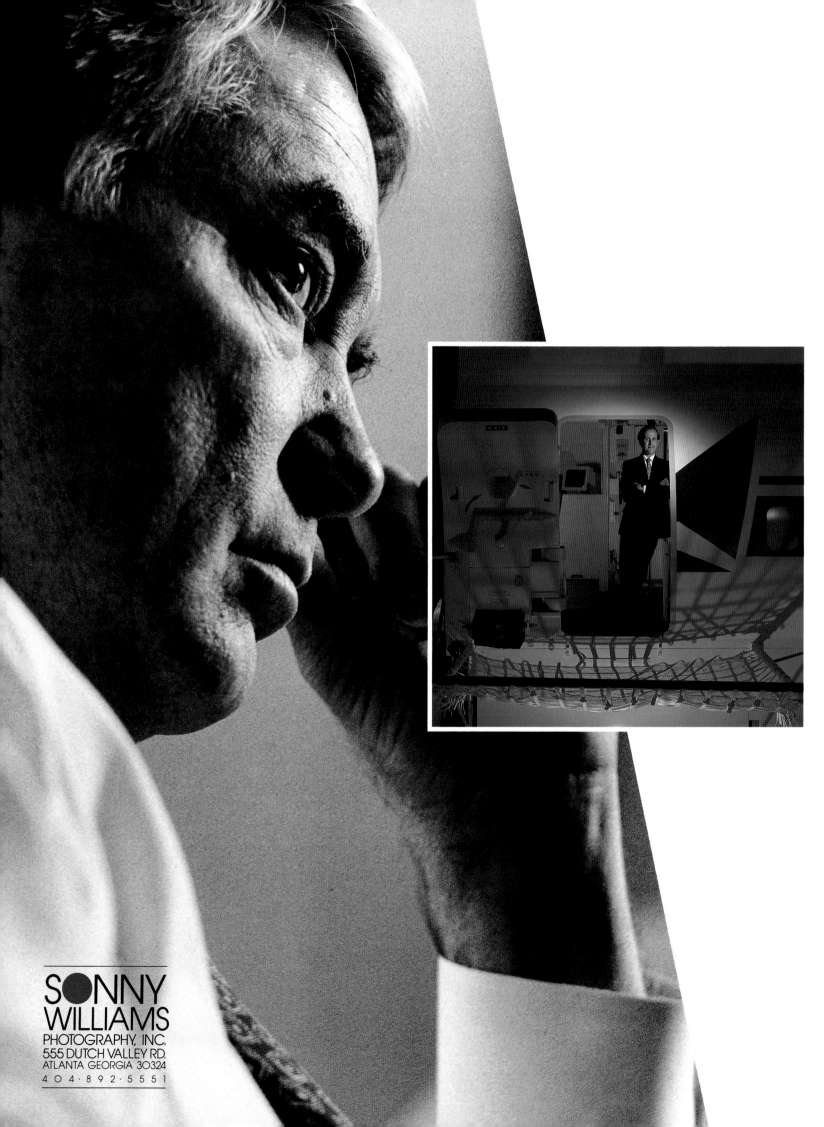

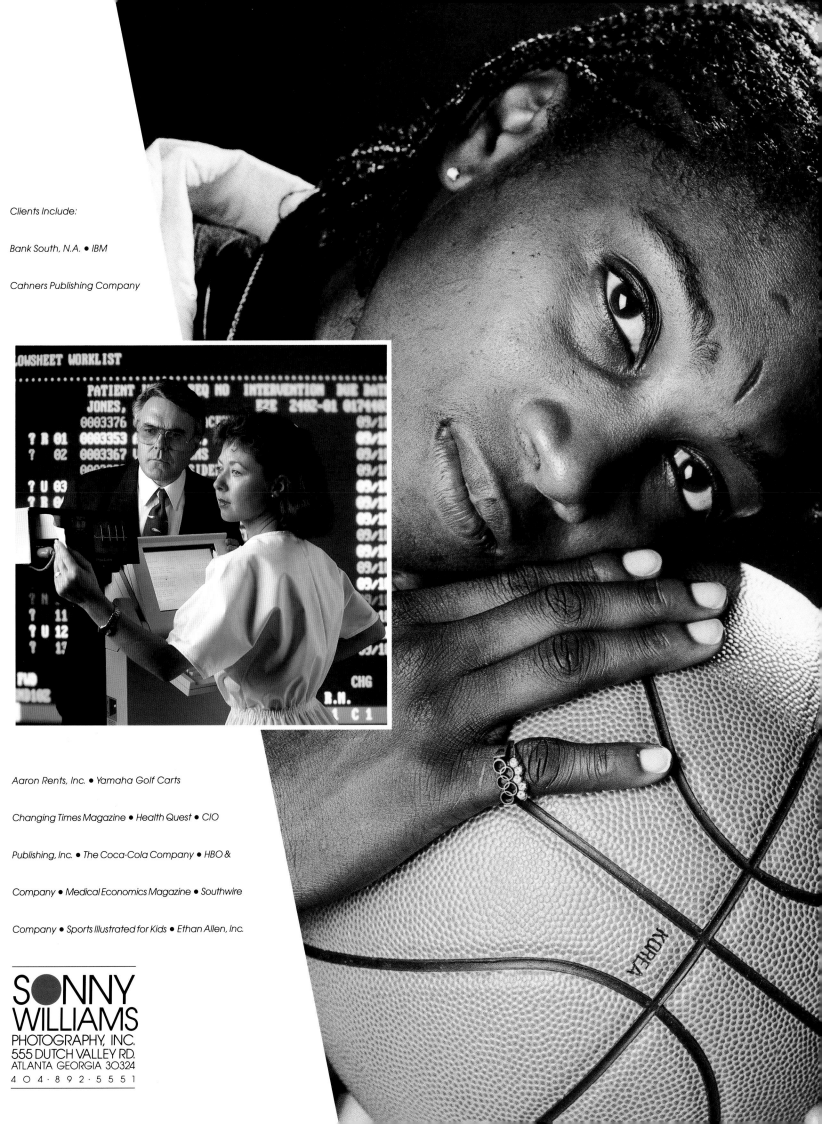

Clients Include:

Bank South, N.A. • IBM

Cahners Publishing Company

Aaron Rents, Inc. • Yamaha Golf Carts

Changing Times Magazine • Health Quest • CIO

Publishing, Inc. • The Coca-Cola Company • HBO &

Company • Medical Economics Magazine • Southwire

Company • Sports Illustrated for Kids • Ethan Allen, Inc.

SONNY
WILLIAMS
PHOTOGRAPHY, INC.
555 DUTCH VALLEY RD.
ATLANTA GEORGIA 30324
4 0 4 · 8 9 2 · 5 5 5 1

LANGONĒ

516 NORTHEAST 13TH STREET, FORT LAUDERDALE, FLORIDA 33304

LANGONE STUDIO (305) 467-0654 FAX # (305) 522-2562

DETROIT
JIM SLATER
(313) 258-5930

ST. LOUIS
MARY WILLIAMS
(314) 436-1121

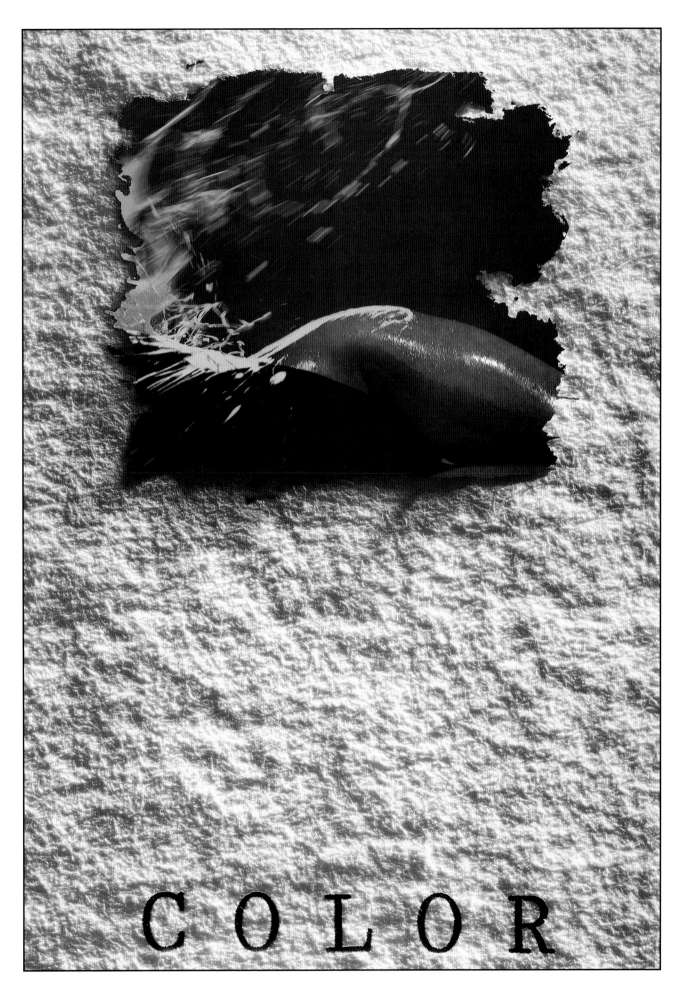

C O L O R

FT. LAUDERDALE
PETER LANGONE (305) 467-0654
FAX (305) 522-2562

FREE "COLOR" POSTER
SIZE 20 X 30
FAX OR MAIL BUSINESS CARD

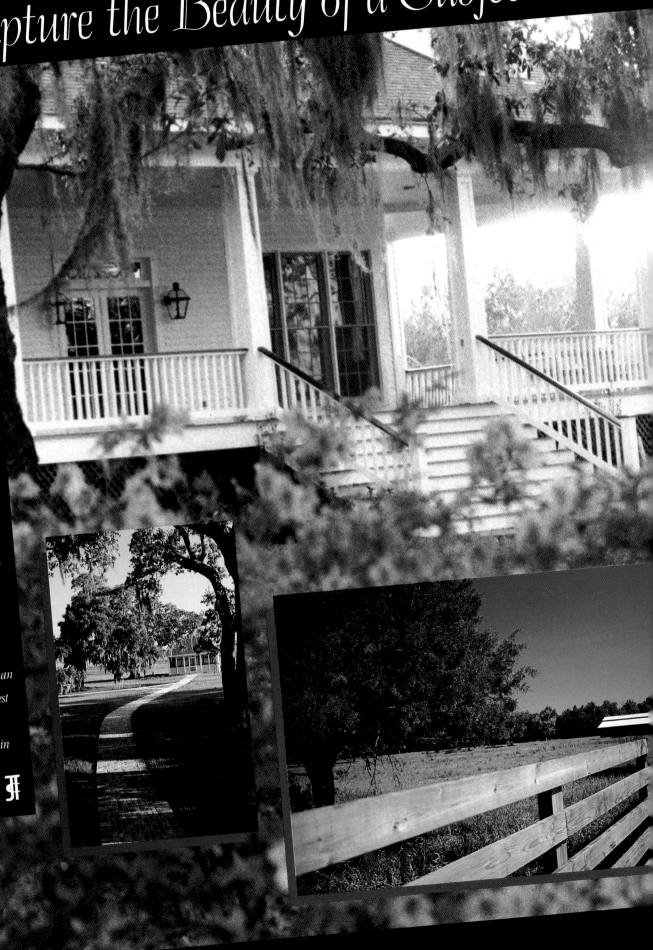

JOHN CHRISTIAN THOMSON

"To Capture the Beauty of a Subject ...

Early in my career I relocated to the North, out of the notion that I had outgrown my native South.

But as I pursued my goal of producing the best work possible, I became aware of the need to know a subject in order to truly capture its essence on film.

That realization has brought me back to a subject, rather a place, whose people and customs I know well. A place where I can produce my best work.
Back home – in the South.

You Must First Know & Understand It."

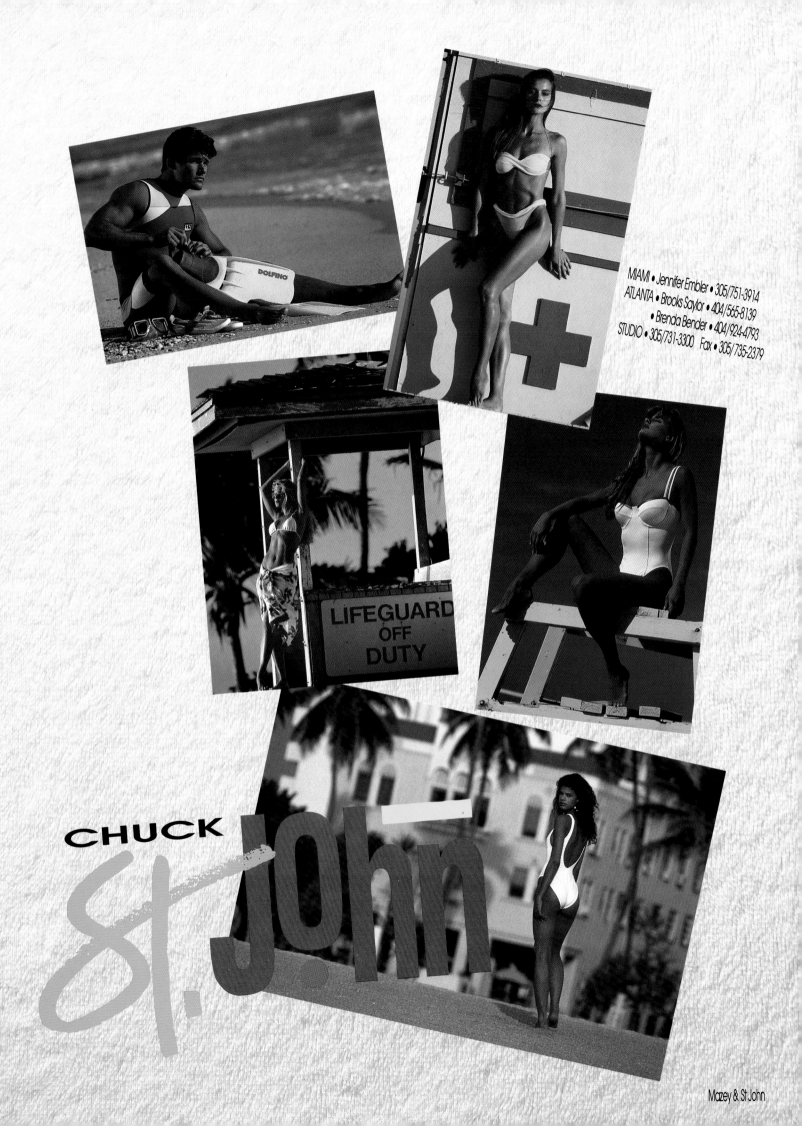

MIAMI • Jennifer Embler • 305/751-3914
ATLANTA • Brooks Saylor • 404/565-8139
• Brenda Bender • 404/924-4793
STUDIO • 305/731-3300 Fax • 305/735-2379

CHUCK

St. John

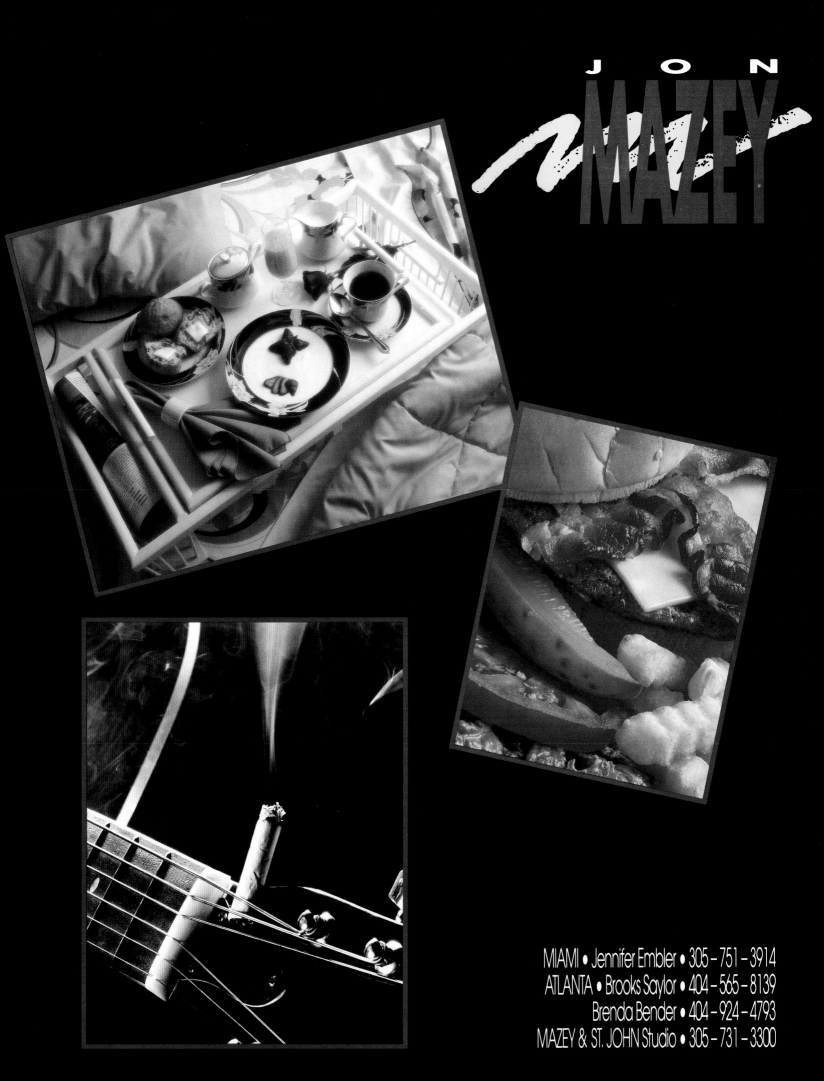

JON
MAZEY

MIAMI • Jennifer Embler • 305 – 751 – 3914
ATLANTA • Brooks Saylor • 404 – 565 – 8139
Brenda Bender • 404 – 924 – 4793
MAZEY & ST. JOHN Studio • 305 – 731 – 3300

BILL MELTON PRODUCTIONS

1400 Resurgens Plaza
945 East Paces Ferry Road

Atlanta, GA 30326
404 814-9600 (Fax) 404 237-2150

New England Office:
603 668-0110 (Fax) 603 622-5180

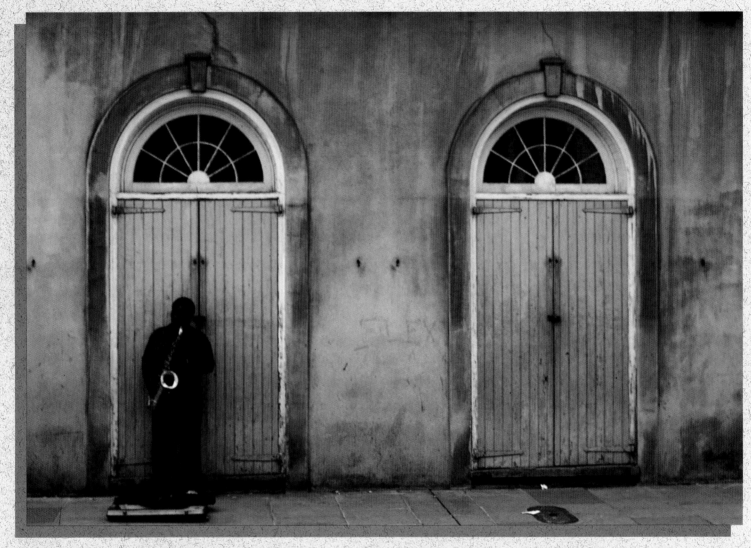

Member ASMP

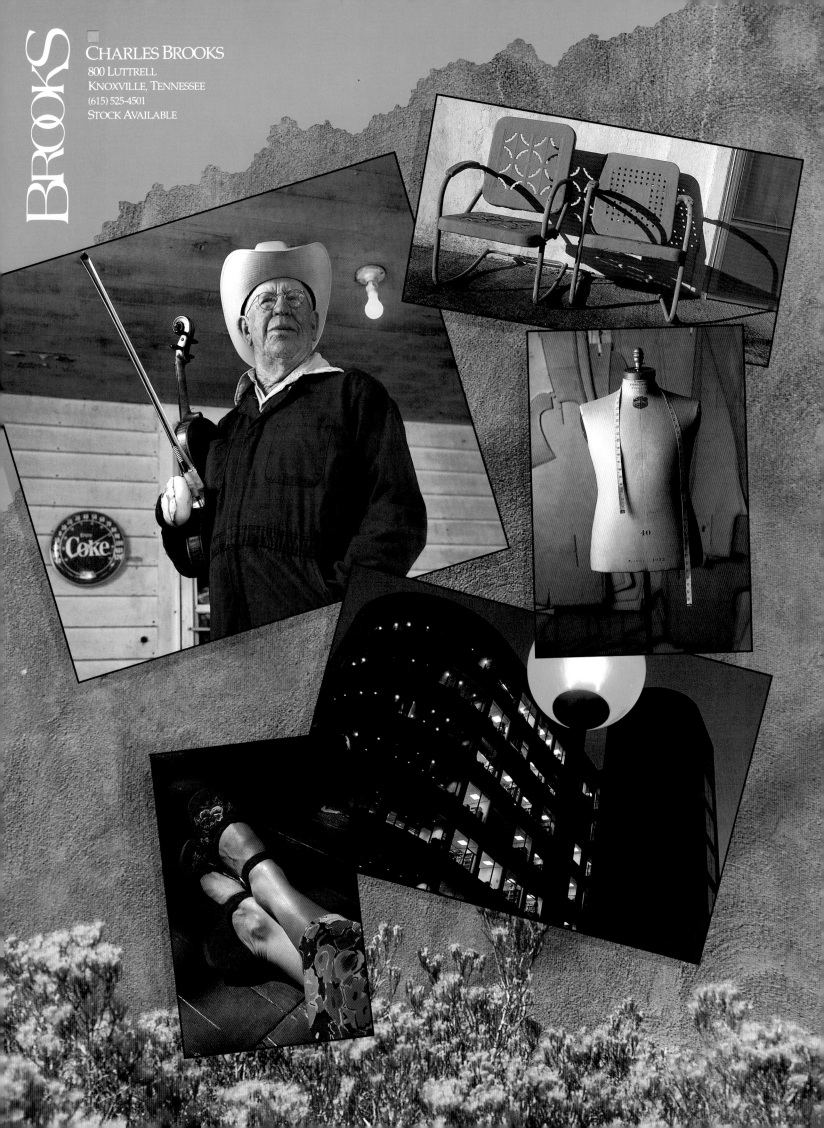

BROOKS

CHARLES BROOKS
800 LUTTRELL
KNOXVILLE, TENNESSEE
(615) 525-4501
STOCK AVAILABLE

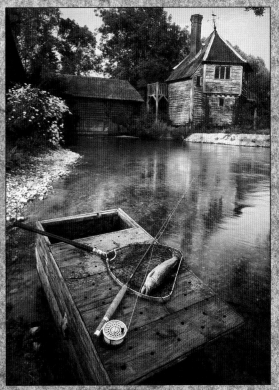

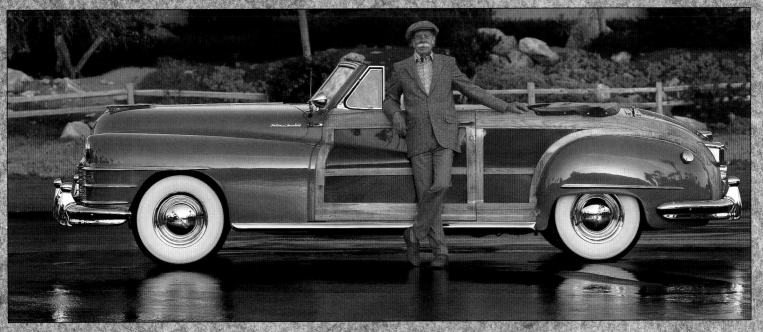

BRAD MILLER PHOTOGRAPHER

(305) 666-1617

er|ik
s. LESSER

A

greater

PHOTOGRAPHER

ERIK S. LESSER

360 PONCE DELEON AVENUE , N.E. #28

ATLANTA , GEORGIA 30308-2087

404 872 4319

PAGER 404 760 3981

EDITORIAL

+

CORPORATE

+

ADVERTISING

170

BOBBY BEAN SEES THINGS IN A DIFFERENT LIGHT

MARTIN FOX

STUDIO / LOCATION

88 CHARLOTTE ST.

ASHEVILLE, NC

28801

704.258.8003

FAX 704.258.8052

STOCK

REPRESENTED

BY PICTURESQUE

919.828.0023

TONY ARRUZA

RED MORGAN

MARK M. LAWRENCE

DAVID DIETRICH
PHOTOGRAPHY

ADVERTISING

Still Life, Products, Architecture/Interiors
People, Studio/Location

CORPORATE

David Dietrich Photography • Miami, Florida • Telephone (305) 594-5902 • Fax (305) 592-1094

Raleigh, NC

VandeZande
PHOTOGRAPHY

919-832-2499

197 million square miles
of studio space.

MIKE HAMEL
7110 S.W. 63RD AVENUE
MIAMI, FL 33143 • 305-665-8583

COLOR STOCK AVAILABLE THRU
SHARPSHOOTERS
800-666-1266

MIKE HAMEL

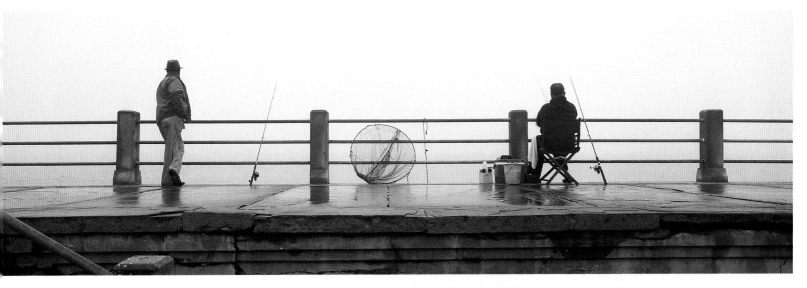

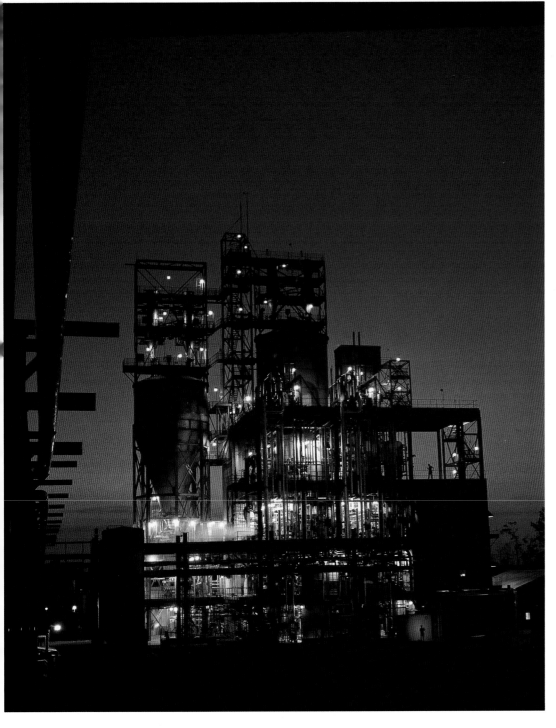

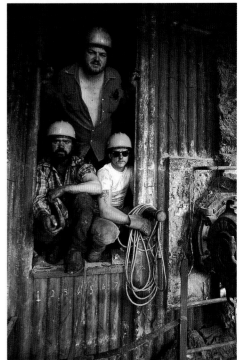

I. Wilson Baker
1094 Morrison Drive
Charleston, SC 29403

(803) 577-0828
(Fax) 723-7282

MARK M. LAWRENCE

P.O. Box 23950 • Ft. Lauderdale, FL 33307 • (305) 565-8866 • Fax (305) 565-4927

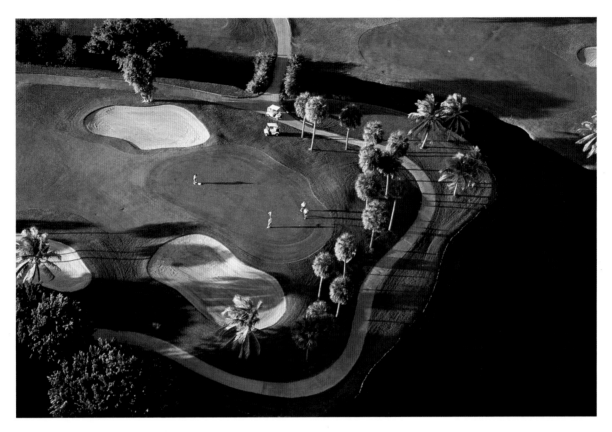

1910 EAST FRANKLIN STREET
RICHMOND, VIRGINIA 23223
804.649.1400
FACSIMILE 804.649.8012

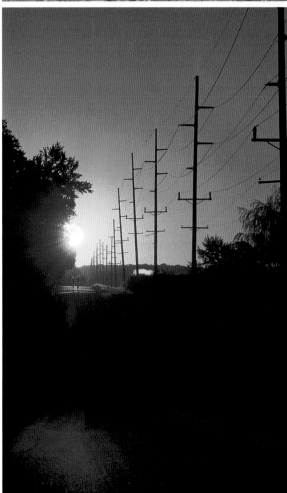

CHUCK
SAVAGE
PHOTOGRAPHY

113 SOUTH JEFFERSON STREET • RICHMOND, VIRGINIA 23220 • 804-780-0304

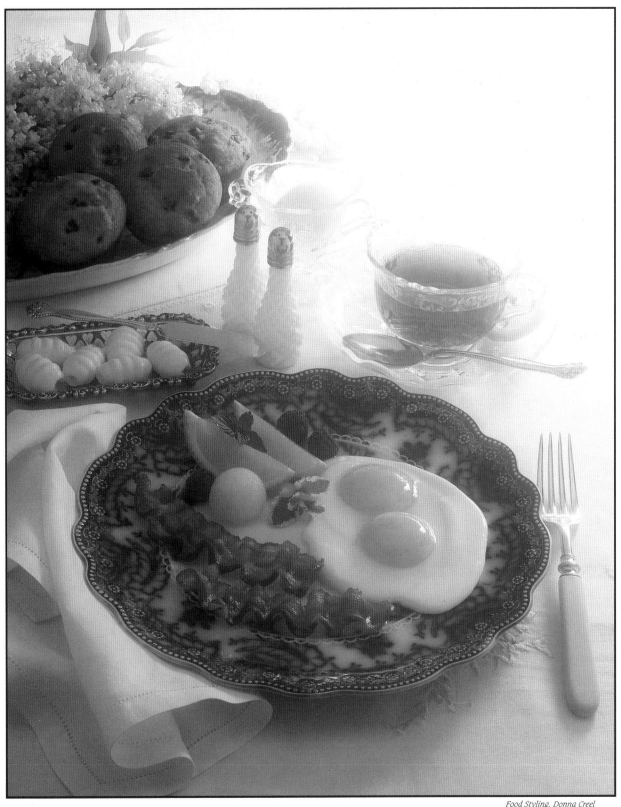

Food Styling, Donna Creel

Charlie Lathem/559 Dutch Valley Road NE/Atlanta, Georgia 30324/404 873-5858

Miami

Morris

STUDIO 305-757-6700, FAX 751-7574, P.O. Box 530894, Miami, Florida 33153-0894

Specializing in location photography for Corporate and Advertising clients.
Call today for an updated portfolio, client list, and more information on all your assignment needs.
Additional work can be seen in American Showcase 14.

Paul Morris, Photographer

Jeff Amberg Photography
1001 Hickory Street
Columbia, South Carolina 29205
(803) 787-7661

Advertising
Corporate
Editorial
Industrial

Call or write for portfolios.

Bill Bachmann
Florida and the Earth
PO Box 950833
Lake Mary, Florida 32795-0833
(407) 322-4444 Orlando

We shoot people!! Our specialty is creating that "Magic Moment" of bright color & energy. We love to shoot and it shows!

Portfolio and large selection of stock photos available upon request.

Clients include: AAA, Arvida, Bahamas Tourism, CBS News, Chevrolet, Citibank Visa, Coca-Cola, Delta Airlines, Epcot, Florida Tourism, General Mills, Grenelefe, HBJ, Heathrow, Hyatt, Lee County Tourism, Merv Griffin's Paradise Island, Jamaica Tourism, Kodak, Marriott, Nickelodeon, Pan Am, Paragon Group, People, Pepsi-Cola, Pinellas County Tourism, Pres. George Bush, Pres. Ronald Reagan, Olive Garden Radisson, RCI, Red Lobster, Regal Marine, Sea Escape Cruises, Sears, Sheraton, Tempest Marine, Time, Trammel Crow, United Way, Universal Studios, Walt Disney World, Wendy's.

Philip Bekker
Atlanta
(404) 876-1051
FAX: (404) 876-1051

See additional work in:
Graphis Photo 1989
Graphis Photo 1990
The Workbook 1992

**Bob Blankenship
Photography**
1 Newport Place Northwest
Atlanta, Georgia 30318
(404) 351-8938
FAX: (404) 351-8938

Represented By
Judy McDowell
(404) 351-8938

People. Places. Things.
Studio & Location.
Clients: Cox Enterprises, Altama, OKI,
Ritz-Carlton, Abatement Technologies,
Hitachi, Stouffer Hotels, Westin Hotels.
Mini Portfolio Available.

See Showcase 14, pg. 196

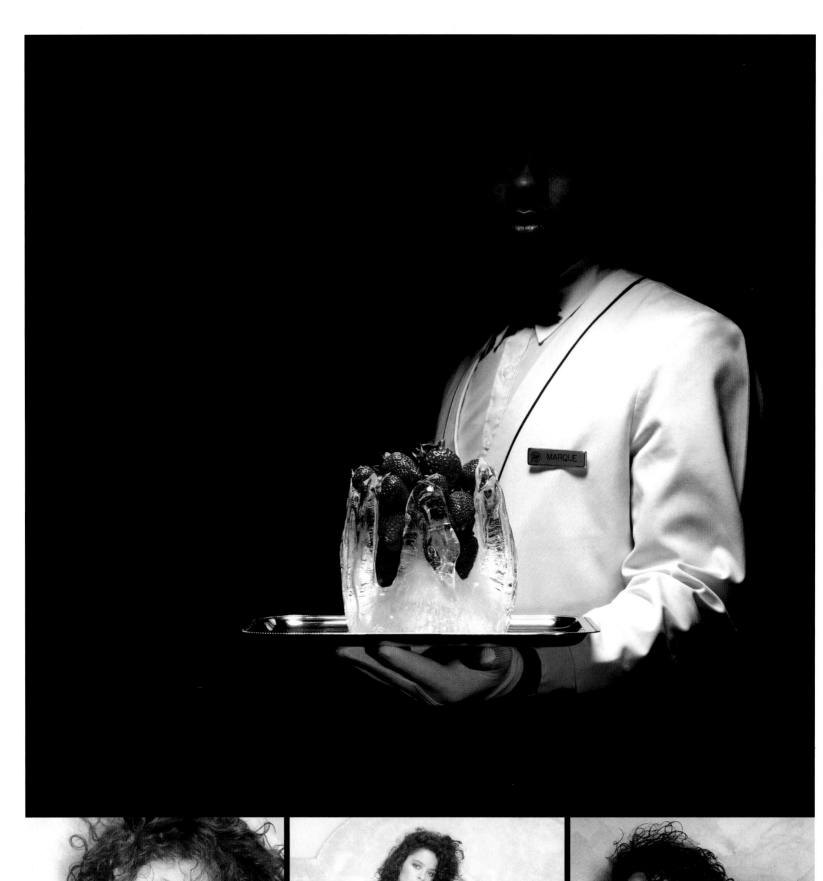

Cosby Bowyer, Inc.
209 North Foushee Street
Richmond, Virginia 23220
(804) 643-1100
FAX: (804) 644-2226

For twelve years, Herb Cosby and Sonny Bowyer have been building a national reputation for consistently outstanding studio and location work. Their three-floor facility includes every resource imaginable for world-class photography, from a 22' cyc wall and an E-6 lab to a complete kitchen, dressing rooms, and client work/meeting space. All backed by one of the most responsive, experienced staffs in the mid- Atlantic.

RICK CARROLL—ADVERTISING ASSOCIATES, INC.

GLENN IVIE—THE WILLIAM COOK AGENCY

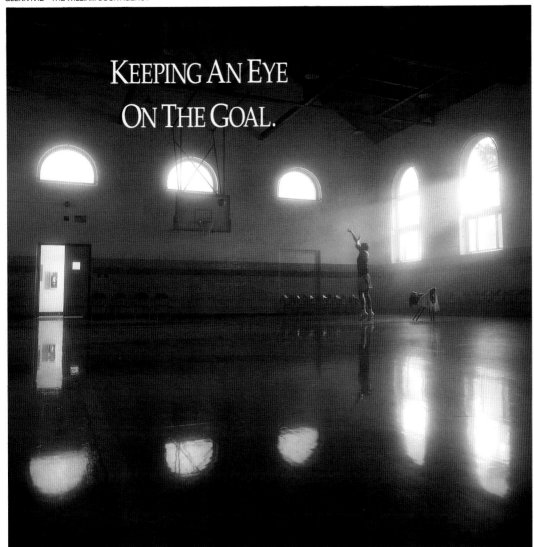

KEEPING AN EYE ON THE GOAL.

187

Dick Dickinson
1781 Independence Boulevard
Number One
Sarasota, Florida 34234
(813) 355-7688
(800) 229-7688
FAX: (813) 355-4104

Specializing in people on location.
Resorts, hotels, destinations.
Corporate image and annual reports.
4,500 sq. ft. studio with complete
custom photo lab.

Clients include Hyatt, Marriott, Mobil
Oil, Florida Progress, Anchor Glass,
Bealls Department Stores, Johnsons
Wax, Rhone-Poulenc, DuPont, General
Electric, Kodak, and many others.

Carlos M. Domenech
photography
Miami, Florida
(305) 666-6964
FAX: (305) 666-6964

Client list and portfolio
available upon request.

SOUTHERN ACCENTS

RUSKIN MANUFACTURING

COURTESY ARCHITECTURAL DIGEST

BLOOMINGDALE'S

189

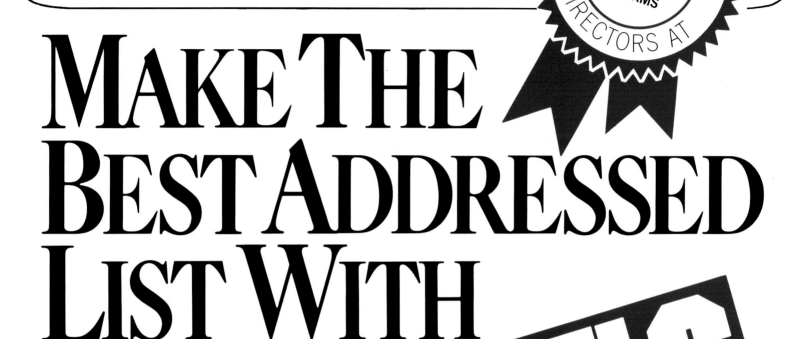

Ken Glaser & Associates
New Orleans
(504) 895-7170
FAX: (504) 833-7244

Advertising
Architectural
Corporate

Studio
Location
Stock

American Express, Suntory
International, DuPont, Kraft, AT&T

See American Showcase 10,11,12,13

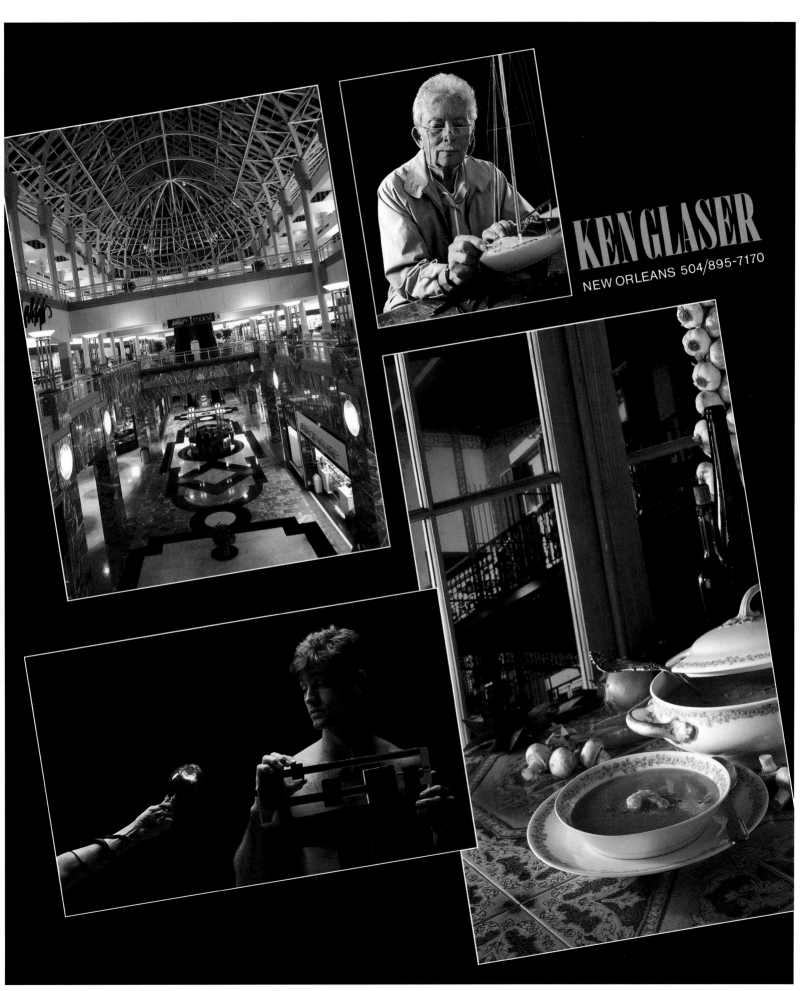

KEN GLASER
NEW ORLEANS 504/895-7170

David Guggenheim
167 Mangum Street
Atlanta, Georgia 30313
(404) 577-4676
FAX: (404) 875-9733

Represented by
Alexander/Pollard
(404) 875-1363 • Atlanta, Georgia
1-800-347-0734

Additional work can be seen in
American Showcase Volumes 13 & 14
and CA Photography Annual, 1988

David Guggenheim
167 Mangum Street
Atlanta, Georgia 30313
(404) 577-4676
FAX: (404) 875-9733

Represented by
Alexander/Pollard
(404) 875-1363 • Atlanta, Georgia
1-800-347-0734

Additional work can be seen in
American Showcase Volumes 13 & 14
and CA Photography Annual, 1988

Loren Hosack
509 Inlet Road
North Palm Beach, Florida 33408
(407) 848-0091

© LOREN HOSACK 1991

LOREN HOSACK
509 Inlet Road
North Palm Beach, Fl 33408
(407) 848-0091

Stock: Sharpshooters 1-800-666-1266

Chipp Jamison
2131 Liddell Drive, NE
Atlanta, Georgia 30324
(404) 873-3636
FAX: (404) 873-4034

404/873-3636 ATLANTA
EXTENSIVE STOCK FILES

© Chipp Jamison 1992

Jack Kenner
Photographer
PO Box 3269
Memphis, Tennessee 38173-0269
(901) 527-3686
FAX: (901) 525-8003

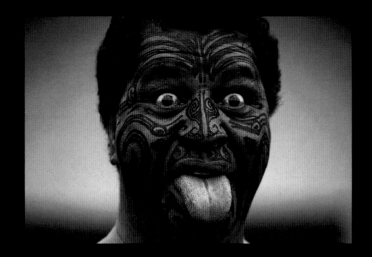
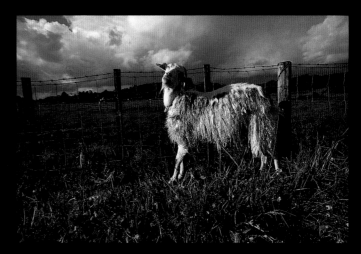

JACK KENNER, PHOTOGRAPHER

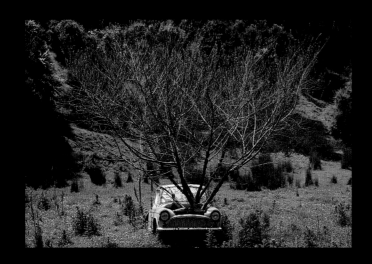

JACK KENNER, PHOTOGRAPHER ■ P.O. BOX 3269 MEMPHIS, TN 38173-0269 ■ (901) 527-3686 FAX (901) 525-8003

Bevil Knapp
118 Beverly Drive
Metairie, Louisiana 70001
(504) 831-1496

Studio and location photography for
advertising, corporate and editorial use.

Member ASMP

Stock photography:
Stock South Atlanta, GA
(404) 352-0538

See additional work in American
Showcase Volume 14

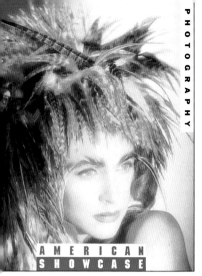

American Showcase Photography

Alexander Luege
Photographer
(305) 445-5795

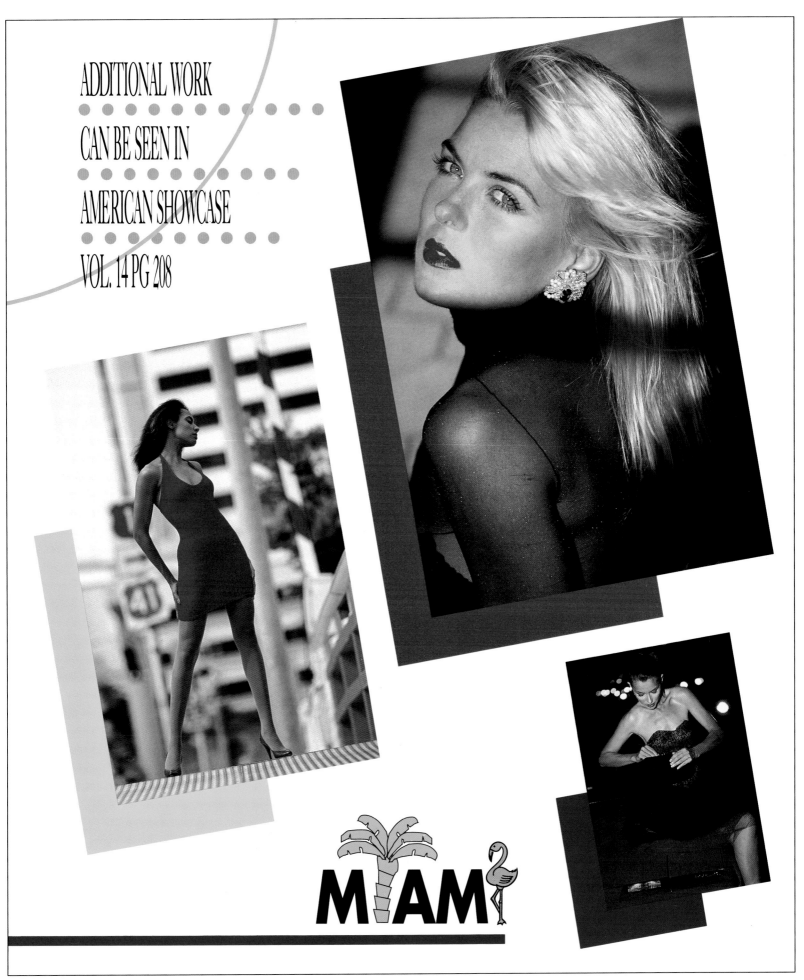

ADDITIONAL WORK

CAN BE SEEN IN

AMERICAN SHOWCASE

VOL. 14 PG 208

MIAMI

David Luttrell
5117 Kesterwood Drive
Knoxville, Tennessee 37918
(615) 688-1430

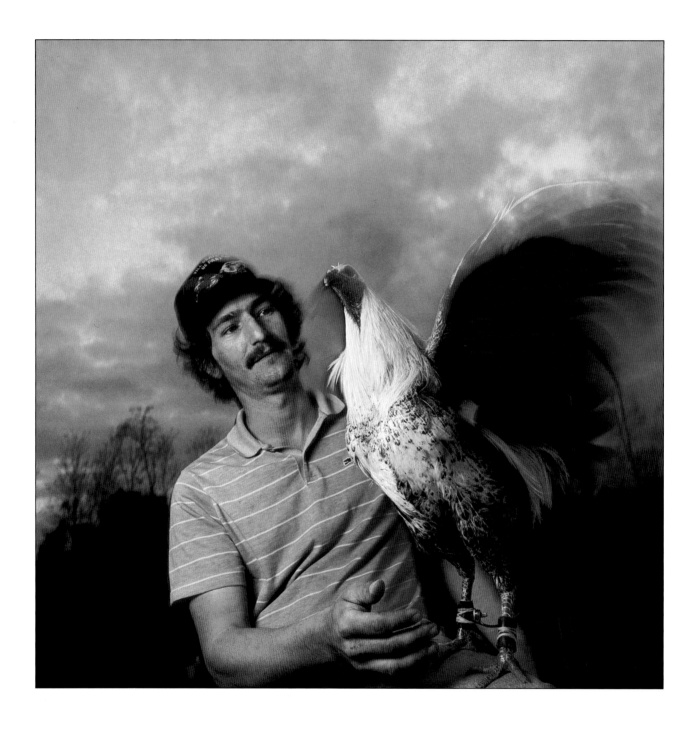

David Luttrell
5117 Kesterwood Drive
Knoxville, Tennessee 37918
(615) 688-1430

Tom McCarthy
8960 SW 114 Street
Miami, Florida 33176
(305) 233-1703
(800) 344-2149

Joan Jedell
NY Representative
370 East 76th Street
New York, NY 10021
(212) 861-7861
(212) 249-1951

Advil, Kodak, AGFA, Pillsbury,
Mead Johnson, Perrier, Lipton,
Burger King, Seagrams, Dole,
Blue Shield/Blue Cross, Salem

Richard Mikeo
Mikeo Photography
Fort Lauderdale, Florida 33069
(305) 960-0485 Studio
FAX: (305) 960-0485

Location and studio photography
for corporate, industrial and
advertising clients.

Additional work,
Black Book 1990
Art Director Index 1989
Art Director Index 1988

John Petrey
John Petrey Studios, Inc.
841 Nicolet Avenue, #3
PO Box 2401
Winter Park, Florida 32790
(407) 645-1718
FAX: (407) 645-1935

Studio and location photography for advertising, corporate and editorial clients.

Please refer to American Showcase 11, 12, 13 and 14 for more of my work.

Portfolio available upon request.

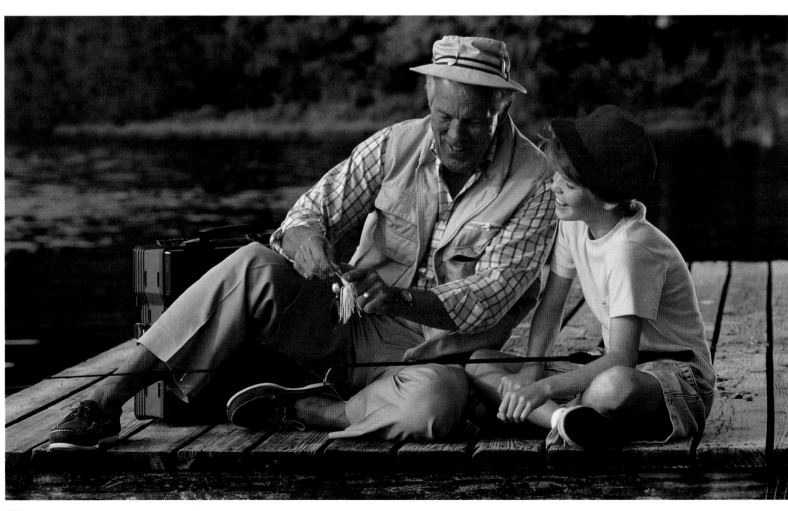

Don Rogers
Langonē Studio
516 Northeast 13th Street
Fort Lauderdale, Florida 33304
(305) 467-0654
FAX: (305) 522-2562

Michael W. Rutherford
Rutherford Studios
(615) 242-5953

Represented in N.Y. by
Lily Kimmel Associates,
Howard Fox (212) 794-1542

Represented in Chicago by
Rick Soldat & Pam Cardoni
(312) 201-9662

Bob Schatz
112 Second Avenue North
Nashville, Tennessee 37201
(615) 254-7197 Studio
(615) 943-4222 Cellular
FAX: (615) 242-3220

Stock available.

Partial list of clients:
Nissan Motor Mfg. Corp., Trane Corp.,
Provident Insurance, Dollar General
Corp., BG Automotive Motors, Vangard
Labs, Emery Worldwide, UPS, and
Steiner-Liff Metals Group.

Additional work can be found in the
Silver Book 6 & 7,
Corporate Showcase 8 & 10, and
American Showcase 13.

207

Christopher Stickney
321 Tenth Avenue North
St. Petersburg, Florida 33701
(813) 821-3635
FAX: (813) 821-7032

There are a variety of techniques used in the production of these images; in-camera masking, darkroom manipulation, a little this, a little that. All done under the supervision of a highly trained expert. Kids - please don't try this at home.

CHRISTOPHER STICKNEY ■ 813-821-3635

THE WORLD'S A BEAUTIFUL PLACE.

ARTHUR KEEPS PEOPLE FROM SCREWING IT UP.

Even the most dazzling backdrop can put on an ugly face
if the people in the foreground aren't giving it their all.

That's a major reason so many of the country's top art
directors and designers call on Arthur Tilley.

Working with Arthur's like shooting with your best
friend. His warm, low-key demeanor makes his subjects
feel calm, cool and confident. Allowing
them to be captured on film at their most
spontaneous, natural best. Regardless of
whether they're rank amateurs or seasoned pros.

Arthur is equally adept with locations. Bringing out the
true spirit of the landscape, even when shooting conditions
are less than optimal.

To see more of what separates Arthur Tilley from your
garden-variety photographer, call any of the numbers below.
Because when it comes to combining beautiful places
with beautiful faces, nobody does it better.

Atlanta: (404) 371-8086
Orlando: (407) 234-1218
South Florida: (305) 670-2111

ARTHUR TILLEY
Your best defense against Murphy's Law.

For more of Arthur's
work see recent
issues of Workbook
& Showcase.

209

Pete Winkel
3760 Prestwick Drive
Atlanta, Georgia 30084
(404) 934-5434
FAX: (404) 493-1007

Stock available from
Stock South
(404) 352-0538

John Zillioux/Photographer
9127 Southwest 96 Avenue
Miami, Florida 33176
(305) 270-1270
FAX: (305) 270-1270

Zillioux

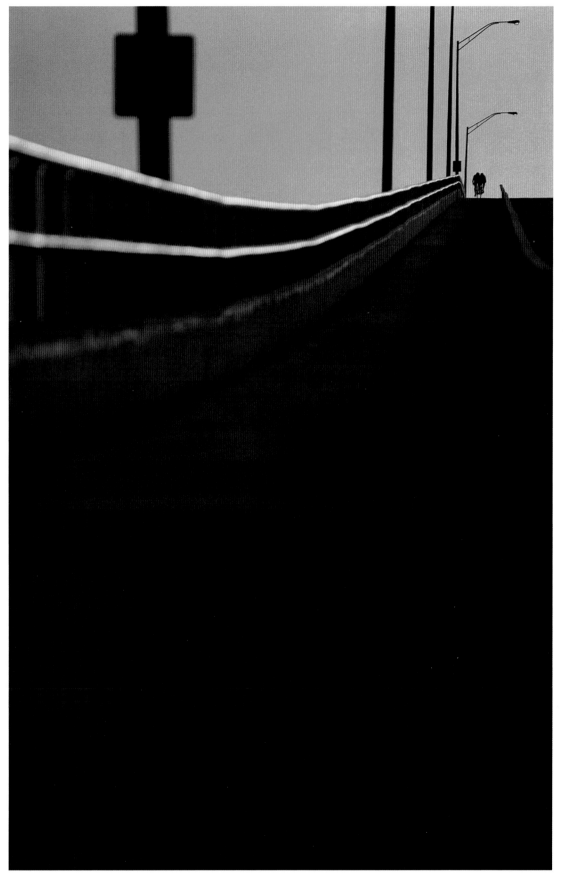

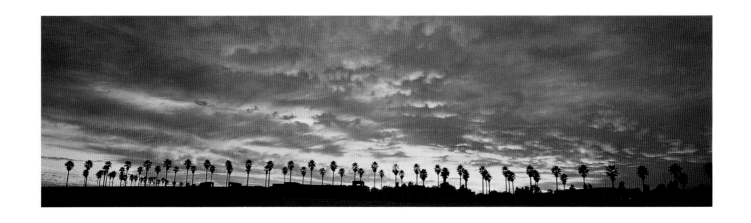

Mark Segal Photography 230 North Michigan Avenue Chicago, Illinois 60601 (312)236-8545

Represented by: *Chicago:* Susan Katz (312) 549-5379 *Los Angeles:* Debra Weiss (213) 466-0701 *Phoenix:* Marla Matson (602) 252-5072 *Washington D.C./New York:* Judi Giannini (301) 565-0275

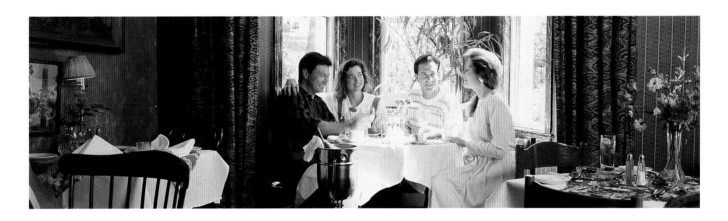

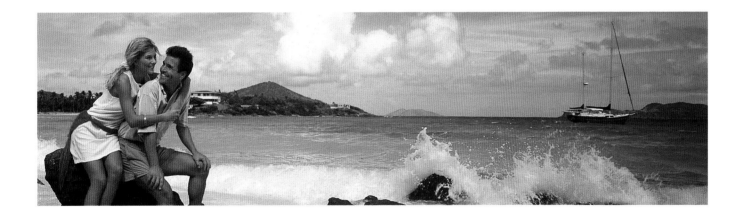

MARK SEGAL

P H O T O G R A P H Y

Mark Segal Photography 230 North Michigan Avenue Chicago, Illinois 60601 (312)236-8545

Represented by: Chicago: Susan Katz (312) 549-5379 *Los Angeles:* Debra Weiss (213) 466-0701 *Phoenix:* Marla Matson (602) 252-5072 *Washington D.C./New York:* Judi Giannini (301) 565-0275

POPLIS

POPLIS.

217

Gillis

Greg Gillis Photography
952 West Lake
Chicago, Illinois 60607
312.733.2340
FAX: 312.733.1536

Gillis

Greg Gillis Photography
952 West Lake
Chicago, Illinois 60607
312.733.2340
FAX: 312.733.1536

KARL SCHULTZ ASSOCIATES INC.
740 WEST WASHINGTON
CHICAGO, ILLINOIS 60661
FAX 312-454-0936
312-454-0303

Image Studios

Steve Eliasen
Dave Wallace
1100 South Lynndale Drive
Appleton, Wisconsin 54914

For representation contact
Jim Weiland
(414) 738-4080
FAX: (414) 738-4089

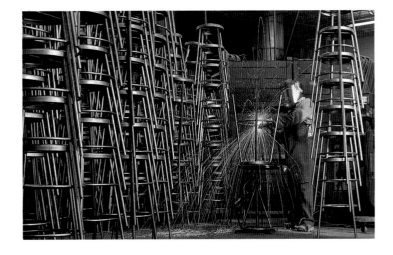

IDEAS

D.R.GOFF

FITNESS

FASHION

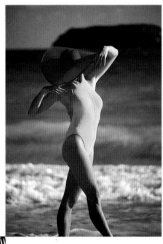

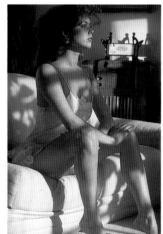

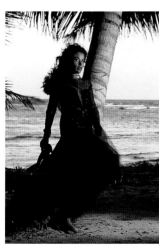

QUICKSILVER PHOTOGRAPHY

66 WEST WHITTIER STREET

COLUMBUS, OHIO 43206

614 ▪ 443 ▪ 6530

LOCATION

Representative

LARRY CUNNINGHAM

JOEL CONISON
PHOTOGRAPHY
18 WEST 7
CINCINNATI, OHIO 45202
513 241-1887
FAX
513 241-3333

ANDREW**SACKS**

20727 SCIO CHURCH ROAD • CHELSEA (DETROIT), MICHIGAN 48118 • STUDIO AND LOCATION PHOTOGRAPHY
EDITORIAL AND CORPORATE ASSIGNMENTS • CALL FOR SAMPLE PORTFOLIIO • 313 475-2310 • FAX 313 475-3010
ADDITIONAL STOCK FROM TONY STONE WORLDWIDE • 800-234-7880

Greg Sereta / Photographic Illustration

2440 Lakeside Avenue/Cleveland Ohio 44114
Phone: (216) 861-7227 Fax: (216) 861-1232
Portfolio available upon request.

Lucky Curtis
1540 N. North Park Avenue
Chicago, Illinois 60610
(312) 787-4422
FAX: (312) 751-1904

Represented by
Ron Chambers
(312) 787-4422

CURTIS PHOTOGRAPHY

LUCKY CURTIS PHOTOGRAPHY INC.

1540 N. NORTH PARK AVENUE

CHICAGO, ILLINOIS 60610

REPRESENTED BY

RON CHAMBERS

312.787.4422

FAX 312.751.1904

Ken Frick - Photographer
66 Northmoor Place
Columbus, Ohio 43214
(614) 263-9955

Location and Studio Photography
for Advertising, Corporate and
Editorial Clients.

Member ASMP

© Ken Frick 1992

Additional Work May Be Seen In
American Showcase Volumes 12 and 14

Isenberger Photography
Brent Isenberger
108 3rd Street, Suite 360
Des Moines, Iowa 50309
(515) 243-2376

Unique photography for catalog, product, location and annual reports.

Kalman & Pabst
Photo Group
400 Lakeside Avenue Northwest
Cleveland, Ohio 44113
(216) 574-9090
FAX: (216) 574-4835

Studio and Location Photography for advertising, corporate, editorial & annual reports.

Specializing in children & people, still life, photo illustration & manipulation. Please see other examples of our work in Showcase #14 pg. 224, and Ohio Sourcebook #1 pg. 52.

Members of A.S.M.P., C.S.C.A., and A.I.G.A.

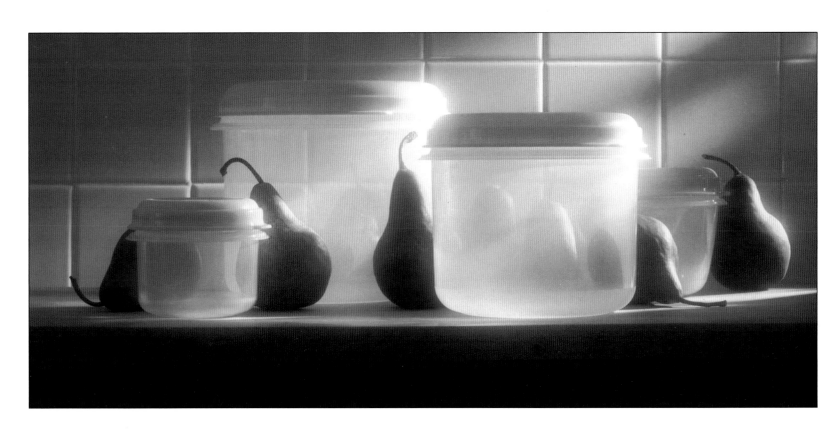

**John Lehn &
Associates Advertising
Photography, Inc.**
2601 East Franklin Avenue
Minneapolis, Minnesota 55406
(612) 338-0257
FAX: (612) 338-6102

Partial Client List Includes:
3M, B Dalton, Cadillac, Citicorp,
Control Data, County Seat, Dayton
Hudson, General Mills, Homecrest,
Honeywell, IBM, International
Multifoods, Jostens, Levi-Strauss,
Mercury & Mercruiser, Pacific Bell,

Pearle Vision, Pillsbury, Radisson Hotel,
Rollerblades, Timex, Tonka Toys.

Additional work can be seen in
Showcase volumes 10, 11, 12, 13 and 14
and Corporate Showcase '88 and '89.

Location and Studio Photography for
Advertising and Corporate clients.
International Travel Experience.

© 1991, John Lehn

Charles Schridde
600 Ajax Drive
Madison Heights, Michigan 48071
(313) 589-0111

1612 Via Garfias
Palos Verdes Estates, California 90274
(213) 791-7119

Reel on request.

MARK GREEN

MARK GREEN

MARK GREEN

MARK GREEN

MARK GREEN

MARK GREEN

MARK GREEN

For Assignments and Stock

2406 Taft Street

Houston, Texas 77006

713-523-6146

Fax 713-523-6145

MARK GREEN

MARKOW SOUTHWEST

Paul Markow
shoots on location. Anywhere.

Markow Southwest, Phoenix.
602-273-7985

MARKOW SOUTHWEST

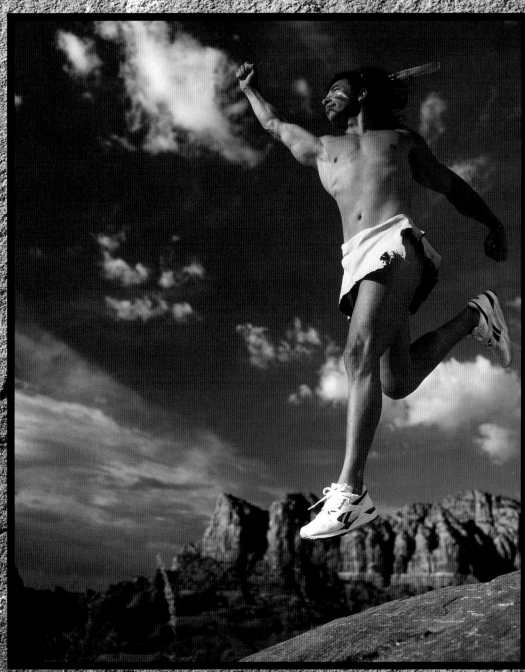

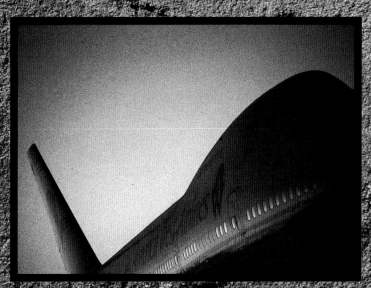

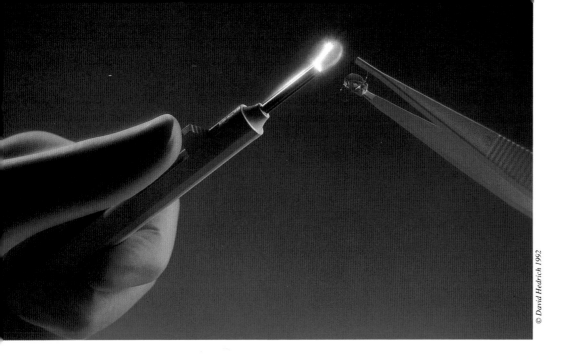

DAVID HEDRICH

American Express

Best Foods

The Dial Corp.

General Foods

Hershey's

Ore-Ida/Heinz

Pepsi-Cola

Represented by Photo Group, Contact Pam Black (602) 381-1332, Fax (602) 381-1406, Studio (602) 220-0090

RCA

Sony

Tech Medical

The Western La Paloma Resort

Al Payne

CRS Sirrine

Gensler & Assoc.

Hilton Hotels

H. K. S. Architects

Represented by Photo Group, Contact Pam Black (602) 381-1332, Fax (602) 381-1406, Studio (602) 258-3506

Hyatt Regency Hotels

La Costa Spa & Resort

Marriott Hotels

Melvin Simon & Assoc.

Richards Group

Ritz-Carlton Hotels

Trammel Crow Co.

STEVEN MECKLER

121 SOUTH FOURTH AVENUE

TUCSON ARIZONA 85701

602.792.2467 FAX 602.882.6141

➤ Jeff Noble

688 West First Street

Tempe, Arizona

602 968 1434

fax: 602 968 1446

NOBLE

CLIENT LIST: First Interstate Bank · The Dial Corp · Phoenix Suns

American Express · US West Communications · Westin Hotels & Resorts

Mayo Clinic Scottsdale · Best Western International · AmericaWest Airlines

"ARIZONA: DISTINCTION"

PROMOTIONAL SERIES

FEATURING OLYMPIANS

FROM ARIZONA

THE 1990 PDN/NIKON

FIRST PLACE WINNER

CATEGORY:

BEST OVERALL CAMPAIGN,

ESTABLISHED TALENT

CALL TO RECEIVE

THE SERIES OR TO

REVIEW THE BOOK

Siegel Photographic, Inc. Dave Siegel 224 North 5th Avenue Phoenix, Arizona 85003 (602) 257-9509 Fax: (602) 340-8058

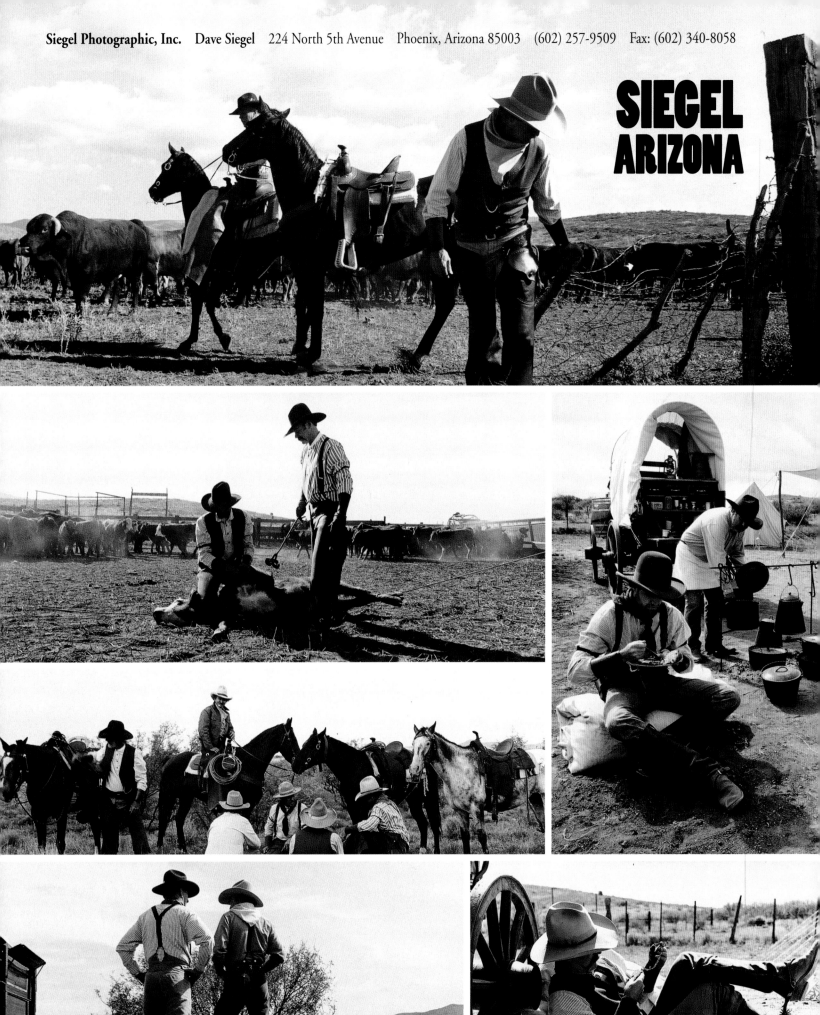

SIEGEL ARIZONA

Randy Anderson
Anderson Studio
3401 Main Street
Dallas, Texas 75226
(214) 939-1740
FAX: (214) 939-9827

Photographs of people for advertising, catalog, or corporate venues.

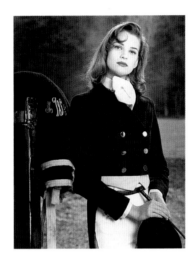

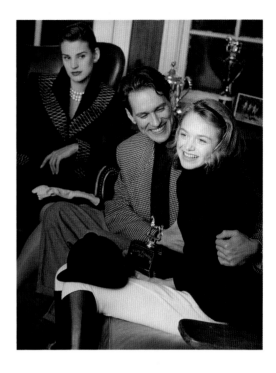

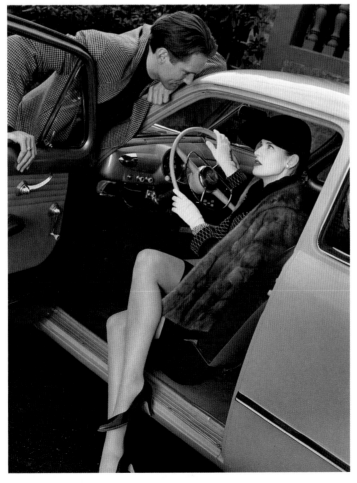

Jim Caldwell
101 West Drew
Houston, Texas 77006
(713) 527-9121

Corporate/commercial/advertising/
editorial photography on location or
in the studio. Stock available through
FPG International Corp. (212) 777-4210
The Showcase images and others are
available direct.

Photographs © 1991 Jim Caldwell

Corporate clients include:
AT&T, American Funds Group, Coca
Cola Foods, Columbia Artists, Coldwell
Banker, Continental Can, Exxon U.S.A.,
Foley's, Grafica, Houghton Mifflin
Publishers, Houston Lighting & Power
Co., Humana Hospitals, Kentucky Fried
Chicken, Kingdom of Saudi Arabia,

Lyondell Petrochemical, Otto York Co.,
Owens-Corning, Mass. Mutual Ins.,
Phillips Petroleum, Pitney Bowes,
Prudential Insurance, Reinforced Earth,
Research-Cottrell, Ryder Truck,
Southwestern Bell, Texas Heart
Institute, Unisys Corp., Warner Amex
Communications....

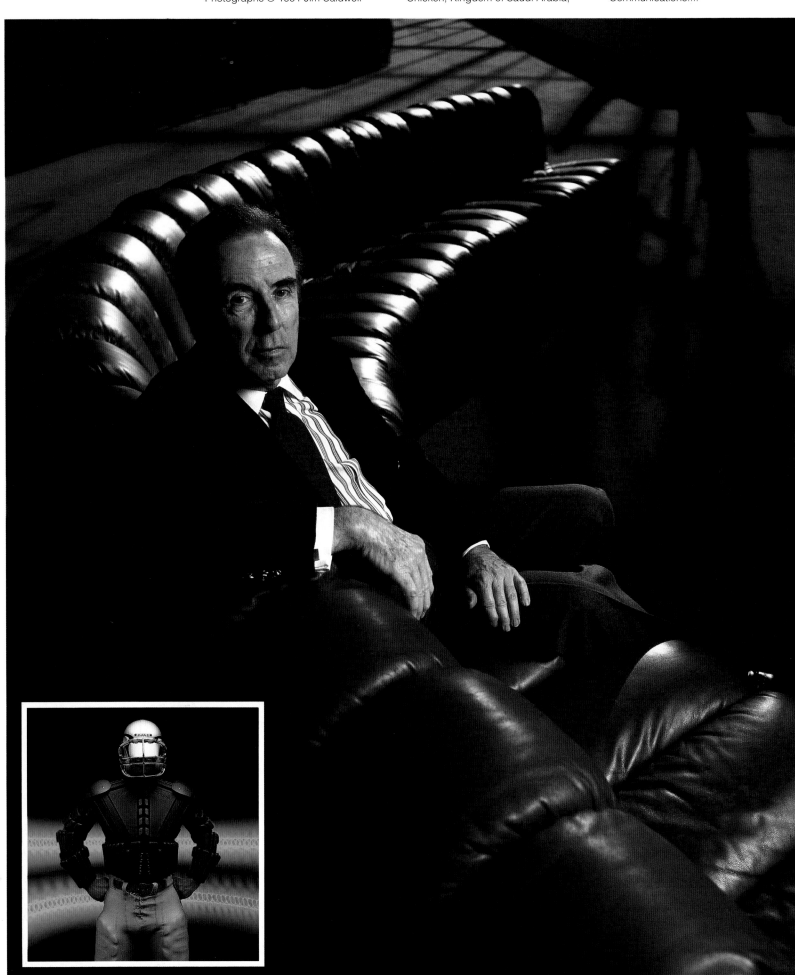

Jim Caldwell
101 West Drew
Houston, Texas 77006
(713) 527-9121

For more examples of my work, please consult American Showcase Volumes 8 through 14 and Corporate Showcase Volumes 4, 6, 7, 8, & 9. Or...call for a packet of samples rushed directly to you.

Photographs © 1991 Jim Caldwell

Advertising/design clients include: Compaq Computers; Creative Edge; D'Orucci; Exxon Chemical Americas; Generon Systems; Halcyon Inc.; Herring Design; Lion Adv.; Live Home Video; McCann Erickson; Ogilvy & Mather; Power by Riddell; Size, Inc.; The Marketing Group; Watermark Design....

Editorial clients include: Black Enterprise Mag., CASE, Computer World, DanceMagazine, Houston Metropolitan, Inc.Mag., Longevity, Newsweek, Nostalgia, Opera News, Selling Red, Southern Living, Texas Monthly, The NY Times Mag.; Time Mag., Travel & Leisure, Update....

Pete Lacker
235 Yorktown Street
Dallas, Texas 75208
(214) 748-7488
FAX: (214) 748-1463

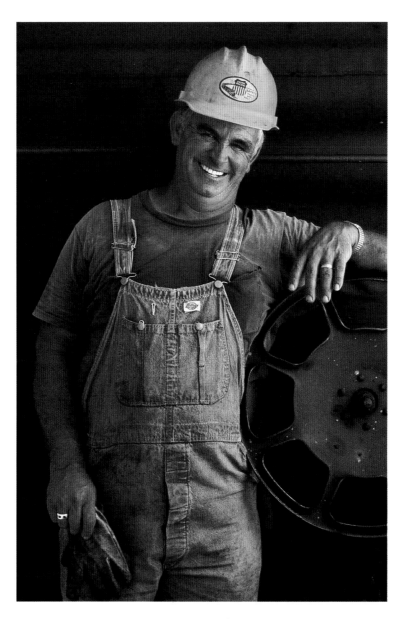

Pete Lacker
235 Yorktown Street
Dallas, Texas 75208
(214) 748-7488
FAX: (214) 748-1463

P R A Y

IT'S A MYSTERY, A LEGEND, A WORK OF ART. It's everywhere in New York City, yet very nearly invisible. If you ask people if they've seen the PRAY graffiti campaign, you are asking if they have looked at almost any street-level door frame in New York. There, and on every other window frame and phone booth and subway column and railing and lamp post, PRAY quietly chants its message.

A whisper is often louder than a shout. Especially when it's repeated thousands of times. This is a brilliant strategy accomplished with the simplest, most direct means. The word is always scratched with a stylus, always vertically, in crude half-inch caps. Considering that the distance for legibility of the message is quite close, it assumes your eyes are focused on the foreground, that you are momentarily myopic (a dangerous thing on the street). If lost in thought, you are predisposed to this message. You will only physically "discover" it at the time you are psychologically open to it. In their sophisticated simplicity, the signs could be the result of years of psychological testing and focus groups.

The message itself could have been brainstormed at the conference table of an advertising agency. It is immediate, memorable and universal. It is nondenominational (pray to whom?) and vague (pray for what?) but there is no mistaking its earnestness and emotional impact. The message dovetails placement to its target audience: There are few better locations than at eye-level on the streets of New York to invoke this ancient placebo.

The longevity of the program looms legendary. I first discovered it nine years ago; some say it's older than that. Like any good legend, it seems it's always been there, and judging from the fresh applications still being sighted, it always will be there. One day I hope to see the writer in action.

What have we really got here? I doubt there were any brainstorming sessions, any focus groups or psychological studies. I think it is actually the work of a single obsessed person and a few imitators. But to discount the program as vandalism or a cry in the dark is to miss some important lessons. If painters trained in academic traditions can look at the work of Grandma Moses and find Beauty and Truth, then designers can look at PRAY and feel we have found our first anonymous genius of "folk" environmental graphic design.

Tom Wojciechowski
Wojciechowski Design
(environmental and communication graphics)
New York City
He has been heard to confess that the job he's always wanted is writing headlines for the New York Post-or being a scribe in a monastery.

Jim Marshall
382 North 1st Avenue
Phoenix, Arizona 85003
(602) 258-4213

Clients include:
United Airlines, America West Airlines,
Clipper Cruise Lines, DuPont, 3M,
Motorola, Heidelburg West, Whittle
Communications, CVL Engineering,
Inc. Magazine, Best Western Hotels,
Ramada Inn, Arizona Highways,
Arizona Office of Tourism, Casados

Farms, Ticketmaster, UDC Homes.

For additional work see:
American Showcase Vol.14, Graphis
Photo '88, NY Art Directors 66th Annual,
Print Regional Design Annual '87, CA
Photography Annuals '86 & '85, AR
Volumes 2 & 3.

Extensive SW Stock through Visual
Images West (800) 433-4765.

© Jim Marshall 1991.

Jim Olvera
235 Yorktown Street
Dallas, Texas 75208
(214) 760-0025
FAX: (214) 748-1463

I'm at home in the studio. Everything I need is close at hand, so I can concentrate on what is before my camera.

Parkland Blood Bank asked me to photograph people for a brochure appealing to donors. I chose to photograph these children. Alive today because of the efforts of my client, they are the subjects of tragic stories with happy endings.

I've shot in the studio for a number of other clients, as well, including American Airlines, Newsweek and TGI Friday's. Their stories had happy endings, too. If you'd like to see some, just send for a portfolio.

Jim Olvera
235 Yorktown Street
Dallas, Texas 75208
(214) 760-0025
FAX: (214) 748-1463

I'm at home on location. I enjoy the excitement of going to new places and solving unexpected problems. When I photographed these people for the Pilgrim's Pride annual report, it was dark and wet in the processing plants, and the sound was deafening. Despite all that, we were able to capture the spontaneity of the people.

I've done location work for Fred Woodward, Woody Pirtle, Jack Summerford and Jerry Herring. They hire me because I prepare thoroughly and keep an open mind while shooting, so I'm ready to respond to those "happy accidents."

They're happy with the results. But it's no accident.

Creation by design, not accident.

Outstanding visual images rarely just happen. They are the result of careful premeditation, planning and design.

This new book by Henry Wolf, one of today's foremost photographers and art directors, examines the many creative methods he employs – from use of strange perspective to settings in improbable places to unexpected combinations.

Here are 17 chapters of techniques for translating words into photographic images that will be more com-

pelling, more unique and therefore more memorable.

Any visual communicator will find inspiration in these pages.

Clothbound with hundreds of full-color photographs, as well as reproductions of many classic works of art that have been an influence on them.

184 pages. $45.00. All major credit cards accepted. Order now! American Showcase, 915 Broadway, New York, New York 10010, (212) 673-6600.

"Flamingoes"

DAVID HOLT

Photography/an alternative view
(310) 478-1188

Kirin/Seagram, Japan

DAVID HOLT

Photography/an alternative view
(310) 478-1188

CHRISTOPHER

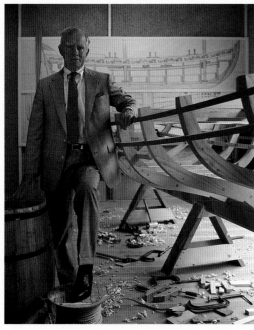

Thomas Vaughan, Portland Historical Society

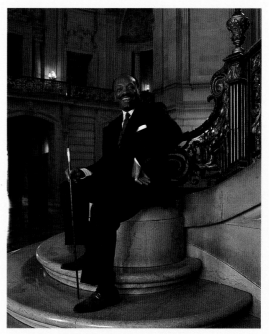

Willie Brown, Speaker of the California Assembly

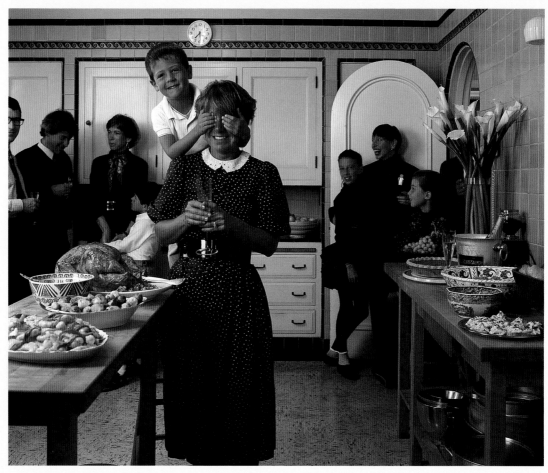

Patricia Unterman, San Francisco food critic

Apple Computer • Bank of America • Herman Miller •

IRION

415.896.0752
Fax 415.896.1904

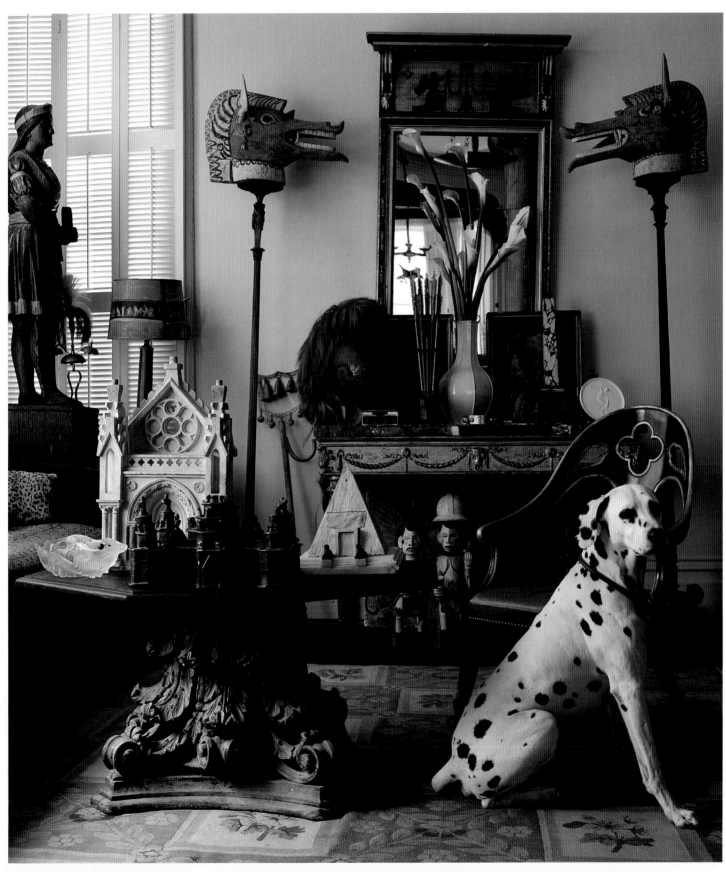

Hennessy, San Francisco dog

Architectural Digest • Sheraton Hotels • Travel and Leisure

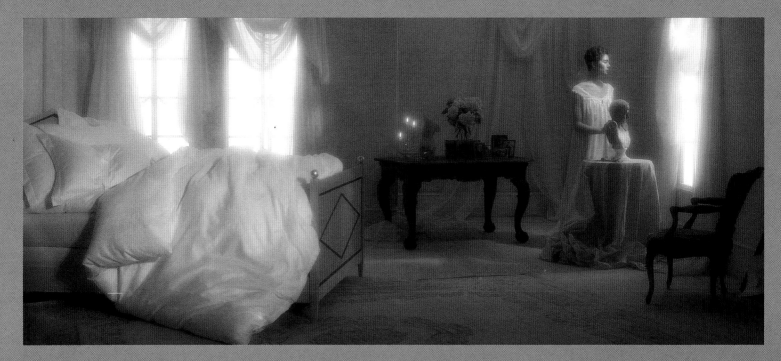

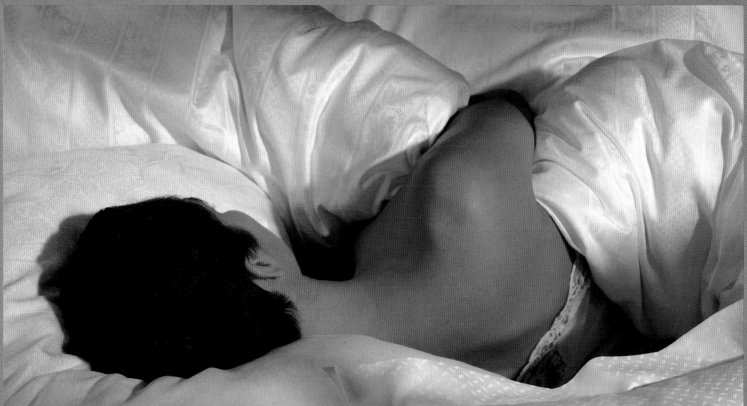

CLIENTS: BOEING, CODE BLEU, EDDIE BAUER, MCI, MICROSOFT, NIKE, NORDSTROM, SCANDIA DOWN, UNYSIS, WEYERHAUSER

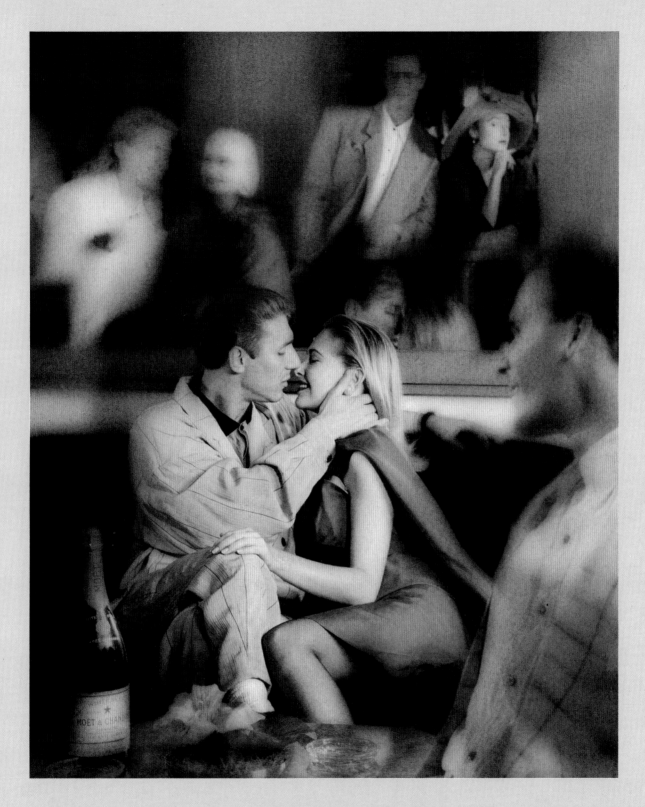

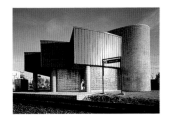

RUSSELL

ABRAHAM

PHOTOGRAPHY

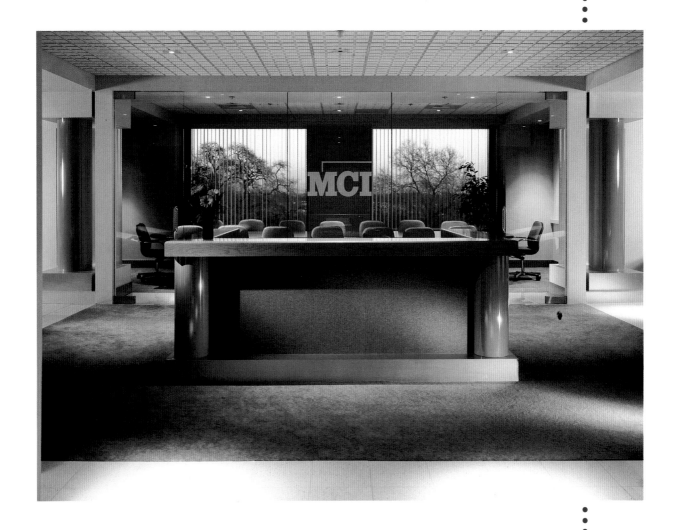

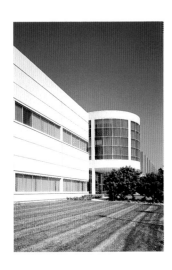

Cody Assoc. • Cornerstone Concilium
de Tienne Assoc. • Designers West
Hellmuth Obata Kassabaum
Hood Miller Archts. • Leo A. Daly Intl.
MMAP • RED Archts. • RIA Archts.
Swatt Archts. • Takenaka Intl.

60 FEDERAL ST • SAN FRANCISCO CA • 94107

(4 1 5) 8 9 6 - 6 4 0 0

REPRESENTED IN NEW YORK BY MOSS & MEIXLER (212)868-0078

RUSSELL

ABRAHAM

PHOTOGRAPHY

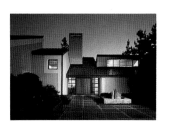

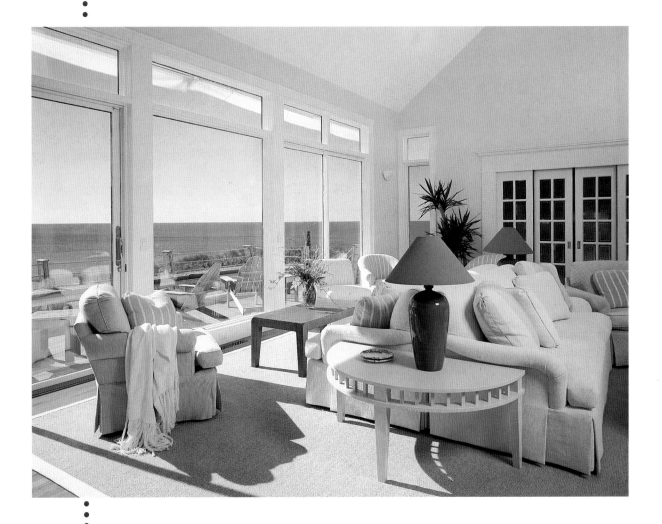

JIM DOUGLASS

PHOTOGRAPHY

1-800-942-9466

IN LA

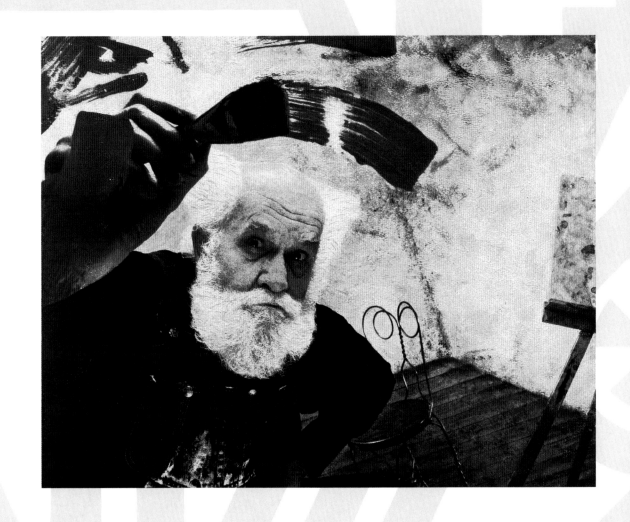

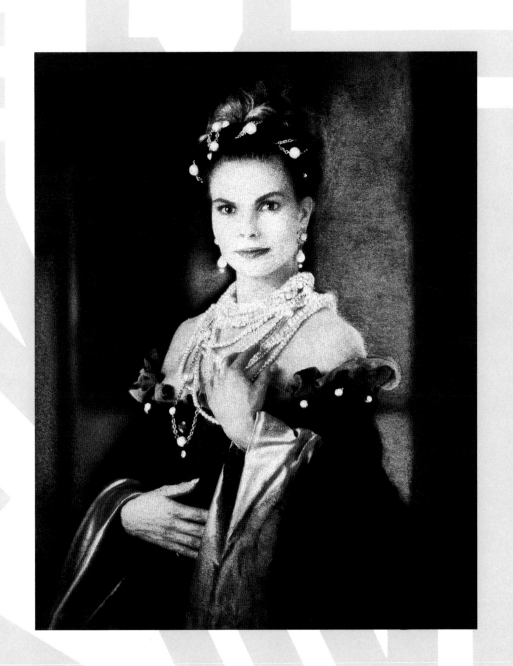

deGENNARO ASSOCIATES

HEIDI'S

PERKINS

902 SOUTH NORTON AVE., LOS ANGELES, CALIFORNIA 90019
(213) 935-5179 FAX (213) 935-9120

Marshal Safron Studios, Inc.

1041 North

McCadden Place

Los Angeles

California

90038

tel 213 461 5676

fax 213 461 1411

Doubletree Hotels / Ayer

Modern Living / JMA

Marshal Safron Studios, Inc.

1041 North

McCadden Place

Los Angeles

California

90038

tel 213 461 5676

fax 213 461 1411

MARSHAL SAFRON STUDIOS

Loews Hotels / Editorial

Westinghouse / Ketchum

Camino Real Hotels / Intercon

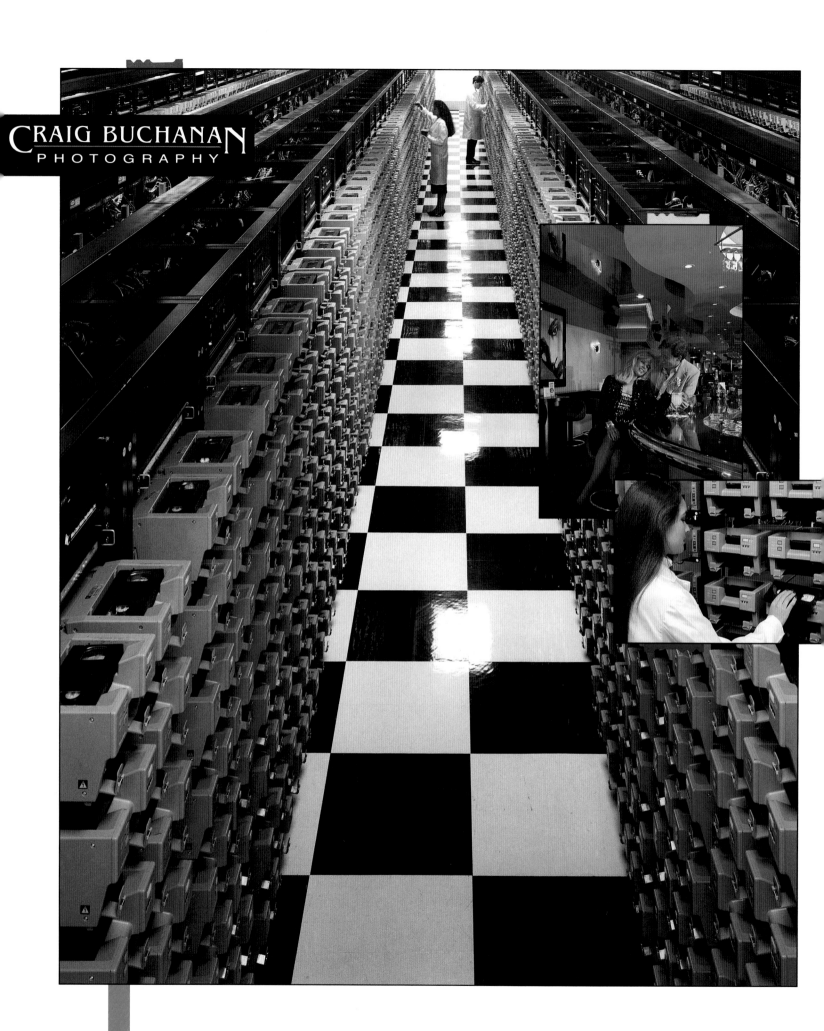

CRAIG BUCHANAN
PHOTOGRAPHY

LOCATION WORK · COMPLEX LIGHTING SITUATIONS · AERIALS · DIRECTION OF TALENT

NO WONDER YOU GET
PRESIDENTIAL TREATMENT AT THE
STOUFFER STANFORD COURT.
WE'VE HAD A LOT OF PRACTICE.

...ve played ...'s top ... business ... presiden... You...

In understated elegance, pers... and

that befits our Nob Hill address.

hotel for seventeen consecu-

tive years. To experience

presidential treatment, call

1•800•HOTELS•1.

281

MARC MUENCH

ASSIGNMENTS

805 · 967 · 4488

GARY NOLTON

for Advertising and Design
DIO (503) 228-0844

P
H
O
T
O
G
R
A
P
H
Y

➤ 213 650 7906

213 654 1270 FAX

PARTIAL CLIENT LIST:

UNOCAL
MCA/UNIVERSAL
CITY OF BEVERLY HILLS
USC
YAMAHA
KEEBLER
GREAT WESTERN BANK

ELIOT

CROWLEY

3221 Benda Place

Hollywood, California 90068

phone 213.851.5110

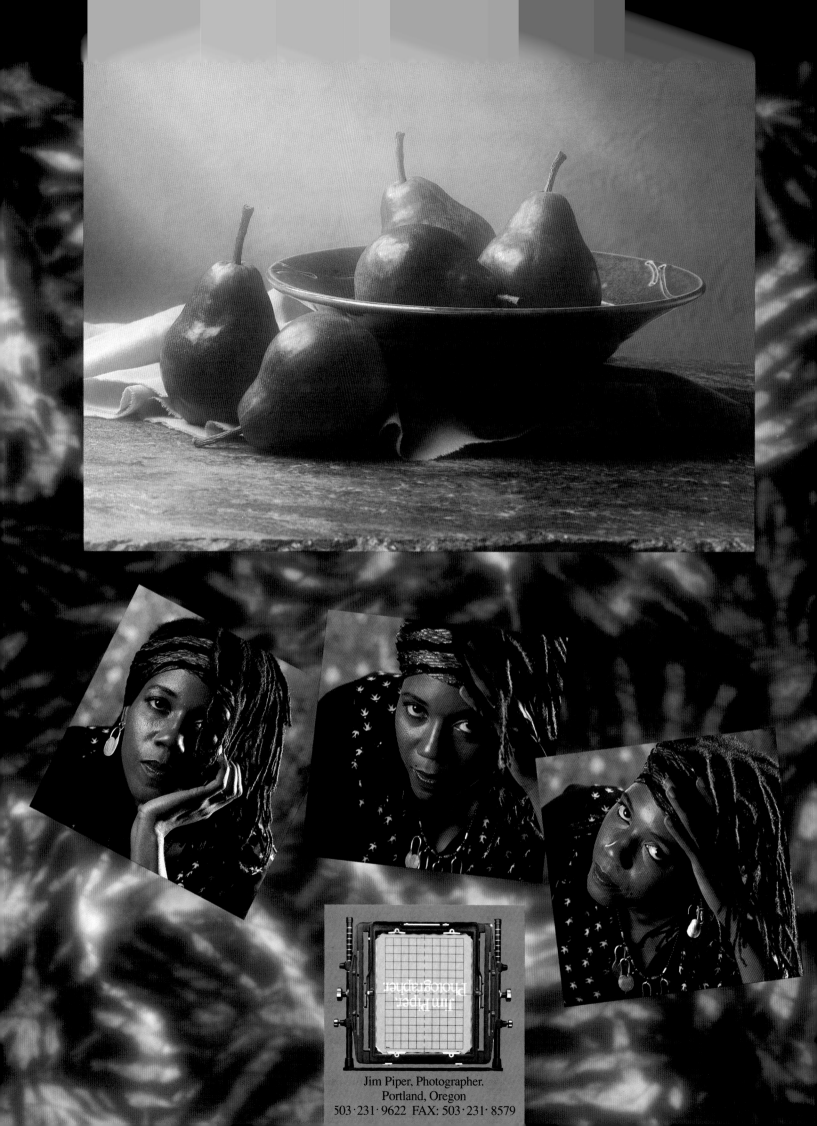

Jim Piper, Photographer.
Portland, Oregon
503·231·9622 FAX: 503·231·8579

Earth Spirit

"But, Monument Valley has been shot to death! . . ."

With that provocative thought, I began the assignment of creating <u>Earth Spirit</u>, a "unique and inspiring" multi-image show of Monument Valley. The challenge was irresistable; the ghosts of a million photographers lurked behind every rock . . .

Write or call for a free video of <u>Earth Spirit</u>, and see what a new viewpoint can do to an old cliche.

JILL SABELLA

Original Photography & Hand Coloring

LEVI NORDSTROM COORS SEAFIRST TUTTO MIO EDDIE BAUER SEE'S CANDIES

2607 9TH AVENUE WEST SEATTLE, WASHINGTON 98119 TEL 206 285 4794 FAX 206 284 8161

BURKE/TRIOLO

L os A n g e l e s

JEFFREY BURKE *photographer* LORRAINE TRIOLO *stylist*
213.687.4730 fax 213.687.3226
Represented by France Aline, Inc.

CREATIVE
ILLUSTRATIVE

FASHION
PEOPLE

STUDIO
LOCATION

SAN FRANCISCO BAY AREA
510 • 536 • 4811

Ron Starr specializes
in location photography
world wide for hotel/resorts,
advertising agencies,
corporations and design
professionals. Working
experience in Japan and
the Pacific Rim.

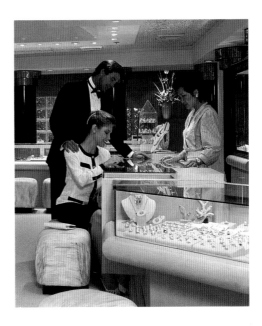

CLIENTS INCLUDE:
Azabu Group USA
Hotel Seiyo, Ginza
Hyatt Hotels Corporation
Marriot's Tenaya Lodge, Yosemite
Mauna Lani Bay Hotel, Kona
Media 5
Monsanto Corporation
Ogilvy and Mather
Poole Communications
Ramada Renaissance Hotels

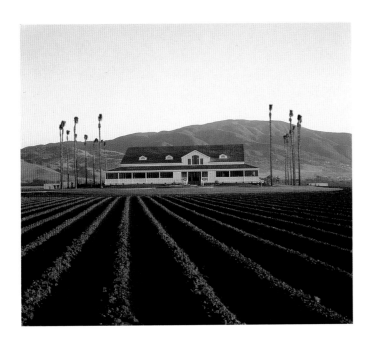

SAN FRANCISCO 415-541-7732

LOS ANGELES 213-271-4632

MARC SOLOMON

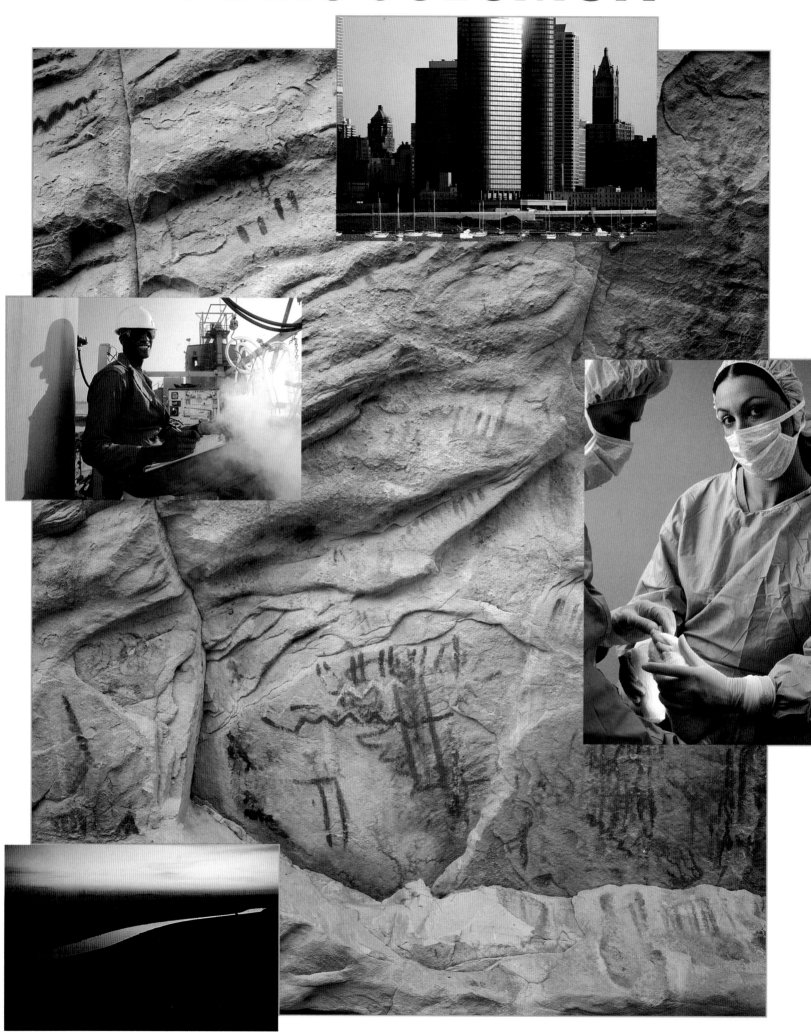

BOX 480574 LOS ANGELES, CALIF. 90048 (213) 935-1771

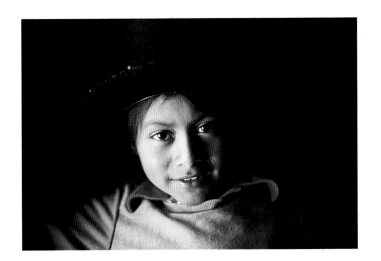

KENT MILES PHOTOGRAPHY (801) 364-5755

REPRESENTED IN NEW YORK BY
PIX PRODUCERS INC 212 ∘ 226-0012

SEE ADDITIONAL WORK IN SHOWCASE 12-14, CORPORATE SHOWCASE 6-10, BLACK BOOK 92,

(206)682-7818
FAX: 682-0515

MOVING·IMAGES

STEWART·TILGER

STEWART·TILGER

BARRY GREGG

84 UNIVERSITY, SUITE 210 • SEATTLE, WA 98101 • 206·285·8695 • FAX: 206·622·8089

BRILLIANT THINGS WITH LIGHT

THIS YEAR'S CLIENTS INCLUDE:
HEWLETT/PACKARD, MICROSOFT, MILLSTONE COFFEE,
NASTY MIX RECORDS, ORCA BAY SEAFOODS, OROWEAT
FOODS, CHATEAU STE. MICHELLE, WINDSTAR CRUISES

DON SMITH PHOTOGRAPHY

Member: American Society of Magazine Photographers ◆ International Society of the Arts, Sciences and Technology ◆ Seattle Design Association

206.324.5748
Fax: 206.329.8377

E-mail: Domain: dsp@polari.UU
UUCP: uunet!sumax.seattleu.
edu!polari!dsp

JAMES KAY PHOTOGRAPHY
P.O. BOX 581042 • SALT LAKE CITY, UTAH 84158
801-583-7558 • FAX 801-582-4724 • MEMBER ASMP

PAT O'HARA
PHOTOGRAPHY

P.O. BOX 955, PORT ANGELES, WA. 98362 PHONE 206-457-4212

STOCK · LOCATION · FINE ART PRINTS

SPECIALIZING IN NATURAL LIGHT ENVIRONMENTAL PHOTOGRAPHY

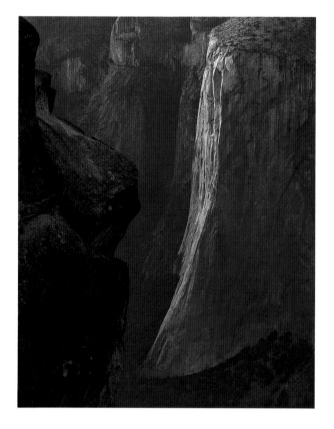

CLIENTS INCLUDE: LEVI'S, HITACHI, CIGNA INSURANCE, PANASONIC, EDDIE BAUER, NATIONAL GEOGRAPHIC PUBLICATIONS, READER'S DIGEST BOOKS, HALLMARK INC., AUDUBON, ARCHITECTURAL DIGEST. **PAT'S** COLOR IMAGES HAVE BEEN SHOWCASED IN FOURTEEN LARGE FORMAT BOOKS WITH SEVERAL OTHERS CURRENTLY IN PRODUCTION. **RECIPIENT** OF NEW YORK ART DIRECTOR'S PHOTOGRAPHY GOLD MEDAL AND COMMUNICATION ARTS AWARD OF EXCELLENCE. **MEMBER** ASMP.

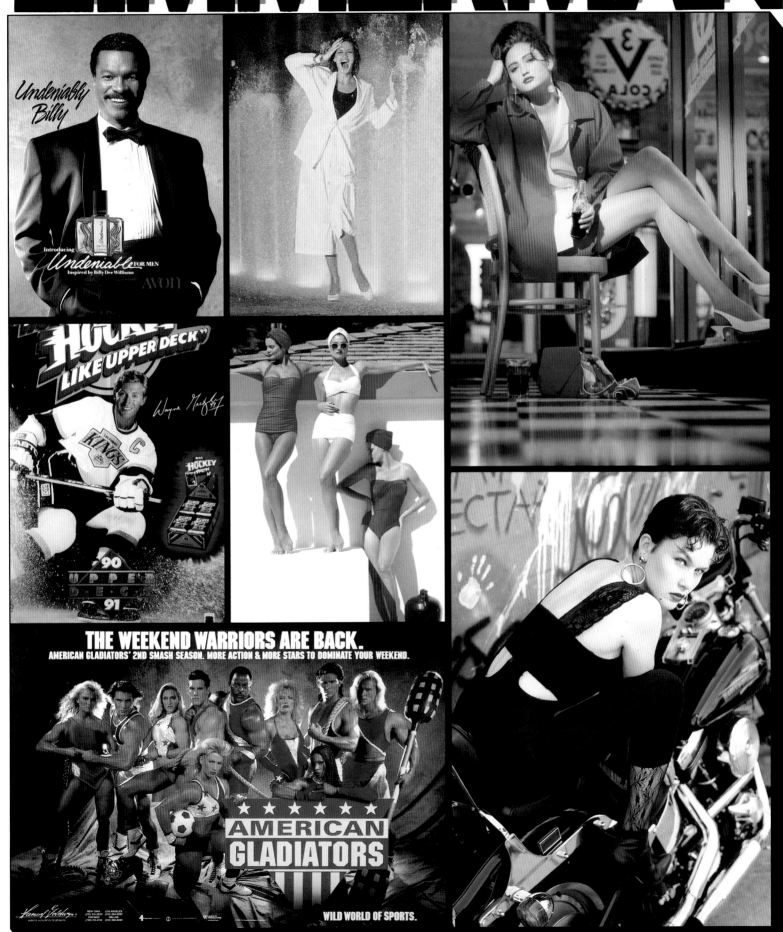

ZIMMERMAN

Dick Zimmerman Studio 8743 W. Washington Blvd. LA, CA 90230 (213) 204-2911

ALASKA

Alaska Artists Guild
PO Box 91982
Anchorage, AK 99059-1982
(907) 248-4818

ARIZONA

Arizona Artists Guild
8912 North Fourth Street
Phoenix, AZ 85020
(602) 944-9713

CALIFORNIA

Advertising Club of Los Angeles
3600 Wilshire Boulevard, Suite 432
Los Angeles, CA 90010
(213) 382-1228

APA Los Angeles, Inc.
7201 Melrose Avenue
Los Angeles, CA 90046
(213) 935-7283

APA San Francisco
22 Cleveland Street
San Francisco, CA 94103
(415) 621-3915

Art Directors and Artists Club
2791 24th Street
Sacramento, CA 95818
(916) 731-8802

Book Club of California
312 Sutter Street, Suite 510
San Francisco, CA 94108
(415) 781-7532

Los Angeles Advertising Women
3900 West Alameida
The Tower Building, 17th Floor
Burbank, CA 91505
(818) 972-1771

San Francisco Art Directors Club
Box 410387
San Francisco, CA 94141-0387
(415) 387-4040

San Francisco Creative Alliance
Box 410387
San Francisco, CA 94141-0387
(415) 387-4040

Society of Illustrators of Los Angeles
5000 Van Nuys Boulevard, Suite 300
Sherman Oaks, CA 91403-1717
(818) 784-0588

Society of Motion Pictures & TV Art Directors
11365 Ventura Boulevard, #315
Studio City, CA 91604
(818) 762-9995

Visual Artists Association
2550 Beverly Boulevard
Los Angeles, CA 90057
(213) 388-0477

Western Art Directors Club
PO Box 996
Palo Alto, CA 94302
(408) 998-7058

Women's Graphic Commission
1126 Highpoint Street
Los Angeles, CA 90035
(213) 935-1568

COLORADO

Art Directors Club of Denver
1900 Grant Street
Denver, CO 80203
(303) 830-7888

International Design Conference in Aspen
Box 664
Aspen, CO 81612
(303) 925-2257

CONNECTICUT

Connecticut Art Directors Club
PO Box 639
Avon, CT 06001
(203) 651-0886

DISTRICT OF COLUMBIA

American Advertising Federation
1400 K Street NW, Suite 1000
Washington, DC 20005
(202) 898-0089

American Institute of Architects
1735 New York Avenue, NW
Washington, DC 20006
(202) 626-7300

American Society of Interior Designers/National Headquarters
608 Massachusetts Avenue NE
Washington, DC 20002
(202) 546-3480

Art Directors Club of Metropolitan Washington
1420 K Street NW, Suite 500
Washington, DC 20005
(202) 842-4177

NEA: Design Arts Program
1100 Pennsylvania Avenue, NW
Washington, DC 20506
(202) 682-5437

FLORIDA

APA Miami
2545 Tiger Tail Avenue
Coconut Grove, FL 33033
(305) 856-8336

continued

HOLLY
FREEDMAN

PHOTOGRAPHY

3 1 0 472-1715

**Noel Barnhurst
Photographer**
34 Mountain Spring Avenue
San Francisco, California 94114
(415) 731-9979
FAX: (415) 566-0306

Represented by
Rick Chapman

Sebastiani
Evian Waters of France
Guild Wineries & Distilleries
Chase-Limogere Champagne
Chevron
Evans and Sutherland

Wells Fargo
Epson-Seiko
Hal Riney & Partners
Burson-Marsteller
California Milk Advisory Board
Italian Trade Commission

Phil Borges
(206) 284-2805

TRUE VISION BEGINS IN THE HEART

phil borges
P H O T O G R A P H Y

Bill Bossert
2009 Irvine Avenue
Newport Beach, California 92660
(714) 631-7222
FAX in studio

Studio and Location

Call for portfolio

Member ASMP and PP of A

Bill Bossert
PHOTOGRAPHY

Cindy Charles
631 Carolina Street
San Francisco, California 94107
(415) 821-4457

CINDY CHARLES
PHOTOGRAPHER

631 Carolina, San Francisco, CA 94107 • 415-821-4457

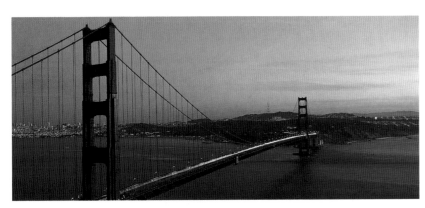

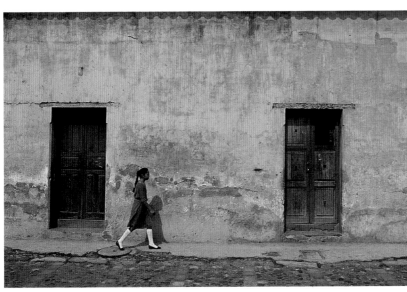

Kathleen Norris Cook

PO Box 2159
Laguna Hills, California 92653
(714) 770-4619

Represented by:
Warren Cook

Landscapes, Aerials, Panoramics
Assignments and Stock

For additional examples, see earlier
Showcase and Black Book Volumes.

Recent Clients:
Alaska Airlines, Amoco, General Motors,
Honda, Hyatt, Kodak, Mexico Tourism,
Phillip-Morris, Proctor & Gamble, Shell,
Toyota, Westin Hotels, Xerox.

Mel Curtis Photography
2400 East Lynn Street
Seattle, Washington 98112
(206) 323-1230

Represented by
Donna Jorgensen
Annie Barrett, Associate
(206) 634-1880

People and Places
Elegant
Dramatic
Unique
Always

Black & white, hand-tinted and color
portfolios available upon request.
Additional work In American Showcase,
Volume 14.

Steve Firebaugh
6750 55th Avenue South
Seattle, Washington 98118
(206) 721-5151
FAX: (206) 721-0507

Location photography worldwide that
combines a thoughtful approach,
elegant lighting and an eye for design.

S *t e v e*

F *i r e b a u g h*

P *h o t o g r a p h e r*

GEORGIA

APA Atlanta
PO Box 20471
Atlanta, GA 30325-1471
(404) 881-1616

Creative Club of Atlanta
PO Box 12483
Atlanta, GA 30355
(404) 266-8192

Atlanta Art Papers, Inc.
PO Box 77348
Atlanta, GA 30357
(404) 588-1837

Creative Arts Guild
PO Box 1485
Dalton, GA 30722-1485
(404) 278-0168

HAWAII

APA Hawaii
733 Auani Street
Honolulu, HI 96813
(808) 524-8269

ILLINOIS

APA Chicago
1725 West North Avenue, #2D2
Chicago, IL 60622
(312) 342-1717

Institute of Business Designers
341 Merchandise Mart
Chicago, IL 60654
(312) 467-1950

American Center For Design
233 East Ontario Street, Suite 500
Chicago, IL 60611
(312) 787-2018

Women in Design
2 North Riverside Plaza, Suite 2400
Chicago, IL 60606
(312) 648-1874

INDIANA

Advertising Club of Indianapolis
3833 North Meridian, Suite 305 B
Indianapolis, IN 46208
(317) 924-5577

IOWA

Art Guild of Burlington
Arts for Living Center
PO Box 5
Burlington, IA 52601
(319) 754-8069

MAINE

APA Portland
PO Box 10190
Portland, ME 04104
(207) 773-3771

MASSACHUSETTS

Boston Visual Artists Union
33 Harrison Avenue
Boston, MA 02111
(617) 695-1266

Creative Club of Boston
155 Massachusetts Avenue
Boston, MA 02115
(617) 338-6452

Center for Design of Industrial Schedules
221 Longwood Avenue
Boston, MA 02115
(617) 734-2163

Graphic Artists Guild
425 Watertown Street
Newton, MA 02158
(617) 244-2110

Guild of Boston Artists
162 Newbury Street
Boston, MA 02116
(617) 536-7660

Society of Environmental Graphic Designers
47 Third Street
Cambridge, MA 02141
(617) 577-8225

MICHIGAN

APA Detroit
32588 Dequindre
Warren, MI 48092
(313) 795-3540

Michigan Guild of Artists and Artisans
118 North Fourth Avenue
Ann Arbor, MI 48104
(313) 662-3382

MINNESOTA

Advertising Federation of Minnesota
4248 Park Glen Road
Minneapolis, MN 55416
(612) 929-1445

continued

Michael Fritz
PO Box 4386
San Diego, California 92164
(619) 281-3297

Studio or Location
Advertising
Commercial
Fashion

For more examples please see
Showcase Volumes 13 and 14

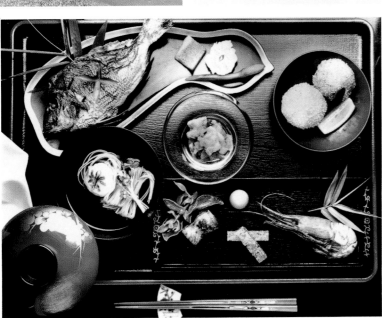

315

Kevin Laubacher
(503) 233-4594

Represented by:
Photogroup
DJ Strausbaugh
FAX: (503) 233-7172

MISSOURI

Advertising Club of Greater St. Louis
10 Broadway, #150-A
St. Louis, MO 63102
(314) 231-4185

Advertising Club of Kansas City
9229 Ward Parkway, Suite 260
Kansas City, MO 64114
(816) 822-0300

American Institute of Graphic Arts
112 West Ninth
Kansas City, MO 64105
(816) 474-1983

NEW JERSEY

Federated Art Associations of New Jersey, Inc.
PO Box 2195
Westfield, NJ 07091
(908) 232-7623

Point-of-Purchase Advertising Institute
66 North Van Brunt Street
Englewood, NJ 07631
(201) 894-8899

NEW YORK

The Advertising Club of New York
155 East 55th Street
New York, NY 10022
(212) 935-8080

The Advertising Council, Inc.
261 Madison Avenue, 11th Floor
New York, NY 10016
(212) 922-1500

APA
Advertising Photographers of America, Inc.
27 West 20th Street, Room 601
New York, NY 10011
(212) 807-0399

Advertising Production Club of NY
60 East 42nd Street, Suite 1416
New York, NY 10165
(212) 983-6042

TANY Inc.
408 8th Avenue, #10A
New York, NY 10001
(212) 629-3232

Advertising Women of New York Foundation, Inc.
153 East 57th Street
New York, NY 10022
(212) 593-1950

A.A.A.A.
American Association of Advertising Agencies
666 Third Avenue, 13th Floor
New York, NY 10017
(212) 682-2500

American Booksellers Association, Inc.
137 West 25th Street
New York, NY 10001
(212) 463-8450

American Council for the Arts
1285 Avenue of the Americas, 3rd Floor
New York, NY 10019
(212) 245-4510

The American Institute of Graphic Arts
1059 Third Avenue, 3rd Floor
New York, NY 10021
(212) 752-0813

American Society of Interior Designers
New York Metro Chapter
200 Lexington Avenue
New York, NY 10016
(212) 685-3480

American Society of Magazine Photographers, Inc.
419 Park Avenue South, #1407
New York, NY 10016
(212) 889-9144

Art Directors Club of New York
250 Park Avenue South
New York, NY 10003
(212) 674-0500

Association of American Publishers
220 East 23rd Street
New York, NY 10010
(212) 689-8920

Association of the Graphic Arts
5 Penn Plaza, 20th Floor
New York, NY 10001
(212) 279-2100

The Children's Book Council, Inc.
568 Broadway, #404
New York, NY 10012
(212) 966-1990

CLIO
336 East 59th Street
New York, NY 10022
(212) 593-1900

Graphic Artists Guild
11 West 20th Street, 8th Floor
New York, NY 10011
(212) 463-7730

Guild of Book Workers
521 Fifth Avenue, 17th Floor
New York, NY 10175
(212) 757-6454

Institute of Outdoor Advertising
342 Madison Avenue, #702
New York, NY 10173
(212) 986-5920

International Advertising Association, Inc.
342 Madison Avenue, Suite 2000
New York, NY 10173
(212) 557-1133

continued

Ron Levy Photography
Box 3416
Soldotna, Alaska 99669
(907) 262-7899

Worldwide Assignments
Corporate, Advertising, Editorial
Travel • Nature • People • Animals

Clients include National Geographic,
BBC, Time, Allstate, Yellow Freight,
First National Bank of Anchorage,
World Wildlife Fund, People, Fame
and publications on every continent.

**The
F stop's
here**™...

Ron Levy Photography

Corporate Advertising and Editorial Assignments

RON LEVY LISTENS TO HIS CLIENTS

Mel Lindstrom
Lindstrom Photography
63 Encina
Palo Alto, California 94301
(415) 325-9677
FAX: (415) 325-9781

Mel Lindstrom
Lindstrom Photography
63 Encina
Palo Alto, California 94301
(415) 325-9677
FAX: (415) 325-9781

Scott Lockwood
PhotoIllustration
2109 Stoner Avenue
Los Angeles, California 90025
(310) 312-9923
FAX: (310) 479-4010

"Exciting ideas for the minds of progress"

**Milroy/McAleer
Photography**
711 West 17th Street, G-7
Costa Mesa, California 92627
(714) 722-6402
FAX: (714) 722-6371

Mark Milroy and Mary McAleer have specialized in location photography since 1979.

Our clients include Hyatt, Marriott, Ritz Carlton, Prudential and Tishman.

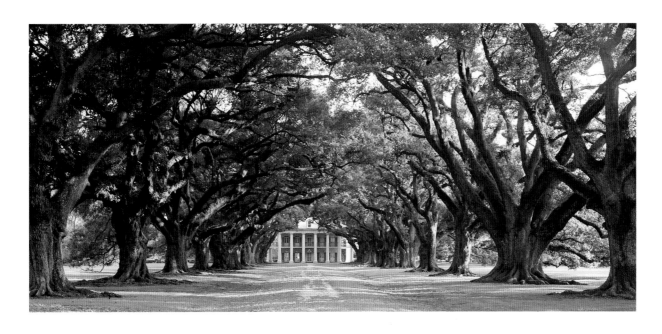

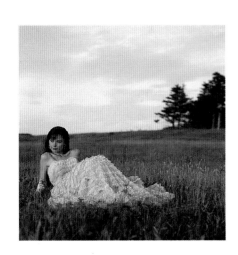

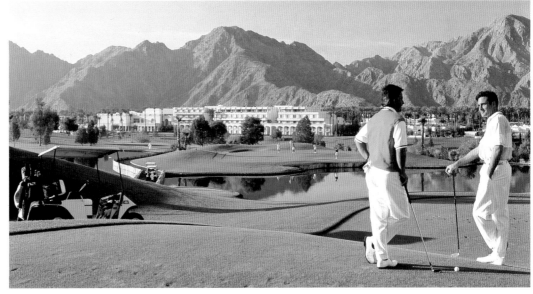

William Neill Photography

PO Box 162
Yosemite National Park,
California 95389
(209) 379-2841
FAX: (209) 379-2328

...the natural choice
for stock or assignment

...specializing in timeless landscapes
and intimate details emphasizing mood,
magic light, and graphic design of
natural elements

...also environmental imagery, foreign
cultures, aerials, adventure travel, limited-
edition prints, natural backgrounds

Clients have included:
National Geographic Books, Timberland,
Conde Nast Traveler, Freidrick Grohe,

The Nature Company, Outside,
Gentlemen's Quarterly.

...see feature article on my work in
Communication Arts Jan/Feb 1988
...and my book, The Sense of Wonder
published by The Nature Company
© 1992 William Neill

RAINFOREST, OLYMPIC NATIONAL PARK, WASHINGTON

WATERFALL, GREAT SMOKEY MOUNTAINS

MOON FLOWER, FLORIDA

MOUNT EVEREST, TIBET

SLOT CANYON, ARIZONA

CAMEL TRAIN, RAJASTHAN DESERT, INDIA

AUTUMN FOLIAGE, NEW HAMPSHIRE

Michael Neveux
13450 South Western Avenue
Gardena, California 90249
(800) 359-5143
FAX: (213) 515-6714

Seen a good
"motion picture"
lately?

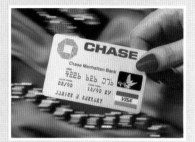

Call us toll free,

and we'll rush

you our portfolio.

We think

you'll find it

very moving!

800·359·5143

Fax

213·515·6714

Neil B. Nissing
Photog
711 South Flower
Burbank, California 91502
(213) 849-1811

Product
Special Effects
Imagination

Clients include:
American Honda
Argus Publications
Automobile Quarterly
Auto Trend Graphics
Cadillac
Circle Track Magazine

Franklin Mint
General Motors
Leisure Publications
Motor Trend Magazine
Sears
Suzuki Motor Corp.
Winston Tire Co.

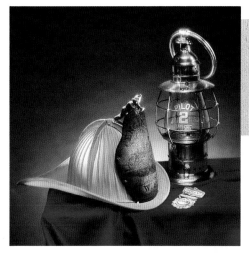

Chris Noble
8415 Kings Hill Drive
Salt Lake City, Utah 84121
(801) 942-8335
FAX: (801) 943-1162

Commercial Clients:
Nike, DuPont, The North Face, Goretex,
Patagonia, Swissair, K2 Skis, Kodak,
Borden/Wylers, Shaklee, Entrant,
Ocean Pacific, Vuarnet, Hi-Tec

Editorial:
Life, Rolling Stone, Outside, Sierra,
Powder, Summit, Skiing, Backpacker,
Sports International, National
Geographic Books & Calendars

From the Extreme to the Sublime!
Adventure & Action Sports Worldwide.
Stock & Assignment

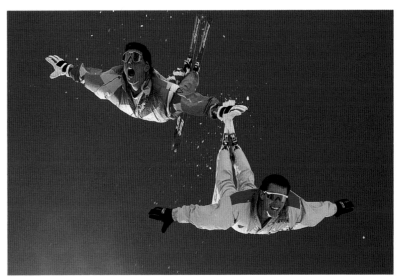

Rosanne Olson
Seattle
(206) 633-3775

National Representative:
Santee Lehmen Dabney Inc.
(206) 467-1616

Midwest Representative:
Linda Pool
(816) 761-7314

Black & white, hand-tinted and color
portfolios available.
See American Showcase Volumes
12, 13 and 14.

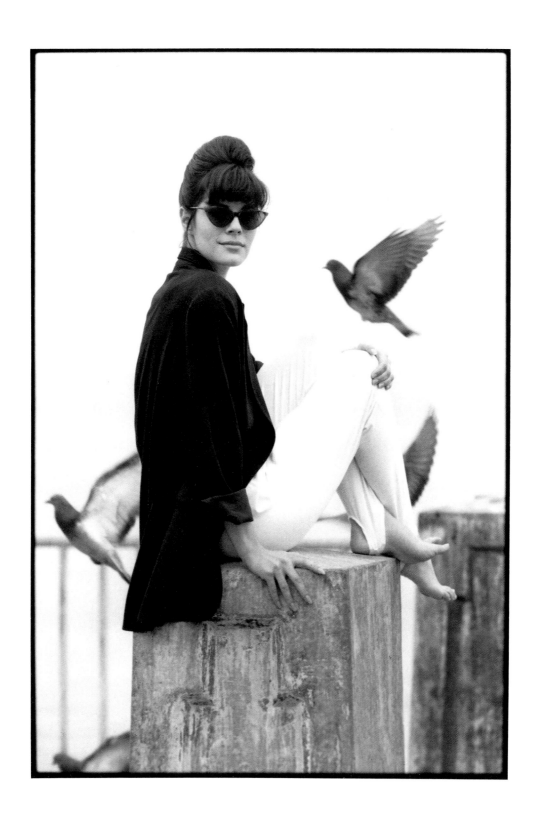

rosanne olson

Rosanne Olson
Seattle
(206) 633-3775

National Representative:
Santee Lehmen Dabney Inc.
(206) 467-1616

Midwest Representative:
Linda Pool
(816) 761-7314

Black & white, hand-tinted and color
portfolios available.
See American Showcase Volumes
12, 13 and 14.

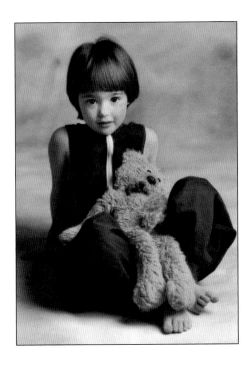
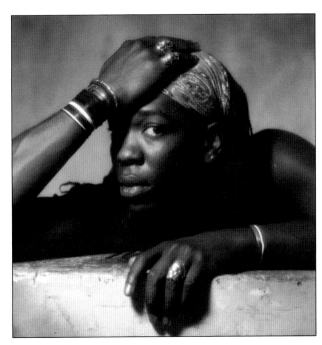

r o s a n n e o l s o n

The One Club
3 West 18th Street
New York, NY 10011
(212) 255-7070

The Public Relations Society of America, Inc.
33 Irving Place
New York, NY 10003
(212) 995-2230

Society of American Graphic Artists
32 Union Square, Room 1214
New York, NY 10003
(212) 260-5706

Society of Illustrators
128 East 63rd Street
New York, NY 10021
(212) 838-2560

Society of Photographers and Artists Representatives
1123 Broadway, Room 914
New York, NY 10010
(212) 924-6023

Society of Publication Designers
60 East 42nd Street, Suite 1416
New York, NY 10165
(212) 983-8585

Television Bureau of Advertising
477 Madison Avenue, 10th Floor
New York, NY 10022
(212) 486-1111

Type Directors Club of New York
60 East 42nd Street, Suite 1416
New York, NY 10165
(212) 983-6042

U.S. Trademark Association
6 East 45th Street
New York, NY 10017
(212) 986-5880

Volunteer Lawyers for the Arts
1285 Avenue of the Americas, 3rd Floor
New York, NY 10019
(212) 977-9270

Women in the Arts
c/o Roberta Crown
1175 York Avenue, #2G
New York, NY 10021
(212) 751-1915

NORTH CAROLINA
Davidson County Art Guild
224 South Main Street
Lexington, NC 27292
(704) 249-2742

OHIO
Advertising Club of Cincinnati
PO Box 43252
Cincinnati, OH 45243
(513) 576-6068

Design Collective
D.F. Cooke
130 East Chestnut Street
Columbus, OH 43215
(614) 464-2883

PENNSYLVANIA
Art Directors Club of Philadelphia
2017 Walnut Street
Philadelphia, PA 19103
(215) 569-3650

TEXAS
Advertising Club of Fort Worth
1801 Oak Knoll
Colleyville, TX 76034
(817) 283-3615

Art Directors Club of Houston
PO Box 271137
Houston, TX 77277
(713) 961-3434

Dallas Society of Visual Communications
3530 High Mesa Drive
Dallas, TX 75234
(214) 241-2017

VIRGINIA
Industrial Designers Society of America
1142-E Walker Road
Great Falls, VA 22066
(703) 759-0100

National Association of Schools of Art and Design
11250 Roger Bacon Drive, #21
Reston, VA 22090
(703) 437-0700

WASHINGTON
Allied Arts of Seattle, Inc.
107 South Main Street, Rm 201
Seattle, WA 98121
(206) 624-0432

Seattle Ad Federation
2033 6th Avenue, #804
Seattle, WA 98121
(206) 448-4481

WISCONSIN
Coalition of Women's Art Organizations
123 East Beutel Road
Port Washington, WI 53074
(414) 284-4458

Milwaukee Advertising Club
231 West Wisconsin Avenue
Milwaukee, WI 53203
(414) 271-7351

Andy Pearlman Studio
4075 Glencoe Avenue
Marina del Rey, California 90292
(310) 306-9449
FAX: (310) 306-6151

Extensive stock available directly or
through TSW/LA and Shooting Star.

Member APA

Portfolio available upon request.

Please refer to American Showcase 14
for additional work.

The Tropical Flavor of the Caribbean!

David E. Perry
PO Box 4165 Pioneer Square Station
Seattle, Washington 98104
(206) 932-6614
FAX: (206) 935-8958

Additional Black and White and Color work may be seen in American Showcase, Volumes 7 & 9-14 and Corporate Showcase, Volumes 8-10. Or call for speedy delivery of a tray.

Photographers:
Mark Carleton
Bruce Gillette
Timark Hamilton
Kevin Laubacher

Bill Neuman
Scott Rook
Pattie Sherwood
Jerry Taylor
Frank Wooldridge

David Quinney
Studio Q
423 East Broadway
Salt Lake City, Utah 84111
(801) 363-0434
FAX: (801) 328-5607

Specializing in:
Illustration
Architecture
Corporate Communications

Clients include: Aldus Corp, American Barrick Resources, Axonix, Chevron, Coldwell Banker, Control Data, Cover - Pools, Cura Financial, DOD Electronics, Evans and Sutherland, Franklin International Institute, Hilton Hotel, IOMEGA, Jackson Hole, Jetway Systems, Mountain Fuel, USA Weekend, Unimobil Systems, UNISYS, United States Film Festival, WordPerfect.

STUDIO
Q

Santee Lehmen Dabney Inc.
900 First Avenue South, Suite 404
Seattle, Washington 98134
(206) 467-1616 Phone/FAX
(206) 623-1999 Studio

Stock available:
Allstock
(206) 282-8116

RAYMOND GENDREAU

UNIVERSAL SCANS

THE UNIVERSE

UNIVERSAL

UNIVERSAL COLOUR SCANNING LTD.

BLOCK A, B, C, 10TH FLOOR, AIK SAN FACTORY BUILDING, 14 WESTLANDS ROAD, HONG KONG. TEL: (852) 565-0311, 562-6506 FAX: (852) 565-7770.

THESE THREE VOLUMES WERE SEPARATED ENTIRELY BY UNIVERSAL COLOR SCANNING LTD.
FOR MORE INFORMATION CONTACT MR. ROBIN TANG.

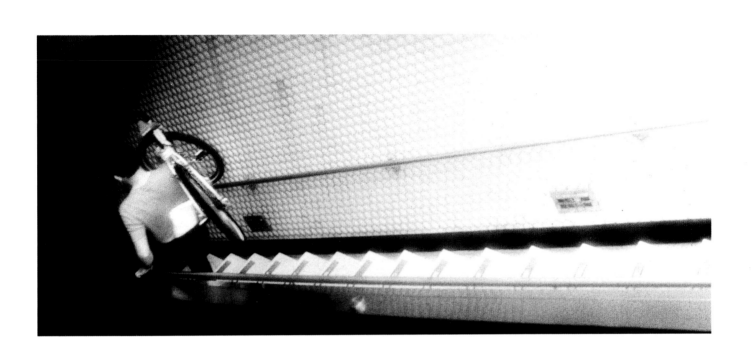

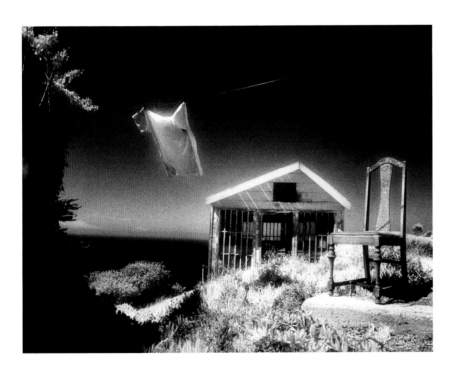

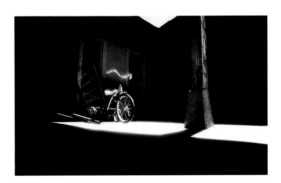

SCHĀF

305 SOUTH KALORAMA
VENTURA CALIFORNIA 93001

(805) 652-1441

Susan Segal Photography
(818) 763-7612
FAX: (818) 985-9228

Fashion accessories for advertising
and editorial.

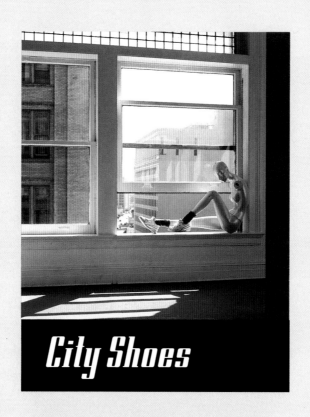

City Shoes

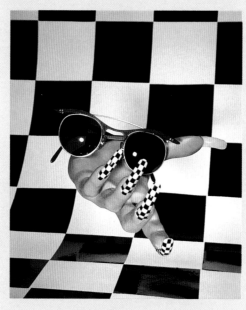

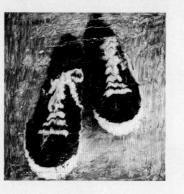

Susan Segal Photography
(818) 763-7612
FAX: (818) 985-9228

Portraiture / people for advertising
and editorial.

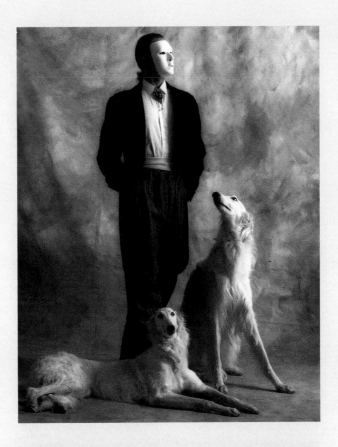

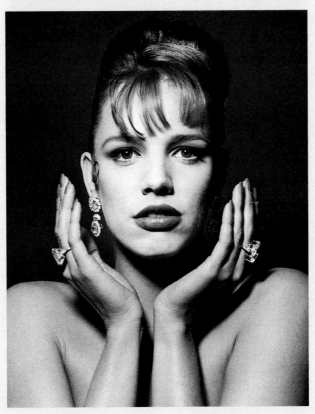

WANTED

Problem-solvers.

Sages.

Wits.

Philosophers.

Boat-rockers.

■

We hope you've enjoyed reading the VIEWPOINTS in American Showcase 15. This popular feature is designed to enlighten and entertain our readers by providing unique insights on the current state of photography, graphic design, illustration, advertising, and corporate marketing.

We'd like to take this opportunity to invite you to share your own thoughts, opinions and methods with thousands of your colleagues worldwide.

The average VIEWPOINT is 1,000 words but we'll consider longer (or shorter) pieces. Have the article titled, typed double-space, and be sure to include your own name, job title, company and address. If we publish your submission in our next Showcase, you will receive a copy of the book, 500 reprints of your article and our eternal gratitude.

(Of course, we can't guarantee that yours will be published, but we do promise to acknowledge and read every submission.)

Go ahead, write down all those things you've always wanted to get off your chest. Speak out to those photographers, illustrators and designers you hire . . . share confidences with your colleagues . . . tell off your boss. Do it while you're feeling outraged/ satisfied/ frustrated about the work you create. Do it today and mail it to:

Cynthia Breneman
Viewpoints Editor
American Showcase, Inc.
915 Broadway
New York, New York 10010

Thanks a lot. We're looking forward to hearing from you and hope to see you in AMERICAN SHOWCASE VOLUME 16!

Francisco Villaflor
(415) 921-4238

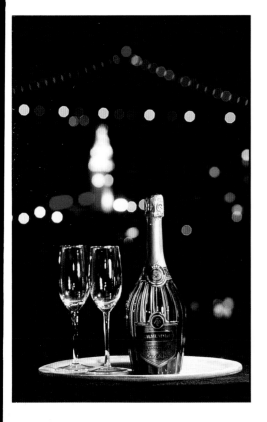

f. Villaflor

David Weintraub
San Francisco, California
(415) 931-7776
FAX: (415) 931-1410

People on location for corporate and editorial publications. Executive portraits, people at work or play, press and publicity photographs. Call for a FAX'd estimate on your next project. See American Showcase 14. Call for stock list.

Recent clients include: American Bar Association, Apple Computer, Audubon Magazine, Consolidated Freightways, First Nationwide Bank, Mercedes-Benz, The Rowland Company, Smithsonian Magazine, Texaco.

Stock: Photo Researchers & West Stock.

Member: ASMP

DAVID WEINTRAUB PHOTOGRAPHY

PHONE 415.931.7776

STOCK & PHOTO SERVICES

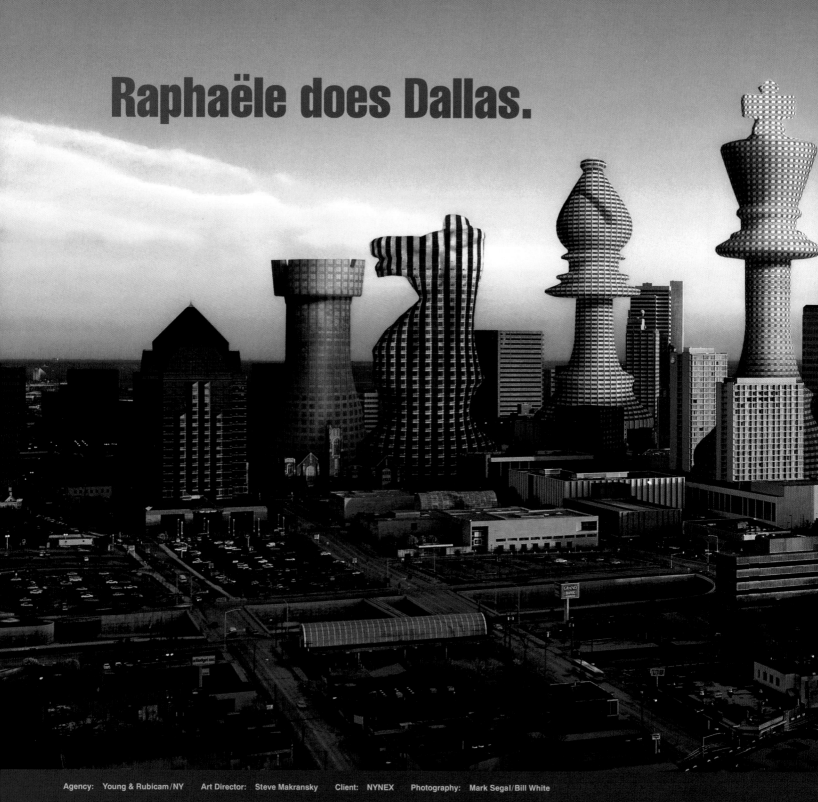

Raphaële does Dallas.

Agency: Young & Rubicam/NY Art Director: Steve Makransky Client: NYNEX Photography: Mark Segal/Bill White

Our clients come to us again and again. And that says more about our abilities than anything else. Our client list for the past year includes:

	American Express	Blue Cross/Blue Shield	Continental Foods	Hewlett-Packard
	AIG	BMW	Dow Chemical	Hines Interests
	American Red Cross	Brown & Root	Du Pont	Intel
	Anheuser-Busch	Budweiser	Ford	Isuzu
	AT&T	Chrysler	Frito-Lay	Jeep
Adolph Coors Company	Beechnut	Clarion Cosmetics	Gilbey's Gin	Jolly Rancher
Alfa Romeo	Benson & Hedges	Club Med	Greyhound	Kikkoman
Allergan	Bill Blass	Coca-Cola	Hanes	Kodalux
American Airlines	BizMart	Colombo Yogurt	Herman Miller	La-Z-Boy

Black Book: 1984-1992 Showcase: 1984-1992

TONY STONE WORLDWIDE

MASTERING

THE ART

OF STOCK

PHOTOGRAPHY

WEST
6100 Wilshire Blvd.
Suite 240
Los Angeles, CA 90048
213.938.1700
213.938.0731 Fax

EAST/MIDWEST
233 E. Ontario St.
Suite 1100
Chicago, IL 60611
312.787.7880
312.787.8798 Fax

1.800.234.7880

Call for the Latest Volume of Our Catalog

▲ A1SW5 *Bruce Ayres*

TONY STONE WORLDWIDE

1.800.234.7880

Call for the Latest Volume of Our Catalog

▼ B1SW5 *Laurie Rubin*

THEN
AND
NOW

FPG is both. Striking and evocative images that capture the past. Classic and timeless images that convey today. Past and present. **Then and now.** Exceptional stock photography. Available to you in just one effortless call. For a free catalog, 212.777.4210. Open 8am to 8pm EST. **FPG.**

F P G

INTERNATIONAL

Leo de Wys INC.

Tel: 212·689·5580
FAX: 212·545·1185
1·800·284·3399

For your *free* copy
of this catalogue
call **1-800-284-3399**

S T O C K V O L . I I I

Is it magic?

No, it's IMAGIC.

Quantel and Macintosh Digital Imaging and Retouching, Digital Input and Output ▪ Conventional Dye, Print
and Transparency Retouching ▪ Composite Dye Transfers, C Prints and R prints ▪ Composite Transparencies
and Black & White Prints ▪ Digital Transparencies up to 11 x 14 ▪ Digital Print Proofs up to 16 x 20

1545 N. Wilcox Ave., Hollywood, CA 90028
213 461-7766 Fax 213 461-2036

IMAGIC

5308 Vineland Ave., N. Hollywood, CA 91601
818 753-0001 Fax 818 753-2701

Bette S. Garber
3160 Walnut Street
Thorndale, Pennsylvania 19372
(215) 380-0342
FAX: (215) 380-0315

Specializing in the Trucking Industry

Stock Photos/Assignments
Member: ASMP

Golfoto, Inc.
522 South Jefferson
Suite B
PO Box 3045
Enid, Oklahoma 73702
(405) 234-8284
FAX: (405) 234-8335

Photo Group
President:
Mike Klemme

Stock Editor:
Margaret Wright

Member ASMP
Sponsor Member of the
National Golf Foundation
See additional images
in Showcase 13 and 14

All Photos © Golfoto, Inc.

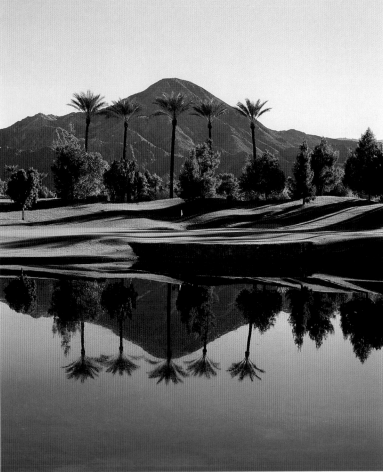

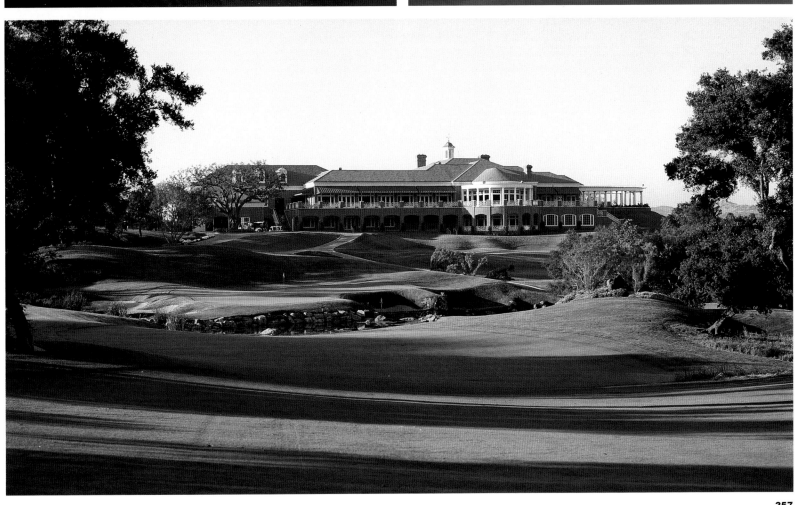

Tom & Pat Leeson
"America Gone Wild" Collection
PO Box 2498
Vancouver, Washington 98668
(206) 256-0436

50,000 transparencies capturing North America's wildside--elk bugling, deer running, wolves howling, many endangered species.

Dynamic bald eagles--flying, fishing, fighting, nesting, perching & portraits. See our award-winning photo book The American Eagle.

We specialize also in travel photography of the Canadian Rockies, Alaska and the Pacific Northwest; old growth forests and western national parks.

Copyright 1991 Tom and Pat Leeson

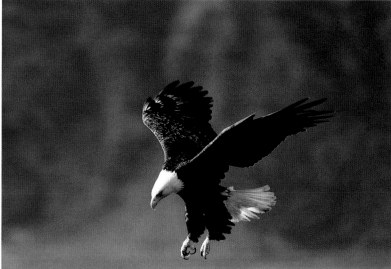

Mountain Light Photography

1483 A Solano Avenue
Albany, California 94706
(415) 524-9343
FAX: (415) 524-5009

Over 250,000 images of magical light from the ends of the earth: Tibet, Nepal, India, China, USSR, South America, Alaska, Canada, and U.S.

Mountain Light represents the photography of Galen Rowell who frequently works for National Geographic and other national magazines, as well as doing commercial work on location. His photographs have been exhibited at the Smithsonian, the Carnegie, ICP, and other major galleries. He has produced ten large format books, writes a column for Outdoor Photographer, and has done more than 1,000 mountain climbs, from Yosemite to the Himalaya. Mountain Light handles Galen's stock and gallery sales. Full-time photo researchers normally ship same day.

Popperfoto,
The Old Mill,
Overstone Farm,
Overstone, Northampton,
NN6 OAB, England
011 44 604 414144
FAX: 011 44 604 415383.
Contact: Monte Fresco

Represented in the USA by
David Joyner
453 Brook St
Framingham
Massachusetts 01701
(508) 877-8795
FAX: (508) 877-1982

Popperfoto contains over 12 million
images dating from 1860 to the present
day. Each and every subject imaginable
is under the Popperfoto roof including
a fine collection of Second World War
colour transparencies and H.G.
Ponting's original glass negatives.
Catalogues available on request.

ROYAL ASCOT

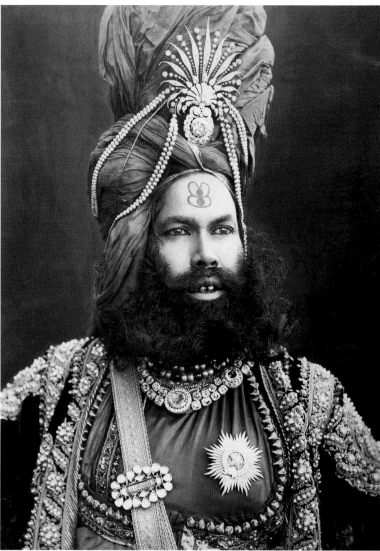

THE MAHARAJAH 1880

THE SHOW MUST GO ON - LONDON BLITZ 1940

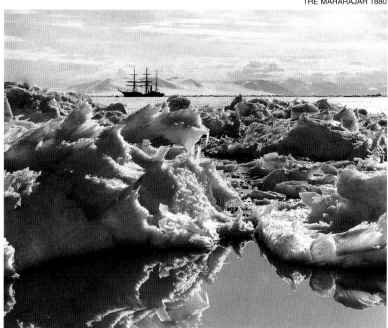

SCOTT OF THE ANTARCTICA 1911

AUSTIN TOURER 1922

**Bob Thomas
Sports Photo Inc.**
453 Brook Street
Framingham, Massachusetts 01701
(508) 877-8795
FAX: (508) 877-1982
Contact: David Joyner

European Office:
19 Charnwood Avenue
Northampton,
NN3 3DX, England
011 44 604 414144
FAX: 011 44 604 415383
Contact: Pete Norton

Number One For Soccer.

Catalogue available upon request

DIVISION 1. WIMBLEDON (1) v LIVERPOOL (2)

NATIONAL HUNT RACING

1986 WORLD CUP FINAL

PHONE LISTINGS & ADDRESSES OF REPRESENTATIVES, VISUAL ARTISTS & SUPPLIERS

CONTENTS

REGIONS

New York City

Northeast
Connecticut
Delaware
Maine
Maryland
Massachusetts
New Hampshire
New Jersey
New York State
Pennsylvania
Rhode Island
Vermont
Washington, D.C.
West Virginia

Southeast
Alabama
Florida
Georgia
Kentucky
Louisiana
Mississippi
North Carolina
South Carolina
Tennessee
Virginia

Midwest
Illinios
Indiana
Iowa
Kansas

Miichigan
Minnesota
Missouri
Nebraska
North Dakota
Ohio
South Dakota
Wisconsin

Southwest
Arizona
Arkansas
New Mexico
Oklahoma
Texas

Rocky Mountain
Colorado
Idaho
Montana
Utah
Wyoming

West Coast
Alaska
British Columbia
California
Hawaii
Nevada
Oregon
Washington

International

R E P S
N Y C

A

Altamore, Bob/237 W 54th St 4th Fl212-977-4300
Cailor/Resnick, (P)
American Artists/353 W 53rd St #1W212-682-2462
Keith Batcheller, (I), Bart Bemus, (I), Roger Bergendorff, (I),
Robert Burger, (I), Chris Butler, (I), Gary Ciccarelli, (I),
Jim Deigan, (I), Jacques Devaud, (I), Bob Dorsey, (I), Lane
DuPont, (I), Michael Elins, (I), Malcolm Farley, (I), Russell
Farrell, (I), George Gaadt, (I), Rob Gage, (P), Bill Garland, (I),
Jackie Geyer, (I), John Hamagami, (I), Pam Hamilton, (I), Steve
Hendricks, (I), Doug Henry, (I), Michael Hill, (I), John Holm, (I),
Mitch Hyatt, (I), Richard Kriegler, (I), Alan Leiner, (I), Maurice
Lewis, (I), Ed Lindlof, (I), Jerry LoFaro, (I), Ron Mahoney, (I),
Jean-Claude Michel, (I), David Noyes, (I), Erik Olson, (I), Jim
Owens, (I), Charles Passarelli, (I), Tony Randazzo, (I), Jan
Sawka, (I), Todd Schorr, (I), Michael Schumacher, (I), Joe
Scrofani, (I), Jim Starr, (I), Mike Steirnagle, (I), Thomas Tonkin,
(I), Stan Watts, (I), Will Weston, (I), Ron Wolin, (I), Jonathan
Wright, (I), Gary Yealdhall, (I), Andy Zito, (I)
Anton, Jerry/119 W 23rd St #203212-633-9880
Bobbye Cochran, (I), Abe Echevarria, (I), Norman Green, (I),
Aaron Rezny, (P), Chris Vincent, (P), Oliver Williams, (I)
Arnold, Peter Inc/1181 Broadway 4th Fl212-481-1190
Yann Arthus-Bertrand, (P), Fred Bavendam, (P), Dieter Blum,
(P), Herb Comess, (P), Martha Cooper, (P), Dennis diCicco,
(P), Bob Evans, (P), Helmut Gritscaher, (P), Jacques Jangoux,
(P), Manfred Kage, (P), Steve Kaufman, (P), Stephen
Krasemann, (P), Werner Muller, (P), Jim Olive, (P), Hans
Pfletschinger, (P), Jeffrey L Rotman, (P), Galen Rowell, (P),
David Scharf, (P), Erika Stone, (P), Bruno Zehnder, (P)
Art & Commerce/108 W 18th St212-206-0737
William Claxton, (P), Clint Clemens, (P)
The Art Farm/163 Amsterdam Ave212-873-2227
Bruce Aruffenbart, (I), Mona Mark, (I), Linda Pascual, (I), Bob
Walker, (I), Bill Zdinak, (I)
Artco/232 Madison Ave #402212-889-8777
Ed Acuna, (I), Alexander & Turner, (I), Edmund Alexander, (I),
George Angelini, (I), Gene Boyer, (I), Dan Brown, (I), Alain
Chang, (I), Anne Cook, (I), Jeff Cornell, (I), Joann Daley, (I), Beau
& Alan Daniels, (I), Mort Drucker, (I), Ed Gazsi, (I), Michael
Helsop, (I), Lisa Henderling, (I), Kathy Jeffers, (I), David Loew, (I),
Rick McCollum, (I), Jean Restivo Monti, (I), Susan Richman, (P),
Marcel Rozenberg, (I), Paul Sheldon, (I), Oren Sherman, (I), Mark
Smollin, (I), Cynthia Turner, (I), Sally Vitsky, (I), Rob Zuckerman, (I)
Artists Associates/211 E 51st St #5F212-755-1365
Norman Adams, (I), Don Brautigam, (I), Michael Deas, (I), C
Michael Dudash, (I), Mark English, (I), Alex Gnidziejko, (I), Robert
Heindel, (I), Steve Karchin, (I), Dick Krepel, (I), Skip Liepke, (I),
Fred Otnes, (I), Daniel Schwartz, (I), Norman Walker, (I)
Artworks Illustration/270 Park Ave S #10B212-260-4153
Paul Bachem, (I), Linda Benson, (I), Sterling Brown, (I),
Jim Campbell, (I), Deborah Chabrian, (I), Donna Diamond, (I),
Richard Dickens, (I), Sandra Filippucci, (I), Peter Fiore, (I), Enid
Hatton, (I), Bob Jones, (I), Michael Koester, (I), Rudy Lasco, (I),
Dennis Lyall, (I), Patrick Milbourn, (I), Marcia Pyner, (I), Romas,
(I), Mort Rosenfeld, (I), Larry Schwinger, (I), Jim Sharpe, (I),
Philip Singer, (I), Evan T Steadman, (I), Tom Stimpson, (I),
Michael Storrings, (I), Brad Teare, (I)
Asciutto Art Reps/19 E 48th St212-838-0050
Anthony Accardo, (I), Eliot Bergman, (I), Alex Bloch, (I),
Deborah Borgo, (I), Olivia Cole, (I), Mark Corcoran, (I), Daniel
Delvalle, (I), Suzanne DeMarco, (I), Len Epstein, (I), Gershom
Griffith, (I), Meryl Henderson, (I), Al Leiner, (I), Morissa
Lipstein, (I), Loreta Lustig, (I), James Needham, (I), Sherry
Niedigh, (I), Charles Peale, (I), Jan Pyk, (I)

B

Badd, Linda/568 Broadway #601212-431-3377

Tom Clayton, (P)
Badin, Andy/15 W 38th St ..212-532-1222
Bahm, Darwin/6 Jane St ..212-989-7074
Harry DeZitter, (P), Gordon Kibbe, (I), Joan Landis, (I), Rick
Meyerowitz, (I), Don Ivan Punchatz, (I), Arno Sternglass, (I),
John Thompson, (I), Robert Weaver, (I), Chuck Wilkinson, (I)
Baker, Valerie/152 W 25th St 12th Fl212-807-7113
Skylite Photo Productions, (P)
Barboza, Ken Assoc/853 Broadway #1603212-505-8635
Anthony Barboza, (P), Leonard Jenkins, (I), Peter Morehand,
(P), Man Tooth, (P), Marcus Tullis, (P)
Barnes, Fran/25 Fifth Ave #9B212-505-2720
Barracca, Sal/381 Park Ave S #919212-889-2400
Becker, Erika/150 W 55th St212-757-8987
Esther Larson, (I)
Becker, Noel/150 W 55th St ..212-757-8987
Sy Vinopoll, (I)
Beidler, Barbara/648 Broadway #506212-979-6996
Richard Dunkley, (P), Bob Hiemstra, (I), Robert Levin, (P),
Nana Watanabe, (P)
Beilin, Frank/405 E 56th St ..212-751-3074
Bernstein & Andriulli/60 E 42nd St #505212-682-1490
Tony Antonios, (I), Pat Bailey, (I), Jim Balog, (P), Garie
Blackwell, (I), Rick Brown, (I), Daniel Craig, (I), Creative
Capers, (I), Everett Davidson, (I), Jon Ellis, (I), Ron Finger, (I),
Ron Fleming, (I), Brett Froomer, (P), Victor Gadino, (I), Joe
Genova, (I), Christina Ghergo, (P), John Harwood, (I), Bryan
Haynes, (I), Frank Herholdt, (P), Kevin Hulsey, (I), Tim Jessell,
(I), Alan Kaplan, (P), Hiro Kimura, (I), Daniel Kirk, (I), Peter
Kramer, (I), Mary Ann Lasher, (I), John Lawrence, (I), Bette
Levine, (I), Todd Lockwood, (I), Hakan Ludwigsson, (I), Lee
MacLeod, (I), Greg J Martin, (I), Tom McCavera, (P), David B
McMacken, (I), Chris Moore, (I), Bill Morse, (I), Pete Mueller,
(I), Craig Nelson, (I), Jeff Nishinaka, (I), Greg J Petan, (I),
Laura Phillips, (I), Gunther Raupp, (P), Mike Rider, (I), Peggi
Roberts, (I), Ray Roberts, (I), Vittorio Sacco, (P), Goro Sasaki,
(I), Marla Shega, (I), Gunar Skillins, (I), Chuck Slack, (I), Peter
Stallard, (I), David Harry Stewart, (I), John Stoddart, (P),
Tommy Stubbs, (I), Thomas Szumowski, (I), Peter Van Ryzin,
(I), Pam Wall, (I), Richard Warren, (P), Brent Watkinson, (I),
Matthew Zumbo, (I)
Big City Prodctns/5 E 19th St #303212-473-3366
Earl Culberson, (P), Tony DiOrio, (P), David Massey, (P), Pete
Stone, (P), Dan Weaks, (P)
Black Star/116 E 27th St ..212-679-3288
John W. Alexanders, (P), Nancy Rica Schiff, (P), Arnold Zann, (P)
Black, Fran/116 E 27th St 12th fl212-725-3806
Rob Blackard, (I), Dennis Murphy, (P), Jose Ortega, (I),
Aernout Overbeeke, (P), Roger Tully, (P), Kenneth Willardt, (P),
Tom Zimberoff, (P)
Black, Pamela/73 W Broadway212-385-0667
William Heuberger, (P), Irada Icaza, (P), Rick Young, (P)
Blanchard, Jean/1175 York Ave #10M212-371-1445
Ellen Denuto, (P)
Bloncourt, Nelson/666 Greenwich St212-924-2255
Chris Dawes, (P), Jim Huibregtse, (P), Joyce Tenneson, (P)
Boghosian, Marty/201 E 21st St #10M212-353-1313
James Salzano, (P)
Booth, Tom Inc/425 W 23rd St #17A212-243-2750
Thom Gilbert, (P), Joshua Greene, (P), Thibault Jeanson, (P),
Charles Lamb,`(P), Gordon Munro, (P), Robert Reed, (P), Lara
Rossignol, (P)
Brackman, Henrietta/415 E 52nd St212-753-6483
Brennan, Dan/568 Broadway #1005212-925-8333
Knut Bry, (P), Mark Bugzester, (P), Charles Ford, (P), Scott
Hagendorf, (P), Anthony Horth, (P), Kenji Toma, (P), Claus
Wickrath, (P)
Brindle, Carolyn/203 E 89th St #3D212-534-4177
Brody, Sam/12 E 46th St #402212-758-0640
Fred Hilliard, (I), Allen Lieberman, (P), Jacques Lowe, (P),
Steve Peringer, (I), Carroll Seghers, (P), Elsa Warnick, (I)
Brown, Deborah & Assoc/1133 Broadway #1508212-463-7732
Brown, Doug/17 E 45th St #1008212-953-0088
Dennis Blachut, (P), Abe Seltzer, (P)
Bruck, Nancy & Eileen Moss/333 E 49th St212-982-6533
Tom Curry, (I), Warren Gelbert, (I), Ken Goldammer, (I), Joel
Peter Johnson, (I), Lionsgate, (I), Robert Neubecker, (I), Adam
Niklewicz, (I), Pamela Patrick, (I), Ben Perini, (I), Robert Pizzo,

(I), Scott Pollack, (I), Rebecca Ruegger, (I), Mark Yankus, (I)

Bruml, Kathy/201 W 77th St ..212-874-5659
Grant Peterson, (P)

Buck, Sid & Kane, Barney/566 Seventh Ave #603212-221-8090
Jacques Alschech, (I), Ken Call, (I), Claudia Callander, (I),
Joseph Denaro, (I), Ann Fox, (I), Nate Giorgio, (I), Laura
Hesse, (I), John Hickey, (I), David Jarvis, (I), Mark Kaufman,
(I), Steven Keyes, (I), Bob Labsley, (I), Saul Lambert, (I), Dan
Lavigne, (I), Peter Lloyd, (I), Robert Melendez, (I), Jess
Nicholas, (I), Gary Nichols, (I), Wally Niebart, (I), Paul Palnik,
(I), Ric Powell, (I), Jerry Schurr, (I), Joseph Sellers, (I), Tad
Skozynski, (I), Lynn Stephens, (I), Bill Thomson, (I), Vahid, (I)

Burris, Jim/350 W 39th St ...212-239-6767

Bush, Nan/135 Watts St ..212-226-0814
Barry Lategan, (P), Bruce Weber, (P)

Byrnes, Charles/435 W 19th St ...212-473-3366
Steve Steigman, (P)

C

Cahill, Joe/43 W 24th St #9A ..212-924-4744
Shig Ikeda, (P), Brad Miller, (P)

Camp, Woodfin & Assoc/116 E 27th St212-481-6900
Kip Brundage, (P), Jason Laure, (P)

Caputo, Elise & Assoc/PO Box 6898/Grand Central Stn212-725-0503
Becker/Bishop, (P), Steve Brady, (P), Didier Dorot, (P),
James Kozyra, (P), Steve Prezant, (P), Sean Smith, (P),
Pete Turner, (P)

Carp, Stan/2166 Broadway ..212-362-4000
Dick Frank, (P), Dennis Gray, (P), Dennis Kitchen, (P)

Casey and Sturdevant/245 E 63rd St #201212-486-9575
Jade Albert, (P), Albaino Ballerini, (P), Geoffrey Clifford, (P),
Thomas Hooper, (P), Michael Luppino, (P), Zeva Oelbaum, (P),
Louis Wallach, (P)

Casey, Judy/96 Fifth Ave ...212-255-3252
Richard Bailey, (P), Calliope, (P), William Garrett, (P), Torkil
Gudnason, (P), Christopher Micaud, (P), Jim Reiher, (P), Tim
Simmons, (P)

Chislovsky, Carol/853 Broadway #1201212-677-9100
Karen Bell, (I), Taylor Bruce, (I), Russell Cobane, (I),
Jim Cohen, (I), Jon Conrad, (I), Jan Evans, (I), Chris Gall, (I),
Jeff George, (I), Bob Gleason, (I), Ignacio Gomez, (I),
Ken Graning, (I), Steve Gray, (I), Mark Herman, (I), Oscar
Hernandez, (I), Mike Kowalski, (I), Joe Lapinski, (I), Julie Pace,
(I), Chuck Schmidt, (I), Rick Schneider, (I), Sandra Shap, (I),
Randy South, (I), C A Trachok, (I)

Collignon, Daniele/200 W 15th St212-243-4209
Diane Bennett, (I), Dan Cosgrove, (I), Bill Frampton, (I), David
Gambale, (I), Steve Lyons, (I), Dennis Mukai, (I), Mitch
O'Connell, (I), Cindy Pardy, (I), Irena Roman, (I), Hisashi
Sekine, (I), Doug Suma, (I), Alex Tiani, (I), Don Weller, (I)

Conlon, Jean/461 Broome St ...212-966-9897
Elizabeth Brady, (I), Roberto Brosan, (P), Kenro Izu, (P),
Ivano Piza, (P), Evan Polenghi, (I)

Connections Unlimited/37 E 28th St #506212-696-4120
Robert Buchanan, (P), Randy Douglas, (I),
Ian Ross, (I)

Cornelia/232 Front St ...212-732-6240
Tom Fogliani, (P), Richard Pierce, (P), Peter Zander, (P)

Creative Freelancers/25 W 45th St212-398-9540
Peter Angelo, (I), Gil Ashby, (I), Philip Bliss, (I), Wende Caporale,
(I), Karen Chandler, (I), Heidi Chang, (I), Judith Cheng, (I),
Dan Cooper, (I), Howard Darden, (I), Joseph DeCerchio, (I), Jim
DeLapine, (I), Steve Dinnino, (I), Glenn Dodds, (I), Peggy
Dressel, (I), John Duncan, (I), Steven Duquette, (I), John
Dzedzy, (I), John Edens, (I), Gregg Fitzhugh, (I), Stephen
Fritsch, (I), Gretta Gallivan, (I), Rick Geary, (I), Cameron
Gerlach, (I), Blake Hampton, (I), Gary Hanna, (I), Traci Harmon,
(I), R Mark Heath, (I), Amy Huelsman, (I), Chet Jezierski, (I), Kid
Kane, (I), Barbara Kiwak, (I), Salem Krieger, (I), Tim Lee, (I),
James Martin, (I), Susan Melrath, (I), A J Miller, (I), Burton Morris,
(I), Michael Ng, (I), Jan North, (I), Russ North, (I), Greg Olanoff,
(I), Jim Owens, (I), Richard Parisi, (I), Robert Pasternak, (I),
Elena Poladian, (I), Girair Poladian, (I), Meryl Rosner, (I), Barry
Ross, (I), Joanna Roy, (I), Glen Schofield, (I), Clare Sieffert, (I),
Tom Starace, (I), Wayne Anthony Still, (I), Steve Sullivan, (I),
Stephen Sweny, (I), Glen Tarnowski, (I), Bill Teodecki, (I), Kurt
Wallace, (I), Roger White, (I)

Creative Workforce/270 Lafayette #401212-925-1111
Ashkan Sahihi, (P)

Cuevas, Robert/118 E 28th St #306212-679-0622
Ron Brown, (P), Barnett Plotkin, (I)

Cullom, Ellen/55 E 9th St ...212-777-1749
Robert Grant, (P)

D

Dagrosa, Terry/12 E 22nd St ...212-254-4254

Davies, Nora/370 E 76th St #C103212-628-6657
Michael Pateman, (P)

Dedell, Jacqueline Inc/58 W 15th St 6th Fl212-741-2539
Scott Baldwin, (I), Cathie Bleck, (I), Ivan Chermayeff, (I),
Teresa Fasolino, (I), David Frampton, (I), Griesbach/Martucci,
(I), Hiroko, (I), Paula Munck, (I), Merle Nacht, (I), Edward
Parker, (I), Barry Root, (I), Kimberly B Root, (I), Marco Ventura,
(I), Mick Wiggins, (I), Richard Williams, (I), Heidi Younger, (I)

Des Verges, Diana/73 Fifth Ave212-691-8674
Paccione Photography, (P)

DiBartolo/Lemkowitz/310 Madison Ave212-297-0041
Chris Collins, (P), Steve Krongard, (P), Gary Kufner, (P),
Nancy Moran, (P), Michael O'Neill, (P), James Porto, (P),
Jerry Simpson, (P)

DiParisi, Peter/250 W 99th St #3A212-663-8330
Gary Buss, (P), Ellen Denuto, (P), Lucille Khornack, (P),
Cyndy Warwick, (P)

Dorman, Paul/430 E 57th St ...212-826-6737
Studio DGM, (P)

Dorr, Chuck/1123 Broadway #1015212-627-9871
John Bean, (P), Robert Carroll, (P), Robert Farber, (P),
Michael Gerger, (P)

Drexler, Sharon/451 Westminster Rd, Brooklyn718-284-4779
Les Katz, (I)

DuCane, Alex/111 E 64th St ...212-772-2840
Tony Kent, (P), Niel Kirk, (P), Cheryl Koralik, (P),
Christopher Micaud, (P), Maria Robledo, (P)

EF

Erlacher, Bill/Artists Assoc/211 E 51st St #5F212-755-1365
Michael Deas, (I), C Michael Dudash, (I), Mark English, (I),
Alex Gnidziejko, (I), Dick Krepel, (I), Skip Liepke, (I), Fred
Otnes, (I), Daniel Schwartz, (I), Norman Walker, (I)

Feinstein, Ron/312 E 9th St ...212-353-8100

Feldman, Robert/133 W 17th St #5A212-243-7319
Brian Hagiwara, (P), Lizzie Himmel, (P), Alen MacWeeney, (P)

Fischer, Bob/135 E 54th St ..212-755-2131
Alex Chatelain, (P), James Moore, (P)

Fishback, Lee/350 W 21st St ...212-929-2951
JAEL, (I)

Foster, Pat Artists Rep/6 E 36th St #1R212-685-4580
Sandro Biffignandi, (I), Ken Birdsong, (I), Dru Blair, (I), Lina
Chesak, (I), David Cook, (I), Louis Henderson, (I), Ken Otsuka,
(I), Keith Simmons, (I)

Foster, Peter/870 UN Plaza ..212-593-0793
Donald Penny, (P), Charles Tracey, (P)

G

Gaynin, Gail/241 Central Park West212-580-3141
Karen Cipolla, (P), Terry Clough, (P)

Gebbia, Doreen/501 Cathedral Pkwy212-678-0160

Ginsberg, Michael/407 Park Ave S #25F212-679-8881

Giraldi, Tina/42 Harmon Pl, N Haledon, NJ201-423-5115
Frank Giraldi, (P)

Godfrey, Dennis/231 W 25th St #6E212-807-0840
Jeffrey Adams, (I), Daryl Cagle, (I), Dean Flemming, (I),
Joel Nakamura, (I), Wendy Popp, (I), David Stimson, (I)

Goldman, David Agency/41 Union Sq W #918212-807-6627
Michele Barnes, (I), Norm Bendell, (I), Keith Bendis, (I),
Rosemary Fox, (I), Kazu, (I), Mitch Rigle, (I), David Anson
Russo, (I), James Yang, (I), Kang Yi, (I)

Gomberg, Susan/41 Union Sq W #636212-206-0066
Marty Blake, (I), Neil Brennan, (I), Steve Carver, (I), Robert
Dale, (I), G Allen Garns, (I), Ralph Giguere, (I), Franklin
Hammond, (I), Scott Hunt, (I), Jacobson/Fernandez, (I), Laurie
LaFrance, (I), Jeff Leedy, (I), Daniel McGowan, (I), Enzo &

Schmidt, Urs Messi, (I), Marti Shohet, (I), James Tughan, (I), Jack Unruh, (I), Mark Weakley, (I)

Goodwin, Phyllis A/10 E 81st St ..212-570-6021
Whistl'n Dixie, (I), John Paul Endress, (P), Carl Furuta, (P), Dennis Gottlieb, (P), Howard Menken, (P), Carl Zapp, (P)

Gordon, Barbara Assoc/165 E 32nd St212-686-3514
Craig Bakley, (I), Ron Barry, (I), Bob Clarke, (I), Jim Dietz, (I), Wendy Grossman, (I), Glenn Harrington, (I), Robert Hunt, (I), Nenad Jakesevic, (I), Jackie Jasper, (I), Sonja Lamut, (I), Jacquie Marie Vaux, (I)

Gotham Art Agency/1123 Broadway #600212-989-2737
Manuel Boix, (I), Petra Mathers, (I), JJ Sempe, (I), Peter Sis, (I), Tomi Ungerer, (I), F K Waechter, (P)

Grande, Carla/444 W 52nd St ..212-977-9214
John Dugdale, (P), Helen Norman, (I)

Grant, Lucchi/800 West End Ave #15C212-663-1460
Claire Phipps, (I)

Green, Anita/718 Broadway ..212-674-4788
Bret Lopez, (P), Rita Maas, (P), Michael Molkenthin, (P)

Grien, Anita/155 E 38th St ...212-697-6170
Dolores Bego, (I), Fanny Mellet Berry, (I), Julie Johnson, (I), Hal Just, (I), Jerry McDaniel, (I), Don Morrison, (I), Alan Reingold, (I), Alex Zwarenstein, (I)

H

Hankins & Tegenborg/60 E 42nd St #1940212-867-8092
Bob Berran, (I), Ralph Brillhart, (I), Joe Burleson, (I), Michael Cassidy, (I), Jamie Cavaliere, (I), Jim Cherry, (I), Mac Conner, (I), Guy Deel, (I), John Taylor Dismukes, (I), Bill Dodge, (I), Danilo Ducak, (I), Marc Ericksen, (I), Robert Evans, (I), George Fernandez, (I), David Gaadt, (I), Steve Gardner, (I), James Griffin, (I), Ray Harvey, (I), Edwin Herder, (I), Michael Herring, (I), Aleta Jenks, (I), Rick Johnson, (I), Mia Joung, (I), Tom Kasperski, (I), Dave Kilmer, (I), Uldis Klavins, (I), Bob Maguire, (I), Neal McPheeters, (I), Cliff Miller, (I), Wendell Minor, (I), Miro, (I), Mitzura, (I), Walter Rane, (I), Kirk Reinert, (I), Frank Riley, (I), Don Rodell, (I), Sergio Roffo, (I), Kenneth Rosenberg, (I), Ron Runda, (I), Harry Schaare, (I), Bill Schmidt, (I), Diane Slavec, (I), Dan Sneberger, (I), Frank Steiner, (I), Peter Van Ryzin, (I), Jeff Walker, (I), Romeo Washington, (I), John Youssi, (I)

Hansen, Wendy/126 Madison Ave ...212-684-7139
Metin Enderi, (P), Jon Holderer, (P), Masaaki Takenaka, (P)

Hardy, Allen/121 W 27 #703 ...212-986-8441
Phillip Dixon, (P), Mike Russ, (I), Thomas Schenk, (P), Steven Wight, (I)

Hayes, Kathy Associates/131 Spring St 3rd Fl212-925-4340
Derek Buckner, (I), James Ennis Kirkland, (I), Ken Krafchek, (I)

Head, Olive/155 Riverside Dr #10C ..212-580-3323
Lauren Hámmer, (P), Nesti Mendoza, (P), Jackie Nickerson, (P), Thomas Sullivan, (P), Frans Van Der Heyden, (P)

Henderson, Akemi/44 W 54th St ..212-581-3630
Hitoshi Fugo, (P), Sonia Katchian, (P), Bob Osborn, (P), Liu Chung Ren, (P), Toshiro Yoshida, (P)

Henry, John/237 E 31st St ..212-686-6883
Amos Chan, (P), Lois Greenfield, (P), Irutchka, (P), Eric Jacobson, (P)

Herron, Pat/80 Madison Ave ...212-753-0462
Larry Dale Gordon, (P), Malcolm Kirk, (P), Kep Meyer, (P)

Heyl, Fran/230 Park Ave #2525 ...212-581-6470

Hill, Lilian/107 W 25th St #3A ...212-627-5460

Holmberg, Irmeli/280 Madison Ave #1402212-545-9155
Gary Aagaard, (I), Jenny Adams, (I), Pat Alexander, (I), Toyce Anderson, (I), Alexander Barsky, (I), Dan Bridy, (I), Bob Byrd, (I), Lindy Chambers, (I), Rita Chow, (I), Henk Haselaar, (I), Deborah Healy, (I), Stephen Johnson, (I), Barbara Kelley, (I), Sue Llewellyn, (I), John Martinez, (I), Lu Matthews, (I), Marilyn Montgomery, (I), Cyd Moore, (I), John Nelson, (I), Jacqueline Osborn, (I), Judy Pedersen, (I), Deborah Pinkney, (I), Karen Pritchett, (I), Nikolai Punin, (I), Bob Radigan, (I), Donald Ranaldi, (I), Lilla Rogers, (I), Pat Thacker, (I), Randie Wasserman, (I), Cindy Wrobel, (I)

Hovde, Nob/1438 Third Ave ..212-753-0462
Larry Dale Gordon, (P), Hiro, (P), Malcolm Kirk, (P)

Hurewitz, Gary/38 Greene St ..212-925-2999
Howard Berman, (P), Steve Bronstein, (P)

IJ

In Focus Assoc/21 E 40th St #903 ...212-779-3600
Andrew Eccles, (P), Mark Hill, (P), Raul Vega, (P)

Indre, Christina/26 E 81st St 3N ...212-794-7110

Ivy League of Artists/156 Fifth Ave #617212-243-1333
Ernest Albanese, (I), Ivey Barry, (I), Cheryl Chalmers, (I), William Colrus, (I), Ric Del Rossi, (I), John Dyess, (I), Paula Goodman, (I), David Klein, (I), Chris Murphy, (I), Justin Novack, (I), Frederick Porter, (I), Tom Powers, (I), Tanya Rebelo, (I), Herb Reed, (I), John Rice, (I), B K Taylor, (I), Kyuzo Tsugami, (I), Allen Welkis, (I)

Jedell, Joan/370 E 76th St ...212-861-7861
George Agalias, (P), Charles Bush, (P), Ken Chung, (P), Marty Evans, (P), David Guilbert, (P), Elyse Lewin, (P), Mike Malyszko, (P), Tom McCarthy, (P), James Moore, (P), Jeff Nadler, (P), Michael Pruzan, (P), John Stember, (P)

Johnson, Arlene/5 E 19th St ...212-725-4520

Johnson, Bud & Evelyne/201 E 28th St212-532-0928
Kathy Allert, (I), Betty de Araujo, (I), Irene Astrahan, (I), Cathy Beylon, (I), Lisa Bonforte, (I), Carolyn Bracken, (I), Frank Daniel, (I), Larry Daste, (I), Jill Dubin, (I), Ted Enik, (I), Carolyn Ewing, (I), Bill Finewood, (I), George Ford, (I), Robert Gunn, (I), Erasmo Hernandez, (I), Tien Ho, (I), Mei-ku Huang, (I), Yukio Kondo, (I), Tom LaPadula, (I), Turi MacCombie, (I), Darcy May, (I), Eileen McKeating, (I), John O'Brien, (I), Heidi Petach, (I), Steven Petruccio, (I), Frank Remkiewicz, (I), Christopher Santoro, (I), Stan Skardinski, (I), Barbara Steadman, (I), Tom Tierney, (I)

Joyce, Tricia/342 W 84th St ..212-962-0728
Reuven Afanador, (P), Michaela Davis, (S), Sara Feldmann, (S), Barry Harris, (P), Pat Lacroix, (P), Wei Lang, (MU), Sam Pellesier, (P), Peter Sakas, (P), Jeffrey Thomas, (S), Betty Wilson, (S)

K

Kahn, Harvey Assoc Inc/14 E 52nd St212-752-8490
Bernie Fuchs, (I), Nick Gaetano, (I), Gerald Gersten, (I), Robert Peak, (I), Bill Sienkiewicz, (I), Joel Spector, (I)

Kane, Odette/236 W 27th St 10th Fl ...212-807-8730
Richard Atlan, (I), Albano Guatti, (P), Maria Perez, (I), Charles Seesselberg, (P)

Kapune, Laurel/370 Central Park West212-222-2378
Steven Randazzo, (P)

Kauss, Jean-Gabriel/235 E 40th St ..212-370-4300
Serge Barbeau, (P), Gianpaolo Barbieri, (P), Karel Fonteyne, (P), Jesse Gerstein, (P), Francois Halard, (P), Mark Hispard, (P), Dominique Isserman, (P), Mark Kayne, (P), Jean La Riviere, (P), Isabel Snyder, (P), Lance Staedler, (P)

Kenney, John Assoc/145 E 49th St ..212-758-4545
Gary Hanlon, (I), Elizabeth Heyert, (P)

Ketcham, Laurie/210 E 36th St #6C ...212-481-9592
Timothy Hill, (P), Victoria Luggo, (P), Gerard Musy, (P), Dick Nystrom, (P), David O'Connor, (P)

Kim/137 E 25th St 11 Fl ...212-679-5628
Carl Shiraishi, (P)

Kimche, Tania/425 W 23rd St #10F ...212-242-6367
Paul Blakey, (I), Kirk Caldwell, (I), Rob Colvin, (I), Joe Fleming, (I), Hom & Hom, (I), Rafal Olbinski, (I), Miriam Schottland, (I), Christopher Zacharow, (I)

Kirchoff-Wohlberg Inc/866 UN Plaza #525212-644-2020
Angela Adams, (I), Esther Baran, (I), Bob Barner, (I), Esther Baron, (I), Maryjane Begin, (I), Liz Callen, (I), Steve Cieslawski, (I), Brian Cody, (I), Gwen Connelly, (I), Donald Cook, (I), Floyd Cooper, (I), Betsy Day, (I), Rae Ecklund, (I), Lois Ehlert, (I), Al Fiorentino, (I), Frank Fretz, (I), Jon Friedman, (I), Dara Goldman, (I), Jeremy Guitar, (I), Konrad Hack, (I), Ron Himler, (I), Rosekrans Hoffman, (I), Kathleen Howell, (I), Chris Kalle, (I), Mark Kelley, (I), Christa Kieffer, (I), Dora Leder, (I), Tom Leonard, (I), Susan Lexa, (I), Don Madden, (I), Susan Magurn, (I), Jane McCreary, (I), Lyle Miller, (I), Carol Nicklaus, (I), Sharon O'Neil, (I), Robin Oz, (I), Diane Paterson, (I), Jim Pearson, (I), J Brian Pinkney, (I), Charles Robinson, (I), Bronwen Ross, (I), Mary Beth Schwark, (I), Robert Gantt Steele, (I), Arvis Stewart, (I), Pat Traub, (I), Lou Vaccaro, (I), Joe Veno, (I), Alexandra Wallner, (I), John Wallner, (I), Arieh Zeldich, (I)

Klein, Leslie D/255 Sherman St, Brooklyn718-435-6541

Klimt, Bill & Maurine/15 W 72nd St............212-799-2231
Randy Berrett, (I), Wil Cormier, (I), Jamie DeJesus, (I), Steve
Ferris, (I), Mark Heath, (I), Paul Henry, (I), Jeffrey Lindberg, (I),
Frank Morris, (I), Shusei Nagaoka, (I), Alan Neider, (I), Frank
Ordaz, (I), Gary Penca, (I), Rob Sauber, (I), Mark Skolsky, (I),
Carla Sormanti, (I), Charles Tang, (I), Susan Tang, (I)
Knight, Harrison/1043 Lexington Ave #4..........212-288-9777
Barbara Campbell, (P)
Korman, Alison/95 Horatio St212-633-8407
David Bishop, (P), Dana Buckley, (P)
Korn, Elaine Assoc/234 Fifth Ave 4th fl............212-679-6739
Klaus Laubmayer, (P), Francis Murphy, (P), Jim Varriale, (P),
Jim Wood, (P), Frank Yarborough, (P)
Korn, Pamela & Assoc/32 W 40th St #9B............212-819-9084
Brian Ajhar, (I), Jeff Moores, (I), Kurt Vargo, (I)
Kramer, Ina/61 Lexington Ave #1H.............212-779-7632
Lewis Calver, (I), Sharon Ellis, (I), Ken & Carl Fischer, (P),
Jeffrey Holewski, (I), Ellen G Jacobs, (I), Lauren Keswick, (I),
Randee Ladden, (I), Stan Sholik, (P)
Kramer, Joan & Assoc/49 E 21 St.............212-567-5545
Richard Apple, (P), Bill Bachmann, (P), Roberto Brosan, (P),
David Cornwell, (P), Micheal DeVecka, (P), Clark Dunbar, (P),
Stan Flint, (P), Stephen Frink, (P), Peter Kane, (P), John Lawlor,
(P), Roger Marschutz, (P), James McLoughlin, (P), Ralf
Merlino, (P), Frank Moscati, (P), Bill Nation, (P), John Russell,
(P), Ed Simpson, (P), Roger Smith, (P), Glen Steiner, (P),
Janice Travia, (P), Ken Whitmore, (P), Gary Wunderwald, (P),
Edward Young, (P), Eric Zucker, (P)
Kreis, Ursula G/63 Adrian Ave, Bronx212-562-8931
Bill Farrell, (P), George Kamper, (P)
Krongard, Paula/210 Fifth Ave #301212-683-1020
Douglas Foulke, (P), Bill White, (P)

L

Lada, Joe/330 E 19th St.............212-475-3647
Lamont, Mary/56 Washington Ave, Brentwood212-242-1087
Jim Marchese, (P)
Lane, Judy/444 E 82nd St.............212-861-7225
Larkin, Mary/308 E 59th St212-832-8116
Lynn St John, (P), Mort Klein, (MM), Charles Masters, (P)
Lavaty, Frank & Jeff/509 Madison Ave 10th Fl212-355-0910
John Berkey, (I), Jim Butcher, (I), Bernard D'Andrea, (I),
Domenick D'Andrea, (I), Don Daily, (I), Donald Demers, (I),
Roland DesCombes, (I), Chris Duke, (I), Bruce Emmett, (I),
Gervasio Gallardo, (I), Tim Hildebrandt, (I), Martin Hoffman, (I),
Stan Hunter, (I), Chet Jezierski, (I), David McCall Johnston, (I),
Mort Kunstler, (I), Paul Lehr, (I), Lemuel Line, (I), Robert
LoGrippo, (I), Carlos Ochagavia, (I), Ben Verkaaik, (I)
Lee, Alan/33 E 22nd St #5D.............212-673-2484
Jim Barber, (P)
Leff, Jerry Assoc Inc/420 Lexington Ave #2760.............212-697-8525
Franco Accornero, (I), Lisa Adams, (I), Roger Barcilon, (I),
Ken Barr, (I), Semyon Bilmes, (I), Alex Boies, (I), Tracy Britt,
(I), Ron Broda, (I), Bradford Brown, (I), Mike Bryan, (I),
Michael Bull, (I), Brian Callanan, (I), Gwen Connelly, (I),
Denise Chapman Crawford, (I), Ron DiCianni, (I), Bill
Donovan, (I), Norm Eastman, (I), Charles Gehm, (I), Penelope
Gottlieb, (I), Kate Brennan Hall, (I), Richard High, (I), Fred
Hilliard, (I), Terry Hoff, (I), Lars Justinen, (I), Armen Kojoyian,
(I), Lingta Kung, (I), Ron Lesser, (I), Francis Livingston, (I),
Steven Mach, (I), Kelly Maddox, (I), Dennis Magdich, (I),
Michele Manning, (I), Frank Marciuliano, (I), Alan Mazzetti, (I),
Gary McLaughlin, (I), Celia Mitchell, (I), Rick Ormond, (I),
John Parsons, (I), Kenn Richards, (I), Sue Rother, (I), Rob
Ruppel, (I), John Sayles, (I), Jackie Snider, (I), Mary Thelen,
(I), James Woodend, (I), Judy York, (I)
Leone, Mindy/381 Park Ave S #710212-696-5674
Bill Kouirinis, (P)
Leonian, Edith/220 E 23rd St212-989-7670
Philip Leonian, (P)
Lerman, Gary/113 E 31st St #4D.............212-683-5777
John Bechtold, (P), Jan Cobb, (P)
Levin, Bruce/1123 Broadway212-243-3810
Levy, Leila/4523 Broadway #7G.............212-942-8185
David Bishop, (P), Yoav Levy, (P)
Lewin, Betsy/152 Willoughby Ave, Brooklyn718-622-3882
Ted Lewin, (I)

LGI/241 W 36th St 7th Fl.............212-736-4602
John Bellissimo, (P), Bruce Birmelin, (P), Peter Dokus, (P),
Douglas Dubler, (P), Lynn Goldsmith, (P), Jim Graham, (P),
Todd Gray, (P), Stephen Harvey, (P), Marc Hauser, (P),
Christopher Kehoe, (P), Richard Pasley, (P), Don Weinstein, (P)
Lindgren & Smith/41 Union Sq W #1228212-929-5590
Julian Allen, (I), Barbara Banthien, (I), Harry Bliss, (I), Bradley
Clark, (I), Regan Dunnick, (I), Cameron Eagle, (I), Douglas
Fraser, (I), Jan Grashow, (I), Joe & Kathy Heiner, (I), Lori
Lohstoeter, (I), Richard Mantel, (I), John Mattos, (I), Yan
Nascimbene, (I), Kathy O'Brien, (I), Michael Paraskevas, (I),
Charles S Pyle, (I), Tim Raglin, (I), Robert Gantt Steele, (I),
Cynthia Torp, (I), Stefano Vitale, (I), Jean Wisenbaugh, (I)
Liz-Li/260 Fifth Ave212-889-7067
Martin Mistretta, (P), Roy Volkmann, (P)
Locke, John Studios Inc/15 E 76th St.............212-288-8010
Avoine, (I), Tudor Banus, (I), John Cayea, (I), Andre Dahan, (I),
Oscar DeMejo, (I), Jean-Pierre Desclozeaux, (I), James
Endicott, (I), Jean Michel Folon, (I), Michael Foreman, (I),
Andre Francois, (I), Edward Gorey, (I), Dale Gottlieb, (I), Michel
Granger, (I), Catherine Kanner, (I), Peter Lippman, (I), Richard
Oden, (I), William Bryan Park, (I), Robert Pryor, (I), Hans-Georg
Raugh, (I), Victoria Roberts, (I), Fernando Puig Rosado, (I),
Ronald Searle, (I), Peter Sis, (I), Tim, (I), Roland Topor, (I),
Carol Wald, (I)
Lott, Peter & George/60 E 42nd St #1146212-953-7088
Juan C Barberis, (I), Ted Chambers, (I), Tony Cove, (I), Keith
Hoover, (I), Ed Kurtzman, (I), Eric J W Lee, (I), Wendell
McClintock, (I), Mark Nagata, (I), Tim O'Brien, (I), Marie
Peppard, (I), John Suh, (I), Barbara Tyler, (I)
Lynch, Alan/155 Ave of Americas 10th Fl212-255-6530
Michael Armson, (I), Jim Burns, (I), John Clementson, (I),
Merritt Dekle, (I), Stephen Hall, (I), John Harris, (I), Jane
Human, (I), Daniel Torres, (I), Jenny Tylden-Wright, (I), Jim
Warren, (I), Janet Woolley, (I)
Lysohir, Chris/80 8th Ave.............212-741-3187
Leland Bobbe, (P), John Uher, (P)

M

Mahar, Therese Ryan/233 E 50th St #2F212-753-7033
Mark Platt, (P)
Mandell, Ilene/61 E 86th St212-860-3148
Mann & Dictenberg Reps/20 W 46th St212-944-2853
Terry Heffernan, (P), Brian Lanker, (P), Ulf Skogsbergh, (P)
Marek & Assoc Inc/160 Fifth Ave #914.............212-924-6760
Chase Aston, (MU), Susan Breindel, (S), David Cameron, (F),
Pascal Chevallier, (P), Walter Chin, (P), Gad Cohen, (H), Hans
Feurer, (P), BJ Gillian, (MU), Sonia Kashuk, (MU), Eddy Kohli,
(P), Just Loomis, (P), Andrew MacPherson, (P), Nori, (MU), Mel
Rau, (MU), Roseann Repetti, (S), Francesco Scavullo, (P),
Ronnie Stam, (H), Edward Tricomi, (H), Deborah Turbeville,
(P), Basia Zamorska, (S)
Marlon Inc/115 Fourth Ave #8C.............212-777-5757
Tierney Gearon, (P), Piero Gemelli, (P), Marco Glaviano, (P),
Dominique Guillemot, (P), Christophe Jouany, (P)
Marshall, Mel & Edith/40 W 77th St.............212-877-3921
Marzena/229 E 79th St212-772-2522
Chris Callis, (P)
Mason, Pauline/267 Wycoff St, Brooklyn.............718-624-1906
Clifford Harper, (I), Peter Knock, (I), Peter Till, (I)
Mattelson Assoc Ltd.............212-684-2974
Karen Kluglein, (I), Marvin Mattelson, (I)
McKay, Colleen/229 E 5th St #2212-598-0469
Marili Forastieri, (P), Russell Porcas, (P), Lilo Raymond, (P),
Robert Tardio, (P)
Mendola Ltd/420 Lexington Ave #PH4,5.............212-986-5680
Gus Alavezos, (I), Paul R Alexander, (I), Steve Brennan, (I), Ellis
Chappell, (I), Garry Colby, (I), Jim Deneen, (I), Vincent DiFate,
(I), John Eggert, (I), Dominick Finelle, (I), Phil Franke, (I), Tom
Gala, (I), Hector Garrido, (I), Elaine Gignilliat, (I), Chuck Gillies,
(I), Dale Gustafson, (I), Michael Halbert, (I), Chuck Hamrick, (I),
Attila Hejja, (I), Dave Henderson, (I), Mitchell Hooks, (I), James
Ibusuki, (I), Bill James, (I), Dean Kennedy, (I), Alfons Kiefer, (I),
Joyce Kitchell, (I), Ashley Lonsdale, (I), Dennis Luzak, (I), Jeffrey
Lynch, (I), Jeffrey Mangiat, (I), Edward Martinez, (I), Bill
Maughan, (I), Geoffrey McCormack, (I), Mark McMahon, (I), Ann
Meisel, (I), Roger Metcalf, (I), Ted Michener, (I), Mike Mikos, (I),

William Miller, (I), Tom Newsome, (I), Chris Notarile, (I), RadenStudio, (I), Phil Roberts, (I), Brian Sauriol, (I), David Schleinkofer, (I), Bill Silvers, (I), Mike Smollin, (I), Kipp Soldwedel, (I), John Solie, (I), George Sottung, (I), Cliff Spohn, (I), Robert Tanenbaum, (I), Jeffrey Terreson, (I), Thierry Thompson, (I), Mark Watts, (I), Don Wieland, (I), Larry Wimborg, (I), Mike Wimmer, (I), David Womersley, (I), Ray Yeldham, (I)

Mennemeyer, Ralph/364 W 18 St........................212-691-4277
Les Jorgenson, (P), Steve Robb, (P), David Weiss, (P)

Meo, Frank/220 E 4th St #510........................212-353-0907

Miller, Susan/1641 Third Ave #29A........................212-427-9604
Desmond Burdon, (P), Bill Frakes, (P), Ainslie MacLeod, (I), Michael Questa, (P), Bill Robbins, (P), Richard Hamilton Smith, (P)

Mintz, Les/111 Wooster St #PH C........................212-925-0491
Istvan Banyai, (I), Robert Bergin, (I), Bernard Bonhomme, (I), Grace DeVito, (I), Curt Doty, (I), Mark Fisher, (I), Oscar Hernandez, (I), Amy Hill, (I), Elizabeth Lennard, (I), Roberta Ludlow, (I), David Lui, (I), Julia McLain, (I), Bobbie Moline-Kramer, (I), Rodica Prato, (I), Tommy Soloski, (I), Barton Stabler, (I), Maria Stroster, (I), Randall Zwingler, (I)

Monaco Reps/280 Park Ave S........................212-979-5533
Hans Gissinger, (P), Gabriella Imperatori, (P), Roger Neve, (P), John Peden, (P), Danny Sit, (P), Otto Stupakoff, (P)

Morgan, Vicki Assoc/194 Third Ave........................212-475-0440
Nanette Biers, (I), Ray Cruz, (I), Patty Dryden, (I), Vivienne Flesher, (I), Joyce Patti, (I), Joanie Schwarz, (I), Kirsten Soderlind, (I), Nancy Stahl, (I), Steam Inc, (I), Dahl Taylor, (I), Willardson + Assoc, (I), Bruce Wolfe, (I), Wendy Wray, (I)

Mosel, Sue/310 E 46th St........................212-599-1806

Moses, Janice/155 E 31st St #20H........................212-779-7929
Brad Guice Studio, (P), Karen Kuehn, (P)

Moskowitz, Marion/315 E 68 St #9F........................212-517-4919
Dianne Bennett, (I), Diane Teske Harris, (I), Arnie Levin, (I), Geoffrey Moss, (I)

Moss & Meixler/36 W 37th St........................212-868-0078

Moss, Eileen & Nancy Bruck/333 E 49th St #3J........................212-980-8061
Tom Curry, (I), Warren Gebert, (I), Joel Peter Johnson, (I), Lionsgate, (I), Adam Niklewicz, (I), Pamela Patrick, (I), Ben Perini, (I), Robert Pizzo, (I), Scott Pollack, (I)

Muth, John/37 W 26th St........................212-532-3479
Pat Hill, (P)

N

Neail, Pamela R Assoc/27 Bleecker St........................212-673-1600
Margaret Brown, (I), Greg Dearth, (I), David Guinn, (I), Celeste Henriquez, (I), Thea Kliros, (I), Michele Laporte, (I), Marina Levikova, (I), Tony Mascio, (I), Peter McCaffery, (I), Cary McKiver, (I), CB Mordan, (I), Manuel Nunez, (I), Brenda Pepper, (I), Janet Recchia, (I), Linda Richards, (I), Kenneth Spengler, (I), Glenn Tunstull, (I), Jenny Vainisi, (I), Vicki Yiannias, (I)

Network Representatives/206 W 15th St 4th Fl........................212-727-0044
Philippe Gamand, (P), Ross Whitaker, (P)

Newborn, Milton/135 E 54th St........................212-421-0050
John Alcorn, (I), Stephen Alcorn, (I), Braldt Bralds, (I), Robert Giusti, (I), Dick Hess, (I), Mark Hess, (I), Victor Juhasz, (I), Simms Taback, (I), David Wilcox, (I)

The Organisation/267 Wyckoff St, Brooklyn........................718-624-1906
Grahame Baker, (I), Enikoe Bakti, (I), Zafer Baran, (I), Yvonne Chambers, (I), Emma Chichester Clark, (I), David Eaton, (I), Mark Entwisle, (I), Michael Frith, (I), Peter Goodfellow, (I), Glyn Goodwin, (I), Neil Gower, (I), Susan Hellard, (I), M Hill, (), Rod Holt, (I), Leslie Howell, (I), Nicholas Hely Hutchinson, (I), Natacha Ledwidge, (I), Toby Leetham, (I), Alan McGowan, (I), Alan Morrison, (I), Lawrence Mynott, (I), Kevin O'Brien, (I), Michael O'Shaughnessy, (I), Janet Pontin, (I), Fred Preston, (I), Mark Reddy, (I), Ruth Rivers, (I), Max Schindler, (I), Christopher Sharrock, (I), Jane Smith, (I), Linda Smith, (I), Amanda Ward, (I), Paul Wearing, (I), Nadine Wickenden, (I), Nick Williams, (I), Chris Winn, (I), Alison Wisenfeld, (I)

P

Page Assoc/219 E 69th St........................212-772-0346
Bob Abraham, (P), David Cornwell, (P), John Curtis, (P), Sam Haskins, (P), Michael Horikawa, (P), Rick Peterson, (P), Lincoln Potter, (P), Franco Salmoiraghi, (P), Ford Smith, (P), William

Sumner, (P), Phil Uhl, (P), Gert Wagner, (P), William Waterfall, (P), Steve Wilkings, (P), John Zimmerman, (P)

Palmer-Smith, Glenn Assoc/150 W 82 St........................212-769-3940
John Manno, (P), Charles Nesbitt, (P)

Parallax Artist's Reps/350 Fifth Ave........................212-695-0445
Adah, (MU), Aragao, (P), Patti Dubroff, (MU), Marc Gourou, (P), Christian Kettiger, (P), Hilmar Meyer-Bosse, (P), Pauline St Denis, (P)

Penny & Stermer Group/31 W 21st St 7th Fl Rear........................212-243-4412
Manos Angelakis, (F), Doug Archer, (I), Ron Becker, (I), Scott Gordley, (I), Mike Hodges, (I), Don Kahn, (I), Julia Noonan, (I), Thomas Payne, (I), Deborah Bazzel Pogue, (I), Terri Starrett, (I), James Turgeon, (I), Judy Unger, (I)

Photography Bureau/400 Lafayette St #4G........................212-255-3333

Pierce, Jennifer/1376 York Ave........................212-744-3810

Pinkstaff, Marsha/25 W 81st St 15th Fl........................212-799-1500
Neal Barr, (P)

Polizzi, Antonia/125 Watts St........................212-925-1571
Mark Lyon, (P)

Pritchett, Tom/130 Barrow St #316........................212-688-1080
George Kanelous, (I), George Parrish, (I), Terry Ryan, (I)

Pushpin Assoc/215 Park Ave S #1300........................212-674-8080
Elliott Banfield, (I), Lou Beach, (I), Eve Chwast, (I), Seymour Chwast, (I), Alicia Czechowski, (I), Michael Anthony Donato, (I), Moira Hahn, (I), Dave Jonason, (I), R Kenton Nelson, (I), Nishi, (I), Roy Pendleton, (I)

R

Rapp, Gerald & Cullen Inc/108 E 35th St (P 12,13)........**212-889-3337**
Ray Ameijide, (I), Emmanuel Amit, (I), Michael David Brown, (I), Lon Busch, (I), Jose Cruz, (I), Ken Dallison, (I), Jack Davis, (I), Bob Deschamps, (I), Bill Devlin, (I), Ray Domingo, (I), Lee Duggan, (I), Dynamic Duo Studio, (I), Randy Glass, (I), Thomas Hart, (I), Lionel Kalish, (I), Laszlo Kubinyi, (I), Sharmen Liao, (I), Lee Lorenz, (I), Bernard Maisner, (I), Allan Mardon, (I), Hal Mayforth, (I), Elwyn Mehlman, (I), Alex Murawski, (I), Lou Myers, (I), Marlies Merk Najaka, (I), Bob Peters, (I), Sigmund Pifko, (I), Jerry Pinkney, (I), Camille Przewodek, (I), Deborah Roundtree, (P), David Art Sales, (I), Charles Santore, (I), Nora Scarlett, (P), Steve Spelman, Drew Struzan, (I), Michael Witte, (I)

Ray, Marlys/350 Central Pk W........................212-222-7680
Bill Ray, (P)

Reactor Worldwide Inc/156 Fifth Ave #508........................212-967-7699
Jamie Bennett, (I), Federico Botana, (I), Blair Brawson, (I), Henrik Drescher, (I), Bob Fortier, (I), Gail Geltner, (I), Carolyn Gowdy, (I), Steven Guarnaccia, (I), Jeff Jackson, (I), Jerzy Kolacz, (I), Ross MacDonald, (I), James Marsh, (I), Simon Ng, (I), Tomio Nitto, (I), Bill Russell, (I), Joe Salina, (I), Fiona Smyth, (I), Jean Tuttle, (I), Maurice Vellekoop, (I), Rene Zamic, (I)

Reese, Kay Assoc/225 Central Park West........................212-799-1133
Lee Baltimore, (P), Paul Cranham, (P), Ashvin Gatha, (P), Lowell Georgia, (P), Peter Gullers, (P), Arno Hammacher, (P), Dellan Haun, (P), Sergio Jorge, (P), Simpson Kalisher, (P), Jay Leviton, (P), Tim Long, (P), Jonathan Love, (P), Ben Martin, (P), Lynn Pelham, (P), T Tanuma, (P)

Reid, Pamela/66 Crosby St........................212-925-5909
Thierry des Fontaines, (P), Bert Stern, (P)

Renard Represents/501 Fifth Ave #1407........................212-490-2450
Steve Bjorkman, (I), Joseph Cellini, (I), William Cigliano, (I), Glenn Dean, (I), Carol Donner, (I), Bart Forbes, (I), Dan Garrow, (I), Tim Girvin, (I), Jud Guitteau, (I), William Harrison, (I), Matthew Holmes, (I), Jane Hurd, (I), Hideaki Kodama, (I), Lamb & Hall, (P), John Martin, (I), Wayne McLoughlin, (I), Richard Newton, (I), Robert Rodriguez, (I), Theo Rudnak, (I), Maso Saito, (I), Kazuhiko Sano, (I), Michael Schwab, (I), Valerie Sinclair, (I), Doug Struthers, (I), Jozef Sumichrast, (I), Kim Whitesides, (I)

Rep Rep/211 Thompson St #1E........................212-475-5911
Rob Fraser, (P), Marcus Tullis, (P)

Ridgeway, Karen/330 W 42nd St #3200NE........................212-714-0130
Ronald Ridgeway, (I)

Riley Illustration/81 Greene St........................212-925-3053
Quentin Blake, (I), William Bramhall, (I), CESC, (I), Paul Degen, (I), Chris DeMarest, (I), Jeffrey Fisher, (I), Paul Hogarth, (I), Benoit Van Innis, (I), Pierre Le-Tan, (I), Paul Meisel, (I), Jim Parkinson, (I), Cheryl Peterson, (I), J J Sempe, (I), David Small, (I)

Riley, Catherine/12 E 37th St........................212-532-8326
Riley & Riley Photo, (P)

Robinson, Madeleine/31 W 21st St................212-243-3138
Jamie Hankin, (P), Russell Kirk, (P), Chuck Kuhn, (P),
Michel Tcherevkoff, (P)
Roderick-Payne, Jennifer/80 Varick St #6A.........212-268-1788
Brian Goble, (P), Deborah Klesenski, (P), Bob Ward, (P)
Roman, Helen Assoc/140 West End Ave #9H.............212-874-7074
Lou Carbone, (I), Roger T De Muth, (I), Mena Dolobowsky, (I),
Naiad Einsel, (I), Walter Einsel, (I), Myron Grossman, (I), Jeff
Lloyd, (I), Sandra Marziali, (I), Andrea Mistretta, (I)

S

S I International/43 East 19th St.................212-254-4996
Jack Brusca, (I), Oscar Chichoni, (I), Daniela Codarcea, (I),
Richard Corben, (I), Richard Courtney, (I), Bob Cowan, (I),
Robin Cuddy, (I), Dennis Davidson, (I), Allen Davis, (I), Andre
Debarros, (I), Ted Enik, (I), Blas Gallego, (I), Vicente
Gonzalez, (I), Mel Grant, (I), Devis Grebu, (I), Oscar Guell,
(I), Steve Haefele, (I), Sherri Hoover, (I), Susi Kilgore, (I),
Richard Leonard, (I), Sergio Martinez, (I), Fred Marvin, (I),
Francesc Mateu, (I), Jose Miralles, (I), Isidre Mones, (I),
Steve Parton, (I), Joan Pelaez, (I), Jordi Penalva, (I), Vince
Perez, (I), Martin Rigo, (I), Melodye Rosales, (I), Aristides
Ruiz, (I), Paul Wenzel, (I)
Sacramone, Dario/302 W 12th St.................212-929-0487
Tracy Aiken, (P), Marty Umans, (P)
Samuels, Rosemary/14 Prince St #5E..............212-477-3567
Beth Galton, (P), Chris Sanders, (P)
Sander, Vicki/155 E 29th St #28G...............212-683-7835
John Manno, (P)
Santa-Donato, Paul/25 W 39th St #1001............212-921-1550
Saunders, Gayle/145 E 36th St #2...............212-481-3860
Tiziano Magni, (P), Dewy Nicks, (P), Michael O'Brien, (P)
Saunders, Michele/84 Riverside Dr #5.............212-496-0268
Ricardo Bertancourt, (P), Francis Giacobetti, (P), David
Hamilton, (P), Cheryl Koralik, (P), Uwe Ommer, (P)
Schecter Group, Ron Long/212 E 49th St...........212-752-4400
Scher, Dotty/235 E 22nd St..................212-689-7273
Harry Benson, (P), David Katzenstein, (P), Frank Spinelli, (P),
Elizabeth Watt, (P), Denis Waugh, (P)
Schneider, Jonathan/175 Fifth Ave #2291..........212-459-4325
Dennis Dittrich, (I), Mike Kreffel, (I), Adam Max, (I), Harley
Schwadron, (I), Steve Smallwood, (I), Jay Taylor, (I)
Schochat, Kevin R/150 E 18th St #14N.............212-475-7068
Thom DeSanto, (P), Mark Ferri, (P)
Schramm, Emily/167 Perry St.................212-620-0284
Schub, Peter & Robert Bear/136 E 57th #1702.......212-246-0679
Robert Freson, (P), Irving Penn, (P), Rico Puhlmann, (P)
Seigel, Fran/515 Madison Ave 22nd Fl............212-486-9644
Kinuko Craft, (I), John Dawson, (I), Catherine Deeter, (I), Lars
Hokanson, (I), Mirko Ili'c, (I), Earl Keleny, (I), Larry McEntire, (I)
Shamilzadeh, Sol/214 E 24th St #3D..............212-532-1977
Strobe Studio, (P)
Sharlowe Assoc/275 Madison Ave...............212-288-8910
Claus Eggers, (P), Nesti Mendoza, (P)
Sheer, Doug/59 Grand St.................212-274-8446
Siegel, Tema/234 Fifth Ave 4th Fl..............212-696-4680
Susan David, (I), Loretta Krupinski, (I)
Sigman, Joan/336 E 54th St.................212-832-7980
Robert Goldstrom, (I), John H Howard, (I)
Smith, Emily/30 E 21st St.................212-674-8383
Jeff Smith, (P)
Solomon, Richard/121 Madison Ave..............212-683-1362
Kent Barton, (I), Tom Blackshear, (I), Steve Brodner, (I), John
Collier, (I), Paul Cox, (I), Jack E Davis, (F), David A Johnson,
(I), Gary Kelley, (I), Greg Manchess, (I), Bill Nelson, (I), C. F.
Payne, (I), Douglas Smith, (I), Mark Summers, (I)
Speart, Jessica/150 E 18th St #1F..............212-673-2289
Stein, Jonathan & Assoc/353 E 77th St...........212-517-3648
Roy Wright, (P)
Stevens, Norma/1075 Park Ave.................212-427-7235
Richard Avedon, (P)
Stockland-Martel Inc/5 Union Sq W 6th Fl.........212-727-1400
Joel Baldwin, (P), Hank Benson, (P), Richard Corman, (P),
Anthony Gordon, (P), Tim Greenfield-Sanders, (P), Hashi, (P),
Reudi Hoffman, (P), Walter Iooss, (P), Nadav Kander, (P), Eric
Meola, (P), Sheila Metzner, (P), Tim Mitchell, (P),Claude Mougin,
(P), Michael Pruzan, (P), Timothy White, (P), Bruce Wolf, (P)

TUV

Testino, Giovanni/251 Fifth Ave...............212-889-8891
Enrique Badulescu, (P), Martin Brady, (P), Franck Dieleman,
(P), Stephane Gerbier, (P), Arnold Hugh, (P), Wayne Stambler,
(P), Mario Testino, (P), Alberto Tolot, (P), Javier Valhonrat, (P)
Thomas, Pamela/254 Park Ave S #5D..............212-529-4033
Three/236 W 26th St #805.................212-463-7025
Frank Marchese, (G), William Sloan, (I)
Tise, Katherine/200 E 78th St.................212-570-9069
Raphael Boguslav, (I), John Burgoyne, (I), Bunny Carter, (I),
Judy Pelikan, (I)
Torzecka, Marlena/531 E 81st St #1C.............212-861-9892
Andrzei Czeczot, (I), Tomek Olbinski, (I), Voytek Wolynski, (I),
Paul Zwolak, (I)
Tralongo, Katrin/144 W 27th St................212-255-1976
Mickey Kaufman, (P)
Turk, Melissa/370 Lexington Ave #1002............212-953-2177
Juan Barberis, (I), Barbara Bash, (I), Susan Johnston Carlson,
(I), Paul Casale, (I), Nancy Didion, (I), Robert Frank, (I), Kevin
O'Malley, (I), Wendy Smith-Griswold, (I)
Turner, John/55 Bethune St..................212-243-6373
Troy Word, (P)
Umlas, Barbara/131 E 93rd St.................212-534-4008
Hunter Freeman, (P), Nora Scarlett, (P)
Vallon, Arlene/47-37 45th St #4K, Long Island City...718-706-8112
Van Arnam, Lewis/881 7th Ave #405..............212-541-4787
Paul Amato, (P), Mike Reinhardt, (P)
Van Orden, Yvonne/119 W 57th St...............212-265-1223
Von Schreiber, Barbara/315 Central Park West #4N....212-580-7044
Josef Astor, (P), Oberto Gili, (P), Tim Gummer, (P), Dennis
Manarchy, (P), Sarah Moon, (P), Jean Pagliuso, (P), Neal
Slavin, (P)

WY

Wainman, Rick/341 W 11th St #4D...............212-360-2518
Ward, Wendy/200 Madison Ave #2402..............212-684-0590
Mel Odom, (I)
Wasserman, Ted/.....................212-867-5360
Michael Watson, (P)
Wayne, Philip/66 Madison Ave #9C...............212-696-5215
Denes Petoe, (P), Douglas Whyte, (P)
Weber, Tricia Group/125 W 77th St..............212-799-6532
Raul Colon, (I), Abe Gurvin, (I), Seth Jaben, (I), Rick Lovell, (I),
Bill Mayer, (I), David McKelzey, (I), Pat Mollica, (I), John
Robinette, (I), Jim Salvati, (I), Danny Smythe, (I), Dale Verzaal, (I)
Weissberg, Elyse/299 Pearl St #5E..............212-406-2566
Michael Mazzel, (P), Jack Reznicki, (P)
Wilson, Scott/160 Fifth Ave #906...............212-633-0105
Salvatore Baiano, (P), John Falocco, (P), Rolf Juario, (P),
Greg Weiner, (P)
Yellen/Lachapelle/420 E 54th St #21E............212-838-3170
Joe Francki, (P), Tim Geaney, (P), Thom Jackson, (P),
Palmer Kolansky, (P), Olaf Wahlund, (P)

NORTHEAST

A

Ackermann, Marjorie/2112 Goodwin Lane, North Wales, PA.........215-646-1745
H Mark Weidman, (P)
Anderson, Laurel/5-A Pirates Lane, Gloucester, MA......508-281-6880
John Curtis, (P), Elizabeth Henderson, (P)
The Art Source/444 Bedford Rd/PO Box 257, Pleasantville, NY......914-747-2220
James Barkley, (I), Karen Bell, (I), Liz Conrad, (I), Hui Han Lui,
(I), Richard Redowl, (I)
Artco/227 Godfrey Rd, Weston, CT...............203-222-8777
Artists International/7 Dublin Hill Dr, Greenwich, CT......203-869-8010
Tony Chen, (I), David Chestnut, (I), Eric D'Zenis, (I), Gino, (I),
Michael Hampshire, (I), Paul Lopez, (I), John Nez, (I), Earl
Parker, (I), Paul Vaccarello, (I)

B

Bancroft, Carol & Friends/7 Ivy Hill Rd/Box 959, Ridgefield, CT ..203-438-8386
Lori Anderson, (I), Mary Bausman, (I), Kristine Bollinger, (I),
Stephanie Britt, (I), Chi Chung, (I), Jim Cummins, (I), Susan
Dodge, (I), Andrea Eberbach, (I), Barbara Garrison, (I), Toni
Goffe, (I), Ethel Gold, (I), Mark Graham, (I), Linda Graves, (I),
Fred Harsh, (I), Ann Iosa, (I), Laurie Jordan, (I), Ketti Kupper,
(I), Karen Loccisano, (I), Laura Lydecker, (I), Steve Marchesi,
(I), Kathleen McCarthy, (I), Elizabeth Miles, (I), Yoshi Miyake,
(I), Steven Moore, (I), Rodney Pate, (I), Cathy Pavia, (I), Ondre
Pettingill, (I), Larry Raymond, (I), Beverly Rich, (I), Gail Roth,
(I), Sandra Shields, (I), Cindy Spencer, (I), Linda Boehm
Weller, (I), Ann Wilson, (I)
Beranbaum, Sheryl/115 Newbury St, Boston, MA617-437-9459
David Barber, (I), Ronald Dellicolli, (I), James Edwards, (I),
Bob Eggleton, (I), Mike Gardner, (I), Michael Joyce, (I), Manuel
King, (I), Greg Mackey, (I), Michael McLaughlin, (I), Stephen
Moscowitz, (I), Matthew Pippin, (I)
Birenbaum, Molly/7 Williamsburg Dr, Cheshire, CT203-272-9253
Peter Beach, (I), Alice Coxe, (I), W E Duke, (I), Sean Kernan,
(P), Joanne Schmaltz, (P), Paul Selwyn, (I), Bill Thomson, (I)
Bogner, Fred/911 State St, Lancaster, PA..717-393-0918
brt Photo Illustration, (P)
Bookmakers Ltd/25-Q Sylvan Rd S, Westport, CT.........................203-226-4293
David Bolinsky, (I), Steve Botts, (I), Dawn DeRosa, (I), George
Guzzi, (I), Lydia Halverson, (I), Keith LoBue, (I), Judith
Lombardi, (I), Kathy McCord, (I), David Neuhaus, (I), Karen
Pellaton, (I), Marsha Serafin, (I), Dick Smolinski, (I), Harriet
Sullivan, (I)
Brewster, John Creative Svcs/597 Riverside Ave, Westport, CT203-226-4724
Don Almquist, (I), Mike Brent, (I), Wende L Caporale, (I), Lane
Dupont, (I), Tom Garcia, (I), Glen Gustafson, (I), Steve
Harrington, (I), Seth Larson, (I), Dolph LeMoult, (I), Howard
Munce, (I), Alan Neider, (I), Nan Parsons, (I), Rick Schneider,
(I), Richard Sparks, (I), Steven Stroud, (I), Al Weston, (I)
Breza-Collier, Susan/235 South 15, Philadelphia, PA.....................215-790-1014
Vince Cucinotta, (I), Nancy Johnston, (I), Frank Margasak, (I),
Bot Roda, (I), Meryl Treatner, (I), Lane Yerkes, (I)
Brigitte Inc/202 48th St, Union City, NJ..201-867-4846
Peter Castellano, (P), Robert DiScalfani, (P), Alan Messer, (P),
David Stetson, (P), Christopher Von Hohenberg, (P)
Browne, Pema Ltd/Pine Rd HCR Box 104B, Neversink, NY............914-985-2936
Robert Barrett, (I), Todd Doney, (I), Richard Hull, (I), Ron
Jones, (I), Kathy Krantz, (I), John Rush, (I), John Sandford, (I)

C

Cadenbach, Marilyn/149 Oakley Rd, Belmont, MA617-484-7437
Susie Cushner, (P), John Huet, (P), Jack Richmond, (P)
Campbell, Rita/129 Valerie Ct, Cranston, RI...................................401-826-0606
Caton, Chip/15 Warrenton Ave, Hartford, CT.................................203-523-4562
Bob Durham, (I), Phillip Dvorak, (I), Mike Eagle, (I), Andy
Giarnella, (I), Simpson Kalisher, (P), Kathleen Keifer, (I), Joe
Klim, (I), David Mendelsohn, (P), Diana Minisci, (I), Mark
Panioto, (I), Aina Roman, (I), Linda Schiwall-Gallo, (F),
Frederick Schneider, (I), Shaffer-Smith Photo, (P), Marc Sitkin,
(P), Janet Street, (I), Andy Yelenak, (I)
City Limits/80 Wheeler Ave, Pleasantville, NY914-747-1422
Colucci, Lou/POB 2069/86 Lachawanna Ave, W Patterson, NJ........201-890-5770
Joe Colucci, (P)
Conn, Adina/3130 Wisconsin Ave NW #413, Washington, DC202-296-3671
Rosemary Henry-May, (I), Carl Schoanberger, (I), Peter Steiner, (I)
Cornell/McCarthy/2-D Cross Hwy, Westport, CT.............................203-454-4210
Creative Advantage Inc/620 Union St, Schenectady, NY518-370-0312
Jack Graber, (I)
Creative Arts International Inc/1024 Adams St, Hoboken, NJ201-659-7711
Scott Bryant, (P), Ralph Butler, (I), Stephanie Causey, (I), David
Chen, (I), Gene Garbowski, (I), Richard Laliberte, (I), Scott
Mutter, (P), Wayne Parmeter, (I), Jerry Pavey, (I), Michael
Powell, (I), Mark Seidler, (I), Tibor Toth, (I)
Creative Option/50 Washington St, S Norwalk, CT..........................203-854-9393

DE

D'Angelo, Victoria/620 Centre Ave, Reading, PA215-376-1100
Andy D'Angelo, (P)

Disckind, Barbara/2939 Van Ness St NW #1042,
Washington, DC, ..202-362-0448
Ella/229 Berkeley #52, Boston, MA...617-266-3858
Anatoly, (I), Krista Brauckman, (I), Rob Cline, (I), Robert Gunn, (I),
Kevin Hawkes, (I), Doug Henry, (I), Roger Leyonmark, (I), William
L Petersen, (I), Kathy Petrauskas, (I), Philip Porcella, (P), Jim
Raycroft, (P), Cheryl Roberts, (I), Robert Roth, (I), Bruce Sanders,
(I), Ron Toelke, (I), Bryan Wiggins, (I), Francine Zaslow, (P)
Ennis Inc/78 Florence Ave, Arlington, MA..617-643-2656
Erwin, Robin/54 Applecross Cir, Chalfont, PA.................................215-822-8258
Callaghan Photography, (P)
Esto Photographics/222 Valley Pl, Mamaroneck, NY914-698-4060
Peter Aaron, (P), Scott Frances, (P), Jeff Goldberg, (P),
John Margolies, (P), Jock Pottle, (P), Ezra Stoller, (P)

G

Geng, Maud/25 Gray St, Boston, MA ...617-236-1920
Caroline Alterio, (I), Julie Fillipo, (I), Robert Kasper, (I),
Jon McIntosh, (I), Glenn Robert Reid, (I), Michael Ryan, (P),
Vicki Smith, (I)
Giandomenico, Bob/13 Fern Ave, Collingswood, NJ......................609-854-2222
Giannini & Talent/201 Tulip Ave, Takoma Park, MD.......................301-565-0275
Mark Daniels, (P), Sheldon Greenberg, (I), Breton Littlehales,
(P), Mark Segal, (P), Joyce Tenneson, (P)
Goldstein, Gwen/8 Cranberry Lane, Dover, MA508-785-1513
Cathy Diefendorf, (I), Steve Fuller, (I), Lane Gregory, (I),
Marcus Hamilton, (I), Gary Phillips, (I), Terry Presnall, (I),
Patrick Soper, (I), Susan Spellman, (I), Gary Torrisi, (I), Joe
Veno, (I), Mel Williges, (I)
Goodman, Tom/1424 South Broad St, Philadelphia, PA..................215-468-5842
Barney Leonard, (P), Steven Pollock, (P), Matt Wargo, (P)

H

Heisey, Betsy/109 Somerstown Rd, Ossining, NY914-762-5335
Whitney Lane, (P)
HK Portfolio/458 Newtown Trnpk, Weston, CT203-454-4687
Anthony Carnabuci, (I), Abby Carter, (I), Randy Chewning, (I),
Carolyn Croll, (I), Bert Dodson, (I), Eldon Doty, (I), JAK
Graphics, (I), Anne Kennedy, (I), Benton Mahan, (I), Susan
Miller, (I), Stephanie O'Shaughnessy, (I), Jan Palmer, (I),
Sandra Speidel, (I), Peggy Tagel, (I), Jean & Mou-sein Tseng,
(I), George Ulrich, (I), Randy Verougstraete, (I), Scott Webber,
(I), David Wenzel, (I)
Holt, Rita/920 Main St, Fords, NJ..212-683-2002
David Burnett, (P), Glen Daly, (P), Chuck Ealovega, (P),
Rodney Rascona, (P)
Hone, Claire/859 N 28th St, Philadelphia, PA.................................215-765-6900
Stephen Hone, (P)
Hurewitx, Barbara Talent/72 Williamson Ave, Hillside, NJ...........201-923-0011
Hyams, Ron/185 Moseman Ave, Katonah, NY914-962-5777

IJK

ICON Graphics/34 Elton St, Rochester, NY......................................716-271-7020
Jagow, Linda/PO Box 425, Rochester, NY.......................................716-546-7606
Ron Brancato, (I), Bob Conge, (I), Susan Covert, (I), Bob
Dorsey, (I), Paul Alois Jutton, (I), Malik Maliki, (I), Jeff Marinelli,
(I), Jean K Stephens, (I)
Kerr, Ralph/239 Chestnut St, Philadelphia, PA215-592-1359
Joseph Mulligan, (P)
Knecht, Cliff/309 Walnut Rd, Pittsburgh, PA412-761-5666
David Bowers, (I), Janet Darby, (I), Jim Deigan, (I), Jackie
Geyer, (I), Deborah Pinkney, (I), George Schill, (I), Greg
Schooley, (I), Lee Steadman, (I), Jim Trusilo, (I), Phil Wilson, (I)
Kurlansky, Sharon/192 Southville Rd, Southborough, MA...............508-872-4549
Colleen, (I), John Gamache, (I), Peter Harris, (I), Geoffrey
Hodgkinson, (I), Bruce Hutchison, (I), Donald Langosy, (I),
Julia Talcott, (I)

M

Manasse, Michele/200 Acuetone Rd, New Hope, PA.....................215-862-2091
Traian Alexandru-Filip, (I), Maxine Boll, (I), Sheldon Greenberg,
(I), Carol Inouye, (I), Narda Lebo, (I), Cathy Christi O'Connor,
(I), Terry Widener, (I)
Marc, Stephen/1301 Veto St, Pittsburgh, PA...................................412-231-5160

AD-1 Ad Agency, (GD), Markpoint Creative, (I), Mirage Visuals, (AV), Mike Robinson, (P)
Mattelson Associates Ltd/37 Cary Rd, Great Neck, NY..............212-684-2974
Karen Kluglein, (I), Marvin Mattelson, (I)
McConnell McNamara & Co/182 Broad St, Wethersfield, CT.......203-563-6154
Jack McConnell, (P)
Metzger, Rick/5 Tsienneto Rd, Derry, NH.................................603-432-3356
Jon Chomitz, (P), Dave Deacon, (R)
Monahan, Terry/16 Kinsman Pl, Natick, MA...........................508-651-0671
Fabia DePonte, (I), Sara DePonte, (I)
Morgan, Wendy/5 Logan Hill Rd, Northport, NY.....................516-757-5609
Karl Edwards, (I), Brad Gaber, (I), Scott Gordley, (I), Fred Labitzke, (I), Al Margolis, (I), ParaShoot, (P), Fred Schrier, (I), Mark Sparacio, (I)
Murphy, Brenda/72 High St #2, Topsfield, MA.......................508-887-3528
Diane Bigda, (I), Joe Goebel, (I), Howie Green, (I), William Kurt Lumpkins, (I), Valentine Sahleanu, (I), Mark Seppala, (I), Paul Wasserboehr, (I), Richard Watzulik, (I)

OP

O'Connor, Leighton/15 Ives St, Beverly, MA.........................508-922-9478
Jeffrey Coolidge, (P), Joe Veno, (I)
Oreman, Linda/22 Nelson St, Rochester, NY716-244-6956
Nick Agnello, (I), Jim Bliss, (I), Roger DeMuth, (I), Paul Facklam, (I), Bill Finewood, (I), Peter Lautenslager, (I), Bob Radigan, (I), Pete Smith, (I), Karen Tomaselli, (I), Vicki Wehrman, (I)
Palulian, Joanne Reps/18 McKinley St, Rowayton, CT203-866-3734
M John English, (I), Bonnie Hofkin, (I), Gayle Kabaker, (I), David Lesh, (I), Kirk Moldoff, (I), Dickran Palulian, (I), Bonnie Timmons, (I)
Publishers Graphics/251 Greenwood Ave, Bethel, CT203-797-8188
Robert Alley, (I), Dan Andreasen, (I), Ellen Beier, (I), Paige Billin-Frye, (I), Deborah Borgo, (I), Patti Boyd, (I), Robin Brickman, (I), Ray Burns, (I), Jean Cassels, (I), Eulala Conner, (I), Kees de Kiefte, (I), Marie DeJohn, (I), Leslie Dunlap, (I), Julie Durrell, (I), Allan Eitzen, (I), Marlene Ekman, (I), Gioia Fiammenghi, (I), Fuka, (I), T R Garcia, (I), Patrick Girouard, (I), Paul Harvey, (I), Benrei Huang, (I), Pamela Johnson, (I), Brian Karas, (I), Kathie Kelleher, (I), Robin Kramer , (I), Barbara Lanza, (I), Gary Lippincott, (I), Bob Marstall, (I), Lisa McCue, (I), Peter Palagonia, (I), Robert A Parker, (I), Larry Raymond, (I), Dana Regan, (I), David Rickman, (I), S D Schindler, (I), Joel Snyder, (I), Barbara Todd, (I), James Watling, (I), Kathy Wilburn, (I)
Putscher, Terri/1214 Locust St, Philadelphia, PA......................215-569-8890
Bob Byrd, (I), Tom Herbert, (I), Bob Jones, (I), Adam Matthews, (I), Kimmerle Milnazik, (I), Bob Neumann, (I), Andrew Nitzberg, (I), Gary Undercuffler, (I)

R

Redmond, Sharon/8634 Chelsea Bridge Way, Lutherville, MD301-823-7422
Jim Owens, (I)
Reese-Gibson, Jean/4 Puritan Rd, N Beverly, MA508-927-5006
Dennis Helmar, (P), Dan Morrill, (P), Steve Rubican, (P)
Reitmeyer, Roxanne/2016 Walnut St, Philadelphia, PA...................215-972-1543
Terrence McBride, (P)
Roland, Rochel/20150 Locust Dale Terrace, Germantown, MD.......301-353-9431
Tom Engeman, (P), Mike Mitchell, (I), Michael Pohuski, (P), Jim Sloane, (P)

ST

Satterthwaite, Victoria/115 Arch St, Philadelphia, PA215-925-4233
Michael Furman, (P)
Schnitzel, Gary/PO Box 297, Pineville, PA215-598-0214
Sheehan, Betsy/7928 Ruxway Rd, Baltimore, MD.........................410-828-4020
Shokie Bragg, (I), Gary Crane, (I), Don Dudley, (I), RJ Shay, (I), Steve Uzzell, (P)
Skeans, Hillary/PO Box 158, Miquon, PA...............................215-825-1047
Sonneville, Dane/PO Box 155, Passaic, NJ..............................201-472-1225
Bryn Barnard, (I), Tim Barrall, (I), Barry Blackman, (P), DL Creamer, (I), Sid Evans, (I), Ken Korsh, (P), Art Kretzchmar, (I), Sergio Levin, (P), Angelo Santeniello, (P), Stuart Simons, (P), Art Thompson, (I), Bill Truran, (P), Greg Voth, (P), Pam Voth, (I)
Soodak, Arlene/11135 Korman Dr, Potomac, MD.........................301-983-2343
Renee Comet, (P), Anthony Edgeworth, (P), Martin Rogers,

(P), Scott Sanders, (P)
Star, Lorraine/1 Canterbury Circle, Kennebunk, ME........................207-967-5319
Hank Gans, (P)
Stemrich, J David/213 N 12th St, Allentown, PA215-776-0825
Mark Bray, (I), Bob Hahn, (P)
Stockwell, Jehremy/97 Highwood Ave, Englewood, NJ201-567-3069
Michael Conway, (I)
Studioworks/237 Hopmeadow St, Simsbury, CT........................203-658-2583
Talbot & Assoc, TJ/3101 New Mexico Ave #514, Washington, DC,...202-364-1947
TVI Creative Specialists/1146 19th St NW, Washington, DC........202-331-7722
June Chaplin, (P), Mark Freeman, (I), Isaac Jones, (P), Eucalyptus Tree Studio, (I)

UVW

Unicorn/120 American Rd, Morris Plains, NJ201-292-6852
Greg Hildebrandt, (I)
Veloric, Philip M/128 Beechtree Dr, Broomall, PA215-356-0362
Michael W Adams, (I), Deb Troyer Bunnell, (I), Suzanne K Clee, (I), Rick L Cooley, (I), Don Dyen, (I), Len Ebert, (I), Kathy Hendrickson, (I), Patricia Gural Hinton, (I), John Holder, (I), Robert R Jackson, (I), Polly Krumbhaar Lewis, (I), Richard Loehle, (I), Laurie Marks, (I), Eileen Rosen, (I), Ed Sauk, (I), Nancy Schill, (I), Dennis Schofield, (I), Samantha Carol Smith, (I), Wayne Anthony Still, (I), Brad Strode, (I), Lane Yerkes, (I)
Warner, Bob/1425 Belleview Ave, Plainfield, NJ.............................908-755-7236
Phil Harrington, (P), Lester Lefkowitz, (P), Hank Morgan, (P), Tomo Narashina, (I), Lou Odor, (P), Victor Valla, (I)
Wolfe, Deborah Ltd/731 North 24th St, Philadelphia, PA.................215-232-6666
Skip Baker, (I), Robert Burger, (I), Richard Buterbaugh, (I), Dia Calhoun, (I), Jenny Campbell, (I), Dave Christiana, (I), Jeff Cook, (I), Robert Cooper, (I), Ray Dallasta, (I), Jeff Fitz-Maurice, (I), John Paul Genzo, (I), Patrick Gnan, (I), Randy Hamblin, (I), Jim Himsworth 3rd, (I), Michael Hostovich, (I), Robin Hotchkiss, (I), Marianne Hughes, (I), Neal Hughes, (I), John Huxtable, (I), Scott Johnston, (I), Tony Mascio, (I), Joe Masterson, (I), Tom Miller, (I), Verlin Miller, (I), Bill Morse, (I), Andy Myer, (I), Steven Nau, (I), Lisa Pomerantz, (I), Richard Waldrep, (I), Bea Weidner, (I), Larry Winborg, (I)
Wolff, Timmi/1509 Park Ave, Baltimore, MD410-383-7059
Steven Biver, (P), Burgess Blevins, (P), R Mark Heath, (I), Meg Kratz, (P), Ron Solomon, (P), Richard Ustinich, (P)

SOUTHEAST

A

Addison Paramount Images/1416 Forest Hills Dr, Winter Springs, FL...407-339-1711
Aldridge, Donna Reps Inc/755 Virginia Ave NE, Atlanta, GA404-872-7980
Catpack, (I), Thomas Gonzalez, (I), Bill Jenkins, (I), Chris Lewis, (I), Carol H Norby, (I), Marcia Wetzel, (I)
Anders, Phil/704 Churchill Dr, Chapel Hill, NC.................................919-929-0011
Ray Dugas, (I), Dan Johnson, (I), Jan Lukens, (I), Bob Murray, (I), Chuck Primeau, (I), Keith Simmons, (I), Elizabeth Traynor, (I)

B

Beck, Susanne/2721 Cherokee Rd, Birmingham, AL205-871-6632
Charles Beck, (P)
Brenner, Harriet/901 Martin Downs Blvd, Palm City, FL..................407-283-9945
Dick Krueger, (P), Erich Schremp, (P), Tony Soluri, (P)
Burnett, Yolanda/571 Dutch Vall Rd, Atlanta, GA404-881-6627

C

Cary & Co/666 Bantry Lane, Stone Mountain, GA404-296-9666
Robert August, (I), Johnna Bandle, (I), Kathi Brown, (I), Mike Hodges, (I), Kevin Hulsey, (I), David Marks, (I), Shawn McKelvey, (I), Charlie Mitchell, (I), Greg Olsen, (I), John Sommerfeld, (P)
Comport, Allan/241 Central Ave, St Petersburg, FL........................813-821-9050
Sally Wern Comport, (I), Neverne Covington, (I), Chris Coxwell, (P), Vicki Gullickson, (I), Douglas Studio Johns, (P), Berney Knox, (I), Jim Lange, (I), Dick Loader, (I)

Cuneo, Jim/5620 Executive Dr, New Port Richey, FL.........................813-848-8931
Eric Oxendorf, (P)

EFG

Embler, Jennifer/738 NE 74th St, Miami, FL.................................305-372-9425
Forbes, Pat/11459 Waterview Cluster, Reston, VA.............................703-478-0434
Kay Chernush, (P), Lautman Photography, (P), Claude
Vasquez, (P), Taren Z, (P)
Gaffney, Steve/PO Box 9285, Alexandria, VA..................................703-751-1991
Lee Anderson, (P), Paul Fetters, (P), Lightscapes Photo, (P),
Lisa Masson, (P), Len Rizzi, (P)
Green, Cindy/772 Edgewood Ave NE, Atlanta, GA.............................404-525-1333
Kurt Fisher, (P)

JKL

Jett & Assoc Inc/1408 S Sixth St, Louisville, KY502-561-0737
Ron Bell, (I), Gary Bennett, (I), Dan Brawner, (I), Annette Cable,
(I), Mark Cable, (I), Toby Lay, (I), John Mattos, (I), Mario Noche,
(I), Cynthia Torp, (I), David Wariner, (I), Roy Wiemann, (I),
Paul Wolf, (I)
Klinko, Julia/2843 S Bayshore Dr #11E, Coconut Grove, FL.............305-445-5540
Lee, Wanda/3647 Cedar Ridge Dr, Atlanta, GA404-432-6309
Flying Photo Factory, (A)
Linden, Tamara/3490 Piedmont Rd #1200, Atlanta, GA..................404-262-1209
Gail Chirko, (I), Tom Fleck, (I), Joe Ovies, (I), Charles
Passarelli, (I), Larry Tople, (I)

M

McGee, Linda/1816 Briarwood Ind Ct, Atlanta, GA404-633-1286
Alan McGee, (P)
McLean & Friends/571 Dutch Valley Rd, Atlanta, GA...................404-881-6627
Al Clayton, (P), Michael Harrel, (I), Mitch Hyatt, (I), Martin Pate,
(I), Joe Sapphold, (I), Steve Spetseris, (I), Pamela Trowe, (I),
Michael West, (P)
McPheeters, Wilson/3737 Orange St, Norfolk, VA..........................804-966-5889
Moore, Carolyn/PO Box 37108, Charlotte, NC704-335-1733
Joseph Ciarlante, (P), Judy Nemeth, (P)

P

Pollard, Kiki/848 Greenwood Ave NE, Atlanta, GA.........................404-875-1363
Betsy Alexander, (G), Dianne Borowski, (I), Lindy Burnett, (I),
Cheryl Cooper, (I), David Guggenheim, (P), Leslie Harris, (I),
Allen Hashimoto, (I), Kathy Lengyel, (I), Pat Magers, (I), Julie
Muller-Brown, (I), Brian Otto, (I), Frank Saso, (I), James
Soukup, (I), Elizabeth Traynor, (I)
Prentice, Nancy/919 Collier Rd NW, Atlanta, GA............................404-351-5090
Rene Faure, (I), Pat Harrington, (I), Kenny Higdon, (I), Ed
Horlbeck, (I), Robbie Short, (I), Derek Yanicer, (I), Bruce
Young, (I)

ST

Satterwhite, Joy/PO Box 398, Concord, VA....................................212-219-0808
Al Satterwhite, (P)
St John, Julia/5730 Arlington Blvd, Arlington, VA703-845-5831
David Hathcox, (P)
Stock South/75 Bennett St, Atlanta, GA...404-352-0538
Sumpter, Will/1728 N Rock Springs Rd, Atlanta, GA404-874-2014
Charles Cashwell, (I), Flip Chalfant, (P), Brit Taylor Collins, (I),
Bob Cooper, (I), David Gaadt, (I), Brenda Losey, (I), David
Moses, (I), Jackie Pitman, (I), Drew Rose, (I), R M Schnieder,
(I), Garcia Studios, (I), Clark Tate, (I), Phil Wende, (I)
Trlica/Reilly: Reps/7436 Leharne Court, Charlotte, NC.................704-372-6007
Tim Anderson, (I), Tim Bruce, (I), Gerin Choiniere, (P), Sally
Wern Comport, (I), Gary Crane, (I), Laura Gardner, (I), Marcus
Hamilton, (I), Steve Knight, (P), Jim McGuire, (P), Mike
McMahon, (I), Gary Palmer, (I), Harry Roolaart, (I), Greg Rudd,
(I), Walter Stanford, (I), David Taylor, (I), Jack Vaughan, (I),
John White, (I), David Wilgus, (I), Robin Wilgus, (I)

W

Wells, Susan/5134 Timber Trail NE, Atlanta, GA404-255-1430
Paul Blakey, (I), Ted Burn, (I), Tom Cain, (I), David Clegg, (I),

Elaine Dillard, (L), John Findley, (I), Alex Hackworth, (I), Laura
Hesse, (I), Bob Hogan, (I), Keith Kohler, (I), Don Loehle, (I),
Kelley Maddox, (I), Randall McKissick, (I), Christine Mull, (I),
John Nelson, (I), Bob Pitt, (I), Bob Radigan, (I), Tommy Stubbs,
(I), Monte Varah, (I), Janie Wright, (I)
Williams Group, The/1270 W Peachtree St #8C, Atlanta, GA404-873-2287
Boris/Pittman, (G), Luis Fernandez, (I), Abe Gurvin, (I), Jack
Jones, (I), Rick Lovell, (I), Bill Mayer, (I), David McKelvey, (I),
Pat Mollica, (I), Tom Nikosey, (I), John Robinette, (I), Danny
Smythe, (I), Dale Verzaal, (I)

M I D W E S T

A

Altman, Elizabeth/1420 W Dickens, Chicago, IL312-404-0133
Ben Altman, (P), Don DuBroff, (P), Jack Perno, (P), Abby
Sadin, (P)
Art Staff Inc/1000 John R Rd #110, Troy, MI...................................313-583-6070
John Arvan, (I), Joy Brosious, (I), Larry Cory, (I), Caryl
Cunningham, (I), Brian Foley, (I), Jim Gutheil, (I), Vicki Hayes, (I),
Ben Jaroslaw, (I), Dan Kistler, (I), John Martin, (I), Dick Meissner,
(I), Jerry Monteleon, (I), Linda Nagle, (I), Jeff Ridky, (I), Jody
Ridky, (I), Al Schrank, (I), Ken Taylor, (I), Alan Wilson, (I)
Atols, Mary/405 N Wabash #1305, Chicago, IL312-222-0504

B

Ball, John/203 N Wabash, Chicago, IL...312-332-6041
Wilson-Griak Inc, (P)
Bartels, Ceci Assoc/3286 Ivanhoe, St Louis, MO...........................314-781-7377
Bill Bruning, (I), Lindy Burnett, (I), Justin Carroll, (I), Gary
Ciccarelli, (I), Robert Craig, (I), David Davis, (I), Paul Elledge,
(P), Mark Fredrickson, (I), Michael Halbert, (I), Bill Jenkins, (I),
Keith Kasnot, (I), Leland Klanderman, (I), Shannon
Kriegshauser, (I), Greg MacNair, (I), Pete Mueller, (I), John
Nelson, (I), Kevin Pope, (I), Guy Porfirio, (I), Jean Probert, (I),
Mike Randal, (I), B B Sams, (C), Todd Schorr, (I), Terry Sirrell,
(I), Terry Speer, (I), Judy Unger, (I), Wayne Watford, (I), Morgan
Weistling, (I), Linden Wilson, (I), Ted Wright, (I)
Bauer, Frank/6641 W Burleigh St, Milwaukee, WI...........................414-449-2081
Bryan Peterson, (I)
Bernstein, Joanie/PO Box 3635, Minneapolis, MN........................612-374-3169
Lee Christiansen, (I), Tom Garrett, (I), Eric Hanson, (I), Todd
Jones, (L), Jack A Molloy, (I), Stan Olson, (I), Dan Picasso, (I)
Blue Sky Projects/1237 Chicago Rd, Troy, MI313-583-2828
Steve Jungquist, (P), Tom Kirby, (P), Glen Rohde, (P)
Bracken, Laura/215 W Illinois, Chicago, IL....................................312-644-7108
William Sladcik, (P), James Wheeler, (P)
Brenna, Allen Reps/112 N Third St #204, Minneapolis, MN...........612-349-3805
Don Ellwood, (I), Lou Flores, (I), Christy Krames, (I), Richard
Kriegler, (I), Lynn Tanaka, (I), Judy Unger, (I)
Brooks & Assoc/855 W Blackhawk St, Chicago, IL........................312-642-3208
Nancy Brown, (P), David Kogan, (P), Deborah VanKirk, (P)
Burchill, Linda/680 N Lakeshore Dr, Chicago, IL............................312-664-4703
Bussler, Tom/1728 N Wood St #2F, Chicago, IL312-649-5553
Sid Evans, (I), Frank Kasy, (I), Phoenix Studio, (I)

C

Coleman, Woody/490 Rockside Rd, Cleveland, OH.........................216-661-4222
Eric Apel, (I), Jeffrey Bedrick, (I), Alex Bostic, (I), Larry Elmore,
(I), Jack Jones, (I), Michael Koester, (I), Vladimir Kordic, (I),
John Letostak, (I), Jeff Lloyd, (I), Charles Manus, (I), Al
Margolis, (I), Manuel Morales, (I), Bill Morse, (I), David Moses,
(I), Ernest Norcia, (I), Vincent Perez, (I), Bob Radigan, (I),
James Seward, (I), Marla Shegal, (I), Tom Shephard, (I), Bill
Silvers, (I), David Taylor, (I), Ezra Tucker, (I), Tom Utley, (I),
Monte Varah, (I), Chuck Wimmer, (I), Tom Yurcich, (I)
Cowan, Pat/604 Division Rd, Valparaiso, IN....................................219-462-0199
Ralph Cowan, (P)
Creative Network/3313 Croft Dr, Minneapolis, MN.........................612-781-7385

D

DeWalt & Assoc/210 E Michigan St #403, Milwaukee, WI414-276-7990

Craig Calsbeek, (I), Tom Fritz, (P), Rick Karpinski, (I), Chris
Krenzke, (I), Mark Mille, (I), Brian Otto, (I)
Dodge Account Srvcs/301 N Waters St 5th Fl, Milwaukee, WI.......414-271-3388
Ken Hanson, (G), Dave Vander Veen, (P), Matthew Zumbo, (I)
Dolby, Karen/333 N Michigan #2711, Chicago, IL.................312-855-9336
Sandra Bruce, (I), Cam Chapman, (P), Diane Davis, (I), Jan
Jones, (I), Julie Pace, (I), Fran Vuksanovich, (I), Eddie Yip, (I)

E

Edsey, Steve/520 N Michigan Ave #706, Chicago, IL312-527-0351
Stuart Block, (P), Michael Carroll, (I), Wil Cormier, (I), Deszo
Csanady, (I), Mike Dammer, (I), Tom Durfee, (I), Richard Erickson,
(I), Mike Hagel, (I), Lou Heiser, (I), Kelly Hume, (L), Keith Jay, (P),
Al Lipson, (I), Rob Magiera, (I), Betty Maxey, (I), Tom McKee, (I),
Manny Morales, (I), Mike Phillips, (I), John Rau, (I), Joe Sapulich,
(I), Harlan Scheffler, (I), Shanoor, (P), Sue Shipley, (I), Mike Sobey,
(I), Sam Thiewe, (I), Bobbi Tull, (I), Terry Wickart, (I)
Eldridge Corp/916 Olive St #300, St Louis, MO314-231-6800
Gayle Asch, (I), Jana Brunner, (I), Rob Cline, (I), Bob
Commander, (I), David FeBland, (I), Ted Fuka, (I), Kuni Hagio,
(I), John Hanley, (I), Bud Kemper, (I), Tom Killeen, (I), Doug
Klauba, (I), Nora Koerber, (I), Gary Krejca, (I), David Larks, (I),
Greg Litwicki, (I), Tom Lungstrom, (I), Jane Meredith, (I), Bill
Miller, (I), Dean Mitchell, (I), Marilyn Montgomery, (I), Garry
Nichols, (I), Ernest Norcia, (I), Virginia Peck, (I), Eduardo Reyes,
(I), Carol Robbins, (I), Ed Scarisbrick, (I), William Simon, (I),
John Van Hamersveld, (I), Jay Vigon, (I), Charles White III, (I)
Erdos, Kitty/210 W Chicago, Chicago, IL312-787-4976
Finished Art, (I)

F

Feldman, Kenneth/333 E Ontario #2011B, Chicago, IL.................312-337-0447
Fiat, Randi & Assoc/211 E Ohio #621, Chicago, IL312-784-2343
David Csicsko, (I), Marc Hauser, (P), John Kleber, (I)
Foster, Teenuh/4200 Flad Ave, St Louis, MO........................314-436-1121
Sandy Appleoff, (I), Brian Battles, (I), Sandra Filippucci, (I), Jim
Hancock, (I), Bryan Haynes, (I), Michael P. Haynes, (I),
Daphne Hewett, (I), Warren Hile, (I), Kelly Hume, (I), Mark
Langeneckert, (I), Mike Lynch, (I), Jeff May, (I), James Olvera,
(P), Joe Saffold, (I), Frank Steiner, (I), Beth Tipton, (I)
Frazier, Bob/617 W Fulton St #2, Chicago, IL.......................312-845-9650

GH

Graphic Access/401 E Illinois #310, Chicago, IL...........................312-222-0087
Gregg & Assoc/112 W 9th St 2nd Fl, Kansas City, MO...................816-421-4473
Hahn, Holly/770 N Halstead #102, Chicago, IL.........................312-243-5356
Nan Brooks, (I), Lina Chesak, (I), Dan Coha, (P), Jane Dierksen,
(I), Ted Fuka, (I), Doug Githens, (I), Tom Lindfors, (P), Wendell
McClintock, (I), Steve Snodgrass, (I), Dan Zaitz, (P)
Handelan-Pedersen/1165 North Clark, Chicago, IL.................312-664-1200
Hanson, Jim and Talent/777 N Michigan Ave #706, Chicago, IL312-337-7770
Sandi Fellman, (P), Glen Gyssler, (P), Maria Krajcirovic, (P),
Rob Porazinski, (I), Hannes Schmid, (P), Craig Smallish, (I),
Christian Vogt, (P), Richard Wahlstrom, (P), Harry Whitver, (I)
Harlib, Joel Assoc/405 N Wabash #3203, Chicago, IL.................312-329-1370
Richard Anderson, (I), Nick Backes, (I), Michael Backus, (I),
Bart Bemus, (I), Tim Bieber, (P), Al Brandtner, (I), Russell
Cobane, (I), Esky Cook, (I), Mike Dean, (I), Lawrence Duke, (I),
Chuck Eckart, (I), Paul Elledge, (P), Robert Farber, (P), Abe
Gurvin, (I), Scott Harris, (I), Karel Havlicek, (I), Barbara
Higgins-Bond, (I), Roger Hill, (I), David McCall Johnston, (I),
Tim Langenderfer, (I), Richard Leech, (I), Peter Lloyd, (I),
Albert Lorenz, (I), Kenvin Lyman, (I), Don Margolis, (I), Bill
Morse, (I), Dennis Mukai, (I), Steve Nozicka, (P), Fred Pepera,
(I), Kevin Pope, (I), Ray Roberts, (I), Buc Rogers, (I), Delro
Rosco, (I), Boris Vallejo, (I), Bill Vann, (I), Ron Villani, (I), Kim
Whitesides, (I), Michael Witte, (I), Bruce Wolfe, (I), Jonathan
Wright, (I), Bob Ziering, (I)
Harmon, Ellen & Michaline Siera/950 W Lake St, Chicago, IL...312-829-8201
Harry Przekop, (P)
Harris, Gretchen & Assoc/5230 13th Ave S, Minneapolis, MN.....612-822-0650
Ken Jacobsen, (I), Nathan Jarvis, (I), Jim Rownd, (I), Mary
Worcester, (I)
Hartig, Michael/3602 Pacific, Omaha, NE402-345-2164
Hellman Assoc Inc/1225 W 4th St, Waterloo, IA...................319-234-7055

Kim Behm, (I), Deb Bovy, (I), Greg Hargreaves, (I), Dan
Hatala, (I), Mitchell Heinze, (I), Steve Hunter, (I), Doug
Knutson, (I), Paul Lackner, (I), Pat Muchmore, (I), David
Olsson, (I), John Thompson, (I), Todd Treadway, (I)
Hogan, Myrna & Assoc/333 N Michigan, Chicago, IL...................312-372-1616
Horton, Nancy/939 Sanborn, Palatine, IL708-934-8966
Hull, Scott Assoc/68 E Franklin St, Dayton, OH............................513-433-8383
Mark Braught, (I), Tracy Britt, (I), Andy Buttram, (I), John
Buxton, (I), John Ceballos, (I), Greg Dearth, (I), Andrea
Eberbach, (I), Josef Gast, (I), David Groff, (I), Peter Harritos,
(I), Julie Hodde, (I), Bill James, (I), Greg LaFever, (I), John
Maggard, (I), Gregory Manchess, (I), Larry Martin, (I), Ted
Pitts, (I), Mark Riedy, (I), Don Vanderbeek, (I)

IK

Image Source, The/801 Front St, Toledo, OH419-697-1111
Jay Langlois, (P), Joe Sharp, (P)
In Flight Productions/3114 St Mary's Ave, Omaha, NE402-345-2164
Inman, J W/2149 N Kenmore, Chicago, IL...............................312-525-4955
Rose Divita, (I), Ilene Ehrlich, (P), Barbara Karant, (P), Chris
Sheban, (I), Russell Thurston, (I)
Kamin, Vince & Assoc/111 E Chestnut, Chicago, IL.................312-787-8834
Sara Anderson, (I), Tom Berthiaume, (P), Steve Bjorkman, (I),
Dave Jordano, (P), Mary Anne Shea, (I), Dale Windham, (P)
Kastaris, Harriet & Assoc/3301-A S Jefferson Ave, St Louis, MO....314-773-2600
Creative Partners NY, (F), Eric Dinyer, (I), Jason Dowd, (I),
John Dyess, (I), Dan Erdmann, (I), Mike Fehar, (P), Steve Hix,
(P), Greg Johannes, (I), Rip Kastaris, (I), Tony Ravenelli, (P),
Tracy Rea, (I), Greg Spalenka, (P), Jeff Tull, (I), Arden Von
Haeger, (I), April Goodman Willy, (I)
Keltsch, Ann/9257 Castlegate Dr, Indianapolis, IN317-849-7723
Kleber, Gordon/1711 N Honore, Chicago, IL.............................312-276-4419
Knutsen, Jan/10740 Toledo Ct, Bloomington, MN.......................612-884-8083
Kogen, Judi/315 W Walton, Chicago, IL................................312-266-8029
Richard Izui, (P)
Koralik, Connie/900 West Jackson Blvd #7W, Chicago, IL...........312-944-5680
Ron Criswell, (I), Ted Gadecki, (I), Myron Grossman, (I), Robert
Keeling, (P), Chuck Ludecke, (I), David Lyles, (P), Michelle
Noiset, (I), Bob Scott, (I), Scott Smudsky, (P), Bill Weston, (I),
Andy Zito, (I)
Kuehnel, Peter & Assoc/30 E Huron Plaza #2108, Chicago, IL...312-642-6499
Ted Carr, (I), Dan Hurley, (I), Racer & Reynolds, (I), Phoenix
Studio, (I), Jim Weiner, (P)

LM

Langley, Sharon/770 N Halstead #P-102, Chicago, IL312-243-8580
Zack Burris, (P), Vince Chiaramonte, (I), Eddie Corkery, (I),
Roxanne Donnelli, (I), Dale Fleming, (I), Diane Johnson, (I),
Tim Jonke, (I), Don Margolis, (I), Dave Rotoloni, (I)
Lawrence, Lydia/1250 N La Salle Dr #1001, Chicago, IL.............415-267-3087
Lux & Asssociates, Frank/20 W Hubbard #3E, Chicago, IL312-222-1361
Maloney, Tom & Assoc/307 N Michigan Ave #1008, Chicago, IL312-704-0500
Dave Allen, (I), Scott Ernster, (I), John Hamagami, (I), Mitch
O'Connell, (I), Stephen Rybka, (I), Skidmore Sahratian, (I),
John Schmelzer, (I), John Youssi, (I)
Marie, Rita & Friends/405 N Wabash Ave #2709, Chicago, IL312-222-0337
David Beck, (I), James Bradley, (I), Chris Consani, (I), Mort
Drucker, (I), Jim Endicott, (I), Rick Farrell, (I), Marla Frazee, (I),
Mark Frueh, (I), Ken Goldammer, (I), Rick Gonnella, (I), Robert
Gunn, (I), Karel Havlicek, (I), Dave Jonason, (I), Bob Krogle,
(I), Robert Pryor, (I), Renwick, (I), Paul Rogers, (I), Dick
Sakahara, (I), Tim Schultz, (P), Danny Smythe, (I), Jackson
Vereen, (P), Bill Wilson, (I), Greg Wray, (I)
Masheris, R Assoc Inc/1338 Hazel Ave, Deerfield, IL...............708-945-2055
McGrath, Judy/612 N Michigan Ave 4th Fl, Chicago, IL.................312-944-5116
Sandi Appleoff, (I), Bob Bullivant, (P), Joanne Carney, (P), Bret
Lopez, (P)
McNamara Associates/1250 Stephenson Hwy, Troy, MI................313-583-9200
Max Altekruse, (I), Perry Cooper, (I), Garth Glazier, (I), Hank
Kolodziej, (I), Kurt Krebs, (I), Jack Pennington, (I), Tony
Randazzo, (I), Gary Richardson, (I), Don Wieland, (I)
McNaughton, Toni/233 E Wacker #2904, Chicago, IL....................312-938-2148
Pam Haller, (P), Rodica Prato, (I), James B. Wood, (P)
Miller, Richard Assoc/405 N Wabash #1204, Chicago, IL..............312-527-0444
Montagano, David/405 N Wabash #1606, Chicago, IL.................312-527-3283
Munro, Goodman/405 N Wabash #3112, Chicago, IL...................312-321-1336

Tom Bookwalter, (I), Chris Butler, (I), Bill Cigliano, (I), Pat Dypold, (I), Malcolm Farley, (I), Clint Hansen, (I), Quang Ho, (I), Mike Kasun, (I), Ben Luce, (I), Randy Nelsen, (I), David Schweitzer, (I), Michael Steirnagle, (I)

NO

Neis, The Group/11440 Oak Drive, Shelbyville, MI616-672-5756
Bender + Bender, (P), Tom Bookwalter, (I), Liz Conrad, (I), Gary Eldridge, (I), Clint Hansen, (I), William Hosner, (I), Rainey Kirk, (I), Nancy Munger, (I), Bill Ross, (I), David Schweitzer, (I), Rick Thrun, (I)
Nicholson, Richard B/2310 Denison Ave, Cleveland, OH216-398-1494
Mark Molesky, (P), Mike Steinberg, (P)
Nicolini, Sandra/230 N Michigan #523, Chicago, IL312-871-5819
Elizabeth Ernst, (P), Tom Petroff, (P)
O'Grady Advertising Arts/111 E Wacker Dr #3000, Chicago, IL...312-565-2535
Jerry Dunn, (P)
Ores, Kathy, Frank Lux & Assoc/21 W Hubbard #3RE, Chicago, IL...312-222-1361
Osler, Spike/2616 Industrial Row, Troy, MI.................................313-280-0640
Madison Ford, (P), Rob Gage, (P), Mark Harmer, (P), Eric W Perry, (P), Dennis Wiand, (P)

P

Paisley, Shari/402 Newberry Ave, La Grange Park, IL.....................708-482-9060
Peterson, Vicki/211 E Ohio, Chicago, IL......................................312-467-0780
John Cascarano, (P), Whistl'n Dixie, (I), Elyse Lewin, (P), Howard Menken, (P), Garrick Peterson, (P)
Pool, Linda/7216 E 99th St, Kansas City, MO816-761-7314
Roseanne Olson, (P), Michael Radencich, (P)
Potts, Carolyn & Assoc/4 E Ohio #11, Chicago, IL......................312-944-1130
Mark Battrell, (P), Karen Bell, (I), John Craig, (I), Alan Dolgins, (P), Byron Gin, (I), Bob Gleason, (I), Alan Kaplan, (P), Don Loehle, (I), John McCallum, (P), Susan Nees, (I), Joe Ovies, (I), Stacey Previn, (I), Donna Ruff, (I), Jack Slattery, (I), Rhonda Voo, (I), Tim Walters, (P), Leslie Wolf, (I)
Potts, Vicki/PO Box 31279, Chicago, IL.....................................312-631-0301
Preston, Lori/449 W Belden Ave #1F, Chicago, IL..........................312-528-5483

R

Rabin, Bill & Assoc/680 N Lake Shore Dr #1020, Chicago, IL........312-944-6655
John Alcorn, (I), Steve Alcorn, (I), Joel Baldwin, (P), Joe Baraban, (P), Roger Beerworth, (I), Michael Bennallack-Hart, (I), Hank Benson, (P), Guy Billout, (I), Howard Bjornson, (P), Thomas Blackshear, (I), Charles William Bush, (P), Richard Corman, (P), Etienne Delessert, (I), Anthony Gordon, (P), Tim Greenfield-Sanders, (P), Robert Guisti, (I), Lamb & Hall, (P), Min Jae Hong, (I), Walter Iooss, (P), Victor Juhasz, (I), Art Kane, (P), Steve Mayse, (I), Sheila Metzner, (P), Jonathan Milne, (I), Claude Mougin, (P), Robert Rodriguez, (I), Michael Schwab, (I), David Wilcox, (I), Bruce Wolf, (P)
Ramin, Linda/6239 Elizabeth Ave, St Louis, MO...............................314-781-8851
Phil Benson, (I), Richard Bernal, (I), Don Curran, (I), Richelle Fleck, (I), Pam King, (I), Starr Mahoney, (I), David Niehaus, (I), William O'Donnell, (I), Roy Smith, (I), Jack Whitney, (I), Mike Whitney, (I), John Zileinski, (I)
Ray, Rodney/405 N Wabash #2709, Chicago, IL312-222-0337
David Beck, (I), Mort Drucker, (I), Jim Endicott, (I), Rick Farrell, (I), Marla Frazee, (I), Mark Frueh, (I), Ken Goldammer, (I), Rick Gonnella, (I), Robert Gunn, (I), Karel Havlicek, (I), Dave Jonason, (I), Robert Krogle, (I), Robert Pryor, (I), Paul Rogers, (I), Gary Ruddell, (I), Dick Sakahara, (I), Tim Schultz, (P), Danny Smythe, (I), Bill Wilson, (I), Greg Wray, (I)
Ridgeway Artists Rep/444 Lentz Ct, Lansing, MI517-371-3086
Darwin Dale, (P), Barbara Hranilouish, (I), Kim Kauffman, (P)

S

Sell, Dan/233 E Wacker, Chicago, IL..312-565-2701
Bob Boyd, (I), Lee Lee Brazeal, (I), Daryll Cagle, (I), Kirk Caldwell, (I), Wayne Carey, (I), Bobbye Cochran, (I), Sally Wern Comport, (I), Lee Dugan, (I), Mike Elins, (I), Christian Ellithorpe, (I), Bill Ersland, (I), Eucalyptus Tree Studio, (I), Dick Flood, (I), Alex Gross, (I), Bill Harrison, (I), Dave Kilmer, (I), Tom Lochray, (I), Gregory Manchess, (I), Bill Mayer, (I), Frank

Morris, (I), Stanley Olson, (I), WB Park, (I), Ian Ross, (I), Mark Schuler, (I), R J Shay, (I), Dave Stevenson, (I), Dale Verzaal, (I), Arden Von Haeger, (I), Phil Wendy, (I), Jody Winger, (I), Paul Wolf, (I), John Zielinski, (I)
Shulman, Salo/215 W Ohio, Chicago, IL ...312-337-3245
Stan Stansfield, (P)
Skillicorn, Roy/233 E Wacker #1209, Chicago, IL312-856-1626
Tom Curry, (I), David Scanlon, (I)
Spectrum Reps/206 N 1st St, Minneapolis, MN..............................612-332-2361
Steiber, Doug/405 N Wabash #1503, Chicago, IL.........................312-222-9595
Sullivan, Tom/3805 Maple Court, Marietta, GA................................404-971-6782
Terry Buchanan, (I), John Burns, (I), Alan David, (P), Clinton Davies, (P), Ralph Frost, (I), Jay Greer, (I), Ray Herbert, (P), Richard Hicks, (I), Bruce Hull, (I), Mark Kiesgen, (I), Sylvia Martin, (P), Harrison Northcutt, (P), Darrell Odom, (P), Charles Scogins, (I), Hart Shardin, (I), Philip Shore, (I), George Sipp, (I), Mark & Laura Stutzman, (I), Top Drawer Design, (I), Ed Wolkis, (P), Art Woodle, (I)

TVW

Tuke, Joni/325 W Huron #310, Chicago, IL312-787-6826
Dan Blanchette, (I), Steven Chorney, (I), Mary Grandpre, (I), John Hull, (I), Susan Kinast, (P), Cyd Moore, (I), Michel Tcherevkoff, (P), Bill Thomson, (I), Pam Wall, (I), John Welzenbach, (P), Ken Westphal, (I)
Virnig, Janet/2116 E 32nd St, Minneapolis, MN..............................612-721-8832
Rick Allen, (I), Mary Grandpre, (I), Dean Kennedy, (I), Robin Moline, (I), Brian Otto, (I), Kate Thomssen, (I)
Wolff, Carol/655 W Irving Park Rd #4602, Chicago, IL312-871-5359

SOUTHWEST

AB

Art Rep Inc/3525 Mockingbird Lane, Dallas, TX.............................214-521-5156
Sara Anderson, (I), Lee Lee Brazeal, (I), Kirk Caldwell, (I), Lindy Chambers, (I), Ellis Chappell, (I), Tom Curry, (I), Jay Dickman, (P), M John English, (I), Tim Girvin, (I), Janie Hughes, (I), Jim Jacobs, (I), Greg King, (I), Kent Kirkley, (P), Matthew Savins, (P), Elle Schuster, (P), Stephen Turk, (I), Andrew Vracin, (P), Terry Widener, (I)
Brooke & Company/4323 Bluffview Blvd, Dallas, TX......................214-969-0034
Sandy Appleoff, (I), Robin Brisker, (I), David Chasey, (P), Bryan Haynes, (I), Michael P Haynes, (I), Gary Head, (I), Mike Hodges, (I), Lynn McClain, (I), Cap Pannell, (I), Al Pisano, (I), Alain Redder, (P), Mike Reed, (I), Sherle Stevens, (I), Joe Viesti, (P), Benjamin Vincent, (I), Paul Wolf, (I), Keith Photography Inc Wood, (P)
Butler Creative Resources/7041 E Orange Blossom Lane, Scottsdale, AZ ...602-941-5216
Rand Carlson, (I), Robert Case, (I), Jeff Dorgay, (P), Michael Hale, (I), RB Photographic, (P), Peggi Roberts, (I), Ray Roberts, (I), Jerry Roethig, (I)

C

Campbell, Pamela/314 N Rock Island, Angleton, TX....................713-523-5328
Richard Anderson, (I), Mark Busacca, (I), George Campbell, (I), Frankie Flores, (I), Ralph Hughes, (I), Don McQueen, (I), Alexander Molinello, (I), Tom Nikosey, (I), Kevin Phillips, (I), Kevin Richert, (I)
Cedeno, Lucy/PO Box 254, Cerrillos, NM505-473-2745
David Michael Kennedy, (P)
Creative Connections of Dallas/1505 Bella Vista, Dallas, TX......214-327-7889
Dana Adams, (I), Matt Bowman, (P), Marc Burckhardt, (I), Curtis Eaves, (I), Ed Holmes, (I), Matthew McFarren, (I), Randy Nelson, (I), Peter Papadopolous, (P)
Creative Department Inc, The/3030 NW Expressway #400, Oklahoma City, OK ...405-942-4868
Douglas Bowman, (I)
Creative Services/233 Yorktown, Dallas, TX214-748-8663
John Cook, (I), Glenn David, (I), Richard Deweese, (P), Tim McClure, (I), Dave Miller, (I), Tina Rosenbaum, (I), Terry Sollenberger, (I), Michael Sours, (I), Sharon Watts, (I), Roger Xavier, (I)

Cuomo, Celeste/3311 Oaklawn Ave #300, Dallas, TX214-443-9111
Linda Bleck, (I), Lynn Rowe Reed, (I), Roxanne Villa, (I), David
Yuhl, (I)

DF

DiOrio, Diana/2829 Timmons Ln, Houston, TX...................................713-960-0393
Justin Carroll, (I), John Collier, (I), Chris Consani, (I), Mike
Dean, (I), Michael Elins, (I), John Hamagami, (I), Larry Keith,
(I), Dennis Mukai, (I), William Rieser, (I), Steven Scott, (I),
Bruce Wolfe, (I)
Freeman, Sandra/3333 Elm St #202, Dallas, TX...................................214-871-1956
Jennifer Harris, (I), Mary Haverfield, (I), Gretchen Shields, (I)
Friend & Johnson/2811 McKinney Ave #206, Dallas, TX214-855-0055
Kent Barker, (P), Connie Connally, (I), Ray-Mel Cornelius, (I),
Dave Cutler, (I), Robert Forsbach, (I), Michael Johnson, (P),
Margaret Kasahara, (I), Donald Keene, (I), Robb Kendrick, (P),
Geof Kern, (P), Mercedes McDonald, (I), Michael McGar, (I),
Hilary Mosberg, (I), Richard Myers, (P), R Kenton Nelson, (I),
Steve Pietzsch, (I), Theo Rudnak, (I), Tom Ryan, (P), Jim Sims,
(P), James Noel Smith, (I), Joel Spector, (I), Kelly Stribling, (I),
Michele Warner, (I), Neill Whitlock, (P)

KLP

KJ Reps/4527 Travis #200, Dallas, TX ...214-559-0805
Kline, Sandy/637 Hawthorne, Houston, TX713-522-1862
Tom Bookwalter, (I), Lee Lee Brazeal, (I), Mark Chickinelli, (I),
Keith Graves, (I), Clint Hansen, (I), Rolf Laub, (I), Dave Maloney,
(I), Jimmy Margulies, (I), Mike Robins, (I), Denise Watt, (I)
Lynch/Repertoire, Larry & Andrea/5521 Greenville, Dallas, TX214-369-6990
Amy Bryant, (I), Charles William Bush, (P), Denise Chapman
Crawford, (I), Diane Kay Davis, (I), Bob Depew, (I), Glenn
Gustafson, (I), Kate Brennan Hall, (I), Dan Ham, (P), Aaron
Jones, (P), Christopher Kean, (P), Jeff Kosta, (P), Ron
Lieberman, (I), Gary Nolton, (P), Brian Otto, (I), Ambrose
Rivera, (I), John Saxon, (P), Mike Wimmer, (I)
Photocom Inc/3005 Maple Ave #104, Dallas, TX214-720-2272
Robb Depenport, (P), Phillip Esparza, (P), Bart Forbes, (I),
Iskra Johnson, (I), Claude Mougin, (P), Tom Nikosey, (I), Andy
Post, (P), Rick Smith, (I), Michael Steirnagle, (I), Richard
Wahlstrom, (P), Gordon Willis, (P)
Production Services/1711 Hazard, Houston, TX.............................713-529-7916
Wright Banks Films, (F)

RST

Ryan St Clair Ltd/7028 Wabash Circle, Dallas, TX..........................214-826-8118
Dean St Clair, (I), Becky Cutler, (I), Faith DeLong, (I), Laura
Hesse, (I), Chris Hoover, (I), Mark Mroz, (I), John Nelson, (I),
Bob Radigan, (I), Kevin Short, (I), Leslie Wu, (I)
Simpson, Elizabeth/1415 Slocum St #105, Dallas, TX...................214-761-0001
Jeff Baker, (P), Kathleen Kinkopf, (I), John Parrish, (P), Michael
Simpson, (P)
Those Three Reps/2909 Cole #118, Dallas, TX214-871-1316
Dave Albers, (I), Diane Bennett, (I), Gary Blockley, (P), Phil
Boatwright, (I), Tim Boole, (P), Steve Brady, (P), Gary Ciccarelli,
(I), Bill Debold, (P), Regan Dunnick, (I), Mike Fisher, (I), Ted
Gadecki, (I), Myron Grossman, (I), Rick Kroninger, (P), Larry
Martin, (I), Richard Reens, (P), George Toomer, (I), Ka Yeung, (P)

W

Washington, Dick/4901 Broadway #152, San Antonio, TX512-822-1336
Patti Bonham, (I), Larry Brooks, (I), Ken Coffelt, (I), Joseph
DeCerchio, (I), Darius Detwiler, (I), Stephen Durke, (I),
Cameron Eagle, (I), Kari Kaplan, (I), Rick Kroninger, (P), Mark
Mroz, (I), Reuben Njaa, (P), Terry Powell, (I), Dan Soder, (I),
Mark Weakley, (I)
Whalen, Judy/2336 Farrington St, Dallas, TX...................................214-630-8977
Robert LaTorre, (P)
Willard, Paul Assoc/217 E McKinley #4, Phoenix, AZ602-257-0097
Jim Bolek, (I), Jack Graham, (I), Mike Gushock, (I), Liz
Kenyon, (I), Gary Krejca, (I), Kevin MacPherson, (I), Frank
Mendeola, (I), Jan Nelson, (I), Curtis Parker, (I), Nancy
Pendleton, (I), Sharon Singley, (I), Wayne Watford, (I), Anne
Romney Weaver, (I), Jean Wong, (I)

ROCKY MTN

Carol Guenzi Agents Inc/130 Pearl St #1602, Denver, CO............303-733-0128
Gus Alavezos, (I), John Ceballos, (I), Frank Cruz, (P), Eldridge
Corporation, (I), Phillip Fickling, (I), Hellman Animates, (FA),
Jeff Lauwers, (I), Bill Lesniewski, (I), Todd Lockwood, (I), Brian
Mark, (P), Dan McGowan, (I), Greg Michaels, (I), Prism
Productions, (FA), Jill Sabella, (I), Don Sullivan, (I), Carl
Yarbrough, (P)
Comedia/1664 Lafayette St, Denver, CO ...303-832-2299
Larry Laszlo, (P)
Matson, Marla/74 W Culver St, Phoenix, AZ...................................602-252-5072
Kent Knudson, (P), David Schmidt, (P)
No Coast Graphics/2629 18th St, Denver, CO303-458-7086
Robert August, (I), John Cuneo, (I), Bill Kastan, (I), Patrick
Merewether, (I), Tom Nikosey, (I), C F Payne, (I), Jim Salvati, (I)

WEST COAST

AB

April & Wong/41 Sutter St #1151, San Francisco, CA415-398-6542
Ayerst, Deborah/2546 Sutter St, San Francisco, CA415-567-3570
Tom Bonauro, (P), Robert Cardellino, (P), Charlie Brown & Co,
(M), Ann Field, (I), Jeffrey Newbury, (P), Thea Schrack, (P),
Malcolm Tarlofsky, (PI)
Baker, Kolea/2125 Western Ave #400, Seattle, WA206-443-0326
George Abe, (I), Don Baker, (I), Jeff Brice, (I), Elaine Cohen,
(I), Tom Collicott, (P), Tim Lord, (I), Pete Saloutos, (P), Bruce
Sharp, (I), Al Skaar, (I), Jere Smith, (I), Kris Wiltse, (I)
Braun, Kathy/75 Water St, San Francisco, CA..................................415-775-3366
Pat Allen, (PS), Laurence Bartone, (P), Steve Bonini, (P),
Sandra Bruce, (L), Michael Bull, (I), Eldon Doty, (I), Lamb &
Hall, (P), John Huxtable, (I), Bob Johnson, (I), Sudi McCollom,
(I), Jaqueline Osborn, (I), Stephen Osborn, (I), Gary Pierazzi,
(AB), Doug Schneider, (I), Koji Takei, (P)
Brenneman, Cindy/1856 Elba Cir, Costa Mesa, CA714-641-9700
Dean Armstrong, (P), Steve Ellis, (I), Pierre Kopp, (P), Gregory
Miller, (I), Brian Murray, (I), Jim Stefl, (I)
Brock, Melissa Reps/43 Buena Vista Terrace, San Francisco, CA415-255-7393
Franklin Avery, (P), Barbara Callow, (C), Michele Collier, (I),
John Cuneo, (I), Miriam Fabbri, (I), Shelby Hammond, (I),
Mike Kowalski, (I), Chuck Pyle, (I), David Wasserman, (P),
Dave Wilhelm, (P)
Brown, Dianne/402 N Windsor Blvd, Los Angeles, CA....................213-462-5598
Burlingham, Tricia/9538 Brighton Way #318, Beverly Hills, CA213-271-3982
Greg Gorman, (P), Robert Grigg, (P), Kam Hinatsu, (P),
Charles Hopkins, (P), John Konkal, (P), Karen Krasner, (P),
Dennis Manarchy, (P), Peggy Sirota, (P)
Busacca, Mary/1335 Union St, San Francisco, CA.........................415-776-4247
Richard Anderson, (I), Willardson & Assoc, (I), Olden Budwine,
(I), Mark Busacca, (I), Ignacio Gomez, (I), Paul Hoffman, (P),
John Lund, (P), Tom Nikosey, (I), Michael Pearce, (I),
Jack Slattery, (I)

C

Campbell, Marianne/Pier 9 Embarcadaro, San Francisco, CA415-433-0353
Michael Lamotte, (P), Will Mosgrove, (P)
Carriere, Lydia/PO Box 8382, Santa Cruz, CA408-425-1090
Don Faia, (GD), Danilo Gonzalez, (I), Glenn Harvey, (I), Steve
Hathaway, (I), Jeff Hicks, (P), Steve Kurtz, (P), John Sutton, (P)
Collier, Jan/166 South Park, San Francisco, CA415-552-4252
Barbara Banthien, (I), Gary Baseman, (I), Bunny Carter, (I),
Chuck Eckart, (I), Rae Ecklund, (I), Douglas Fraser, (I), Yan
Nascimbene, (I), Kathy O'Brien, (I), David Rawcliffe, (P),
Robert Gantt Steele, (I), Peter Sui, (I), Cynthia Torp, (I), Vahid,
(I), Don Weller, (I)
Conrad, James/2149 Lyon #5, San Francisco, CA.............................415-921-7140
Patrick Cone, (P), Jon Conrad, (I), Tom Curry, (I), Andrzej
Dudzinski, (I), Jack Eadon, (P), David Fisher, (P), Ron
Flemming, (I), Nick Gaetano, (I), Tim Jessell, (I), John Jinks, (I),
Charles Kemper, (P), Leland Klanderman, (I), Bret Lopez, (P),
Rafael Lopez, (I), Michael Maydak, (I), Gregory Miller, (I),
Robin Moline, (I), Kim Scholle, (I), Michael Steirnagle, (I), Dave

Stevenson, (I), Brenda Walton, (I)

Cook, Warren/PO Box 2159, Laguna Hills, CA714-770-4619
Kathleen Norris Cook, (P)

Cormany, Tom Reps/7740 Manchester Ave #110, Playa
Del Rey, CA ..213-578-2191
Mark Busacca, (I), Greg Call, (I), Dave Clemons, (I), Jim
Heimann, (I), Rich Mahon, (I), Penina Meisels, (P), Gary
Norman, (I), Ted Swanson, (I), Stan Watts, (I), Will Weston, (I),
Dick Wilson, (I), Andy Zito, (I)

Cornell, Kathleen/741 Millwold Ave, Venice, CA213-301-8059
Hank Benson, (P), John Cuneo, (I), Nancy Duell, (I), Seith
Erlich, (P), John Jones, (P), Joe Saputo, (I), Glen Wexler, (P)

Creative Resource/12056 Summit Circle, Beverly Hills, CA............213-276-5282
Bill Atkins, (I), Colin James Birdseye, (I), Bonsey, (P), Eldon
Doty, (I), Nancy French, (P), Herve Grison, (P), Toni Hanson-
Kurrasch, (I), Hal Jurcik, (I), Wendy Lagerstrom, (I), Jean-
Claude Maillard, (P), Darlene McElroy, (I), Mercier/Wimberg,
(P), Karen Miller, (P), Levon Parion, (P), Tony Ratiner, (P), Robin
Riggs, (P), Norman Stevens, (P), Dave Stevenson, (I), Thom
Tatku, (I), Anne Teisher, (I), Sandi Turchyn, (I), Brett Wagner, (I),
Dave Wilhelm, (P), Greg Winters, (I)

D

DeMoreta, Linda/PO Box 587/1839 9th St, Alameda, CA415-769-1421
Sam Allen, (I), Piet Halberstadt, (I), Ron Miller, (P), Diane
Naugle, (I), Steven Nicodemus, (I), Michael Pierazzi, (P), Zhee
Singer, (I), Steven Underwood, (P)

Dodge, Sharon/3033 13th Ave W, Seattle, WA................................206-284-4701
Robin Bartholick, (P), Maggie Bellis, (I), Bart Bemus, (I),
George Cribs, (G), Nancy Davis, (I), John Fortune, (L), Lani
Fortune, (I), Jud Guitteau, (I), Jim Henkens, (I), G Brian Karas,
(I), Mike Kowalski, (I), Jerry Nelson, (I), Ken Orvidas, (I), Frank
Renlei, (I), Patricia Ridenour, (P), John Schilling, (I), Paul
Schmid, (I), Keith Witmer, (I)

EF

Epstein, Rhoni/Photo Rep/3814 Franklin Ave, Los Angeles, CA...213-663-2388
Charles Bush, (P), Cheryl Mader, (P), Bill Robins, (P), Stuart
Watson, (P)

Ericson, William/1024 Mission St, South Pasadena, CA213-461-4969
Feliciano, Terrianne/16812 Red Hill #B, Irvine, CA........................714-250-3377
Michael Jarrett, (P)

Fleming, Laird Tyler/5820 Valley Oak Dr, Los Angeles, CA............213-469-3007
Fox & Spencer/8350 Melrose Ave #201, Los Angeles, CA213-653-6484
Jody Dole, (P), David FeBland, (I), Raphaelle Goethals, (I), Larry
Dale Gordon, (P), Abe Gurvin, (I), William Hawkes, (P), Bo Hylen,
(P), Michael Manoogian, (I), Bill Mather, (I), Sue Rother, (I),
Steven Rothfeld, (P), Joe Spencer Design, (I), Trudi Unger, (P)

France Aline Inc/1076 S Ogden Dr, Los Angeles, CA213-933-2500
Daniel E Arsenault, (P), Guy Billout, (I), Thomas Blackshear, (I),
Elisa Cohen, (I), Pierre Yves Goavec, (P), Peter Greco, (L),
Thomas Hennessy, (I), Steve Huston, (I), Steve Johnson, (I),
John Mattos, (I), Jacqui Morgan, (I), Craig Mullins, (I), Jesse
Reisch, (I), Ezra Tucker, (I), Steve Umland, (P), Kim
Whitesides, (I), Bruce Wolfe, (I)

G

Gardner, Jean/348 N Norton Ave, Los Angeles, CA213-464-2492
John Reed Forsman, (P), Richard Hume, (P), Brian Leatart, (P),
Rick Rusing, (P), Steve Smith, (P), Tim Street-Porter, (P)

George, Nancy/302 N LaBrea Ave #116, Los Angeles, CA..............213-655-0998
Dianne Bennett, (I), Robert Cooper, (I), Daniels & Daniels, (I),
Diane Davis, (I), Bruce Dean, (I), Richard Drayton, (I), Dean
Foster, (I), Penelope Gottlieb, (I), Steve Hendricks, (I), Hank
Hinton, (I), Gary Hoover, (I), Richard Kriegler, (I), Gary Lund,
(I), Julie Pace, (I), Jeremy Thornton, (I), Jeannie Winston, (I),
Corey Wolfe, (I)

Glick, Ivy/350 Townsend St #426, San Francisco, CA........................415-543-6056
Jerry Dadds, (I), Jane Dill, (I), Malcolm Farley, (I), Martin
French, (I), Raphaelle Goethals, (I), Derek Grinnell, (I),
Matthew Holmes, (I), Dean Kennedy, (I), Rhonda Voo, (I)

Goldman, Caren/4504 36th St, San Diego, CA619-284-8339
Pete Evaristo, (I), Susie McKig, (I), Gary Norman, (I),
Mark GW Smith, (I)

Graham, Corey/Pier 33 North, San Francisco, CA415-956-4750

Frank Ansley, (I), Roger Boehm, (I), Byron Coons, (I), Steve
Dininno, (I), Gordon Edwards, (P), Betsy Everett, (I), Bob
Gleason, (I), Peg Magovern, (I), Patricia Mahoney, (I), Joel
Nakamura, (I), Gretchen Schields, (I), Doug Suma, (I), David
Tillinghast, (I)

Group West Inc/5455 Wilshire Blvd #1212, Los Angeles, CA213-937-4472
Kathleen Hession, (R), Larry Salk, (I), Ren Wicks, (I)

H

Hackett, Pat/101 Yesler #502, Seattle, WA....................................206-447-1600
Bill Cannon, (P), Jonathan Combs, (I), Steve Coppin, (I), Eldon
Doty, (I), Larry Duke, (I), Bill Evans, (I), Martin French, (I),
David Harto, (I), Gary Jacobsen, (I), Larry Lubeck, (R), Dan
McGowan, (I), Bill Meyer, (I), Leo Monahan, (I), Bruce Morser,
(I), Dennis Ochsner, (I), Chuck Pyle, (I), Jill Sabella, (P), Yutaka
Sasaki, (I), Michael Schumacher, (I), John C Smith, (I), Kelly
Smith, (I), Chuck Solway, (I), Bobbi Tull, (I), Dean Williams, (I)

Hall, Marni & Assoc/1010 S Robertson Blvd #10, LA, CA..............213-652-7322
Kevin Aguilar, (I), Dave Arkle, (I), Gary Baseman, (I), Dave
Erramouste, (I), Stan Grant, (I), Dennis Gray, (P), Pam
Hamilton, (I), Miles Hardiman, (I), Fred Hilliard, (I), John Holm,
(I), Elyse Lewin, (P), Peggi Roberts, (I), Ray Roberts, (I), Ken
Sabatini, (I), Nancy Santullo, (P), John Turner, (P), Perry Van
Shelt, (I), James Wood, (P)

Hardy, Allen/1680 N Vine #1000, Los Angeles, CA213-466-7751
Phillip Dixon, (P), Mike Russ, (P), Thomas Schenk, (P), Steven
Wight, (P)

Hart, Vikki/780 Bryant St, San Francisco, CA415-495-4278
Jan Evans, (I), G K Hart, (P), Kevin Hulsey, (I), Aleta Jenks, (I),
Tom Kamifuji, (I), Julie Tsuchiya, (I), Jonathan Wright, (I)

Hedge, Joanne/1838 El Cerrito Pl #3, Hollywood, CA213-874-1661
Antar Dayal, (I), Cathy Deeter, (I), Tom Dillon, (I), Future Fonts,
(L), Rick McCollum, (I), David McMacken, (I), Ken Perkins, (I),
Laura Phillips, (I), Jim Salvati, (I), Dave Schweitzer, (I), Julie
Tsuchiya, (I), Brent Watkinson, (I)

Hillman, Betsy/Pier 33 North, San Francisco, CA415-391-1181
Istvan Banyai, (I), Hank Benson, (P), Greg Couch, (I), Jud
Guitteau, (I), John Hyatt, (I), John Marriott, (P), Randy South,
(I), Greg Spalenka, (I), Kevin Spaulding, (I), Joe Spencer, (I),
Jeremy Thornton, (I), Trudi Unger, (P)

Hodges, Jeanette/12401 Bellwood, Los Alamitos, CA213-431-4343
Ken Hodges, (I)

Hunter, Nadine/80 Wellington Ave/Box 307, Ross, CA415-456-7711
Jeanette Adams, (I), Rebecca Archey, (I), Charles Bush, (P),
Mercedes McDonald, (I), Cristine Mortensen, (I), Alan Ross,
(P), Jill Sabella, (P), Jan Schockner, (L), Liz Wheaton, (I)

JK

Jaz, Jerry/223 Prospect St, Seattle, WA ...206-783-5373
Jorgensen, Donna/PO Box 19412, Seattle, WA..............................206-634-1880
Susan Marie Anderson, (P), Mel Curtis, (P), Sandra Dean, (I),
Steve Firebaugh, (P), Fred Hilliard, (I), Dale Jorgenson, (I), Mits
Katayama, (I), Richard Kehl, (I), Doug Keith, (I), Tim Kilian, (I),
David Lund, (I), Greg McDonald, (I), Cheri Ryan, (I), Nancy
Stentz, (I)

Karpe, Michele/6671 Sunset Blvd #1592, Los Angeles, CA818-760-0491
Carol Ford, (P), Claude Morigin, (P), Victoria Pearson-
Cameron, (P), Mike Reinhardt, (P), Joyce Tenneson, (P)

Kirsch Represents/7316 Pyramid Dr, Los Angeles, CA213-651-3706
David Kimble, (I), Joyce Kitchell, (I), Royce McClure, (I), Todd
Smith, (P), Jeff Wack, (I)

Knable, Ellen/1233 S La Cienega Blvd, Los Angeles, CA213-855-8855
Roger Chouinard, (I), Bob Commander, (I), John Dearstyne,
(I), Coppos Films, (F), Randy Glass, (I), Bob Gleason, (I), Jeff
Kosta, (P), Lamb & Hall, (P), Bret Lopez, (I), James Skistimas,
(I), Jonathan Wright, (I), Brian Zick, (I)

Koeffler, Ann/5015 Clinton St #306, Los Angeles, CA.....................213-957-2327
Istvan Banyai, (I), Karen Bell, (I), Dick Cole, (I), Byron Coons,
(I), Jan Evans, (I), Chuck Kuhn, (P), Rik Olson, (I), Frank
Ordaz, (I), Dan Picasso, (I), Katherine Salentine, (I), Sandra
Speidel, (I), James Stagg, (I), Pam Wall, (I)

Kramer, Joan & Assoc/LA/10490 Wilshire Blvd #605, LA, CA......213-446-1866
Richard Apple, (P), Bill Bachmann, (P), Roberto Brosan, (P),
David Cornwell, (P), Micheal DeVecka, (P), Clark Dunbar, (P),
Stan Flint, (P), Stephen Frink, (P), Peter Kane, (P), John Lawlor,
(P), Roger Marschutz, (P), James McLoughlin, (P), Ralf

Merlino, (P), Frank Moscati, (P), Bill Nation, (P), John Russell, (P), Ed Simpson, (P), Roger Smith, (P), Glen Steiner, (P), Janice Travia, (P), Ken Whitmore, (P), Gary Wunderwald, (P), Edward Young, (P), Eric Zucker, (P)

L

Laycock, Louise/1351 Ocean Frt Walk #106, Santa Monica, CA213-204-6401
Lesli-Art Inc/PO Box 6693, Woodland Hills, CA818-999-9228
Lilie, Jim/251 Kearny St #510, San Francisco, CA415-441-4384
Ron Chan, (I), Craig Marshall, (I), Bruno Mezzapelle, (I), Dugald Stermer, (I), Ezra Tucker, (I), Sarah Waldron, (I), Stan Watts, (I), Dennis Ziemienski, (I)
London, Valerie/9301 Alcott St, Los Angeles, CA...........................213-278-6633
Neal Brown, (I), Ann Cutting, (I), Diego Uchitel, (P)
Ludlow, Catherine/1632 S Sherburne Dr, Los Angeles, CA213-859-9222
James Calderara, (P), John Colao, (P), Amanda Freeman, (P), Chris Haylett, (P), Michael Miller, (P), Dewy Nicks, (P)
Luna, Tony/39 E Walnut St, Pasadena, CA818-584-4000

M

Marie, Rita & Friends/183 N Martel Ave #240, LA, CA..................213-934-3395
Bob August, (I), David Beck, (I), James Bradley, (I), Chris Consani, (I), Todd Doney, (I), Mort Drucker, (I), Jim Endicott, (I), Rick Farrell, (I), Marla Frazee, (I), Mark Frueh, (I), Ken Goldammer, (I), Rick Gonnella, (I), Robert Gunn, (I), Karel Havlicek, (I), Dave Jonason, (I), Robert Krogle, (I), Robert Pryor, (I), Renwick, (I), Paul Rogers, (I), Dick Sakahara, (I), Tim Schultz, (P), Danny Smythe, (I), Jackson Vereen, (P), Bill Wilson, (I), Greg Wray, (I)
Martha Productions/4445 Overland Ave, Culver City, CA..............213-204-1771
Pearl Beach, (I), Bob Brugger, (I), Kirk Caldwell, (I), Bobbye Cochran, (I), Stan Evenson Dsgn, (GD), Mike Elins, (I), Allen Garns, (I), Jeff George, (I), Bryon Gin, (I), Joe & Kathy Heiner, (I), Mark Jasin, (I), John Kleber, (I), Dan Lavigne, (I), Catherine Leary, (I), R Kenton Nelson, (I), Cathy Pavia, (I), Delro Rosco, (I), Kevin Short, (I), Steve Vance, (I), Rhonda Voo, (I), Wayne Watford, (I)
Mix, Eva/2129 Grahn Dr, Santa Rosa, CA707-579-1535
Morgan, Michele/4621 Teller #108, Newport Beach, CA714-474-6002
Bill Brown, (I), Rob Court, (I), Elaine DaVault, (I), Kevin Davidson, (I), Diane Davis, (I), Shelby Hammond, (I), Mark McIntosh, (I), Morgan Pickard, (I)

NOP

Newman, Carol/1119 Colorado Ave #23, Santa Monica, CA213-394-5031
Karen Anderson, (P), Ted Burns, (I), Paul Conrath, (P), David Fairman, (P), Tim Huhn, (I), Michael Humphries, (I), Paul Janovsky, (I), Patty McClosky, (I), Kim Passey, (I), Ken Tiesson, (I), Tom Slacky/Outerspace, (R), James Wolnick, (I), Eddie Young, (I)
Onyx/7515 Beverley Blvd, Los Angeles, CA...213-965-0899
Max Aguilera-Hellweg, (P), Eika Aoshima, (P), Fredrich Cantor, (P), Davies & Starr, (P), Nancy Ellison, (P), Darryl Estrine, (P), Michael Garland, (P), D Gorton, (P), Mark Hanauer, (P), Aaron Rapoport, (P), Joyce Ravid, (P), Tim Redel, (P), Philip Saltonstall, (P), Bonnie Schiffman, (P), Mark Sennet, (P), Brian Smale, (P), David Strick, (P), Bob Wagoner, (P), Barbra Walz, (P), Timothy White, (P), Tom Wolff, (P), Firooz Zahedi, (P)
Parrish, Dave/Photopia/PO Box 2309, San Francisco, CA415-441-5611
Curtis Degler, (P), Rick Kaylin, (P), Curtis Martin, (P), Jeff Richey, (P), Vince Valdes, (P)
Partners & Artists Assoc/13480 Contour, Sherman Oaks, CA.....818-995-6883
Pate, Randy/3408 W Burbank Blvd, Burbank, CA818-985-8181
Capstone Studios, (I), Chris Dellorco, (I), John Taylor Dismukes, (I), Robert Florczak, (I), Kunio Hagio, (I), Bryan Haynes, (I), Robert Hunt, (I), Marvin Mattelson, (I), Mick McGinty, (I), Kazuhiko Sano, (I), Hugh Syme, (I)
Peek, Pamela/10834 Blix #116, Toluca Lake, CA...............................818-760-0746
Randy Berrett, (I), David Hanover, (P), Patrick James, (I), Ann Mitchel, (I), Chuck Pyle, (I), Leonard Robledo, (I), Greg Alan Rowe, (I), Gretchen Schields, (I), Randy South, (I), Harry Vamos, (P), Jim Warren, (I)
Pelkin, Christine/1962 San Pablo Ave #3, Berkeley, CA..................415-841-2238
Rob Barber, (I), John Chui, (I), Penina Meisels, (P), Frank Remkiewicz, (I), Cathy Trachok, (I), Mark Trousdale, (P)

Peterson, Linda/310 1st Ave S #333, Seattle, WA206-624-7344
Piscopo, Maria/2038 Calvert Ave, Costa Mesa, CA........................714-556-8332
Jack Boyd, (P), J W Burkey, (P), John Connell, (P), Yuri Dojc, (P), Stan Sholik, (P)
Prentice Assoc Inc, Vicki/1245 McClellan Dr #314, LA, CA........213-305-7143
Dave Albers, (I), Steve Bjorkman, (I), Greg Hally, (I), John Hull, (I), John Huxtable, (I), Catherine Kanner, (I), Ken Rosenberg, (I), Andrea Tachiera, (I)

R

Rappaport, Jodi/5410 Wilshire Blvd #1008, Los Angeles, CA213-934-8633
Glen Erler, (P), Guzman, (P), David Jensen, (I), Lauren Landau, (P), Meryl Rosenberg, (P)
Repertory/6010 Wilshire Blvd #505, Los Angeles, CA....................213-931-7449
Kaz Aizawa, (I), Richard Arruda, (I), Jim Britt, (P), Rhonda Burns, (I), Craig Calsbeek, (I), Jon Conrad, (I), Laurie Gerns, (I), Scott Hensey, (MM), Hom & Hom, (I), Haruo Ishioka, (I), Rob Kline, (I), Paul Kratter, (I), Gary Krejca, (I), Ling-ta Kung, (I), Russell Kurt, (P), Bob Maile, (L), Joel Nakamura, (I), Karl Parry, (P), Teresa Powers, (I), Robert Schaefer, (I), Steve Walters, (I)
Rosenthal Represents/3443 Wade St, Los Angeles, CA213-390-9595
Dave Allen, (I), Joel Barbee, (I), Jody Eastman, (I), Marc Erickson, (I), Robert Evans, (I), Bill Hall, (I), R Mark Heath, (I), Jim Henry, (I), Reggie Holladay, (I), Mia Joung, (I), Dennis Kendrick, (I), Rick Kinetader, (I), Kyounja Lee, (I), Roger Leyonmark, (I), Roger Loveless, (I), David Mann, (I), Roger Marchutz, (P), Kathleen McCarthy, (I), Erik Olsen, (I), Tom Pansini, (I), Kim Passey, (I), Stephen Peringer, (I), Bob Radigan, (I), Ed Renfro, (I), Ching Reyes, (I), Scott Ross, (I), Larry Salk, (I), Chris Tuveson, (I), Erik Van der Palen, (I), Bill Vann, (I), Ren Wicks, (I), Larry Winborg, (I), Kenny Yamada, (I), Allen Yamashiro, (I)

S

Salzman, Richard W/716 Sanchez St, San Francisco, CA415-285-8267
Doug Bowles, (I), Kristen Funkhouser, (I), Manuel Garcia, (I), Marty Gunsaullus, (I), Denise Hilton-Putnam, (I), Jewell Homad, (I), Dan Jones, (I), Chris McAllister, (I), Dave Mollering, (I), Everett Peck, (I), Greg Shed, (I), Walter Stuart, (I)
Santee Lehmen Dabney Inc/900 1st Ave S #404,
Seattle, WA (P 337)..206-467-1616
Fred Birchman, (I), Laurine Bowerman, (J), Raymond Gendreau, (P), Peter Goetzinger, (I), Rolf Goetzinger, (I), Linnea Granryd, (I), Obadinah Heavner, (I), Chuck Kuhn, (P), Anita Lehmann, (I), Jim Linna, (P), Kong Lu, (I), Matt Myers, (I), Rosanne W Olson, (P), Julie Pace, (I), Stan Shaw, (I), Allen Yamashiro, (I)
Scott, Freda/244 Ninth St, San Francisco, CA415-621-2992
Sherry Bringham, (I), Ed Carey, (P), Lon Clark, (P), Terry Hoff, (I), Scott Johnson, (I), Francis Livingston, (I), Alan Mazzetti, (I), R J Muna, (P), Sue Rother, (I), Susan Schelling, (P), William Thompson, (P), Carolyn Vibbert, (I), Pam Wall, (I), Elisabet Zeilon, (I)
Scroggy, David/2124 Froude St, San Diego, CA619-222-2476
Ed Abrams, (I), Jodell D Abrams, (I), Willardson + Assoc, (I), Rick Geary, (I), Jean "Moevius" Giraud, (I), Jack Molloy, (I), Hal Scroggy, (I), Lionel Talaro, (I)
Shaffer, Barry/PO Box 48665, Los Angeles, CA..............................213-939-2527
Ann Bogart, (P), Wayne Clark, (I), Todd Curtis, (I), Doug Day, (I)
Sharpe & Assoc/3952 W 59th St, Los Angeles, CA.........................213-290-1430
Alan Dockery, (P), Lois Frank, (P), Hugh Kretschmer, (P), John LeCoq, (P), Paul Maxon, (P), Bob McMahon, (I), Greg Moraes, (I), C David Pina, (L), Judy Reed, (I), Lionel Talaro, (I)
Slobodian, Barbara/745 N Alta Vista Blvd, Hollywood, CA213-935-6668
Pearl Beach, (I), Bob Greisen, (I), Scott Slobodian, (P)
Sobol, Lynne/4302 Melrose Ave, Los Angeles, CA........................213-665-5141
Laura Manriquez, (I), Arthur Montes de Oca, (P)
Stefanski, Janice Reps/2022 Jones St, San Francisco, CA415-928-0457
Jeffrey Bedrick, (I), Adrian Day, (I), Karl Edwards, (I), Emily Gordon, (I), Gary Hanna, (I), Barbara Kelley, (I), Laurie La France, (I), Beth Whybrow Leeds, (I), Katherine Salentine, (I)
Studio Artists/638 S Van Ness Ave, Los Angeles, CA.....................213-385-4585
Chuck Coppock, (I), George Francuch, (I), Bill Franks, (I), Joe

Garnett, (I), George Williams, (I)

Susan & Company/2717 Western Ave, Seattle, WA.........................206-728-1300
Bryn Barnard, (I), David M Davis, (I), Gary Eldridge, (I), Jeff
Foster, (I), Craig Holmes, (I), Linda Holt-Ayrris, (I), Iskra
Johnson, (I), Larry Jost, (I), Kristin Knutson, (I), Nina Laden, (I),
Don Mason, (P), Karen Moskowitz, (P), Stephen Peringer, (I),
Joe Saputo, (I), John Schmelzer, (I), Teresa Snyder, (I), Karl
Weatherly, (P)

Sweeney, Karen/1345 Chautauqua Blvd, Pacific Palisades, CA213-459-0331
Karen Knauer, (P), Jeff Nadler, (P), Nancy Stahl, (P)

Sweet, Ron/716 Montgomery St, San Francisco, CA.........................415-433-1222
Randy Barrett, (I), Charles Brown, (I), Randy Glass, (I), Richard
Leech, (I), Tom Lochray, (I), Steve Mayse, (I), Will Nelson, (I),
Chris Shorten, (P), Darrell Tank, (I), Jeffrey Terreson, (I), Jack
Unruh, (I), Bruce Wolfe, (I), James B Wood, (P)

TVW

Thornby, Kirk/611 S Burlington, Los Angeles, CA.............................213-933-9883
Myron Beck, (P), Darryl Estrine, (PP)

Valen Assocs/950 Klish Way, Del Mar, CA...619-259-5774
George Booth, (C), Richard Cline, (C), Whitney Darrow, (C),
Eldon Dedini, (I), Joe Farris, (C), Mort Gerberg, (C), Bud
Handelsman, (C), Stan Hunt, (C), Henry Martin, (C), Warren
Miller, (C), Frank Modell, (C), Mischa Richter, (C), Mick
Stevens, (C), Henry Syverson, (C), Robert Weber, (C), Gahan
Wilson, (C), Bill Woodman, (C), Jack Ziegler, (C)

Vandamme, Vicki/35 Stillman #206, San Francisco, CA..................415-543-6881
Lee Lee Brazeal, (I), Kirk Caldwell, (I), John Collier, (I), Flatland
Studios, (I), Kathy & Joe Heiner, (I), Alan Krosnick, (P), Steve
Lyons, (I), Rik Olson, (I), Jennie Oppenheimer, (I), Will Rieser,
(I), Kim Whitesides, (I), Nic Wilton, (I)

Wagoner, Jae/654 Pier Ave #C, Santa Monica, CA213-392-4877
David Edward Byrd, (I), David Danz, (I), Dennis Doheny, (I),
Stephen Durke, (I), Ken Durkin, (I), William Harrison, (I), Steve
Jones, (I), Nobee Kanayama, (I), Maurice Lewis, (I), Leo
Monahan, (I), Jeff Nishinaka, (I), Doug Suma, (I), Joan Weber,
(I), Don Weller, (I)

Wiley, David/251 Kearny St #510, San Francisco, CA415-989-2023
Steve Bjorkman, (I), Chris Consani, (I), Richard Eskite, (P), Ben
Garvie, (I), Scott Sawyer, (I), Keith Witmer, (I), Paul Wolf, (I)

Winston, Bonnie/195 S Beverly Dr #400, Beverly Hills, CA..............213-275-2858
Eshel Ezer, (P), Marco Franchina, (P), Joe Hill, (P), Mark
Kayne, (P), Neil Kirk, (P), Susan Shacter, (P)

I N T E R N A T I O N A L

Durcher, Marcel/512 Richmond St E, Toronto, ON............................416-367-2446
Kane, Dennis/135 Rose Ave, Toronto, ON416-323-3677
Link/Diane Jameson/2 Silver Ave, Toronto, ON...............................416-530-1500
Nina Berkson, (I), Normand Cousineau, (I), Pierre Pratt, (I),
Paul Rivoche, (I)
Miller + Comstock Inc/180 Bloor St W #1102, Toronto, ON416-925-4323
Organisation, The/69 Caledonian Rd, London, England,
Grahame Baker, (I), Emma Chichester Clark, (I), Neil Gower,
(I), Michael O'Shaughnessy, (I), Max Schindler, (I)
Osner, Margrit/, Toronto, ON ...416-961-5767
Audra Geras, (I)
Sharp Shooter/524 Queen St E, Toronto, ON416-860-0300
Three in a Box/512 Richmond St E, Toronto, ON416-367-2446
Vernell, Maureen/128 Fieldgate Dr, Nepean, ON.............................613-825-4740

PHOTOGRAPHERS

NYC

A

Abatelli, Gary/80 Charles St #3W	212-924-5887
Abramowitz, Ellen/166 E 35th St #4H	212-686-2409
Abramowitz, Jerry/680 Broadway	212-420-9500
Abramson, Michael/301 W Broadway	212-941-1970
Accornero, Franco/620 Broadway (P 44,45)	**212-674-0068**
Acevedo, Melanie/244 W 11th St #2F	212-243-5333
Adam & Adams Photo/7 Dutch St	212-619-2171
Adamo, Jeff/50 W 93rd St #8P	212-866-4886
Adams, Eddie/80 Warren St #14	212-406-1166
Addeo, Edward/151 W 19th St 10th Fl	212-206-1686
Addio, Edward/220 W 98th St #11B	212-932-9120
Adelman, Barbara Ellen/5 E 22nd St #25A	212-353-8931
Adelman, Bob/151 W 28th St	212-736-0537
Adelman, Menachem Assoc/45 W 17th St 5th Fl	212-675-1202
Adler, Arnie/70 Park Terrace W	212-304-2443
Afanador, Reuven/342 W 84th St	212-724-4590
Agor, Alexander/108-28 Flatlands 7 St, Brooklyn	718-531-1025
Aich, Clara/218 E 25th St	212-686-4220
Aiken, Tracy/155 E 31st St	212-722-2136
Aiosa, Vince/5 W 31st St	212-563-1859
Albert, Jade/59 W 19th St #3B	212-242-0940
Alberts, Andrea/121 W 17th St #7A	212-242-5794
Alcorn, Richard/160 W 95th St #7A	212-866-1161
Alexander, Robert/560 W 43rd St #12A	212-231-9248
Alexanders Studio/500 Seventh Ave 18th Fl	212-560-2178
Alexanders, John W/308 E 73rd St	212-734-9166
Allbrition, Randy/212 Sullivan St	212-529-1228
Allison, David/42 E 23rd St	212-460-9056
Alper, Barbara/202 W 96th St	212-316-6518
Alpern/Lukoski/149 W 12th St	212-645-8148
Altamari, Christopher/56 W 22nd St	212-645-8484
Amato, Paul/881 Seventh Ave #405	212-541-4787
Amrine, Jamie/30 W 22nd St	212-243-2178
Anders, Robert/724 Beverly Rd, Brooklyn	718-438-8746
Andrews, Bert/50 W 97th St	212-662-6732
Anik, Adam/111 Fourth St #1-I	212-529-2359
Anthony, Don/79 Prall Ave, Staten Island	718-317-6340
Antonio/Stephen Photo/5 W 30th St 4th Fl	212-629-9542
Apoian, Jeffrey/66 Crosby St	212-431-5513
Apple, Richard/80 Varick St #4B	212-966-6782
Arago, Chico/One Fifth Ave	212-982-2661
Aranita, Jeffrey/60 Pineapple St, Brooklyn	718-625-7672
Arbus, Amy/60 E 8th St #19H	212-353-9418
Ardito, Peter/64 N Moore St	212-941-1561
Aref, Jaramay/601 W 26th St	212-727-1996
Aresu, Paul/568 Broadway #608	212-334-9494
Arky, David/140 Fifth Ave #2B	212-242-4760
Arlak, Victoria/40 East End Ave	212-879-0250
Arma, Tom/38 W 26th St	212-243-7904
Arndt, Dianne/400 Central Park West	212-866-1902
Arslanian, Ovak/344 W 14th St	212-255-1519
Ashe, Bill/534 W 35th St	212-695-6473
Ashworth, Gavin/110 W 80th St	212-874-3879
Astor, Joseph/154 W 57th St	212-307-2050
Attoinese, Deborah/11-42 44th Dr, L I City	718-729-5614
Aubry, Daniel/365 First Ave	212-598-4191
Auster, Evan/215 E 68th St #3	212-517-9776
Auster, Walter/18 E 16th St	212-627-8448
Ava, Beth/87 Franklin St	212-966-4407
Avedis/130 E 65th St	212-472-3615
Avedon, Richard/407 E 75th St	212-879-6325
Axon, Red/17 Park Ave	212-532-6317
Azzato, Hank/348 W 14th St 3rd Fl	212-929-9455

B

Baasch, Diane/41 W 72nd St #11F	212-724-2123
Babchuck, Jacob/132 W 22nd St 3rd Fl	212-929-8811
Babushkin, Mark/110 W 31st St	212-239-6630
Back, John/15 Sheridan Sq	212-243-6347
Baiano, Salvatore/160 Fifth Avenue #906	212-633-0105
Baiano, Salvatore/160 Fifth Ave #818	212-633-1050
Bailey, Richard/96 Fifth Ave	212-255-3252
Baillie, Allan & Gus Francisco/220 E 23rd St 11th Fl	212-683-0418
Bakal-Schwartzberg/40 E 23rd St	212-254-2988
Baker, Chuck/1630 York Ave	212-517-9060
Baker, Gloria/415 Central Park West	212-222-2866
Bakerman, Nelson/220 E 4th St #2W	212-777-7321
Baldwin, Joel/350 E 55th St	212-308-5991
Baliotti, Dan/19 W 21st St	212-627-9039
Ballerini, Albano/231 W 29th St	212-967-0850
Baptiste, Beth	212-691-5674
Barash, Howard/349 W 11th St	212-242-6182
Baratta, Nicholas/450 W 31st St	212-947-7445
Barba, Dan/305 Second Ave #322	212-420-8611
Barber, James/873 Broadway	212-598-4500
Barbieri, Gianpaolo	212-370-4300
Barcellona, Marianne/175 Fifth Ave #2422	212-463-9717
Barclay, Bob Studios/5 W 19th St 6th Fl	212-255-3440
Barclay, Michelle/75 Bank St #4H	212-929-0763
Barkentin, George/15 W 18th St	212-243-2174
Barker, Christopher/420 E. 66th St	212-512-9118
Barnett, Nina/295 Park Ave S Pnthse B	212-979-8008
Barnett, Peggy/26 E 22nd St	212-673-0500
Barns, Larry/21 W 16th St	212-242-8833
Barr, Neal/222 Central Park South	212-765-5760
Barr, Paula/144 E 24th St	212-473-4191
Barrett, John E/215 W 95th St #9R	212-864-6381
Barrick, Rick/12 E 18th St 4th Fl	212-741-2304
Barrows, Wendy Photography/175 Fifth Ave #2508 (P 76)	**212-685-0799**
Bartlett, Chris/21 E 37th St #2R	212-213-2382
Barton, Paul/111 W 19th St #2A	212-691-1999
Basile, Joseph/448 W 37th St	212-564-1625
Basilion, Nicholas/150 Fifth Ave #532	212-645-6568
Baumann, Jennifer/682 Sixth Ave	212-633-0160
Baumann, Michael/206 E 26th St	212-532-6696
Bean, John/5 W l9th St	212-242-8106
Bechtold, John/117 E 31st St	212-679-7630
Beck, Arthur/119 W 22nd St	212-691-8331
Becker, Jonathan/451 West 24th St	212-929-3180
Beebe, Rod/1202 Lexington Ave #205	212-996-8926
Beechler, Greg/200 W 79th St PH #A	212-580-8649
Begleiter, Steven/38 Greene St	212-334-5262
Behl, David/13-17 Laight St 2nd Fl	212-219-8685
Belinsky, Jon/134 W 26th St #777	212-627-1246
Belk, Michael	212-691-8255
Bell, Hugh/873 Broadway	212-260-2260
Beller, Janet/225 Varrick St	212-727-0188
Belott, Robert/236 W 26th St	212-924-1503
Belushin, Blandon/56 W 22nd St	212-691-0301
Benedict, William/530 Park Ave	212-832-3164
Benson, Harry/181 E 73rd St	212-249-0284
Bercow, Larry/344 W 38th St	212-629-9000
Berenholtz, Richard/600 W 111th St #6A	212-222-1302
Berger, Joseph/121 Madison Ave #3B	212-685-7191
Bergman, Beth/150 West End Ave	212-724-1867
Bergreen, John Studio/31 W 21st St #5RW	212-366-6316
Berkwit, Lane (Ms)/262 Fifth Ave	212-889-5911
Berman, Howard/38 Greene St	212-925-2999
Berman, Malcolm/446 W 25th St	212-727-0033
Bernstein, Audrey/33 Bleecker St	212-353-3512
Bernstein, Bill/38 Greene St	212-334-3982
Bernstein, Mariann/110 W 96th St	212-663-6674
Bernstein, Steve/47-47 32nd Place, Long Island City	718-786-8100
Bersell, Barbara/12 E 86th St	212-734-9049
Bester, Roger/55 Van Dam St 11th Fl	212-645-5810
Betz, Charles/138 W 25th St 10th Fl	212-675-4760
Bevilacqua, Joe/202 E 42nd St	212-490-0355
Biddle, Geoffrey/5 E 3rd St	212-505-7713
Bies, William/21-29 41st St #1A, LI City	718-278-0236
Bijur, Hilda/190 E 72nd St	212-737-4458
Biondo, Michael/464 Greenwich St	212-226-5299
Birdsell, Doreen/126 W 22nd St 2nd Fl	212-924-7772
Bisbee, Terry/290 W 12th St	212-242-4762
Bischoff, Beth/448 W 37th St	212-714-1751

Bishop, David/251 W 19th St ..212-929-4355
Blachut, Dennis/145 W 28th St 8th Fl212-947-4270
Blackburn, Joseph M/568 Broadway #800212-966-3950
Blackman, Barry/150 Fifth Ave #220 ...212-627-9777
Blackman, Jeffrey/2323 E 12th St, Brooklyn718-769-0986
Blackstock, Ann/484 W 43rd St #22S ..212-695-2525
Blake, Jeri/227 E 11th St ..212-473-2739
Blake, Rebecca/584 Broadway #310 ..212-925-1290
Blanch, Andrea/434 E 52nd St..212-888-7912
Blanchard, Sharland/45 W 85th St #4A212-874-3388
Blechman, Jeff/591 Broadway ..212-226-0006
Blecker, Charles/350 Bleecker St #140212-242-8390
Blegen, Alana ..718-769-2619
Blell, Dianne/125 Cedar St #11N ...212-732-2990
Blinkoff, Richard/147 W 15th St 3rd Fl212-620-7883
Block, Helen/385 14th St, Brooklyn...718-788-1097
Block, Ira Photography/215 W 20th St..212-242-2728
Block, Ray/458 W 20th St #4D ..212-691-9375
Bloom, Teri/300 Mercer St #6C ..212-475-2274
Blum, Frederick/111 E 14th St ..212-969-8695
Boas, Christopher/20 Bond St (P 20,21)**212-982-8576**
Bobbe, Leland/51 W 28th St ...212-685-5238
Bocconi, Joseph/310 W 4th St ..212-645-4157
Bodi Studios/340 W 39th St ..212-947-7883
Bogertman, Ralph Inc/34 W 28th St ..212-889-8871
Boisseau, Joseph/3250 Hering Ave #1, Bronx212-519-8672
Bolesta, Alan/11 Riverside Dr #13SE ...212-873-1932
Boljonis, Steven/555 Ft Washington Ave #4A212-740-0003
Boman, Eric/32 W 20th St ...212-989-1253
Bonin, Jean-Pierre/10 W 15th St ...212-924-6208
Bonin, Jean-Pierre/11 W 95th St #3F ...212-678-8534
Bonomo, Louis/118 W 27th St #2F ..212-242-4630
Boon, Sally/108 Bowery ..212-334-9160
Borderud, Mark/78 Fifth Ave ...212-242-5425
Bordnick, Barbara/39 E 19th St ..212-533-1180
Bosch, Peter/477 Broome St ...212-925-0707
Boszko, Ron/140 W 57th St ...212-541-5504
Bottomley, Jim/125 Fifth Ave ..212-677-9646
Bourbeau, Katherine/484 W 43rd St ...212-268-1595
Bowditch, Richard/175 Fifth Ave #2613212-564-5413
Bozman, James/207 East 30th St #6F (P 80)**212-889-8319**
Brady, Steve/240 E 27th St..212-725-0503
Brakha, Moshe/77 Flfth Ave #17D ..212-645-7946
Brandt, Peter/73 Fifth Ave #6B ...212-242-4289
Braun, Yenachem/666 West End Ave ..212-873-1985
Bredel, Walter/21 E 10th St ...212-228-8565
Breitrose, Howard/443 W 18th St ...212-242-7825
Brello, Ron/400 Lafayette St ..212-982-0490
Brenner, George/31 W 31st St ...212-244-0025
Breskin, Michael/133 Second Ave ...212-979-8245
Brett, Clifton/242 W 30th St ...212-947-0139
Brey, Albert/312 W 90th St #4A ..212-874-8163
Bridges, Kiki/147 W 26th St 3rd Fl ...212-807-6563
Brill Studio/270 City Island Ave, City Island...............................212-885-0802
Brill, James/108 Fifth Ave #17C ..212-645-9414
Britton, Peter/315 E 68th St ...212-737-1664
Brizzi, Andrea/405 W 23rd St ..212-627-2341
Brochmann, Kristen/236 W 27th St ...212-989-6319
Brody, Bob/5 W 19th 2nd Fl ...212-741-0013
Bronstein, Steve/38 Greene St ...212-925-2999
Brooke, Randy/179 E 3rd St ...212-677-2656
Brosan, Roberto/873 Broadway ...212-473-1471
Brown, Cynthia/448 W 37th St ...212-564-1625
Brown, Nancy/6 W 20th St 2nd Fl ...212-924-9105
Brown, Owen Studio/224 W 29th St #PH212-947-9470
Brucker, Andrew/225 Central Park W ..212-724-3236
Bruderer, Rolf/435 E 65th St ..212-684-4890
Bruno Burklin/873 Broadway ...212-420-0208
Brunswick, Cecile/127 W 96th St ..212-222-2088
Bryan-Brown, Marc/4 Jones St #4 ..212-594-1360
Bryce, Sherman E/60 E 8th St #19D ...212-580-9639
Bryson, John/12 E 62nd St...212-755-1321
Bucci, Andrea/287 E 3rd St ...212-260-1939
Buceta, Jaime/56 W 22nd St 6th Fl ...212-807-8485
Buck, Bruce/39 W 14th St ..212-645-1022
Buck, Monica/200 W 15th St ..212-627-1976
Buckler, Susanne/344 W 38th St ...212-279-0043
Buckley, Dana/156 Waverly Pl ...212-206-1807

Buckmaster, Adrian/332 W 87th St ...212-799-7318
Buckner, Bill/131 W 21st St ...212-366-1859
Buhl Studio/114 Green St ..212-274-0100
Buonnano, Ray/237 W 26th St...212-675-7680
Buren, Jodi/466 Washington St ...212-925-2316
Burnie, Ellen Forbes/19 Hubert St ..212-219-1091
Burns, Tom/534 W 35th St ...212-927-4678
Burquez, Felizardo/15 W 28th St ...212-725-5490
Burris, Todd/211 E. 3rd St #2F ...212-254-7758
Buss, Gary/250 W 14th St ..212-645-0928
Butera, Augustus/300 Riverside Dr #11F212-864-7772
Butler, Robert/400 Lafayette St ...212-982-8051
Butts, Harvey/77 Fifth Ave #8B ...212-459-4689
Buzoianu, Peter/32-15 41st St, Long Island City718-278-2456
Byers, Bruce/11 W 20th St 5th Fl ...212-242-5846

C

Cacorius, Kathleen/250 W 57th St #1527-170............................212-316-9509
Cadge, Jeff/344 West 38th St #10B ..212-246-6155
Cailor/Resnick/237 W 54th St 4th Fl ..212-977-4300
Cal, Mario/31 W 21st St #5RW ...212-366-5047
Cali, Deborah/333 W 86th St ...212-873-8800
Callis, Chris/91 Fifth Ave (P 016,17) ..212-722-2522
Camera Communications/110 Greene St212-925-2722
Camp, E J (Ms)/20 E 10th St ...212-475-6267
Campbell, Barbara/138 W 17th St ...212-929-5620
Campbell, Kelly/954 Lexington Ave #231212-879-6170
Campos, John/411 W 14th St 2nd Fl (P 86,87)**212-675-0601**
Canady, Philip/1411 Second Ave ...212-737-3855
Cannon, Gregory/876 Broadway 2nd Fl.......................................212-228-3190
Cantor, Phil/75 Ninth Ave 8th Fl ...212-243-1143
Caplan, Skip/124 W 24th St ...212-463-0541
Cardacino, Michael/20 Ridge Rd, Douglaston212-947-9307
Carlson-Emberling Studio/9 E 19th St ..212-473-5130
Carr, E J/236 W 27th St 5th fl ..212-242-0818
Carroll, Robert/270 Park Ave S ...212-477-4593
Carron, Les/15 W 24th St 2nd Fl ...212-255-8250
Carson, Donald/115 W 23rd St ..212-807-8987
Carter, Dwight/120 W 97th St #14C ..212-932-1661
Casarola, Angelo/165 W 18th St 3rd Fl212-620-0620
Casey/10 Park Ave #3E ...212-684-1397
Cashin, Art/5 W 19th St ...212-255-3440
Cassill, Orin/243 East 78th St ..212-734-7289
Castelli, Charles/41 Union Sq W #425 ..212-620-5536
Caulfield, Patricia/115 W 86th St #2E ...212-362-1951
Cavanaugh, Ken/6803 Ft Hamilton Pkwy, Brooklyn718-745-6983
Caverly, Kat/504 W 48th St ..212-757-8388
Cearley, Guy/460 Grand St #10A ...212-979-2075
Celnick, Edward/36 E 12th St ..212-420-9326
Cementi, Joseph/133 W 19th St 3rd Fl ..212-924-7770
Cempa, Andrew/301 E 50th St #12 ..212-935-4787
Cenicola, Tony Studio/325 W 37th St 11th Fl212-695-0773
Chakmakjian, Paul/35 W 36th St 8th Fl212-563-3195
Chalfant, Todd/85 E 10th St #5C ...212-260-3726
Chalk, David/215 E 81st St...212-744-6005
Chalkin, Dennis/5 E 16th St ...212-929-1036
Chamberlain, Dean/106 E 19th St 10th fl....................................212-505-2374
Chan, John/225 E 49th St ..212-755-3816
Chan, Michael/22 E 21st St ..212-460-8030
Chaney, Scott/36 W 25th St 11th Fl...212-924-8440
Chanteau, Pierre/80 Warren St...212-227-4931
Chapman, Mike/543 Broadway 8th Fl..212-966-9542
Charles, Frederick/254 Park Ave S #7F212-505-0686
Charles, Lisa/119 W 23rd St #500 ..212-807-8600
Chauncy, Kim/123 W 13th St ...212-242-2400
Checani, Richard/333 Park Ave S...212-674-0608
Chelsea Photo/Graphics/641 Ave of Americas212-206-1780
Chen, Paul Inc/133 Fifth Ave..212-674-4100
Chernin, Bruce/330 W 86th St..212-496-0266
Chestnut, Richard/236 W 27th St ..212-255-1790
Chiba/303 Park Ave S #412 ...212-674-7575
Chin, Ted/9 W 31st St #7F ...212-947-3858
Chin, Walter/160 Fifth Ave #914 ...212-924-6760
Christensen, Paul H/286 Fifth Ave ..212-279-2838
Chrynwski, Walter/154 W 18th St ...212-675-1906
Cipolla, Karen/103 Reade St 3rd Fl ..212-619-6114
Cirone, Bettina/211 W 56th St #14K..212-262-3062

Clarke, Kevin/900 Broadway 9th Fl.................................212-460-9360
Claxton, William/108 W 18th St.....................................212-206-0737
Clayton, Tom/568 Broadway #601.................................212-431-3377
Clementi, Joseph Assoc/133 W 19th St 3rd Fl...............212-924-7770
Clough, Terry/147 W 25th St...212-255-3040
Coates, Joann/320 Central Park W #8M.........................212-362-2223
Cobb, Elijah/133 E 4th St..212-982-3743
Cobb, Jan/5 W 19th St 3rd Fl..212-255-1400
Cobin, Martin/145 E 49th St..212-758-5742
Cochnauer, Paul/1186 Broadway #833...........................212-532-9033
Cochran, George/381 Park Ave S....................................212-689-9054
Cohen, James/36 E 20th St 4th Fl..................................212-533-4400
Cohen, Lawrence Photo/247 W 30th St...........................212-967-4376
Cohen, Marc David/5 W 19th...212-741-0015
Cohen, Steve/37 W 20th St #304....................................212-727-3884
Cohn, Debra/421 E 80th St..212-472-6081
Cohn, Ric/137 W 25th St #1...212-924-4450
Colabella, Vincent/304 E 41st St (P 66) 212-949-7456
Coleman, Bruce/381 Fifth Ave 2nd Fl.............................212-683-5227
Coleman, Gene/250 W 27th St..212-691-4752
Colen, Corrine/519 Broadway...212-431-7425
Collin, Fran/295 Park Ave S...212-353-1267
Collins, Arlene/64 N Moore St #3E..................................212-431-9117
Collins, Benton/873 Broadway...212-254-7248
Collins, Chris/35 W 20th St..212-633-1670
Collins, Joe J/208 Garfield Pl, Brooklyn.........................718-965-4836
Collins, Ken/14 E 17th St...212-563-6025
Colliton, Paul/310 Greenwich St.....................................212-807-6192
Colombo, Michel/119 W 23rd St......................................212-727-9238
Colton, Robert/1700 York Ave...212-831-3953
Conn, John/1639 Plymouth Ave #2..................................212-931-9051
Contarsy, Ron/297 W 96th St...212-678-0660
Cook, Irvin/534 W 43rd St..212-925-6216
Cook, Rod/29 E 19th St..212-995-0100
Cooke, Colin/380 Lafayette St..212-254-5090
Cooper, Martha/310 Riverside Dr #805............................212-222-5146
Corbett, Jane/303 Park Ave S #512.................................212-505-1177
Corbo, Sal/18 E 18th St..212-242-3748
Cordoza, Tony/15 W 18th St...212-243-8441
Corman, Richard/385 West End Ave................................212-799-2395
Cornish, Dan/594 Broadway #1204..................................212-226-3183
Corporate Photographers Inc/45 John St.........................212-964-6515
Corti, George/10 W 33rd St...212-239-4490
Cosimo/43 W 13th St...212-206-1818
Costa, Herman/213 W 80th St...212-595-0309
Coupon, William/170 Mercer St.......................................212-941-5676
Couzens, Larry/16 E 17th St...212-620-9790
Cowley, Jay/225 E 82nd St...212-988-3893
Cox, David/25 Mercer St 3rd Fl.......................................212-925-0734
Cox, Rene/395 South End Ave..212-321-2749
Crampton, Nancy/35 W 9th St...212-254-1135
Crawford, Nelson/10 E 23rd St #600...............................212-673-9098
Cronin, Casey/115 Wooster St...212-334-9253
Crum, John R Photography/124 W 24th St......................212-463-8663
Cubillo, Enrique/85 Eighth Ave.......................................212-243-9601
Cuesta, Michael/37 W 20th St #606.................................212-929-5519
Cuington, Phyllis/36 W 25th St 11th Fl............................212-691-1901
Culberson, Earl/5 E 19th St #303....................................212-473-3366
Cunningham, Peter/53 Gansevoort St..............................212-633-1077
Curatola, Tony/18 E 17th St...212-243-5478
Cutler, Craig/39 Walker St..212-966-1652
Czaplinski, Czeslaw/90 Dupont St, Brooklyn...................718-389-9606

D

D'Addio, James/12 E 22nd St #10E.................................212-533-0668
D'Amico, John/3418 Ave "L", Brooklyn............................718-377-4246
D'Antonio, Nancy/303 W 92nd St....................................212-666-1107
D'Innocenzo, Paul/568 Broadway #604............................212-925-9622
Daley, James D/568 Broadway...212-925-7192
Daly, Jack/247 W 30th St...212-695-2726
Dantuono, Paul/433 Park Ave So....................................212-683-5778
Dantzic, Jerry/910 President St, Brooklyn........................718-789-7478
Dauman, Henri/4 E 88th St...212-860-3804
Davidian, Peter/144 W 23rd St..212-675-8077
Davidson, Bruce/79 Spring St...212-475-7600
Davidson, Cameron/24 W 30th St 8th Fl..........................212-679-5933
Davis, David Photo/477 W 143rd St #4C..........................212-234-9429

Davis, Dick/400 E 59th St..212-751-3276
Davis, Don/61 Horatio St...212-989-2820
Davis, Harold/2673 Broadway #107.................................212-316-5903
Dawes, Chris/666 Greenwich St......................................212-924-2255
Day, Lee/55 Hudson St...212-619-4117
De Olazabal, Eugenia/828 Fifth Ave...............................212-980-8075
Decanio, Steve/448 W 37th St #11C...............................212-594-0593
DeGrado, Drew/250 W 40th St 5th Fl..............................212-302-2760
DeLeon, Katrina/286 Fifth Ave #1206..............................212-279-2838
DeLeon, Martin/286 Fifth Ave #1206................................212-714-9777
DeLessio, Len/121 E 12th St #4F.....................................212-353-1774
DeMarchelier, Patrick/162 W 21st St...............................212-924-3561
DeMelo, Antonio/126 W 22nd St.....................................212-929-0507
DeMilt, Ronald/873 Broadway 2nd Fl...............................212-228-5321
Denker, Deborah/460 Greenwich St.................................212-219-9263
Denner, Manuel/249 W 29th St 4th Fl.............................212-947-6220
Dennis, Lisl/135 E 39th St..212-532-8226
DePra, Nancy/15 W 24th St..212-242-0252
Derr, Stephen/420 W 45th St 4th Fl................................212-246-5920
DeSanto, Thomas/116 W 29th St 2nd Fl.........................212-967-1390
Deutsch, Jack/48 W 21st St...212-633-1424
DeWys, Leo/1170 Broadway (P 354)212-689-5580
Di Chiaro, Dennis/46 W 37th St......................................212-268-9270
Dian, Russell/432 E 88th St #201....................................212-722-4348
Diaz, Jorge/596 Broadway..212-925-0102
Diaz/Schneider Studio /318 W 39th St.............................212-695-3620
Dick, David/138 W 25th St..212-633-1780
Dillon, Jim/39 W 38th St 12th Fl.....................................212-849-8158
DiMicco/Ferris Studio/40 W 17th St #2B..........................212-627-4074
DiVito, Michael/320 7th Ave #1, Brooklyn........................718-499-0640
Dodge, Jeff/133 Eighth Ave..212-620-9652
Doerzbacher, Cliff/12 Cottage Ave, Staten Island............718-981-3144
Doherty, Marie/43 E 22nd St...212-674-8767
Dole, Jody (Mr)/95 Horatio St..212-691-9888
Dorf, Myron Jay/205 W 19th St 3rd Fl (P 46,47)212-255-2020
Dorot, Didier/48 W 21st St 9th Fl....................................212-206-1608
Dorrance, Scott/3 W 18th St 7th Fl..................................212-675-5235
Dorris, Chuck/492 Broome St..212-334-9282
Doubilet, David/1040 Park Ave #6J..................................212-348-5011
Drabkin, Si Studios Inc/40-10 Littleneck Pkwy, Littleneck.......718-279-4512
Dressler, Marjory/4 E Second St......................................212-254-9758
Drew, Rue Faris/177 E 77th St...212-794-8994
Drivas, Joseph/15 Beacon Ave, Staten Island.................718-667-0696
Drollette, Dan/495 Ninth St #4, Brooklyn........................212-472-7453
Druse, Ken/105 Cambridge Pl, Brooklyn..........................718-230-0184
Dubler, Douglas/162 E 92nd St.......................................212-410-6300
Duchaine, Randy/70 Terrace Pl, Brooklyn........................718-243-4371
Ducote, Kimberly/445 W 19th St #7F...............................212-989-3680
Dugdale, John/59 Morton St..212-691-5264
Duke, Dana/620 Broadway..212-260-3334
Duke, Randy/2825 Grand Concourse, Bronx....................212-364-2584
Duke, William/155 Chambers St......................................212-285-2404
Dunas, Jeff/1181 Broadway...212-447-0666
Dunkley, Richard/648 Broadway #506..............................212-979-6996
Dunn, Phoebe/19 W 21st St #901....................................212-627-4060
Dunning, Hank/50 W 22nd St..212-675-6040
Dunning, Robert/57 W 58th St...212-688-0788
Duomo Photo Inc/133 W 19th St.....................................212-243-1150

E

Eagan, Timothy/319 E 75th St...212-969-8988
Eberle, Todd/54 W 21st St #901......................................212-243-2511
Eberstadt, Fred/791 Park Ave..212-794-9471
Eccles, Andrew/305 Second Ave.#346.............................212-725-4520
Eckerie, Tom/32 Union Sq E #707...................................212-677-3635
Eckstein, Ed/234 Fifth Ave 5th Fl....................................212-685-9342
Edahl, Edward/236 W 27th St..212-929-2002
Edinger, Claudio/456 Broome St......................................212-219-8619
Edwards, Harvey/420 E 54th St #21E..............................516-261-5239
Eggers, Claus/900 Broadway...212-473-0064
Eguiguren, Carlos/196 W Houston St...............................212-727-7550
Ehrenpreis, Dave/2 W 31st St #405.................................212-947-3535
Eisenberg, Steve/448 W 37th St......................................212-563-2061
Eisner, Sandra/873 Broadway 2nd Fl...............................212-727-0669
Ekmekji, Raffi/377 Park Ave S...212-696-5577
Elbers, Johan/18 E 18th St...212-929-5783
Elgar, Nick/160 W 16th St #5B..212-929-7572

Elgort, Arthur/136 Grand St	212-219-8775
Elios-Zunini Studio/142 W 4th St	212-228-6827
Ellman, Elaine/60 Grammercy Park	212-925-7151
Elmore, Steve/60 E 42nd St #411	212-472-2463
Elness, Jack/236 W 26th St	212-242-5045
Emberling, David/9 E 19th St	212-473-5130
Emerson, John/48 W 21st St 10th Fl	212-741-3818
Emil, Pamela/327 Central Park West	212-749-4716
Emrich, Bill/448 W 19th St Penthse A	212-889-7482
Endress, John Paul/254 W 31st St	212-736-7800
Enfield, Jill/211 E 18th St	212-777-3510
Engel, Mort Studio/260 Fifth Ave 4th Fl	212-769-6826
Englander, Maury/43 Fifth Ave	212-242-9777
Engle, Mort Studio/260 Fifth Ave	212-889-8466
Englehardt, Duk/80 Varick St #4E	212-226-6490
Englert, Michael/142 W 24th St	212-243-3446
Essel, Robert/39 W 71st St #A	212-877-5228
Estevez, Herman/480 Broadway	212-941-0330
Estrada, Sigrid/902 Broadway	212-673-4300
Ewing, Lee B/3111 Broadway #6K	212-864-2104
Exit Productions/180 Franklin St	212-925-8750

F

Falco, Rick/302 W 87th St #6F	212-874-7967
Famighetti, Thomas/40 W 24th St	212-255-8334
Farber, Enid/PO Box 1770/Church St Sta	212-451-6744
Farber, Robert/207-A 62nd St	212-486-9090
Faria, Rui/304 Eighth Ave #3	212-929-2993
Farrell, Bill/343 E 30th St #17C (P 93)	**212-683-1425**
Farwell, Linda/55 East End Ave	212-988-6015
Favero, Jean P/208 Fifth Ave #3E	212-683-9188
Feinstein, Gary/19 E 17th St	212-242-3373
Felder, Sharon/420 E 86th St	212-517-3938
Feldman, Simon/39 W 29th St 4th Fl (P 96)	**212-213-1397**
Fellerman, Stan/152 W 25th St	212-243-0027
Fellman, Sandi/548 Broadway	212-925-5187
Ferguson, Phoebe/289 Cumberland St, Brooklyn	718-643-1675
Ferich, Lorenz/516 E 78th St #D	212-517-6838
Ferorelli, Enrico/50 W 29th St	212-685-8181
Ferrante, Terry/555 Third Ave	212-683-7967
Ferrari, Maria/37 W 20th St #1207	212-924-1241
Ferri, Mark/463 Broome St	212-431-1356
Fery, Guy/31 W 21st St	212-255-4646
Feurer, Hans/160 Fifth Ave	212-924-6760
Fields, Bruce/71 Greene St	212-431-8852
Filari, Katrina/286 Fifth Ave	212-279-2838
Fineman, Dana/40 W 24th St	212-627-0631
Finkelman, Allan/118 E 28th St #608	212-684-3487
Finlay, Alastair/13-17 Laight St 5th Fl	212-334-8001
Finzi, Jerry Studio/36 W 20th St	212-255-2110
Firman, John/434 E 75th St	212-794-2794
Fischer, Carl/121 E 83rd St	212-794-0400
Fischer, Ken/121 E 83rd St	212-794-0400
Fisher, Jon/236 W 27th St 4th Fl (P 97)	**212-206-6311**
Fisher, Steven/233 W 99th St	212-666-0121
Fishman, Chuck/473 Broome St	212-941-8582
Fishman, Robert/340 E 74th St #4C	212-734-3537
Fitz, Mike/160 Fifth Ave #912	212-243-6995
Fiur, Lola Troy/360 E 65th St	212-861-1911
Flatow, Carl/20 E 30th St (P 99)	**212-683-8688**
Fleischer, Francine/271 Mulberry St	212-431-3133
Floret, Evelyn/3 E 80th St	212-472-3179
Floyd, Bob/PO Box 216	212-684-0795
Flying Camera/114 Fulton St	212-619-0808
Flynn, Matt/99 W 27th St	212-627-2985
Flynn, Richard/306 W 4th St	212-243-0834
Fogliani, Tom/84 Thomas St 5th Fl	212-766-8809
Forastieri, Marili/426 W Broadway #6G	212-431-1840
Ford, Carol/236 W 27th St	212-627-2627
Ford, Charles/32 E 22nd St	212-460-5320
Forelli, Chip/529 W 42nd St #3R	212-564-1835
Fornuff, Doug/323 Park Ave South	212-529-4440
Forrest, Bob/273 Fifth Ave 3rd Fl	212-288-4458
Foto Shuttle Japan/47 Greene St	212-966-9641
Foulke, Douglas/140 W 22nd St	212-243-0822
Fox, Howard/12 E 86th St #1522	212-517-3700
Fox, Jeffrey/6 W 20th St	212-620-0147

Foxx, Stephanie/36 Horatio St #4B	212-242-3842
Frailey, Stephen/11 Charlton St	212-741-2630
Frajndlich, Abe/30 E 20th St #605	212-995-8648
Frame, Bob/225 Lafayette #503	212-431-6707
Frampton, Jerald/23-25 Astoria Blvd, Long Island City	718-726-1373
Francais, Isabelle/873 Broadway	212-678-7508
Francekevich, Al/73 Fifth Ave (P 100,101)	**212-691-7456**
Frances, Scott/175 Fifth Ave #2401	212-529-6642
Francisco, Gus/220 E 23rd St	212-683-0418
Francki, Joe/420 E 54th St #21E	212-838-3170
Frank, Dick/11 W 25th St	212-242-4648
Fraser, Douglas Photo/9 E 19th St	212-777-8404
Fraser, Rob/211 Thompson St #1E	212-677-4589
Frazier, David/7 Second Ave	212-459-4491
Fredericks, Bill/124 W 24th St #6B	212-463-0955
Freed, Leonard/79 Spring St	212-966-9200
Freeman, Don/457 Broome St	212-941-6727
Freidman, Lee/76 E 1st St	212-529-4544
Freithof, Wolfgang/628 Broadway #401	212-274-8300
Freni, Al/381 Park Ave S #809	212-679-2533
Friedman, Benno/26 W 20th St	212-255-6038
Friedman, Jerry/873 Broadway	212-505-5600
Friedman, Lee/251 W 19th St	212-929-0103
Friedman, Steve/545 W 111th St	212-864-2662
Froomer, Brett/7 E 20th St	212-533-3113
Fruitman, Sheva/28 Grove St	212-727-9829
Fuchs, Rafael/410 E 13th St	212-529-0518
Funk, Mitchell/500 E 77th St (P 102,103)	**212-988-2886**
Furones, Claude Emile/40 Waterside Plaza	212-683-0622
Fusco, Paul/79 Spring St	212-966-9200

G

Gaffney, Joe/118 E 93rd St #5A	212-534-3985
Galante, Dennis/133 W 22nd St 3rd Fl	212-463-0938
Galante, Jim/678 Broadway	212-529-4300
Galipo, Frank/257 Park Ave S 9th Fl	212-995-8720
Gall, Sally/266 W 11th St	212-242-1458
Gallucci, Ed/568 Broadway #602	212-226-2215
Galton, Beth/230 W 26th St	212-242-2266
Gamba, Mark/115 W 23rd St #31	212-727-8313
Ganges, Halley/245 W 29th St 7th Fl	212-868-1810
Gardiner, Lynton/11 W 30th St #7R	212-629-3001
Garg, Arvind/116 W 72nd St #5E	212-595-8051
Garik, Alice/ Photo Comm/173 Windsor Pl, Brooklyn	718-499-1456
Garn, Andrew/85 E 10th St #5D	212-353-8434
Geaney, Tim/648 Broadway #1009	212-677-7913
Geller, Bonnie/57 W 93rd St	212-864-5922
Gelsobello, Paul/245 W 29th St #1200	212-947-0317
Generico, Tony/130 W 25th St (P 104)	**212-627-9755**
Gentieu, Penny/87 Barrow St	212-691-1994
George, Michael/525 Hudson St	212-627-5868
Gershman, Neil/135 W 29th St	212-629-5877
Gerstein, Jesse/249 W 29th St	212-629-4688
Gescheidt, Alfred/175 Lexington Ave	212-889-4023
Getlen, David/60 Gramercy Park	212-475-6940
Ghergo, Christina/160 Fifth Ave #817	212-243-6811
Gibbons, George/292 City Islnd Ave, Bronx	212-885-0769
Gigli, Ormond/327 E 58th St	212-758-2860
Gilbert, Gil/29 E 22nd St	212 254-3096
Gilbert, Thom/438 W 37th St	212-563-3219
Gillardin, Andre/6 W 20th St	212-675-2950
Giordano, John A/60 E 9th St #538	212-477-3273
Giovanni, Raeanne/311 E 12 th St	212-673-7199
Giraldo, Anita/83 Canal #611	212-431-1193
Givotovsky, Andrei/105 E 10th St	212-777-8028
Gladstone, Gary/237 E 20th St #2H	212-777-7772
Glancz, Jeff/822 Greenwich St #2A	212-741-2504
Glassman, Keith/365 First Ave 2nd Fl (P 67)	**212-353-1214**
Glaviano, Marco/21 E 4th St	212-529-9080
Glinn, Burt/41 Central Park W	212-877-2210
Globus Brothers/44 W 24th St	212-243-1008
Gloos, Conrad/155 W 68th St	212-724-1536
Goble, Brian/80 Varick St #6A	212-268-1788
Godlewski, Stan/1317 Laight St	212-941-1230
Goff, Lee/32 E 64th St	212-223-0716
Gold, Bernie/873 Broadway #301	212-677-0311
Gold, Charles/56 W 22nd St	212-242-2600

Goldberg, Les/147 W 22nd St ...212-242-3825
Goldman, Michael/177 Hudson St ..212-966-4997
Goldman, Richard/36 W 20th St ...212-675-3033
Goldman, Susan/380 Lafayette St 5th Fl212-674-8298
Goldring, Barry/568 Broadway #608212-334-9494
Goldsmith, Lynn/241 W 36th St ...212-736-4602
Goldstein, Art/66 Crosby St ..212-966-2682
Goll, Charles R/404 E 83rd St ..212-628-4881
Golob, Stanford/10 Waterside Plaza212-532-7166
Goltz, Jason/16 First Ave ...212-677-0929
Gonzalez, Luis/85 Livingston St, Brooklyn718-834-0426
Goodman, Michael/71 W 23rd St 3rd Fl212-727-1760
Gordon, Andrew/48 W 22nd St ...212-807-9758
Gordon, Anthony/155 Wooster St ...212-529-3711
Gordon, Joel/112 Fourth Ave 4th Fl212-254-1688
Gordon, T S/153 W 18th St ..212-978-4056
Gorin, Bart/126 11th St 5th Fl ..212-727-7344
Gotman, John/111 W 24th St ...212-255-0569
Gottfried, Arlene/523 E 14th St ..212-260-2599
Gottlieb, Audrey/34-32 33rd St, Long Island City718-706-7556
Gottlieb, Dennis/137 W 25th St ..212-620-7050
Gould, Jeff/98-41 64th Rd, Rego Park718-897-0610
Gove, Geoffrey/117 Waverly Pl ..212-260-6051
Gozo Studio/40 W 17th St ..212-620-8115
Graff, Randolph/160 Bleecker St ..212-254-0412
Graflin, Liz/111 Fifth Ave 12th Fl ..212-529-6700
Grant, Joe/447 W 36th St 6th Fl ...212-947-6807
Grant, Robert/62 Greene St (P 52,53)**212-925-1121**
Graves, Tom/136 E 36th St ...212-683-0241
Gray, Darren R/60 W 13th St #13C212-886-1833
Gray, Katie/1160 5th Avenue ...212-868-0078
Gray, Katie/1160 Fifth Ave ..212-868-0078
Gray, Robert/160 West End Ave ..212-721-3240
Green-Armytage, Stephen/171 W 57th St #7A
(P 106,107) ..**212-247-6314**
Greenberg, David/54 King St ...212-316-9196
Greenberg, Joel/265 Water St ...212-285-0979
Greene, Jim/20 W 20th St #703 ..212-741-3764
Greene, Joshua/448 W 37th St #8D212-243-2750
Greene, Richard Photo/56 W 22nd St212-242-5282
Greenfield, Lois/52 White St ...212-925-1117
Greenfield-Sanders, Timothy/135 E 2nd St212-674-7888
Greenwald, Seth/195 Adams St, Brooklyn718-802-1531
Gregoire, Peter/448 W 37th St ..212-967-4969
Gregory, John/39 E 19th St 6th Fl ...518-794-8365
Gregory, Kevin/237 W 26th St ...212-807-9859
Greyshock, Caroline/578 Broadway #707212-266-7563
Griffiths, Philip Jones/79 Spring St212-966-9200
Grill, Tom/30 Irving Place ...212-353-8600
Grimes, Tom/930 Columbus Ave ..212-316-3741
Grinaldi, Michael/45 Tudor City Pl #1410212-599-1266
Groen, Michael/119 W 23rd St #1002212-929-1620
Gross, David/922 Third Ave #3R ...212-688-4729
Gross, Garry/235 W 4th St ...212-807-7141
Gross, Geoffrey/40 W 27th St 12th Fl212-685-8850
Gross, Pat/315 E 86th St #1S East212-427-9396
Grossman, David/211 E 7th St, Brooklyn718-438-5021
Grossman, Eugene/310 Greenwich St #22H212-962-6795
Grossman, Henry/37 Riverside Dr ...212-580-7751
Grotell, Al/170 Park Row #15D ...212-349-3165
Gruen, John/20 W 22nd St ...212-242-8415
Guatti, Albano/250 Mercer St #C403212-674-2230
Gudnason, Torkil/58 W 15th St ..212-929-6680
Guice, Brad Studio/232 W Broadway 2nd Fl212-206-0966
Gumpel, Roy/10 Bank St ...212-206-8602
Gurney, Manning/25 W 38th St 3rd Fl212-391-0965
Gurovitz, Judy/207 E 74th St ...212-988-8685
Guyaux, Jean-Marie/29 E 19th St ...212-529-5395
Guzman/31 W 31st St ...212-643-9375

H

Haar, Thomas/463 West St ...212-929-9054
Haas, Ken Inc/15 Sheridan Square212-255-0707
Haber, Graham/344 W 38th St ..212-268-4148
Hagen, Boyd/448 W 37th St #6A ..212-244-2436
Haggerty, David/17 E 67th St ..212-879-4141
Hagiwara, Brian/504 La Guardia Pl212-674-6026

Haimann, Todd/26 W 38th St ..212-391-0810
Halaska, Jan/PO Box 6611 FDR Sta718-389-8923
Haling, George/130 W 25th St ..212-989-8819
Hall, Barnaby/347 W 36th St #17PH212-967-2912
Hamilton, Joe/15-22 Central Ave, Far Rockaway718-868-4501
Hamilton, Keith/749 FDR Dr #6D ..212-982-3375
Hamilton, Mark/119 W 23rd St ...212-242-9814
Hammond, Francis/24 Wycoff St, Brooklyn718-935-9038
Hammond, Maury/9 E 19th St ...212-460-9990
Hampton Studios/515 Broadway #4A212-431-4320
Hamsley, David/47 W 90th St ...212-580-8667
Handelman, Dorothy/10 Gay St ..212-242-3058
Hansen, Barbara/2278 Bronx Park East #F13, Bronx212-798-6013
Hansen, Constance/31 W 31st St 9th Fl212-643-9375
Hanson, Kent/147 Bleecker St #3R212-777-2399
Harbutt, Charles/1 Fifth Ave ...212-645-4274
Hardin, Ted/454 W 46th St #5A-N ...212-307-6208
Harrington, Grace/312 W 48th St ..212-246-1749
Harris, Jeff/45 White St 2nd Fl ...212-334-0125
Harris, Michael/18 W 21st St ..212-255-3377
Harris, Ronald G/119 W 22nd St (P 110,111)**212-255-2330**
Harrison, Howard/150 W 22nd St 2nd Fl212-989-9233
Hartmann, Erich/79 Spring St ...212-966-9200
Haruo/126 W 22nd St 6th Fl Rear ...212-505-8800
Harvey, Ned/164 W 25th St 11th fl ..212-807-7043
Hashi Studio/49 W 23rd St 3rd Fl ...212-675-6902
Hashimoto/153 W 27th St #1202 ..212-645-1221
Hathon, Elizabeth/8 Greene St ..212-219-0685
Hausman, George/1181 Broadway 6th Fl212-686-4810
Hautzig, David/209 E 25th St #2F ..212-779-1595
Haviland, Brian/34 E 30th St 4th Fl212-481-4132
Hayward, Bill/21 E 22nd St ...212-979-7352
Hecker, David/568 Broadway ..212-925-1233
Heiberg, Milton/71 W 23rd St 5th Fl212-741-6405
Heinlein, David/56 W 22nd St ...212-645-1158
Heir, Stewart/30 W 22nd St 5th Fl East212-633-2187
Heisler, Gregory/568 Broadway #800212-777-8100
Heitner, Marty/299 West 12th Street212-645-8056
Helburn, Bill/161 E 35th St ...212-683-4980
Hellerman, William/31 Linden St, Brooklyn718-443-2611
Hellerstein, Stephen A/56 W 22nd St 12th Fl212-645-0508
Helms, Bill/1175 York Ave ...212-759-2079
Hemsay, Yvonne/4520 Henry Hudson Pkwy, Riverdale212-549-0095
Henze, Don Studio/39 W 29th St 4th Fl212-689-7375
Heron, Michal (Ms)/28 W 71st St ..212-787-1272
Herr, H Buff/56 W 82nd St ..212-595-4783
Hess, Brad/5 W 29th St 9th fl ...212-684-3131
Heuberger, William/140 W 22nd St212-242-1532
Heyert, Elizabeth/251 W 30th St #12AW212-594-1008
Heyman, Ken Photo/2 Charlton St ...212-366-5555
Hilaire, Max/218 E 27th St ..212-889-1685
Hill, Mark/119 W 23rd St #1003 ..212-727-1528
Hill, Pat/37 W 26th St ...212-532-3479
Hill, Steve/220 E 25th St #4D ...212-683-1642
Hill, Timothy/336 Clinton Ave, Brooklyn718-783-3896
Himmel, Lizzie/218 E 17th St ..212-777-6482
Hine, Skip/117 E 24th St #4B ...212-529-6100
Hing/Norton Photography/24 W 30th St 8th Fl212-683-4258
Hiro/50 Central Park West ...212-580-8000
HII, Timothy/336 Clinton Ave, Brooklyn718-783-3896
Hochman, Allen Studio/9-11 E 19 St212-777-8404
Hochman, Richard/210 Fifth Ave ..212 532-7766
Hodgson, David/550 Riverside Dr ..212-864-6941
Holbrooke, Andrew/50 W 29th St ..212-889-5995
Holderer, John/37 W 20th St #606 ..212-620-4260
Holdorf, Thomas/132 W 22 St 3rd Fl212-727-7981
Holland, Robin/430 Greenwich St ...212-431-5351
Hollyman, Stephanie/85 South St ..212-825-1828
Hollyman, Tom/300 E 40th St #19R212-867-2383
Holub, Ed/83 Canal St #309 ...212-431-2356
Holz, George/400 Lafayette ..212-505-5607
Hom, Frank/601 W 26th St #13A ...212-979-5533
Hooper, Thomas/126 Fifth Ave #5B212-691-0122
Hopkins, Douglas/PO Box 185 ..212-243-1774
Hopkins, Stephan/475 Carlton Ave, Brooklyn718-783-6461
Hopson, Gareth/22 E 21st St ..212-535-3800
Hori, Richard/111 W 19th St #2G ..212-645-8333
Horowitz, Ross M/206 W 15th St ..212-206-9216

Horowitz, Ryszard/137 W 25th St.....................................212-243-6440
Horst/188 E 64th St #1701...212-751-4937
Horvath, Jim/95 Charles St..212-741-0300
Houze, Philippe Louis/123 Prince St.................................212-226-9299
Howell, Josephine/127 Pacific St, Brooklyn..........................718-858-2451
Hoyt, Wolfgang/18 W 27th St...212-686-2569
Huang, Ken/287 Avenue C...212-982-6976
Huibregtse, Jim/54 Greene St..212-925-3351
Hume, Adam/231 E 76th St Box 30.....................................212-794-1754
Huntzinger, Bob/76 Ninth Ave..212-929-9001
Hurwitz, Harrison/14 Horatio St #2E.................................212-989-4113
Huston, Larry/40 E 21st St..212 777-7541
Huszar, Steven/377 Park Ave South...................................212-532-3772
Hyman, Barry/319 E 78th St #3C......................................212-879-3294
Hyman, Paul/124 W 79th St...212-255-1532

I

Ian, Michael/214 W 30th St 11th Fl..................................212-947-0583
Iannuzzi, Tom/141 Wooster St #6A....................................212-563-1987
Icaza, Iraida/412 E 50th St...212-688-8137
Ichi/303 Park Ave S #506..212-254-4810
Ihara/568 Broadway #507...212-219-9363
Ikeda, Shig/636 Sixth Ave #4C.......................................212-924-4744
Image Makers/310 E 23rd St #9F......................................212-533-4498
Imperatori, Gabriella/438 Broome St.................................212-941-0010
Ing, Francis/112 W 31st St 5th Fl...................................212-279-5022
Intrater, Roberta/1212 Beverly Rd, Brooklyn.........................718-462-4004
Iooss, Walter/4730 Independence Ave, Riverdale......................212-601-3232
Irwin, William/70 Remsen St #9B, Brooklyn...........................718-237-2598
Isaacs, Norman/277 W 11th St..212-243-5547
Ishimuro, Eisuke/130 W 25th St 10th Fl..............................212-255-9198
Ivany, Sandra/6 W 90th St #6..212-580-1501
Ivy, Lawrence/504 E 54th St...212-475-6696
Izu, Kenro/140 W 22nd St..212-254-1002

J

J & M Studio/107 W 25th St #3A......................................212-627-5460
Jackson, Martin/217 E 85th St #110..................................215-271-5149
Jacobs, Marty/59 W 19th St #2A......................................212-206-0941
Jacobs, Robert/448 W 37th St..212-967-6883
Jacobson, Eric/39 W 29th St 4th Fl (P 114,115)............212-696-4279
Jacobson, Jeff/230 Hamilton Ave, Staten Island......................718-720-0533
James, Don/PO Box 901, Brooklyn.....................................718-797-9850
Jawitz, Louis H/13 E 17th St #PH....................................212-929-0008
Jeffery, Richard/119 W 22nd St......................................212-255-2330
Jeffrey, Lance/30 E 21st St #4A.....................................212-674-0595
Jenssen, Buddy/34 E 29th St...212-686-0865
Joern, James/125 Fifth Ave..212-260-8025
Joester, Steve/27 W 20th St #405....................................212-645-1766
Johansky, Peter/152 W 25th St 7th Fl................................212-242-7013
Jones, Carolyn/167 Spring St..212-431-9696
Jones, Chris/240 E 27th St..212-685-0679
Jones, Spencer/23 Leonard St #5 (P 34).................212-941-8165
Jones, Steve Photo/120 W 25th St #3E................................212-929-3641
Jordon, Steve/116 W 72nd St...212-724-7309
Joseph, Meryl/158 E 82nd St...212-861-5057
Jouany, Christophe/19 Bond St.......................................212-477-3138
Juario, Rolf/160 Fifth Avenue.......................................212-633-0105

K

Kahan, Eric/36 W 20th St 3rd Fl.....................................212-243-9727
Kahlil, Sean/200 E 37th St 4th Fl...................................212-686-5084
Kahn, R T/156 E 79th St...212-988-1423
Kalinsky, George/2 Pennsylvania Plaza 14th Fl.......................212-465-6741
Kalleberg, Garrett/520 E 5th St #2B.................................212-674-2716
**Kamper, George Productions Ltd/15 W 24th St
(P 116,117)...212-627-7171**
Kamsler, Leonard/140 Seventh Ave....................................212-242-4678
Kan Photography/153 W 27th St #406..................................212-645-2684
Kana, Titus/876 Broadway..212-473-5550
Kanakis, Michael/144 W 27th St 10th Fl..............................212-807-8232
Kane, Art/568 Broadway..212-925-7334
Kane, Peter T/236 W 26th St #502....................................212-924-4968
Kaniklidis, James/1270 E 18th St, Brooklyn..........................718-338-0931
Kaplan, Alan/7 E 20th St..212-982-9500

Kaplan, Michael/171 W 23d St #3A....................................212-741-3271
Kaplan, Peter B/7 E 20th St #4R.....................................212-995-5000
Kaplan, Peter J/924 West End Ave....................................212-749-1193
Karales, James H/147 W 79th St......................................212-799-2483
Karia, Bhupendra/9 E 96th St #15B...................................212-860-5479
Kasten, Barbara/251 W 19th St #8C...................................212 627-5229
Kasterine, Dmitri/237 Lafayette St..................................212-226-0401
Katchian, Sonia/44 W 54th St..212-586-5304
Katrina/286 Fifth Ave #1206...212-279-2838
Katvan, Moshe/40 W 17th St (P 18,19)...............212-242-4895
Katz, Paul/65-61 Saunders St #1L, Queens............................718-275-3615
Katzenstein, David/21 E 4th St......................................212-529-9460
Kaufman, Curt/215 W 88th St...212-873-9841
Kaufman, Elliott/255 W 90th St......................................212-496-0860
Kaufman, Jeff/27 W 24th St..212-627-1878
Kaufman, Mickey/144 W 27th St.......................................212-255-1976
Kaufman, Ted/121 Madison Ave #4E....................................212-685-0349
Kawachi, Yutaka/33 W 17th St 2nd Fl.................................212-929-4825
Kaye, Nancy/77 Seventh Ave #7U......................................818-886-1180
Kayser, Alex/211 W Broadway...212-431-8518
Keeve, Douglas/50 Ave A...212-777-5405
Keller, Tom/440 E 78th St...212-472-3693
Kellerhals, Michael/265 W 37th St #2102.............................212-382-2593
Kelley, Charles W Jr/649 Second Ave #6C-30..........................212-686-3879
Kelley, David/265 W 37th St #23E....................................212-869-7896
Kellner, Jeff/16 Waverly Pl...212-475-3719
Kelly, Bill/140 Seventh Ave...212-989-2794
Kennedy, Donald J/521 W 23rd St 10th Fl.............................212-643-0609
Kent, Karen/29 John St..212-962-6793
Kent, Mary/358 Seventh Ave 4th Fl...................................212-563-0261
Kerbs, Ken/100 Dean St #1, Brooklyn.................................718-858-6950
Keyser, James/630 Hudson St...212-243-6405
Khornak, Lucille/425 E 58th St......................................212-593-0933
Kilkelly, James/40 W 73rd St #2R....................................212-873-6820
King, Wm Douglas/1766 E 32nd St, Brooklyn...........................718-998-8351
Kinmonth, Rob/3 Rutherford Pl.......................................212-475-6370
Kintzing, Chuck/596 Broadway, 10th fl...............................212-941-8445
Kirk, Barbara/447 E 65th St...212-734-3233
Kirk, Charles/276 Winchester Ave, Staten Island.....................212-677-3770
Kirk, Malcolm/12 E 72nd St..212-744-3642
Kirk, Russell/31 W 21st St..212-206-1446
Kitchen, Dennis/80 Fourth Ave 3rd fl................................212-674-7658
Kittle, Kit/27 W 20th St #1100......................................212-243-1300
Klauss, Cheryl/463 Broome St..212-431-3569
Klein, Arthur/35-42 80th St, Jackson Heights........................718-278-0457
Klein, Matthew/104 W 17th St #2E....................................212-255-6400
Knopf, Gunther..212-740-1496
Kohli, Eddy/160 Fifth Ave #914......................................212-924-6760
Kojima, Tak/25 W 23rd St 2nd Fl.....................................212-243-2243
Kolansky, Palma/55 Vandam St #15....................................212-727-7300
Konstantin Photography/306 W 57th St................................212-765-8973
Kopelow, Paul/135 Madison Ave 14th Fl...............................212-689-0685
Kopin, Therese/228 E 25th St..212-684-2636
Kopitchinski, Reuven/98 Riverside Dr (P 119)...............212-724-1252
Korsh, Ken/118 E 28th St..212-685-8864
Kosoff, Brian/28 W 25th St 6th Fl...................................212-243-4880
Koudis, Nick/40 E 23rd St 2nd Fl....................................212-475-2802
Kouirinis, Bill/381 Park Ave S #710.................................212-696-5674
Kovner, Richard/80 East End Ave #10A................................212-775-7989
Kozan, Dan/108 E 16th St..212-979-5400
Kozyra, James/568 Broadway..212-431-1911
Kramer, Daniel/110 W 86th St..212-873-7777
Kramer, Nathaniel/730 Park Ave......................................212-737-6098
Krasner/Trebitz/PO Box 1548 Cooper Sta..............................212-777-2132
Kratochvil, Antonin/448 W 37th St #6G...............................212-947-1589
Kraus, Brian/126 W 22nd St..212-691-1813
Krein, Jeffrey/119 W 23rd St #800...................................212-741-5207
Krementz, Jill/228 E 48th St..212-688-0480
Kremer, Warren/2 Park Avenue..212-686-2914
Krinke, Michael/107 W 25th St #3A...................................212-627-5460
Kroll, Eric/118 E 28th St #1005.....................................212-684-2465
Kron, Dan/154 W 18th St...212-463-9333
Krongard, Steve/466 Washington St #1W...............................212-334-1001
Kuczera, Mike/20 W 22nd St #817.....................................212-620-8112
Kudo/39 Walker St...212-473-2892
Kuehn, Karen/49 Warren St...212-406-3005
Kugler, Dennis/43 Bond St...212-677-3826
Kuhn, Ann Spanos/107 W 86th St......................................212-595-7611

Kung, Yat Fae/55 Bayard St #11212-349-2123
Kunze, George/601 Tenth Ave212-268-4456

L

LaChappelle, David/613 E 6th St #4A212-529-7020
Lachenauer, Paul/876 Broadway212-529-7059
Lacombe, Brigitte/30 E 81st St212-472-9660
Lacy, John/24746 Rensselaer, Oak Park, MI313-548-3842
Lafontaine, Marie Josee/160 Fifth Ave #914212-924-6760
LaMoglia, Anthony/63 Eighth Ave #3B, Brooklyn ...718-636-9839
LaMonica, Chuck/20 Mountain Ave, New Rochelle ...212-727-7884
Lane, Morris/212-A E 26th St212-696-0498
Lang, Rob/243 West End Ave #1612212-595-2217
Lange, George/817 West End Ave212-666-1414
Lange, Paul/157 Chambers St212-513-1400
Lange-Kelly, Gordon/2813 Astoria Blvd, Astoria ...718-956-3619
Langley, David/536 W 50th St212-581-3930
Lanting, Ted/61 Horatio St212-206-1263
Laperruque, Scott/157 Chambers St 12th Fl212-962-5200
Larrain, Gilles/95 Grand St (P 30, 31)212-925-8494
Larson, Susan/56 W 22nd St212-929-8980
Laszlo Studio/11 W 30th St 2nd fl212-736-6690
Lategan, Barry/502 LaGuardia Pl212-228-6850
Lattabzio, James/2520 42nd St, Long Island City ...212-905-7001
Lattari, Tony/448 W 37th St #7A212-947-7488
Laubmayer, Klaus/874 Broadway #1001212-598-4066
Laurance, Bruce Studio/253 W 28th St 5th Fl212-947-3451
Laure, Jason/8 W 13th St 11th Fl212-691-7466
Laurence, Mary/PO Box 1763212-903-4025
Lavoie, Raymond/1371 First Ave #1R212-472-7596
Lawrence, Christopher/12 E 18th St212-807-8028
Lawrence, David/160 Ave of Americas 2nd Fl212-274-0710
Lax, Ken/239 Park Ave S212-228-6191
Layman, Alex/142 W 14th St 6th Fl212-989-5845
Lazar, Dov/240 E 25th St #22212-213-6140
Le Duc, Grant/41 E 7th St #22212-869-3050
LeBaube, Guy/310 E 46th St212-986-6981
Ledbetter, Anthony Rush/333 E 14th St #11K212-533-5949
Lederman, Ed/166 E 34th St #12H212-685-8612
LeDuc, Grant/41 E 7th St #22212-869-3050
Leduc, Lyle/320 E 42nd St #1014212-697-9216
Ledzian, Mark/245 W 29th St212-563-4589
Lee, Jung (Ms)/132 W 21st St 3rd Fl212-807-8107
Lee, Vincent/155 Wooster St #3F212-254-7888
Lee, Wellington/381 Park Ave S #617212-696-0800
Lefkowitz, Jay Alan/5 E 16th St212-929-1036
Legrand, Michel/152 W 25th St 12th Fl (P 122) ...212-807-9754
Lehman, Amy/210 E 75th St212-535-7457
Leibovitz, Annie/55 Vandam St 14th Fl212-807-0220
Leicmon, John/200 W 15th St212-675-3219
Leighton, Thomas/321 E 43rd St PH #12 (P 123) ...212-370-1835
Lein, Kevin/83 Leonard St 3rd Fl212-966-2764
Lenaas, John/27 W 76th St212-799-4379
Lenore, Dan/480 Broadway212-274-8650
Leo, Donato/866 Ave of Americas212-685-5527
Leonian, Phillip/220 E 23rd St212-989-7670
Lesinski, Martin/40 W 17th St #2B212-463-7857
Lesnick, Steve/27 W 24th St 10th Fl212-929-1078
Leung, J Ming/60 Pineapple St #6B, Brooklyn718-522-1894
Leven, Barbara/48 W 21st St 12th fl212-645-4828
Levin, James/165 W 66th St212-734-0315
Levine, Jonathan/366 Broadway212-791-7578
Levinson, Ken/35 East 10th St212-254-6180
Levy, Peter/119 W 22nd St212-691-6600
Levy, Richard/5 W 19th St212-243-4220
Lewin, Gideon/25 W 39th St212-921-5558
Lewin, Ralph/156 W 74th St212-580-0482
Lewis, Robert/333 Park Ave S 4th Fl212-475-6564
Liebman, Phil/315 Hudson212-269-7777
Lindner, Steven/18 W 27th St 3rd Fl212-683-1317
Lippman, Marcia/220 E 63rd St212-832-0321
Lisi-Hoeltzell Ltd/156 Fifth Ave212-255-0303
Little, Christopher/4 W 22nd St212-691-1024
Lloyd, Harvey/310 E 23rd St212-533-4498
Lock, Al/438 Broome St #1N212-886-1851
Loete, Mark/33 Gold St #405212-571-2235
Loew, Anthony/503 Broadway212-226-1999

Logan, Kevin/119 W 23rd St #803212-206-0539
Lois, Luke/594 Broadway #1106 (P 68)212-925-4501
Lombardi, Frederick/180 Pinehurst Ave212-568-0740
Lomeo, Angelo/336 Central Park W212-663-2122
Lonninge, Lars/121 W 19th St212-627-0100
Loomis, Just/160 Fifth Ave #914212-924-6760
Loppacher, Peter/39 Jane St212-929-1322
Lorenz, Robert/80 Fourth Ave212-505-8483
Louise, Stephanie/160 Fifth Ave #914212-924-6760
Love, Robin/676 Broadway 4th Fl212-777-3113
Lowe, Jacques/138 Duane St212-227-3298
Lubianitsky, Leonid/1013 Ave of Americas212-391-0197
Ludwig, Gerd/40 W 24th St212-627-5356
Luftig, Allan/873 Broadway212-533-4113
Lulow, William/126 W 22nd St212-675-1625
Lund, Birgitte/55 Morton St212-206-7784
Lupino, Stephan/543 Broadway #4212-334-6474
Luppino, Michael/126 W 22nd St 6th Fl212-633-9486
Lyon, Mark/145 W 58th St (P 63)212-333-2631
Lyon, Preston/39 White St212-226-0619
Lypides, Chris/119 W 23rd St212-741-1911

M

Maas, Rita/40 W 27th St 12th fl212-447-0410
Maass, Rob/166 E 7th St212-473-5612
Macdonald, Keith (MKM Studios)/144 E 22nd St ...212-979-9640
Macedonia, Carmine/866 Ave of Americas212-889-8520
Mackiewicz, Jim/160 Fifth Ave #908212-989-8438
MacLaren, Mark/430 E 20th St212-674-0155
MacWeeney, Alen Inc/171 First Ave212-473-2500
Madere, John/75 Spring St 5th Fl212-966-4136
Magni, Tiziano/145 E 36th St #2212-481-3860
Mahdavian, Daniel/PO Box 1850 Canal St Sta212-226-6265
Maisel, David/16 E 23rd St 3rd Fl (P 15)212-228-2288
Maisel, Jay/190 Bowery212-431-5013
Malignon, Jacques/34 W 28th St212-532-7727
Maloof, Karen/110 W 94th St #4C212-678-7737
Mandarino, Tony/114 E 32nd St212-686-2866
Manella, Robert/132 W 21st St212-645-6419
Mangia, Tony/11 E 32nd St #3B212-889-6340
Manna, Lou/347 E 53rd St #6D212-683-8689
Manno, John/20 W 22nd St #802212-243-7353
Maraschiello, Frank/325 E 83rd St212-879-0894
Marco, Phil/104 Fifth Ave 4th Fl212-929-8082
Marcus, Barry/23 Second Ave212-420-9443
Marcus, Helen/120 E 75th St212-879-6903
Maresca, Frank/236 W 26th St212-620-0955
Margerin, Bill/41 W 25th St212-645-1532
Marshall, Elizabeth/200 Central Pk S #31A212-463-7884
Marshall, Jim Studio/20 Jay St, Brooklyn718-797-9449
Marshall, Lee/201 W 89th St212-799-9717
Martin, Bard/142 W 26th St212-929-6712
Martin, Dennis/175 Fifth Ave #2538212-260-3750
Martin, Gene/157 E 72nd St #10A212-861-0811
Martin, Gregg/169 Columbia Hts, Brooklyn718-522-3237
Martinez, Oscar/303 Park Ave S #408212-673-0932
Marvullo Photomontage/141 W 28th St #502212-564-6501
Marx, Richard/130 W 25th St212-929-8880
Masca/109 W 26th St212-929-4818
Mason, Donald/111 W 19th St #2E212-675-3809
Massey, David/5 E 19th St #303212-473-3366
Massey, Philip/475 W 186th St212-928-8210
Masullo, Ralph/111 W 19th St212-727-1809
Masunaga, Ryuzo/119 W 22nd St 5th Fl212-807-7012
Mathews, Barbara Lynn/16 Jane St212-691-0823
Mathews, Bruce Photo/95 E 7th St212-529-7909
Matsuo, Toshi/105 E 29th St212-532-1320
Matthews, Cynthia/200 E 78th St212-288-7349
Matura, Ned/119 W 23rd St #1002212-463-9692
Mauro, Aldo/496 LaGuardia Pl #524212-989-4989
Maynard, Chris/297 Church St212-255-8204
Mazzeo, Michael/37 W 20th St #606212-627-3766
McCabe, David/39 W 67th St #1403212-874-7480
McCabe, Robert/117 E 24th St212-677-1910
McCarthy, Jo Anna/535 Greenwich St212-675-2757
McCarthy, Margaret/31 E 31st St212-696-5971
McCartney, Susan/902 Broadway #1608212-533-0660

McDermott, Brian/48 W 21st St..212-675-7273
McGlynn, David/18-23 Astoria Blvd, Long Island City.....................718-626-9427
McGoon, James/317 E 18th St...212-779-3905
McGrath, Norman/164 W 79th St #16.......................................212-799-6422
McLaughlin, Glenn/6 W 20th St 2nd Fl.....................................212-645-7028
McLoughlin, James Inc/148 W 24th St 5th Fl...............................212-206-8207
McNally, Brian T/234 E 81st St #1A..212-744-1263
McNally, Joe/305 W 98th St #6D S..212-219-1014
McPherson, Andrew/160 Fifth Ave #914....................................212-924-6760
McQueen, Mark/265 E 7th St..212-995-8965
Mead, Chris/108 Reade St...212-619-5616
Megna, Richard/210 Forsyth St...212-473-5770
Meisel, Steven/303 Park Ave S #409..212-777-7130
Melford, Michael/13 E 47th St 5th Fl.......................................212-473-3095
Mella, Michael/217 Thompson St..212-777-6012
Mellon/69 Perry St...212-691-4166
Memo Studio/39 W 67th St #1402...212-787-1658
Mena, Marcos/49 W 44th St..212-921-0739
Menashe, Abraham/306 E 5th St #27 (P 129)..............212-254-2754
Menken, Howard Studios/119 W 22nd St...................................212-924-4240
Mensch, Barbara/274 Water St..212-349-8170
Meola, Eric/535 Greenwich St...212-255-5150
Merle, Michael G/54 W 16th St..212-741-3801
Mervar, Louis/36 W 37th St...212-868-0078
Messin, Larry/64 Carlyle Green, Staten Island............................718-948-7209
Metz, Simon/56 W 22nd St...212-807-6106
Meyer, Kip/80 Madison Ave #7E...212-683-9039
Meyer, Rich/13 Laight St...212-744-9531
Meyer-Bosse, Hilmar/487 W Broadway.....................................212-979-1616
Meyerowitz, Joel/151 W 19th St...212-242-0740
Micaud, Christopher/143 Ave B..212-473-7266
Michals, Duane/109 E 19th St...212-473-1563
Michelson, Eric T/101 Lexington Ave #4B..................................212-683-6259
Mieles, Peter/20 Ave D #11I...212-475-6025
Milbauer, Dennis/15 W 28th St..212-255-8998
Milisenda, John/424 56th St, Brooklyn......................................718-439-4571
Milla, Edgar/234 E 4th St #7...212-979-7316
Miller, Bert/30 Dongan Pl..212-567-7947
Miller, Bill Photo/239 Park Ave S #5C......................................212-777-3304
Miller, Brad/43 W 24th St #9A...212-924-4744
Miller, Donald L/295 Central Park W (P 130,131)..........212-496-2830
Miller, Eileen/28 W 38th St..212-944-1507
Miller, Rex/34-28 29th St, Astoria..718-392-3263
Miller, Sue Ann/115 W 27th St 9th Fl.......................................212-645-5172
Milne, Bill/140 W 22nd St..212-255-0710
Mincey, Dale/50 Grand St #5F...212-420-9387
Ming Studio/60 Pineapple St #6B, Brooklyn...............................212-254-8570
Minh Studio/200 Park Ave S #1507...212-477-0649
Minks, Marlin/34-43 82nd St, Jackson Hts.................................718-507-9513
Mistretta, Martin/220 W 19th St 11th Fl....................................212-675-1547
Mitchell, Andrew/220 Berkeley Pl, Brooklyn...............................718-783-6727
Mitchell, Benn/119 W 23rd St..212-255-8686
Mitchell, Diane/175 W 73rd St...212-877-7624
Mitchell, Jack/356 E 74th St...212-737-8940
MKM Studios, Inc/117 E 31st St...212-447-0711
Molkenthin, Michael/135 W 26th St #6......................................212-727-2788
Montaine, Allan/61 W 8th St #3R..212-879-8162
Montezinos, Joseph/142 W 26th St...212-645-4385
Moore, Chris/20 W 22nd St #810...212-242-0553
Moore, Robert/11 W 25th St...212-691-4373
Moore, Truman/873 Broadway 4th Fl..212-533-3655
Moran, Nancy/143 Greene St..212-505-9620
Morello, Joe/40 W 28th St...212-684-2340
Morgan, Jeff/27 W 20th St #604...212-924-4000
Morissa/37 W 20th St #1201...212-741-2620
Morosse, Mark/122 Montague St #5, Brooklyn............................212-642-5264
Morris, Bill/34 E 29th St 6th Fl..212-685-7354
Morris, Leonard/200 Park Ave S #1410.....................................212-473-8485
Morris, Robert/243 E 52nd St..212-369-7316
Morrison, Ted/286 Fifth Ave...212-279-2838
Morsch, Roy/1200 Broadway #2B..212-697-5537
Morsillo, Les/13 Laight St...212-219-8009
Morton, Keith/39 W 29th St 11th Fl...212-889-6643
Moscati, Frank/1181 Broadway..212-686-4810
Moskowitz, Sonia/5 W 86th St #18B...212-877-6883
Mougin, Claude/227 W 17th St..212-691-7895
Mroczynski, Claus/529 W 42nd St #2L......................................212-947-2767
Mucchi, Fabio/5 W 20th St...212-620-0167

Mucci, Tina/119 W 23rd St #902...212-206-9402
Mullane, Fred/116 E 27th St 8th Fl...212-580-4045
Muller, Rick/23 W 31st St #3...212-967-3177
Muller, Rudy/318 E 39th St..212-679-8124
Mundy, Michael/220 E 5th St #1E...212-529-7114
Munro, Gordon/381 Park Ave S..212-889-1610
Munson, Russell/458 Broadway 5th Fl......................................212-226-8875
Murphy, Arthur A/421 E 64th St #6F..212-628-1332
Myers, Robert J/407 E 69th St...212-249-8085
Myriad Communications Inc/208 W 30th St.................................212-564-4340

N

Nadelson, Jay/116 Mercer St..212-226-4266
Nahoum, Ken/95 Greene St PH-E..212-219-0592
Naideau, Harold/233 W 26th St..212-691-2942
Nakamura, Tohru/112 Greene St..212-334-8011
Nakano, George/8 1/2 MacDougal Alley....................................212-228-9370
Namuth, Hans/20 W 22nd St...212-691-3220
Nanfra, Victor/222 E 46th St...212-687-8920
Naples, Elizabeth/210 Fifth Ave...212-889-1476
Nault, Corky/251 W 19th St..212-807-7310
Nedboy, Robin/335 W 38th St..212-563-1924
Needham, Steven Mark/111 W 19th St 2nd Fl..............................212-206-1914
Neil, Joseph/150 Fifth Ave #319...212-691-1881
Neitzel, John/152 W 25th St (P 122)..................212-807-9754
Neleman, Hans/77 Mercer St (P 133)..................212-274-1000
Nelken, Dan Studio/43 W 27th St (P 134,135)..........212-532-7471
Nesbit, Charles/62 Greene St..212-925-0225
Neumann, Peter/30 E 20th St 5th Fl..212-420-9538
Neumann, William/119 W 23rd St #206......................................212-691-7405
Neve, Roger/88 Lexington Ave...212-684-2933
Newman, Arnold/39 W 67th St...212-877-4510
Ney, Nancy/108 E 16th St 6th Fl...212-260-4300
Nguyen, Minh/200 Park Ave S...212-477-0649
Nicholas, Peter/29 Bleecker St..212-529-5560
Nicholson, Nick/121 W 72nd St #2E...212-362-8418
Nicks, Dewy/361 W 36th St #9B..212-563-2971
Nicolaysen, Ron/448 W 37th St #12A..212-947-5167
Niederman, Mark/119 W 25th St...212-255-9052
Niefield, Terry/12 W 27th St 13th Fl..212-686-8722
Nielsen, Anne/288 W 12th St...212-463-0712
Nisnevich, Lev/133 Mulberry St...212-219-0535
Nivelle, Serge/145 Hudson St 14th Fl.......................................212-226-6200
Niwa Studio/5 E 16th St..212-627-4608
Nons, Leonard/536 W 29th St..212-268-7547
Noren, Catherine/15 Barrow St..212-627-7805
Norris, Lionel/805 Puttam Ave, Brooklyn...................................718-919-5314
Norvila, Algis/963 Lorimer St, Brooklyn....................................718-388-0516
Nystrom, Dick/158 Spring St...212-431-6793

O

O'Brien, Michael/145 E 36th St #2..212-481-3860
O'Bryan, Maggie/344 E 9th St...212-777-8574
O'Connor, David/153 E 26th St #7B...212-689-5892
O'Connor, Thom/74 Fifth Ave..212-620-0723
O'Neill, Michael/134 Tenth Ave...212-807-8777
O'Rourke, J Barry/578 Broadway #707......................................212-226-7113
Obremski, George/1200 Broadway #2A......................................212-684-2933
Ochi, Toru/70 W 95th St #4B...212-865-1865
Ockenga, Starr/68 Laight St...212-431-5158
Oelbaum, Zeva/600 W 115th St #84L..212-864-7926
Ogilvy, Stephen/245 W 29th St 7th Fl.......................................212-643-9330
Okenfels III, Frank/245 E 30th St...212-683-1304
Olivo, John/545 W 45th St..212-765-8812
Olman, Bradley/15 W 24th St 11th Fl..212-243-0649
Ommer, Uwe/84 Riverside Dr...212-496-0268
Onaya-Ogrudek Ltd/17 W 17th St...212-645-8008
Oner, Matt/231 E 14th St #4R..212-529-2844
Oringer, Hal/568 Broadway #503...212-219-1588
Ort, Samuel/3323 Kings Hwy, Brooklyn......................................718-377-1218
Ortner, Jon/64 W 87th St...212-873-1950
Oshimoto, Ryuichi/286 Fifth Ave..212-279-2838
Otero, George/40 W 24th St..212-243-4942
Otfinowski, Danuta/165 W 20th St...212-243-6625
Otsuki, Toshi/241 W 36th St...212-594-1939
Owens, Frank/11 W 29th St...212-686-2535

Owens, Sigrid/221 E 31st St212-686-5190

P

Paccione/73 Fifth Ave212-691-8674
Padys, Diane/11 Worth St 4th Fl212-941-8532
Page, Lee/310 E 46th St212-286-9159
Pagliuso, Jean/12 E 20th St212-674-0370
Pagnano, Patrick/217 Thompson St212-475-2566
Palmisano, Giorgio/309 Mott St #4A212-431-7719
Palubniak, Jerry/144 W 27th St212-645-2838
Palubniak, Nancy/144 W 27th St (P 65)**212-645-2838**
Pappas, Tony/73-37 Austin St, Forest Hills718-261-6898
Paras, Michael/668 Ave of Americas 2nd Fl212-243-8546
Parker, Bo/448 W 37th St212-564-1131
Parks, Claudia/210 E 73rd St #1G212-879-9841
Passmore, Nick/150 W 80th St212-724-1401
Pastor, Mariano/54 W 21st St212-645-7115
Pateman, Michael/155 E 35th St212-685-6584
Paul, Tina/101 W 69th St212-580-3284
Peden, John/155 W 19th St 6th Fl212-255-2674
Pederson/Erwin/76 Ninth Ave 16th Fl212-929-9001
Pelaez, Jose Luis/126 Eleventh Ave (P 138,139)**212-995-2283**
Pellesier, Sam/458 W 22nd St #4F212-242-7222
Pemberton, John/377 Park Ave S 2nd Fl212-532-9285
Penn, Irving/89 Fifth Ave 11th Fl212-880-8426
Penny, Donald Gordon/505 W 23rd St #PH212-243-6453
Peoples, Joe/11 W 20th St 6th Fl (P 140)**212-633-0026**
Peress, Gilles/72 Spring St212-966-9200
Perkell, Jeff/36 W 20th St 6th fl212-645-1506
Perry, Linda/PO Box 340398/Ryder Sta, Brooklyn718-376-0763
Perweiler, Gary/873 Broadway212-254-7247
Peterson, Grant/568 Broadway #1003212-475-2767
Peticolas, Kip/210 Forsyth St212-473-5770
Petoe, Denes/39 E 29th St212-213-3311
Pettinato, Anthony/42 Greene St212-226-9380
Pfeffer, Barbara/40 W 86th St212-877-9913
Pfizenmaier, Edward/236 W 27th St212-627-5659
Philipeaux, Eddy Jean/Rockefeller Centr Sta212-468-2889
Philippas, Constantine/446 E 20th St #9E212-674-5248
Phillips, James/82 Greene St212-219-1799
Photographic Impact/126 Eleventh Ave212-206-7962
Picayo, Jose/32 Morton St212-989-8945
Pich, Tom/310 E 65th St212-288-3376
Piel, Denis/458 Broadway 9th Fl212-925-8929
Pierce, Richard/241 W 36th St #8F212-947-8241
Pilgreen, John/140 E 13th St 2nd Fl212-982-4887
Pilossof, Judd/142 W 26th St212-989-8971
Pinderhughes, John/122 W 26th St 12th Fl212-989-6706
Pioppo, Peter/50 W 17th St212-243-0661
Piscioneri, Joe/333 Park Ave S212-473-3345
Pite, Jonathan/244 E 21st St #7212-777-5484
Pizzarello, Charlie/15 W 18th St212-243-8441
Platt, Mark/305 2nd Ave212-475-1481
Plessner International/121 W 27th St #502212-645-2121
Plotkin, Bruce/3 W 18th St 7th Fl212-691-6185
Pobereskin, Joseph/139 Lincoln Pl, Brooklyn212-619-3711
Pobiner, Ted Studios Inc/381 Park Ave S212-679-5911
Pohl, Birgit/PO Box 2206212-420-0350
Poli, Bruce/110 Christopher St #55212-242-6853
Polsky, Herb/1024 Sixth Ave212-730-0508
Popper, Andrew J/330 First Ave212-982-9713
Porges, Danny/37 W 39th St #1002212-391-4117
Portnoy, Neal/1 Hudson St516-292-9364
Porto, Art/333 Park Ave S 2nd Fl212-353-0488
Porto, James/87 Franklin St212-966-4407
Poster, James Studio/210 Fifth Ave #402212-206-4065
Pottle, Jock/301 W 89th St #15212-874-0216
Powers, Guy/534 W 43rd St (P 32, 33)**212-563-3177**
Prezant, Steve Studios/666 Greenwich St #720212-727-0590
Pribula, Barry/59 First Ave212-777-7612
Price, Clayton J/205 W 19th St212-929-7721
Price, David/4 E 78th St212-794-9040
Priggen, Leslie/215 E 73rd St212-772-2230
Prozzo, Marco/270 Bowery212-966-8917
Pruzan, Michael/1181 Broadway 8th Fl212-686-5505
Puhlmann, Rico/530 Broadway 10th Fl212-941-9433
Putnam, Quentin/1141 Brooklyn Ave, Brooklyn718-693-7567

QR

Quinn, Ed/311 Greenwich St #8F212-233-7833
Raab, Michael/831 Broadway212-533-0030
Raboy, Marc/205 W 19th St212-242-4616
Rackley, Paul/130 W 29th St 3rd Fl212-929-7667
Rajs, Jake/252 W 30th St #10A212-947-9403
Randazzo, Steven/873 Broadway212-533-8327
Rapoport, David/55 Perry St #2D212-691-5528
Rappaport, Sam/515 Ave I #3H, Brooklyn718-253-5175
Rattner, Robert/106-15 Jamaica Ave, Richmond Hill718-441-0826
Ratzkin, Lawrence/740 West End Ave212-222-0824
Ravid, Joyce/12 E 20th St212-477-4233
Ravis, Sara/33 Bleecker St 2nd Fl212-777-0847
Ray, Bill/350 Central Park West #3C212-222-7680
Raymond, Lilo/212 E 14th St212-362-9546
Rea, Jimmy/512 Broadway212-627-7903
Reeks, Deck/145 W 58th St212-459-9816
Regan, Ken/6 W 20th St 8th Fl212-989-2004
Regen, David/878 West End Ave #4B212-222-0532
Reichert, Robert/149 W 12th St212-645-9515
Reinhardt, Mike/881 Seventh Ave #405212-541-4787
Rentmeester, Co/4479 Douglas Ave, Riverdale212-757-4796
Reznicki, Jack/568 Broadway #704212-925-0771
Rezny, Aaron/119 W 23rd St212-691-1894
Rezny, Abe/28 Cadman Plz W/Eagle Wrhse, Brooklyn Heights212-226-7747
Rhodes, Arthur/325 E 64th St212-249-3974
Rice, Douglas/44 Ann St212-766-7676
Richardson, Alan/23 E 4th St 4th Fl212-979-7872
Richman, Susan/119 W 25th St 11th fl.212-929-8801
Ricucci, Vincent/109 W 27th St 10th Fl212-807-8295
Ries, Henry/204 E 35th St212-689-3794
Ries, Stan/48 Great Jones St212-533-1852
Riggs, Cole/39 W 29th St212-481-6119
Riley, David & Carin/152 W 25th St212-741-3662
Rivelli, William/303 Park Ave S #508212-254-0990
Roberts, Grant/120 Eleventh Ave212-242-2000
Roberts, Mathieu/122 E 13th St #3A212-460-5160
Robinson, CeOtis/4-6 W 101st St #49A212-663-1231
Robinson, Herb/20 W 20th St #807212-627-1478
Robinson, James/155 Riverside Dr212-580-1793
Robison, Chuck/21 Stuyvesant Oval212-777-4894
Robledo, Maria/43 W 29th St212-213-1517
Rodamar, Richard/370 Ninth St, Brooklyn718-965-2758
Rodin, Christine/38 Morton St212-242-3260
Rohr, Robert/325 E 10th St #5W212-674-1519
Rolo Photo/214 W 17th St212-691-8355
Rosa, Douglas/151 W 19th St 6th Fl212-727-2422
Rose, Uli/975 Park Ave #8A212-988-8890
Rosenberg, Ken/514 West End Ave212-362-3149
Rosenthal, Barry/205 W 19th St212-645-0433
Rosenthal, Ben/20 E 17th St212-807-7737
Rosenthal, Marshall M/231 W 18th St212-807-1247
Ross, Kenneth/80 Madison Ave #7H (P 50, 51)**212-213-9205**
Ross, Mark/345 E 80th St212-744-7258
Ross, Steve/10 Montgomery Pl, Brooklyn718-783-6451
Rossi, Emanuel/78-29 68th Rd, Flushing718-894-6163
Rossignol, Lara/425 W 23rd St #17A212-243-2750
Rossum, Cheryl/310 E 75th St212-628-3173
Roth, Seth/137 W 25th St212-620-7050
Rothaus, Ede/34 Morton St212-989-8277
Rozsa, Nick/325 E 64th St212-734-5629
Rubenstein, Raeanne/8 Thomas St212-964-8426
Rubin, Al/250 Mercer St #1501212-674-4535
Rubin, Daniel/126 W 22nd St 6th Fl212-989-2400
Rubin, J Ivan/240 W 23rd St212-645-0020
Rubin, Susan/4700 Broadway #4A212-569-4860
Rubinger, Diane/36 W 35th St212-714-0955
Rubyan, Robert/270 Park Ave S #7C212-460-9217
Rudnick, James/799 Union Street, Brooklyn212-466-6337
Rudolph, Nancy/35 W 11th St212-989-0392
Rugen-Kory/27 W 20th St #603212-242-2772
Ruggeri, Francesco/71 St Marks Pl #9212-505-8477
Rumbough, Stan/154 W 18th St #8A212-206-0183
Russell, Dawn/222 E 21st St212-228-2963
Russo, Gary/309 E 8th St #2A212-228-1736
Ryan, Will/16 E 17th St 2nd Fl212-242-6270

Rysinski, Edward/115 E 9th St #12K.................212-807-7301
Ryuzo/119 W 22nd St 5th Fl..............................212-807-7012

S

Sabal, David/20 W 20th St #501........................212-242-8464
Sacco, Vittorio/542 E 14th St #23.....................212-929-9225
Sacha, Bob/370 Central Park W212-749-4128
Sachs, Joseph/151 W 19th St 12th Fl.................212-242-0297
Sahaida, Michael/5 W 19th St 5th Fl..................212-924-4545
Sahihi, Ashkan/301 E 12th St...........................212-533-4026
Sailors, David/123 Prince St.............................212-505-9654
Sakas, Peter/400 Lafayette St...........................212-254-6096
Salaff, Fred/322 W 57th St................................212-246-3699
Saltiel, Ron Cameron/78 Fifth Ave 7th fl..............212-627-0003
Salvati, Jerry/206 E 26th St..............................212-696-0454
Salzano, Jim/29 W 15th St.................................212-242-4820
Samardge, Nick/302 W 86th St..........................212-226-6770
Sander, J T/107 E 88th St #3F............................212-996-6189
Sanders, Chris/130 W 23rd St #2........................212-645-6111
Sandone, A J/132 W 21st St 9th Fl......................212-807-6472
Sanford, Tobey/888 Eighth Ave #166...................212-245-2736
Santos, Antonio/202 E 21st St...........................212-477-3514
Sartor, Vittorio/10 Bleecker St #1-D....................212-674-2994
Sato Photo/152 W 26th St..................................212-741-0688
Satterwhite, Al/80 Varick St #7B.........................212-219-0808
Saunders, Daryl-Ann/254 Park Ave S #3M.............212-242-0942
Savides, Harris/648 Broadway #1009....................212-260-6816
Saville, Lynn/440 Riverside Dr #45 (P 141)...........212-932-1854
Sawyer, David/270 Park Ave S #3A......................212-473-2577
Saylor, H Durston/219 W 16th St #4B...................212-620-7122
Scala, Jed/531 E 20th St....................................212-677-5753
Scalora, Suza/3 W 30th St..................................212-643-0058
Scanlan, Richard/1601 Third Ave #31D..................212-996-4571
Scarlett, Nora/37 W 20th St (P 12, 13)................212-741-2620
Scavullo, Francesco/212 E 63rd St.......................212-838-2450
Schaefer, Carolyn/542 E 14th St.........................212-228-3224
Schecter, Lee/13-17 Laight St 3rd Fl....................212-431-0088
Schein, Barry/118-60 Metropolitan Ave, Kew Gardens.........718-849-7808
Schenk, Fred/112 Fourth Ave..............................212-677-1250
Schenk, Thomas/311 Greenwich St........................212-587-3445
Schiavone, Carmen/271 Central Park West...............212-496-6016
Schierlitz, Tom/544 W 27th St.............................212-595-1699
Schiller, Judy/328 W 19th St...............................212-924-7612
Schinz, Marina/222 Central Park S........................212-246-0457
Schlachter, Trudy/160 Fifth Ave...........................212-741-3128
Schneider, Josef/119 W 57th St...........................212-265-1223
Schneider, Peter/31 W 21st St.............................212-366-6242
Schramm, Frank/59 Bank St.................................212-807-1390
Schreck, Bruno/873 Broadway #304.......................212-254-3078
Schuld, Karen/77 Bleecker St #120........................212-674-0031
Schulze, Fred/38 W 21st St.................................212-242-0930
Schurink, Yonah (Ms)/666 West End Ave.................212-362-2860
Schwartz, Marvin/223 W 10th St...........................212-929-8916
Schwartz, Sing-Si/15 Gramercy Park S...................212-475-9222
Schwerin, Ron/889 Broadway................................212-228-0340
Sclight, Greg/322 Second Ave 3rd Fl.....................212-736-2957
Scruggs, Jim/32 W 31st St #3...............................212-629-6495
Secunda, Shel/112 Fourth Ave 3rd Fl (P 24-27).........212-477-0241
Seesselberg, Charles/236 W 27th St 10th Fl.............212-807-8730
Seidman, Barry/85 Fifth Ave................................212-255-6666
Seitz, Sepp/12 E 22nd St #9F...............................212-505-9917
Selby, Richard/113 Greene St...............................212-431-1719
Seliger, Mark/251 W 19th St................................212-633-0848
Seligman, Paul/163 W 17th St..............................212-242-5688
Selkirk, Neil/515 W 19th St.................................212-243-6778
Seltzer, Abe/443 W 18th St..................................212-807-0660
Serling, Peter/157 W 74th St................................212-496-9824
Sewart, David Harry/100 Chambers St....................212-619-7783
Shaffer, Stan/2211 Broadway................................212-580-5522
Shapiro, Pam/11 W 30th St 2nd Fl.........................212-967-2363
Sheldon, Joshua/601 W 176th St..........................212-928-4199
Sherman, Guy/108 E 16th St 6th Fl........................212-675-4983
Shiki/119 W 23rd St #1009..................................212-838-1659
Shipley, Christopher/41 Fifth Ave #4D....................212-529-2988
Shiraishi, Carl/137 E 25th St 11th Fl.....................212-679-5628
Shorr, Kathy/137 Duane St..................................212-349-6577
Silbert, Layle/505 LaGuardia Pl...........................212-677-0947

Silva-Cone Studios/260 E 36th St.........................212-279-0900
Silver, Larry/236 W 26th St.................................212-807-9560
Simko, Robert/395 South East Ave #28E.................212-912-1192
Simon, Peter Angelo/520 Broadway #702................212-925-0890
Simone, Luisa/222 E 27th St #18..........................212-679-9117
Simons, Chip/165 Ave A #5..................................212-228-7459
Simpson, Coreen/599 West End Ave........................212-877-6210
Simpson, Jerry/244 Mulberry St...........................212-941-1255
Simson, Emily/102 E 30th St 5th Fl........................212-689-6423
Singer, Mara/270 Park Ave South #3A.....................212-982-8838
Sinnott, Joseph/1251 Bay Rudge Pkwy #4, Brooklyn.....718-680-7615
Sint, Steven/45 W 17th St 5th Fl...........................212-463-8844
Sit, Danny/280 Park Ave S #11J.............................212-979-5533
Skalski, Ken L/873 Broadway................................212-777-6207
Skelly, Ariel/80 Varick St #6A...............................212-226-4091
Skinner, Marc/216 Van Buren St, Brooklyn................718-455-7749
Sklar, Lori/117/01 Park Lane S #83D, Kew Gardens.......212-431-7652
Skogsbergh, Ulf/5 E 16th St.................................212-255-7536
Skolnick-Chany/1063 E 19th St.............................212-254-3409
Skolnik, Lewis/135 W 29th St 4th Fl.......................212-239-1455
Slavin, Fred/43 W 24th St 8th Fl...........................212-627-2652
Slavin, Neal/62 Greene St....................................212-925-8167
Sleppin, Jeff/3 W 30th St.....................................212-947-1433
Slotnick, Jeff/225 Lafayette St..............................212-966-5162
Small, John/400 Second Ave.................................212-645-4720
Smilow, Stanford/333 E 30th St/Box 248.................212-685-9425
Smith, Jeff/30 E 21st St.......................................212-674-8383
Smith, Michael/140 Claremont Ave #5A..................212-724-2800
Smith, Rita/666 West End Ave #10N.........................212-580-4842
Smith, Sean/111 W 11th St #5RE............................212-366-5182
Smith, William E/498 West End Ave.........................212-877-8456
Snider, Lee/221 W 82nd St #9D..............................212-873-6141
Snyder, Norman/98 Riverside Dr #16C.......................212-219-0094
SO Studio Inc/412 E 65th St..................................212-988-0517
Sobel, Jane/2 W 45th St #1200..............................212-382-3939
Sochurek, Howard/680 Fifth Ave.............................212-582-1860
Solomon, Chuck/114 Horatio St..............................212-645-4853
Solomon, Paul/440 W 34th St #13E..........................212-760-1203
Solowinski, Ray/154 W 57th St #826........................212-757-7940
Soluri, Michael/95 Horatio St #633.........................212-645-7999
Somekh, Ric/13 Laight St.....................................212-219-1613
Soot, Olaf/419 Park Ave S....................................212-686-4565
Sorce, Wayne/20 Henry St #5G, Brooklyn..................718-237-0497
Sorensen, Chris/PO Box 1760................................212-684-0551
Sorokin, Lauren/866 Broadway...............................212-777-0971
Sotres, Craig/440 Lafayette St 6th Fl.......................212-979-6161
Spatz, Eugene/264 Sixth Ave.................................212-777-6793
Specht, Diane/167 W 71st St #10............................212-877-8381
Speier, Leonard/190 Riverside Dr............................212-595-5480
Speliotis, Steven/114 E 13th St #5D (P 143)............212-529-4765
Spelman, Steve/260 W 10th St (P 14)....................212-242-9381
Spinelli, Frank/22 W 21st St 12th Fl........................212-243-8318
Spinelli, Paul/1619 Third Ave #21K.........................212-410-3320
Spiro, Ed/340 W 39th St......................................212-947-7883
Spreitzer, Andy/225 E 24th St...............................212-685-9669
Springston, Dan/135 Madison Ave/PH So...................212-689-0685
St Denis, Pauline/150 E 18th St.............................212-677-2197
St John, Lynn/308 E 59th St..................................212-308-7744
Staedler, Lance/154 W 27th St..............................212-243-0935
Stahman, Robert/1200 Broadway #2D.......................212-679-1484
Standart, Joe/5 W 19th St 5th Fl............................212-924-4545
Stanton, William/160 W 95th St #9D........................212-662-3571
Stark, Philip/245 W 29th St 15th Fl.........................212-868-5555
Starkoff, Robert/140 Fifth Ave...............................212-741-0669
Steedman, Richard C/214 E 26th St.........................212-684-7878
Steele, Bill/534 W 43rd St....................................212-563-3177
Steele, Kim/640 Broadway #7W...............................212-777-7753
Steigman, Steve/5 E 19th St #303...........................212-627-3400
Steinbrenner, Karl/225 E 24th St 3rd Fl...................212-779-1120
Steiner, Charles/61 Second Ave.............................212-777-0813
Steiner, Christian/300 Central Park West..................212-724-1990
Stember, John/881 Seventh Ave #1003.....................212-757-0067
Stephanie Studios/277 W 10th St #2D.......................212-929-1029
Stephens, Greg/450 W 31st St 10th Fl......................212-643-9477
Stern, Anna/261 Broadway #3C..............................212-349-1134
Stern, Bert/66 Crosby St......................................212-925-5909
Stern, Bob/12 W 27th St......................................212-889-0860
Stern, Cynthia/515 Broadway #2B...........................212-925-2677

Stern, John/201 E 79th St #15C ..212-988-0505
Stern, Laszlo/11 W 30th St 2nd Fl212-239-6600
Stettner, Bill/118 E 25th St ...212-460-8180
Stevenson, Monica/360 W 36th St ..212-594-5410
Stewart, David Harry/100 Chambers St212-619-7783
Stewart, John/80 Varick St ..212-966-6783
Stiles, James/413 W 14th St ..212-627-1766
Stinnett, Taryn/305 2nd Ave #324 ...212-533-0613
Stoeker, Karl/34 W 15th St ..212-727-9366
Stone, Erika/327 E 82nd St ...212-737-6435
Stroili, Elaine/416 E 85th St #3G ...212-879-8587
Strongin, Jeanne/61 Irving Pl ...212-473-3718
Stuart, John/80 Varick St #4B ...212-966-6783
Stupakoff, Otto/80 Varick St ...212-334-8032
Sugarman, Lynn/40 W 22nd St ..212-691-3245
Sun Photo/29 E 22nd St #2-N ...212-505-9585
Sussman, David/138 W 25th St ..212-675-5863
Svensson, Steen/52 Grove St ...212-242-7272
Swedowsky, Ben/381 Park Ave S ..212-684-1454
Swick, Danille/276 First Ave #11A ...212-777-0653
Sylvestre, Lorraine/175 Fifth Ave #2583212-675-8134
Symons, Abner/27 E 21st St 10th Fl212-777-6660

T

Tannenbaum, Ken/16 W 21st St ..212-675-2345
Tanous, Dorothy/214 W 30th St 11th Fl212-581-6470
Tara Universal Studios/34 E 23rd St ..212-260-8280
Tardio, Robert/19 W 21st St ..212-463-9085
Taufic, William/166 W 22nd St ..212-620-8143
Taylor, Curtice/29 E 22nd St #2S ..212-473-6886
Taylor, Jonathan/5 W 20th St 2nd Fl212-741-2805
Tcherevkoff, Michel/15 W 24th St (P 22, 23)212-228-0540
Teare, Nigel/38 W 26th St ...212-243-3015
Teboul, Daniel/146 W 25th St ..212-645-8227
Tegni, Ricardo/100 E Mosholu Pkwy S #6F212-367-8972
Temkin, Jay/64-21 Douglaston Pkwy, Douglaston718-229-9212
Ten West Productions/10 W 18th St ..212-929-4899
Tenneson, Joyce/114 W 27th St ..212-741-9371
Tessler, Stefan/115 W 23rd St ...212-924-9168
Teuwen, Geert/76 Ninth Ave WPH ...212-929-9001
Thomas, Mark/141 W 26th St 4th Fl ..212-741-7252
Thompson, Kenneth/220 E 95th St ...212-348-3530
Thomson, Walter/311 Smith St, Brooklyn718-797-3818
Tighe, Michael/110 E 1st St #12 ...212-254-4252
Tillinghast, Paul/20 W 20th St 7th Fl212-741-3764
Tillman, Denny/39 E 20th St ...212-674-7160
Timpone, Robert/126 W 22nd St ...212-989-4266
Togashi/36 W 20th St ...212-929-2290
Tohi Photography/147 W 25th St 12th Fl212-366-4872
Tornberg-Coghlan Assoc/6 E 39th St212-685-7333
Toto, Joe/13-17 Laight St ..212-966-7626
Tracy, Charles/568 Broadway ..212-219-9880
Tran, Clifford/17 W 20th St 6W #C ...212-675-8492
Trzeciak, Erwin/145 E 16th St ...212-254-4140
Tucker, Judy/350 E 53rd St ...212-888-8103
Tullis, Marcus/13 Laight St 3rd fl ..212-966-8511
Tully, Roger/64 Bay Rd, Brookhaven ..516-286-1700
Tung, Matthew/78 Fifth Ave 7th Fl ...212-741-0570
Turbeville, Deborah/160 Fifth Ave #914212-924-6760
Turin, Miranda Penn/71 W 10th St #2212-979-9712
Turner, Pete Photography/154 W 57th St 9th Fl212-765-1733
Turyn, Anne/228 Seventh Ave ..212-989-3869
Tweedy-Holmes, Karen/180 Claremont Ave #51212-866-2289
Tweel, Ron/241 W 36th St ..212-563-3452
Tyler, Mark/233 Broadway #822 ..212-962-3690

UV

Uher, John/529 W 42nd St ..212-594-7377
Umans, Marty/29 E 19th St ...212-995-0100
Unangst, Andrew/381 Park Ave S ..212-889-4888
Ursillo, Catherine/1040 Park Ave ..212-722-9297
Vaccaro, Nick/530 Laguardia Pl #4 ...212-477-8620
Vaeth, Peter/295 Madison Ave ...212-685-4700
Vail, Baker Photography Inc/111 W 24th St212-463-7560
Valente, Jerry/193 Meserole Ave, Brooklyn718-389-0469
Valeska, Shonna/140 E 28th St (P 64)212-683-4448

Van De Heyning, Sam/318 E 18th St212-982-2396
Van Der Heyden, Frans/60-66 Crosby St #4D212-226-8302
Varriale, Jim/36 W 20th St 6th Fl ..212-807-0088
Vega, Julio/428 W 26th St ...212-645-1867
Vega, Luis/1551 Glover St, Bronx ..212-829-7868
Veldenzer, Alan/160 Bleecker St ...212-420-8189
Vera, Cesar/284 Lafayette St #5A ...212-941-8594
Veretta Ltd/318 W 39th St PH ..212-563-0650
Veronsky, Frank/1376 York Ave ...212-744-3810
Vest, Michael/343 E 65th St #4RE ..212-532-8331
Vhandy Productions/401 E 57th St ..212-759-6150
Vickers & Beechler/200 W 79th St PH #A212-580-8649
Vickers, Camille/200 W 79th St PH #A212-580-8649
Vidal, Bernard/450 W 31st St #9C ...212-629-3764
Vidol, John/37 W 26th St ..212-889-0065
Viesti, Joe/PO Box 20424, Cherokee Sta212-734-4890
Vincent, Chris/119 W 23rd St ..212-691-1894
Vine, David/873 Broadway 2nd Fl ..212-505-8070
Visual Impact Productions/15 W 18th St 10th Fl212-243-8441
Vitale, Peter/157 E 71st St ..212-249-8412
Vogel, Allen/348 W 14th St ...212-675-7550
Vogel, Rich/119 W 23rd St #800 ...415-435-9207
Volkmann, Roy/260 Fifth Ave ..212-889-7067
Volpi, Rene/121 Madison Ave #11-I ...212-532-7367
Von Briel, Rudi/PO Box 2017 ..212-288-7512
Von Hassell, Agostino/277 W 10th St PH-D212-242-7290
Vos, Gene/9 W 31st St ..212-714-1155

W

Wagner, Daniel/12 E 32nd St 4th Fl ..212-481-0786
Wagner, David A/126 Eleventh Ave ..212-243-4800
Wahlund, Olof/7 E 17th St ...212-929-9067
Waldo, Maje/PO Box 1156 Cooper Sta718-638-4909
Waldron, William/463 Broome St ...212-226-0356
Wallace, Randall/43 W 13th St #3F ..212-242-2930
Wallach, Louis/417 Lafayette St ..212-925-9553
Wallis, Stephen/238 W 4th St ...212-924-2283
Walsh, Bob/401 E 34th St ...212-684-3015
Waltzer, Bill/110 Greene St #96 ..212-925-1242
Waltzer, Carl/873 Broadway #412 ..212-475-8748
Walz, Barbra/143 W 20th St ..212-242-7175
Wan, Stan/310 E 46th St ...212-986-1555
Wang, Harvey/574 Argyle Rd, Brooklyn718-282-2800
Wang, John Studio Inc/30 E 20th St ..212-982-2765
Wang, Tony Studio Inc/118 E 28th St #908 (P 71)212-213-4433
Warchol, Paul/133 Mulberry St ...212-431-3461
Ward, Bob/151 W 25th St ...212-627-7006
Warwick, Cyndy/144 E 22nd St ...212-420-4760
Watanabe, Nana/31 Union Sq W #12C212-741-9740
Watson, Albert M/777 Washington St212-627-0077
Watson, Michael/133 W 19th St 2nd Fl212-620-3125
Watt, Elizabeth/22 W 21st St 12th Fl212-929-8504
Watts, Cliff/650 Amsterdam Ave ..212-362-3354
Watts, Judy/311 E 83rd St #5C ...212-439-1851
Waxman, Dani/242 E 19th St ...212-995-2221
Wayne, Meri/170 Mercer St #5E ..212-925-2771
Weaks, Dan/5 E 19th St #303 ...212-473-3366
Webb, Alex/79 Spring St ...212-966-9200
Weber, Bruce/135 Watts St ...212-685-5025
Weckler, Chad/210 E 63rd St ..212-355-1135
Weidlein, Peter/122 W 26th St ...212-989-5498
Weinberg, Carol/40 W 17th St ...212-206-8200
Weiner, Greg/100 Fifth Ave #906 ...212-633-0105
Weinstein, Michael/508 Broadway ...212-925-2612
Weinstein, Todd/47 Irving Pl ...212-254-7526
Weiss, David/15 W 24th St ..212-924-1030
Weiss, Mark/262 Mott St ...212-941-9866
Weiss, Michael Photo/10 W 18th St 2nd Fl212-929-4073
Welles, Harris/84 Forsyth St ...212-226-1961
West, Bonnie/636 Ave of Americas #3C212-929-3338
Westheimer, Bill/167 Spring St #3W ...212-431-6360
Wexler, Jayne/24 Prince St ..212-334-0229
Wexler, Mark/484 W 43rd St ...212-564-7733
Wheatman, Truckin/251 W 30th St #4FW212-239-1081
Whipple, George III/301 E 73rd St ...212-219-0202
Whitaker, Ross/206 W 15th 4th Fl ...212-727-0044
White, Bill/34 W 17th St ..212-243-1780

White, David/31 W 21st St ..212-727-3454
White, James/666 Greenwich St ...212-924-2255
White, John/11 W 20th St 6th Fl ...212-691-1133
White, Steven/666 Greenwich St ..212-924-2255
White, Timothy/448 W 37th St PH ...212-971-9039
Whitehurst, William/32 W 20th St ..212-206-8825
Whitely Presentations/60 E 42nd St #419212-490-3111
Whitman, Robert/1181 Broadway 7th Fl212-213-6611
Whyte, Douglas/519 Broadway ...212-431-1667
Wick, Kevin/484 E 24th St, Brooklyn718-858-6989
Wick, Walter/560 Broadway #404 (P 152,153) 212-966-8770
Wien, Jeffrey/29 W 38th St ...212-354-8024
Wier, John Arthur/36 W 25th St 11th fl212-691-1901
Wiesehahn, Charles/249 W 29th St #2E212-563-6612
Wilby, Dan/45 W 21st St 5th Fl ..212-929-8231
Wilcox, Shorty/DPI/19 W 21st St #901212-627-4060
Wildes, Brett/156 Chambers St 4th Fl212-431-3496
Wilkes, John/42 E 23rd St 6th Fl ...212-475-0794
Wilkes, Stephen/48 E 13th St ...212-475-4010
Wilks, Harry/234 W 21st St ...212-929-4772
Willardt, Kenneth/100 W 23rd St ...212-242-2223
Willocks, Curtis/20 "J" St #1104, Brooklyn718-797-9458
Wills, Bret/38 Greene St ..212-925-2999
Wilson, Mike/441 Park Ave S ...212-683-3557
Wing, Peter/56-08 138th St, Flushing718-762-3617
Winstead, Jimmy/453 Washington Ave, Brooklyn718-789-2997
Wohl, Marty/40 E 21st St 6th Fl ..212-460-9269
Wojcik, James/256 Mott St ...212-431-0108
Wolf, Bruce/136 W 21st St 8th Fl ...212-633-6660
Wolf, Henry/167 E 73rd St ...212-472-2500
Wolf, Robert/6864 Yellowstone Blvd #A16, Forest Hills718-997-8879
Wolff, Brian R/560 W 43rd St #5K ..212-465-8976
Wolff, Cynthia ..212-721-1919
Wolfson, Robert/236 W 26th St #501212-924-1510
Wolfson, Steve and Jeff/13-17 Laight St 5th Fl212-226-0077
Wong, Daniel Photography/395 Broadway #4C212-966-3230
Wong, Leslie/303 W 78th St ..212-595-0434
Wood, Susan/641 Fifth Ave ...212-371-0679
Woods, Patrick/41-15 45th St #5N, Sunnyside718-786-5742
Word, Troy/305 E 21st St ...212-420-9285
Wormser, Richard L/800 Riverside Dr212-928-0056
Wright, Roy/353 E 77th St ..212-517-3648
Wylie, Bill/146 W 17th St ..212-627-1007
Wynn, Dan/170 E 73rd St ..212-535-1551
Wyville, Mark/25-40 31st Ave, Long Island City718-204-2816

YZ

Yalter, Memo/14-15 162nd St, Whitestone718-767-3330
Yamashiro, Tad/224 E 12th St ...212-473-7177
Yee, Tom/141 W 28th St ...212-947-5400
Yoav/4523 Broadway ..212-942-8185
Young, Donald/166 E 61st St Box 148212-593-0010
Young, James/133 W 71st St #5B ..212-477-6413
Young, Ken/530 W 23rd St ...212-989-2219
Young, Rick/27 W 20th St #1003 (P 42, 43) 212-929-5701
Youngblood, Lee/200 W 70th St #8F212-595-7913
Yuen, Dan/PO Box 0070/Prince St Sta212-925-4746
Zager, Howard/245 W 29th St ...212-239-8082
Zan Productions/108 E 16th St 6th Fl.212-477-3333
Zander, George/141 W 28th St ...212-971-0874
Zander, Peter/312 E 90th St #4A ...212-534-3125
Zanetti, Gerry/536 W 50th St ...212-767-1717
Zapp, Carl/119 W 22nd St #2 ...212-924-4240
Zehnder, Bruno/PO Box 5996 ...212-840-1234
Zeray, Peter/113 E 12th St ...212-674-0332
Zimmerman, Marilyn/100 W 25th St 4th Fl212-206-1000
Zingler, Joseph/18 Desbrosses St ...212-226-3867
Zoiner, John/12 W 44th St ..212-972-0357
Zwiebel, Michael/42 E 23rd St ...212-477-5629

NORTHEAST

A

Abarno, Richard/PO Box 540, Carolina, RI401-364-2037

Abbey Photographers/268 Broad Ave, Palisades Park, NJ201-947-1221
Abbott, James/303 N 3rd St 1st Fl, Philadelphia, PA215-925-9706
Abbott, Monty/PO Box 98, Still River, MA ...508-456-3408
Abdelnour, Doug/Rt 22 PO Box 64, Bedford Village, NY914-234-3123
Abel, Jim/216 Towd Pt Rd, South Hampton, NY516-287-4357
Abel, Pat/23 N Wycome Ave, Landsdowne, PA215-928-0499
Abell, Ted/51 Russell Rd, Bethany, CT ..203-777-1988
Abend, Jay/18 Central St, Southborough, MA508-624-0464
Abraham, Jack/229 Inza St, Highland Park, NJ908-572-6093
Abramson, Dean/PO Box 610, Raymond, ME207-655-7386
Abstract Studios/9723 Baltimore Blvd #1, College Park, MD301-441-4600
Accame, Deborah/5161 River Rd Bldg 2B, Bethesda, MD301-652-1303
Adams Studio Inc/1523 22nd St NW Courtyard, Washington, DC202-785-2188
Adams, John P/78 Beane Lane, Newington, NH603-436-0039
Adams, Jon/PO Box 2, Jenkintown, PA ...215-886-6658
Adams, Neill/2305 Coleridge Dr, Silver Spring, MD301-206-5104
Addis, Kory/144 Lincoln St #4, Boston, MA ..617-451-5142
Adsit-Pratt, Diane/RD1/Box 220, Blairstown, NJ908-459-5815
Afterglow Studios/165B New Boston St, Woburn, MA617-938-6960
Agalias, George/25 Washington Valley Rd, Watchung, NJ212-874-7615
Agelopas, Mike/2510 N Charles St, Baltimore, MD410-235-2823
Ahrens, Gene/544 Mountain Ave, Berkeley Heights, NJ908-464-4763
Aiello, Frank/35 S Van Brunt St, Englewood, NJ201-894-5120
Aikins, John/7401 New Hampshire Ave #70, Hyattsville, MD301-439-1534
Akis, Emanuel/145 Lodi St, Hackensack, NJ201-342-8070
Aladdin Studio/9 Columbine Dr, Nashua, NH603-883-1011
Albee, Larry/PO Box 501, Kennet Square, PA215-388-6741
Albers, Debra/9153 Brookville Rd, Silver Spring, MD301-588-5703
Albert, Sharon/PO Box 370, Newton High, MA617-964-2826
Albrizio, Linda/112 Center Ave, Chatham, NJ201-635-2276
Alcarez, Mark/86 Bartlett St, Charlestown, MA617-451-2629
Alejandro, Carlos Photography/8 E 37th St,
Wilmington, DE (P 73) .. 302-762-8220
Alexander, Bruce/127 Harantis Lake Rd, Chester, NH603-887-2530
Alexander, Dean/1035 N. Calvert St, Baltimore, MD301-385-3120
Alexander, Jules/9 Belmont Ave, Rye, NY ...914-967-8985
Alexanian, Nubar/11 Sumner St, Gloucester, MA508-281-6152
Allen, Bryan/40 Budd St, Morristown, NJ ..201-540-9551
Allen, C J/67 Brookside Ave/Box 1137, Boston, MA617-524-1925
Allen, Carole/11 Crescent St, Keene, NH ...603-357-1375
Allsopp, Jean Mitchell/16 Maple St/RR 2/PO Box 224, Shirley, MA617-425-2296
Alonso, Manuel/One Circle West, Stamford, CT203-359-2838
Althaus, Mike/5161 River Rd Bldg 2B, Bethesda, MD301-652-1303
Altman, Steve/46 Prescott #1, Jersey City, NJ201-434-0022
Alves, Antonio/339 Lafayette St, Newark, NJ201-589-9268
Ambrose, Ken/129 Valerie Court, Cranston, RI401-826-0606
Ames, Thomas Jr/85 Mechanic St, Lebanon, NH603-448-6168
Amicucci, Nick/55 Fourth Ave, Garwood, NJ908-789-1669
Amos, James/PO Box 118, Centreville, MD ...410-758-2649
Amranand, Ping/4502 Saul Rd, Kensington, MD301-564-0938
Amstock/12 Appleton Terrace, Watertown, MA617-926-4749
Ancker, Clint/3 Hunters Trl, Warren, NJ ...908-356-4280
Ancona, George/Crickettown Rd, Stony Point, NY914-786-3043
Andersen-Bruce, Sally/19 Old Mill Rd, New Milford, CT203-355-1525
Anderson, Lee/2828 10th St NE, Washington, DC202-547-1989
Anderson, Monica/11 Ranelegh Rd, Boston, MA617-787-5510
Anderson, Richard Photo/2523 N Calvert St, Baltimore, MD410-889-0585
Anderson, Ronald N/898 New mark Esplanade, Rockville, MD301-294-3218
Anderson, Theodore/235 N Madison St, Allentown, PA215-437-6468
Andersson, Monika L/11 Ranelegh Rd, Brighton, MA617-787-5510
Ando, Tom/541 Commerce St #5, Franklin Lake, NJ201-405-0301
Andrews Studios/RD 3/Box 277, Pine Bush, NY914-744-5361
Andris-Hendrickson Photography/408 Vine St,
Philadelphia, PA (P 74,75) ... 215-925-2630
Angier, Roswell/65 Pleasant St, Cambridge, MA617-354-7784
Ankers Photo/316 F St NE, Washington, DC202-543-2111
Ansin, Mikki/2 Ellery Square, Cambridge, MA617-661-1640
Anstett, Carol Gaegler/3825 Keswick Rd, Baltimore, MD410-366-0346
Anthony, Greg/107 South St, Boston, MA ..617-423-4983
Anyon, Benjamin/206 Spring Run Ln, Downington, PA215-363-0744
Appleton, Hal/Kingston, Doug/6 Stickney Terrace, Hampton, NH603-926-0763
Arbor Studios/56 Arbor St, Hartford, CT ..203-232-6543
Arce Studios/48 S Main St, S Norwalk, CT ..203-866-8845
Arkadia Photography/72 Cedar Hill Rd, Marlborough , MA508-481-7650
Armen, James/P O Box 586, Belmont, MA ..617-923-1908
Armor, Jan Douglas/2701 E Main Rd, Portsmouth, RI401-683-3754
Armstrong, Christine/4701 Bel Air Rd, Baltimore, MD410-488-5603
Armstrong, James/125 Russelville Rd, Easthampton, MA413-572-1078

Aron, Jon/39 Union St, Nantucket, MA ..508-228-2855
Aronson/Hayward Studio/1168 Commonwealth Ave, Boston, MA617-731-6900
Arruda, Gary/17 Clinton Dr, Hollis, NH ..603-889-3722
Arruda, Robert/37 Norse's Pond Rd, Wellesley, MA617-482-1425
Asterisk Photo/2016 Walnut St, Philadelphia, PA215-972-1543
Atlantic Photo/Boston/669 Boylston St, Boston, MA617-267-7480
Augenstein, Ron/509 Jenne Dr, Pittsburgh, PA412-653-3583
Augustine, Paula ...215-455-4311
Avanti Studios/46 Waltham St, Boston, MA617-574-9424
Avarella, Russell/35-02 Berdan Ave, Fair Lawn, NJ201-796-5588
Avatar Studio/1 Grace Dr, Cohasset, MA ..617-383-1099
Avics Inc/116 Washington Ave, Hawthorne, NJ201-444-8118
Avid Productions Inc/10 Terhune Place, Hackensack, NJ201-343-1060
Avimeleh, Larry/221 Oakwood Ave, N Haledon, NJ201-423-1956
Avis, Paul/300 Bedford, Manchester, NH ..603-627-2659
Azel, Robert/RR 1/Box 924, E Stoneham, ME207-928-2325

B

B & H Photographics/2035 Richmond, Philadelphia, PA215-425-0888
Bach, Stanley/720 Monroe St #18, Hoboken, NJ201-656-2887
Bacharach Inc/44 Hunt St, Watertown, MA617-924-6200
Baehr, Sarah/708 South Ave, New Canaan, CT203-966-6317
Baer, Rhoda/3006 Military Rd NW, Washington, DC202-364-8480
Bailey, Philip/245 Lexington Rd, Concord , MA508-369-8466
Baitz, Otto/130 Maple Ave #9B1, Red Bank, NJ908-530-8809
Baker, Bill Photo/1045 Pebble Hill Rd RD3, Doylestown, PA215-348-9743
Bakhtiar, Sherry/7927 Iverness Ridge Rd, Potomac, MD301-299-2671
Baldwin, Steve/8 Eagle St, Rochester, NY716-325-2907
Bale, J R/1283 Cambridge Ave, Plainfield, NJ908-561-9762
Baleno, Ralph/192 Newtown Rd, Plainview, NY516-293-3399
Balmain, Maxwell/2 E Elm St #35, Greenwich, CT203-629-7913
Bancroft, Monty/Mt Holly Rd, Katonah, NY914-232-3855
Banville, Andre/Chevalier Ave, Greenfield, MA413-773-7513
Barao, S J/580 Arcade Ave, Seekonk, MA508-336-5015
Bard, M/Box 126AA/Lily Pond Rd, Parksville, NY914-292-5972
Barker, Robert/35 Buffalo Dr, Rochester, NY719-383-8850
Barlow, Len/8 Gloucester St, Boston, MA617-266-4030
Barnes, Christopher/116 Winnisimmet St, Chelsea, MA617-884-2745
Barocas, Melanie Eve/78 Hart Rd, Guilford, CT203-457-0898
Baron, Greg/35 E Stewart Ave, Lansdowne, PA215-626-8677
Barone, Christopher/381 Wright Ave, Kingston, PA717-287-4680
Barrett, Bob/323 Springtown Rd, New Paltz, NY914-255-1591
Barron, David M/247 Dutton Rd, Sudbury, MA508-443-7423
Barros, Ricardo/91 Birch Ave, Princeton, NJ609-497-2161
Barrow, Pat/10 Post Office Rd, Silver Spring, MD301-588-3131
Barrow, Scott/44 Market St, Cold Spring,
NY (P 35-37) ..**914-265-4242**
Barrows, Wendy Photography/15 Westway Rd,
Westport, CT (P 76) ..**212-685-0799**
Barth, Stephen/37 S Clinton St, Doylestown, PA215-340-0900
Bartlett; Harry/82 Lowell St, Somerville, MA617-628-0084
Bartlett, Linda/3316 Runnymede Pl NW, Washington, DC202-362-4777
Bartz, Michael A/723 Greenleaf St, Allentown, PA215-434-1117
Basch, Richard/2627 Connecticut Ave NW, Washington, DC202-232-3100
Baskin, Gerry/12 Union Park St, Boston, MA617-482-3316
Bassett, Betsy/ 123 Washington Ave, Newton, MA617-332-8072
Bates, Carolyn/PO Box 125, Burlington, VT802-862-5386
Baumel, Ken/RR 1/Box 306, Milford, PA ..717-686-2900
Bavendam, Fred/PO Box 276, E Kingston, NH603-642-3215
Beach, Jonathan/116 Townline Rd, Syracuse, NY315-455-8261
Beall, Gordon/4411 Bradley Lane, Chevy Chase, MD301-718-6238
Bean, Jeremiah/98 North Ave, Garwood, NJ908-789-2200
Beards, James/45 Richmond St, Providence, RI401-273-9055
Beardsley, John/322 Summer 5th Fl, Boston, MA617-482-0130
Beatty, Alex/32 Lincoln Ave, Lynnfield, MA617-334-4069
Beauchesne Photo/4 Bud Way/Vantage Pt III/#2, Nashua, NH603-880-8686
Beck, Richard/116 Manor Dr, Red Bank, NJ908-747-8948
Beckelman, Mark/8 Remer Ave, Springfield, NJ201-467-3456
Becker, Art/2617 Peach St, Erie, PA ..814-453-4198
Becker, Tim/266 Burnside Ave, E Hartford, CT203-528-7818
Beckerman, Arnold/Star Route 70, Great Barrington, MA413-229-8619
Beebe, Jay/186 Atlantic Ave, Marblehead, MA617-631-2730
Beigel, Daniel/1615 St MArgarets Rd, Annapolis, MD410-974-1234
Bell, Mike/630 N Second St, Philadelphia, PA215-925-2084
Bender, Frank/2215 South St, Philadelphia, PA215-985-4664
Bender, Larry/334 Windsor Park Lane, Havertown, PA215-449-9703
Benedetto, Angelo/825 S 7th St, Philadelphia, PA215-627-1990

Bennett, Robert J/310 Edgewood St, Bridgeville , DE302-337-3347
Bennett, William/128 W Northfield Rd, Livingston, NJ201-992-7967
Bennis, Raymond S/300 N Black Horse Pike, Runnemede, NJ609-939-9401
Benoit, David/31 Blackburn Ctr, Gloucester , MA508-281-3079
Benson, Gary/PO Box 29, Peapack, NJ ..908-234-2216
Benson, Robert/150 Huyshope Ave, Hartford, CT203-724-2939
Benvenuti, Judi/12 N Oak Ct, Madison, NJ201-377-5075
Berenson, Barry/16 Front St, Salem, MA508-740-3112
Bergman, LV & Assoc/East Mountain Rd S, Cold Spring, NY914-265-3656
Bergman, Michael/134 Farnsworth Ave, Bordentown, NJ609-291-1869
Bergold Jr., James/410 Gravel Hill Rd, Kinnelon, NJ201-492-8578
Berinstein, Martin/215 A St 6th Fl, Boston,
MA (P 77) ..**617-268-4117**
Berndt, Jerry/41 Magnolia Ave, Cambridge, MA617-354-2266
Berner, Curt/211 A St, Boston, MA..617-269-1698
Bernstein, Daniel/7 Fuller St, Waltham, MA617-894-0473
Berry, Michael/838 S Broad St, Trenton, NJ609-396-2413
Bertling, Norbert G Jr/2125 N Charles St, Baltimore, MD410-727-8766
Bessler, John/503 Broadway 5th Fl ..212-941-6179
Bethoney, Herb/23 Autumn Circle, Hingham, MA617-740-2290
Bevan, Pat/200 Fort Meade Rd #907, Laurel, MD301-498-7808
Bezushko, Bob/1311 Irving St, Philadelphia, PA215-735-7771
Bezushko, George/1311 Irving St, Philadelphia, PA215-735-7771
Bibikow, Walter/76 Batterymarch St, Boston, MA617-451-3464
Biegun, Richard/56 Cherry Ave, West Sayville, NY516-567-2645
Bilyk, I George/314 E Mt Airy Ave, Philadelphia, PA215-242-5431
Bindas, Jan Jeffrey/205 A St, Boston, MA617-268-3050
Bingham, Jack/PO Box 738, Barrington, NH....................................603-664-9000
Binzen, Bill/49 Weatogue Rd, Salisbury, CT203-824-0093
Birn, Roger/150 Chestnut St, Providence, RI401-421-4825
Bishop, Ed/39 Commercial Wharf, Boston, MA617-227-6286
Bishop, Jennifer/2732 St Paul St, Baltimore, MD............................410-366-6662
Bitters, David C/62 Teakettle Lane PO Box 322, Duxbury, MA617-934-2838
Blackfan Studio/266 Meetinghouse Rd, New Hope, PA215-862-3503
Blair, Jonathan/2301 N Grant Ave, Wilmington, DE..........................302-652-4122
Blair, Randall/3939 McKinley St NW, Washington, DC202-364-1019
Blake, Mike/47 Harvard St, Newton, MA..617-965-7711
Blakely, Peter/Box 263, Francestown, NH603-547-3600
Blakeslee-Lane Studios/916 N Charles St, Baltimore, MD................410-727-8800
Blank, Bruce/228 Clearfield Ave, Norristown, PA215-539-6166
Blate, Samuel R/10331 Watkins Mill Dr, Gaithersburg, MD301-840-2248
Blevins, Burgess/601 N Eutaw St #713, Baltimore, MD410-685-0740
Blizzard, William/PO Box 302, Vorhees, NJ609-784-4406
Bloomberg, Robert/4 Pleasant St, Danbury, CT203-794-1764
Bloomenfeld, Richard/200-19 E 2nd St, Huntington Sta, NY516-424-9492
Blouin, Craig/PO Box 892, Henniker, NH ..603-428-3036
Boehm, J Kenneth/96 Portland Ave, Georgetown, CT......................203-544-8524
Bogacz, Mark F/11 Pondview Place, Tyngsboro, MA617-649-3886
Bogart, Del/211 Conanicus Ave, Jamestown, RI401-423-1709
Bognovitz, Murray/4980 C Wyaconda Rd, Rockville, MD..................301-984-7771
Bohm, Linda/7 Park St, Montclair, NJ ..201-746-3434
Boisvert, Paul/229 Loomis St, Burlington, VT802-862-7249
Boldt, Scott/438 Brickyard Rd, Freehold, NJ..................................201-780-4575
Bolster, Mark/502 W North Ave, Pittsburgh,
PA (P 78,79) ..**412-231-3757**
Bonifield, Roger/3021 Hebron Drive, Pittsburgh, PA........................412-242-2602
Bonito, Arthur/5 Nolans Point Rd, Lake Hopatcong, NJ201-663-1555
Bonjour, Jon/496 Congress St, Portland, ME207-773-5398
Bookbinder, Sigmund/Box 833, Southbury, CT203-264-5137
Booker, David/8 Lum Lane, Newark, NJ ..201-465-0944
Borg, Erik/RR #3/Drew Lane, Middlebury, VT802-388-6302
Borkoski, Matthew/305 Ladson Rd, Silver Spring, MD......................301-681-3051
Borkovitz, Barbara/2844 Wisconsin Ave NW #806, Washington, DC ..202-338-2533
Borris, Daniel/126 11th St SE, Washington, DC................................202-546-3193
Bossi, Robert/Box 4784, Portsmouth, NH603-431-7366
Boston Photographers/56 Creighton St, Boston, MA617-491-7474
Botelho, Tony/505 Greenwich Ave, W Warwick, RI401-828-0567
Bounds, Pierce/225 West Baltimore Street, Carlisle, PA717-249-6617
Bova, David/123 Dayton St, Danvers, MA508-750-4346
Bowen, Dave/PO Box 937, Wellsboro, PA717-326-1212
Bowl, Greg Studio/409 W Broadway, S Boston, MA..........................617-268-1210
Bowman, Gene/86 Lackawanna Ave, West Paterson, NJ201-256-9060
Bowman, Jo/1102 Manning St, Philadelphia, PA..............................215-625-0200
Bowman, Ron/PO Box 4071, Lancaster, PA717-898-7716
Bowne, Bob/708 Cookman Ave, Asbury Park, NJ908-988-3366
Boxer, Jeff Photography/520 Harrison Ave, Boston, MA617-266-7755
Boyer, Beverly/17 Llanfair Rd, Ardmore, PA215-649-0657
Brack, Dennis/318 Third St Rear NE, Washington, DC202-547-1176

Bradley, Dave/840 Summer St, Boston, MA ..617-268-6644
Bradtke, Andrew/1611 Wilson Place, Silver Spring, MD301-588-8724
Brady, Rick/3062 Riverview Rd, Riva, MD..410-798-5386
Branner, Debra/4528 Maryknoll Rd, Pikesville, MD.............................410-486-4665
Brassard, Paul/44 Spring St, Adams, MA ...413-743-2265
Braverman, Ed/337 Summer St, Boston, MA617-423-3373
Bravo, David/18 S Marshall St, Norwalk, CT.......................................203-866-9090
Brega, David/PO Box 13, Marshfield Mills, MA...................................617-555-1212
Brennan, James/231 Curtis Corner Rd, Peace Dale, RI401-789-7170
Brenner, Jay/24 S Mall St, Plainview, NY..516-752-0610
Breslin, Daniel/1480 Pleasant Valley Wy #42, W Orange, NJ............201-736-4585
Bress, Pat/7324 Arrowood Rd, Bethesda, MD....................................301-469-6275
Briel, Petrisse/36 Middlesex Rd, Winchester, MA617-729-8953
Briglia, Thomas/PO Box 487, Linwood, NJ...609-748-0864
Brignoli, Frank & Christine/PO Box 778, E Dennis, MA......................508-385-8191
Brignolo, Joseph B/Oxford Springs Rd, Chester, NY..........................914-496-4453
Brilliant, Andy/107 South St #203, Boston, MA..................................617-482-8938
Brink, Fred/94 Harvard Ave, Brookline, MA ..617-566-5223
Brittany Photo/B241/4201 Neshaminy Blvd #108, Bensalem, PA........215-752-1107
Britz Fotograf/2619 Lovegrove St, Baltimore, MD410-338-1820
Broock, Howard/432 Sharr Ave, Elmira, NY..607-733-1420
Bross, Tom ...617-227-4137
Brough Schamp, J/3616 Ednor Rd, Baltimore, MD.............................410-235-0840
Brown, Christopher/, Boston, MA...617-555-1212
Brown, Constance/PO Box 2346, Providence, RI................................401-274-2712
Brown, Dorman/POB 0700/Coach Rd #8B, Quechee, VT802-296-6902
Brown, Gerald/1929 Chestnut St, Harrisburg, PA713-236-4698
Brown, Martin/Cathance Lake, Grove Post Office, ME207-454-7708
Brown, Nan/12 Spaulding St, Boston, MA...617-522-3344
Brown, Porter/1213 Swingingdale Dr, Silver Spring, MD.....................301-384-3055
Brown, Richard W/RFD, Barnet, VT...802-592-3567
Brown, Skip/6514 75th St, Cabin John, MD ..301-320-0752
Brown, Stephen R/1882 Columbia Rd NW, Washington, DC................202-667-1965
Brown, Valerie/2468 Belmont Rd NW, Washington, DC,202-362-4899
Brownell, David/PO Box 60, Andover, NH..603-735-6640
Brownell, William/1411 Saxon Ave, Bay Shore, NY516-665-0081
Brt Photographic Illustrations/911 State St, Lancaster, PA..................717-393-0918
Brundage, Kip/66 Union St, Belfast, ME..207-338-5210
Bruno Photo/326 A Street, Boston, MA..617-451-6152
Bryan, Gail/285 Jerusalem Rd, Cohasset, MA617-383-0483
Bryn, Deborah/PO Box 504, Waterford, NY...518-235-4656
Bubbenmoyer, Kevin/RD #2 Box 110, Orefield,
PA (P 81) ..**215-395-3052**
Bubriski, Kevin/817 Main St, Bennington, VT802-442-4516
Buchanan, Robert Photography/56 Lafayette Ave,
White Plains, NY (P 82,83) ..**914-948-9260**
Buckley Assoc/3190 Vaughan St, Portsmouth, NH..............................603-431-9313
Buckman, Sheldon/17 Kiley Dr, Randolph, MA....................................617-986-4773
Buff, Cindy/580 Patten Ave #55, Long Branch, NJ.............................908-870-3223
Bulkin, Susan/5453 Houghton Place, Philadelphia, PA.......................215-483-4881
Bulvony, Matt/2715 Sarah St, Pittsburgh, PA412-431-5344
Burak, Chet/130 Taunton Ave, E Providence, RI.................................401-431-0625
Burdick, Gary Photography/9 Parker Hill, Brookfield, CT.....................203-775-2894
Burger, Oded/9 Wickford Rd, Framingham, MA508-788-0677
Burke, Bill/6 Melville Ave, Dorchester, MA..617-265-3070
Burke, John/60 K St, Boston, MA (P 85)**617-269-6677**
Burke, John & Judy/116 E Van Buren Ave, New Castle, DE................302-322-8760
Burke, Robert/35 Darrow Dr, Catonsville, MD410-744-4314
Burns, Steve/30 Westwood Ave/POB 175, Westwood, NJ201-358-1890
Burrell, Fred/25 Shadyside Ave, Nyack, NY..914-358-4902
Burris, Ken/PO Box 592, Shelburne, VT ...802-985-3263
Burwell/Burwell/6925 Willow St NW, Washington, DC202-882-1337
Busch, Gisele/836 Kings Croft, Cherry Hill, NJ...................................609-667-3517
Buschner Studios/450 West Metro Park, Rochester, NY......................716-475-1170
Butler, Herbert/200 Mamaroneck Ave, White Plains, NY....................914-683-1767
Butler, Jeff/106 Wood St, Rutherford, NJ..201-460-1071
Buxbaum, Jack/33 Queen Ave, New Castle, DE302-656-5121
Byron, Pete/75 Mill Rd, Morris Plains, NJ..201-538-7520

C

Cacicedo, Kathy/53 Briarwood Dr E, Berkeley Heights, NJ908-665-7892
Caffee, Chris/216 Blvd of Allies, Pittsburg, PA412-642-7734
Cafiero, Jeff/410 Church Ln, North Brunswick, NJ..............................908-297-8979
Caggiano, Angelo/214 S 17th St, Philadelphia, PA.............................215-433-8312
Cali, Guy/Layton Rd, Clarics Summit, PA..717-587-1957
Callaghan, Charles/54 Applecross Circle, Chalfont, PA......................215-822-8258
Campbell, Tyler/PO Box 373, Chestertown, MD..................................410-778-4938

Canavino, Kay/1 Fitchburg St, Somerville, MA....................................617-625-1115
Canner, Larry/413 S Ann St, Baltimore, MD.......................................410-276-5747
Cantor-MacLean, Donna/2828 10th St NE, Washington, DC...............202-789-1200
Capobianco, Ron/10 Arlington Lane, Bayville, NY...............................516-628-2670
Capone, Frank/230-D Ferry St, Easton, PA ...215-252-4100
Carbone, Fred/1041 Buttonwood St, Philadelphia, PA........................215-236-2266
Carrino, Nick/710 S Marshall St, Philadelphia, PA..............................215-925-3190
Carroll, Hanson/11 New Boston Rd, Norwich, VT................................802-649-1094
Carroll, Mary Claire/POB 67, Richmond, VT802-434-2312
Carroll, Michael Photo/25 Main St, Pepperell, MA..............................508-433-6500
Carstens, Don/2121 N Lovegrove St, Baltimore, MD410-385-3049
Carter, J Pat/3000 Chestnut Ave #116, Baltimore, MD.......................410-243-6074
Carter, John/111 Orange St, Wilmington, DE302-652-4353
Carter, Philip/PO Box 479, Bedford Hills, NY......................................914-232-5882
Casciano, Jerry/59 Rivington Ave, W Long Branch, NJ.......................908-389-8941
Castalou, Nancy/RD 2/ Box 145, Valatie, NY......................................518-758-9565
Castay, Joseph/PO Box 208, Newburyport, MA...................................508-462-8008
Castle, Ed/4242 East West Highway #509, Chevy Chase, MD301-585-9300
Cataffo, Linda/PO Box 460, Palisades Park, NJ..................................201-694-5047
Catalano, Adrian/219 5th St, Cambridge, MA617-868-5352
Catania, Vin/77 King Philip St, S Weymouth, MA617-337-3435
Cateriniccio, Russell Paul/1974 St George Ave #4, Rahway, NJ908-499-7162
Caudill, Dennis/1814 Lancaster St, Baltimore, MD410-563-0906
Caughey, Bern/59 Pond St, Cohasset, MA..617-357-3165
Cavallo, Frank/666 Anderson Ave, Cliffside, NJ..................................201-941-9522
Cavanaugh, James/On Location/PO Box 158, Tonawanda, NY...........716-633-1885
Cerniglio, Tom/1115 E main St, Rochester, NY...................................716-654-8561
Cessna, John/198 Mohegan Rd, Huntington, CT.................................203-387-1143
Chachowski, Hank/119 N Fifth Ave, Manville, NJ................................908-722-0948
Chadbourne, Bob/595-603 Newbury St, Boston, MA617-262-3800
Chambers, Tom R/411 Atwells Ave, Providence, RI401-861-3963
Chandoha, Walter/RD 1 PO Box 287, Annandale, NJ.........................908-782-3666
Chao, John/Bayview Business Pk, Gilford, NH.....................................603-293-2727
Chaplain, Ira/44 Brimmer St, Boston, MA...617-227-5662
Chaplin, June/230 Dunkirk Rd, Baltimore, MD410-377-2742
Chapman, Kathy/322 Summer St 5th Fl, Boston, MA..........................617-482-9502
Chapman, Larry/Box 90220, Washington, DC,....................................202-328-6767
Charland, Robert/840 Summer St, Boston, MA...................................617-268-4599
Chase, Richard/70 Central St, Acton, MA ...508-263-0368
Chase, Thomas W/PO Box 720, Wolfeboro, NH..................................603-875-2808
Chatwin, Jim/5459 Main St, Williamsville, NY716-634-3436
Chauve, Karyn/75 Highland Rd, Glenn Cove, NY516-676-0365
Cherin, Alan/907 Penn Ave, Pittsburgh, PA..412-261-3755
Child, Andrew/12205 Village Sq Terr #202, Rockville, MD..................301-251-0720
Chisolm, Bill/35 Kingston, Boston, MA ..617-338-9224
Chiusano, Michael/39 Glidden St, Beverly, MA....................................508-927-7067
Chomitz, Jon/3 Prescott St, Somerville, MA...617-625-6789
Choroszewski, Walter J/1310 Orchard Dr/S Branch, Somerville, NJ.....908-369-3555
Christian, Douglas/443 Albany St, Boston, MA617-482-6206
Christoph/149 Broadway, Greenlawn, NY..516-757-0524
Christopoulos Photography/45 Lee St, Pawtucket, RI..........................401-722-0350
Chromographics/9 May St, Beverly, MA...508-927-7451
Ciaglia, Joseph/2036 Spruce St, Philadelphia, PA..............................215-985-1092
Ciuccoli, Stephen/575 Broad St #528, Bridgeport, CT203-333-5228
Clancy, Paul/95 Chestnut St, Providence, RI.......................................401-421-8025
Clare, William/416 Bloomfield Ave, Montclair, NJ................................201-783-0680
Clark, Carl/2068 Linden Ave, Baltimore, MD410-523-5602
Clark, Conley/9003 Linton St, Silver Spring, MD.................................301-445-4650
Clark, Leigh/1359 Beacon St, Brookline, MA.......................................617-566-1612
Clark, Michael/PO Box 423, Stowe, VT..802-888-5373
Clarke, Jeff/266 Pine St, Burlington, VT ..802-863-4393
Clarkson, Frank/PO Box 148, Portsmouth, NH....................................603-427-0006
Clary, Jim/1090 Eddy St, Providence, RI...401-941-8100
Cleff, Bernie Studio/715 Pine St, Philadelphia, PA215-922-4246
Clegg, Cheryl/27 Dry Dock Ave, Boston, MA.......................................617-439-4343
Clemens, Clint/1800-D Abbot Kinney Blvd, Venice, CA.......................213-574-3955
Clemens, Peter/153 Sidney St, Oyster Bay, NY...................................516-922-1759
Clements/Howcroft/59 Wareham St, Boston, MA.................................617-423-3516
Clermont, Paula/10A Anderson Circle, Londonderry, NH.....................603-432-3634
Clifford, Joan/38 Hudson St, Quincy, MA ..617-328-4623
Clifford, Len/RD Box 1628, Columbia, NJ ...908-475-4021
Clineff, Kindra/16 Hillside Ave, Winchester, MA..................................617-756-0020
Clymer, Jonathan/180-F Central Ave, Englewood, NJ.........................201-568-1760
Coan, Stephen/750 South 10th St, Philadelphia, PA...........................215-923-3183
Cobos, Lucy/PO Box 8491, Boston, MA (P 62)**617-876-9537**
Coffee Pond Productions/72 Lincoln St #14, Newton High, MA...........617-965-2323
Cohen, Daniel/744 Park Ave, Hoboken, NJ...201-659-0952
Cohen, Evan/323 N Paca St, Baltimore, MD410-539-0111

Cohen, Marc Assoc/23 Crestview Dr, Brookfield, CT203-775-1102
Cohen, Stuart/PO Box 2007, Salem, MA ...617-631-7150
Coletti, John/3-1/2 Lynn Shore Dr, Lynn, MA....................................617-593-1742
Collegeman, Stephen R/7812 Temple St, Hyattsville, MD301-422-2790
Collins & Collins/PO Box 10736, State College, PA............................814-234-2916
Collins, Sheldon/6 Louisa Pl, Union City, NJ......................................201-867-6297
Colorworks Inc/14300 Cherry Lane Ct #106, Laurel Center, MD...........301-490-7909
Colucci, Joe/Box 2069/86 Lackawanna Ave, W Patterson, NJ..............201-890-5770
Colwell, David/3405 Keats Terrace, Ijamsville, MD.............................301-865-3931
Comb, David/107 South St 2nd Fl, Boston, MA...................................617-426-3644
Comella, Jeff/12 Pecan Dr, Pittsburgh, PA...412-795-2706
Comet, Renee/410 8th St NW, Washington, DC...................................202-347-3408
Comick, Joe/11428 Mapleview Dr, Silver Spring, MD...........................301-946-0860
Conaty, Jim/30 Rock St, Norwood, MA...617-469-6990
Conboy, John/1225 State St, Schenectady, NY...................................518-346-2346
Confer, Holt/2016 Franklin Pl, Wyomissing, PA..................................215-678-0131
Congalton, David/206 Washington St, Pembroke, MA..........................617-826-2788
Conner, Marian/456 Rockaway Rd #15, Dover, NJ..............................201-328-1823
Connor, Donna/272 Fourth Ave, Sweetwater, NJ................................609-965-3396
Connors, Gail/9 Alpen Green Ct, Burtonsville, MD..............................301-890-9645
Contrino, Tom/22 Donaldson Ave, Rutherford, NJ..............................212-947-4450
Conway Photography/PO Box 165, Charlestown, MA...........................617-242-0064
Cooke, Doug/23 Pond View Ave #2, Jamaica Plain, MA617-522-7591
Coolidge, Jeffrey/322 Summer St, Boston, MA617-338-6869
Coonan, Steve/3921 Old Town Rd, Huntingtown, MD...........................301-855-1441
Cooper, John F/One Bank St, Summit, NJ...908-273-0368
Cooper, Jon/4050 Washington St, Boston, MA....................................617-666-3453
Cooperman, Bill/7030 Powder Valley Rd, Zionsville, PA.......................215-965-2733
Corbett Jr, J D/Box 1219, Browns Mill, NJ..609-893-3516
Corcoran, John/310 Eighth St, New Cumberland, PA...........................717-774-0652
Cordingley, Ted/31 Blackburn Center, Gloucester, MA.........................617-283-2591
Cornell, Linc/31 Farm Hill Rd, Natick, MA..508-650-1612
Cornetti, James/Box 1167, Pleasantville , NJ......................................609-641-5023
Cornicello, John/317 Academy Terr, Linden, NJ..................................908-925-6675
Cornwell, Carol/10 Jordan Mill Ct, Whitehall, MD...............................410-343-1391
Corporate Graphics/Oxford/28 Corporate Cir, Albany, NY....................518-452-8410
Corsiglia, Betsy/PO Box 934, Martha's Vineyard, MA..........................508-693-5107
Cortesi, Wendy/3034 'P' St NW, Washington, DC................................202-965-1204
Cosloy, Jeff/35 Morrill St, W Newton, MA...617-965-5594

Coughlin, Suki/Main St/Box 1498, New London,
NH (P 89) **603-526-4645**

Courtney, David M/36 Tremont St, Concord, NH..................................603-228-8412
Coxe, David/, Cambridge, MA...617-547-4957
CR 2/36 St Paul St, Rochester, NY..716-232-5140
Crabtree, Shirley Ann/1 Prospect St #2A, New Rochelle, NY914-636-5494
Crandall, Steve/320 Hoboken Rd, E Rutherford, NJ.............................201-460-7722
Crane, Tom/113 Cumberland Pl, Bryn Mawr, PA..................................215-525-2444
Cranna, Greig/55 Pemberton St, Cambridge, MA617-868-8808
Crawford, Carol/14 Fortune Dr Box 221, Billerica, MA..........................617-663-8662
Creamer, Robert/2220 Eutaw Pl, Baltimore, MD..................................410-728-1586
Creative Image Photo/325 Valley Rd, West Orange, NJ201-325-2352
Creative Images/122 Elmcroft Rd, Rochester, NY...............................716-482-8720
Creative Photography/Bustleton & Tyson Aves, Philadelphia, PA...........215-332-8080
Croes, Larry/256 Charles St, Waltham, MA...617-894-4897
Crossan, Eric/473 Blackbird Landing Rd, Townsend, DE.......................302-834-7474
Crossley, Dorothy/Mittersill Rd, Franconia, NH...................................603-823-8177
Cullen, Betsy/125 Kingston St, Boston, MA..617-542-0965
Cunningham, Chris/9 East St, Boston, MA..617-542-4640
Curtis, Jackie/Alewives Rd, Norwalk, CT..203-866-9198
Curtis, John/27 Dry Dock, Boston, MA...617-451-9117
Cury, Valerie/2153 California St NW #404, Washington, DC202-332-3403
Cushner, Susie/354 Congress St, Boston, MA.....................................617-542-4070
Czamanske, Marty/61 Commercial St, Rochester, NY..........................716-546-1434
Czepiga, David/101 Fitzrandolph Ave, Hamilton, NJ.............................609-396-2976

D

D'Amico, Sam/142 Worden Ave, Hopelawn, NJ....................................908-442-8246
D'Angelo, Andy/620 Centre Ave, Reading, PA.....................................215-376-1100
Dai, Ping/30 Park St, Wakefield, MA..617-246-4704
Dalia, Gerald/26 Park Place, Morristown, NJ.......................................201-267-2217
Dalton, Douglas/236 Armington St, Cranston, RI.................................401-781-4099
Danello, Peter/386 Kerrigan Blvd, Newark, NJ....................................201-371-5899
Daniels, Craig/3925 Beech Ave #314, Baltimore, MD...........................410-467-7536
Daniels, Jim/386 Fore St, Portland, ME ...207-772-5797
Daniels, Mark/8413 Piney Branch Rd, Silver Spring, MD......................301-587-1727
Dannenberg, Mitchell/261 Averill Ave, Rochester, NY716-473-6720
Darling, Paul/418 County Rd, Barrington, RI.......................................401-245-8330

Davidson, Heather/RD 2/Box 215, Rock Hall, MD410-639-7368
Davis, Howard/19 E 21st St, Baltimore, MD410-625-3838
Davis, James/159 Walnut St, Montclair, NJ...908-747-6972
Davis, Neal Assoc/42 Breckenridge, Buffalo, NY................................716-881-4047
Davis, Pat Photo/14620 Pinto Ln, Rockville, MD.................................301-424-0577
Davis, Rick/210 Carter Dr #9/Matlack Ind, West Chester, PA...............215-436-6050
Davis, Rita G/26 Ryder Ave, Dix Hills, NY..516-595-9368
Day, Joel/421 Walnut St, Lancaster, PA...717-291-7228
De Lorenzo, Bob/211 Steward St, Trenton, NJ....................................609-586-2421
De Lucia, Ralph/120 E Hartsdale Ave, Hartsdale, NY914-472-2253
De Maio, Joe/529 Main St, Charlestown, MA......................................617-242-2000
De Simone, Bill/43 Irving St, Cambridge, MA......................................617-491-4583
De Zanger, Arie/Sugarloaf, NY...914-469-4498
De Zitter, Harry/268 Deer Meadow Lane, Chatham, MA.......................508-945-4487
Dean, Floyd/2-B S Poplar St, Wilmington, DE302-655-7193
Dean, John/2435 Maryland Ave, Baltimore, MD..................................410-243-8357
Debas, Bruno/49 Melcher St, Boston, MA..617-451-1394
Dee, Monica/208 Willow Ave #403, Hoboken, NJ................................201-963-6086
Deering, William/700 Nottingham Rd, Wilmington, DE.........................302-888-2267
DeFilippis, Robert/70 Eighth St, Woodridge, NJ.................................201-896-9241
Degginger, Phil/189 Johnson Rd, Morris Plains, NJ.............................201-455-1733
Degnan, Dennis/Box 246, Bryn Mawr, PA..215-527-5295
Degrado, Drew/37 Midland Ave, Elmwood Park, NJ............................201-797-2890
Del Palazzo, Joe/122 W Church St, Philadelphia, PA...........................215-627-1333
Delaney, Ray/403 Charles St, Providence, RI......................................401-331-9450
Delano, Jon/227 Christopher Columbus Dr, Jersey City, NJ..................201-309-2110
Delbert, Christian/19 Linell Circle, Billerica, MA..................................617-273-3138
DeLellis, R A/43 Merrimack St, Lawrence, MA....................................508-681-0588
Delevingne, Lionel/123 Audubon Rd, Leeds, MA................................413-586-3424
Delmas, Didier/1 Mill St, Burlington, VT...802-862-0120
DeMichele, Bill/40 Broadway, Albany, NY..518-436-4927
Dempsey-Hart, Jonathan/60 K Street, Boston, MA..............................617-268-0777
Dempster, David/5 Pirates Ln, Gloucester, MA...................................508-281-5118
Denison, Bill/302 Thornhill Rd, Baltimore, MD....................................410-323-1114
Denuto, Ellen/24 Mill St, Patterson, NJ...201-881-0614
Derenzis, Philip/421 N 23rd St, Allentown, PA....................................215-776-6465
DeSoto, Toni/457 Main St, Danbury, CT...203-797-9999
Desroches, David/443 Albany St #403, Boston, MA.............................617-482-0300
Devenny, Joe/RR 1/Box 900, Jefferson, ME.......................................207-549-7693
Deveraux, Joanne/123 Oxford St, Cambridge, MA...............................617-876-7618
DeVito, Mary/2528 Cedar Ave, Ronkonkoma, NY................................516-981-4547
DeVito, Michael Jr/40-A N Village Ave, Rockville Ctr, NY.....................212-243-5267
DeWaele, John/14 Almy St, Lincoln, RI..401-726-0084
Dey, Kinsley/78 Mill Run West, Hightstown, NJ...................................609-426-9762
Di Meo, Martha/69 Laconia Rd, Cranston, RI......................................401-942-2974
Dibble, Warren/373 Commonwealth Ave #504, Boston, MA..................617-236-1606
Dickenson, Townsend P/208 Flax Hill Rd #60, Norwalk, CT..................203-853-4834
Dickstein, Bob/101 Hillturn Lane, Roslyn Heights, NY.........................516-621-2413
Diebold, George/416 Bloomfield Ave, Montclair, NJ.............................212-645-1077
DiGiacomo, Melchior/32 Norma Rd, Harrington Park, NJ.......................201-767-0870
Dillard, Ted/16 Ayer Rd/Box 112, Harvard, MA...................................508-456-8779
Dillon, Emile Jr/PO Box 39, Orange, NJ...201-675-5668
Dillon, George/210 South St, Boston, MA...617-482-6154
DiMaggio, Joe/512 Adams St, Centerport, NY.....................................516-271-6133
DiMarco, Salvatore C Jr/1002 Cobbs St, Drexel Hill, PA.......................215-789-3239
DiMartini, Sally/1 Oyster lane, E Hampton, NY...................................516-329-1236
DiMarzo, Bob/109 Broad St, Boston, MA..617-720-1113
Dinet Associates/5858 Molloy Rd #100, Syracuse, NY.........................315-455-6673
Dinn, Peter/52 Springtree Lane, S Berwick, ME..................................207-384-2877
Disario, George/50 Washington St, Newburyport, MA..........................508-465-2218
Distefano, Paul/Hasbrouck Heights, NJ...201-471-0368
Distler, Dan/618 Allen St, Syracuse, NY..315-475-1938
Dodge, Brooks/PO Box 247/Eagle Mtn Rd, Jackson, NH......................603-383-6830
Dodson, George/692 Gennessee St, Annapolis, MD............................301-261-2099
Dolgin, Marcia/Box 127, Sharon, MA...617-784-4454
Donnelly, Gary/137 S. Easton Rd, Glenside, PA..................................215-576-6223
Donovan, Bill/165 Grand Blvd, Scarsdale, NY.....................................914-472-0938
Dorfmann, Pam/5161 River Rd Bldg 2B, Bethesda, MD........................301-652-1303
Dorman-Brown Photography/Coach Rd, Quechee, VT..........................802-296-6902
Dosch, Patrick/5 Concord Ave #64, Cambridge, MA............................617-492-4777
Douglass, Jim Photogroup Inc/5161 River Rd
Bldg 2A, Bethesda, MD (P 274,275)................................**301-652-1303**
Dovi, Sal/2935 Dahlia St, Baldwin, NY...516-379-4273
Dow, Jim/95 Clifton St, Belmont, MA...617-484-4624
Dow, Norman/52 Concord Ave, Cambridge, MA..................................617-492-1236
Dowling, John/521 Scott Ave, Syracuse, NY.......................................315-446-8189
Dragan, Dan/PO Box 2, N Brunswick, NJ...908-566-3431
Dratch, Howard/2173 Stoll Rd, Saugerties, NY...................................914-246-5213

Dreyer, Peter H/916 Pleasant St #11, Norwood, MA617-762-8550
Driscoll, Dan/20 Forest Ave, Hawthorne, NJ201-423-1415
Dubroff, Richard/1900 Tatnall St, Wilmington, DE302-655-7718
Duffy, Daniel/50 Croydon Rd, Worcester, MA508-853-9116
Dugas, Rich/6 Laurel Lane, N Smithfield, RI401-765-1863
Dunham, Tom/335 Gordon Rd, Robinsville, NJ609-259-6042
Dunn, Jeffrey/32 Pearl St, Cambridge, MA..................................617-864-2124
Dunne, Paul/28 Southpoint Dr, S Sandwich, MA508-420-5511
Dunoff, Rich/1313 Delmont Ave, Havertown, PA215-642-6137
Dunwell, Steve/20 Winchester St, Boston,
MA (P 54,55) ...**617-423-4916**
Dupont, Iris/7 Bowdoin Ave, Dorchester, MA617-436-8474
Durrance, Dick/Dolphin Ledge, Rockport, ME207-236-3990
Durvin, Bill/135 Webster St, Pawtucket, RI401-728-0091
Dutkovic, Bill/160 William Pitt Way, Pittsburgh, PA412-826-5235
Dweck, Aboud/2300 Walnut St #301, Philadelphia, PA215-564-9325
Dwiggins, Gene/204 Westminster Mall, Providence, RI401-421-6466
Dworsky, Jeff/PO Box 32, Stonington, ME207-367-5546
Dwyer, James/91 School St, Westwood , MA................................617-326-8916
Dyekman, James E/14 Cherry Hill Circle, Ossining, NY914-941-0821
Dyer, Ed/414 Brandy Lane, Mechanicsburg, PA717-737-6618

E

Earle, John/PO Box 63, Cambridge, MA617-628-1454
Eastern Light Photo/113 Arch St, Philadelphia, PA215-238-0655
Eastwood, Henry C/800 3rd St NE, Washington, DC202-543-9229
Edelman, Harry/2790 McCully Rd, Allison Park, PA412-486-8822
Edenbaum, Josh/232 W Exchange St, Providence, RI401-943-5568
Edgar, Andrew/135 McDonough St, Portsmouth, NH603-436-4221
Edgerton, Brian/Box 364/11 Old Route 28, Whitehouse, NJ.........908-534-9400
Edgeworth, Anthony/11135 Korman Dr, Potomac, MD301-983-2343
Edson, Franz Inc/26 Watch Way, Huntington, NY516-692-4345
Edson, Steven/25 Otis St, Watertown, NY617-357-8032
Edwards, Robert/14020-B Justin Way, Laurel, MD.......................301-490-9659
Egan, Jim/Visualizations/150 Chestnut St, Providence, RI............401-331-6220
Ehrlich, George/PO Box 186, New Hampton, NY914-355-1757
Eich, Ed/10 Chapman Ave, Andover, MA.....................................508-470-1424
Eisenberg, Leonard J/85 Wallingford Rd, Brighton, MA617-787-3366
El-Darwish, Mahmoud/6925-A Willow St NW, Washington, DC202-291-5424
Elder, Tommy/40 Stowe St, Concord, MA508-369-1658
Electro/Grafiks/1238 Callow Hill St #404, Philadelphia, PA215-923-6440
Elson, Paul/8200 Blvd East, North Bergen,
NJ (P 90,91) ..**201-662-2882**
Emmott, Bob/700 S 10th St, Philadelphia, PA215-925-2773
Ennis, Phil/98 Smith St, Freeport, NY ...516-379-4273
Enos, Chris/1 Fitchburg St, Somerville, MA617-625-8686
Epstein, Alan Photography/295 Silver St, Agawam, MA413-789-3320
Epstein, Robert/6677 MacArthur Blvd, Bethesda, MD301-320-3946
Epstein, William/Box 9067, N Bergen, NJ....................................201-662-7983
Erle, Steve/87 Gainsborough St, Boston, MA...............................617-357-3042
Esposito, Anthony Jr/48 Old Amity Rd, Bethany, CT....................203-393-2231
Esposito, James/220 Little Falls Rd, Cedar Grove, NJ201-239-1887
Esto Photo/222 Valley Pl, Mamaroneck, NY914-698-4060
Evans, John C/223 Fourth Ave #1712, Pittsburgh, PA412-281-3663
Everett Studios/22 Barker Ave, White Plains, NY.........................914-997-2200
Everett, Michael/1744 Kalorama Rd NW, Washington, DC202-234-2349
Everson, Martha/219 Fisher Ave, Brookline, MA...........................617-232-0187
Ewing Galloway/100 Merrick Rd, Rockville Centre, NY516-764-8620
Eyle, Nicolas Edward/205 Onondaga Ave, Syracuse, NY315-422-6231

F

F-90 Inc/60 Sindle Ave, Little Falls, NJ201-785-9090
Falkenstein, Roland/142 North Bread St, Philadelphia, PA215-592-7138
Falocco, John/1 Forest Dr, Warren, NJ ..908-769-9044
Fanelli, Chip/10 Nevada Ave, Somerville, MA617-623-8374
Faraghan, George/940 N Delaware Ave, Philadelphia, PA...........215-928-0499
Farina, Ron/916 Berkeley Ave, Trenton, NJ609-393-7890
Farkas, Alan/114 St Paul St #2, Rochester, NY716-232-1124
Farley, G R/701 John St, Utica, NY ...315-894-4438
Farr, Julie/135 West Market St, Scranton, PA717-961-8523
Farrer, Herman/1305 Sheridan St NW, Washington, DC202-723-7979
Farris, Mark/8804 Monard Dr, Silver Spring, MD301-588-6637
Fatone, Bob/166 W Main St, Niantic, CT203-739-2427
Fatta, Carol Studio/25 Dry Dock Ave, Boston,
MA (P 94,95) ..**617-423-6638**
Faulkner, Robert I/14 Elizabeth Ave, East Brunswick, NJ908-390-6650

Fay Foto/45 Electric Ave, Boston, MA ...617-267-2000
Feil, Charles W III/36 Danforth St, Portland, ME..........................207-773-3754
Feiling, David/1941 Teall Ave, Syracuse, NY315-437-7059
Feinberg, Paul/5207 Colorado Ave NW, Washington, DC202-291-0662
Feingersh, Jon/110-E Frederick Ave, Rockville, MD301-340-1525
Feinstein, Claire/201 Tilton Rd #13-A, Northfield, NJ609-383-8622
Felber, Richard/8 Ore Hill Rd, S Kent, CT203-927-4016
Felker, Richard/RR 1/Box 200-B, Pembroke, ME207-726-5890
Fell, Derek/PO Box 1, Gardenville, PA ...215-766-2858
Fellows, Dick/401 N 21st St, Philadelphia, PA215-977-7788
Fennell, Mary/57 Maple Ave, Hastings on Hudson, NY914-478-3627
Feraulo, Richard/760 Plain St, Marshfield, MA617-837-9563
Ferreira, Al/237 Naubuc Ave, East Hartford, CT...........................203-569-8812
Ferrino, Paul/PO Box 3641, Milford, CT203-878-4785
Fetter, Frank/19 Haggers Lane, Fair Haven, NJ908-530-4098
Fetters, Paul/3333 K St NW #50, Washington, DC202-342-0333
Ficksman, Peter/468 Fore St, Portland, ME207-773-3555
Fields, Tim/916 Dartmouth Glen Way, Baltimore, MD410-323-7831
Filipe, Tony/PO Box 1107, Block Island, RI..................................401-728-2339
Findlay, Christine/Hwy 36 Airport Plaza, Hazlet, NJ908-264-2211
Fine, Jerome/4594 Brookhill Dr N, Manlius, NY...........................315-682-7272
Fink, Arthur/190 Danforth St, Portland, ME207-774-3465
Finlayson, Jim/PO Box 337, Locust Valley, NY516-676-5816
Finnegan, Michael/PO Box 901, Plandome, NY516-676-0653
Fiore, Anthony/600 Cooper Center W, Pennsauken, NJ609-662-1884
Fisher, Al/601 Newbury St, Boston, MA617-536-7126
Fisher, Elaine/7 McTernan St, Cambridge, MA.............................617-492-0510
Fisher, Patricia/2234 Cathedral Ave NW, Washington, DC202-232-3781
Fitch, Roberrt/725 Branch Ave, Providence, RI............................401-521-5959
Fiterman, Al/1415 Bayard St, Baltimore, MD410-625-1265
Fitton, Larry/2029 Maryland Ave, Baltimore, MD.........................410-727-0092
Fitzhugh, Susan/3406 Chestnut Ave, Baltimore, MD....................410-243-6112
Fitzpatrick, Bill/3609 Jenifer St NW, Washington, DC..................202-431-3133
Flanigan, Jim/1325 N 5th St #F4, Philadelphia, PA215-236-4448
Fleming, Daniel/1140 Washington St, Boston, MA........................617-426-9340
Fleming, Kevin/1669 Chinford Trail, Annapolis, MD410-268-4484
Flesch, Patrice/46 McBride St, Jamaica Plains, MA617-522-7199
Fleshner, Ed/11 Exchange Pl, Portland, ME207-797-5982
Fletcher, John C/64 Murray Hill Terrace, Bergenfield, NJ.............201-387-2171
Fletcher, Sarah/389 Charles St, Providence, RI............................401-751-3557
Flint, Stan/2315 Maryland Ave, Baltimore, MD410-837-9923
Flowers, Morocco/520 Harrison Ave, Boston, MA.........................617-426-3692
Floyd Dean Inc/2-B S Poplar St, Wilmington, DE302-655-7193
Flynn, Bryce/14 Perry Dr Unit A, Foxboro, MA508-543-3020
Fogle, John/25 Vine St, Marblehead, MA617-631-4238
Foley, Paul/791 Tremont #E110, Boston, MA617-266-9336
Foote, James/22 Tomac Ave, Old Greenwich, CT..........................203-637-3228
Forbes, Fred/1 South King St, Gloucester City, NJ.......................609-456-1919
Forbes, Peter/3833 Rexmere Rd, Baltimore, MD410-889-5420
Ford, Sandra Gould/7123 Race St, Pittsburgh, PA.......................412-731-7039
Ford, Tim/7922 Ellenham Ave, Baltimore, MD410-296-3039
Fordham, Eric S/282 Moody St, Waltham, MA..............................617-647-7927
Forster, Daniel/124 Green End Ave, Middletown, RI401-847-4866
Fortin, Paul/318 W Washington St, Hanson, MA...........................617-447-2614
Foster, Cynthia/143 Riverview Ave, Annapolis, MD410-224-4746
Foster, Frank/PO Box 518, W Harwich, MA617-536-8267
Foster, Nicholas/143 Claremont Rd, Bernardsville, NJ908-766-7526
Fota, Gregory M/1935 Fernway Ave, Bethlehem, PA215-865-9851
Foti, Arthur/8 W Mineola Ave, Valley Steam, NY516-872-0941
Fournier, John/P O Box 121, Block Island, RI...............................401-466-2523
Fox, Debi/5161 River Rd Bldg 2B, Bethesda, MD301-652-1303
Fox, Jon Gilbert/RR 1/Box 307G, Norwich, VT.............................802-649-2828
Fox, Peggy/701 Padonia Rd, Cockeysville, MD.............................410-252-0003
Fracassa, Glen/272 W Exchange St #200, Providence, RI401-751-5882
Francisco, Thomas/21 Quine St, Cranford, NJ..............................908-272-1155
Francois, Emmett W/208 Hillcrest Ave, Wycoff, NJ201-652-5775
Francouer, Norm/144 Moody St, Waltham, MA617-891-3830
Frank, Carol/1032 N Calvert St, Baltimore, MD............................410-244-0092
Frank, Diane/208 North Ave West, Cranford, NJ...........................908-276-2229
Frank, Laurence/219 Henry St, Stamford, CT...............................203-975-7720
Frank, Richard/48 Woodside Ave, Westport, CT............................203-227-0496
Frankel, Felice/202 Ellington Rd, Longmeadow, MA.....................413-567-0222
Fraser, Renee/1260 Boylston St, Boston, MA617-646-4296
Frederick, Leigh/333 Robinson Lane, Wilmington, DE..................302-428-6109
Fredericks, Michael Jr/RD 2 Box 292, Ghent, NY518-672-7616
Freeman, Charles Photo/3100 St Paul St, Baltimore, MD.............410-243-2416
Freeman, Roland/117 Ingraham St NW, Washington, DC,202-882-7764
Freer, Bonnie/265 S Mountain Rd, New City, NY212-535-3666

Freeze Frame Studios/255 Leonia Ave, Bogota, NJ201-343-1233
Freid, Joel Carl/1501 14th St NW, Washington, DC800-869-7413
Freihofer, Sue/PO Box 146, Boston, MA ..617-262-1953
French, Larry/162 Linden Lane, Princeton, NJ609-924-2906
French, Russell/496 Congress St, Portland, ME207-874-0011
Freund, Bud/1425 Bedford St #9C, Stamford, CT203-359-0147
Friedman, Rick/133 Beaconsfield Rd, Brookline, MA617-734-8125
Fries, Janet/4439 Ellicott St NW, Washington, DC202-362-4443
Friscia, Santa/395 Carriage Shop Rd, E Falmouth, MA508-548-7995
Frog Hollow Studio/Box 897, Bryn Mawr, PA ..215-353-9898
Fuchs, Betsy/75 Sumner St, Newton Ctr, MA617-332-6363
Furman, Michael/115 Arch St, Philadelphia, PA215-925-4233
Furnaldi, Kim/300 Ocean Ave, Marblehead , MA617-631-1899
Furst, Arthur/4 Noon Hill Ave, Norfolk, MA ...508-520-1703

G

G/Q Studios/1217 Spring Garden St, Philadelphia, PA215-236-7770
Gabrielsen, Kenneth/11 Tuttle St #15, Stamford, CT203-964-8254
Gadomski, Michael P/RD 1/Box 201-B, Greentown, PA717-676-3998
Gale, Howard & Judy/712 Chestnut St, Philadelphia, PA215-629-0506
Gale, John & Son/712 Chestnut St, Philadelphia, PA215-629-0506
Gallant, Arthur/125 Northfield Ave #A1-2C, W Orange, NJ201-736-3533
Gallery, Bill/86 South St, Boston, MA ..617-542-0499
Gallo, Peter/1238 Callowhill St #301, Philadelphia, PA215-925-5230
Gans, Hank/RR 1/Box 2564, Wells, ME ...207-646-9871
Gans, Harriet/50 Church Lane, Scarsdale, NY914-723-7017
Ganson, John/14 Lincoln Rd, Wayland, MA ...508-358-2543
Ganton, Brian/882 Pompton Ave, Cedar Grove, NJ201-857-5099
Garaventa, John/105 Constock Rd, Manchester, CT203-647-1579

**Garber, Bette S/3160 Walnut St, Thorndale,
PA (P 356)** ..**215-380-0342**

Garber, Ira/150 Chestnut St, Providence, RI ...401-274-3723
Garcia, Richard/30 Kimberly Pl, Wayne, NJ ..201-956-0885
Gardner, Charles/12 N 4th St, Reading, PA ..215-376-8086
Garfield, Peter/7370 MacArthur Blvd, Glen Echo, MD301-229-6800
Garnier, William/155 New Boston St, Woburn, MA617-933-4301
Garrett, Rodney/Box 353-Rt3, Bernville, PA ...215-488-7552
Gates, Ralph/364 Hartshorn Dr Box 233, Short Hills, NJ201-379-4456
Gawrys, Anthony P/163 Lowell St, Peabody, MA508-531-5877
Gee, Elizabeth/186 Rte 24/RFD #1, Mendham, NJ201-543-2447
Geer, Garry/183 St Paul St, Rochester, NY ...716-232-2393
Geiger, Michael/PO Box 146, Tillson, NY ...914-658-3106
Geiger, William/4944 Quebec St NW, Washington DC,301-564-1256
Generalli, Janet/21 Russell St, Brookline, MA617-566-0782
Gensheimer, Rich/2737 E 41st St, Erie, PA ...814-825-5822
George, Fred/737 Canal St/Bldg #35/2nd Fl, Stamford, CT203-348-7454
George, Walter Jr/20 Main St, Clinton, NJ ..908-735-7013
Geraci, Steve/106 Keyland Ct, Bohemia, NY ...516-567-8777
Gerardi Studios/27 Tippen Pl, New City, NY ...914-639-9809
Germer, Michael/27 Industrial Ave, Chelmsford, MA508-250-9282
Getgen, Linda/237 Middle St, Weymouth, MA617-331-7291
Getzoff, Joseph/1 Ellis Rd, W Caldwell, NJ ...201-226-5259
Giandomenico, Bob/13 Fern Ave, Collingswood, NJ609-854-2222
Giese, Al/RR 1/Box 302, Poundridge, NY ...914-764-5512
Giglio, Harry/925 Penn Ave #305, Pittsburgh, PA412-261-3338
Gilbert, Gary/Box 1068, Watertown, MA ..617-924-5263
Gilbert, Mark/12 Juliette St, Boston, MA ..617-265-1038
Giles, Frank/182 Main St #35, Burlington, VT ..802-658-3615
Gillette, Guy/133 Mountaindale Rd, Yonkers, NY914-779-4684
Gilligan Group/Rte 517/Crossrds Ctr, Hackettstown, NJ908-813-0901
Gilstein, Dave/25 Amflex Dr, Cranston, RI ..401-946-6100
Giraldi, Frank/42 Harmon Pl, N Haledon, NJ ...201-423-5115
Glasofer, David/176 Main St, Metuchen, NJ ...908-549-1845
Glass, Mark/814 Garden St, Hoboken, NJ ..201-798-0219
Glass, Peter/15 Oakwood St, East Hartford, CT203-528-8559
Glick, Robert/3 Dohrmann Ave, Teaneck, NJ ..201-836-3911
Gluck, Mike/2 Bronxville Rd, Bronxville, NY ..914-961-1677
Goell, Jon/535 Albany St, Boston, MA ...617-423-2057
Goembel, Ponder/666 Easton Rd, Reigelsville, PA215-749-0337
Gold, Gary D/One Madison Pl, Albany, NY ..518-434-4887
Goldblatt, Steven/32 S Strawberry St, Philadelphia, PA215-925-3825
Goldenberg, Barry/70 Jackson Dr/Box 412, Cranford, NJ908-276-1510
Goldman, Mel/329 Newbury St, Boston, MA ...617-536-0539
Goldman, Rob/15 South Grand Ave, Baldwin, NY516-223-4018
Goldsmith, Bruce/1 Clayton Ct, Park Ridge, NJ201-391-4946
Goldstein, Alan/702 Gist Ave, Silver Spring, MD301-589-1690
Goldstein, Robert/PO Box 1127, Dennis, MA ...508-385-5030

Good, Richard/5226 Osage Ave, Philadelphia, PA215-472-7659
Goodman, Howard/PO Box 453, Peekskill, NY (P 105) ...**914-737-1162**
Goodman, John/337 Summer St, Boston, MA ..617-482-8061
Goodman, John D/5 East Rd, Colchester, VT ...802-878-0200
Goodman, Lou Photography/322 Summer St, Boston, MA617-542-8254
Goodman/Van Riper Photo/3502 Quesada St NW, Washington, DC202-362-8103
Goodwin, Scott/326 A Street, Boston, MA ..617-451-8161
Gorany, Hameed/413 Beacon Hill Terrace, Gaithersburg, MD301-840-0012
Gorchev & Gorchev/11 Cabot Rd, Woburn, MA617-933-8090
Gordon, David A/1413 Hertel Ave, Buffalo, NY716-833-2661
Gorodnitzki, Diane/Main St/Box 357, Sagaponack, NY516-537-1788
Gorrill, Robert B/PO Box 206, North Quincy, MA617-328-4012
Gothard, Bob/1 Music St, W Tisbury, MA ...508-693-1060
Gottheil, Philip/1278 Lednam Ct, Merrick, NY516-378-6802
Gottlieb, Steve/3601 East-West Hwy, Chevy Chase, MD301-951-9648
Gozbekian, Leo/117-A Gayland St, Watertown, MA617-923-1666
Graham, Jim/720 Chestnut St, Philadelphia, PA215-592-7272
Graham, Steffi/5726 Cross Country Blvd, Baltimore, MD410-664-8493
Grant, Gail/7006 Valley Ave, Phildelphia, PA ..215-482-9857
Grant, Jarvis/1650 Harvard St NW #709, Washington, DC202-387-8584
Grant/Miller/5 Lake St, Morris, NY ...607-263-5060
Graphic Accent/446 Main St PO Box 243, Wilmington, MA508-658-7602
Grassl, Jennie Lawton/5 Sycamore St, Cambridge, MA617-876-1321
Gray, Sam/17 Stilling St, Boston, MA ...617-237-2711
Grayson, Jay/9 Cockenoe Dr, Westport, CT ...203-222-0072
Green, Elisabeth/52 Springtree Lane, S Berwick, ME207-384-2877
Green, Jeremy/1720 Lancaster St, Baltimore, MD410-732-5614
Greenaway, Malcolm/642 Corn Neck Rd, Block Island, RI401-466-2122
Greenberg, Chip/325 High St, Metuchen, NJ ..908-548-5612
Greenberg, Steven/560 Harrison Ave, Boston, MA617-423-7646
Greene, Joe/Box 148, Allston, MA ...617-338-1388
Greenfield, David/56 Fordham Dr, Matawan, NJ908-747-2662
Greenhouse, Richard/7532 Heatherton Ln, Potomac, MD301-365-3236
Greenlar, Michael/305 Hillside St, Syracuse, NY315-454-3729
Gregg, Sandy/PO Box 5027, North Branch, NJ908-231-9617
Greniers Commercial Photo/127 Mill St, Springfield, MA413-532-9406
Griebsch, John/25 N Washington St, Rochester, NY716-546-1303
Griffin, Arthur/22 Euclid Ave, Winchester, MA617-729-2690
Griffiths-Belt, Annie/1301 Noyes Dr, Silver Spring, MD301-495-3127
Griggs, Dennis/Box 44A/Foreside Rd, Topsham, ME207-725-5689
Grohe, Stephen F/451 D St #809, Boston, MA617-426-2290
Gross, Jay/258 Plum Dr, Marlboro, NJ ...908-303-0413
Gruol, Dave/92 Western Ave, Morristown, NJ201-267-2847
Guarinello, Greg/252 Highwood St, Teaneck, NJ201-384-2172
Gude, Susann/Slip 1-A/Spruce Dr, E Patchogue, NY516-654-8093
Guidera, Tom III/403 N Charles St #200, Baltimore, MD410-752-7676
Guisinger, Gary/293 Read St, Portland, ME ..207-878-3920
Gummerson, Anne/225 W 25th St, Baltimore, MD410-235-8325
Gunderson, Gary/PO Box 397, Danbury, CT ...203-792-2273
Guynup, Sharon/813 Willow Ave, Hoboken, NJ201-798-0781

H

**H/O Photographers/197 Main St/POB 548, Hartford,
VT (P 109)** ...**802-295-6321**
Hagan, Robert/PO Box 6625, Providence, RI ..401-421-4483
Hagerman, Ron/389 Charles St/Bldg 6, Providence, RI401-272-1117
Hahn, Bob/3522 Skyline Dr, Bethlehem, PA ..215-868-0339
Haisfield, Ron/1267 Battery Ave, Baltimore, MD410-385-0294
Hales, Mick/44 Market St, Cold Spring, NY ...914-265-1053
Hall, Gary Clayton/PO Box 838, Shelburne, VT802-985-8380
Hallinan, Peter J/PO Box 183, Boston, MA ..617-924-1539
Halsman, Irene/297 N Mountain Ave, Upper Montclair, NJ201-746-9155
Halstead, Dirck/3332 P St NW, Washington, DC202-338-2028
Haman, Stuart/13 Dorset Hill Ct, Owings Mill, MD410-356-2048
Hambourg, Serge/Box 753, Crugers, NY ..212-866-0085
Hamburg, Karen/218 Cedar Ave, Blackwood, NJ609-232-0737
Hamerman, Don/19 Bellmere Ave, Stamford, CT212-627-5474
Hamilton, Bruce/444 Western Ave, Brighton, MA617-783-9409
Hamlin, Elizabeth/434 Franklin St, Cambridge, MA617-876-6821
Hamor, Robert/2308 Columbia Cir, Merrimack, NH603-424-6737
Handler, Lowell/147 Main St, Coldspring, NY ..914-265-4023
Hangarter, Jean/1 Fitchburg St. C104D, Somerville, MA617-403-2896
Hansen-Mayer Photography/281 Summer St, Boston, MA617-542-3080
Hansen-Sturm, Robert/334 Wall St, Kingston, NY914-338-8753
Hanstein, George/389 Belmont Ave, Haledon, NJ201-790-0505
Harholdt, Peter/4980C Wyaconda Rd, Rockville, MD301-984-7772
Haritan, Michael/1701 Eben St, Pittsburgh, PA412-343-2112

Harkey, John/90 Larch St, Providence, RI401-831-1023
Harkins, Kevin F/219 Appleton St, Lowell, MA508-452-9704
Harp, David/6027 Pinehurst Rd, Baltimore, MD410-433-9242
Harrington, Blaine III/2 Virginia Ave, Danbury, CT203-798-2866
Harrington, John/315 King St, Port Chester, NY914-939-0702
Harrington, Phillip A/Wagner Ave/ PO Box 10, Fleischmann's, NY914-254-5227
Harris, Brownie/POB 164/McGuire Lane, Croton-on-Hudson, NY914-271-6426
Harris, Eunice & Leonard/19 Clarendon Ave, Providence, RI401-331-9784
Harrison, Jim/One Thompson Square, Charleston, MA617-242-4314
Harting, Christopher/327 Summer St, Boston, MA617-451-6330
Hartlove, Chris/802 Berry St, Baltimore, MD410-889-7293
Harvey, Milicent/49 Melcher St, Boston, MA617-482-4493
Hastings, Marsden/PO Box 703, Rockport, ME207-236-2564
Hathaway, Dwayne/404 W Baltimore St #8, Baltimore, MD410-659-0282
Hatos, Kathleen/3418 Keins St, Philadelphia, PA215-425-3960
Hausner, Clifford/37-14 Hillside Terrace, Fairlawn, NJ201-791-7409
Hayes, Barry/53 Main St, St Johnsbury, VT802-748-8916
Hayman, Jim Studio/100 Fourth Ave, York, PA717-843-8338
Haywood, Alan/39 Westmoreland Ave, White Plains, NY914-946-1928
Hazlegrove, Cary/PO Box 442/One Main St, Nantucket, MA508-228-3783
Headden, George/PO Box 730, Matawan, NJ908-290-0040
Heard, Gary/274 N Goodman St, Rochester, NY416-271-6780
Heath, Penny/Rt 1/Box 94, Redwood, NY315-482-5636
Heayn, Mark/17 W 24th St, Baltimore, MD410-235-1608
Heeriein, Karen/200 William St, Port Chester, NY914-937-7042
Height, Edward/58 White Birch Dr, Rockaway, NJ201-627-9212
Heilman, Grant/506 W Lincoln Ave, Lititz, PA717-626-0296
Heintz, F Michael Photography/14 Perry Ave, Norwalk, CT203-847-6820
Heist, Scott/616 Walnut St, Emmaus, PA215-965-5479
Helldorfer, Fred/1 Sassafras Ct, Voorhees, NJ609-772-1039
Helmar, Dennis/416 W Broadway, Boston, MA617-269-7410
Henderson, Brent/178 Country Club Lane, Scotch Plain, NJ908-789-4278
Henderson, Elizabeth/107 South St, Boston, MA617-695-1313
Hendren, Lelia/PO Box 556, Glen Echo, MD301-229-1327
Henig, Les/Box 530, Garrett Park, MD301-933-5762
Herbert, Jeff/Box 474, Ramsey, NJ201-529-4599
Herity, Jim/601 Riverside Ave, Westport, CT203-454-3979
Herko, Robert/121 Hadley St, Piscataway, NJ908-563-1613
Herrera, Frank/318 Kentucky Ave SE, Washington, DC301-229-7930
Hess, Allen/17 Sandpiper Lane, Pittsford, NY716-381-9796
Hewett, Ian/124 Webster Ave, Jersey City, NJ201-216-9388
Hewitt, Malcolm/323 Newbury St, Boston, MA617-262-7227
Hewitt, Scott/501 Tatnal St, Wilmington, DE302-654-1397
Hickey, Bill/54 Summit Ave, Westwood, NJ201-666-3861
Hickman, Louis/Box 5358, Plainfield, NJ908-561-2696
Higgins & Ross/281 Princeton St, N Chelmsford, MA508-454-4248
Highsmith, Carol/3299 K St NW #404, Washington, DC202-347-0910
Hill, Britian (Ms)/Pleasnat Pond Rd/Box 238, Francestown, NH603-547-8873
Hill, John T/388 Amity Rd, New Haven, CT203-393-0035
Hill, Jon/159 Burlington St, Lexington, MA617-862-6456
Hill, Rob/24 Hoagland Rd, Blairstown, NJ908-459-4667
Hilliard, Bruce/125 Walnut St, Watertown, MA617-923-0916
Hilliard, Henry/14 Harvard Ave 3rd Fl, Boston, MA617-789-4415
Hinton, Ron/1 Fitchburg St C318, Somerville, MA617-666-3565
Hirsch, Linda/7 Highgate Rd, Wayland, MA508-653-0161
Hirshfeld, Max/1027 33rd St NW, Washington, DC202-333-7450
Hitchcox, Glen/7 Blauvelt St, Nanuet, NY914-623-5859
Hoachlander, Anice/1001 Sigsbee Pl NE, Washington, DC202-269-0587
Hodges, Sue Anne/87 Gould Rd, Andover, MA617-475-2007
Hoffman, Dave/15 Maxwell Ct, Morristown, NJ201-538-3281
Hollander, David/147 S Maple Ave/Box 443, Springfield, NJ201-467-0870
Holmes, Greg/2007 Hickory Hill Ln, Silver Spring, MD301-460-3643
Holoquist, Marcy/2820 Smallman St, Pittsburgh, PA412-261-4142
Holt, John/25 Dry Dock Ave, Boston, MA617-426-4658
Holt, Walter/PO Box 936, Media, PA215-565-1977
Holt/Aiguier Photography/535 Albany St, Boston, MA617-338-7674

**Holtz, Ron/9153 Brookville Rd, Silver Spring,
MD (P 112,113)****301-589-7900**

**Homan, Mark/1916 Old Cuthbert Rd #B24,
Cherry Hill, NJ (P 58,59)****609-795-6763**

Hone, Stephen/859 N 28th St, Philadelphia, PA215-765-6900
Hood, Sarah/1924 37th St NW, Washington, DC202-337-2585
Hopkins, Tom/15 Orchard Park, Box 7A, Madison, CT203-245-0824
Horizon Aerial/6 Lakeside Ave, Nashua, NH603-889-8318
Hornick/Rivlin Studio/25 Dry Dock Ave, Boston, MA617-482-8614
Horowitz, Abby/915 N 28th St, Philadelphia, PA215-925-3600
Horowitz, Ted/214 Wilton Rd, Westport, CT203-454-8766
Horsman, Bill/248 Moss Hill Rd, Boston, MA617-522-4545

Hotshots/35 Congress St/PO Box 896, Salem, MA617-744-1557
Houck, Julie/21 Clinton St, S Portland, ME207-767-3365
Houser, Robert/PO Box 299, Litchfield, CT203-567-4241
Houston, Robert/1512 E Chase St, Baltimore, MD410-327-2632
Howard, Jerry/317 N Main, Natick, MA617-653-7610
Howard, Peter/7 Bright Star Ct, Baltimore, MD410-866-5013
Howard, Richard/45 Walnut St, Somerville, MA617-628-5410
Hoyt, Russell/171 Westminister Ave, S Attleboro, MA508-399-8611
Hubbell, William/99 East Elm St, Greenwich, CT203-629-9629
Huber, William Productions/49 Melcher, Boston, MA617-426-8205
Huet, John/27 Dry Dock Ave 7th Fl, Boston, MA617-439-9393
Hundertmark, Charles/6264 Oakland Mills Rd, Sykesville, MD301-242-8150
Hungaski, Andrew/Merribrook Lane, Stamford, CT203-327-6763
Hunsberger, Douglas/115 W Fern Rd, Wildwood Crest, NJ609-522-6849
Hunt, Barbara/12017 Nebel St, Rockville, MD301-468-1613
Hunter, Allan/56 Main St 3rd Fl, Milburn, NJ201-467-4920
Hurwitz, Joel/PO Box 1009, Leominster, MA617-537-6476
Husted, Dan/143 Sagamore Rd, Milburn, NJ201-761-1348
Hutchings, Richard/24 Pinebrook Dr, Larchmont, NY914-834-9633
Hutchins Photography/309 Main St, Watertown, MA617-926-8880
Hutchinson, Clay/Viewfinder Pub/Box 41, Old Chatham, NY518-794-7767
Hutchinson, Gardiner/PO Box 41, Old Chatham, NY518-794-7767
Hutnak, Gene/269 Greenville Ave, Johnston, RI401-232-5090
Huyler, Willard/107 Jerome St, Roosevelt Plns, NJ908-245-1081
Hyde, Dana/PO Box 1302, South Hampton, NY516-283-1001
Hyon, Ty & Minnicks, John/65 Drumhill Rd, Wilton, CT203-834-0870

IJ

Iafrate, Doreen/8 Blackstone Valley Pl #201, Lincoln, RI401-333-2886
Iannazzi, Robert F/450 Smith Rd, Rochester, NY716-624-1285
Ibberson, Chris/35 W William St, Corning , NY607-937-5487
Ide, Roger/529 Main St, Charlestown, MA617-242-7872
Iglarsh, Gary/855 Tyson St, Baltimore, MD410-383-1208
Image Designs/345 Cornwall Ct, Katonah, NY914-232-8231
Image Photographic Svcs/622 Thomas Blvd, E Orange, NJ201-675-6555
Image Source Inc/PO Box 1929, Wilmington, DE302-658-5897
Images Commercial Photo/360 Sylvan Ave, Englewood Cliffs, NJ........201-871-4406
Impact Multi Image Inc/117 W Washington 2nd fl, Pleasantville, NJ.....609-484-8100

**Impact Studios/1084 N Delaware Ave, Philadelphia,
PA (P 60,61)****215-426-3988**

Insight Photo/55 Gill Lane #5, Iselin, NJ908-283-4727
IntVeldt, Gail/5510 Corral Lane, Frederick, MD301-473-4531
Irwin, Jerry/PO Box 399, Paradise, PA717-442-9827
Iverson, Bruce/7 Tucker St #65, Pepperell, MA617-433-8429
Jackson, Cappy/1034 Monkton Rd, Monkton, MD410-343-1313
Jackson, Glenwood/3000 Chestnut Ave #10, Baltimore, MD410-366-0049
Jackson, Martin/314 Catherine St #401, Philadelphia, PA215-271-5149
Jackson, Philip/534 E Second St, Plainfield, NJ800-878-5999
Jackson, Reggie/135 Sheldon Terr, New Haven, CT203-787-5191
Jacobs, Kip/208 E Miami Ave, Cherry Hill, NJ609-427-0019

**Jacoby, Edward/108 Mt Vernon, Boston,
MA (P 48,49)****617-723-4896**

Jagger, Warren/150 Chestnut St Box 3330, Providence, RI...................401-351-7366
Jakubek, Alan/P O Box 562, Winooski, VT802-863-8299
Jamison, Jon/247 Bly Rd, Schenectady, NY518-869-6211
Jaramillo, Alain/107 E Preston St, Baltimore, MD410-727-2220
Jarvis, Guy/109 Broad St, Boston, MA617-482-8998
Jaynes, Claude/122 Waverly St, Everett, MA617-389-4703
Jeffries, William C/232 Market St, Middletown, PA717-944-5694
Jenkins, Hank/234 Arlington Ave, Paterson, NJ201-956-7244
Jenkins, John/1900 N Tatnall St, Wilmington, DE302-658-5897
Jesudowich, Stanley/200 Henry St, Stamford, CT...................203-359-8886
Joachim, Bruno/326 A Street, Boston, MA617-451-6156
Johnson, Alan/201-744-0999
Johnson, April L/3 Rowe Ave, Rockport, MA...................617-298-5448
Johnson, Cynthia/316 10th St NE, Washington, DC202-546-9864
Johnson, Stella/137 Langdon Ave, Watertown, MA617-923-1263
Jones, Isaac/3000 Chestnut Ave, Baltimore, MD...................410-889-5779

Jones, Lou/22 Randolph St, Boston, MA (P 40,41)**617-426-6335**

Jones, Marvin T/5203 14th St NW, Washington, DC202-726-4066
Jones, Peter/43 Charles St, Boston, MA617-227-6400
Jones, Tom Photo/89 Pleasant St, Brunswick, ME207-725-5238
Joseph, Ed/3081 Cypress Ct, Monmouth Junctn, NJ908-329-0550
Joubert, Larry/728 Auburn St #G4, Whitman, MA...................617-447-1178
Judice, Ed/83 W Main St, Orange, MA508-544-2739
Juracka, Frank/179 Widmer Rd, Wappingers Falls, NY914-297-2074

K

Kaetzel, Gary/PO Box 3514, Wayne, NJ................................201-696-6174
Kagan, BC/43 Winter St 4th Fl, Boston, MA617-482-0336
Kahn, Michael/PO Box 335, Uniondale, PA............................215-347-0745
Kalfus, Lonny/226 Hillside Ave, Leonia, NJ..........................201-944-3909
Kalischer, Clemens/Main St, Stockbridge, MA413-298-5500
Kalish, JoAnne/512 Adams St, Centerport, NY.......................516-271-6133
Kalisher, Simpson/North St, Roxbury, CT.............................203-354-8893
Kaltman, Len/225 S 18th St #1524, Philadelphia, PA..............215-545-4566
Kaminsky, Saul/36 Sherwood Ave, Greenwich, CT...................203-869-3883
Kan, Dennis/PO Box 248, Clarksburg, MD.............................301-428-9417
Kane, John/POB 731, New Milford, CT (P 69)203-354-7651
Kane, Martin/401 Sharpless St, West Chester, PA...................215-696-0206
Kannair, Jonathan/91 Quaker Lane, Bolton, MA.....................508-779-2266
Kaplan, Barry/5 Main St, Wickford, RI.................................212-254-8461
Kaplan, Carol/20 Beacon St, Boston, MA..............................617-720-4400
Karlin, Lynn/RD Box 12, Harborside, ME.............................207-326-4062
Karlsson, Bror/543 Park St, Montclair, NJ............................201-783-6491
Karnow, Catherine/1707 Columbia Rd #518,
Washington, DC (P 118)**202-332-5656**
Karosis, Rob/855 Islington St, Portsmouth, NH.....................603-436-8876
Karten, Roy/803 Malcolm Dr, Silver Spring, MD....................301-445-0751
Karzen, Marc/53 Georgetown Rd, Weston, CT.......................212-722-5347
Kaskons, Peter/Westech Ind Park, Tyngsboro, MA..................508-649-7788
Kasper, Ken/1232 Cobbs St, Drexel Hill, PA..........................215-789-7033
Katz, Baruch/121 W 27th St #1205......................................212-645-6085
Katz, Bruce/2700 Connecticut Ave NW #103B, Washington, DC........202-332-5848
Katz, Dan/36 Aspen Rd, W Orange, NJ................................201-731-8956
Katz, Philip/286 Meetinghouse Rd, New Hope, PA..................215-862-3503
Kauffman, Bob/28 Hemlock Dr, Farmingdale, NY....................516-454-9637
Kauffman, Kenneth/915 Spring Garden St, Philadelphia, PA........215-649-4474
Kaufman, Robert/58 Roundwood Rd, Newton Upper Falls, MA.......617-964-4080
Kawalerski, Ted/7 Evergreen Way, North Tarrytown, NY...........212-242-0198
Kawamoto, Noriko/9727 Softwater Way, Columbia, MD.............301-953-0467
Keating, Roger/102 Manatee Rd, Hingham, MA......................617-749-5250
Keeley, Chris/4000 Tunlaw Rd NW #1119, Washington, DC.........202-337-0022
Keiser, Anne B/3760 39th St #f144, Washington, DC................202-966-6733
Keith, David/96 Reservation Rd, Sunderland, MA413-665-7944
Keller & Peet Assoc/107 Park Ave, Arlington, MA...................617-641-2523
Kelley, Edward/20 White St, Red Bank, NJ............................908-747-0596
Kelley, Patsy/70 Atlantic Ave/PO Box 1147, Marblehead, MA......617-639-1147
Kelley, William/10 Loring Ave, Salem, MA............................508-744-5914
Kelly, Joanne/92 Marlborough #1, Boston, MA.......................617-266-5690
Kelly/Mooney Photography/87 Willow Ave, North Plainfield, NJ....908-757-5924
Kenik, David Photography/16 Atlantic Ave, W Warwick, RI401-823-3080
Kennedy, Thomas/4002 Laird Pl, Chevy Chase, MD.................202-857-7458
Kenner, Ray/401 W Redwood #506, Baltimore , MD...............410-837-4742
Kernan, Sean/School St, Stony Creek, CT..............................203-481-4478
Kerper, David/1018 E Willow Grove Ave, Philadelphia, PA.........215-836-1135
Kim, Chang/9425 Bethany Pl, Gaithersburg, MD....................301-840-5741
Kimball, Sandra/409 W Broadway, Boston, MA......................617-268-1980
King, Joseph/5 Michael Dr, Lincoln, RI.................................401-272-9560
Kingdon, David/40 Church St, Fair Haven, NJ........................908-741-6621
Kinney, Barbara/2025 Kalorama Rd NW #3, Washington, DC........202-387-6629
Kinum, Drew/Glen Avenue, Scotia, NY.................................518-382-7566
Kipperman, Barry/529 Main St, Charlestown, MA...................617-241-7323
Kirkman, Tom/58 Carley Ave, Huntington, NY.......................212-628-0973
Kirschbaum, Jed/102 N Wolfe St, Baltimore, MD....................410-332-6940
Kitman, Carol/147 Crescent Ave, Leonia, NJ..........................201-947-2969
Kittle, James Kent/49 Brinckerhoff Ln, New Canann, CT............203-966-2442
Klapatch, David/2049 Silas Deane Hwy, Rocky Hill, CT203-563-3834
Klebau, James/5806 Maiden Lane, Bethesda, MD....................301-320-2666
Klein, Robert D/273 Rock Rd, Glen Rock, NJ.........................201-445-6513
Kleinschmidt, Carl/408 Cobble Creek Curve, Newark, DE..........302-733-0456
Kligman, Fred/2323 Stewart Rd, Silver Spring, MD.................301-589-4100
Klim, Greg/14 Nichols Rd, Needham , MA............................617-327-3980
Kline, Andrew/, Montpelier, VT..802-229-4924
Klinefelter, Eric/10963 Hickory Ridge Rd, Columbia, MD410-964-0273
Klonsky, Arthur/RR1/Box 235, Londonderry, VT....................802-824-4135
Kloppenburg, Guy/59 Garrison Ave, Jersey City, NJ.................201-798-9280
Knapp, Stephen/74 Commodore Rd, Worcester, MA................617-757-2507
Knott, Ken/107 Oak Lynn Dr, Columbus, NJ.........................609-298-8315
Knowles, Robert M/525 Ellendale Ave #PH, Rye Brook, NY.........914-934-2619
Knudsen, Rolf/155 Brookside Ave #6, W Warwick, RI..............401-826-1945
Koby-Antupit Photographers/8 JFK St, Cambridge, MA............617-547-7552
Korona, Joseph/25 Foxcroft Rd, Pittsburgh, PA.......................412-279-9200

Kozlowski, Mark/48 Fourth St, Troy, NY...............................212-684-7487
Koslowski, Wayne/1195 Westfield Ave, Rahway, NJ.................908-381-8189
Kovner, Mark/14 Cindy Lane, Highland Mills, NY...................914-928-6543
Kowerski, Marty/530 Pine Hill Rd, Lilitz, PA..........................717-627-7722
Kramer, Arnold/1839 Ingleside Terr NW, Washington, DC..........202-667-9385
Kramer, Phil/122 W Church St, Philadelphia, PA.....................215-928-9189
Kramer, Rob/409 W Broadway, Boston, MA...........................617-269-9269
Krasner, Stuart/7837 Muirfield Ct, Potomac, MD....................301-983-1599
Kremer, Glenn/374 Congress St, Boston, MA.........................617-482-7158
Kress, Michael/7847 Old Georgetown Rd, Bethesda, MD............301-654-0909
Krist, Bob/333 S Irving, Ridgewood, NJ................................201-445-3259
Krogh, Peter Harold/3301 Oberon St, Kensington, MD.............301-933-2468
Krohn, Lee/RR1/Box 1205, Manchester, VT...........................802-362-4824
Krubner, Ralph/4 Juniper Court, Jackson, NJ.........................908-364-3640
Kruper, Alexander Jr/70 Jackson Dr Box 152, Cranford, NJ.........908-709-0220
KSN Images/475 Linden Lane #203, Media, PA......................215-565-7268
Kucine, Cliff/85 York St #3, Portland, ME.............................207-773-2568
Kusnetz, Shelley/142 Randolph Pl, W Orange, NJ...................201-736-4362
Kvalsvik, Eric/223 W Lanvale St, Baltimore, MD.....................410-669-5422

L

L I Image Works/14-20 Glenn St, Glenn Cove, NY..................516-671-9661
L M Associates/20 Arlington, Newton, MA.............................617-232-0254
LaBadessa, Teresa/219 Commonwealth Ave, Newton, MA.........508-785-0467
LaBua, Frank/377 Hill-Ray Ave, Wycoff,
NJ (P 120,121) ...**201-783-6318**
Labuzetta, Steve/180 St Paul St, Rochester, NY......................716-546-6825
Lamar Photographics/147 Spyglass Hill Dr, Ashland, MA..........508-881-2512
Lambert, Elliot/167 Langley Rd, Newton, MA........................617-965-5496
Lambert, Katherine/6856 Eastern Ave NW #209, Washington, DC......202-882-8383
Landsman, Gary D/12115 Parklawn Dr Bay-S, Rockville, MD.......301-468-2588
Landsman, Meg/27 Industrial Ave, Chelmsford, MA508-250-9282
Landwehrle, Don/9 Hother Ln, Bayshore, NY (P 70)....516-665-8221
Lane, Whitney/109 Somerstown Rd, Ossining, NY...................914-762-5335
Lanes, Scott F/50 Thayer St, Boston, MA..............................617-695-0815
Langone, James A/36 Loring St, Springfield, MA.....................413-732-1174
Lanman, Jonathan/63 South St, Hopkinton, MA.....................508-435-2194
Lapides, Susan Jane/451 Huron Ave, Cambridge, MA..............617-864-7793
LaRaia, Paul/171 Sterling Ave, Jersey City, NJ.......................201-332-7505
Larrimore, Walter/2245 Southland Rd, Baltimore, MD..............410-281-1774
Larson, Al/760 Bartlett Rd, Middle Island, NY........................516-924-8729
Laundon, Samuel A/144 Moody St, Waltham, MA...................617-899-2037
Lautman, Robert & Andrew/4906 41 St NW, Washington, DC......202-966-2800
Lauver, David A/29 S Market St, Selinsgrove, PA.....................717-374-0515
Lavery, Dean/RD4/Box 270C, McKee City, NJ........................609-641-3284
Lavine, David S/4016 The Alameda, Baltimore, MD410-467-0523
Lavoie, George/227 N Brow St, E Providence, RI.....................401-438-4344
Lawfer, Larry/27 Dry Dock Ave, Boston, MA.........................617-439-4309
Lawrence, Stephanie/3000 Chestnut Ave #217, Baltimore, MD......410-235-2454
Leach, Peter/802 Sansom St, Philadelphia, PA........................215-574-0230
Leaman, Chris/42 Old Lancaster Rd, Malvern, PA....................215-647-8455
Leatherman, William/173 Massachusetts Ave, Boston, MA..........617-536-5800
LeBlond, Jerry/7 Court Sq, Rutland, VT.................................802-773-4205
Lee, Raymond/PO Box 9743, Baltimore, MD..........................410-323-5764
Leeming Studios Inc/222 Richmond St, Providence, RI401-421-1916
Lefcourt, Victoria/3207 Coquelin Terr, Chevy Chase, MD..........301-652-1658
Lefebure, Regis/66 Walnut Ave, Takoma Park, MD..................301-270-8325
Lehman, Don/PO Box 3509, Frederick, MD...........................301-662-0444
Leifer, David/251 Kelton St, Boston, MA..............................617-277-7513
Lemay, Charles J/PO Box 6356, Manchester, NH.....................603-669-9380
Leney, Julia/PO Box 434, Wayland, MA................................508-653-4139
Lennon, Jim/24 South Mall, Plainview, NY............................516-752-0610
Lent, Michael/421 Madison St, Hoboken, NJ..........................201-798-4866
Leomporra, Greg/RTE 130 & Willow Drive, Cinnaminson, NJ......609-829-6866
Leonard, Barney/134 Cherry Lane, Wynnewood, PA................215-649-5588
Lepist, Enn/E Park Rd/Gldn Apts, Hyde Park, NY...................914-229-7972
Lerat, Andree/241 Perkins St #H202, Boston, MA....................617-738-9553
Leslie, Barbara/81 Grant St, Burlington, VT...........................802-864-0060
Lesser, John/881 Hampton Way, Williamstown, NJ..................609-728-3840
Lester, Terrell/RR1/Box 469, Deer Isle, ME............................207-348-6253
Leung, Jook /35 S Van Brunt St, Englewood, NJ.....................201-894-5881
Leveille, David/27-31 St Bridget's Dr, Rochester, NY716-423-9474
Levin, Aaron M/3000 Chestnut Ave #102, Baltimore, MD..........410-467-8646
Levin, Rosalind/1 Wall St, Fort Lee, NJ................................201-944-6014
Levin, Sergio/25 Grace Terrace, Passaic, NJ...........................201-472-0650
Levin, Ted/RR 1 Box 313A/Bloodbrk Rd, Fairlee, VT...............802-333-9804
Levine, Allen/2 Merry Lane, East Hanover, NJ........................201-884-1154

Levine, Mimi/8317 Woodhaven Blvd, Bethesda, MD301-469-6550
Levy, Seymour/10 Chestnut St, Needham, MA617-444-4218
Lewis Studios/344 Kaplan Dr, Fairfield, NJ ..201-227-1234
Lewis, Ross/47 North Drive, E Brunswick, NJ908-828-2225
Lewis, Ronald/PO Box 489, East Hampton, NY516-329-1886
Lewis, Steve/63 Endicott Street, Boston, MA617-723-8801
Lewiton, Marvin/18 West St, Arlington, MA ..617-646-9608
Lewitt, Peter/39 Billings Park, Newton, MA ..617-244-6552
Ley, Russell/103 Ardale St, Boston, MA ...617-325-2500
Lidington, John/2 C St, Hull, MA ...617-925-2969
Lieberman, Allen/RR 3/ Box 37, Cranbury, NJ609-799-4448
Lieberman, Fred/2426 Linden Ln, Silver Spring, MD301-565-0644
Lightstruck Studio/613 N Eutaw St, Baltimore, MD301-727-2220
Liller, Tamara/700 7th St SW #418, Washington, DC202-488-3710
Lilley, Weaver/2107 Chancellor St, Philadelphia, PA215-567-2881
Lillibridge, David/Rt 4 Box 1172, Burlington, CT203-673-9786
Linck, Tony/2100 Linwood Ave, Fort Lee, NJ ..201-944-5454
Lincoln, Denise/19 Newtown Trnpke, Westport, CT203-226-3724
Lincoln, James/19 Newtown Trnpke, Westport, CT203-226-3724
Line, Craig/PO Box 11, Marshfield, VT ..802-426-3592
Linehan, Clark/31 Blackburn Ctr, Gloucester, MA808-281-3903
Lippenholz, Richard/10524 Lakespring Way , Cockeysville, MD410-628-0935
Lipshutz, Ellen/Buckhill Farm Rd, Arlington, VT802-375-6316
Litoff, Walter/2919 Union St, Rochester, NY ..716-232-6140
Littell, Dorothy/1 Caroline Pl #3, Jamaica Plain, MA617-522-6181
Littlehales, Breton/9520 Seminole St, Silver Spring, MD202-291-2422
Lobell, Richard/536 West Chester St, Long Beach, NY516-431-8899
Lockwood, Lee/27 Howland Rd, West Newton, MA617-965-6343
Lodriguss, Jerry/20 Millbank Lane, Voorhees, NJ609-770-8246
Logozio, Lou/2 Nathalie Ct, Peekskill, NY ..914-736-0954
Lokmer, John/PO Box 2782, Pittsburgh, PA ...412-765-3565
Long Shots/4421 East West Hwy, Bethesda, MD301-654-0279
Longcor, W K/Bear Pond, Andover, NJ ..201-398-2225
Longley, Steven/2224 North Charles St, Baltimore, MD410-467-4185
Lord, Jim/PO Box 879, Fair Lawn, NJ ...201-796-5282
Lorusso, Larry/1 Main St, Whitinsville, MA ...508-234-2900
Lovering, Talbot/P.O. Box 513, Lincoln, MA ...617-566-6010
Lovett, Kevin/79 Toby St, Providence, RI ..401-861-2556
Lowe, Shawn Michael/2 Horizon Rd #1205, Ft Lee, NJ201-224-0982
Lowe, Thom/1420 E Front St, Plainfield, NJ ..908-769-8485
Lowry, Laurence/47 Moynihan Rd, S Hamilton, MA508-468-2562
Loy, John/1611 Shipley Rd, Wilmington, DE ..302-762-3812
Lukowicz, Jerome/122 Arch St, Philadelphia, PA215-922-7122
Lundell, Jim/266 Lake St, Haverhill, MA ..508-372-3390
Luttenberg, Gene/7608 Hewlett St, New Hyde Park, NY212-620-8112
Lynch, Ron/124 Bloomfield St, Hoboken, NJ ...201-963-3476
Lynch, Tim/160 Merrimack St, Lowell, MA...508-970-1000

M

Macchiarulo, Tony/748 Post Rd E, Westport, CT203-221-7830
Machalaba, Robert/4 Brentwood Dr, Livingston, NJ201-992-4674
MacHenry, Kate/5 Colliston Rd #6, Brookline, MA617-277-5736
Maciel, Chris/RD2 Box 176 Riley Rd, New Windsor, NY914-564-6972
MacKenzie, Maxwell/2641 Garfield St NW, Washington, DC...................202-232-6686
Mackey, Doc/North St Church, Georgetown, MA508-352-7055
MacLean, Alex/25 Bay State Rd, Boston, MA ..617-536-6261
Macomber, Peter/100 Oak St, Portland, ME ..207-772-1208
MacWright, Jeff/RD 4/248 East Main, Chester, NJ908-879-4545
Macys, Sandy (Mr)/552 RR 1, Waitsfield, VT..802-496-2518
Madwed, Steven/1125 Post Rd, Fairfield, CT..203-255-4002
Maggio, Chris/180 St Paul St, Rochester, NY ..716-454-3929
Maglott, Larry/249 A St, Boston, MA ...617-482-9347
Magno, Thomas/19 Peters St, Cambridge, MA617-492-5197
Magro, Benjamin/2 Mechanic St, Camden, ME207-236-4774
Mahoney, Bob/347 Cameo Circle, Liverpool, NY315-652-7870
Malin, Marc/121 Beach St 7th Fl, Boston, MA ..617-338-0434
Malitsky, Ed/337 Summer St, Boston, MA ...617-451-0655
Maloney, Michael J/76 Lyall St, Boston, MA ..617-469-3666
Maltinsky Photo/1140 Washington St, Boston, MA617-426-2128
Malyszko Photography/90 South St, Boston, MA617-426-9111
Mandel, Mitchell T/213 S 17th St, Allentown, PA215-434-1897
Mandelkorn, Richard/309 Waltham St, W Newton, MA617-332-3246
Manheim, Michael Philip/PO Box 35, Marblehead, MA617-631-3560
Manley, Fletcher/PO Box 25, S Londonderry, VT...................................802-824-6148
Mann, Richard J/PO Box 2712, Dix Hills, NY ..516-754-8496
Manning, Ed/875 E Broadway, Stratford, CT ...203-375-3384
Manville, Ron/163 Exchange St #303, Pawtucket, RI.............................401-722-3313

Marc, Jean/791 Tremont St, Boston, MA ...617-536-6094
Marchese, Frank/56 Arbor St, Hartford, CT..203-232-4417
Marchese, Jim/56 Washington Ave, Brentwood, NY212-242-1087
Marchese, Vincent/PO Box AZ, Paterson, NJ ..201-278-2225
Marciak, Alex/931-1/2 F St NW, Washington, DC202-347-2010
Marcotte, Denise/303 Broadway, Cambridge, MA617-864-8406
Marcus, Fred/10 Crabapple Dr, Roslyn, NY ...516-621-3260
Marcus, Joe/100 W Milton St, Easton, PA ...215-258-1407
Mares, Manuel/185 Chestnut Hill Ave, Brighton, MA617-782-4208
Margel, Steve/215 First St, Cambridge, MA ..617-547-4445
Margolis, Paul/109 Grand Ave, Englewood, NJ201-569-2316
Margolycz, Jerry/11 Westchester Rd, Boston,
MA (P 126)..**617-965-6213**
Marinelli, Mary Leigh/4 Salton Stall Pkwy, Salem, MA508-745-7035
Marinosci, Jr, Angelo/Box 385, Warren, RI ...401-245-2707
Markel, Brad/2709 Belleview Ave, Cheverly, MD301-341-6979
Markowitz, Joel/2 Kensington Ave, Jersey City, NJ202-451-0413
Marsel, Steve/215 First St, Cambridge, MA ..617-547-4445
Marshall, Alec/1 Midland Gardens, Bronxville, NY914-779-0022
Marshall, Barbara/172 Chestnut Hill Rd, Chestnut Hill, MA617-734-4375
Marsico, Dennis/110 Fahrenstock, Pittsburgh, PA412-781-6349
Marston, Rose/POB 837 Uphams Corner Station, Boston, MA617-967-0005
Martin Paul Ltd/247 Newbury St, Boston, MA617-536-1644
Martin, Bruce/266-A Pearl St, Cambridge, MA617-492-8009
Martin, Butch/715 Hussa St, Linden, NJ ...908-486-3004
Martin, Jeff/6 Industrial Way W, Eatontown, NJ908-289-0888
Martin, Marilyn/130 Appleton St #2I, Boston, MA..................................617-262-5507
Martin, Michael P/220 E Preston Ave, Wildwood Crest, NJ609-729-0838
Martin-Elson, Patricia/120 Crooked Hill Rd, Huntington, NY516-427-4799
Martson, Sven/228 Dwight St, New Haven, CT203-777-1535
Maschos, Theo/6201 Chelsea Cove Dr, Hopewell Jct, NY914-227-8635
Masiello, Ralph/75 Webster St, Worchester, MA508-752-9871
Mason, Donald W/10 E 21st St, Baltimore, MD410-244-0385
Mason, Phil/15 St Mary's Ct, Brookline, MA ..617-232-0908
Mason, Tom/117 Van Dyke Rd, Hopewell, NJ ..609-466-0911
Massar, Ivan/296 Bedford St, Concord, MA ..617-369-4090
Masser, Randy/15 Barnes Terrace, Chappaqua, NY914-238-8167
Mastalia, Francesco/326 Montgomery St 4th Fl, Jersey City, NJ...........212-772-8449
Mastri, Len/1 Mill St, Burlington, VT ..802-862-4009
Matkins, Leo/904 N Van Buren St, Wilmington, DE302-655-4542
Matt, Phil Studio/PO Box 10406, Rochester,
NY (P 127)..**716-461-5977**
Mattei, George Photography/179 Main St, Hackensack, NJ201-342-0740
Mattie, Gary/Tall Oaks Corp Ctr 1000 Lenola, Maple Shade, NJ...........609-235-3482
Mattingly, Brendan/4404 Independence St, Rockville, MD301-933-3942
Maughart, Brad/13 Church St, Framingham, MA508-875-4447
Mauro, George/9 Fairfield Ave, Little Falls, NJ201-890-0880
Mavodones, Bill/46 Waltham St #105, Boston, MA617-423-7382
May Tell, Susan...516-433-8244
May, Bill/PO Box 1567, Montclair, NJ ..201-624-6782
Mayernik, George/41 Wolfpit Ave #2N, Norwalk, CT203-846-1406
Mayor, Michael/246 Wanaque Ave, Pompton Lakes, NJ201-839-9007
Mazzoleni, Deborah/21012 W Liberty Rd, Whitehall, MD410-329-6807
McBreen, Edward/6727 Harbison Ave, Philadelphia , PA215-331-5149
McCarthy, William/55 Winter St, Auburn, ME ..207-782-2904
McCary, Joe/8804 Monard Dr, Silver Spring, MD301-588-6637
McClintock, Robert/11 Main St, Brattleboro, VT802-257-1100
McConnell & McConnell ...516-883-0058
McConnell, Jack/182 Broad St, Old Wethersfield, CT203-563-6154
McConnell, Russ/8 Adler Dr, E Syracuse, NY315-433-1005
McCormack, Richard/459 Fairmount Ave, Jersey City, NJ201-435-8718
McCormick & Nelson, Inc/34 Piave St, Stamford, CT203-348-5062
McCormick, Ed/55 Hancock St, Lexington, MA617-862-2552
McCoy, Dan/Box 573, Housatonic, MA ..413-274-6211
McDonald, Jean Duffy/14 Imperial Pl #504, Providence, RI401-274-2292
McDonald, Kevin R/319 Newtown Turnpike, Redding, CT203-938-9276
McDonough, Doug/1612 Bolton St, Baltimore, MD410-669-6666
McDowell, Bill/56 Edmonds St, Rochester, NY716-328-7841
McElroy, Philip/23 Main St, Watertown, MA ..617-924-0470
McFarland, Nancy & Lowell/3 Tuck Lane, Westport, CT.........................203-227-6178
McGovern, Michael/502 Worcester St, Baltimore, MD410-825-0978
McGrail, John/1200 New Rogers Rd #C2, Bristol, PA............................215-781-3990
McKaig, Chandler Jr/1819 Lovering Ave, Wilmington, DE302-658-8147
McKean, Howard L/102 Dutton Dr, New Castle, DE302-324-0264
McKean, Thomas R/1418 Monk Rd, Gladwyne, PA215-642-1412
McKiernan, Scott/560 Harrison Ave, Boston, MA617-545-0008
McMullen, Mark/25 Monroe St, Albany, NY ...518-426-9284
McMullin, Forest/183 St Paul St, Rochester, NY716-262-3944

McNamara, Casey/109 Broad St, Boston, MA617-542-5337
McNeely, Robert/2425 Ontario Rd NW #1, Washington, DC202-387-4352
McNeill, Brian/840 W Main St, Lansdale, PA215-368-3326
McNiss, Chase/2308 Columbia Circle, Merrimack, NH603-429-1489
McQueen, Ann/791 Tremont St #W401, Boston, MA617-267-6258
McWilliams, Jack/15 Progress Ave, Chelmsford, MA508-256-9615
Meacham, Joseph/601 N 3rd St, Philadelphia, PA215-925-8122
Meadowlands Photo Srvc/259 Hackensack St, East Rutherford, NJ201-933-9121
Mecca, Jack/RD 6/Box 369B, Branchville, NJ201-702-7438
Mednick, Seymour/316 S Camac, Philadelphia, PA215-735-6100
Medvec, Emily/151 Kentucky Ave SE, Washington, DC202-546-1220
Meech, Christopher/456 Glenbrook Rd, Stamford, CT203-348-1158
Mehling, Joseph/P.O. Box 235, S Strafford, VT802-765-4297
Mehne, Ralph/1501 Rose Terrace, Union, NJ908-686-0668
Meiller, Henry Studios/1026 Wood St, Philadelphia, PA215-922-1525
Melino, Gary/25 Bright Water Dr, Warwick, RI508-379-0166
Mellor, D W/1020 Mt Pleasant Rd, Bryn Mawr, PA215-527-9040
Melo, Michael/RR1/Box 20, Winterport, ME207-223-8894
Melton, Bill/180 Zachary Rd, Manchester, NH (P 166)....603-668-0110
Melton, Janice Munnings/692 Walkhill St, Boston, MA617-298-1443
Mendelsohn, David/15 Tall Pines Rd, Durham, NH603-942-7622
Mendez, Manny/150 Adams St, Newark, NJ201-344-4440
Mendlowitz, Benjamin/Rte 175/Box 14, Brooklin, ME207-359-2131
Mercer, Ralph/451 D St 9th Fl, Boston, MA617-951-4604
Merriam, Douglas/HCR 80/Box 50, Belfast, ME207-338-5769
Merrick, Tad/64 Main St, Middlebury, VT802-388-9598
Merritt Communications/152 N Main St, Natick, MA508-651-3340
Merz, Laurence/215 Georgetown Rd, Weston, CT203-222-1936
Mesmer, Jerry/1523 22nd St NW/Courtyard, Washington, DC202-785-2188
Messina, Sebastian/65 Willard Ave, Bloomfield, NJ908-548-6000
Metzger, Lise/2032 Belmont Rd #301, Washington, DC202-462-5904
Metzner, Sheila/310 Riverside Dr #20212-863-1222
Michaels, John - MediaVisions/17 May St, Clifton, NJ201-772-0181
Milens, Sanders H/38 Mt Philo Rd POB 805, Shelburne, VT.......802-388-9598
Miles, Damian/6 S Broad St, Ridgewood, NJ201-447-4220
Miles, William A/374 Congress St #304, Boston, MA617-426-6862
Miljakovich, Helen/114 Seventh Ave #3C212-242-0646
Millard, Howard/220 Sixth Ave, Pelham, NY914-738-3689
Miller, David Photo/5 Lake St, Morris, NY607-263-5060
Miller, Don/60 Sindle Ave, Little Falls, NJ201-785-9090
Miller, J T/12 Forest Edge Dr, Titusville, NJ609-737-3116
Miller, John L/223 West Fell St, Summit Hill, PA717-645-3661
Miller, Melabee/29 Beechwood Pl, Hillside, NJ908-527-9121
Miller, Michael S/32 Main St, Englishtown, NJ908-446-1331
Miller, Myra/10500 Rockville Pk #121, Rockville, MD301-564-9288
Miller, Peter/RD 1/Box 1515 , Waterbury, VT802-244-5339
Miller, Roger/1411 Hollins St Union Sq, Baltimore, MD410-566-1222
Millman, Lester Jay/PO Box 61H, Scarsdale, NY914-946-2093
Milovich, Dan/590 Summit Dr, Carlisle, PA717-249-0045
Mindell, Doug/811 Boylston St, Boston, MA617-262-3968
Mink, Mike/180 St Paul 5th Fl, Rochester, NY716-325-4865
Miraglia, Elizabeth/50 Fairview Ave #3A, Norwalk, CT203-852-9926
Mirando, Gary Photography/27 Cleveland St, Valhalla, NY914-997-6588
Mitchell, Jane/354 Salem, Wakefield, MA617-245-9878
Mitchell, Les/39 Pittenger Pond Rd, Freehold, NJ908-462-2451
Mitchell, Mike/1501 14th St NW #301, Washington, DC202-234-6400
Mitchell, Richard/51 Bristol St, Boston, MA617-350-3115
Mogerley, Jean/1262 Pines Lake Dr W, Wayne, NJ201-839-2355
Molinaro, Neil R/15 Walnut Ave, Clark, NJ908-396-8980
Monroe, Robert/Kennel Rd, Cuddebackville, NY914-754-8329
Montgomery, Darrow/724 Ninth St NW, Washington, DC202-347-7534
Moore, Cliff/30 Skillman Ave, Rocky Hill, NJ609-921-3754
Mopsik, Eugene/230 Monroe St, Philadelphia, PA215-922-3489
Moree, William/144 Lincoln St 2nd Fl, Boston, MA617-426-7378
Morehand, Peter/200 High Point Ave #3, Weehauken, NJ201-867-8025
Morelli, Mark/44 Roberts Rd, Cambridge, MA617-547-0409
Morgan, Bruce/315 W Sunrise Hwy, Freeport, NY516-546-2034
Morgan, Hank/14 Waterbury Ave, Stamford, CT203-325-3120
Morgan, Rosalind/RFD 2/Box 135, Houlton, ME207-532-7286
Morley, Bob/Brick Kiln Pl, Pembroke, MA617-826-7317
Morrion, Marybeth/345 Cornwall Ct, Katonah, NY914-232-8231
Morrow, Christopher W/PO Box 208, Arlington, MA617-648-6770
Morse, Timothy/148 Rutland St, Carlisle, MA508-369-8036
Moshe, Danny/PO Box 2701, Kensington, MD301-890-9469
Mosley, Gene/9000 Rockville Pike Bldg 1, Rockville, MD201-768-3229
Mottau, Gary/17 Irving Place, Holliston, MA508-429-8645
Moulthrop, David H/RFD 3 Box 2, Great Barrington, MA413-528-3593
Moyer, Stephen/911 State St, Lancaster, PA717-393-0918

Muir, Joe/40 Elm St, Portland, ME207-776-3376
Mullen, Dan/5161 River Rd Bldg 2B, Bethesda, MD................301-652-1303
Mullen, Stephen/825 N 2nd St, Philadelphia, PA215-574-9770
Mulligan, Joseph/239 Chestnut St, Philadelphia, PA215-592-1359
Muro, Dan/101 Beechwood Drive, Wayne, NJ201-628-7479
Murphy, Bill/875 Central Ave, Albany, NY518-489-3861
Murphy, Peter/51 West St, Annandale, NJ908-730-9080
Murray, Chris/110 Brenner Dr, Congers, NY914-268-5531
Murray, Dan/840 Summer St, Boston, MA617-268-6713
Murray, Matt/PO Box 53605, Philadelphia, PA215-430-8136
Murray, Ric/232 W Exchange St, Providence, RI401-751-8806
Murry, Peggy/1913 VWaverly St, Philadelphia, PA215-735-4834
Muskie, Stephen O/23 Lookout Hill, Peterborough, NH603-924-6541
Musto, Tom/225 S Main St, Wilkes-Barre, PA717-822-5798
Mutschler, Bob/177 Main St #183, Ft Lee, NJ201-869-8507
Mydans, Carl/212 Hommocks Rd, Larchmont, NY212-841-2345
Myers Studios Inc/5775 Big Tree Rd, Orchard Park, NY716-662-6002
Myers, Barry/407 Thayer Ave, Silver Spring, MD301-585-8617
Myers, Gene/250 N Goodman St, Rochester, NY716-244-4420
Myers, Steve/PO Box J, Almond, NY607-276-6400
Myron/127 Dorrance St, Providence, RI401-421-1946

N

Nadel, Lee/10 Loveland Rd, Brookline, MA617-451-6646
Nagler, Lanny/56 Arbor St, Hartford, CT203-233-4040
Nathan, Simon/175 Prospect St #21D, E Orange, NJ201-675-5026
Natoli, Tony/202 77th St, N Bergen, NJ201-854-0176
Navin, Christopher/8 Prospect St, Grafton, MA508-839-3227
Neelon, Michael N/349 Lincoln St, Hingham, MA617-740-2066
Nelder, Oscar/93 Hardy St/Box 661, Presque Isle, ME207-769-5911
Nelson, Michael/5 Academy Ave, Cornwall-on-Hudson, NY914-534-4563
Nemerofsky, Jesse/307 Pocasset Ave, Providence, RI401-943-9099
Nerney, Dan/5 Vincent Pl, Rowayton, CT203-853-2782
Nettis, Joseph/1534 Sansom St 2nd Fl, Philadelphia, PA215-563-5444
Neudorfer, Brien/46 Waltham St, Boston, MA617-451-9211
Newler, Michael/1570 N Grand Ave #19, Baldwin, NY516-378-3713
Newman, Alan & Mark O'Neill/65 Commerce Rd, Stamford, CT ...203-327-6225
Newton, Christopher/119 Indian Pond Rd, Kingston, MA617-585-4838
Ngo, Meng H/21 Village Commons, Fishkill, NY914-897-2836
Nicoletti, Vincent/280 Granatan Ave, Mt Vernon, NY914-668-2199
Nighswander, Tim/315 Peck St, New Haven, CT203-789-8529
Nikas, Greg/Drawer 690, Ipswich, MA508-356-0018
Niles, James/238 Sixth St #One, Jersey City, NJ201-659-2408
Noble Inc/2313 Maryland Ave, Baltimore, MD410-235-5235
Nochton, Jack/1238 W Broad St, Bethlehem, PA215-691-2223
Noel, Peter/99 Rear Washington St 2nd Fl, Melrose, MA617-322-7629
Noon, Liz/110 Mill St, Newton, MA617-965-2931
Nordell, John/12 Grove St, Boston, MA617-723-5484
Noren, Arthur/474 Ottawa St, Hasbrouck Heights, NJ201-393-9140
North Light Photo/332 Dante Ct, Holbrook, NY516-585-2900
North, Robert/85 Main St/Box 6, Windsor, VT802-674-2602
Northlight Visual Comm Group Inc/21 Quine St, Cranford, NJ908-272-1155
Norton, Dick/10 Thatcher St #110, Boston, MA617-523-4720
Nowitz, Richard/10844 Brewer House Rd, Rockville, MD301-816-2372
Nute, Edward/20 Middle St, Plymouth, MA508-746-9120
Nutu, Dan/170 Varick Rd, Newton, MA617-332-0713

O

O'Byrne, William/Box 517, Boothbay Harbor, ME.....................207-633-5623
O'Clair, Dennis/75 Stuart Ave, Amityville, NY516-598-3546
O'Connell, Bill/791 Tremont St, Boston, MA617-437-7556
O'Connor, Patrick/44 Front St, Worcester, MA508-798-8399
O'Donnell, John/116 Mile Square Rd, Yonkers, NY914-968-1786
O'Donoghue, Ken/8 Union Park St, Boston, MA617-542-4898
O'Grady, Paul/270 Norfolk St, Canmbride, MA617-868-0086
O'Hagan, J Barry/455 Chestnut St, N Andover , MA508-683-0408
O'Hare, Richard/POB 273, Clifton Heights, PA215-626-1429
O'Neil, Julie/5 Craigie Cir #7, Cambridge, MA617-547-5168
O'Neil, James/1543 Kater St, Philadelphia, PA215-545-3223
O'Neill, Martin/1914 Mt Royal Terr 1st Fl, Baltimore, MD410-225-0522
O'Neill, Michael Photo/162 Lakefield Rd, E Northport, NY516-754-0459
O'Shaughnessy, Bob/23 Dry Dock Ave, Boston, MA617-345-0727
O'Shaughnessy, Leslie/1 Fieldstone Dr, Hollis, NH603-465-2488
O'Toole, Terrence/104 Union Park St, Boston, MA617-426-6357
Obermeyer, Eva/2 Union Ave, Irvington, NJ201-374-6856
Odor, Lou/288 Kerrigan Blvd, Newark, NJ201-371-2669

Ogden, Sam/273 Summer St, Boston, MA617-426-1021
Oglesbee, Brian/126 N Main St, Wellsville, NY716-593-6803
Ohlmeyer, Herb/165G Overmount St, W Paterson, NJ908-878-7773
Okada, Tom/229 Weston Rd, Wellesley, MA617-237-7119
Olbrys, Anthony/41 Pepper Ridge Rd, Stamford, CT203-322-9422
Oliver/McConnell Photo/406 S Franklin St, Syracuse, NY315-428-0344
Olivera, Bob/108 Chestnut St, Rehoboth, MA508-252-9617
Oliwa, Bill/516 Locust Ave, Hillside, NJ908-688-7538
Olmstead Studio/118 South St, Boston, MA617-542-2024
Olsen, Dan/303 Congress St 4th Fl, Boston, MA617-951-0765
Olsen, Peter/1415 Morris St, Philadelphia, PA215-465-9736
Orabona, Jerry/107 Main St, Sayreville, NJ908-613-1141
Orkin, Pete/80 Washington St, S Norwalk, CT203-866-9978
Orrico, Charles/72 Barry Ln, Syosset, NY516-364-2257
Ostrowski, Stephen/RD 1 Box 1544, Charlotte, VT802-425-2349
Ostrowski, Waldemar/386 Brook Ave, Passaic Park, NJ201-471-3033
Ours, Mary Noble/3402 Prospect St NW, Washington, DC202-338-8870
Owen, Edward/443 Eye St NW, Washington, DC202-462-1921
Owens, John/451 D St #810, Boston, MA617-330-1498
Owens, Vick/30 DeYoung Rd, Glen Rock, NJ201-445-9291

P

P & R Associates/382 Springfield Rd, Summit, NJ908-273-1978
Paige, Peter/269 Parkside Rd, Harrington Park, NJ201-767-3150
Painter, Joseph/205 Fairmont Ave, Philadelphia, PA215-592-1612
Palette Studios/399 Market St, Philadelphia, PA215-440-0500
Palma, Luis/54 Richards St, Newark, NJ201-465-0330
Palmer, Gabe/Fire Hill Farm, West Redding, CT203-938-2514
Palmiere, Jorge/516 1/2 8th St SE, Washington, DC202-543-3326
Pamatat, Ken/165 West Ave, Rochester, NY716-235-1222
Panioto, Mark/95 Mohawk Ln, Wethersfield, CT203-529-9016
Panorama International/Box 63, West Newton, MA617-969-0879
Pantages, Tom/34 Centre St, Concord, NH603-224-1489
Pape, Maria/35 Woodway Rd, Stamford, CT203-329-3035
Pappas, Ernest/Box 385, Hibernia, NJ201-627-3453
Paredes, Cesar/332 Clarksville Rd, Princeton, NJ609-799-1404
Parker, Charles A/5 Elm St, Woodstock, VT802-457-1113
Parker, James/PO Box 4542, Annapolis, MD410-528-1099
Parks, Melanie Marder/5 Broadview Lane, Red Hook, NY914-758-0656
Parragos, Dimitrios/107 Fredrich Ave, Babylon, NY516-669-5895
Parrot Productions/3730 Zuck Rd, Erie, PA814-833-8739
Parsons, Andrew/59 Wareham, Boston, MA617-542-9071
Paskevich, John/1500 Locust St #3017, Philadelphia, PA215-735-9868
Pasley, Richard/90 Hamilton St, Cambridge, MA617-864-8386
Patel, Ghanshyam/130 Thorne St, Jersey City, NJ201-653-5839
Patterson, David/3299 K St NW #404, Washington, DC202-347-0910
Paul, Donna/146 W Concord St, Boston, MA617-247-0034
Paul, Martin/37 Winchester St, Boston, MA617-451-1818
Paul, Richard/2011 Noble St, Pittsburgh, PA412-271-6609
Pavlovich, James/49 Worcester St, Boston, MA617-266-9723
Pawlick, John/121 Glen Rd, Wellesley, MA617-235-4029
Paxenos, Dennis F/2125 Maryland Ave #103, Baltimore, MD410-837-1029
Payne, Cymie/87 Cherry St, Cambridge, MA617-868-0758
Payne, John/43 Brookfield Pl, Pleasantville, NY914-747-1282
Payne, Steve/1524 Virginia St E, Charleston, WV304-343-7254
Peabody, Richard/20120 Lavender Pl, Germantown, MD301-353-0371
Pearse, D/223 Parham Rd, Springfield, PA215-328-3179
Pease, Greg/23 E 22nd St, Baltimore, MD (P 136,137) ...410-332-0583
Peck, Daniel/7199 Chesapeake Ave, Silver Spring, MD301-587-1714
Peckham, Lynda/65 S Broadway, Tarrytown, NY914-631-5050
Peet, George/107 Park Ave, Arlington, MA617-641-2523
Pehlman, Barry/542 Merioneth Dr, Exton, PA215-524-1444
Peirce, George E/133 Ramapo Ave, Pompton Lakes, NJ201-831-8418
Peirce, Michael/242 E Berkeey St 5th Fl, Boston, MA617-491-0643
Pellegrini, Lee/381 Newtonville Ave, Newtonville, MA617-964-7925
Peluso, Frank/15 Caspar Berger Rd, Whitehouse Station, NJ908-534-9637
Pendergrast, Mark/1 North Hillcrest Rd, Essex Junction, VT802-879-1784
Penneys, Robert/12 E Mill Station, Newark, DE302-733-0444
Penni, Jay/15A St Mary's Court, Brookline, MA617-232-7281
Perlman, Ilene/483 Hope St, Providence, RI401-273-8087
Perlmutter, Steven/282 Shelton Rd, Monroe, CT203-789-8493
Perluck, David/122 Chestnut St, Providence, RI401-831-5796
Pernold, Marianne/PO Box 722, Rye, NH603-431-8814
Perron, Robert/119 Chestnut St, Branford, CT203-481-2004
Perry, Wade/17 Old Concord Rd, Lincoln, MA617-259-0336
Persons Photography/478 Hanover St, Manchester, NH603-669-5771
Peters, Michael/102 Chestnut St, Kearny, NJ201-998-0175

Peterson, Brent/73 Maple Ave, Tuckahoe, NY212-573-7195
Peterson, Bruce/465-D Medford St, Charlestown, MA617-241-8228
Petrakes, George/242 E Berkeley, Boston, MA617-695-0556
Petronio, Frank/214 Andrews St #4C, Rochester, NY716-454-3804
Petty, David/31 Pleasant St, Metheun, MA508-794-0404
Philips, Jaye R/2 Crescent Hill Ave, Arlington, MA617-646-8491
Photo Craft/202 Perry Pkwy, Gaithersburg, MD301-417-9507
Photo Dimensions/12 S Virginia Ave, Atlantic City, NJ609-344-1212
Photo Synthesis/216 Blvd of Allies, Pittsburgh, PA412-642-7734
Photo-Colortura/PO Box 1749, Boston, MA617-522-5132
Photogenics/52 Garden St, Cambridge, MA617-876-6540
Photographers & Co/113 S Brandywine Ave, Schenectady, NY518-377-9457
Photographic House/158 W Clinton St, Dover, NJ201-366-3000
Photographic Illustration Ltd/7th & Ranstead, Philadelphia, PA215-925-7073
Photographie/630 N 2nd St, Philadelphia, PA215-925-2084
Phototech/9 Church St, Waltham, MA617-899-4141
Photown Studio/190 Vandervoort St, North Tonawanda, NY716-693-2912
Photoworks/211 Glenridge Ave, Montclair, NJ201-509-8840
Picarello, Carmine/12 S Main St, S Norwalk, CT203-866-8987
Pickerell, Jim H/110 Frederick Ave E Bay, Rockville, MD301-251-0720
Pickett, John/109 Broad St, Boston, MA617-542-7308
Picone, Paul Kevin/162 Western Ave, Gloucester , MA508-281-1725
Picture That Inc/880 Briarwood, Newtown Square, PA215-353-8833
Picturesques Studios/1879 Old Cuthbert Rd, Cherry Hill, NJ609-354-1903
Picturewise/10 Terhune Pl, Hackensack, NJ201-343-1060
Pierce, Barbara/P.O. Box 196, Pittsford, VT802-747-3070
Pierlott, Paul/PO Box 1321, Merchantville, NJ609-665-6392
Pietersen, Alex/67 N The Village Green, Budd Lake, NJ201-347-7504
Pinkerton, Margo Taussig/RR1/Box 81, Canaan, NH603-523-4202
Piperno, Lauren/182 Nevins St, Brooklyn, NY718-935-1550
Pivak, Kenneth/605 Pavonia Ave, Jersey City, NJ201-656-0508
Plank, David/Cherry & Carpenter Sts, Reading, PA215-376-3461
Plessner, Vic/52 Ridgefield Ave , Ridgefield, NJ201-440-8317
Plouffe, Reid/PO Box 5142, Portsmouth, NH603-431-2891
Poggenpohl, Eric/12 Walnut St, Amherst, MA413-256-0948
Pohuski, Michael/36 S Paca St #314, Baltimore, MD410-962-5404
Polansky, Allen/1431 Park Ave, Baltimore, MD410-383-9021
Polatty, Bo/4309 Wendy Court, Monrovia, MD301-865-5728
Polcou, Duane/288 Abbey Dr, Somerset, NJ908-805-0608
Pollard, Duncan/33 Knowlton St, Somerville, MA617-666-1173
Pollard, Pat/24 Spring Lane, Farmington, CT203-677-9557
Pollock, Steven/7th & Ranstead Sts, Philadelphia, PA215-925-7073
Polss, Madeline/124 W 38th St, Wilmington, DE302-762-2453
Polumbaum, Ted/326 Harvard St, Cambridge, MA617-491-4947
Poor, Suzanne/280 Bloomfield Ave, Verona, NJ201-857-5161
Pope-Lance, Elton/125 Stock Farm Rd, Sudbury, MD508-443-4393
Porcella, Phil/337 Summer St, Boston, MA617-423-2002
Potter, Anthony/509 W Fayette St, Syracuse, NY315-428-8900
Powell, Bolling/1 Worcester Square, Boston, MA212-627-4392
Powell, Dean/217 California St, Newton, MA617-969-6813
Pownall, Ron/1 Fitchburg St, Somerville, MA617-354-0846
Pressman, Herb/57 West St, Portland, ME207-879-2608
Prezio, Franco/606 Allen Ln, Media, PA215-565-6919
Price, Donald/2849 Kennedy Blvd, Jersey City, NJ201-420-7255
Price, Greg/PO Box 665, Cranford, NJ908-245-1711
Prince, James/329 Mercer St, Stirling, NJ908-580-9080
Procopio, Richard/PO Box 422, Rockport, ME207-596-6379
Profetti, Diane/10 Marne St, Newark, NJ201-344-1699
Profetto, Joe Jr./566 Delsea Dr, Vineland, NJ609-696-3771
Proud, Barbara/1815 Lovering Ave, Wilmington, DE302-429-9345
Proulx, Robert/194 Main St, Woonsocket, RI401-769-8348
Przyborowski, Thomas/PO Box 796, Clark, NJ908-381-2964
Putnam, Sarah/8 Newell St, Carnbridge, MA617-547-3758

QR

Quin, Clark/241 A Street, Boston, MA617-451-2686
Raab, Timothy/4 Central Ave #G-3, Albany, NY518-465-7222
Rabdau, Yvonne/RR2 Box 590 Kelly Ct, Stormville, NY914-221-4643
Rabinowitz, Barry/515 Willow St, Waterbury, CT203-574-1129
Radcliffe, Tom/7002 Carroll Ave, Tokoma Park, MD301-270-2340
Raducanu, Constantin/5-B Jefferson , Bala Cynwyd, PA215-667-0726
Rae, John/148 Worchester St, Boston, MA617-266-5754
Ragsdale, Ralph/1220 Adams St #408, Boston, MA617-296-4629
Raiche Photography/305 Stark Ln, Manchester, NH603-623-7912
Ralston, Peter/60 Ocean St, Rockland, ME207-594-9209
Ramos & Harris Photo/21 Chauncey Ave, E Providence, RI401-434-0534
Ramsdale, Jack/945 North 5th, Philadelphia, PA215-238-1436

Ranck, Rosemary/323 W Mermaid Ln, Philadelphia, PA215-242-3718
Rand, Howard/131 Sedgefield, N kingstown, RI.....................................401-294-3581
Randall Photography/209 4th St, Providence, RI...................................401-273-6418
Randolph, Robert David/905 B-2 Clopper Rd, Gaithersburg, MD301-977-6243
Rapp, Frank/327 A St, Boston, MA..617-542-4462
Ratensperger, Bruno/14 Business Park Dr, Branford, CT203-488-7649
Rauch, Bonnie/Crane Rd, Somers, NY..914-277-3986
Ray, Dean/2900 Chestnut Ave, Baltimore, MD.....................................410-243-3441
Raycroft, Jim/326 A Street #C, Boston, MA...617-542-7229
Raymond, Charlotte/P.O. Box 4000, Princeton, NJ609-921-4983
Rea, Mark/12 Cottage St, Watertown, MA...617-923-3058
Redic, Bill/841 13th St, Oakmont, TX..412-826-1818
Redmond, Ken/13029 Well House Court , Germantown, MD..................301-540-7295
Reed, Geoff/7 Sunrise Dr, Gillette, NJ...908-580-1226
Reed, Tom/9505 Adelphi Rd, Silver Spring, MD....................................301-439-2912
Reichel, Lorna/PO Box 63, E Greenbush, NY518-477-7822
Reilly, Kevin D/1931 Spring Garden St, Philadelphia, PA......................215-988-1737
Reinstein, Mark/2811 Woodstock Ave, Silver Spring, MD.....................301-588-5078
Reis, Jon Photography/141 The Commons, Ithaca, NY..........................607-272-1966
Rembold, Jon A/15823 Easthaven Ct, Bowie, MD.................................301-805-0975
Renard, Jean/142 Berkeley St, Boston, MA ..617-266-8673
Renckly, Joe/1200 Linden Pl, Pittsburgh, PA.......................................412-323-2122
Resnick, Seth/28 Seaverns Ave #8, Boston, MA...................................617-983-0291
Ressmeyer, Roger/61 Hill St #400, South Hampton, NY.......................516-283-6183
Retallack, John/207 Erie Station Rd, West Henrietta, NY......................716-334-1530
Revette, David Photography Inc/111 Sunset Ave,
Syracuse, NY (P 72)..**315-422-1558**
Riccitelli, Bruce/PO Box 1387, Union, NJ...908-688-2129
Rice, Peter/326 A St 5th Fl, Boston, MA ..617-338-6652
Richards, Christopher/12 Magee Ave, Stamford, CT.............................203-964-0235
Richards, Mark/58 Falcon St, Needham, MA...617-449-7135
Richards, Toby/1 Sherbrooke Dr, Princeton Junction, NJ......................609-275-1885
Richardson, Jonathan R/PO Box 305, Andover, MA..............................508-975-7722
Richmond, Jack/374 Congress St #506, Boston, MA.............................617-482-7158
Riemer, Ken/180 St Paul St, Rochester, NY ...716-232-5450
Riley, George/Sisquisic Trail PO Box 102, Yarmouth, ME......................207-846-5787
Riley, Laura/Hidden Spng Fm PO Box 186, Pittstown, NJ.....................908-735-7707
Ritter, Frank/2414 Evergreen St, Yorktown Hts, NY..............................914-962-5385
Rivera, Tony/28 Dutch Lane, Ringoes, NJ...908-788-3991
Rixon, Mike/1 Meadow Lane, Bow, NH...603-228-2362
Rizzi, Len/1027 33rd St NW, Washington, DC.......................................202-337-6453
Rizzo, John/146 Hallstead St, Rochester, NY..716-288-1102
Robb, Steve/535 Albany St, Boston, MA...617-542-6565
Robbins, Christopher/14919 Carlbern Dr, Centreville, VA......................703-830-3823
Roberts, Michael J/126 Washington St, Providence, RI..........................401-751-7579
Roberts, Terrence/1909 N Market St, Wilmington, DE...........................302-658-8854
Robins, Susan/124 N Third St, Philadelphia, PA....................................215-238-9988
Robinson, George A/33 Kilburn St, Burlington, VT.................................802-862-6902
Robinson, Mike/2413 Sarah St, Pittsburgh, PA.....................................412-431-4102
Rocheleau, Paul/Canaan Rd, Richmond, MA..413-698-2676
Rockhill, Morgan/204 Westminster St, Providence, RI...........................401-274-3472
Roe, Bobby/335 S 18th St, Allentown, PA...215-433-2053
Rogers, Paul/PO Box 967, Stowe, VT...802-253-4549
Romanoff, Mark/8 Wessex Rd, Silver Spring, MD.................................301-585-6627
Romanos, Michael/30 Stanton Rd, Brookline, MA.................................617-277-3504
Ronay, Vivian R/3419 Quebec St NW, Washington, DC.........................202-362-1460
Roos, Warren/135 Somerset St, Portland, ME.......................................207-773-3771
Rorstrom, John/13 Summit St, E Hampton, CT......................................203-267-7255
Rose, Edward/2880 Diamond Hill Rd, Cumberland, RI...........................401-334-4169
Roseman, Shelly/1238 Callowhill St, Philadelphia, PA...........................215-922-1430
Rosen, Morton/122 Main St, Sayville, NY..516-589-5337
Rosenblatt, Jay/360 Glenwood Ave, E Orange, NJ201-414-8833
Rosenblum, Bruce/181 W 16th St, Bayonne, NJ....................................201-436-7141
Rosenblum, David/60 Redmont Rd, Stamford, CT.................................203-324-9311
Rosenthal, Karin/150 Irving St, Watertown, MA.....................................617-923-2307
Rosenthal, Stephen/59 Maple St, Auburndale, MA................................617-244-2986
Rosier, Gerald/PO Box 470, Framingham, MA.......................................617-881-2512
Rosner, Stu/One Thompson Sq, Charlestown, MA.................................617-242-2112
Ross, Alex F/1622 Chestnut St, Philadelphia, PA..................................215-576-7799
Ross, Carolyn/107 South St #501, Boston, MA.....................................617-482-6115
Ross, Doug/610 Eighth Ave, E Northport, NY..516-754-0387
Rossi, Dave/121 Central Ave, Westfield, NJ..908-232-8300
Rossotto, Frank/184 E Main St, Westfield, NY.......................................716-326-2792
Roth, Eric/337 Summer St, Boston, MA..617-338-5358
Rothstein, Gary/55 Valley Rd, New Rochelle, NY..................................914-235-6938
Rotman, Jeffrey L/14 Cottage Ave, Somerville, MA...............................617-666-0874
Rowan, Norm R/106 E 6th St, Clifton, NJ..201-340-2284
Rowan, Scott/1 Quail Hill Ln, Downingtown, PA....................................215-269-9583

Rowin, Stanley/791 Tremont St #W515, Boston, MA617-437-0641
Rowland, Elizabeth A/209 Autumn Dr, Exton, PA215-363-0763
Roystos, Richard/76 Van Derveer Rd, Freehold, NJ908-462-5420
Rubenstein, Len/87 Pine St, Easton, MA ..508-238-0744
Rubino, Larry/364 Glenwood Ave, E Orange, NJ..................................201-744-0999
Rubinstein, Len/Boston, MA...617-238-0744
Rudock, Bill/63 West Lane, Sayville, NY...516-567-2985
Ruggeri, Lawrence/10 Old Post Office Rd, Silver Spring, MD301-588-3131
Ruggieri, Ignazio/86 Lackawanna Ave, W Paterson, NJ.......................201-785-2247
Ruiz, Felix/72 Smith Ave, White Plains, NY ...914-949-3353
Ruiz, Robert/818 E Highland Dr, Buffalo, NY..716-837-1428
Rummel, Hal/36 S Paca St #515, Baltimore, MD...................................410-244-8517
Rumph, Charles/3328 N St NW, Washington, DC..................................202-338-4431
Runyon, Paul/113 Arch St, Philadelphia, PA...215-238-0655
Rusnak, John/9303 Sutton Pl, Silver Spring, MD...................................301-587-2746
Russ, Clive/1311 North St, Walpole, MA...508-668-2536
Russell Studios/103 Ardale, Boston, MA..617-325-2500
Russell, Lincoln/Box 1061, Stockbridge, MA..413-637-0082
Russo, Angela/9 Appleton St, Boston, MA..617-338-6640
Russo, Rich/246 Ridgedale Ave, Morristown, NJ...................................201-538-6954
Ryan, Michael/1 Fitchburg St, Somerville, MA.......................................617-623-9866
Ryder, Scott/409 W Broadway, Boston, MA..617-269-5864
Ryerson, Kathleen & Gordon/92 Heritage Lane, Hamburg, NJ.............201-827-6728

S

Sabol, George Jeremy/2B Park Ave, Englishtown, NJ...........................908-446-4944
Sagala, Steve/350 Route 46, Rockaway, NJ...201-625-0484
Sakmanoff, George/323 Newbury St, Boston, MA.................................617-262-7227
Salamon, Londa/2634 Parrish, Philadelphia, PA....................................215-765-6632
Salamone, Anthony/17 Anthol St, Brighton, MA....................................617-254-5427
Salant, Robin/317 Elm St, Westfield, NJ...908-654-6847
Salomone, Frank/296 Brick Blvd, Bricktown, NJ....................................908-920-1525
Samara, Thomas/713 Erie Blvd West, Syracuse, NY.............................315-476-4984
Samia Photography/2828 10th St NE, Washington, DC.........................202-635-0096
Samu, Mark/39 Erlwein Ct, Massapequa, NY..516-795-1849
Samuels Studio/8 Waltham St, PO Box 201, Maynard, MA....................508-897-7901
Sanderson, John/2310 Pennsylvania Ave, Pittsburgh, PA......................412-263-2121
Sanford, Eric/110 Shaw St, Manchester, NH...603-624-0122
Santaniello, Angelo/20 Passaic St, Garfield, NJ....................................201-473-1141
Santos, Don/175-A Boston Post Rd, Waterford, CT................................203-443-5668
Santos, Randy/1438 Fenwick Ln, Silver Spring, MD..............................301-589-2400
Sapienza, Louis A/1344 Martine Ave, Plainfield, NJ..............................908-756-9200
Saraceno, Paul/Box 277, Groton, MA...508-448-2566
Sargent, William/PO Box 331, Woods Hole, MA....................................508-548-2673
Sasso, Ken/116 Mattabaffet Dr, Meriden, CT..203-235-1421
Sauter, Ron Photo/183 St Paul St, Rochester, NY.................................716-232-1361
Savage, Sally/99 Orchard Terrace, Piermont, NY..................................914-359-5735
Sawa, Joji/2 Fenwick Rd, Winchester, MA..617-721-0196
Saydah, Gerard/PO Box 210, Demarest, NJ..201-768-2582
Sayers, Jim/325 Valley Rd, West Orange, NJ..201-325-2352
Scalera, Ron/8 Rosenbrook Dr, Lincoln Park, NJ...................................201-694-0234
Scarpetta, Tony/443 Albany St #305, Boston, MA.................................617-350-8640
Schaefer, Dave/183 Hubbard St, Concord, MA.....................................508-371-2850
Schaeffer, Bruce/631 N Pottstown Pike, Exton, PA...............................215-363-5230
Schafer, Jim/Franklin Ctr #L103/4240, Pittsburgh, PA..........................412-351-5571
Schamp, J Brough/3616 Ednor Rd, Baltimore, MD................................301-235-0840
Scheer, Tracey/250 W Main St, Branford, CT..203-481-0767
Scheller, George/PO Box 402, Hackettstown, NJ..................................908-852-4670
Schenk, Andy/28 Mulberry Ln, Colts Neck, NJ......................................908-946-9459
Scherer, Jim/35 Kingston St, Boston, MA...617-338-5678
Scherlis, James/3900 N Charles St #904, Baltimore, MD......................410-235-4528
Scherzi, James/5818 Molloy Rd, Syracuse, NY315-455-7961
Schill, William Sr/ PO Box 25, Haddon Heights, NJ...............................609-547-0148
Schindler, Allen/129 Westover Ave, N Caldwell, NJ...............................201-403-8919
Schlanger, Irv/946 Cherokee Rd, Huntington Valley, PA.........................215-663-0663
Schlegel, Robert/2 Division St #10-11, Somerville, NJ...........................908-231-1212
Schleipman, Russell/298-A Columbus Ave, Boston, MA........................617-267-1677
Schlowsky, Bob/73 Old Rd, Weston, MA...617-899-5110
Schmaltz, Joanne/28 School St, Stony Creek, CT.................................203-481-0213
Schmitt, Steve/33 Sleeper St #106, Boston, MA....................................617-426-0858
Schneider, Roy/301 Long Hill Rd, Gillette, NJ.......................................908-580-0068
Schoen, Robert/241 Crescent St, Waltham, MA....................................617-647-5546
Schonthal, Caren/77 White Place, Clark, NJ...908-388-6986
Schoon, Tim/PO Box 7446, Lancaster, PA..717-291-9483
Schroeder, H Robert/PO Box 7361, W Trenton, NJ...............................609-883-8643
Schroers, Kenneth/188 Highland Ave, Clifton, NJ.................................201-472-8395
Schulmeyer, Larry/40 W Chesapeake Ave, Towson, MD.......................410-337-8725

Schultz, Jurgen/Rt 100 N/Box 19, Londonderry, VT....................802-824-3475
Schwab, Hilary/4614 Maple Ave, Bethesda, MD301-656-7930
Schwartz, Jon C/1109 C St NE, Washington, DC202-546-4129
Schwartz, Linda Photo/One Franklin Dr, Mays Landing, NJ609-625-7617
Schwartz, Robin/11 North Shore Tr, Sparta, NJ..........................201-729-7020
Schwarz, Ira/2734 Cortland Pl NW, Washington, DC202-232-2054
Schweikardt, Eric/PO Box 56, Southport, CT203-221-7132
Schwoerer, Eliott/778 Oak Ave, Maywood, NJ..............................201-843-6884
Scott, Jesse/114 Broughton Ave, Bloomfield, NJ201-338-1548
Seale, Logan/326 A St, Boston, MA..617-695-9797
Sean Smyth, Dina Ferrante/604 Main St, Belmar, NJ908-280-8955
Seckinger, Angela/11231 Bybee St, Silver Spring, MD................301-649-3138
Sedlak, Eric/PO Box 1087, Valley Stream, NY............................718-949-4398
Seghers, Carroll/9 Cartbridge Rd, Weston, CT203-227-3853
Seidel, Joan/337 Summer St, Boston, MA..................................617-357-8674
Selig, Mark/45 Electric Ave, Boston, MA....................................617-267-2000
Serbin, Vincent/304 Church Rd, Bricktown, NJ908-477-5620
Severi, Robert/813 Richmond Ave, Silver Spring, MD..................301-585-1010
Sewall & Co, James/PO Box 433, Old Town, ME207-827-4456
Shafer, Bob/3554 Quebec St N W, Washington, DC202-362-0630
Shaffer, Nancy/PO Box 333, Lincroft, NJ....................................908-846-6304
Shaffer-Smith Photo/56 Arbor St, Hartford, CT203-236-4080
Shambroom, Eric/383 Albany St, Boston, MA..............................617-423-0359
Shanley, James G/8 West St, Stoneham, MA..............................617-279-9060
Shapiro, Betsy/7 E Burn St, Brighton, MA...................................617-783-2889
Sharp, Barry/30 Tower Hill Rd, N Kingston, RI401-295-1686
Sharp, Steve/153 N 3rd St, Philadelphia, PA..............................215-925-2890
Shaw Studios/836 Richie Highway, Severne Park, MD410-647-1200
Shawn, John/129 Sea Girt Ave, Manasguan, NJ..........................908-223-1190
Shearn, Michael/c/o Deborah Wolfe/214 S 12th, Philadelphia, PA........215-232-6666
Sheldon, John/PO Box 548, Hartford, VT....................................802-295-6321
Shepherd, Francis/PO Box 204, Chadds Ford, PA215-347-6799
Sher, Fred/210 Kinderkamack Rd, Oradell, NJ201-599-1213
Sherer, Larry/3000 Chestnut Ave #343D, Baltimore, MD..............410-235-8443
Sherman, Stephen/49 Melcher St 5th Fl, Boston, MA..................617-542-1496
Sherriff, Bob/963 Humphrey St, Swampscott, MA........................617-599-6955
Shields, Rob/830 Eddy St, Providence, RI401-461-8848
Shinnick, John/3224 Kennedy Blvd, Jersey City, NJ....................201-420-1056
Shive, James/316 Tall Oak Rd, Edison, NJ..................................908-906-9623
Shoemake, Allan Hunter/56 Main St, Millburn, NJ........................201-467-4920
Shooters Photo/PO Box 7822, York, PA......................................717-764-4446
Shopper, David/409 W Broadway #219, Boston, MA....................617-268-2044
Shotwell, John/12 Farnsworth St 1st Fl, Boston, MA....................617-357-7456
Shupe, Greg/483 Water St, Framingham, MA..............................508-877-7700
Siciliano, Richard/809 Albany St, Schenectady, NY....................518-370-4417
Sidney, Rhoda/59 E Linden Ave B7, Englewood, NJ....................201-568-3919
Sieb, Fred/Box480/Birch Hill, North Conway, NH........................603-356-5879
Siegel, Hyam Photography/PO Box 356, Brattleboro, VT802-257-0691
Siegel, Marjorie/, Boston, MA..617-731-2855
Sigall, Dana/348 Congress St 3rd fl, Boston, MA........................617-357-5140
Silk, Georgiana B/190 Godfrey Rd E, Weston, CT........................203-226-0408
Silver Light Studio/735 Sumner Ave, Springfield, MA..................413-737-2003
Silver, David/165 Front St, Chicopee, MA....................................413-594-8353
Silver, Walter S/107 South St #203, Boston, MA..........................617-426-4743
Silverman, Jeff/1 East Front St, Keyport, NJ................................908-264-3939
Silverman, Paul/49 Ronald Dr, Clifton, NJ...................................201-472-4339
Silverstein, Abby/3315 Woodvalley Dr, Baltimore, MD..................410-486-5211
Silverstein, Roy/1604 Gary Rd, East Meadow, NY........................516-481-3218
Silvia, Peter/20 Burdick Ave, Newport, RI....................................401-841-5076

**Simeone, J Paul/116 W Baltimore Pike, Media,
PA (P 38,39)**..**215-566-7197**
Simian, George/566 Commonwealth Ave, Boston, MA..................617-267-3558
Simmons, Erik Leigh/60 K Street, Boston, MA..............................617-268-4650
Simon, David/97 Wayne St, Jersey City, NJ..................................201-795-9326
Simon, Peter S/RFD 280, Chilmark, MA..508-645-9575
Simons, Stuart/71 Highland St, Patterson, NJ..............................201-278-5050
Simpson, John WH/ 98 Linden Lane, Princeton, NJ......................609-924-8996
Sinclair, Dan/150 Preble St, Portland, ME....................................207-772-6161
Sinclair, Jodie/109 Broad St, Boston, MA....................................617-482-0328
Singer, Arthur/Sedgewood RD 12, Carmel, NY.............................914-225-6801
Singer, Jay/20 Russell Park Rd, Syosset, NY516-935-8991
Siteman, Frank/136 Pond St, Winchester, MA..............................617-729-3747
Sitkin, Marc/15 Warrenton Ave, Hartford, CT................................203-523-4562
Skalkowski, Bob/310 Eighth St, New Cumberland, PA717-774-0652
Skibee, John/4 Bud Way, Nashua, NH..603-880-8686
Skoogfors, Leif/415 Church Rd #B2, Elkins Park, PA....................215-635-5186
Slade, Richard/1412 Northcrest Dr, Silver Spring, MD..................301-384-2525
Slezinger, Natan/1191 Chestnut St, Newton, MA..........................617-964-0700

Sloan Photo/182 High St, Waltham, MA......................................617-542-3215
Sloan, Jim/12017 Nevel St, Rockville, MD..................................301-732-7940
Smalley, James C/7 Jackson Rd, Scituate, MA............................617-545-1664
Smalling, Walter Jr/1541 8th St NW, Washington, DC..................202-234-2438
Smaltz, Richard/PO Box 535 Rt 318, W Middlesex, PA................412-528-1234
Smith, Bill Photo/20 Newbury St, Boston, MA..............................617-267-4026
Smith, Brian/7 Glenley Terrace, Brighton, MA..............................617-782-5560
Smith, Dana/140 Ohio St, New Bedford, MA................................508-998-8547
Smith, David K/731 Harrison Ave, Boston, MA..............................617-424-1555
Smith, David L/420 Goldway, Pittsburgh, PA................................412-687-7500
Smith, Gary & Russell/65 Washington St, S Norwalk, CT..............203-866-8871
Smith, Gene/876-K N Lenola Rd, Moorestown, NJ........................609-722-5225
Smith, George E/408 St Lawrence Dr, Silver Spring , MD..............301-593-9618
Smith, Gordon E/65 Washington St, S Norwalk, CT203-866-8871
Smith, Greg/1827 Belmont Rd NW, Washington, DC....................202-328-9282
Smith, Hugh R/2515 Burr St, Fairfield, CT...................................203-255-1942
Smith, Philip W/1589 Reed Rd #2A, W Trenton, NJ......................609-737-3370
Smith, Rodney/Lawrence Lane, Palisades, NY914-359-3814
Smith, Stuart/68 Raymond Lane, Wilton, CT................................203-762-3158
Smyth, Kevin/21 Alexandria Way, Basking Ridge, NJ....................908-580-1150
Snitzer, Herb/64 Roseland St, Cambridge, MA............................617-497-0251
Sobel, Jane/235 Cody Rd, Landgrove, VT....................................802-824-4135
Sobol, Richard/18 Fenno St, Cambridge, MA..............................617-576-2953
Socolow, Carl/2714 Dickinson Ave, Camp Hill, PA........................717-763-7760
Solaria Studio/190 Tuckerton Road, Indian Mills, NJ....................609-268-0045
Solomon, Alan/Rt 33, Chatam, NY..518-392-5220
Solomon, Daryl/8 Illingworth Ave, Tenafly, NJ..............................201-871-3236
**Solomon, Ron/149 W Montgomery St, Baltimore,
MD (P 142)**..**410-539-0403**
Sons, Fred/2424 18th St NW #302, Washington, DC,....................202-745-7718
Soorenko, Barry/5161 River Rd Bldg 2B, Bethesda, MD................301-652-1303
Sortino, Steve/2125 N Charles St, Baltimore, MD..........................410-625-2125
Spahr, David/170 Water St, Hallowell, ME....................................207-623-5067
Spartana, Stephen/19 S Strickler St, Baltimore, MD......................410-945-2173
Spaulding, Matt/49 Dartmouth, Portland, ME................................207-772-4725
Spectrum Photography/PO Box 731, Burfield, MA..........................508-463-4338
Speedy, Richard/1 Sherbrooke Dr, Princeton Junction, NJ............609-275-1885
Spence, George A/132 Bearforte Rd, W Milford, NJ......................201-641-2032
Spencer, Dave/PO Box 726, Hanson, MA617-447-0918
Spencer, Michael/735 Mt Hope Ave, Rochester, NY......................716-475-6817
Spencer, Stephen/145 Crary St, Providence, RI............................401-751-1925
Sperduto, Stephen/18 Willett Ave, Port Chester, NY......................914-939-0296
Spiegel, Ted/RD 2 Box 353 A, South Salem, NY914-763-3668
Spiro, Don/137 Summit Rd, Sparta, NJ..212-484-9753
Spofford, Dean R/556 Main St/Box125, W Boxford, MA................508-352-9854
Spozarsky, Michael/5 Academy St, Newton, NJ201-579-1385
Sprecher, Allan/3600 Clipper Mill Rd #100, Baltimore, MD............410-235-5004
St Hilaire, Linda/78 Waltham St, Boston, MA................................617-423-7066
St Onge, Cheryl/Box 67, Durham, NH..603-659-6528
St Pierre, Joe/135 McDonough St #27, Portsmouth, NH................603-436-6070
Staccioli, Marc/167 New Jersey Ave, Lake Hopatcong, NJ............201-663-5334
**Stagg-Giulano, Sylvia/75 Whitney Rd, Medford,
MA (P 145)**..**617-395-4036**
Stankowics, Tom/791 Tremont St #E209, Boston, MA..................617-536-7140
Stanley, James G/8 West St, Stoneham, MA................................617-279-9060
Stapleton, John/3407 Widener Rd, Philadelphia, PA215-233-3864
Starosielski, Sergei/181 Doty Circle, W Springfield, MA................413-733-3530
Stayner & Stayner Photography/3060 Williston Rd, S Burlington, VT802-865-3477
Stearns, Stan/1814 Glade Ct, Annapolis, MD................................410-268-5777
Stein, Geoffrey R/348 Newbury St, Boston, MA............................617-536-8227
Stein, Jonathan/579 Sagamore Ave, Portsmouth, NH....................603-436-6365
Stein, Larry/51 Union St, Worcester, MA......................................508-754-1470
Stein, Martin/157 Highland Ave, Winthrop, MA..............................617-539-0070
Steiner, Peter Photo/183 Saint Paul St, Rochester, NY..................716-454-1012
Steinkamp, Susan V/1013 Independence SE, Washington, DC..........202-544-4886
Stevens, Ann/4300 47th St NW, Washington, DC,..........................202-244-5633
Stevenson, Jeff/496 Congress St, Portland, ME............................207-773-5175
Stewart, Tom/205 Johnson Point Rd, Penobscot, ME....................207-326-9370
Stier, Kurt/451 "D" St, Boston, MA..617-330-9461
Still, John/281 Summer St, Boston, MA..617-451-8178
Stillings, Jamey/87 N Clinton Ave 5th Fl, Rochester, NY................716-232-5296
Stiltz, Thomas/8210 Thornton Rd, Baltimore, MD..........................410-337-5565
Stites, Bill..203-655-7376
Stockfield, Bob/3000 Chestnut Av #114/Mill Ctr, Baltimore, MD............410-235-7007
Stockwell, Thomas/20 Blue Bell Rd, Worcester, MA......................508-853-1000
Stone, Parker II/6632 Temple Dr, E Syracuse, NY........................315-463-0577
Stone, Steven/20 Rugg Rd, Allston, MA......................................617-782-1247
Stratos, Jim/128 Pine St, Peekskill, NY..212-695-5674

Strauss, Diane/1666 32nd St NW, Washington, DC202-965-1733
Strohmeyer, Damian/14 Daniel St, Arlington, MA617-648-6543
Stromberg, Bruce/PO Box 2052, Philadelphia, PA215-545-0842
Stuart, Stephen Photography/10 Midland Ave, Port Chester, NY914-939-0302
Stuck, John D/RD 1 Box 234, Selinsgrove, PA717-374-8898
Studio Assoc/30-6 Plymouth St, Fairfield, NJ201-575-2640
Studio Capricorn/109 Higginson Ave, Lincoln, RI401-726-8450
Studio Tech/35 Congress St Box 390, Salem, MA617-745-5070
Stultz, Natalie/B5 Meadowbrook Joy Dr, S Burlington, VT802-863-1640
Suarez, Ileana/6901 Bergenkine Ave, Gutenberg, NJ201-869-8910
Sued, Yamil/425 Fairfield Ave Bldg 4, Stamford, CT203-324-0234
Sullivan, Sharon/23 Cedar St, Mt Olive, NJ201-347-5706
Susoeff, Bill/1063 Elizabeth Dr, Bridgeville, PA412-941-8606
Suter, John/1118 Commonwealth Ave #5A, Boston, MA617-735-0812
Sutphen, Chazz/22 Crescent Beach Dr, Burlington, VT802-862-5912
Sutter, Frederick/6123 Blue Whale Ct, Waldorf, MD301-843-7510
Sutton, Humphrey/38 E Brookfield Rd, N Brookfield, MA508-867-4474
Swann Niemann Photography/9 W 29th St, Baltimore, MD301-467-7300
Swanson, Dick/6122 Wiscasset Rd, Bethesda, MD202-965-1185
Swartley, Lowell/28 W Broad St, Souderton, PA215-721-7118
Sway, Fred/, Boston, MA ..617-555-1212
Sweeney Jr, Gene/1200 Monkton Rd, Monkton, MD410-343-1609
Sweet, Ozzie/Sunnyside Acres, Francestown, NH603-547-6611
Swett, Jennifer/PO Box 102, N Sutton, NH603-927-4648
Swisher, Mark/3819 Hudson St, Baltimore, MD410-732-7788
Swoger, Arthur/61 Savoy St, Providence, RI401-331-0440
Szabo, Art/156-A Depot Rd, Huntington, NY516-549-1699

T

Tadder, Morton/1010 Morton St, Baltimore, MD410-837-7427
Tagg, Randall/18 Broxbourne Dr, Fairport, NY716-425-3139
Taglienti, Maria/294 Whippany Rd, Whippany, NJ201-428-4477
Tango, Rick/7 Deer Run, Bethel, CT ..203-748-1652
Tanner, Tom/315 Route 17, Paramus, NJ201-967-0005
Tarantola, Kathy/109 Broad St, Boston, MA617-423-4399
Tardi, Joseph/125 Wolf Rd #108, Albany, NY518-438-1211
Tardiff, Gary/451 D Street #806, Boston,
MA (P 146,147) ...**617-439-9180**
Tarsky, Jeffrey/75 Haynes Rd, Newton, MA617-965-6970
Tartaglia, Vic/42 Dodd St, Bloomfield, NJ (P 148)**201-429-4983**
Taylor, Ed/668 Front St, Teaneck, NJ ...201-836-8345
Taylor, Robert/55 Lane Rd, Fairfield, NJ201-227-5000
Teatum, Marc/28 Goodhue St, Salem, MA508-745-2345
Teitelbaum, Phyliss/917 Lamberton Dr, Silver Spring, MD301-649-1449
Tenin, Barry/PO Box 2660 Saugatuck Sta, Westport, CT203-226-9396
Tepper, Peter/183 Bennett St, Bridgeport, CT203-367-6172
Tesch, Geoffrey/639 Boughton Hill Rd, Honeoye Falls, NY716-624-4096
Tesi, Mike/12 Kulick Rd, Fairfield, NJ ...201-575-7780
Texter, Jay/PO Box 78, Souderton, PA ..215-821-0963
Thauer, Bill/542 Higgens Crowell Rd, W Yarmouth, MA508-362-8222
Thayer, Mark/25 Dry Dock Ave, Boston, MA617-542-9532
The Studio Inc/938 Penn Ave, Pittsburgh, PA412-889-5422
Thellman, Mark/PO Box 1209, Merchantville, NJ609-488-9093
Therrien, Ned/34 Swain Rd, Gilford, NH603-524-6274
Thiebauth, Jeffrey/57 Pine Circle, S Weymouth, MA617-335-2686
Thomas, Edward/140-50 Huyshope Ave, Hartford, CT203-246-3293
Thomas, Melvin III/75 Prospect St #7C, E Orange, NJ201-678-9655
Thomas, Ted/PO Box 2051, Teaneck, NJ201-837-6682
Thompson, Eleanor/PO Box 1304, Weston, CT203-226-8659
Thompson, S./333 Pemberton Browns Mills Rd, New Lisbon, NJ609-893-2726
Thuss, Bill/407 Main St, Rockland, ME ..207-596-0603
Titcomb, Jeffery/423 W Broadway, South Boston, MA617-269-8777
Tkatch, James/2307 18th St NW, Washington, DC202-462-2211
Tobey, Robert ...413-584-7606
Tolbert, Brian/911 State St, Lancaster, PA717-393-0918
Tollen, Cynthia/50 Fairmont St, Arlington, MA617-641-4052
Tong, Darren/28 Renee Terrace, Newton, MA617-527-3304
Tornallyay, Martin/77 Taft Ave, Stamford, CT203-357-1777
Total Concept Photo/95-D Knickerbocker Ave, Bohemia, NY516-567-6010
Tracy, Don/1133 E Oxford St, Philadelphia, PA215-426-5154
Trafidlo, James F/17 Stilling St, Boston, MA617-338-9343
Traub, Willard/PO Box 2429, Framingham, MA508-872-2010
Traver, Joseph/187 Hodge Ave, Buffalo, NY716-884-8844
Treiber, Peter/917 Highland Ave, Bethlehem, PA215-867-3303
Tretick, Stanley/4365 Embassy Park Dr NW, Washington, DC202-537-1445
Tribulas, Michael/1879 Old Cuthbert Rd #14, Cherry Hill, NJ609-354-1903
Tritsch, Joseph/507 Longstone Dr, Cherry Hill, NJ609-424-0433

Troeller, Linda/718 Polk Ave, Lawrenceville, NJ609-396-2660
Troha, John/9030 Saunders Lane, Bethesda, MD301-469-7440
Trola, Bob/1216 Arch St 2nd Fl, Philadelphia, PA215-977-7078
Trottier, Charles/PO Box 581, Burlington, VT802-862-1881
Trueworthy, Nance/PO Box 8353, Portland, ME207-774-6181
Truman, Gary/PO Box 7144, Charleston, WV304-755-3078
Truslow, Bill/855 Islington St, Portsmouth, NH603-436-4600
Trzoniec, Stanley/58 W Main St, Northboro, MA617-393-3800
Tsufura, Satoru/48 Bently Rd, Cedar Grove, NJ201-239-4870
Tuemmler, Stretch/45 Casco, Portland, ME207-871-0350
Tur, Stefan ..914-557-8857
Turner, Steve/286 Compo Rd South, Westport, CT203-454-3999
Turpan, Dennis P/25 Amsterdam Ave, Teaneck, NJ201-837-4242

UV

Ulsaker, Michael/275 Park Ave, E Hartford, CT203-282-0341
Ultimate Image/Photo/PO Box 22, Lawton, PA717-934-2226
Umstead, Dan/7475 Morgan Road 7-6, Liverpool, NY315-457-0365
Urban, John/144 Lincoln St, Boston, MA617-426-4578
Urban, Peter/71 Wachusett St, Jamaica Plain, MA617-983-9169
Urbina, Walt/7208 Thomas Blvd, Pittsburgh, PA412-242-5070
Urdang, Monroe/461-A Oldham Ct, Ridge, NY516-744-3903
Ury, Randy/PO Box 7312, Portland, ME207-871-0291
Usher III, Aaron/1080 Newport Ave, Pawtucket, RI401-725-4595
Ushkurnis, Jim/387 Park Ave, Worcester, MA508-795-1333
Uttrachi, Bud/873 Bloomfield Ave, Clifton, NJ201-777-1128
Uzzle, Burk/737 N 4th St, Philadelphia, PA215-629-1202
Vadnai, Peter/180 Valley Rd, Katonah, NY914-232-5328
Valentino, Thom/25 Navaho St, Cranston, RI401-946-3020
Valerio, Gary/278 Jay St, Rochester, NY716-352-0163
Van Arsdale, Nancy/300 Franklin Turnpike, Ridgewood , NJ201-652-1202
Van Der Wal, Onne/PO Box 609, Newport, RI401-846-9552
Van Gorder, Jon/63 Unquowa Rd, Fairfield, CT203-255-6622
Van Lockhart, Eric/145 Cross Ways Park W, Woodbury, NY516-364-3000
Van Petten, Rob/109 Broad St, Boston, MA617-426-8641
Van Schalkwyk, John/50 Melcher St, Boston, MA617-542-4825
Van Stewn, Shaun/406 Lincoln Ave , Falls Church, VA703-533-7870
Van Valkenburgh, Larry/511 Broadway, Saratoga Springs, NY518-583-3676
Vandall, D C/PO Box 515, Worchester, MA508-852-4582
Vanden Brink, Brian/PO Box 419, Rockport, ME207-236-4035
Vandermark, Peter/523 Medford St, Charlestown, MA617-242-2277
Vanderwarker, Peter/28 Prince St, West Newton, MA617-964-2728
VanderWiele, John/75 Boulevard, Pequannock, NJ201-694-2095
Vangha, Ruhi/PO Box 344, Wayne, PA ..215-293-1315
Vasquez, George/249 8th St, Boston, MA617-482-2882
Vaughan, Ted/351 Doe Run Rd, Manheim, PA717-665-6942
Vazquez, Claudio/2726 Brandwine St NW, Washington, DC202-543-7782
Vecchio, Dan/204 Forest Hill Dr, Syracuse, NY315-437-9019
Vecchione, Jim/PO Box 32094 NW, Washington, DC800-347-7907
Veerasarn, Oi/2707 Adams Hill Rd NW, Washington, DC202-387-8667
Vendikos, Tasso/141 Hawthorne St, Massapequa Park, NY516-541-1635
Ventura, Michael/5016 Elm St, Bethesda, MA301-654-6205
Verderber, Gustav ...802-644-2089
Verheeck, Al/160 Birchwood Rd, Paramus, NJ201-652-4291
Vericker, Joe/111 Cedar St 4th Fl, New Rochelle, NY914-632-2072
Verno, Jay/101 S 16th St, Pittsburgh, PA412-381-5350
Vidor, Peter/48 Grist Mill Rd, Randolph, NJ201-267-1104
Vieira, Jacque/15 Bitterweet Dr, Seekonk, MA508-399-7272
Vierra, Steve/Box 55, Mansfield, MA ..508-477-7043
Visual Productions/2121 Wisconsin Ave NW #470, Washington, DC202-337-7332
Von Falken, Sabine V/Rt 183, Glendale, MA413-298-4933
Von Hoffmann, Trip/2 Green Village Rd, Madison, NJ201-377-0317
Voscar The Maine Photographer/PO Box 661, Presque Isle, ME207-769-5911

W

Waggaman, John/RD 5/ Box 240, Williamsport, PA800-336-6062
Wagner, William/208 North Ave West, Cranford, NJ908-276-2229
Wahl, Paul/PO Box 6, Bogota, NJ ...201-507-9245
Walch, Robert/724 Cherokee St, Bethlehem, PA215-866-3345
Walker, Robert/13 Thorne St, Jersey City, NJ201-659-1336
Wallen, Jonathan/41 Lewis Pkwy, Yonkers, NY914-476-8674
Walley, Chris/1035 N Calvert St, Baltimore, MD301-385-3120
Walling, Kit/18019 Bentley Rd, Sandy Spring, MD301-924-1662
Walp's Photo Service/182 S 2nd St, Lehighton, PA215-377-4370
Walsh, Dan/409 W Broadway, Boston, MA617-268-7615
Walters, Day/PO Box 5655, Washington, DC202-362-0022

Walther, Michael/2185 Brookside Ave, Wantagh, NY516-783-7636
Wanamaker, Roger/PO Box 2800, Darien, CT203-655-8383
Ward, Jack/221 Vine St, Philadelphia, PA215-627-5311
Ward, Michael/916 N Charles St, Baltimore, MD410-727-8800
Ward, Tony/704 South 6th St, Philadelphia, PA215-238-1208
Wargo, Matt/1424 S Broad St, Philadelphia, PA215-468-5842
Waring, Nicholas/5808 63rd Ave, Riverdale, MD301-864-8115
Warinsky, Jim/224 W Hudson Ave, Englewood, NJ212-206-6448
Warner, Roger/409 W Broadway, S Boston, MA671-268-8333
Warniers, Randall/35 Cleveland St, Arlington, MA617-643-0454
Warren, Bob/Box 300, Myersville, MD301-293-8989
Warren, Murray/415 Route 17, Upper Saddle River, NJ201-327-4832
Warunek, Stan/205 Gill Ave, Dupont, PA717-654-0421
Washnik, Andrew/145 Woodland Ave,
Westwood, NJ (P 56,57) ..**201-664-0441**
Wasserman, Cary/Six Porter Rd, Cambridge, MA617-492-5621
Watkins, Charles/75 E Wayne Ave #W-311, Silver Springs, MD301-587-9284
Watkins, Norman/3000 Chestnut Ave #213, Baltimore, MD410-467-3358
Watson, H Ross/Box 897, Bryn Mawr, PA215-353-9898
Watson, Linda M/38 Church St/Box 14, Hopkinton, MA508-435-5671
Watson, Tom/2172 West Lake Rd, Skaneateles, NY315-685-6033
Wawrzonek, John/70 Webster St, Worcester, MA508-798-6612
Way, Herb/241 Waldman Ave, Edison, NJ908-382-3305
Way, James/622-R Main St, Reading, MA617-944-3070
Weber, Kevin/138 Longview Dr, Baltimore, MD410-747-8422
Wee, John/115 Pius St, Pittsburgh, PA412-381-6826
Weems, Al/18 Imperial Pl #5B, Providence, RI401-455-0484
Weidman, H Mark/2112 Goodwin Lane, North Wales, PA215-646-1745
Weigand, Tom/707 North 5th St, Reading, PA215-374-4431
Weiner, Jeff/163 N Main St, Port Chester, NY914-939-8324
Weinrebe, Steve/, Philadelphia, PA215-625-0333
Weinrich, Ken/21 Oriole Terrace, Newton, NJ201-579-6784
Weisenfeld, Stanley/135 Davis St, Painted Post, NY607-962-7314
Weiss, Michael/212 Race St, Philadelphia, PA215-629-1685
Weitz, Allan/147 Harbinson Pl, E Windsor, NJ609-443-5549
Weller, Bruce/3000 Chestnut Ave #11, Baltimore, MD410-235-4200
Wells, Heidi/1284 Beacon St #607, Brookline, MA617-232-7417
Welsch, Dennis/11 Carlton St, Portland, ME207-761-0808
Welsch, Ms Ulrike/4 Dunns Lane, Marblehead, MA617-631-1641
Wendler, Hans/RD 1 Box 191, Epsom, NH603-736-9383
Werner, Perry/259 Continental Ave, River Edge, NJ201-967-7306
West, Judy/8 Newcomb St, Boston, MA617-442-9343
Westphalen, James/75 Prairie Lane, Lyndenhurst, NY516-957-5060
Westwood Photo Productions/PO Box 859, Mansfield, MA617-339-4141
Wexler, Ira/4911 V St NW, Washington, DC202-337-4886
Wexler, Jerome/13 Landshire Dr, Madison, CT203-245-2396
Weydig, Kathy A/275 Myrtle Ave, Bridgeport, CT203-367-8948
Whalen, Mark/PO Box 455, Baldwinsville, NY (P 151)**315-635-2870**
Wheat, Frank/225 W 25th St, Baltimore, MD410-889-1780
Wheeler, Ed/1050 King of Prussia Rd, Radnor, PA215-964-9294
Wheeler, Nick/414 Concord Rd, Weston, MA617-891-5525
Whitcomb, David/212 E Cross St, Baltimore , MD410-727-7507
White, Andrew/5727 29th Ave, Hyattsville, MD301-559-7718
White, Frank/18 Milton Pl, Rowayton, CT203-866-9500
White, Nicole/25 Elm St, Malone, NY518-483-5135
White, Sharon/107 South St, Boston, MA617-423-0577
Whitenack, Ernie/PO Box 332, Newton, MA617-964-3326
Whitman, Edward/107 E Preston St, Baltimore, MD410-727-2220
Whitney, Louise/PO Box 805, Amherst, NH603-886-6950
Whittemore, Patrick/7 Union Park St, Boston, MA617-695-0584
Wieland, Mark/12115 Parklawn Dr Bay-S, Rockville, MD301-468-2588
Wierzbowski, Joe/91 Main St W, Rochester, NY716-546-8381
Wilcox, Jed/PO Box 1271, Newport, RI401-847-3853
Wild, Terry/RD 3/Box 68, Williamsport, PA717-745-3257
Wiley, John Jay/208-A W Wayne Ave, Wayne, PA215-337-9668
Wilkins, Doug/33 Church St, Canton, MA617-828-2379
Wilkinson, Peter/1944 Warwick Ave, Warwick, RI401-738-5059
Willet, Don/113 14th St #4, Hoboken, NJ201-656-1690
Williams, Calvin/2601 Madison Ave #503, Baltimore , MD410-728-1483
Williams, Jay/9101 W Chester Pike, Upper Darby, PA215-789-3030
Williams, Lawrence S/9101 W Chester Pike, Upper Darby, PA215-789-3030
Williams, Woodbridge/PO Box 11, Dickerson, MD301-972-7025
Willson, Hub/1228 Turner St, Allentown, PA215-434-2178
Wilson, John G/2416 Wynnefield Dr, Havertown, PA215-446-4798
Wilson, Kevin/11231 Bybee St, Silver Spring, MD301-649-3151
Wilson, Robert L/PO Box 1742, Clarksburg, WV304-623-5368
Windman, Russell/348 Congress St, Boston, MA617-357-5140
Winstead, Gene/300 Observer Highway #602, Hoboken, NJ201-714-9245

Wise, Harriet/242 Dill Ave, Frederick, MD............................301-662-6323
Wiseman, Pat/93 Prince Ave, Marstons Mills, MA508-420-3395
Witbeck, David/77 Ives St, Providence, RI401-274-9118
Wittkop, Bill/346 Main St, Chatham, NJ201-635-1825
Wojnar, Lee/326 Kater St, Philadelphia, PA215-922-5266
Wolff, Tom/2102 18th St NW, Washington, DC202-234-7130
Wolinski, Cary/70 Green Street, Norwell , MA617-659-2839
Wood, Richard/169 Monsgnr O'Brien Hwy, Cambridge, MA617-661-6856
Woodard, Steve/2003 Arbor Hill Ln, Bowie, MD301-249-7705
Woolf, John/58 Banks St, Cambridge, MA617-876-4074
Wooloff, Warren/20602 West St, Wrentham, MA508-883-8783
Wrenn, Bill/41 Wolfpit Ave, Norwalk, CT203-845-0939
Wright, Jeri/PO box 7, Wilmington, NY518-946-2658
Wright, Ralph/43 Forest Park Dr, Nashua, NH603-882-1519
Wu, Ron/179 St Paul St, Rochester, NY716-454-5600
Wurster, George/128 Berwick, Elizabeth, NJ908-352-2134
Wyatt, Ronald/846 Harned St #1A, Perth Amboy, NJ908-442-7527
Wychunis, Tony/128 Osborne St, Philadelphia, PA215-482-4927
Wyland, Katharine/24 Montague Ave #3, W Trenton, NJ609-771-3705
Wyman, D Jake/PO Box M85, Hoboken, NJ201-420-8462
Wyman, Ira/14 Crane Ave, West Peabody, MA508-535-2880
Wyner, Kenneth/7012 Westmoreland Ave, Takoma Park, MD......301-269-6284

YZ

Yablon, Ron/834 Chestnut St #PH 105, Philadelphia, PA........215-363-2596
Yamashita, Michael/25 Roxiticus Rd, Mendham, NJ201-543-4473
Yellen, Bob/833 Second Ave, Toms River, NJ908-341-6750
Young, Bruce/70C N Bedford St, Arlington, VA703-528-3145
Z, Taran/528 F St Terrace SE, Washington, DC202-543-5322
Zabek, V J/50A Joy St, Boston, MA617-227-3123
Zaccardi, Grace/2523 N Calvert St, Baltimore, MD410-889-1121
Zaporozec, Terry (Mr)/43 Johnson Rd, Hackettstown, NJ908-637-6720
Zappa, Tony/143 Parkway Dr, Roslyn Heights, NY................516-484-4907
Zarember, Sam/26 Old S Salem, Ridgefield, CT203-438-4472
Zaslow, Francine/27 Dry Dock Ave, Boston, MA...................617-261-1878
Zegre, Francois/246 Ridgedale Ave, Morristown, NJ.............201-538-6954
Zickl & Butcher/46 Lincoln St, Jersey City, NJ......................201-656-5680
Zimmerman, Linda/1 Horizon Rd, Ft Lee, NJ201-886-0511
Zito, Roy/PO Box 1123, Fairlawn, NJ...................................201-796-0104
Zmiejko, Tom/PO Box 126, Freeland, PA..............................717-636-2304
Zobian, Berge Ara/17 Amherst St, Providence, RI.................401-751-1970
Zubkoff, Earl/2426 Linden Lane, Silver Spring, MD301-585-7393
Zucker, Gale/PO Box 2281/Short Beach, Branford, CT..........203-488-0499
Zugcic, Joseph/20 Union Hill Rd, Morganville, NJ.................908-536-3288
Zullinger, Carson/1909 N Market St, Wilmington, DE............302-654-3905
Zungoli, Nick/Box 5, Sugar Loaf, NY....................................914-469-9382
Zurich, Robert/445 Highway 35, Eatontown, NJ908-389-9010
Zutell, Kirk/911 State St, Lancaster, PA................................717-393-0918

SOUTHEAST

A

Adcock, James/3108 1/2 W Leigh St #8, Richmond, VA804-358-4399
Adcock, Susan/PO Box 349, Pegram, TN..............................615-646-4114
Alderman Company/325 Model Farm Rd, High Point, NC919-889-6121
Alexander, Rick & Assoc/212 S Graham St, Charlotte, NC......704-332-1254
Allard, William Albert/Rt 689/PO Box 148, Batesville, VA......804-823-5951
Allen, Bob/710 W Lane St, Raleigh, NC................................919-833-5991
Allen, Don/1787 Shawn Dr, Baton Rouge, LA504-925-0251
Allen, Erich/602 Riverside Ave, Kingsport, TN615-246-7262
Allen, Michael/PO Box 11510, Nashville, TN........................615-754-0059
Alston, Cotten/Box 7927-Station C, Atlanta, GA...................404-876-7859
Alterman, Jack/285 Meeting St, Charleston, SC803-577-0647
Alvarez, Jorge/3105 W Granada, Tampa, FL813-831-6765
Amberg, Jeff/4001 Hickory St, Columbia , SC (P 183)....**803-787-7661**
American Image/4303 Granada St, Alexandria, VA703-360-7507
Ames, Kevin/1324 Brainwood Ind Ct, Atlanta, GA404-325-6736
Anderson, Suzanne Stearns/3355 Lenox Rd NE Atlanta, GA......404-261-0439
Arruza, Tony/250 Edmor Rd, West Palm Beach,
FL (P 173) ...**407-832-5978**
Atlantic Photo/319 N Main St, High Point, NC919-884-1474
Axion Inc/120 South Brook St, Louisville, KY........................502-584-7666
Ayres, Jim/2575 Oakhill Dr, Marietta, GA.............................404-578-9857
Azad/246 NW 69th St, Boca Raton, FL.................................407-362-9352

B

**Bachmann, Bill/PO Box 950833, Lake Mary,
FL (P 184)** ... **407-322-4444**
**Baker, I Wilson/1094 Morrison Dr, Charleston,
SC (P 177)** ... **803-577-0828**
Balbuza, Joseph/25 NE 210 St, Miami, FL305-652-1728
Ball, Roger/1402-A Winnifred, Charlotte, NC704-335-0479
Baptie, Frank/1426 9th St N, St Petersburg, FL813-823-7319
Barley, Bill/PO Box 280005, Columbia, SC803-755-1554
Barnes, Billy E/313 Severin St, Chapel Hill, NC919-942-6350
Barnes, Will/4600 Trenholm Rd, Columbia, SC803-782-8088
Barr, Ian/2640 SW 19th St, Fort Lauderdale, FL305-584-6247
**Barreras, Anthony/1231-C Booth St NW, Atlanta,
GA (P 156,157)** .. **404-352-0511**
Barrs, Michael/6303 SW 69th St, Miami, FL305-665-2047
Bartlett & Assoc/2309 Silver Star Rd, Orlando, FL407-295-0818
Bassett, Donald/9185 Green Meadows Way, Palm Bch Gardens, FL...407-694-1109
Bateman, John H/3500 Aloma Ave W #18, Winter Park, FL...407-671-2516
Bates, G W /185 Lakeview Dr #203, Ft Lauderdale, FL305-389-7033
Bean, Bobby/420 West 5th St, Charlotte, NC (P 171) ...**704-377-1588**
Beck, Charles/2721 Cherokee Rd, Birmingham, AL205-871-6632
Becker, Joel/5121 Virginia Bch Blvd #E3, Norfolk, VA804-461-7886
Bekker, Philip/667 B 11th St NW, Atlanta , GA (P 185) ...**404-876-1051**
Belk, Michael/1708 Peachtree St NW #203, Atlanta, GA404-874-6304
Belloise, Joe/2729 NE 30th Ave, Lighthouse, FL305-941-9895
Bennett, Robert/6194 Deer Path Court, Manassas, VA703-361-7705
Bentley, Gary/921 W Main St, Hendersonville, TN615-822-7770
Berg, Audrey & Fronk, Mark/7655 Fullerton Rd, Springfield, VA...........703-455-7343
Bergeron, Joe/516 Natchez, New Orleans, LA504-522-7503
Bernstein, Alan/6766 NW 43rd Pl, Coral Springs, FL306-753-1071
Bertsch, Werner J/441 NE 4th Ave #3, Fort Lauderdale, FL ...305-463-1912
Beswick, Paul/4479 Westfield Dr, Mableton, GA404-944-8579
Bewley, Glen/428 Armour Circle, Atlanta, GA404-872-7277
Bilby, Glade/1715 Burgundy, New Orleans, LA504-866-0031
Biver, Steven/2402 Mt Vernon Ave, Alexandria, VA703-548-1188
Blakeley, Ron/3917 SW Lejeune Rd, Miami, FL305-667-9430
**Blankenship, Bob Photo/1 Newport Place NW,
Atlanta, GA (P 186)** ... **404-351-8938**
Blanton, Jeff/5515 S Orange Ave, Orlando, FL407-851-7279
Blaskowski, Paul/3071 Hanover Ct, Atlanta, GA404-451-6253
Blount, Ron/4118 S 36th St, Arlington, VA703-671-8160
Boatman, Mike/3430 Park Ave, Memphis, TN901-324-9337
Bollman, Brooks/1183 Virginia Ave NE, Atlanta, GA404-876-2422
Bondarenko, Marc/212 S 41st St, Birmingham, AL205-933-2790
Booth's Studio/1747 Independence Blvd #E10, Sarasota, FL ...813-359-3456
Borchelt, Mark/4398-D Eisenhower Ave, Alexandria, VA703-751-2533
Borum, Michael/625 Fogg St, Nashville, TN615-259-9750
Bose, Patti/1413 Haven Dr, Orlando, FL407-895-3005
Bostick, Rick/489 Semoran Blvd #109, Casselberry, FL407-331-5717
Boughton, Mark/302 King Rd, Fairview, TN615-799-2143
Bouley, Ray/2955 Pharr Court S, Atlanta, GA404-231-3136
Bowie, Ed/312 W Vermillion, Lafayette, LA318-234-0576
Boxer, Bill/118-35 Canon Blvd #C104, Newport News, VA804-873-3686
Boyd, Richard/PO Box 5097, Roanoke, VA703-366-3140
Boyle, Jeffrey/8725 NW 18th Terrace #215, Miami, FL305-592-7032
Bradshaw, David/9 West Main St, Richmond, VA804-225-1883
Branan, Tom/P O Box 4075, Ocala, FL904-351-1405
Brasher/Rucker Photography/3373 Park Ave, Memphis, TN901-324-7447
Braun, Bob/PO Box 547755, Orlando, FL407-425-7921
Braun, Paulette/1500 N Orange #42, Sarasota, FL813-366-6284
Bridgeforth, Lauri/129 S Loudon St #201, Winchester, VA703-665-9484
Bridges, Bob/205 Wolverine Rd, Cary, NC919-469-3359
Brill, David/Route 4, Box 121-C, Fairbourn, GA404-461-5488
Brinson, Rob/PO Box 93372, Atlanta, GA404-874-2497
**Brooks, Charles/800 Luttrell St, Knoxville,
TN (P 168)** ... **615-525-4501**
Broomell, Peter/1 South Third St, Amelia Island, FL904-261-8557
Brown, Billy/2700 7th Ave South, Birmingham, AL205-251-8327
Brown, Charlie/5649-H General Washington Dr, Alexandria, VA703-354-6688
Brown, Doug/2900-A Jefferson Davis Hwy, Alexandria, VA703-684-8778
Brown, George/961 3rd St NW, Atlanta, GA404-875-3238
Brown, Richard Photo/PO Box 830, Asheville, NC704-253-1634
Bryant, Scott/11089 Stagestone Way, Manassas , VA703-369-6902
Buchman, Tim/212 S Graham St, Charlotte, NC704-332-1254
Bumpus, Ken/1770 W Chapel Dr, Deltona, FL904-789-3080
Burgess Photography, Lee/1359 Chesterfield Dr, Clearwater, FL........813-586-3022

Burgess, Ralph/PO Box 36, Chrstnsted/St Croix, VI809-773-6541
Burgess, Robert/6238 27th St N, Arlington, VA703-533-7741
Burnette, David/1915 N Upton St, Arlington, VA703-527-2388
Burns, Jerry/331-B Elizabeth St NE, Atlanta, GA404-522-9377
Busch, Scherley/4186 Pamona Ave, Miami, FL305-661-6605
Byrd, Syndey/3470 Esplanade Ave, New Orleans, LA504-865-7218

C

Calahan, Walter P/4656 S 34th St #B2, Arlington, VA703-998-8380
Calamia, Ron & Assoc/8140 Forshey St, New Orleans, LA504-482-8062
Cameron, Larry/1314 Lincoln St #301, Columbia, SC.............803-799-7558
Carlton, Chuck/120 S Brook St , Louisville, KY502-584-7666
Carnemark, Curt/2316 Kimbro St., Alexandria, VA703-768-7505
Carolina Photo Grp/120 W Worthington Ave, Charlotte, NC ...704-334-7874
Carpenter, Michael/7704 Carrleigh Pkwy, Springfield, VA703-644-9666
Carriker, Ronald/565 Alpine Rd, Winston Salem, NC919-765-3852
Carter, Art/1314 Lincoln St #301, Columbia, SC803-799-7558
Carter, Lynel/108 Alpharetta Hwy #200 C8, Roswell, GA404-442-0088
Caswell, Sylvia/PO Box 9890, Birmingham, AL......................205-252-2252
Caudle, Rod Studio/248 Holland Rd, Powder, GA404-424-3730
Cavedo, Brent/714 Cleveland St, Richmond, VA804-355-2777
Cerny, Paul/5200 Wood St, Zephyr Hills, FA813-782-4386
Cerri, Robert/1465 NE 121st St #B302, N Miami, FL305-895-1500
Chalfant, Flip/1867 Windemere DR NE, Atlanta, GA404-881-8510
Chamowitz, Mel/3931 N Glebe Rd, Arlington, VA703-536-8356
Chapple, Ron/501 N College, Charlotte, NC704-377-4217
Chernush, Kay/3855 N 30th St, Arlington, VA703-528-1195
Chesler, Donna & Ken/6941 NW 12th St, Plantation, FL305-581-6489
Choiniere, Gerin/1424 N Tryon St, Charlotte, NC704-372-0220
Clark, Marty/1105 Peachtree St NE, Atlanta, GA404-873-4618
Clark, Robert/1237-F Gadsen St, Columbia, SC803-779-1907
Clayton, Al/141 The Prado NE, Atlanta, GA404-577-4141
Clayton, Julie Ann/8123-B Northboro Ct, W Palm Beach, FL ...407-642-4971
Clear Light Studio/1818-102 St Albans, Raleigh, NC919-876-5544
Cody, Dennie/5880 SW 53rd Terrace, Miami, FL305-666-0247
Colbroth, Ron/8610 Battailles Ct, Annandale, VA703-978-5879
Coleman, Michael John/Torpedo Factory Art Ctr, Alexandria, VA ...703-548-2353
Compton, Grant/7004 Sand Nettles Dr, Savannah, GA912-897-3771
Contorakes, George/7160 SW 47th St, Miami, FL305-661-0731
Conway, Tim/406 8th St, Augusta, GA404-722-1131
Cook Photography, Al/153 Colony Tr, Lanexa, VA804-966-5889
Cook, Jamie/1740 Defoor Pl, Atlanta, GA404-351-1883
Cook, Tony/PO Box 290260, Tampa, FL813-634-4490
Copeland, Jim/2135-F Defoor Hills Rd, Atlanta, GA404-881-0221
Cornelia, William/PO Box 5304, Hilton Head Island, SC803-671-2576
Cornelius, John/915 W Main St, Abington, MA703-628-1699
Corry, Leon/4072 Park Ave, Miami, FL305-667-7147
Cosby-Bowyer Inc/209 N Foushee St, Richmond, VA804-643-1100
Coste, Kurt/929 Julia, New Orleans, LA504-523-6060
Cravotta, Jeff/PO Box 9487, Charlotte, NC704-377-4912
Crawford, Dan/RT 9/ Box 546-D, Chapel Hill, NC919-968-4290
Crawford, Pat/918 Lady St, Columbia, SC.............................803-799-0894
Crewe, Coates/1331 Hagood Ave, Columbia, SC803-771-7432
Crocker, Will/1806 Magazine St, New Orleans, LA504-522-2651
Cromer, Peggo/1206 Andora Ave, Coral Gables, FL305-667-3722
Crosby, David/229 Trade Ave, Hickory, NC704-327-6575
Crum, Lee/1536 Terpsichore St, New Orleans, LA504-529-2156
Crum, Robert/3402 El Prado, Tampa, FL813-839-3719
Culpepper, Mike Studios Inc/PO Box 1371, Columbus, GA404-323-5703
Cutrell, Gary/317 Draper St, Warner Robins, GA912-929-3191

D

Daigle, James/1500 Bay Rd, Miami Beach, FL305-673-6633
Dakota, Irene/2121 Lucerne Ave, Miami Beach, FL305-674-9975
Dakota, Michael/808 NW 8th St Rd, Miami, FL......................305-325-8727
Dale, John/576 Armour Circle NE, Atlanta, GA404-872-3203
Daniel, Ralph/1305 University Dr NE, Atlanta, GA404-872-3946
David, Alan/416 Armour Circle NE, Atlanta, GA.....................404-872-2142
Dawson, Bill/289 Monroe, Memphis, TN901-522-9171
Deal Bowie & Assoc/809 W University, Lafayette, LA318-234-0576
Degast, Robert/PO Box 282, Wachapreague, VA804-787-8060
Deits, Katie/2001 Bomar Dr #4, N Palm Beach, FL407-775-3399
DeKalb, Jed/PO Box 22884, Nashville, TN615-331-8527
Design & Visual Effects/1228 Zonolite Rd, Atlanta, GA..........404-872-3283
DeVault, Jim/2400 Sunset Pl, Nashville, TN615-269-4538
Dewein, Norman/691 Ringgold Rd, Clarksville, TN.................615-648-0293

Diaz, Rick/4884 SW 74th Ct, Miami, FL305-264-9761
Dickerson, John/1895 Annwicks Dr, Marietta, GA.......................404-977-4138
Dickey, Bo/PO Box 20151, Atlanta, GA404-875-0290
Dickinson, Dick/1781 Independence Blvd #1,
Sarasota, FL (P 188) ...**813-355-7688**
Dietrich, David/8453 NW 70th St, Miami, FL (P 174)...**305-594-5902**
Dixon, Tom/3404-D W Windover Ave, Greensboro, NC919-294-6076
Dobbs, David/1098 Greenbriar Cir, Decatur, GA404-297-0623
Doby III, Welton B/816 N St Asaph St, Alexandria, VA.................703-684-3813
Domenech, Carlos/6060 SW 26th St, Miami,
FL (P 189) ..**305-666-6964**
Doody, David/104 Sharps Rd, Williamsburg, VA.........................804-295-3258
Dorin, Jay/10076 Bay Harbor, Harris Bay Harbor Is, FL...............305-866-3888
Doty, Gary/PO Box 23697, Ft Lauderdale, FL305-742-7422
Douglas, Keith/405 NE 8th St, Ft Lauderdale,
FL (P 167) ..**305-763-5883**
Dressler, Brian/300-A Huger St, Columbia, SC803-254-7171
Dry, Dan/897 Starks Bldg, Louisville, KY502-581-0661
Duncan, Thom/PO Box 726, Falls Church, VA703-532-1444
Durbak, Dave/14280 Carlson Circle, Tampa, FL........................813-855-8051
Duvall, Joe/2477 Harbor Way, Casselberry, FL407-671-0421
Duvall, Thurman III/1021 Northside Dr NW, Atlanta, GA...............404-875-0161
Dyess, Sam Todd/2101 G Powers Ferry Rd, Marietta, GA................404-952-8791

E

Eastep, Wayne/4512 Ascot Circle S, Sarasota, FL.....................813-355-9605
Eastmond, Peter/PO Box 856 E, Barbados,W Indies,809-429-7757
Easton, Steve/5937 Ravenswood Rd #H-19, Ft Lauderdale, FL...........305-983-6611
Edwards, Jim/416 Armour Circle NE, Atlanta, GA......................404-875-1005
Eighme, Bob/1520 E Sunrise Blvd, Ft Lauderdale, FL..................305-527-8445
Elkins, John/Northgate Mall #223, Durham, NC.......................919-286-4049
Elliot, Tom/19756 Bel Aire Dr, Miami, FL305-251-4315
Ellis, Gin/1203 Techwood Dr, Atlanta, GA404-892-3204
Ely, Scott Rex/816 N St Asaph St, Alexandria, VA703-683-3773
Engelman, Suzanne/1621 Woodbridge Lk Cir, W Palm Beach, FL407-969-6666
Epley, Paul/3110 Griffith St, Charlotte, NC704-332-5466
Erickson, Jim/117 S West St, Raleigh, NC919-833-9955
Escher, Mark/428 Armour Circle NE, Atlanta, GA......................404-874-3272
Esplinoza, Patrick/153 Patchen Dr #28, Lexington, KY................606-269-2378
Evenson, Thomas/Bruce Studio/79-25 4th St N, St Petersburg, FL......813-577-5626

F

Fedusenko, David/4200 NW 79th Ave #2A, Miami, FL305-599-2364
Fernandes, Marge/885E South Pickett St, Alexandria, VA..............703-751-8500
Figall, Fred/Box 92, Warrenton, VA703-349-1587
Fineman, Michael/7521 SW 57th Terrace, Miami, FL305-666-1250
Fisher, Kurt/280 Elizabeth St #A-105, Atlanta, GA...................404-525-1333
Fisher, Ray/10700 SW 72nd Ct, Miami, FL305-665-7659
Flynn, Rusty/379 W Michigan St #200, Orlando, FL....................407-843-6767
Foley, Roger/325 N Manchester St, Arlington, VA703-524-6274
Folsom, William/7600 Tremayne Place, McLean , VA703-893-4459
Forer, Dan/1970 NE 149th St, North Miami, FL........................305-949-3131
Fortenberry, Mark/128 Wonderwood Dr, Charlotte, NC..................704-365-4774
Fotoworks/1419 W Waters Ave #118, Tampa, FL........................813-935-5103
Fowley, Douglas/103 N Hite Ave, Louisville, KY502-897-7222
Fox, Martin/88 Charlotte St, Ashville, NC (P 172)....**704-258-8003**
Frasier, Richard/2857 Nutley St, Fairfax, VA703-385-3761
Frazier, Jeff/1025 8th Ave S, Nashville, TN615-242-5642
Frazier, Steve/2168 Little Brook Lane, Clearwater, FL...............813-736-4235
Freeman, Tina/POB 30308, New Orleans, LA504-523-3000
Frink, Stephen/PO Box 2720, Key Largo, FL305-451-3737
Fritz, Gerard/2420 Arnold Dr, Charlotte, NC704-536-6797
Fulton, George/1237 Gadsden St, Columbia, SC803-779-8249

G

G L Studios/103 W Intendencia, Pensacola, FL904-433-2400
Gamand, Philippe/2636 Key Largo Lane, Fort Lauderdale, FL305-583-7262
Gandy, Skip/302 East Davis Blvd, Tampa, FL813-253-0340
Gardella Photography & Design/781 Miami Cr NE, Atlanta, GA..........404-231-1316
Garner Studios/1114 W Peachtree St, Atlanta, GA404-875-0086
Garrett, Kenneth/PO Box 208, Broad Run, VA703-347-5848
Garrison, Gary/1052 Constance St, New Orleans, LA504-588-9422
Gefter, Judith/1725 Clemson Rd, Jacksonville, FL904-733-5498
Gelberg, Bob/7035-E SW 47th St, Miami, FL305-665-3200
Gemignani, Joe/13833 NW 19th Ave, Miami, FL.........................305-685-7636

Geniac, Ruth/13353 Sorrento Dr, Largo, FL813-595-2275
Genser, Howard/837 E New York Ave, Deland, FL.......................904-734-9688
Gentile, Arthur Sr/3200 Quilting Rd, Matthews, NC704-846-3793
Gerlich, Fred S/1220 Spring St NW, Atlanta, GA404-872-3487
Gillian, John/14378 SW 97th Lane, Miami, Fl305-251-4784
Glaser, Ken & Assoc/923-D Metairie Rd,
New Orleans, LA (P 191) ...**504-895-7170**
Gleasner, Bill/132 Holly Ct, Denver, NC704-483-9301
Glover, Robert/709 Second Ave, Nashville, TN612-726-0790
Golden, Jon/PO Box 2826, Charlottesville, VA804-971-8100
Gomez, Rick/2545 Tigertail Ave, Miami, FL305-856-8338
Gooch, Mark/PO Box 55744, Birmingham, AL205-328-2868
Good, Jay/20901 NE 26th Ave, N Miami Beach, FL305-935-4884
Goraum, Steve/717-1/2 Dauphin Island Pkwy, Mobile , AL205-478-9882
Gordon, Lee/1936 Church St, West Palm Beach, FL407-686-6360
Gornto, Bill/590 Ponce De Leon Ave, Atlanta, GA404-876-1331
Grace, Arthur/4044 N Vacation Ln, Arlington, VA703-524-3097
Graham, Curtis/648 First Ave S, St Petersburg, FL813-821-0444
Graham, Michael/771 NW 122nd St, North Miami, FL305-687-5446
Granberry Studios/578 Montgomery Ferry Dr, Atlanta, GA..............404-874-2426
Grant, Peter/3414 Wilson Blvd, Arlington, VA703-525-0389
Greenberg, Bob/15505 Bull Run Rd #253, Miami Lakes, FL305-433-8888
Greentree, Neil/3431 Carlin Springs Rd, Falls Church, VA703-379-1121
Griffiths, Simon/2003 Fairview Rd, Raleigh, NC919-829-9109
Grigg, Roger Allen/PO Box 52851, Atlanta, GA404-876-4748
Groendyke, Bill/6344 NW 201st Ln, Miami, FL305-625-8293
Grogan, Daniel/616 North Ave, Charlottesville, VA804-295-3258
Grove, Bob/210 N Lee St #208 2nd Fl Rear, Alexandria, VA703-548-3972
Guggenheim, David/167 Mangum St, Atlanta,
GA (P 192,193) ..**404-577-4676**
Guider, John/517 Fairground Ct, Nashville, TN615-255-4495
Guillermety, Edna/3133 Lakestone Dr, Tampa, Fl813-962-1748
Gupton, Charles/5720-J North Blvd, Raleigh, NC919-850-9441
Guravich, Dan/PO Box 891, Greenville, MS601-335-2444

H

Hackney, Kerry/8171 NW 67th St, Miami, FL305-592-3664
Haggerty, Richard/656 Ward St, High Point, NC919-889-7744
Hall, Don/2922 Hyde Park st, Sarasota, FL813-365-6161
Hall, Ed/7010 Citrus Point, Winter Park, FL.........................407-657-8182
Hall, Keith/4607 N Lois Ave #C, Tampa, FL...........................813-875-6629
Hamel, MIke/7110 SW 63rd Ave, Miami, FL (P 176)......**305-665-8583**
Hamilton, Tom/2362 Strathmore Dr, Atlanta, GA.......................404-266-0177
Hannau, Michael/3800 NW 32nd Ave, Miami, FL.........................305-633-1100
Hansen, Eric/3005 7th Ave S/Box 55492, Birmingham, AL...............205-251-5587
Harbison, Steve/1516 Crestwood Dr, Greeneville, TN..................615-638-2535
Hardy, Frank/1003 N 12th Ave, Pensacola, FL.........................904-438-2712
Harkins, Lynn S/1900 Byrd Ave #101, Richmond, VA....................804-285-2900
Harkness, Chris/1412 Fairway Dr, Tallahassee, FL....................904-224-9805
Harrison, Michael/1124-A S Mint St, Charlotte, NC...................704-334-8008
Hathcox, David/5730 Arlington Blvd, Arlington, VA...................703-845-5831
Haviland, Patrick/413 W 10th St #4C, Charlotte, NC..................704-376-7574
Hayden, Kenneth/1318 Morton Ave, Louisville, KY.....................502-583-5596
Heger, Jeff/2406 Nemeth Ct, Alexandria, VA..........................703-765-1552
Heinen, Ken/4001 Lorcom Lane, Arlington, VA.........................703-528-0186
Heller, David/202 West Jean St, Tampa, FL...........................813-251-7326
Henderson, Collins & Muir Photo/6005 Chapel Hill Rd, Raleigh, NC ...919-851-0458
Henderson, Eric/1200 Foster St NW, Atlanta, GA......................404-352-3615
Hendley, Arington/454 Irwin St NE, Atlanta, GA......................404-577-2300
Henley, John/1910 E Franklin St, Richmond, VA
(P 179) ...**804-649-1400**
Henry, Benton/Rt 1/ Box 6C, Latta, SC803-752-2097
Heston, Ty/4505 131st Ave N #18, Clearwater, FL.....................813-573-4878
Heyl, Steven/P O Box 150, Leesburg, VA..............................703-771-9355
Higgins, Neal/2300 Peachtree Rd NW, Atlanta, GA.....................404-355-3240
Hill, Dan/9132 O'Shea Ln, W Springfield, VA.........................703-451-4705
Hill, Jackson/2032 Adams St, New Orleans, LA........................504-861-3000
Hill, Tom/207 E Parkwood Rd, Decatur, GA............................404-377-3833
Hillyer, Jonathan/450-A Bishop St, Atlanta, GA......................404-351-0477
Hirsch, Butch/932 Euclid Ave #10, Miami Beach, FL...................212-929-3024
Hoflich, Richard/544 N Angier Ave NE, Atlanta, GA...................404-584-9159
Hogben, Steve/3180 Oakcliff Indus St, Atlanta, GA...................404-266-2894
Holland, Ralph/3706 Alliance Dr, Greensboro, NC.....................919-855-6422
Holland, Robert/14602 SW 82nd Ct, Miami, FL.........................305-255-6758
Hood, Robin/1101 W Main St, Franklin, TN615-794-2041
Hope, Christina/2720 3rd St S, S Jacksonville Bch, FL...............904-246-9689
Horan, Eric/PO Box 6373, Hilton Head Island, SC.....................803-842-3233

Hosack, Loren/509 Inlet Rd, North Palm Bch,
FL (P 194) ..**407-848-0091**
Hosking, Bruce/1847 Sunrise Blvd, Clearwater, FL......................813-535-1947
Humphries, Gordon/Boozer Shopping Ctr, Columbia, SC803-772-3535
Humphries, Vi/Boozer Shopping Ctr, Columbia, SC803-772-3535
Hunter, Bud/1911 27th Ave S, Birmingham, AL205-879-3153
Hunter, Fil/2402 Mt Vernon Ave, Alexandria, VA........................703-836-2910

IJ

In Motion/PO Box 1380, Silver Springs, FL..................................904-625-3241
Isaacs, Lee/629 22nd Ave S, Birmingham, AL.............................205-591-1191
Isgett, Neil/4303-D South Blvd, Charlotte, NC.............................704-376-7172
Jackson Photographics, R/520 N Willow Ave, Tampa, FL813-254-6806
Jamison, Chipp/2131 Liddell Dr NE, Atlanta,
GA (P 195) ..**404-873-3636**
Jann, Gail/US 19/Box 41, Byson City, NC704-488-8576
Jarrett Photo/1210 Spring St NW, Atlanta, GA404-892-6547
Jautz, Ron/PO Box 566, Alexandria, VA703-548-5578
Jeffcoat, Russell/1201 Hagood Ave, Columbia, SC......................803-799-8578
Jeffcoat, Wilber L/1864 Palomino Cir, Sumter, SC803-773-3690
Jimison, Tom/5929 Annunciation, New Orleans, LA.....................504-891-8587
Johns, Douglas/2535 25th Ave N, St Petersburg, FL...................813-321-7235
Johnson, Dennis/10909 Santa Clara Dr, Fairfax, VA....................703-263-0129
Johnson, Everette/5024 Williamsburg Blvd, Arlington, VA............703-536-8483
Johnson, Forest/7200 SW 129th St, Miami, FL............................305-251-1300
Johnson, George L Photo/16603 Round Oak Dr, Tampa, FL.........813-963-3222
Johnson, Silvia/6110 Brook Dr, Falls Church, VA.........................703-532-8653
Jones, David/319-F South Westgate Dr, Greensboro, NC919-294-9060
Jones, Samuel A/131 Pineview Rd, West Columbia, SC...............803-791-4896
Jureit, Robert A/916 Aguero Ave, Coral Gables, FL.....................305-667-1346
Jurgens, Daniel/202 S 22nd St, Tampa, FL.................................813-248-3636

K

Kaplan, Al/PO Box 611373, North Miami, FL...............................305-891-7595
Kaplan, Martin & Laura/PO Box 7206, McLean, VA......................703-893-1660
Kappiris, Stan/PO Box 14331, Tampa, FL...................................813-886-3740
Katz, Arni/PO Box 724507, Atlanta, GA404-953-1168
Kaufman, Len/740 Tyler St, Hollywood, FL..................................305-920-7822
Kearney, Mitchell/301 E 7th St, Charlotte, NC704-377-7662
Kennedy, Chuck Group /2745-B Hidden Lake Blvd, Sarasota, FL........813-951-0393
Kennedy, M Lewis/2700 7th Ave S, Birmingham, AL....................205-252-2700
Kenner, Jack/PO Box 3269, Memphis, TN (P 196)**901-527-3686**
Kent, David/7515 SW 153rd Ct #201, Miami, FL..........................305-382-1587
Kern Photography/1243 N 17th Ave, Lake Worth, FL....................407-582-2487
Ketchum, Larry/530 Pylon Dr, Raleigh, NC.................................919-856-1860
King, J Brian/1267 Coral Way, Miami, FL.....................................305-856-6534
King, Tom/7401 Chancery Lane, Orlando, FL...............................407-856-0618
Kinney, Greg/238 Burlington Pl, Nashville, TN615-297-8084
Kinsella, Barry/1010 Andrews Rd, West Palm Beach, FL407-832-8736
Kirby, Jim/2057Swans Neck Way, Reston, VA..............................703-476-9828
Klass, Rubin & Erika/5200 N Federal Hwy, Fort Lauderdale, FL...305-565-1612
Klemens, Susan/5803 Queens Gate Ct, Alexandria, VA...............703-960-5085
Kling, David Photography/502 Armour Circle, Atlanta, GA.............404-881-1215
Knapp, Bevil/118 Beverly Dr, Metairie, LA (P 197)........**504-831-1496**
Knibbs, Tom/4149 NW 5th Ave, Boca Raton, FL..........................407-338-3614
Knight, Steve/1212 E 10th St, Charlotte, NC704-334-5115
Kogler, Earl/PO Box 3578, Longwood, FL....................................407-331-4035
Kohanim, Parish/1130 W Peachtree NW, Atlanta, GA..................404-892-0099
Kollar, Robert E/1431 Cherokee Trail #52, Knoxville, TN.............615-573-8191
Koplitz, William/729 N Lime Ave, Sarasota, FL............................813-366-5905
KPC Photo/PO Box 32188, Charlotte, NC704-358-5855
Krafft, Louise/1008 Valley Dr, Alexandria, VA..............................703-998-8648
Kreider, R C/13105 Pennerview Ln, Fairfax, VA............................703-631-7257
Kufner, Gary/2032 Harrison St, N Hollywood, FL.........................305-944-7740

L

LaCoe, Norm/PO Box 855, Gainesville, FL...................................904-466-0226
Lafayette, James/181 Club Course Dr/Sea Pines, Hilton Head, SC803-785-3201
Lai, Bill/PO Box 13644, Atlanta, GA..404-982-9008
Lair, John/1122 Roger St, Louisville, KY502-589-7779
Lane, M/2200 Sunderland Rd #133K, Winston-Salem, NC............919-768-0803
Langone, Peter/516 NE 13th St, Ft Lauderdale,
FL (P 160,161) ...**305-467-0654**
Lanpher, Keith/865 Monticello Ave, Norfolk, VA804-627-3051
Larimer, Richard/209 N Foushee, Richmond, VA804-643-1100

Larkin, Paul/710 Tenth St, Atlanta, GA.......................................404-432-6309
Lathem, Charlie & Assoc/559 Dutch Valley Rd NE,
Atlanta, GA (P 181) ..**404-873-5858**
Latil, Michael/816 N St Asaph St, Alexandria, VA........................703-548-7645
Lauber, Christopher/7519 Dartmouth Ave N, St Petersburg, FL............813-347-4440
Lauzon, Denis/5170 NE 12th Ave, Ft Lauderdale, FL...................305-771-0077
Lavenstein, Lance/348 Southport Cir #103, Virginia Beach, VA804-499-9959
Lawrence, David/PO Box 835, Largo, FL.....................................813-586-2112
Lawrence, John R/Box 330570, Coconut Grove, FL.....................305-447-8621
Lawrence, Mark M/PO Box 23950, Ft Lauderdale,
FL (P 173,178) ...**305-565-8866**
Lawson, Robert/4220 Bay to Bay Blvd, Tampa, FL813-264-7023
Lawson, Slick/3801 Whitland Ave, Nashville, TN615-383-0147
Lazzo, Dino/PO Box 452606, Miami, FL......................................305-856-1148
Ledis, Wendy/19377 Northeast 10th Ave, N Miami Beach, FL......305-652-4378
Lee, Chung P/7820 Antiopi St, Annandale, VA.............................703-560-3394
Lee, George/423 S Main St, Greenville, SC.................................803-232-4119
Leggett, Albert/1415 Story Ave, Louisville, KY............................502-584-0255
Leo, Victor/121 W Main St, Louisville, KY....................................502-589-2423
Lesser, Eric/360 Ponce DeLeon Ave NE #28,
Atlanta, GA (P 170) ..**404-872-4319**
Levin, Sari/PO Box 23398, Lexington, KY...................................606-273-8197
Lex, Debra/132 NW 98th Terrace, Plantation, FL.........................305-285-0999
Lightbenders/11450 SW 57th St, Miami, FL................................305-595-6174
Lightscapes Photo/7655 Fullerton Rd, Springfield, VA.................703-455-7343
Lipson, Stephen/409 Miller Rd, Coral Gables, FL........................305-662-8656
Little, Chris/PO Box 467221, Atlanta, GA....................................404-641-9688
Long, Lewis/3130 SW 25th St, Miami, FL....................................305-448-7667
Looking Glass Photo/3689 Hwy AIA S, St Augustine, FL..............904-823-9667
Loumakis, Constantinos/826 SW 13th St, Ft Lauderdale, FL........305-525-7367
Lowery, Ron/409 Spears Ave, Chattanooga, TN..........................615-265-4311
Lubin, Jeff/6641 Backlick Rd, Springfield, VA..............................703-569-5086
Lucas, Steve/16100 SW 100th Ct, Miami, FL..............................305-238-6024
Luege, Alexander/5290 SW 5th St, Miami, FL (P 199)....**305-445-5795**
Luttrell, David/5117 Kesterwood Rd, Knoxville, TN
(P 200,201) ..**615-688-1430**
Luzier, Winston/1122 Pomelo Ave, Sarasota, FL.........................813-952-1077
Lynch, Warren/1324 E Washington St, Louisville, KY502-587-7722

M

Macuch, Rodger/1133 Spring St, Atlanta, GA..............................404-876-7002
Magee, Ken/7928 Ferara Dr, New Orleans, LA.............................504-889-3928
Malles, Ed/1013 S Semoran Blvd, Winter Park, FL.......................407-679-4155
Mann, James/1007-B Norwalk, Greensboro, NC..........................919-288-2508
Mann, Rod/5082 Woodleigh Rd, Knotts Island, NC919-429-3009
Maratea, Ronn/4338 Virginia Beach Blvd, Virginia Beach, VA......804-340-6464
Marcus, Joel/2250 ULmerton Rd East #15, Clearwater, FL813-573-0575
Markatos, Jerry/Rt 2 Box 419/Rock Rest Rd, Pittsboro, NC.........919-542-2139
Marquet, Carolou/4628 N 21st St, Arlington, VA..........................703-243-5354
Marquez, Toby/1709 Wainwright Dr, Reston, VA...........................703-471-4666
Marshall, Chuck/2512 Buildamerica Dr, Hampton, VA..................804-826-9383
Martin, Fred/110 Country View Dr, Simpsonville, SC....................803-297-0010
Martineau, Gerald/300 S Harrison St, Arlington, VA.....................703-931-8561
Mason, Chuck/8755 SW 96th St, Miami, FL................................305-270-2070
Masson, Lisa/3122 S Abingdon St, Arlington, VA.........................703-379-1401
Mathieson, Greg/6601 Ashmere Lane, Centreville, VA.................703-968-0030
May, Clyde/1037 Monroe Dr NE, Atlanta, GA...............................404-873-4329
Mayor, Randy/2007 Fifteenth Ave S, Birmingham, AL..................205-933-2818
Mazey & St John/2724 NW 30th Ave, Ft Lauderdale,
FL (P 164,165) ...**305-731-3300**
Mazey, Jon/2724 NW 30th Ave, Ft Lauderdale,
FL (P 165) ..**305-731-3300**
McBride, Tal/3510 Lorcom Ln, Arlington, VA................................703-525-8331
McCannon, Tricia/416 Armour Cir NE, Atlanta, GA404-873-3070
McCarthy, Tom/8960 SW 114th St, Miami, FL (P 202)...**305-233-1703**
McClure, Dan/320 N Milledge, Athens, GA..................................404-354-1234
McCord, Fred/2720 Piedmont Rd NE, Atlanta, GA404-262-1538
McElhinney, Susan/3526 N Third St, Arlington, VA.......................703-527-8293
McGee, E Alan/1816-E Briarwd Ind Ct, Atlanta, GA404-633-1286
McGurkin, Douglas/5600 Glenridge Dr #B-55, Atlanta, GA...........404-252-7108
McIntyre, William/3746 Yadkinville Rd, Winston-Salem, NC..........919-922-3142
McKenzie & Dickerson/133 W Vermont Ave, Sthrn Pines, NC.......919-692-6131
McLaren, Lynn/PO Box 2086, Beaufort, SC.................................803-524-0973
McLaughlin, Ken/623 7th Ave S, Nashville, TN.............................615-256-8162
McNabb, Tommy/4015 Brownsboro Rd, Winston-Salem, NC.........919-625-3014
McNamee, Win/467 N Thomas St, Arlington, VA...........................703-553-6027
McNeely, Burton/PO Box 338, Land O'Lakes, FL..........................813-996-3025

McQuerter, James/4518 S Cortez, Tampa, FL .. 813-839-8335
McVicker, Sam/PO Box 880, Dunedin, FL .. 813-734-9660
Meacham, Ralph/Rt 6 Garrison Rd, Franklin, TN .. 615-794-1988
Mellott, Jack/PO Box 4100, Charlottesville, VA .. 804-295-7772
Melton, Bill/945 E Paces Ferry Rd/#1400, Atlanta,
GA (P 166) .. **404-814-9600**
Meredith, David/2900 NE 30th St #2H, Ft Lauderdale, FL 305-564-4579
Michaels, Gary/4190 Braganza Rd, Coconut Grove, FL 305-661-6202
Mikeo, Rich/2189 N Powerline Rd, Ft Lauderdale,
FL (P 203) .. **305-960-0485**
Miller, Brad/3645 Stewart, Coconut Grove,
FL (P 169) .. **305-666-1617**
Miller, Bruce/9401 61st Court SW, Miami, FL ... 305-666-4333
Miller, Randy/6666 SW 96th St, Miami, FL .. 305-667-5765
Milligan, Mark/8022 Stillbrook Rd, Manassas, VA 703-791-2175
Millington, Rod/PO Box 49286, Sarasota, FL .. 813-388-1420
Mills, Henry/5514 Starkwood Dr, Charlotte, NC ... 704-535-1861
Mims, Allen/107 Madison Ave, Memphis, TN .. 901-527-4040
Minardi, Mike/PO Box 14247, Tampa, FL .. 813-251-1696
Mitchell, Deborah Gray/7000 NE 4th Ct, Miami, FL 305-757-4233
Molina, Jose/3250 SW 24th St, Miami, FL .. 305-443-1617
Molony, Bernard/PO Box 15081, Atlanta, GA ... 404-457-6934
Montage Studio/422 E Howard Ave, Decatur, GA .. 404-377-7715
Moore, George Photography/1301 Admiral St, Richmond, VA 804-355-1862
Moore, Leslie/8551 NW 47th Ct, Fort Lauderdale, FL 305-742-4074
Moore, Mark/3803 W Gray, Tampa, FL .. 813-874-0410
Moore, Rick/955 Church St, Mobile, AL ... 205-432-8689
Moreland, Mike/PO Box 250388, Atlanta, GA .. 404-993-6059
Morgan, Frank/400 35th St, Virginia Beach, VA ... 804-422-9328
Morgan, Red/13885 Columbine Ave, W Palm Beach,
FL (P 173) .. **407-793-6085**
Morris, Paul /PO Box 530894, Miami Shores,
FL (P 182) .. **305-757-6700**
Mouton, Girard M III/3535 Buchanan St, New Orleans, LA 504-288-4338
Muldez, Richard/122 Executive Blvd #105, Chesapeake, VA 804-490-6640
Murphy, Lionel Jr/4317 Iola Dr, Sarasota, FL ... 813-925-1212
Murphy, Michael/3200 S Westshore Blvd, Tampa, FL 813-831-1210
Murray, Steve/1520 Brookside Dr #3, Raleigh, NC 919-828-0653
Myers, Fred/114 Regent Ln, Florence, AL .. 205-766-4802
Myhre, Gordon/PO Box 1226, Ind Rocks Beach, FL 813-238-0360

NO

Narod, Bob/12213 Sugar Creek Ct, Hendron, VA ... 703-444-1964
Nemeth, Bruce Studio ... 704-522-7782
Nemeth, Judy/930 N Poplar St, Charlotte, NC .. 704-375-9292
Neubauer, John/1525 S Arlington Ridge Rd, Arlington, VA 703-920-5994
Nicolay, David/4756 W Napolean #3, Metarie, LA 504-888-7510
Noa, Orlando/885 W 32nd St, Hialeah, FL ... 305-822-3320
Nodine, Dennis/PO Box 30353, Charlotte, NC .. 704-373-3374
Noel, Rip/707 Maryville Pke, Knoxville, TN ... 615-573-6635
Norling Studios Inc/221 Swathmore Ave/Box 7167, High Point, NC 919-434-3151
Norris, Robert Photo/224 Lorna Square, Birmingham, AL 205-979-7005
Norton, Mike/4917 W Nassau, Tampa, FL .. 813-876-3390
Novak, Jack/3701 S George Mason Dr/C-2 No, Falls Church, VA 703-931-8600
Novicki, Norb/6800 North West 2nd St, Margate, FL 305-971-8954
O'Connor, Michael/9041 Froude, Surfside, FL .. 305-861-3746
O'Kain, Dennis/102 W Main, Lexington, GA .. 404-743-3140
O'Sullivan, Brian/1401 SE 8th St, Deerfield Beach, FL 305-429-0712
Oesch, James/3706 Ridge Rd, Annadale, VA .. 703-941-3600
Olive, Tim/754 Piedmont Ave NE, Atlanta, GA ... 404-872-0500
Olivier, Rick/225 N Peters St #3, New Orleans, LA 504-522-7646
Olsen, Larry/4544 Eisenhowr Ave, Alexandria, VA 703-751-8051
Olson, Carl/3325 Laura Way, Winston, GA .. 404-949-1532
Oquendo, William/4680 SW 27th Ave, Ft Lauderdale, FL 305-981-2823
Osborne, Mitchel L/920 Frenchman St, New Orleans, LA 504-949-1366
Ottman, Matthew/4410 Providence Ln #8, Winston-Salem, NC 919-998-0408

P

Paganelli, Manuello/6003-E Curtier Dr, Alexandria, VA 703-719-9567
Parker, Phillip M/385 S Main St, Memphis, TN .. 901-529-9200
Parrish, David/PO Box 208, Springfield, TN .. 615-384-2664
Parsley, Keith/801-K Atando Ave, Charlotte, NC .. 704-331-0812
Patterson, Pat/233 Rose Haven Dr, Raleigh, NC .. 919-787-4260
Pearce, Frank/215-A Pine Knoll Dr, Greenville, SC 803-292-9016
Peeler, Alan/2175 Madison Ave, Memphis, TN .. 901-272-1769
Pelosi & Chambers/684 Greenwood Ave NE, Atlanta, GA 404-872-8117

Peters, J Dirk/PO Box 15492, Tampa, FL .. 813-888-8444
Petrey, John/841 Nicolet Ave/POB 2401, Winter Park,
FL (P 204) .. **407-645-1718**
Phillips, Bernard/3100 Stony Brook Dr, Raleigh, NC 919-878-1611
Phillips, David/20 Topsail Tr, New Port Richey, FL 813-849-9458
Photo-Synthesis/1239 Kensington Rd, McLean, VA 703-734-8770
Photographic Group/7407 Chancery Ln, Orlando, FL 407-855-4306
Photographic Ideas/701 E Bay St/Box 1216, Charleston, SC 803-577-7020
Photography Unlimited/3662 S West Shore Blvd, Tampa, FL 813-839-7710
Picture Credits/2820 Dorr Ave #210, Fairfax, VA 703-876-9588
Pierson, Art/1107 Lincoln Ave, Falls Church, VA ... 703-237-5937
Pinckney, Jim/PO Box 22887, Lake Buena Vista, FL 407-239-8855
Pinnacle Studios/2420 Schirra Pl, Highpoint, NC .. 919-886-6565
Pishnery, Judy/405 Cherokee Pl, Atlanta, GA ... 404-525-4829
Pittenger, Kerry/100 Northeast 104th St, Miami Shores, FL 305-756-8830
Plachta, Greg/721 N Mangum, Durham, NC ... 919-682-6873
Pocklington, Mike/9 W Main St, Richmond, VA .. 804-783-2731
Ponzoni, Bob/703 Westchester Dr, High Point, NC 919-885-8733
Posey, Mike/3524 Canal St, New Orleans, LA ... 504-488-8000
Premier Photo Group/8171 NW 67th St, Miami, FL 305-592-3664
Prism Studios/1027 Elm Hill Pike, Nashville, TN .. 615-255-1919
Profancik, Larry/2101 Production, Louisville, KY ... 502-499-9220
Pruett, Charlie/12213 Sugar Creek Court, Herndon, VA 707-444-1964
Pryor, Maresa/1122 Pamelo Ave, Sarasota, FL .. 813-952-1077
Purin, Thomas/14190 Harbor Lane, Lake Park, FL 407-622-4131
Putnam, Don/623 7th Ave So, Nashville, TN ... 615-242-7325

R

Ramos, Victor/8390 SW 132 St, Miami, FL ... 305-255-3111
Randolph, Bruce/132 Alan Dr, Newport News, VA 804-877-0992
Rank, Don/2265 Lawson Way, Atlanta, GA .. 404-452-1658
Ratcliffe, Rodney/206 Rogers St NE #11, Atlanta, GA 404-373-2767
Rathe, Robert A/8451-A Hilltop Rd, Fairfax, VA ... 703-560-7222
Raymond, Tom/3211-A Hanover Dr, Johnson City, TN 615-928-2700
Redel, Tim/5055 Seminary Rd #723, Alexandria, VA 703-931-7527
Regan, Mark/10904 Barton Hill Court, Reston, VA 703-620-5888
Ribar, Tim/PO Box 1665 807A 66th Ave N, Myrtle Beach, SC 803-449-6115
Richards, Courtland William/PO Box 59734, Birmingham, AL 205-871-8923
Richards, R K/1565 Louchlomond Tr SW, Atlanta, GA 404-349-2450
Richardson, Lynda/PO Box 8296, Richmond, VA .. 804-272-0965
Richardson-Wright Photo Studio/PO Box 8296, Richmond, VA 804-272-1439
Rickles, Tom/5401 Alton Rd, Miami, FL ... 305-866-5762
Ricksen, John/13572 Exotica Ln, W Palm Beach, FL 407-790-5465
Riggall, Michael/403 8th St NE, Atlanta, GA .. 404-872-8242
Riley & Riley Photo/1078 Tunnel Rd #G, Ashville, NC 212-532-8326
Riley, Richard/6751 SW 91st Ave, Miami, FL ... 305-596-1115
Rippey, Rhea/PO Box 50093, Nashville, TN .. 615-646-1291
Rob/Harris Productions/PO Box 15721, Tampa, FL 813-258-4061
Rodgers, Ted/544 Plasters Ave, Atlanta, GA .. 404-892-0967
Rodriguez, Richard/2728 N Washington Blvd, Arlington, VA 703-820-8452
Rogers, Chuck/2480 Briarcliff Rd #306/4, Atlanta, GA 404-633-0105
Rogers, Don/516 Northeast 13th St, Ft Lauderdale,
FL (P 205) .. **305-467-0654**
Rogers, Tommy/3694 Niagara Dr, Lexington, KY .. 606-271-5091
Rosen, Olive/3415 Arnold Ln, Falls Church, VA .. 703-560-5557
Royals, Ron/2295 Pine Burr Dr, Kernersville, NC ... 919-869-3878
Rubio, Manny/1203 Techwood Dr, Atlanta, GA .. 404-892-0783
Runion, Britt/7409 Chancery Ln, Orlando, FL .. 407-857-0491
Russell, John Photo/PO Box 2141, High Point, NC 919-887-1163
Rutherford, Michael W/623 Sixth Ave S, Nashville,
TN (P 206) .. **615-242-5953**

S

Salerno, Lawrence/4201 W Cypress, Tampa, FL .. 813-876-7580
Salmon, George/10325 Del Mar Circle, Tampa, FL 813-961-8687
Salter, Jeff/4215 Bethel Church Rd #B12, Columbia, SC 803-787-8620
Sanacore, Steve/87 Westbury Close, West Palm Beach, FL 407-795-1510
Sanchez, Robert/10089 SW 26th St, Miami, FL ... 305-687-8008
Sandlin, Mark/45 Little Rd, Sharpsburg, GA ... 404-251-5207
Sansone, Carla A/5401 Robline Dr, Metarie, LA ... 504-588-5339
Santos, Roberto/15929 NW 49th Ave, Hialeah, FL 305-621-6047
Savage, Chuck/113 S Jefferson St, Richmond,
VA (P 180) .. **804-780-0304**
Saylor, Ted/2312 Farwell Dr, Tampa, FL ... 813-879-5636
Schaedler, Tim/PO Box 1081, Safety Harbor, FL ... 813-796-0366
Schatz, Bob/112 Second Ave N, Nashville, TN (P 207) **615-254-7197**

Schenck, Gordon H/PO Box 35203, Charlotte, NC704-332-4078
Schenker, Richard/7401 Clearview, Tampa, FL813-885-5413
Schermerhorn, Tim/3408 Langdale Dr, High Point, NC919-887-6644
Schettino, Carmen/5638 Country Lakes Dr, Sarasota, FL813-351-4465
Schiavone, George/7340 SW 48th St #102, Miami, FL305-662-6057
Schiff, Ken/4884 SW 74th Ct, Miami, FL305-667-8685
Schneider, John/4203 Hewitt St #14G, Greensboro, NC919-855-0261
Schrecker, Scott/3513-A Central Ave, Nashville, TN615-664-1075
Schulke, Debra/6770 SW 101st St, Miami, FL305-667-0961
Schulke, Flip/14730 SW 158th St, Miami, FL305-251-7717
Schumacher, Karl/6254 Park Rd, McLean, VA703-241-7424
Scott, Bill/PO Box 6281, Charlotte, NC704-534-0421
Scott, James/210 N Fillmore St, Arlington, VA703-522-8261
Seifried, Charles/Rt 3 Box 162, Decatur, AL205-355-5558
Seitz, Arthur/1905 N Atlantic Blvd, Ft Lauderdale, FL305-563-0060
Sharpe, David/816 N St Asaph St, Alexandria, VA703-683-3773
Shea, David/217 Florida Blanca Pl, Ft Walton Beach, FL904-244-0666
Sheffield, Scott/1126 North Blvd, Richmond, VA804-358-3266
Sheldon, Mike/RR 3/Box 365, Waynesville, NC704-648-0508
Sherman, Ron/PO Box 28656, Atlanta, GA404-993-7197
Shoffner, Charles/PO Box 3232, Charlottesville, VA804-978-1277
Shone, Phil/544 Plasters Ave, Atlanta, GA404-487-5766
Shrout, Bill/Route 1 Box 317, Theodore, AL205-973-1379
Silla, Jon/400 S Graham St, Charlotte, NC704-377-8694
Silver Image Photo/5128 NW 58th Ct, Gainesville, FL904-373-5771
Sink, Richard/1225 Cedar Dr, Winston Salem, NC919-784-8759
Sisson, Barry/6813 Bland St, Springfield, VA703-569-6051
Skelly, Ariel/Swash Bay Route 605, Quinby, VA804-442-2055
Smart, David/PO Box 11743, Memphis, TN901-685-1431
Smeltzer, Robert/29 Stone Plaza Dr, Greenville, SC803-235-2186
Smith, Clark/618 Glenwood Pl, Dalton, GA404-226-2508
Smith, Deborah/1007-13 Norwalk St, Greensboro, NC919-292-1190
Smith, Ramsey/720-C Hembree Pl, Roswell, GA404-664-4402
Smith, Randy/4450 S Tiffany Dr, West Palm Beach, FL407-697-9122
Smith, Richard & Assoc/1007 Norwalk St #B, Greensboro, NC ...919-292-1190
Smith, Richard Photo/1625 NE 3rd Ct, Ft Lauderdale, FL305-523-8861
Snow, Chuck/2700 7th Ave S, Birmingham, AL205-251-7482
Southern Exposures/4300 NE 5th Terrace, Oakland Park, Fl ...305-565-4415
Sparkman, Clif/161 Mangum St SW #301, Atlanta, GA404-588-9687
Sparks, Don/1069 S Fletcher Ave, Amelia Island, FL904-261-0365
Speidell, Bill/1030 McConville Rd, Lynchburg, VA804-237-6426
Spelios, James S/1735 Brantley Rd #507, Ft Myers, FL813-939-3304
Spence, Christopher/3368 NW 64th St, Ft Lauderdale, FL305-979-8295
St John, Chuck/2724 NW 30th Ave, Ft Lauderdale,
FL (P 164) ...**305-731-3300**
St John, Michael/PO Box 1202, Oldsmar, FL813-872-0007
Stansfield, Ross/4938-D Eisenhower Ave, Alexandria, VA703-370-5142
Staples, Neil/5092 NE 12th Ave, Ft Lauderdale, FL305-493-8833
Starling, Robert/PO Box 25827, Charlotte, NC704-568-7611
Starr, Steve/2425 Inagua Ave, Coconut Grove, FL305-856-5801
Staub, Pat/529 N College St, Charlotte, NC704-377-2153
Steckbeck, Mark/47 Bentley Dr, Sterling, VA703-430-4757
Stein, Art/2419 Mt Vernon Ave, Alexandria, VA703-684-0675
Stein, Leslie/9931 NW 11th St, Plantation, FL305-424-1656
Stern, John/1240 Center Pl, Sarasota, FL813-388-3244
Stevenson, Aaron/707 Jackson Ave, Charlotte, NC704-332-3147
Stewart, Harvey & Co Inc/836 Dorse Rd, Lewisville, NC919-945-2101
Stewart, Phillip/2208 Essex Rd, Richmond, VA804-782-0988
Stickney, Christopher/321 10th Ave N,
St Petersburg, FL (P 208)**813-821-3635**
Stoppee Photographics Group/13 W Main St, Richmond, VA ...804-644-0266
Stover, David/3132 Ellwood Ave, Richmond, VA804-782-0988
Stratton, Jimi/670 11th St NW, Atlanta, GA404-876-1876
Strode, William A/1008 Kent Rd, Goshin, KY502-228-4446
Sumner, Bill/3400 Pan Am Dr, Coconut Grove, FL303-856-5958
Suraci, Carl/216 Hillsdale Dr, Sterling, VA703-620-6645
Swann, David/PO Box 7313, Atlanta, GA404-873-3003
Sweetman, Gary Photo/2904 Manatee Ave W, Bradenton, FL ...813-748-4004

TUV

Tack, Charles/11345 Sunset Hills Rd, Reston, VA703-471-1511
Taylor, John Michael/2214-B E 7th St, Charlotte, NC704-347-8822
Telesca, Chris/PO Box 51449, Raleigh, NC919-846-0101
Tenney, Michael/PO Box 37287, Charlotte, NC704-372-7700
Terranova, Michael/1135 Cadiz St, New Orleans, LA504-899-7328
Tesh, John/904-A Norwalk St, Greenboro, NC919-299-1400
Tetro, Jim/1921 Woodford Rd, Vienna, VA703-847-9650

The Waterhouse/PO Box 2487, Key Largo, FL800-451-3737
Thiel, Erhard/7637 Webbwood Ct, Springfield, VA703-569-7579
Thomas, J Clark/235 Lauderdale Rd, Nashville, TN615-269-7700
Thomas, Jay/2955 Cobb Pkwy #195, Atlanta, GA404-432-1735
Thomas, Larry/1212 Spring St, Atlanta, GA404-881-8850
Thomas, Norm/ PO Box 468, Mayo, FL904-294-2911
Thompson & Thompson/5180 NE 12th Ave, Ft Lauderdale, FL ...305-772-4411
Thompson, Darrell/124 Rhodes Dr, Marietta, GA404-641-2020
Thompson, Ed C/2381 Drew Valley Rd, Atlanta, GA404-636-7258
Thompson, Michael Photography/PO Box 110, Talking Rock, GA ...404-692-5876
Thompson, Rose/4338 NE 11th Ave, Oakland Park, FL305-563-7937
Thompson, Thomas L/731-B Highland Ave, Atlanta, GA404-892-3499
Thomson, John Christian/3820 Hardy St,
Hattiesburg, MS (P 162,163)**601-264-2878**
Tilley, Arthur/290 Heaton Park Dr, Decatur,
GA (P 209) ...**404-371-8086**
Tobias, Jerry/2117 Opa-Locka Blvd, Miami, FL305-685-3003
Toth, Craig/1420 E River Dr, Margate, FL305-974-0946
Traves, Stephen/360 Elden Dr, Atlanta, GA404-255-5711
Tropix /PO Box 6398, West Palm Beach, FL (P 173)**407-790-2790**
Trufant/Dobbs/1902 Highland Rd, Baton Rouge, LA504-344-9690
Tucker, Mark/114 Third Ave North, Nashville, TN615-254-6802
Turnau, Jeffrey/4950 SW 72nd Ave #114, Miami, FL305-666-5454
Tuttle, Steve/12 Fort Williams Pkwy, Alexandria, VA703-751-3452
Uzzell, Steve/1419 Trap Rd, Vienna, VA703-938-6868
Uzzle, Warren/5201 William & Mary Dr, Raleigh, NC..........919-266-6203
Valada, M C/2192 Oakdale Rd, Cleveland, OH216-397-9308
Van Camp, Louis/713 San Juan Rd, New Bern, NC919-633-6081
Van de Zande, Doug/307 W Martin St, Raleigh,
NC (P 175) ...**919-832-2499**
Vance, David/150 NW 164th St, Miami, FL305-354-2083
Vaughn, Marc/11140 Gßriffing Blvd, Biscayne Park, FL305-895-5790
Verlent, Christian/PO Box 530805, Miami, FL305-751-3385
Victor, Ira/2026 Prairie Ave, Miami Beach, FL305-532-4444
Viola, Franklin/9740 Coleman Rd, Roswell, GA404-594-1086
Visual Art Studios/3820 Hardy St, Hattiesburg, MS601-264-2878
Vogtner, Robert A/PO Box 9163, Mobile, AL205-694-8725
Von Hoene, Jeff/655 Highland Ave #3, Atlanta, GA404-577-8231
Vullo, Phillip Photography/565 Dutch Valley Rd NE, Atlanta, GA ...404-874-0822

WYZ

Wagoner, Mark/12-H Wendy Ct Box 18974, Greensboro, NC ...919-854-0406
Waine, Michael/1923 E Franklin St, Richmond,
VA (P 149) ...**804-644-0164**
Walker, Reuel Jr/PO Box 5421, Greenville, SC803-834-9836
Walker, Wes/301 Calvin St, Greenville, SC803-242-9108
Wallace, Doyle/2408 Summit Springs Dr, Dunwoody, GA404-448-8300
Walpole, Gary/193 Pine St, Memphis, TN901-726-1155
Walters, Tom/3108 Airlie St, Charlotte, NC704-537-7908
Wayne, Michael ...804-644-0164
Webb, Jon/2023 Kenilworth Ave, Louisville, KY502-587-7722
Webster & Co/2401 Euclid Ave, Charlotte, NC704-522-0647
Weinlaub, Ralph/1100 S Dixie Hwy W, Pompano Beach, FL ...305-941-1368
Weinmiller Inc/201 W Moorehead St, Charlotte, NC704-377-1595
Welsh, Kelley/11450 SE 57th St, Miami, FL305-595-6174
Westerman, Charlie/Central Amer Bldg/Bowman Fld, Louisville, KY ...502-458-1532
Wheless, Rob/3039 Amwiler Rd #114, Atlanta, GA404-729-1066
Whipps, Dan/816 N St Asaph St, Alexandria, VA703-684-3808
White, Drake/PO Box 40090, Augusta, GA404-733-4142
Whitehead, Dennis R/1410 N Nelson St, Arlington, VA703-524-6814
Whitman, Alan/724 Lakeside Dr, Mobile, AL205-661-0400
Whitman, John/604 N Jackson St, Arlington, VA703-524-5569
Wien/Murray Studio/2480 W 82nd St #8, Hialeah, FL305-828-7400
Wiley & Flynn/379 W Michigan Ave #200, Orlando, FL407-843-6767
Willard, Jean/684 Greenwood Ave, Atlanta, GA404-872-8117
Willi, Bryan/PO Box 24468, Ft Lauderdale, FL305-484-6867
Williams, Jimmy/3801 Beryl Rd, Raleigh, NC919-832-5971
Williams, Ron/105 Space Park Dr #A, Nashville, TN615-331-2500
Williams, Sonny/555 Dutch Valley Rd NE, Atlanta,
GA (P 158,159) ...**404-892-5551**
Willis, Joe/105 Lake Emerald Dr #314, Ft Lauderdale, FL305-485-7185
Willison, Dusty/4302 SW 70th Tr, Davey, FL305-474-3271
Wilson, Andrew/1640 Smyrna-Roswell Rd SE, Smyrna, GA ...404-436-7553
Winkel, Pete/3760 Prestwick Dr, Atlanta, GA (P 210)...**404-934-5434**
Winner, Alan/PO Box 695249, Miami, FL305-653-6778
Winters, Nina/650 Island Way #107, Clearwater, FL813-449-0114
Wolf, David/1770 Quail Ridge Rd, Raleigh, NC919-782-8395

Wolf, Lloyd/5710 First St, Arlington, VA.................................703-671-7668
Wood, James/PO Box 510129, Melbourne Beach, FL.........................407-725-4581
Wood, Michael/470 Woods Mill Rd NW, Gainesville, GA....................404-536-9006
Woodbury, Mark & Assoc/6801 NW 9th Ave, Ft Lauderdale, FL..........305-977-9000
Woodson, Richard/PO Box 12224, Raleigh, NC............................919-833-2882
Wright, Christopher/404 East Davis Blvd, Tampa, FL...................813-251-5206
Wright, Tim/PO Box 8296, Richmond, VA................................804-272-1439
Wright, Timothy/4920 Cleveland St #104, Virginia Bch, VA.............804-497-6249
Wrisley, Bard/PO Box 1021, Dahlonega, GA.............................404-524-6929
Yankus, Dennis/223 S Howard Ave, Tampa, FL..........................813-254-4156
Young, Chuck/1199-R Howell Mill Rd, Atlanta, GA.......................404-351-1199
Zeck, Gerry/1939 S Orange Ave, Sarasota, FL.........................813-366-9804
Zillioux, John/9127 SW 96th Ave, Miami, FL (P 211)....305-270-1270
Zimmerman, Mike/4054 N 30th Ave, Hollywood, FL.......................305-963-6240
Zinn, Arthur/2661 S Course Dr, Pompano Beach, FL.....................305-973-3851

M I D W E S T

A

Abel Photographics/7035 Ashland Dr, Cleveland, OH216-526-5732
Abramson, Michael Photo/3312 W Belle Plaine, Chicago, IL312-267-9189
Adamo, Sam/490 Parkview Dr, Seven Hills, OH..........................216-447-9249
Adams Group/703 E 30th St #17, Indianapolis, IN......................317-924-2400
Adams, Steve Studio/3101 S Hanley, Brentwood, MO.....................314-781-6676
Adcock, Gary/70 W Huron St #1009, Chicago, IL........................312-943-6917
AGS & R Studios/314 W Superior St, Chicago, IL.......................312-649-4500
Alan, Andrew/20727 Scio Church Rd, Chelsea, MI.......................313-475-2310
Alexander Glass Ingersol/3000 South Tech, Miamisburg, OH.............513-885-2008
Alexander, Mark/412 Central Ave, Cincinnati, OH......................413-651-5020
Allan-Knox Studios/450 S 92nd St, Milwaukee, WI......................414-774-7900
Alpert, Paul/1703 Simpson #5, St Louis, MO..........................314-664-0705
Altman, Ben/1420 W Dickens St, Chicago, IL312-404-0133
Amenta/555 W Madison #3802, Chicago, IL..............................312-248-2488
American Images/104 E 2nd St, Marshfield, WI.........................715-387-8682
Anderson, Craig/105 7th St, W Des Moines, IA.........................515-279-7766
Anderson, Rob/900 W Jackson, Chicago, IL.............................312-942-0551
Anderson, Whit/650 West Lake St, Chicago, IL.........................312-933-7644
Andre, Bruce/436 N Clark, Chicago, IL................................312-661-1060
Andrew, Larry/1632 Broadway, Kansas City, MO.........................816-471-5565
Anmar Photography/3310 Jamieson, St Louis, MO314-644-1010
Ann Arbor Photo/670 Airport Blvd, Ann Arbor, MI......................313-995-5778
Apple Photography Group/2301 W Nordale Dr, Appleton, WI..............414-739-4224
Arciero, Anthony/70 E Long Lake Rd, Bloomfield Hills, MI313-645-2222
Armour, Tony/1035 West Lake, Chicago, IL.............................312-733-7338
Arndt, David M/4620 N Winchester, Chicago, IL........................312-334-2841
Arndt, Jim/400 First Ave N #510, Minneapolis, MN.....................612-332-5050
Arsenault, Bill/1244 W Chicago Ave, Chicago, IL312-421-2525
Ascherman, Herbert Jr/1846 Coventry Vllg , Cleveland Heights, OH ...216-321-0055
Atevich, Alex/325 N Hoywe, Chicago, IL...............................312-942-1453
Atkinson, David/14 North Newstead, St Louis, MO......................314-535-6484
Au, King/108 3rd St #218, Des Moines, IA.............................515-243-2218
Audio Visual Impact Group/100 West Erie, Chicago, IL.................312-664-6247
Ayala/320 E 21 St, Chicago, IL.......................................312-326-0728

B

Baer Studio/5807 Capri Ln, Morton Grove, IL708-966-4759
Baer, Gordon/18 E 4th St #903, Cincinnati, OH........................513-381-4466
Bagnoli, Susan/74-24 Washington Ave, Eden Prairie, MN................612-944-5750
Bahm, Dave/711 Commercial, Belton, MO................................816-331-0257
Baker, Gregory/4630 Charles St, Rockford, IL815-398-1114
Baker, Jim/1632 Broadway, Kansas City, MO............................816-471-5565
Baker, Stephen/7075 W 21st St, Indianapolis, IN......................317-243-8090
Balogh, Jim/6114 Park Ave, St Louis, MO..............................314-781-4231
Balterman, Lee/910 N Lake Shore Dr, Chicago, IL......................312-642-9040
Baltz, Bill/3615 Superior Ave, Cleveland, OH.........................216-431-0979
Banna, Kevin/617 W Fulton St #2, Chicago, IL.........................312-845-9650
Banner & Burns Inc/452 N Halstead St, Chicago, IL....................312-644-4770
Bannister, Will/849 W Lill Ave #K, Chicago, IL.......................312-327-2143
Barkan Keeling Photo/905 Vine St, Cincinnati, OH.....................513-721-0700
Barlow Productions Inc/1115 Olivette Executive Pkwy, St Louis, MO....314-994-9990
Barnett, Jim/5580 N Dequincy St, Indianapolis, IN....................317-257-7177
Baron, Jim/812 Huron St #314, Cleveland, OH..........................216-781-7729
Barrett, Bob Photo/3733 Pennsylvania, Kansas City, MO................816-753-3208
Barton, Mike/5019 Nokomis Ave S, Minneapolis, MN.....................612-831-9557

Bartz, Carl Studio Inc/1307 Washington St #706, St Louis, MO314-231-8690
Basdeka, Pete/1254 N Wells, Chicago, IL..............................312-944-3333
Bass, Alan/824 North Racine #1, Chicago, IL..........................312-666-6111
Battrell, Mark/1611 N Sheffield, Chicago, IL.........................312-642-6650
Baver, Perry L/2923 W Touhy, Chicago, IL.............................312-674-1695
Bayles, Dal/4431 N 64th St, Milwaukee, WI............................414-464-8917
Beasley, Michael/1210 W Webster, Chicago, IL.........................312-248-5769
Beaugureau Studio/704 N Sylviawood, Park Ridge, IL...................708-696-1299
Beaulieu, Allen/400 N First Ave #604, Minneapolis, MN................612-338-2327
Beck, Bruce/1980 Stonington Ct, Rochester Hills, MI313-652-0550
Beck, Peter/718 Washington Ave N #605, Minneapolis, MN...............612-338-5712
Beckett Photography/117 S Morgan, Chicago, IL........................312-733-6550
Bednarski, Paul S/981 Beaconsfield, Grosse Pt, MI....................313-259-6565
Behr Images/6717 Odana Rd, Madison, WI...............................608-833-4994
Bellville, Cheryl Walsh/2823 8th St S, Minneapolis, MN...............612-333-5788
Belter, Mark/640 N LaSalle St #555, Chicago, IL......................312-337-7676
Benda, Tom/20555 LaGrange, Frankfurt, IL.............................815-469-3600
Bender + Bender/281 Klingel Rd, Waldo, OH............................614-726-2470
Benkert, Christine/27 N 4th St #501, Minneapolis, MN.................612-340-9503
Bennet, Patrick/330 E 47th St, Indianapolis, IN......................317-283-7530
Benoit, Bill/1708 1/2 Washington, Wilmette, IL.......................708-251-7634
Bentley, David/208 West Kinzie, Chicago, IL312-836-0242
Benyas-Kaufman Photo/8775 W 9 Mile Rd, Oak Park, MI313-548-4400
Bergerson, Steven/3349 45th Ave S, Minneapolis, MN...................612-724-0720
Berglund, Peter/718 Washington Ave N, Minneapolis, MN................612-371-9318
Bergos, Jim Studio/122 W Kinzie St, Chicago, IL......................312-527-1769
Berkman, Elie/125 Hawthorn Ave, Glencoe, IL..........................708-835-4158
Berlin Chic Photo/1708 W School Rd 3rd Fl, Chicago, IL312-327-2266
Berlow, Marc Photography/867 Tree Ln #105, Prospect Hts, IL312-787-6528
Berr, Keith/1220 W 6th St #608, Cleveland, OH........................216-566-7950
Berthiaume, Tom/1008 Nicollet Mall, Minneapolis, MN..................612-338-1999
Bevacqua, Alberto/821 W Bradley, Chicago, IL.........................312-935-5101
Bidak, Lorne/827 Milwaukee Ave, Chicago, IL..........................312-733-3997
Bieber, Tim/3312 W Belle Plaine, Chicago, IL.........................312-463-3590
Biel Photographic Studios/2289-91 N Moraine Blvd, Dayton, OH.........513-298-6621
Bilsley, Bill/613 Mariner Dr, Elgin, IL..............................708-931-7666
Bishop, Robert/5622 Delmar St #103 West, St Louis, MO................314-367-8787
Bjornson, Howard/300 N Ashland, Chicago, IL..........................312-243-8200
Blackburn, Charles A/1100 S Lynndale Dr, Appleton, WI414-738-4080
Blahut, Joseph/2400 Lakeview #906, Chicago, IL.......................312-525-2946
Blakeley, Pamela/876 Castelgate, Lake Forest, IL.....................708-234-3256
Block, Ernie/1138 Cambridge Cir Dr, Kansas City, KS..................913-321-3080
Block, Stuart/1242 W Washington Blvd, Chicago, IL....................312-733-3600
Bock, Edward/400 N First Ave #207, Minneapolis, MN...................612-332-8504
Bond, Paul/1421 N Dearborn #302, Chicago, IL.........................312-280-5488
Borde, Richard & Dawn/5328 29th Ave S, Minneapolis, MN...............612-729-1913
Bornefeld, William/586 Hollywood Pl, St Louis, MO....................314-962-5596
Boschke, Les/1839 W Fulton, Chicago, IL..............................312-666-8819
Bosek, George/1301 S Wabash 2nd Fl, Chicago, IL......................312-939-0777
Bosy, Peter/120 North Green, Chicago, IL.............................312-243-9220
Boucher, Joe/5765 S Melinda St, Milwaukee, WI414-281-7653
Bowen, Paul/Box 3375, Wichita, KS....................................316-263-5537
Brackenbury, Vern/1516 N 12th St, Blue Springs, MO...................816-229-6703
Braddy, Jim/PO Box 11420, Chicago, IL................................312-337-5664
Bradley, Rodney/329 10th Ave SE, Cedar Rapids, IA....................319-365-5071
Brandenburg, Jim/708 N 1st St, Minneapolis, MN612-341-0166
Brandt & Assoc/Rt 7/Box 148, Barrington Hills, IL708-428-6363
Braun Photography/3966 W Bath Rd, Akron, OH216-666-4540
Brayne, TW/326 W Kalamazoo Ave, Kalamazoo, MI........................616-375-4422
Brettell, Jim/2152 Morrison Ave, Lakewood, OH........................216-228-0890
Brimacombe, Gerald/7212 Mark Terrace, Minneapolis, MN................612-941-5860
Briskey, Bob/508 N Hoyne St, Chicago, IL.............................312-226-5055
Broderson, Fred/935 W Chestnut, Chicago, IL..........................312-226-0622
Brody, David & Assoc/6001 N Clark, Chicago, IL.......................312-761-2735
Brody, Jerry/70 W Hubbard, Chicago, IL...............................312-329-0660
Brosilow, Michael/480 Menomonee, Chicago, IL.........................312-266-1136
Brown, Alan J/815 Main St, Cincinnati, OH............................513-421-3345
Brown, Ron/1324 N Street, Lincoln, NE................................402-476-1760
Brown, Steve/107 W Hubbard, Chicago, IL..............................312-467-4666
Browne, Warren/1012 W Randolph St, Chicago, IL.......................312-733-8134
Bruno, Sam/1630 N 23rd, Melrose Park, IL.............................708-345-0411
Bruton, Jon/3838 W Pine Blvd, St Louis, MO314-533-6665
Brystrom, Roy/6127 N Ravenswood, Chicago, IL.........................312-973-2922
Bukva, Walt/10464 W 400 N, Michigan City, IN.........................219-872-9469
Bundt, Nancy/1908 Kenwood Parkway, Minneapolis, MN...................612-377-7773
Burjoski, David/511 West Dr, St Louis, MO............................314-725-4060
Burress, Cliff/5420 N Sheridan, Chicago, IL..........................312-651-3323
Burris, Zack/407 N Elizabeth, Chicago, IL............................312-666-0315

Buschauer, Al/728 S Northwest Hwy, Barrington, IL708-382-8484
Bush, Tim/617 W Fulton St, Chicago, IL......................................708-654-4373

C

C-H Studios/517 S Jefferson 7th Fl, Chicago, IL312-922-8880
Cabanban, Orlando/531 S Plymouth Ct, Chicago, IL........................312-922-1836
Cable, Wayne/401 W Superior, Chicago, IL312-951-1799
Cain, C C/420 N Clark, Chicago, IL...312-644-2371
Camacho, Mike/124 W Main St, West Dundee, IL...........................708-428-3135
Camera Works Inc/1260 Carnegie Ave, Cleveland, OH....................216-687-1788
Camerawork Ltd/400 S Greens St #203, Chicago, IL.......................312-666-8802
Campbell, Bob/722 Prestige, Joliet, IL...815-725-1862
Candee, Michael Studios/1212 W Jackson Blvd, Chicago, IL............312-226-3332
Caporale, Michael/6710 Madison Rd, Cincinnati, OH513-561-4011
Carell, Lynn/3 E Ontario #25, Chicago, IL......................................312-935-1707
Carney, Joann/401 N Racine, Chicago, IL......................................312-829-2332
Carosella, Tony/4138-A Wyoming, St Louis, MO..............................314-664-3462
Carr Photography/21836 Schmeman, Warren, MI............................313-776-8852
Carter, David/2901 N Lincoln, Chicago, IL.......................................312-929-0306
Carter, Mary Ann/5954 Crestview, Indianapolis, IN..........................317-255-1351
Casalini, Tom/10 1/2 Main St, Zionsville, IN....................................317-873-5229
Cascarano, John/657 W Ohio, Chicago, IL......................................312-733-1212
Caswell, George/700 Washington Ave N #308, Minneapolis, MN.......612-332-2729
Cedrowski, Dwight/2870 Easy St, Ann Arbor, MI..............................313-971-3107
Ceolla, George/5700 Ingersoll Ave, Des Moines, IA.........................515-279-3508
Chadwick Taber Inc/617 W Fulton, Chicago, IL...............................312-454-0855
Chambers, Tom/1735 N Paulina, Chicago, IL..................................312-227-0009
Chapman, Cam/126 W Kinzie, Chicago, IL......................................312-222-9242
Chare, Dave/1045 N Northwest Hwy, Park Ridge, IL.........................708-696-3188
Charlie Company/2148 Lakeside, Cleveland, OH.............................216-566-7464
Charlton, James/11518 N Pt Washington Rd, Mequon, WI.................414-241-8634
Chauncey, Paul C/388 N Hydraulic, Wichita, KS...............................316-262-6733
Cherup, Thomas/PO Box 84, Dearborn Hts, MI...............................313-561-9376
Chicago Photographers/430 West Erie St, Chicago, IL.....................312-944-4828
Chobot, Dennis/2857 E Grand Blvd, Detroit, MI...............................313-875-6617
Christman, Gerald/985 Ridgewood Dr, Highland Park, IL...................708-433-2279
Church, Dennis/301 S Bedford St #6, Madison, WI...........................608-255-2726
Clark, Junebug/36264 Freedom Rd, Farmington, MI.........................313-478-3666
Clark, Thom/1927 W Farwell, Chicago, IL..312-338-5829
Clarke, Jim/1114 Washington Ave, St Louis, MO..............................314-421-6840
Classic Visions Photography/4725 West North Ave, Milwaukee, WI.....414-447-7800
Clawson, David/6800 Normal Blvd, Lincoln, NE.................................402-489-1302
Clawson, Kent/2530 West Wilson Ave, Chicago, IL............................312-583-0001
Clayton, Curt/2655 Guoin, Detroit, MI...313-567-3897
Clemens, Jim/1311 Gregory, Wilmette, IL...708-256-5413
Cloudshooters/Aerial Photo/4620 N Winchester, Chicago , IL.............312-334-2841
Coats & Greenfield Inc/2928 Fifth Ave S, Minneapolis, MN................612-827-4676
Cocose, Ellen/445 E Ohio #222, Chicago, IL.....................................312-527-9444
Coffey, Mark/3660 N Lake Shore Dr #416, Chicago, IL.......................312-883-4652
Coha, Dan/9 W Hubbard, Chicago, IL...312-664-2270
Coil, Ron Studio/15 W Hubbard St, Chicago, IL.................................312-321-0155
Color Associates/10818 MW Industrial Blvd, St Louis, MO................800-456-SEPS
Comess, Herb/540 Custer St, Evanston, IL.......................................312-791-3152
Compton, Ted/112 N Washington, Hinsdale, IL..................................312-654-8781
Condie, Thomas M/535 N 27th St, Milwaukee, WI..............................414-342-6363
**Conison, Joel Photography/18 W 7th St, Cincinnati,
OH (P 226)** ..**513-241-1887**
Conklin, David/112 W Main St, West Branch, IA.................................319-643-7272
Conner/Nichols Photo/520 Virginia Ave, Indianapolis, IN317-634-8710
Cool, Nick/1892 N Lincoln Ave, Salem, NY.......................................216-332-1509
Copeland, Burns/6651 N Artesian, Chicago, IL..................................312-465-3240
Coscarelli, Robert/1922 N Orchard, Chicago, IL.................................312-280-8528
Cote, Eaton/26 Spring Ave, Waukon, IA...319-568-2253
Cowan, Ralph/604 Division Rd, Valparaiso, IN....................................219-462-0199
Cox, D E/Detroit/22111 Cleveland #211, Dearborn, MI........................313-561-1842
CR Studio/1859 W 25th St, Cleveland, OH...216-861-5360
Crane, Arnold/666 N Lake Shore Dr, Chicago, IL................................312-337-5544
Crane, Michael/1717 Wyandotte St, Kansas City, MO..........................816-221-9382
Croff, Will/1100 S Lynndale, Appleton, WI...414-738-4080
Crofoot, Ron/6140 Wayzata Blvd, Minneapolis, MN..............................612-546-0643
Crofton, Bill/326R Linden Ave, Wilmette, IL...708-256-7862
Cromwell, Patrick/1739 Coolidge, Berkley, MI......................................313-543-5610
Crosby, Paul/1083 Tenth Ave SE, Minneapolis, MN..............................612-378-9566
Cross, Emil/1886 Thunderbird, Troy, MI..313-362-3111
Crowther Photography/1108 Kenilworth Ave, Cleveland, OH..................216-566-8066
Culbert-Aguilar, Kathleen/1338 W Carmen, Chicago, IL.........................312-561-1266
Culp, John L Jr/1133 E 45th St, Chicago, IL...312-285-5570

**Curtis, Lucky/1540 N North Park Ave, Chicago, IL
(P 229)** ..**312-787-4422**

D

D'Orio, Tony/1147 W Ohio, Chicago, IL...312-421-5532
Dacuisto, Todd/840 N Old World 3rd St, Milwaukee, WI........................414-272-8772
Dale, LB/7015 Wing Lake Rd, Birmingham, MI.....................................313-851-3296
Dapkus, Jim/Westfield Photo/Rte 1 Box 247, Westfield, WI....................608-296-2623
Davito, Dennis/638 Huntley Heights, Manchester, MO..........................314-394-0660
Deahl, David/70 W Hubbard, Chicago, IL...312-644-3187
Debacker, Michael/231 Ohio, Wichita, KS..316-722-3075
DeBolt, Dale/120 West Kinzie St, Chicago, IL.......................................312-644-6264
DeLaittre, Bill/7661 Washington Ave S, Edina, MN...............................612-941-4884
Delich, Mark/304 W 10th St #200, Kansas City, MO.............................816-474-6699
DeNatale, Joe/2129 W North Ave, Chicago, IL.....................................312-489-0089
Denning, Warren/231 Ohio St, Wichita, KS..316-262-4163
Design Photography Inc/2001 Hamilton Ave, Cleveland, OH.................216-687-0099
Dieringer, Rick/19 W Court St, Cincinnati, OH......................................513-621-2544
Dinerstein, Matt/606 W 18th St, Chicago, IL...312-243-4766
Ditlove, Michel/18 W Hubbard, Chicago, IL...312-644-5233
Ditz, Michael/2292 Cole St, Birmingham, MI...313-642-8884
Donner, Michael/5534 S Dorchester, Chicago, IL..................................312-241-7896
Donofrio, Randy/6459 S Albany, Chicago, IL...312-737-0990
Doyle, Tim/1550 E 9 Mile Rd, Ferndale, MI...313-543-9440
Drea, Robert/1909 S Halstead, Chicago, IL...312-472-6550
Drew, Terry-David/452 N Morgan #2E, Chicago, IL................................312-829-1630
Drickey, Pat/1412 Howard St, Omaha, NE..402-344-3786
Drier, David/804 Washington St #3, Evanston, IL...................................708-475-1992
Dublin, Rick/414 Third Ave W, Minneapolis, MN....................................612-332-8924
DuBroff, Don/2031 W Cortez, Chicago, IL...312-252-7390
DuFresne, Gilmore/PO Box 291, Maryville, MO......................................816-582-7545

E

Eagle, Lin/1725 W North Ave, Chicago, IL...312-276-0707
Ebel, Bob Photography/1376 W Carroll, Chicago, IL...............................312-222-1123
Ebenoh, Tom/7050 Justamere Hill, Hause Springs, MO...........................314-671-0439
Eckhard, Kurt/1306 S 18th St, St Louis, MO...314-241-1116
Edwards, Bruce/930 S Park Ave, Winthrop Harbor, IL..............................708-746-5168
Edwards, Thomas/PO Box 1193, Milwaukee, WI.....................................414-258-6331
Eggebenn, Mark/1217 Center Ave, Dostburg, WI....................................414-564-2344
Einhorn, Mitchell/311 N Des Plaines #603, Chicago, IL............................312-944-7028
Elacy, John/24746 Rensselaer, Oak Park, MI..313-548-3842
Elan Photography/1130 S Wabash #203, Chicago, IL...............................312-431-0746
**Eliasen, Steve/100 S Lyndale Dr, Appleton, WI
(P 222,223)** ...**414-738-4080**
Elledge, Paul/1808 W Grand Ave, Chicago, IL..312-733-8021
Elmore, Bob and Assoc/315 S Green St, Chicago, IL...............................312-641-2731
Englehard, J Versar/1156 West Grand, Chicago, IL..................................312-787-2024
Eshelman, Charlie/59 W Hubbard, Chicago, IL..312-527-1330
ETM Studios/9201 King St, Chicago, IL...708-671-5150
Evans, Patricia/1153 E 56th St, Chicago, IL...312-288-2291
Ewert, Steve/17 N Elizabeth, Chicago, IL..312-733-5762

F

Faitage, Nick Photography/1914 W North Ave, Chicago, IL........................312-276-9321
Farber, Gerald/4925 Cadieux, Detroit, MI...313-885-4300
Farmer, Terry/524 S 2nd St #510, Springfield, IL......................................217-785-0975
Faverty, Richard/1019 W Jackson, Chicago, IL...312-633-0566
Feferman, Steve/462 Fern Dr, Wheeling, IL..708-459-3695
Fegley, Richard/777 North Michigan Ave #706, Chicago, IL.......................312-337-7770
Feher, Michael/1818 Chouteau, St Louis, MO...314-231-9200
Felde Studio Inc/PO Box 4680, Chicago, IL..312-477-7170
Feldkamp-Malloy/180 N Wabash, Chicago, IL...312-263-0633
Feldman, Stephen L/2705 W Agatite, Chicago, IL......................................312-539-0300
Ferderbar Studios/62 W Huron, Chicago, IL..312-642-9296
Ferguson, Ken/400 North May, Chicago, IL...312-829-2366
Ferguson, Scott/710 North Tucker, St Louis, MO..314-241-3811
Fetters, Grant/173 W Clay St, Meuskegon, MI...616-722-4723
Ficht, Bill/244 Blue Spruce La, Aurora, IL...708-851-2185
Finlay & Finlay Photo/141 E Main St, Ashland, OH.....................................419-289-3163
Firak Photography/1043 West Grand St, Chicago, IL..................................312-421-2225
First, Bill/1153 N Dearborn, Chicago, IL..312-943-5647
Fish, Peter Studio/1151 West Adams, Chicago, IL......................................312-829-0129
Fitzsimmons, J Kevin/2380 Wimbledon Rd, Columbus, OH..........................614-457-2010
Fleck, John/9257 Castlegate Dr, Indianapolis, IN..317-849-7723

Fleming, Larry/PO Box 3823, Wichita, KS316-267-0780
Flesher, Robert/102 Waterford Ct, Peachtree City, GA....404-487-2472
Fletcher, Mike/7467 Kingsbury, St Louis, MO314-721-2279
Flood, Kevin/1329 Macklind St, St Louis, MO314-647-2485
Floyd, Bill/404 North Way, Chicago, IL312-243-1611
Fong, John/13 N Huron St, Toledo, OH419-243-7378
Fontayne Studios Ltd/4528 W Oakton, Skokie, IL708-676-9872
Foran, Bob/3930 Varsity Dr, Ann Arbor, MI313-973-0960
Ford, Madison/2616 Industrial Row, Troy, MI313-280-0640
Forrest, Michael/2150 Plainfield Ave NE, Grand Rapids, MI....616-361-2556
Forsyte, Alex/1180 Oak Ridge Dr, Glencoe, IL708-835-0307
Forth, Ron/1507 Dana St, Cincinnati, OH513-841-0858
Fortier, Ron/613 Main #301, Rapid City, SD605-341-3739
Foto-Graphics/2402 N Shadeland Ave, Indianapolis, IN317-353-6259
Fox Commercial Photo/119 W Hubbard, Chicago, IL312-664-0162
Fox Creek Photograpix/PO Box 746, Green Bay, WI414-339-0888
Fox, Fred & Sons/2746 W Fullerton, Chicago, IL312-342-3233
Francis, Dan/4515 Delaware St N, Indianapolis, IN317-283-8244
Frantz, Ken/706 N Dearborn, Chicago, IL312-951-1077
Franz, Bill/820 E Wisconsin, Delavan, WI414-728-3733
Freeman, George/1061 W Balmoral, Chicago, IL312-275-1122
Frerck, Robert/4158 N Greenview 2nd Fl, Chicago, IL312-883-1965
Frey, Jeff Photography Inc/405 E Superior St, Duluth, MN....218-722-6630
Frick, Ken Photographer/66 Northmoor Pl,
Columbus, OH (P 230)**614-263-9955**
Friedman & Karant Studios/400 North May St, Chicago, IL....312-527-1880
Friedman, Susan J/400 North May St, Chicago, IL312-733-0891
Fritz, Tom/2930 W Clybourn, Milwaukee, WI414-344-8300
Futran, Eric/3454 N Bell, Chicago, IL312-525-5020

G

Gabriel Photo/160 E Illinois, Chicago, IL312-743-2220
Gale, Bill/3041 Aldrich Ave S, Minneapolis, MN612-827-5858
Galloway, Scott/2772 Copley Rd, Akron, OH216-666-4477
Gardiner, Howard/9 E Campbell #1, Arlington Hts, IL708-392-0766
Gargano, Pat/3200 Coral Park Dr, Cincinnati, OH513-662-2780
Garmon, Van/312 Eighth St #720, Des Moines, IA515-247-0001
Gates, Bruce/356 1/2 S Main St, Akron, OH216-535-2221
Gaymont, Gregory/1812 N Hubbard St, Chicago, IL312-421-3146
Gerlach, Monte/705 S Scoville, Oak Park, IL708-848-1193
Getsug, Don/1255 South Michigan Ave, Chicago, IL312-939-1477
Giannetti, Joseph/119 4th St N #501, Minneapolis, MN612-339-3172
Gillette, Bill/2917 Eisenhower, Ames, IA515-294-4340
Gillis, Greg/952 West Lake, Chicago, IL (P 218,219)**312-733-2340**
Gilo, Dave/121 N Broadway, Milwaukee, WI414-273-1022
Gilroy, John Photography/2407 West Main St, Kalamazoo, MI616-349-6805
Girard, Connie/609 Renolda Woods Ct, Dayton, OH513-294-2095
Girard, Jennifer/1455 W Roscoe, Chicago, IL312-929-3730
Glass, Greg/3000 South Tech, Miamisburg, OH513-885-2008
Glendinning, Peter/106 W Allegan #408, Lansing, MI517-484-6200
Glenn, Eileen/407 N Elizabeth Pl #101, Chicago, IL312-666-7300
Gluth, Bill/173 E Grand Ave, Fox Lake, IL312-834-4798
Goddard, Will/PO Box 8081, St Paul, MN612-488-5359
Goff, D R/66 W Wittier St, Columbus, OH (P 225)**614-443-6530**
Goldberg, Lenore/210 Park Ave, Glencoe, IL708-835-4226
Goldstein, Steven/343 Copper Lakes Blvd, St Louis, MO314-227-8797
Goodwin, Andy/220 Pottawatamie, New Lenox, IL818-485-8822
Goss, James M/1737 McGee St, Kansas City, MO816-471-8069
Goss, Michael/2444 W Chicago Ave, Chicago, IL312-235-4800
Gould, Christopher/224 W Huron, Chicago, IL312-944-5545
Gould, Ron/1609 N Wolcott, Chicago, IL312-235-0157
Graham, Stephen/1120 W Stadium #2, Ann Arbor, MI313-761-6888
Graham-Henry, Diane/613 W Belden, Chicago, IL312-327-4493
Grajczyk, Chris/126 North 3rd St #405, Minneapolis, MN612-333-6265
Grand, Ruth/8081 Zionsville Rd, Indianapolis, IN317-872-7220
Grande, Ruth/8081 Zionsville Rd, Indianapolis, IN317-872-7220
Gray, Walter/1035 W Lake, Chicago, IL312-733-3800
Grayson, Dan/831 W Cornelia, Chicago, IL312-477-8659
Gregg, Rene/4965 McPherson, St Louis, MO314-361-1963
Griffith, Sam/345 N Canal, Chicago, IL312-648-1900
Grippentrag, Dennis/70 E Long Lake Rd, Bloomfield Hills, MI313-645-2222
Groen, John/676 N LaSalle, Chicago, IL312-266-2331
Grondin, Timothy/815 Main St, Cincinnati, OH513-421-5588
Grubman, Steve/456 N Morgan, Chicago, IL312-226-2272
Grunewald, Jeff/161 W Harrison St, Chicago, IL312-663-5799
GSP/156 N Jefferson, Chicago, IL312-944-3000
Gubin, Mark/2893 S Delaware Ave, Milwaukee, WI414-482-0640

Guenther, Stephen/807 Church St, Evanston, IL708-328-4837
Guerry, Tim/711 S Dearborn #304, Chicago, IL312-294-0070
Gyssler, Glen/221 E Cullerton, Chicago, IL312-842-2202

H

Haberman, Mike/529 S 7th St #427, Minneapolis, MN612-338-4696
Hadley, Alan/140 First Ave NW, Carmel, IN317-846-2259
Haefner, Jim/1407 N Allen, Troy, MI313-583-4747
Hafencher, Lou/2462 E Oakton, Arlington Hts, IL708-593-7977
Hagen Photography/703 S 2nd St, Milwaukee, WI414-643-8684
Hall, Brian/900 W Jackson Blvd #8W, Chicago, IL312-226-0853
Haller, Pam/935 W Chestnut, Chicago, IL312-243-4462
Halsey, Daniel/12243 Nicollet Ave S, Minneapolis, MN612-894-2722
Hamill, Larry/77 Deshler, Columbus, OH614-444-2791
Hammarlund, Vern/135 Park St, Troy, MI313-588-5533
Handley, Robert E/1920 E Croxton, Bloomington, IL309-828-4661
Hanselman, Linda/PO Box 8072, Cincinnati, OH513-321-8469
Harding Studio/2076 N Elston, Chicago, IL312-252-4010
Harlan, Bruce/52922 Camellia Dr, South Bend, IN219-239-7350
Harrig, Rick/3316 South 66th Ave, Omaha, NE402-397-5529
Harris, Bart/70 W Hubbard St, Chicago, IL312-751-2977
Hart, Bob/941 Ridge Ave, Evanston, IL708-328-3040
Hartjes, Glenn/1100 S Lynndale, Appleton, WI414-738-4080
Hauser, Marc/1810 W Cortland, Chicago, IL312-486-4381
Hawker, Chris/119 N Peoria, Chicago, IL312-829-4766
Hayes, Robert Cushman/7350 Gracely Dr, Cincinnati, OH513-941-2447
Hedrich, Sandi/10-A W Hubbard, Chicago, IL312-527-1577
Hedrich-Blessing/11 W Illinois St, Chicago, IL312-321-1151
Henebry, Jeanine/1154 Locust Rd, Wilmette, IL708-251-8747
Henning, Paul/PO Box 92397, Milwaukee, WI414-765-9441
Hermann, Dell/676 N LaSalle, Chicago, IL312-664-1461
Hernandez, Rick/1952 Hazelwood Ave SE, Warren, OH216-369-2847
Hertzberg, Richard/432 N Clark St, Chicago, IL312-836-0464
Hill, John/4234 Howard, Western Springs, IL708-246-3566
Hill, Roger/4040 W River Dr, Comstock Park, MI616-784-9620
Hillery, John/PO Box 2916, Detroit, MI313-345-9511
Hillstrom Stock Photo, Ray/5483 N NW Highway, Chicago, IL312-775-4090
Hirneisen, Richard/306 S Washington St #218, Royal Oak, MI....313-399-2410
Hirschfeld, Corson/316 W Fourth St, Cincinnati, OH513-241-0550
Hix, Steve/517 Southwest Blvd, Kansas City, MO816-421-5114
Hodes, Charles S/233 E Erie, Chicago, IL312-951-1186
Hodge, Adele/405 N Wabash Ave #805, Chicago, IL312-828-0611
Hofer, Charles/2134 North St, Peoria, IL309-676-6676
Holographics Design System/1134 W Washington, Chicago, IL....312-226-1007
Holzemer, Buck/3448 Chicago Ave, Minneapolis, MN612-824-3874
Hopkins, William/445 W Erie, Chicago, IL312-787-2032
Horstman, Mike/700 Forest Edge Dr, Vernon Hills, IL708-634-4505
Hoskins, Sarah/1206 Isabella, Wilmette, IL708-256-5724
Houghton, Michael/Studiohio/55 E Spring St, Columbus, OH614-224-4885
Howrani, Armeen/2820 E Grand Blvd, Detroit, MI313-875-3123
Hurling, Robert/325 W Huron, Chicago, IL312-944-2022
Hutson, David/8120 Juniper, Prairie Village, KS913-383-1123
Hyman, Randy/7709 Carnell Ave, St Louis, MO314-821-8851

I

Iacono, Michael/412 Central Ave, Cincinnati, OH513-621-9108
Iann-Hutchins/2044 Euclid Ave, Cleveland, OH216-579-1570
Image Productions/115 W Church, Libertyville, IL708-680-7100
Image Studios/1100 S Lynndale Dr, Appleton,
WI (P 222,223)**414-738-4080**
Imagematrix/2 Garfield Pl, Cincinnati, OH513-381-1380
Imagination Unlimited/1280 East Miner, Des Plaines, IL708-803-0199
Imbrogno, James/935 West Chestnut St #03, Chicago, IL312-644-7333
Ingram, Russell/2334 W 116th Pl, Chicago, IL312-238-4114
Ingve, Jan & Assoc/235 Forrest Knoll Ave, Palatine, IL708-381-3456
International Photo Corp/1035 Wesley, Evanston, IL708-475-6400
Irving, Gary/PO Box 38, Wheaton, IL708-653-0641
Isenberger, Brent/108 3rd St #360, Des Moines,
IA (P 231)**515-243-2376**
Itahara, Tets/676 N LaSalle, Chicago, IL312-649-0606
Iwata, John/325 W New York Ave, Oshkosh, WI414-426-1487
Izquierdo, Abe/213 W Institute #208, Chicago, IL312-787-9784
Izui, Richard/315 W Walton, Chicago, IL312-266-8029

J

Jackson, David/1021 Hall St, Grand Rapids, MI616-243-3325
Jacobs, Todd/2437 W Wilson, Chicago, IL..............................312-769-0383
Jacobson, Scott/3435 N County Rd #18, Plymouth, MN612-546-9191
Jacquin Enterprise/1219 Holly Hills, St Louis, MO314-832-4221
James, Phillip MacMillan/2300 Hazelwood Ave, St Paul, MN612-777-2303
Janos, James/4202 Archwood Pl, Cleveland, OH216-861-1840
Jelen, Tom/PO Box 115, Arlington Heights, IL........................708-506-9479
Jenkins, David/1416 S Michigan Ave, Chicago, IL312-922-2299
Jensen, Michael/1101 Stinson Blvd NE, Minneapolis, MN612-379-1944
Jilling, Helmut/3420-A Cavalier Trail, Cuyahoga Falls, OH216-928-1330
Jochim, Gary/1324 1/2 N Milwaukee, Chicago, IL312-252-5250
Joel, David Photo Inc/1515 Washington Ave, Wilmette, IL708-256-8792
Johnson, Dave/15840 Forrer, Detroit, MI...............................313-589-0066
Johnson, Donald/PO Box 4053, Northbrook, IL.....................708-480-9336
Johnson, Jim/802 W Evergreen, Chicago, IL312-943-8864
Jolly, Keith/32049 Milton Ave, Madison Hts, MI....................313-588-6544
Jones, Brent/9121 S Merrill Ave, Chicago, IL312-933-1174
Jones, Dawson Inc/23 N Walnut St, Dayton, OH....................513-859-7799
Jones, Dick/325 W Huron St, Chicago, IL..............................312-642-0242
Jones, Duane/5605 Chicago Ave S, Minneapolis, MN612-823-8173
Jones, Harrison/113 North May St, Chicago, IL......................312-421-6400
Jones, Mark/718 Washington Ave N, Minneapolis, MN612-338-5712
Jordan, Jack/840 John St, Evansville, IN...............................812-423-7676
Jordano, Dave/1335 N Wells, Chicago, IL..............................312-280-8212
Joseph, Mark/1007 N La Salle, Chicago, IL312-951-5333
Joyce, Todd/7815 Lake St, Cincinnati, OH.............................513-421-1209
Justice Patterson Studio/7609 Production Dr, Cincinnati, OH513-761-4023

K

**Kalman & Pabst Photo Group/400 Lakeside Ave
NW, Cleveland, OH (P 232)**...**216-574-9090**
Kalyniuk, Jerry/4243 N Winchester, Chicago, IL....................312-666-5588
Kansas City Photographic/1830 Main St, Kansas City, MO......816-221-2710
Kaplan, Dick/708 Waukegan, Deerfield, IL.............................708-945-3425
Kaplan, Matthew/5452 N Glenwood, Chicago, IL312-769-5903
Karant, Barbara/400 N May St, Chicago, IL312-527-1880
Katz, Sue/2828 N Burling #406, Chicago, IL312-549-5379
Katzman, Mark/710 N Tucker St #512, St Louis, MO314-241-3811
Kauck, Jeff/1050 E McMillan, Cincinnati, OH.........................513-751-8515
Kauffman, Kim/444 Lentz Court, Lansing, MI.........................517-371-3036
Kazu Studio/1211 West Webster, Chicago, IL.........................312-348-5393
Kean, Christopher/3 S Prospect/Pickwick Bldg, Park Ridge, IL......312-559-0880
Keefer, KC/2308 Hecker Ave, Rockford, IL.............................815-968-5584
Keeling, Robert/900 West Jackson Blvd #7W, Chicago, IL......312-944-5680
Keeven, Pam/2838 Salena, St Louis, MO...............................314-773-3587
Keisman & Keisman/3417 S Paulina St 1st fl, Chicago, IL.......312-268-7955
Kelly, Patrick/1127 California St, Grand Rapids, MI616-459-7540
Kelly, Tony/1131 Main St, Evanston, IL..................................708-864-0488
Kelsch, R R/4999 Madison Rd, Cincinnati, OH.......................513-271-9017
Keltsch, Steve/9257 Castlegate Dr, Indianapolis, IN317-849-7723
Kent, Jorie Butler/1520 Kensington, Oak Brook, IL708-954-3388
Kern, C S/220 N Walnut St, Muncie, IN..................................317-288-1454
Ketchum, Art/1524 Peoria, Chicago, IL..................................312-733-7706
Kilbourne, Scott/c/o Biomed/801 N Rutledge, Springfield, IL......217-782-2326
Kildow, William/1743 West Cornelia, Chicago, IL312-248-9159
Kimbal, Mark/23860 Miles Rd, Cleveland, OH........................216-587-3555
Kinast, Susan/1504 S Fremont, Chicago, IL...........................312-337-1770
King, Jay Studios/1629 North Milwaukee, Chicago, IL............312-327-0011
King, Richard/510 E Fellos St, Dixon, IL.................................815-284-3871
Kingsbury, Andrew/700 N Washington #306, Minneapolis, MN......612-340-1919
Kitahara, Joe/304 W 10th St, Kansas City, MO.......................816-474-6699
Kloc, Howard/520 W Eleven Mile Rd, Royal Oak, MI..............313-541-1704
Klutho, David E/3421 Meramec St, St Louis, MO....................314-352-4534
Knepp Studio/1742 McKinley St, Mishawaka, IN.....................219-259-1913
Knize, Karl/1920 N Seminary, Chicago, IL..............................312-477-1001
Koechling, William/1307 E Harrison, Wheaton, IL708-665-4419
Kogan, David/1242 W Washington Blvd, Chicago, IL..............312-243-1929
Kolbrener, Bob/12300 Ballas Woods Court, St Louis, MO.......314-567-1361
Kolesar, Jerry Photographics/679 E Mandoline, Madison Hts, MI......313-589-0066
Kompa, Jeff/25303 Lorain Rd, N Olmstead, OH......................216-777-1611
Kondas, Thom Assoc/1529 N Alabama St, Indianapolis, IN......317-637-1414
Kondor, Linda/2141 West Lemoyne, Chicago, IL.....................312-642-7365
Korab, Balthazar/PO Box 895, Troy, MI..................................313-641-8881
Krajcirovic, Maria/1133 W Maple Ave, Evanson, IL708-864-1803

Krantz, Jim/5017 S 24th St, Omaha, NE................................402-734-4848
Krantzen Studios/100 S Ashland, Chicago, IL312-942-1900
Krejci, Donald/3121 W 25th St, Cleveland, OH.......................216-831-4730
Krueger, Dick/2147 W Augusta Blvd, Chicago, IL...................312-384-0008
Kufrin, George/535 N Michigan #1407, Chicago, IL................312-787-2854
Kuhlmann, Brian/10542 Byfield, St Louis, MO.........................314-867-5117
Kuhule, Craig/30 Tenth St, Toledo, OH..................................419-242-9170
Kulp, Curtis/1255 S Michigan, Chicago, IL312-786-1943
Kusel, Bob/2156 W Arthur, Chicago, IL..................................312-465-8283

L

Lacey, Ted/4733 S Woodlawn, Chicago, IL.............................312-624-2419
Lachman, Cary/1927 Grant St, Evanston, IL708-864-0861
Lafavor, Mark/1008 Nicollet Mall, Minneapolis, MN612-338-1999
Lallo, Ed/7329 Terrace, Kansas City, MO...............................816-523-6222
Lambert, Bill/2220 Hassell #308, Hoffeman Estates, IL..........312-519-0189
Lancaster, Bill/114 E Front St #208, Traverse City, MI............616-929-2619
Landau, Allan/1147 West Ohio, Chicago, IL312-942-1382
Lane, Jack Studio/815 N Milwaukee Blvd, Chicago, IL............312-733-3937
Lange, Jim Design/203 N Wabash #1312, Chicago, IL............312-606-9313
Lanza, Scott/3200 S 3rd St, Milwaukee, WI............................414-482-4114
LaRoche, Andre/32588 Dequindre, Warren, MI.......................313-978-7373
Larsen, Kim/Soren Studio/114 W Kinzie, Chicago, IL..............312-527-0344
LaTona, Tony/1317 E 5th, Kansas City, MO............................816-474-3119
Laubacher, Kevin/Portland, OR (P 316,317)................**503-233-4594**
Lause, Lew/127 Prospect St, Marion, OH...............................614-383-1155
Lauth, Lyal/833 W Chicago Ave 6th Fl, Chicago, IL................312-829-9800
Leavenworth Photo Inc/929 West St, Lansing, MI...................517-482-4658
Leavitt, Debbie/2029 W Armitage, Chicago, IL.......................312-235-6777
Leavitt, Fred/916 Carmen, Chicago, IL312-784-2344
Lecat, Paul/820 N Franklin, Chicago, IL312-664-7122
Lee, David/102 N Center St #111, Bloomington , IL................309-825-1646
Lee, Robert Photo/1512 Northlin Dr, St Louis, MO314-965-5832
LeGrand, Peter/413 Sandburg, Park Forest, IL.......................708-747-4923
**Lehn, John & Associates/2601 E Franklin Ave,
Minneapolis, MN (P 233)**..**612-338-0257**
Leick, Jim/1709 Washington Ave, St Louis, MO......................314-241-2354
Leinwohl, Stef/1462 W Irving Park Rd, Chicago, IL.................312-975-0457
Leonard, Steve/825 W Gunnison, Chicago, IL312-275-8833
Leslie, William F/53 Tealwood Dr, Creve Coeur, MO314-993-8349
Levey, Don/15 W Delaware Pl, Chicago, IL312-329-9040
Levin, Daniel/2530 Superior Ave 4th Fl, Cleveland, OH216-781-0600
Levin, Jonathan/1035 W Lake St, Chicago, IL.........................312-226-3898
Lewandowski, Leon/210 N Racine, Chicago, IL312-467-9577
Lightfoot, Robert/311 Good Ave, Des Plaines, IL....................708-297-5447
Likvan Photo/107 S Wapella Ave, Mt Prospect, IL..................708-394-2069
Linc Studio/1163 Tower, Schaumberg, IL...............................708-882-1311
Lindblade, George R/PO Box 1342, Sioux City, IA712-255-4346
Lindwall, Martin/234 E Maple Ave, Mundelein, IL708-566-1578
Lipman, Michael/216 N Clinton St, Chicago, IL.......................312-454-1414
Lipschis, Helmut Photography/2053 N Sheffield, Chicago, IL......312-935-7886
Liss, Leroy/6243 N Ridgeway Ave, Chicago, IL.......................312-539-4540
Lohbeck, Stephen/710 North Tucker, St Louis, MO314-231-6038
Love, Ken/6911 N Mcalpin Ave, Chicago, IL...........................312-775-5779
Lowry, Miles/222 S Morgan #3B, Chicago, IL.........................312-666-0882
Lubeck, Larry/405 N Wabash Ave, Chicago, IL.......................312-726-5580
Lucas, John V/4100 W 40th St, Chicago, IL312-927-4500
Lucas, Joseph/701 Euclid Ave, Island Park, IL708-432-1705
Ludwigs, David/3600 Troost St, Kansas City, MO816-531-1363
Luke, John/1100 S Lynndale Dr, Appleton, WI.........................414-738-4080
Lyles, David/855 W Blackhawk St, Chicago, IL312-642-1223

M

Maas, Curt/5860 Merle Hay Rd/Box 127, Johnston, IA............515-270-3732
MacDonald, Al/1221 Jarvis Ave, Elk Grove, IL........................708-437-8850
MacDonald, Neil/1515 W Cornelia, Chicago, IL.......................312-525-5401
Mack, Richard/2331 Hartzell, Evanston, IL..............................708-869-7794
Mactavish, David/341 Thomas Rd #8N, Maple Park, IL...........708-365-2613
Magin, Betty/412 Spring Valley Ct, Chesterfield, MO..............314-878-5388
Maguire, Jim/144 Lownsdale, Akron, OH................................216-630-9006
Maki & Smith Photo/6156 Olson Mem Hwy, Golden Valley, MN......612-541-4722
Malinowski, Stan/1150 N State #312, Chicago, IL...................312-951-6715
Manarchy, Dennis/229 W Illinois, Chicago, IL.........................312-828-9117
Mandel, Avis/1550 N Lakeshore Dr #10G, Chicago, IL............312-642-4776
Mankus, Gary/835 N Wood St #101, Chicago, IL....................312-421-7747
Mar, Jan/343 Harrison St, Oak Park, IL..................................708-524-1898

Marden Photo/PO Box 20574, Indianapolis, IN317-251-8373
Marianne Studio/117 S Jefferson, Mt Pleasant, IA319-986-6573
Marienthal, Michael/1832 S Halsted, Chicago, IL..............................312-226-5505
Marovitz, Bob/3450 N Lake Shore Dr, Chicago, IL.............................312-975-1265
Marshall, Don Photography/415 W Huron, Chicago, IL.......................312-944-0720
Marshall, Paul/208 W Kinzie, Chicago, IL..312-222-9002
Martin, Barbara E/46 Washington Terrace, St Louis, MO...................314-361-0838
Martone Inc/209 S Main St 5th Fl, Akron, OH.....................................216-434-8200
Marvy, Jim/41 Twelfth Ave N, Minneapolis, MN..................................612-935-0307
Mathews, Bruce/1014 NE 97th, Kansas City, MO...............................816-373-2920
Matlow, Linda/300 N State St #3926, Chicago, IL...............................312-321-9071
Matusik, Jim/2223 W Melrose, Chicago, IL..312-327-5615
Mauney, Michael/1405 Judson Ave, Evanston, IL...............................708-869-7720
May, Ron/PO Box 8359, Ft Wayne, IN ..219-483-7872
May, Sandy/18 N 4th St #506, Minneapolis, MN612-332-0272
McAlpine, Scott/110 S Elm St, N Manchester, IN219-982-8822
McCabe, Mark/1301 E 12th St, Kansas City, MO.................................816-474-6491
McCaffery, Randy/3309 Industrial Pkwy, Jeffersonville, NY812-284-3456
McCall, Paul/1844 Rutherford, Chicago, IL..312-622-4880
McCann, Larry/666 W Hubbard, Chicago, IL..312-942-1924
McCann, Michael/15416 Village Woods Dr, Eden Prairie, MN..............612-949-2407
McCay, Larry Inc/3926 N Fir Rd #14, Mishawaka, IN219-259-1414
McClelan, Thompson/206 S First St, Champaign, IL217-356-2767
McGee, Alan/3050 Edgewood St, Portage, IN......................................219-762-2805
McHale Studios Inc/2827 Gilbert Ave, Cincinnati, OH..........................513-961-1454
McKay, Doug/512 S Hamley, St Louis, MO...314-863-7167
McKellar, William/1643 N Milwaukee Ave, Chicago, IL.........................312-235-1499
McKinley, William/113 North May St, Chicago, IL312-666-5400
McMahon, David/800 Washington Ave N #309, Minneapolis, MN612-339-9709
McMahon, Franklin/595 Buena Rd, Lake Forest, IL..............................708-615-0057
McNichol, Greg/1222 West Elmdale, Chicago, IL..................................312-973-1032
Mead, Robert/711 Hillgrove Ave, La Grange, IL....................................312-354-8300
Media Works/PO Box 3581, Evansville, IN ...812-425-0553
Meleski, Mike/725 W Randolph, Chicago, IL...312-707-8500
Melkus, Larry/679-E Mandoline, Madison Hts, MI.................................313-589-9000
Meoli, Rick/710 N Tucker #306, St Louis, MO314-231-6038
Meyer, Aaron/1302 W Randolph, Chicago, IL..312-243-1458
Meyer, Fred/415 N Dearborn, Chicago, IL...708-747-2742
Meyer, Gordon/216 W Ohio, Chicago, IL..312-642-9303
Meyer, Robert/2007 W Division St, Chicago, IL......................................312-467-1430
Michael, William/225 W Hubbard, Chicago, IL.......................................312-644-6137
Micus Photo/517 S Addison, Villa Park, IL..708-941-8945
Mignard Associates/1950-R South Glenstone, Springfield, MO............417-881-7422
Mihalevich, Mike/9235 Somerset Dr, Overland Park, KS913-642-6466
Miller Photo/7237 W Devon, Chicago, IL..312-631-1255
Miller, Buck/PO Box 33, Milwaukee, WI..414-672-9444
Miller, Frank/6016 Blue Circle Dr, Minnetonka, MN...............................612-935-8888
Miller, Jon/11 W Illinois, Chicago, IL...312-738-1816
Miller, Pat/420 N Fifth St #840, Minneapolis, MN..................................612-339-1115
Miller, Spider/833 North Orleans, Chicago, IL.......................................312-944-2880
Mills, Gary/PO Box 260, Granger, IN ...219-277-8844
Mitchell, John Sr/2617 Greenleaf, Elk Grove, IL...................................708-956-8230
Mitchell, Rick/652 W Grand, Chicago, IL...312-829-1700
Mitzit, Bruce/PO Box 561, Evanston, IL...312-508-1937
Mitzit, Bruce/Architectural Photo/1205 Sherwin, Chicago, IL..............312-508-1937
Mooney, Kevin O/511 N Noble, Chicago, IL...312-738-1816
Moore, Bob c/o Mofoto Graphics/1007 Washington Ave, St Louis, MO...314-231-1430
Moore, Dan/1029 N Wichita Ave, Wichita, KS316-264-4168
Moore, Ross/664 Ridgway Dr, Sidney, OH...513-497-1507
Morrill, Dan/1811 N Sedgwick, Chicago, IL..312-787-5095
Morton & White/7440 Pingue Dr, Worthington, OH................................614-885-8687
Moshman Photography/2700 Central Park Ave, Evanston, IL708-869-6770
Moss, Jean/1255 S Michigan Ave, Chicago, IL......................................312-786-9110
Mottel, Ray/760 Burr Oak Dr, Westmont, IL...708-323-3616
Moustakas, Daniel/1255 Rankin, Troy, MI...313-589-0100
Moy, Clinton Photography/4815 W Winnemar, Chicago, IL...................312-666-5577
Moy, Willie/364 W Erie, Chicago, IL...312-943-1863
Mueller, Linda/1900 Delmar, St Louis, MO..314-621-2400
Muresan, Jon/6018 Horger St, Dearborne, MI.......................................313-581-5445
Murphey, Gregory/22 E Washington St, Indianapolis, IN.......................317-262-8560
Musich, Jack/325 W Huron, Chicago, IL...312-644-5000
Mutrux, John L/5217 England, Shawnee Missn, KS...............................913-722-4343

N

Nagel, Ed/943 W Superior St, Chicago, IL ...312-733-4337
Nathanson, Neal/7531 Cromwell, St Louis, MO314-727-7244
Nawrocki, William S/332 S Michigan Ave, Chicago, IL312-427-8625

Nelson, Tom/800 Washington Ave N #301, Minneapolis, MN...............612-339-3579
Nelson-Curry, Loring/420 N Clark, Chicago, IL......................................312-644-2371
Neumann, Robert/101 S Mason St, Saginaw, MI...................................616-784-7111
New View Photo/5275 Michigan Ave, Rosemont, IL...............................708-671-0300
Newmann, Jeffrey/9960 Mt Eaton, Wadsworth, OH...............................216-336-4790
Niedorf, Steve/700 Washington Ave N #304, Minneapolis, MN............612-332-7124
Nielen, Audrey/33 East Cedar #11E, Chicago, IL..................................312-787-8226
Nielsen, Ron/1313 W Randolph #326, Chicago, IL................................312-226-2661
Nienhuis, John/3623 N 62nd St, Milwaukee, WI.....................................414-442-9109
Nilsen, Audrey/327 W Armitage Ave, Chicago, IL..................................312-787-8226
Njaa, Reuben/5929 Portland Ave S, Minneapolis, MN...........................612-866-9906
Nobart Inc/1133 S Wabash Ave, Chicago, IL...312-427-9800
Nolan, Tim/2548 Shirley, St Louis, MO...314-388-4125
Norman, Rick/1051 S Freemont, Springfield, MO417-865-0772
Norris, James/2301 N Lowell, Chicago, IL..312-342-1050
Northlight Studio/1539 E 22nd St, Cleveland, OH..................................216-621-3111
Novak, Ken/2483 N Bartlett Ave, Milwaukee, WI....................................414-962-6953
Novak, Sam/650 West Lake St, Chicago, IL..312-707-9111
Nozicka, Steve/405 N Wabash #3203, Chicago, IL................................312-329-1370
Nugent Wenckus Inc/110 Northwest Hwy, Des Plaines, IL.....................312-694-4151

O

O'Barski, Don/17239 Parkside Ave, S Holland, IL..................................708-596-0606
O'Keefe, JoAnne/2963 Pacific, Omaha, NE..402-341-4128
Oakes, Kenneth Ltd/902 Yale Ln, Highland Park, IL..............................708-432-4809
Oberle, Frank/6633 Delmar, St Louis, MO..314-721-5838
Oberreich, S/1930 N Alabama St, Indianapolis, IN................................317-923-1980
Officer, Hollis/905 E 5th St, Kansas City, MO..816-474-5501
Olausen, Judy/213 1/2 N Washington Ave, Minneapolis, MN................612-332-5009
Olberding, David/2141 Gilbert Ave, Cincinnati, OH................................513-221-7036
Ollis, Karen/1547 Superior Ave E, Cleveland, OH..................................216-781-8646
Olsson, Russ/215 W Illinois, Chicago, IL..312-329-9358
Ontiveros, Don/1837 West Evergreen, Chicago, IL................................312-342-0900
Oscar & Assoc/63 E Adams, Chicago, IL...312-922-0056
Oxendorf, Eric/1442 N Franklin Pl Box 92337, Milwaukee, WI..............414-273-0654

P

Palmisano, Vito/7346 W Pensacola, Norridge, IL...................................708-453-2308
Panama, David/1100 N Dearborn, Chicago, IL.......................................312-642-7095
Parallel Productions Inc/1008 Nicollet Mall, Minneapolis, MN...............612-338-1999
Parker, Norman/710 N 2nd St #300N, St Louis, MO...............................314-621-8100
Parker, Tim/4457 Miami St, St Louis, MO...314-776-8086
Parks, Jim/210 W Chicago, Chicago, IL..312-321-1193
Paszkowski, Rick/7529 N Claremont #1, Chicago, IL.............................312-761-3018
Paternite, David/1245 S Clevelnd-Massilon Rd #3, Akron, OH..............216-666-7720
Paulson, Bill/5358 Golla Rd, Stevens Point, WI......................................715-344-8484
Payne, Geof/817 Prairie Lane, Columbia, MO..314-443-0384
Payne-Garrett Photo/5301 Michigan Ave, Chicago, IL312-671-0300
Pease, Scott/2020 Euclid Ave 4th Fl, Cleveland, OH
(P 224) ...**216-621-3318**
Pech, Ted/10818 Midwest Industrial Blvd, St Louis, MO........................800-456-7577
Perkins, Ray/222 S Morgan St, Chicago, IL..312-421-3438
Perman, Craig/1645 Hennepin #311, Minneapolis, MN..........................612-338-7727
Perno, Jack/1956 W Grand, Chicago, IL...312-829-5292
Perry, Eric/2616 Industrial Row, Troy, MI...313-280-0640
Perspective Inc/2322 Pennsylvania St, Fort Wayne, IN.........................219-424-8136
Peterson, Jan/325 16th St, Bettendorf, IA..319-355-5032
Peterson, Richard Photo/7660 Washington Ave S, Hopkins, MN...........612-943-2404
Petroff, Tom/19 W Hubbard, Chicago, IL..312-836-0411
Petrovich, Steve/679-E Mandoline, Madison Hts, MI.............................313-589-0066
Phillips, David R/1230 W Washington Blvd, Chicago, IL.........................312-733-3277
Philpott, Keith/13736 W 82nd St, Lenexa, KS...913-492-0715
Photo Concepts/23042 Commerce Dr #2001, Farmington Hills, MI.......313-477-4301
Photo Enterprises/2134 North St, Peoria, IL...309-676-6676
Photo Group/1945 Techny Rd, Northbrook, IL...708-564-9220
Photo Ideas Inc/804 W Washington Blvd, Chicago, IL............................312-666-3100
Photo Images/1945 Techny #9, Northbrook, IL.......................................708-272-3500
Photo Reserve/2924 N Racine St, Chicago, IL..312-871-7371
Photocraft/220 N Walnut St, Muncie, IN..317-288-1454
Photographic Arts/624 W Adams, Chicago, IL...312-876-0818
Photographic Illustration/404 Enterprise Dr, Westerville, OH.................614-888-8682
Pictorial/8081 Zionsville Rd, Indianapolis, IN..317-872-7220
Pierce, Rod/917 N Fifth St, Minneapolis, MN..612-332-2670
Pieroni, Frank/2432 Oak Industrial Dr NE, Grand Rapids, MI................616-459-8325
Pintozzi, Peter/110 W Kinzie, Chicago, IL...312-828-9777
Pioneer Hi-Bred Intern't'l/5860 Merle Hay Rd/Box 127, Johnston, IA ...515-270-3732

Pitt, Tom/1201 W Webster, Chicago, IL312-281-5662
Pohlman Studios Inc/535 N 27th St, Milwaukee, WI414-342-6363
Pokempner, Marc/1453 W Addison, Chicago, IL312-525-4567
Polaski, James/216 W Ohio 3rd Fl, Chicago, IL312-944-6577
Poli, Frank/158 W Huron, Chicago, IL312-944-3924
Polin, Jack Photography/7306 Crawford, Lincolnwood, IL708-676-4312
Pomerantz, Ron/363 West Erie, Chicago, IL312-787-6407
Poon On Wong, Peter/420 5th St N #810, Minneapolis, MN612-340-0798
Pope, Kerig/414 N Orleans, Chicago, IL312-222-8999

Poplis, Paul/3599 Refugee Rd Bldg B, Columbus,
OH (P 216,217)**614-231-2942**
Portney, Michael/4975 Gateshead, Detroit, MI313-881-0378
Portnoy, Lewis/5 Carole Lane, St Louis, MO314-567-5700
Powell, Jim/326 W Kalamazoo, Kalamazoo, Mi616-381-2302
Powers, Pat/240 Mosley Ave, Lansing, MI517-484-5880
Price, Paul/2292 Cole St, Birmingham, MI313-642-8884
Primary Image/515 28th St #109, Des Moines, IA515-283-2102
Proctor, T Shaun/409 N Racine, Chicago, IL312-829-5511
Przekop, Harry Jr Commercial Photo/950 W Lake St, Chicago, IL312-829-8201
Puffer, David/213 W Institute, Chicago, IL312-266-7540
Puza, Greg/PO Box 1986, Milwaukee, WI414-444-9882
Pyrzynski, Larry/2241 S Michigan, Chicago, IL312-472-6550

QR

Quinn, James/518 S Euclid, Oak Park, IL708-383-0654
Quist, Bruce/1370 N Milwaukee, Chicago, IL312-252-3921
Rack, Ron/1201 Main St 1st Fl, Cincinnati, OH513-421-6267
Radencich, Michael/3016 Cherry, Kansas City, MO816-756-1992
Radlund & Associates/4704 Pflaum Rd, Madison, WI608-222-8177
Railsback, Kevin/Box 239, Shellsburg, IA319-436-2813
Randall, Bob/2540 W Huron, Chicago, IL312-235-4613
Randolph, Jon/1434 W Addison, Chicago, IL312-248-9406
Rawls, Ray612-895-9717
Reames-Hanusin Studio/3306 Commercial Ave, Northbrook, IL708-564-2706
Reed, Dick/1330 Coolidge, Troy, MI313-280-0090
Regina, Elvira/201 E Chestnut #16A, Chicago, IL312-943-7670
Reid, Ken/1651 W North Ave, Chicago, IL312-733-2121
Reiss, Ray/2144 N Leavitt, Chicago, IL312-384-3245
Remington, George/1455 W 29th St, Cleveland, OH216-241-1440
Renerts, Peter Studio/633 Huron Rd, Cleveland, OH216-781-2440
Renken, Roger/PO Box 11010, St Louis, MO314-394-5055
Reuben, Martin/1231 Superior Ave, Cleveland, OH216-781-8644
Ricco, Ron/117 W Walker St 4th Fl, Milwaukee, WI414-645-6450
Rice, Ted/2599 N 4th St, Columbus, OH614-263-8656
Richardson, Steve/2528 E Blue Water Hwy, Ionia, MI616-527-6374
Richland, Kathy/839 W Wrightwood, Chicago, IL312-935-9634
River, Milissa/2500 Lakeview, Chicago, IL312-929-5031
Robert, Francois/740 N Wells, Chicago, IL312-787-0777
Robinson, David/1147 W Ohio, Chicago, IL312-942-1650
Roessler, Ryan/2413 N Clyborn Ave, Chicago, IL312-951-8702
Rogowski, Tom/214 E 8th St, Cincinnati, OH513-621-3826
Rohman, Jim/2254 Marengo, Toledo, OH419-865-0234
Rollo, Jim/1800 Central #202, Kansas City, MO816-221-2710
Romine, Mark/227 Fairway Dr, Bloomington, IL309-662-4258
Rosmis, Bruce/833 North Orleans, Chicago, IL312-787-9046
Rossi Studio/4555 Emery Ind Pkwy #105, Cleveland, OH216-831-0688
Rothrock, Douglas/368 West Huron, Chicago, IL312-951-9045
Rottinger, Ed/5409 N Avers, Chicago, IL312-583-2917
Rovtar, Ron/49 Walhalla Rd, Columbus, OH614-261-6083
Rowley, Joe/401 N Racine, Chicago, IL312-829-2332
Rubin, Laurie/1111 W Armitage, Chicago, IL312-348-6644
Rush, Michael/415 Delaware, Kansas City, MO816-471-1200
Russetti, Andy/1260 Carnegie St, Cleveland, OH216-687-1788
Rustin, Barry/934 Glenwood Rd, Glenview, IL708-724-7600
Rutt, Don/324 Munson St, Traverse City, MI616-946-2727
Rutten, Bonnie/414 Sherburne Ave, St Paul, MN612-224-5777
Ryan, Gary/415 W Nine Mile Rd, Ferndale, MI313-398-0850

S

Sacco Photography Ltd/2035 W Grand Ave, Chicago, IL312-243-5757
Sacks, Andrew/20727 Scio Church Rd, Chelsea,
MI (P 227)**313-475-2310**
Sadin, Abby/1420 W Dickens Ave, Chicago, IL312-404-0133
Saks Photo/9257 Castlegate Dr, Indianapolis, IN317-849-7723
Sala, Don/3342 Cumberland Trail, Olympia Trail, IL708-747-6964
Salisbury, Mark/161 W Harrison 12th Fl, Chicago, IL312-922-7599

Salter, Tom/685 Pallister, Detroit, MI313-874-1155
Saltzman, Ben/700 N Washington, Minneapolis, MN612-332-5112
Sanders, Kathy/411 South Sangamon, Chicago, IL312-829-3100
Sanderson, Glenn/1002 Pine St, Green Bay, WI414-437-6200
Sandoz Studios/118 W Kinzie, Chicago, IL312-527-1800
Santow, Loren/2537 West Leland, Chicago, IL312-509-1121
Sapecki, Roman/56 E Oakland Ave, Columbus, OH614-262-7497
Sarnacki, Michael/912 Hilldale Dr, Royal Oak, MI313-541-2210
Sauer, Neil W/2844 Arsenal, St Louis, MO314-664-4646
Schabes, Charles/1220 W Grace St, Chicago, IL312-787-2629
Schanuel, Tony/10901 Oasis Dr, St Louis, MO314-849-3495
Schaugnessy, MacDonald/1221 Jarvis, Elk Grove Village, IL708-437-8850
Schewe, Jeff/624 West Willow, Chicago, IL312-951-6334
Schlismann, Paul/PO Box 412/508 Hermitage Dr, Deerfield, IL708-945-0768
Schmidt, Jerry/Rt 4/Box 882W, Warrensburg, MO816-429-2305
Schneck, Alan/132 W Stevenson Dr, Glendale Heights, IL708-665-2623
Schnepf, James/W277 N2730 Trillium Lane, Pewaukee, WI414-691-3980
Schoenbach, Glenn/329 Enterprise Ct, Bloomfield Hills, MI313-335-5100
Scholtes, Marc/726 Central Ave NE, Minneapolis, MN612-378-1888
Schramm, Ron/7061 N Ridge, Chicago, IL312-973-0246
Schrempp, Erich/723 W Randolph, Chicago, IL312-454-3237
Schridde, Charles Photography Inc/600 Ajax Dr,
Madison Hts, MI (P 234)**313-589-0111**
Schube-Soucek/1735 Carmen Dr, Elk Grove Village, IL708-439-0640
Schuemann, Bill/1591 S Belvoir Blvd, South Euclid, OH216-382-4409
Schuessler, Dave/40 E Delaware, Chicago, IL312-787-6868
Schulman, Bruce/1102 W Columbia, Chicago, IL312-917-6420
Schulman, Lee/669 College Ave/Box 09506, Columbus, OH614-235-5307
Schultz, Karl Assoc/740 W Washington, Chicago,
IL (P 220,221)**312-454-0303**
Schultz, Tim/935 W Chestnut, Chicago, IL312-733-7113
Schwartz, Linda/2033 N Orleans, Chicago, IL312-327-7755
Scott, Denis/216 W Ohio St, Chicago, IL312-467-5663
Secreto, Jim/2140 Austin, Troy, MI313-689-0480
Segal, Doug Panorama/230 N Michigan Ave, Chicago, IL312-236-8545
Segal, Mark/230 N Michigan Ave, Chicago,
IL (P 214,215)**312-236-8545**
Segielski, Tony/1886 Thunderbird, Troy, MI313-362-3111
Sereta, Greg/2440 Lakeside Ave, Cleveland,
OH (P 228)**216-861-7227**
Severson, Kent/529 S 7th St #637, Minneapolis, MN612-375-1870
Sexton, Ken/118 W Kinzie, Chicago, IL312-854-0180
Seymour, Ronald/314 W Superior, Chicago, IL312-642-4030
Shafer, Ronald/1735 N Paulina #305, Chicago, IL312-342-9209
Shaffer, Mac/526 E Dunedin Rd, Columbus, OH614-268-2249
Shambroom, Paul/1607 Dupont Ave N, Minneapolis, MN612-521-5835
Shanoor Photo/116 W Illinois, Chicago, IL312-266-0465
Shaw, George/1032 N Crooks Rd #L, Clawson, MI313-435-4665
Shay, Arthur/618 Indian Hill Rd, Deerfield, IL708-945-4636
Sheagren, Joel/529 S Seventh St #415, Minneapolis, MN612-371-9516
Shelli, Bob/PO Box 2062, St Louis, MO314-664-7793
Shepherd, Clark/461 E College St, Oberlin, OH216-775-4825
Sheppard, Richard/421 N Main St, Mt Prospect, IL708-259-3565
Shigeta-Wright Assoc/1546 N Orleans St, Chicago, IL312-642-8715
Shippert, Philip/1049 N Paulina, Chicago, IL312-235-1500
Shirmer, Bob/11 W Illinois St, Chicago, IL312-321-1151
Shotwell, Chuck/2111 N Clifton, Chicago, IL312-929-0168
Shoulders, Terry/676 N LaSalle, Chicago, IL312-642-6622
Siede/Preis Photo/1526 N Halsted, Chicago, IL312-787-2725
Sierecki, John/56 East Oak St, Chicago, IL312-664-7824
Sigman, Gary/2229 W Melrose St, Chicago, IL312-871-8756
Silker, Glenn/5249 W 73rd St #A, Edina, MN612-835-1811
Sills, Casey/411 N Lasalle, Chicago, IL312-670-3660
Simeon, Marshall/1043 W Randolph St, Chicago, IL312-243-9500
Simmons, Howard D/2033 W North Ave, Chicago, IL312-278-2033
Sindelar, Dan/2517 Grove Springs Ct, St Louis, MO314-846-4775
Singer, Beth/25741 River Dr, Franklin, MI313-626-4860
Sinkler, Paul/420 5th St N #516, Minneapolis, MN612-343-0325
Sinklier, Scott/5860 Merle Hay Rd/Box 127, Johnston, IA515-270-3732
Skalak, Carl/47-46 Grayton Rd, Cleveland, OH216-676-6508
Skrebneski, Victor/1350 N LaSalle St, Chicago, IL312-944-1059
Sky View Aerial Photo/220 S Robert St #201, St Paul, MN612-290-9766
Sladcik, William/215 W Illinois, Chicago, IL312-644-7108
Smetzer, Donald/2534 N Burling St, Chicago, IL312-327-1716
Smith, Bill/600 N McClurgh Ct #802, Chicago, IL312-787-4686
Smith, Crain/POB 30043, Cleveland, OH216-661-0636
Smith, Doug Photo/2911 Sutton, St Louis, MO314-645-1359
Smith, Richard/PO Box 455, Round Lake, IL708-546-0977

Smith, Richard Hamilton/PO Box 14208, St Paul, MN612-645-5070
Smith, Robert/496 W Wrightwood Ave, Elmhurst, IL708-941-7755
Snook, Jim/1433-G W Fullerton, Addison, IL708-495-3939
Snow, Andy/322 S Patterson Blvd, Dayton, OH513-461-2930
Snyder, Don/3700 Superior Ave, Cleveland, OH.........................216-881-5955
Snyder, John/811 W Evergreen, Chicago, IL.........................312-440-1053
Soluri, Tony/1147 W Ohio, Chicago, IL312-243-6580
Sorokowski, Rick/1015 N Halsted, Chicago, IL.........................312-280-1256
Spahr, Dick/1133 E 61st St, Indianapolis, IN.........................317-255-2400
Spectra Studios/213 W Institute #512, Chicago, IL.........................312-787-0667
Spencer, Gary/3546 Dakota Ave S, Minneapolis, MN.........................612-929-7803
Spingola, Laurel/1233 W Eddy, Chicago, IL.........................312-883-0020
Spitz, Robert/1804 Mulford St, Evanston, IL.........................708-869-4992
Stage Three Productions/32588 Dequindre, Warren, MI313-978-7373
Stansfield, Stan/215 W Ohio, Chicago, IL.........................312-337-3245
Starkey, John/551 W 72nd St, Indianapolis, IN.........................317-254-0700
Starmark Photo/706 N Dearborn, Chicago, IL.........................312-944-6700
Stealey, Jonathan/PO Box 611, Findlay, OH.........................419-423-1149
Steele, Charles/1130 S Wabash Ave #200, Chicago, IL.........................312-922-0201
Stegbauer, Jim/421 Transit, Roseville, MN612-333-1982
Stein, Frederic/955 West Lake St, Chicago, IL.........................312-226-7447
Steinberg, Mike/633 Huron Rd, Cleveland, OH216-589-9953
Stenberg, Pete Photography/225 W Hubbard, Chicago, IL.........................312-644-6137
Stenbroten, Scott/107 W Van Buren #211, Chicago, IL.........................312-929-4677
Stevens, Norm/108 Third St, Des Moines, IA515-244-5500
Stewart, Ron/314 E Downer Pl, Aurora, IL708-897-4317
Stone, Tony Worldwide/233 East Ontario #1100,
Chicago, IL (P 350,351)**312-787-7880**
Stornello, Joe/4319 Campbell St, Kansas City, MO816-756-0419
Straus, Jerry/247 E Ontario, Chicago, IL.........................312-337-5939
Strauss, Sara/134 Upland Ave, Youngstown, OH216-794-5881
Stroud, Dan/1414 Illinois St, Midland, MI517-636-9483
Strouss, Sara/524 Warner Rd, Hubbard, OH.........................216-568-0203
Struse, Perry L Jr/232 Sixth St, West Des Moines, IA.........................515-279-9761
Sundlof, John/1324 Isabella St, Wilmette, IL708-256-8877
Sutter, Greg/3030-C Laura Lane, Middleton, WI608-831-5523
Swanson, Michael/215 W Ohio, Chicago, IL312-337-3245
Sykaluk, John/2500 North Main St, Rockford, IL815-968-3819

T

Taber, Gary/305 S Green St, Chicago, IL312-726-0374
Talbot, Mark/1725 North Ave, Chicago, IL.........................312-276-1777
Taxel, Barney/4614 Prospect Ave, Cleveland, OH.........................216-431-2400
Taylor, Dale E/2665-A Scott Ave, St Louis, MO.........................314-652-9665
Technigraph Studio/1212 Jarvis, Elk Grove Village, IL.........................708-437-3334
Tepporton, Earl/8701 Harriet Ave S, Minneapolis, MN612-887-7852
Teri Studios/700 W Pete Rose Way, Cincinnati, OH.........................513-784-9696
Teufen, Al/620 E Smith Rd, Medina, OH.........................216-723-3237
The Picture Place/3721 Grandel Sq, St Louis, MO.........................314-652-6262
The Studio, Inc/4239 N Lincoln, Chicago, IL.........................312-348-3556
Thill, Nancy/537 South Dearborn, Chicago, IL.........................312-939-7770
Thoen, Greg/14940 Minnetonka Indust Rd, Minnetonka, MN.........................612-938-2433
Thomas, Bill/Rt 4 Box 387, Nashville, IN.........................812-988-7865
Thomas, Tony/676 N Lasalle St 6th Fl, Chicago, IL.........................312-337-2274
Thornberg, Russell/PO Box 101, Akron, OH.........................216-928-8621
Tillis, Harvey S/1050 W Kinzie, Chicago, IL.........................312-733-7336
Tirotta, John/PO Box 4654, South Bend, IN.........................219-234-4244
Tolbert, R V/21015 Clare Ave, Maple Hts, OH.........................216-663-9214
Tolchin, Robert/1057 Kenton Rd, Deerfield, IL.........................708-945-9477
TPS Studio/4016 S California, Chicago, IL.........................312-847-1221
Tracy, Janis/213 W Institute Pl, Chicago, IL.........................312-787-7166
Trantafil, Gary/407 N Elizabeth St, Chicago, IL.........................312-666-1029
Traversie, Jim/23 N Walnut St, Dayton, OH.........................513-859-7799
Trotter, Jim/12342 Conway Rd, St Louis, MO.........................314-878-0777
Tucker, Bill/19 N May, Chicago, IL.........................312-243-7113
Tucker/Thompson Photo/613 Second Ave SE, Cedar Rapids, IA.........................319-366-7791
Tushas, Leo/111 N Fifth Ave #309, Minneapolis, MN.........................612-333-5774
Tweton, Roch/524 Hill Ave, Grafton, ND.........................701-352-1513
Tytel, Jeff/500 S Clinton 8th fl, Chicago, IL.........................312-939-5400

UV

Uhlmann, Gina/1872 N Clybourne, Chicago, IL.........................312-871-1025
Umland, Steve/600 Washington Ave N, Minneapolis, MN.........................612-332-1590
Upitis, Alvis/620 Morgan Ave S, Minneapolis, MN.........................612-374-9375
Uttermohlen, Mary Lou/860 Dennison Ave, Columbus, OH.........................614-297-7639
Van Antwerp, Jack/1220 W Sixth St #704, Cleveland, OH.........................216-621-0515

Van Inwegen, Bruce/1422 W Belle Plaine, Chicago, IL.........................312-477-8344
Vandenberg, Greg/161 W Harrison 12th Fl, Chicago, IL.........................312-939-2969
Vander Lende, Craig/129 S Division St, Grand Rapids, MI.........................616-235-3233
Vander Veen, David/5151 N 35th St, Milwaukee, WI.........................414-527-0450
VanKirk, Deborah/855 W Blackhawk St, Chicago, IL.........................312-642-3208
VanMarter, Robert/1209 Alstott Dr S, Howell, MI.........................517-546-1923
Variakojis, Danguole/5743 S Campbell, Chicago, IL.........................312-776-4668
Vaughan, Jim/321 S Jefferson, Chicago, IL.........................312-663-0369
Vedros, Nick/215 W 19th St, Kansas City, MO.........................816-471-5488
Ventola, Giorgio/368 W Huron, Chicago, IL.........................312-951-0880
Vergos Studio/122 W Kinzie 3rd Fl, Chicago, IL.........................312-733-0797
Villa, Armando/1872 N Clybourne, Chicago, IL.........................312-472-7002
Visser, James Photography/4274 Shenandoah Ave, St Louis, MO.........................314-771-6857
Visual Data Systems Inc/5617 63rd Pl, Chicago, IL.........................312-585-3060
Vizanko Advertising Photo/11511 K-Tel Drive, Minnetonka, MN.........................612-933-1314
Vollan, Michael/800 W Huron, Chicago, IL.........................312-997-2347
Von Dorn, John/2301 W Nordale Dr, Appleton, WI.........................414-739-4224
Voyles, Dick & Assoc/2822 Breckenridge Ind Ctr, St Louis, MO.........................314-968-3851
Vuksanovich/318 N Laflin St, Chicago, IL.........................312-664-7523
Vyskocil, Debbie/PO Box 395, Summit, IL.........................708-496-8057

W

Wagenaar, David/1504 N Freemont, Chicago, IL.........................312-944-6330
Waite, Tim/717 S Sixth St, Milwaukee, WI.........................414-643-1500
Wakefield, John/5122 Grand Ave, Kansas City, MO.........................816-531-8448
Walker, Jessie Assoc/241 Fairview, Glencoe, IL.........................708-835-0522
Wallace, David/1100 S Lynndale Dr, Appleton, WI
(P 222,223)**414-738-4080**
Wans, Glen/325 W 40th, Kansas City, MO.........................816-931-8905
Ward, Les/21477 Bridge St #C & D, Southfield, MI.........................313-350-8666
Warkenthien, Dan/117 South Morgan, Chicago, IL.........................312-666-6056
Warren, Lennie/800 West Huron, Chicago, IL.........................312-666-0490
Watts, Dan/245 Plymouth, Grand Rapids, MI.........................616-451-4693
Weber, J Andrew/303 S Donald Ave, Arlington Hts, IL.........................708-255-2738
Weddle, Ben/218 Delaware St #108, Kansas City, MO.........................816-421-2902
Wedlake, James/750 Jossman Rd, Ortonville, MI.........................313-627-2711
Weidemann, Skot/6621-B Century Ave, Middleton, WI.........................608-836-5744
Weiland, Jim/1100 S Lynndale Dr, Appleton, WI.........................414-739-7824
Weiner, Jim/2401 W Ohio, Chicago, IL.........................312-829-0027
Weinstein, John/2413 N Clybourn Ave, Chicago, IL.........................312-509-1003
Weinstein, Phillip/343 S Dearborn, Chicago, IL.........................312-922-1945
Weispfenning, Donna/2425 Franklin E #401, Minneapolis, MN.........................612-333-1453
Welzenbach, John/2011 W Fullerton Ave, Chicago, IL.........................312-772-2011
Wengroff, Sam/3325-D North Racine, Chicago, IL.........................312-248-6623
West, Mike/300 Howard Ave, Des Plaines, IL.........................708-699-7886
West, Stu/212 Third Ave N #320, Minneapolis, MN.........................612-375-0404
Westerman, Charlie/401 E Ontario #2909, Chicago, IL.........................312-664-5837
White, Bob/201 Ward St, Energy, IL.........................618-942-4531
Whitford, T R/1900 Delmar #2, St Louis, MO.........................314-621-2400
Whitmer, Jim/125 Wakeman, Wheaton, IL.........................708-653-1344
Wicks, L Photography/1235 W Winnemac Ave, Chicago, IL.........................312-878-4925
Wiegand, Eric/2339 Ferndale, Sylvan Lake, MI.........................313-682-8746
Wilker, Clarence/2021 Washington Ave, Lorain, OH.........................216-244-5497
Wilkes, Mike/2530 Superior, Cleveland, OH.........................216-781-0605
Willette, Brady T/1030 Nicollett Mall #203, Minneapolis, MN.........................612-338-6727
Williams, Alfred G/Box 10288, Chicago, IL.........................312-947-0991
Williams, Basil/4068 Tanglefoot Terrace, Bettendorf, IA.........................319-355-7142
Williams, Bob/32049 Milton Ave, Madison Heights, MI.........................313-588-6544
Williams, James Photo/119 N 4th St #503, Minneapolis, MN.........................612-332-3095
Wilson, Jack/212 Morgan St, St Louis, MO.........................314-241-1149
Witte, Scott J/219 N Milwaukee St, Milwaukee, WI.........................414-233-4430
Woburn & Ken Carr/4715 N Ronald St, Harwood Heights, IL.........................708-867-5445
Woehrle, Mark/3150 North Lindberg, St Louis, MO.........................314-298-1727
Wojnowski, Tom/5765 Burger St, Dearborn Hts, MI.........................313-561-0043
Wolf, Bobbe/1101 W Armitage, Chicago, IL.........................312-472-9503
Wolff, Ed/11357 S Second St, Schoolcraft, MI.........................616-679-4702
Wolford, Rick/2300 E Douglas, Wichita, KS.........................316-264-3013
Wood, Merrell/3101 Shadow Hill Rd, Middletown, OH.........................513-420-9394
Wooden, John/219 N 2nd St J#306, Minneapolis, MN.........................612-339-3032
Woods, Michael/4387 Laclede, St Louis, MO.........................314-894-7536
Woodward, Greg/811 W Evergreen #204, Chicago, IL.........................312-337-5838
Worzala, Lyle/8164 W Forest Preserve #1, Chicago, IL.........................312-589-0010

YZ

Yamashiro, Paul Studio/1500 N Halstead, Chicago, IL.........................312-321-1009
Yapp, Charles/723 Randolph, Chicago, IL.........................312-558-9338

Yarrington, Todd/897 Ingleside Ave, Columbus, GA..............................614-297-0498
Yates, Peter/1208 Bydding Rd, Ann Arbor, MI.......................................313-995-0839
Yaworski, Don/600 White Oak Ln, Kansas City, MO...............................816-455-4814
Yazback Photo/PO Box 5146, Mishanaka, IN...219-256-1546
Yeager, Alton E/648 W 35th St, Chicago, IL..312-523-5788
Zaitz, Dan/1950 West Thomas, Chicago, IL...312-276-3569
Zake, Bruce/633 Huron Rd 3rd Fl, Cleveland, OH..................................216-694-3686
Zamiar, Thomas/210 W Chicago, Chicago, IL...312-787-4976
Zann, Arnold/502 N Grove Ave, Oak Park, IL...708-386-2864
Zarlengo, Joseph/419 Melrose Ave, Boardman, OH...............................216-782-7797
Zena Photography/633 Huron Rd SE 5th Fl, Cleveland, OH......................216-621-6366
Zimion/Marshall Studio/1043 W Randolph, Chicago, IL...........................312-243-9500
Zorn, Jim/1880 Holste Rd, Northbrook, IL..708-498-4844
Zukas, R/311 N Desplaines #500, Chicago, IL..312-648-0100

S O U T H W E S T

A

Abraham, Joe/11944 Hempstead Rd #C, Houston, TX.............................713-460-4948
Abrial, Larry/1240 N Cowan #256, Louisville, TX...................................214-219-6921
Aker/Burnette Studio/4710 Lillian, Houston, TX......................................713-862-6343
Alexander, Laury/516 111th St NW #3, Albuquerque, NM........................505-843-9165
Alford, Jess/1800 Lear St #3, Dallas, TX..214-421-3107
Allen, Jim Photo/5600 Lovers Ln #212, Dallas, TX.................................214-351-3200
Allred, Mark/904-B W 12th St, Austin, TX...512-472-2972
Anderson, Derek Studio/3959 Speedway Blvd E, Tucson, AZ...................602-881-1205
Anderson, Randy/3401 Main St, Dallas, TX (P 255).......214-939-1740
Angle, Lee/1900 Montgomery, Fort Worth, TX..817-737-6469
Ashe, Gil/Box 686, Bellaire, TX...713-668-8766
Ashley, Constance/2024 Farrington St, Dallas, TX.................................214-747-2501
Associated Photo/2344 Irving Blvd, Dallas, TX......................................214-630-8730
Austin, David/2412 Fifth Ave, Fort Worth, TX..817-335-1881

B

Badger, Bobby/1355 Chemical, Dallas, TX..214-634-0222
Bagshaw, Cradoc/PO Box 9511, Santa Fe, NM......................................505-473-2811
Baker, Bobbe C/1119 Ashburn, College Station, TX...............................409-696-7185
Baker, Jeff/6161 Premier Dr, Irving, TX..214-550-7992
Baker, Nash/2208 Colquitt, Houston, TX...713-529-5698
Baldwin/Watriss Assoc/1405 Branard St, Houston, TX............................713-524-9199
Baraban, Joe/2426 Bartlett #2, Houston, TX..713-526-0317
Bardin, Keith Jr/PO Box 191241, Dallas, TX..214-686-0611
Barker, Kent/2919 Canton St, Dallas, TX..214-760-7470
Baxter, Scott/PO Box 25041, Phoenix, AZ...602-254-5879
Beebe, Kevin/2460 Eliot St, Denver, CO..303-455-3627
Beebower Brothers/9995 Monroe #209, Dallas, TX................................214-358-1219
Bennett, Sue/PO Box 1574, Flagstaff, AZ..602-774-2544
Bennett, Tony R/PO Box 568366, Dallas, TX..214-747-0107
Benoist, John/PO Box 20825, Dallas, TX...214-692-8813
Berman, Bruce/140 N Stevens #301, El Paso, TX...................................915-544-0352
Berrett, Patrick L/2521 Madison NE, Albuquerque, NM...........................505-881-0935
Berry, George S Photography/Rt 2 Box 325B, San Marcos, TX.................512-396-4805
Bissell, Gary/120 Paragon #217, El Paso, TX...915-833-1942
Bland, Ron/2424 S Carver Pkwy #107, Grand Prairie, TX.........................214-660-6600
Blue, Janice/1708 Rosewood, Houston, TX...713-522-6899
Bock, Ken/PO Box 568108, Dallas, TX..214-692-7355
Bondy, Roger/309 NW 23rd St, Oklahoma City, OK................................405-521-1616
Booth, Greg/1322 Round Table, Dallas, TX...214-688-1855
Bowman, Matt/8602 Santa Clara, Dallas, TX...214-637-0211
Bradley, Matt/15 Butterfield Ln, Little Rock, AR....................................501-224-0692
Bradshaw, Reagan/4101 Guadalupe, Austin, TX.....................................512-458-6101
Brady, Steve/5250 Gulfton #2G, Houston, TX..713-660-6663
Britt, Ben/2401 S Ervay #205, Dallas, TX...214-428-2822
Brousseau, Jay/2608 Irving Blvd, Dallas, TX...214-638-1248
Brown, David Photo/280 Edgewood Ct, Prescott, AZ..............................602-445-2485
Buffington, David/2401 S Ervay #105, Dallas, TX..................................214-428-8221
Bumpass, R O/1222 N Winnetka, Dallas, TX..214-742-3414

C

Cabluck, Jerry/Box 9601, Fort Worth, TX..817-336-1431
Caldwell, Jim/101 W Drew, Houston, TX (P 256,257)...713-527-9121
Campbell, Doug/5617 Matalee, Dallas, TX...214-823-9151
Cannedy, Carl/3333 Elm St, Dallas, TX...214-748-1048

Capps, Robbie/5729 Goliad, Dallas, TX...214-827-9339
Captured Image Photography/5131 E Lancaster, Fort Worth, TX...............817-457-2302
Cardellino, Robert/315 Ninth St #2, San Antonio, TX.............................512-224-9606
Carey, Robert "Lobster"/2318 E Roosevelt, Phoenix, AZ..........................602-267-8845
Carr, Fred/2331-D Wirtcrest, Houston, TX...713-680-2465
Chehabi, Saad/5028 Airline, Dallas, TX...214-526-4989
Chenn, Steve/6301 Ashcroft, Houston, TX...713-271-0631
Chisholm, Rich & Assoc/6813 Northampton Way, Houston, TX.................713-957-1250
Clair, Andre/11415 Chatten Way, Houston, TX.......................................713-465-5507
Clark, H Dean/18405 FM 149, Houston, TX..713-469-7021
Clifford, Geoffrey C/4719 Brisa Del Norte, Tucson, AZ...........................602-577-6439
Clintsman, Dick/3001 Quebec #102, Dallas, TX......................................214-630-1531
Cohen, Stewart Charles/2401 S Ervay #206, Dallas, TX...........................214-421-2186
Cole, Ralph Inc/PO Box 2803, Tulsa, OK...918-585-9119
Cooke, Richard & Mary/209 E Ben White Blvd #110, Austin, TX...............512-444-6100
Cotter, Austin/1350 Manufacturing #211, Dallas, TX..............................214-742-3633
Cowlin, James/PO Box 34205, Phoenix, AZ..602-264-9689
Craig, George/314 E 13th St, Houston, TX..713-862-6008
Crittendon, James/5914 Lake Crest, Garland, TX....................................214-226-2196
Crossley, Dave/1412 W Alabama, Houston, TX.......................................713-523-5757
Cruff, Kevin/2328 E Van Buren #103, Phoenix,
AZ (P 253)..602-225-0273
Crump, Bill/1357 Chemical, Dallas, TX...214-630-7745
Cutter, Stephen/1535 E Dolphin Ave, Mesa, AZ.....................................602-962-4359

D

Datoli, Michael/Star Rte/Box 44, Galisteo, NM.......................................505-983-1204
Davey, Robert/PO Box 2421, Prescott, AZ..602-445-1160
Davidson, Josiah/PO Box 607, Cloudcroft, NM..800-537-7810
Davis, Mark/8718 Boundbrook Ave, Dallas, TX.......................................214-348-7679
Dawson, Greg/2211 Beall St, Houston, TX...713-862-8301
Debenport, Robb/2412 Converse, Dallas, TX...214-631-7606
Debold, Bill...512-837-6294
Desrocher, Jack/Rt 3/Box 611, Eureka Springs, AR.................................501-253-6615
Dolin, Penny Ann/Scottsdale, AZ...602-228-3015
Drews, Buzzy/1555 W Mockingbird #202, Dallas, TX..............................214-351-9968
Driscoll, W M/PO Box 8463, Dallas, TX...214-363-8429
DuBose, Bill/6646 E Lovers Lane #603, Dallas, TX.................................214-781-6147
Duering, Doug/2610 Catherine, Dallas, TX..214-946-6597
Duncan, Nena/306 Shady Wood, Houston, TX..713-782-3130
Duran, Mark/66 East Vernon, Phoenix, AZ...602-279-1141
Durham, Thomas/PO Box 4665, Wichita Falls, TX...................................817-691-4414
Dyer, John/107 Blue Star, San Antonio, TX..512-223-1891
Dykinga, Jack/3808 Calle Barcelona, Tucson, AZ....................................602-326-6094

EF

Easley, Ken/2810 S 24th St #109, Phoenix, AZ......................................602-244-9727
Edens, Swain/1905 N St Marys St, San Antonio, TX................................512-226-2210
EDS Photography Services/Mail Code CY-01-68, Plano, TX.......................214-612-5791
Edwards, Bill/3820 Brown, Dallas, TX...214-521-8630
Enger, Linda/915 S 52nd St #5, Tempe, AZ...602-966-5776
Ewasko, Tommy/5645 Hillcroft #202, Houston, TX.................................713-784-1777
Fantich, Barry/PO Box 70103, Houston, TX..713-520-5434
Farris, Neal/500 Expostion #104, Dallas, TX...214-821-5612
Faye, Gary/2421 Bartlett, Houston, TX...713-529-9548
Findysz, Mary/3550 E Grant, Tucson, AZ...602-325-0260
Fontenot, Dallas/6002 Burning Tree Dr, Houston, TX..............................713-988-2183
Ford, Bill/3501 N MacArthur Blvd #421, Irving, TX.................................214-255-5312
Foxall, Steve Photography Inc/6132 Belmont Ave, Dallas, TX..................214-824-1977
Frady, Connie/2808 Fifth Ave, Fort Worth, TX.......................................817-927-7589
Francis, Pam/2700 Albany #303, Houston, TX..713-528-1672
Freeman, Charlie/3333-A Elm St, Dallas, TX..214-742-1446
Fry, John/5909 Goliad, Dallas, TX..214-821-1689
Fuller, Timothy Woodbridge/135 1/2 S Sixth Ave, Tucson, AZ.................602-622-3900

G

Galloway, Jim/2335 Valdina St, Dallas, TX..214-954-0355
Garacci, Benedetto/7315 Ashcroft #102, Houston, TX.............................713-771-3209
Gary & Clark Photographic Studio/2702 Main, Dallas, TX.........................214-939-9070
Gatz, Larry/5250 Gulfton #3B, Houston, TX...713-666-5203
Gayle, Rick/2318 E Roosevelt, Phoenix, AZ..602-267-8845
Geffs, Dale/15715 Amapola, Houston, TX..713-777-2228
Gerczynski, Tom/2211 N 7th Ave, Phoenix, AZ (P 248)...602-252-9229
Germany, Robert/2739 Irving Blvd, Dallas, TX.......................................214-747-4548
Gilmore, Dwight/2437 Hillview, Fort Worth, TX......................................817-536-4825

Gilstrap, L C/132 Booth Calloway, Hurst, TX817-284-7701
Giordano, Michael/PO Box 15497, San Antonio, TX512-734-5552
Glentzer, Don Photography/3814 S Shepherd Dr, Houston, TX..........713-529-9686
Golfoto Inc/522-B South Jefferson, Enid, OK (P 357)405-234-8284
Gomel, Bob/10831 Valley Hills, Houston, TX............................713-988-6390
Goodman, Robert/2025 Levee, Dallas, TX................................214-653-1120
Grass, Jon/3141 Irving #209, Dallas, TX................................214-634-1455
Green, Mark/2406 Taft St, Houston, TX (P 236-243) 713-523-6146
Greenberg, Chip/2521 Madison NE, Albuquerque, NM505-884-1012
Greshon, David/2314 Converse, Houston, TX............................713-723-3283
Grider, James/732 Schilder, Fort Worth, TX............................817-732-7472
Guerrero, Charles/8301 Shoal Creek Blvd, Austin, TX..................512-467-2797

H

Hale, Butch Photography/1319 Conant, Dallas, TX214-637-3987
Ham, Dan/PO Box 5149, Taos, NM.......................................505-758-1463
Hamblin, Steve/4718 Iberia, Dallas, TX................................214-630-2848
Hamburger, Jay/1817 State St, Houston, TX............................713-869-0869
Hamilton, Jeffrey Muir/6719 Quartzite Canyon Pl, Tucson, AZ602-299-3624
Hand, Ray/10921 Shady Trail #100, Dallas, TX.........................214-351-2488
Handel, Doug/3016 Selma, Dallas, TX214-446-2236
Hansen, Brad/PO Box 17347, Tucson, AZ................................602-886-6814
Hansen, Bradley/6061 Village Bend Dr#240, Dallas, TX214-265-7223
Harness, Brian/1402 S Montreal Ave, Dallas, TX214-330-4419
Hart, Michael/7320 Ashcroft #105, Houston, TX........................713-271-8250
Hartman, Gary/911 South St Marys St, San Antonio, TX512-225-2404
Hatcok, Tom/113 W 12th St, Deer Park, TX.............................713-479-2603
Hawks, Bob/1345 E 15th St, Tulsa, OK.................................918-584-3351
Hawn, Gray Photography/PO Box 16425, Austin, TX....................512-328-1321
Haynes, Mike/10343 Best Dr, Dallas, TX...............................214-352-1314
Hedrich, David/4006 South 23rd St #10, Phoenix,
AZ (P 246) 602-220-0090
Heiner, Gary/2039 Farrington, Dallas, TX..............................214-760-7471
Heinsohn, Bill/5455 Dashwood #200, Bellaire, TX.......................713-666-6515
Heit, Don/8502 Eustis Ave, Dallas, TX.................................214-324-0305
Henry, Steve/7403 Pierrepont Dr, Houston, TX.........................713-937-4514
Hixson, George/PO Box 131322, Houston, TX...........................713-225-1421
Hoke, Doug/805 NW 49th St, Oklahoma City, OK.......................405-840-1256
Hollenbeck, Phil/2833 Duval Dr, Dallas, TX............................214-331-8328
Holley, Tom/2709-E Pam Am NE , Albuquerque, NM505-345-1660
Horst, Taylor/2521 Madison NE, Albuquerque, NM......................505-881-7901
Huber, Phil/13562 Braemar Dr, Dallas, TX..............................214-243-4011

JK

Jenkins, Gary/2320 Indian Creek, Irving, TX............................214-952-8868
Jennings, Steve/PO Box 52813, Tulsa, OK..............................918-745-0836
Jew, Kim/1518 Girard NE, Albuquerque, NM.............................505-255-6424
Johnson, Ed/PO Box 823066, Dallas, TX................................214-336-2196
Johnson, Michael/830 Exposition #215, Dallas, TX.....................214-828-9550
Johnson, Norman/2015 7th St NW #A-2, Albuquerque, NM..............505-842-9411
Jolly, Randy/801 E Campbell Rd #110, Richardson, TX..................214-644-8542
Jones, Aaron/PO Box 5799, Santa Fe, NM..............................505-988-5730
Jones, C Bryan/2900 N Loop W #1130, Houston, TX.....................713-956-4166
Jones, Jerry/5250 Gulfton #4A, Houston, TX............................713-668-4328
Jones, Will/4602 E Elwood St #13, Phoenix, AZ.........................602-968-7664
Kaluzny, Zigy/4700 Strass Dr, Austin, TX...............................512-452-4463
Katz, John/5222 Red Field, Dallas, TX..................................214-637-0844
Kellis, Shawn/3433 W earll Dr, Phoenox, AZ............................602-272-7777
Kendrick, Robb/2700 Albany #303, Houston, TX........................713-528-4334
Kennedy, David Michael/PO Box 254, Cerrillos, NM.....................505-473-2745
Kenny, Gill/6541 N Camina Catrina, Tucson, AZ.........................602-577-1232
Kern, Geof/1337 Crampton, Dallas, TX..................................214-630-0856
King, Jackie/450 E French Pl, San Antonio, TX..........................512-732-1934
King, Jennifer/4031 Green Bush Rd, Katy, TX............................713-392-8784
Kirkland, Bill/PO Box 801001, Dallas, TX...............................214-741-7673
Kirkley, Kent/4906 Don St, Dallas, TX..................................214-688-1841
Klumpp, Don/804 Colquitt, Houston, TX................................713-521-2090
Kneten, Rocky/2425 Bartlett, Houston, TX..............................713-528-5235
Knowles, Jim/6102 E Mockingbird Ln #499, Dallas, TX...................214-699-5335
Knudson, Kent/1033 W Maryland, Phoenix, AZ
(P 251) 602-246-0400
Korab, Jeanette/9000 Directors Row, Dallas, TX.........................214-337-0114
Kretchmar, Phil Photography/233 Yorktown, Dallas, TX...................214-744-2039
Kroninger, Rick/PO Box 15913, San Antonio, TX512-733-9931
Kuntz, Bryan Photography/7700 Brenwick #5A, Houston, TX713-667-4200
Kuper, Holly/5522 Anita St, Dallas, TX.................................214-827-4494

LM

Lacker, Pete/235 Yorktown St, Dallas, TX
(P 258,259) 214-748-7488
Larsen, Peter/2410 Farrington, Dallas, TX..............................214-630-3500
Latorre, Robert/2336 Farrington St, Dallas, TX..........................214-630-8977
Laybourn, Richard/4657 Westgrove, Dallas, TX..........................214-931-9984
Leigh, Kevin/1345 Conant, Dallas, TX...................................214-631-6777
Lettner, Hans/830 North 4th Ave, Phoenix, AZ...........................602-258-3506
Lewis, Barry/2401 S Ervay #306, Dallas, TX.............................214-421-5665
Loper, Richard/1000 Jackson Blvd, Houston, TX.........................713-529-9221
Lorfing, Greg/1900 W Alabama, Houston, TX.............................713-529-5968
Loven, Paul/1405 E Marshall, Phoenix, AZ
(P 124,125) 602-253-0335
Luker, Tom/PO Box 6112, Coweta, OK...................................918-486-5264
Mader, Bob/2570 Promenade Center N, Richardson, TX..................214-690-5511
Mageors & Rice Photo/240 Turnpike Ave, Dallas, TX.....................214-941-3777
Manley, Dan/1350 Manufacturing #213, Dallas, TX.......................214-748-8377
Mann, Chris/2001 S Ervay #100, Dallas, TX.............................214-426-1810
Manning, John/1240 Hanna Creek, DeSoto, TX...........................214-224-6787
Manske, Thaine/7313 Ashcroft #216, Houston, TX........................713-771-2220
Maples, Carl/1811 Cohn, Houston, TX...................................713-868-1289
Markham, Jim/2739 S E Loop 410, San Antonio, TX......................512-648-0403
Markow, Paul Southwest/2222 E McDowell Rd,
Phoenix, AZ (P 244,245) 602-273-7985
Marks, Stephen/4704-C Prospect NE, Albuquerque, NM...................505-884-6100
Marshall, Jim/382 N First Ave, Phoenix, AZ (P 261)....602-258-4213
Matthews, Michael/2727 Cancun, Dallas, TX.............................214-306-8000
Maxham, Robert/223 Howard St, San Antonio, TX........................512-223-6000
Mayer, George H/1356 Chemical, Dallas, TX.............................214-424-4409
McClain, Edward/756 N Palo Verde, Tucson, AZ..........................602-326-1873
McCormick, Mike/5950 Westward Ave, Houston, TX......................713-988-0775
McCoy, Gary/2700 Commerce St, Dallas, TX.............................214-320-0002
McKenzie, David/4707 Red Bluff, Austin, TX.............................512-453-1965
McNee, Jim/PO Box 741008, Houston, TX...............................713-796-2633
Means, Lisa/5915 Anita, Dallas, TX....................................214-826-4979
Meckler, Steven/121 S 4th Ave, Tucson, AZ (P 249)602-792-2467
Meredith, Diane/6203 Westcott, Houston, TX............................713-862-8775
Messina, John/4440 Lawnview, Dallas, TX...............................214-388-8525
Meyerson, Arthur/4215 Bellaire Blvd, Houston, TX.......................713-660-0405
Meyler, Dennis/1903 Portsmouth #25, Houston, TX......................713-520-1800
Mills, Jack R/PO Box 32583, Oklahoma City, OK.........................405-787-7271
Moberley, Connie/215 Asbury, Houston, TX.............................713-864-3638
Molen, Roy/3302 N 47 Pl, Phoenix, AZ..................................602-840-5439
Monteaux, Michele/5 Vista Grande Dr, Santa Fe, NM.....................505-982-5598
Moore, Terrence/PO Box 41536, Tucson, AZ.............................602-623-9381
Moot, Kelly/2331-D Wirtcrest Ln, Houston, TX............................713-683-6400
Morgan, Paul/3408 Main St, Dallas, TX..................................214-741-3908
Morris, Garry/9281 E 27th St, Tucson, AZ...............................602-795-2334
Morris, Mike/4003 Gilbert #6, Dallas, TX................................214-528-3600
Morrison, Chet Photography/2917 Canton, Dallas, TX....................214-939-0903
Morrow, James R/PO Box 2718, Grapevine, TX..........................214-402-9960
Muir, Robert/Box 42809 Dept 404, Houston, TX..........................713-784-7420
Murdoch, Lane/1350 Manufacturing #205, Dallas, TX.....................214-651-0200
Murphy, Dennis/101 Howell St, Dallas, TX..............................214-651-7516
Myers, Jeff/5250 Gulfton #4 Suite A, Houston, TX........................713-661-9532
Myers, Jim/165 Cole St, Dallas, TX.....................................214-698-0500

NOP

Neely, David/412 Briarcliff Lane, Bedford, TX817-498-6741
Netzer, Don/1350 Manufacturing St #215, Dallas, TX214-869-0826
Neubauer, Larry/11716 Terry Dr, Balch Springs, TX......................214-284-2480
Newby, Steve/4501 Swiss, Dallas, TX...................................214-821-0231
Noble, Jeff/688 West 1st St #5, Tempe, AZ (P 250)....602-968-1434
Norrell, J B/7315 Ashcroft #110, Houston, TX...........................713-981-6409
Norton, Michael/3427 E Highland Ave, Phoenix, AZ......................602-840-9463
Nufer, David/405 Montano NE #1, Albuquerque, NM......................505-345-9500
O'Dell, Dale/2040 Bissonnet, Houston, TX713-521-2611
Olvera, James /235 Yorktown St, Dallas,
TX (P 262,263) 214-760-0025
Pantin, Tomas/1601 E 7th St #100, Austin, TX...........................512-474-9968
Papadopolous, Peter/PO Box 474, Ranchos de Taos, NM.................505-758-0789
Paparazzi/2917 Canton St, Dallas, TX..................................214-939-0091
Parrish, John/1218 Manufacturing, Dallas, TX............................214-742-9457
Parsons, Bill/518 W 9th St, Little Rock, AR.............................501-372-5892
Patrick, Richard/215-B W 4th St, Austin, TX.............................512-472-9092

Payne, Al /830 North 4th Ave, Phoenix, AZ (P 247) **602-258-3506**
Payne, C Ray/2737 Irving Blvd, Dallas, TX..............................214-638-1355
Payne, Richard/1601 S Shepard #282, Houston, TX..................713-524-7525
Payne, Tom/2425 Bartlett, Houston, TX..................................713-527-8670
Perlstein, Mark/1844 Place One Ln, Garland, TX......................214-690-0168
Peterson, Bruce Photo/2430 S 20th St, Phoenix, AZ.................602-252-6088
Pettit, Steve/206 Weeks, Arlington, TX..................................817-265-8776
Pfuhl, Chris/PO Box 542, Phoenix, AZ...................................602-253-0525
Phelps, Greg/2360 Central Blvd, Brownsville, TX.....................512-541-4909
Photo Group/2512 East Thomas #2, Phoenix, AZ
(P 246,247) ...**602-381-1332**
Photo Media, Inc/2805 Crockett, Fort Worth, TX......................817-332-4172
Pierson, Sam/1019 Forest Home Dr, Houston, TX.....................713-497-3176
Pledger, Nancy/2124 Farrington #300, Dallas, TX....................214-761-9545
Pogue, Bill/1412 W Alabama, Houston, TX..............................713-523-5757
Porter, Albert/7215 Wild Valley, Dallas, TX............................214-349-2230
Post, Andy/4748 Algiers #300, Dallas, TX..............................214-634-4490
Poulides, Peter/PO Box 202505, Dallas, TX............................214-902-8800
Probst, Kenneth/3527 Oak Lawn Blvd #375, Dallas, TX..............214-522-2031

QR

Quilia, Jim/3125 Ross, Dallas, TX...214-276-9956
Rahn, Reed/610 W 11th St, Tempe, AZ...................................602-829-7455
Ralph, Michael/10948 Pelham, El Paso, TX..............................915-595-3787
Raphaele Inc/616 Hawthorne, Houston, TX..............................713-524-2211
Rascona, Donna & Rodney/4232 S 36th Place, Phoenix, AZ.........602-437-0866
Raymond, Rick Photography/382 North First Ave, Phoenix, AZ......602-581-8160
Records, Bill/505 W 38, Austin, TX..512-458-1017
Redd, True/2328 Farrington, Dallas, TX..................................214-638-0602
Reedy, Mark/1512 Edison #100, Dallas, TX.............................214-748-1777
Reens, Louis/4814 Sycamore, Dallas, TX................................214-827-3388
Reese, Donovan/3007 Canton, Dallas, TX...............................214-748-5900
Reinig, Tom/2720 N 68th St#5426, Scottsdale, AZ....................602-966-4199
Reisch, Jim/235 Yorktown St, Dallas, TX................................214-748-0456
Robbins, Joe/7700 Renwick #5A, Houston, TX..........................713-667-5050
Robson, Howard/3807 E 64th Pl, Tulsa, OK.............................918-492-3079
Roe, Cliff/26734 InterstHwy N, Spring, TX...............................713-367-2520
Rose, Kevin/1513 Reisen Dr, Garland, TX...............................214-495-3004
Rubin, Janice/705 E 16th St, Houston, TX...............................713-868-6060
Running, John/PO Box 1237, Flagstaff, AZ..............................602-774-2923
Rusing, Rick/1555 W University #106, Tempe, AZ.....................602-967-1864
Russell, Gail/PO Box 241, Taos, NM......................................505-776-8474
Russell, Nicholas/849-F Harvard, Houston, TX.........................713-864-7664
Ryan, Tom/2919 Canton St, Dallas, TX..................................214-651-7085

S

Salvo/5447 Kingfisher, Houston, TX......................................713-721-5000
Samaha, Sam/1526 Edison, Dallas, TX..................................214-746-6336
Sanders, Chuck/715 W 13th St, Tempe, AZ.............................602-820-3179
Savant, Joseph/4756 Algiers St, Dallas, TX.............................214-951-0111
Savins, Matthew/101 Howell St, Dallas, TX.............................214-651-7516
Saxon, John/1337 Crampton, Dallas, TX.................................214-630-5160
Scheer, Tim/1521 Centerville Rd, Dallas, TX............................214-328-1016
Scheyer, Mark/3317 Montrose #A1003, Houston, TX.................713-861-0847
Schlesinger, Terrence/PO Box 32877, Phoenix, AZ....................602-957-7474
Schmidt, David/74 W Culver, Phoenix, AZ...............................602-258-2592
Schneps, Michael/4311 Benning, Houston, TX.........................713-668-4600
Schuman, Patty/2209 Morse, Houston, TX..............................713-522-4853
Schuster, Ellen/3719 Gilbert, Dallas, TX.................................214-526-6712
Scott, Ron/1000 Jackson Blvd, Houston, TX............................713-529-5868
Seeger, Stephen/2931 Irving Blvd #101, Dallas, TX..................214-634-1309
Segrest, Jerry Photography/1707 S Arvay, Dallas, TX................214-426-6360
Segroves, Jim/170 Leslie, Dallas, TX.....................................214-827-5482
Sellers, Dan/1317 Conant, Dallas, TX....................................214-631-4705
Shands, Nathan/1107 Bryan, Mesquite, TX.............................214-285-5382
Shaw, Robert/1723 Kelly SE, Dallas, TX.................................214-428-1757
Shield-Marley, DeAnne/101 S Victory, Little Rock, AR................501-372-6148
Siegel, Dave/224 N Fifth Ave, Phoenix, AZ (P 254) **602-257-9509**
Sieve, Jerry/PO Box 1777, Cave Creek, AZ............................602-488-9561
Simon, Frank/4030 N 27th Ave #B, Phoenix, AZ......................602-279-4635
Simpson, Michael/1415 Slocum St #105, Dallas, TX.................214-943-9355
Sims, Jim/2811 McKinney Ave #206, Dallas, TX.......................214-855-0055
Slade, Chuck/3329 Wilway Ave NE, Albuquerque, NM...............505-262-1103
Sloan-White, Barbara/1001 Missouri, Houston, TX....................713-529-4055
Smith, Dan/2700 Flora St, Dallas, TX.....................................212-819-0466
Smith, Ralph/2211 Beall, Houston, TX....................................713-862-8301

Smith, Seth/2401 S Ervay #204, Dallas, TX.............................214-428-4510
Smith/Garza Photography/PO Box 10046, Dallas, TX.................214-941-4611
Smothers, Brian/834 W 43rd St, Houston, TX...........................713-695-0873
Snedeker, Katherine/, Dallas, TX..214-745-1250
Sperry, Bill/3300 E Stanford, Paradise Valley, AZ.....................602-955-5626
St Angelo, Ron/PO Box 161702, Las Colinas, TX......................817-481-1833
St Gil & Associates/PO Box 820568, Houston, TX.....................713-347-3337
Staarjes, Hans/20 Lana Lane, Houston, TX.............................713-621-8503
Stewart, Craig/1900 W Alabama, Houston, TX.........................713-529-5959
Storr, Jay/PO Box 7190, Houston, TX.....................................713-861-6111
Studio 3 Photography/2804 Lubbock, Fort Worth, TX.................817-923-9931
Suddarth, Robert/3402 73rd St, Lubbock, TX..........................806-795-4553
Summers, Chris/2437 Bartlett St, Houston, TX.........................713-524-7371
Swindler, Mark/2609 E 21st St, Odessa, TX............................915-332-3515

TUV

Talley, Paul/4756 Algiers St, Dallas, TX.................................214-951-0039
Thatcher, Charles/403 W Mockingbird Lane, Dallas, TX.............214-643-9444
The Quest Group/3007 Paseo, Oklahoma City, OK....................405-946-1757
Thompson, Dennis/15 E Brady, Tulsa, OK...............................918-743-5595
Threadgill, Toby/1345 Chemical, Dallas, TX............................214-638-1661
Timmerman, Bill/1244 E Utopia, Phoenix, AZ...........................602-340-1662
Tomlinson, Doug/9307 Mercer Dr, Dallas, TX...........................214-321-0600
Truitt Photographics/3201 Stuart, Ft Worth, TX........................817-924-8783
Tunison, Richard/7829 E Foxmore Lane, Scottsdale, AZ.............602-998-4708
Turner, Danny/4228 Main St, Dallas, TX.................................214-760-7472
Urban, Linda/2931 Irving Blvd #101, Dallas, TX.......................214-634-9009
Vandivier, Kevin/904 E 44th St, Austin, TX.............................512-450-1506
VanOverbeek, Will/305 E Sky View, Austin, TX........................512-454-1501
Vantage Point Studio/1109 Arizona Ave, El Paso, TX................915-533-9688
Vener, Ellis/2926 Helena St, Houston, TX..............................713-523-0456
Viewpoint Photographers/9034 N 23rd Ave #11, Phoenix, AZ......602-245-0013
Vine, Terry/5455 Dashwood #200, Houston, TX.......................713-664-2920
Vracin, Andrew/4609 Don, Dallas, TX....................................214-688-1841

WZ

Walker, Balfour/1838 E 6th St, Tucson, AZ..............................602-624-1121
Webb, Drayton/5455 Dashwood #300, Belaire, TX....................713-660-7497
Weeks, Christopher/1260 E 31st Pl, Tulsa, OK.........................918-749-8289
Wellman, Jeffrey B/415 Sunset St, Santa Fe, NM.....................505-989-9231
Wells, Craig/537 W Granada, Phoenix, AZ..............................602-252-8166
Welsch, Diana/1505 Forest Trail, Austin, TX............................512-469-0958
Werre, Bob/2437 Bartlett St, Houston, TX..............................713-529-4841
Wheeler, Don/1933 S Boston Ave/Studio C, Tulsa, OK...............918-587-3808
White, Frank Photo/1109 E Freeway, Houston, TX....................713-223-1110
Whitlock, Neill/122 E 5th St, Dallas, TX..................................214-948-3117
Wight, Mark/267-D South Stone, Tucson, AZ............................602-882-1783
Williams, Laura/223 Howard, San Antonio, TX.........................512-223-6000
Williams, Oscar/8535 Fairhaven, San Antonio, TX....................512-690-8807
Williamson, Thomas A/10830 N Central Expy #201, Dallas, TX.....214-373-4999
Willis, Gordon/3910 Buena Vista #23, Dallas, TX......................214-320-4844
Wolenski, Stan/2919 Canton, Dallas, TX.................................214-749-0749
Wolfhagen, Vilhelm/4916 Kelvin, Houston, TX..........................713-522-2787
Wollam, Les/5215 Goodwin Ave, Dallas, TX............................214-760-7721
Wood, Keith Photography Inc/1308 Conant St,
Dallas, TX (P 252) ...**214-634-7344**
Wristen, Don/2025 Levee St, Dallas, TX.................................214-748-5317
Zabel, Ed/PO Box 58601, Dallas, TX.....................................214-748-2910
Zemnick, Mark/3202 Westbell #2202, Phoenix, AZ...................602-866-8711

ROCKY MTN

AB

Aaronson, Jeffrey/PO Box 10131, Aspen, CO..........................303-925-5574
Adams, Butch Photography/1414 S 700 W, Salt Lake City, UT.....801-973-0939
Adamski-Peek, Lori/PO Box 4033, Park City, UT.......................801-649-0259
Aiuppy, Larry/PO Box 26, Livingston, MT...............................406-222-7308
Alaxandar/1201 18th St #240, Denver, CO..............................303-298-7711
Alston, Bruce/PO Box 2480, Steamboat Springs, CO................303-879-1675

Appleton, Roger/3106 Pennslyvania, Colorado Springs, CO719-635-0393
Archer, Mark/228 S Madison St, Denver, CO....................................303-399-5272
Bailey, Brent P/PO Box 70681, Reno, NV......................................702-826-4104
Bartek, Patrick/PO Box 26994, Las Vegas, NV...............................702-368-2901
Bator, Joe/8245 Yarrow St, Arvada, CO...303-425-0833
Bauer, Erwin A/Box 543, Teton Village, WY....................................307-733-4023
Beery, Gale/150 W Byers, Denver, CO...303-777-0458
Berchert, James H/2886 W 119th Ave, Denver, CO.........................303-466-7414
Berge, Melinda/1280 Ute Ave, Aspen, CO......................................303-925-2317
Biggs, Deborah/8335 E Fairmont #11-207, Denver, CO...................719-388-5846
Birnbach, Allen/3600 Tejon St, Denver, CO....................................303-455-7800
Blake, John/4132 20th St, Greeley, CO...303-330-0980
Borowczyk, Jay/353 Pierpont Ave, Salt Lake City, UT.......................801-363-4147
Bosworth/Graves Photo Inc/1055 S 700 W, Salt Lake City, UT...........801-972-6128
Brock, Sidney/3377 Blake St #102, Denver, CO...............................303-296-9462
Burggraf, Chuck/2941 W 23rd Ave, Denver, CO..............................303-480-9053
Busath, Drake/701 East South Temple St, Salt Lake City, UT..............801-364-6645
Bush, Michael/2240 Bellaire St, Denver, CO....................................303-377-1057

CD

Cambon, Jim/216 Racquette Dr, Denver, CO....................................303-221-4545
Cannon, Gregory/3541 Wagon Wheel Way, Park City, UT..................800-727-1807
Captured Light Imagery/4817 S 1740 EA 6, Salt Lake City, UT............801-277-0265
Cava, Greg Photography/2912 S Highland #J, Las Vegas, NV.............702-735-2282
Chesley, Paul/Box 94, Aspen, CO..303-925-1148
Cleary, T Brian/12224 SW 14th, Yukon, OK....................................405-376-0909
Coca, Joe/213 1/2 Jefferson St, Ft Collins, CO303-482-0858
Collector, Stephen/4209 26th St, Boulder, CO.................................303-442-1386
Cook, James/PO Box 11608, Denver, CO.......................................303-433-4874
Coppock, Ron/1764 Platte St, Denver, CO......................................303-477-3343
Cronin, Bill/2543 Xavier, Denver, CO..303-458-0883
Cruz, Frank/1855 Blake St #5E, Denver, CO...................................303-297-1007
Daly, Glenn/155 Lone Pine Rd, Aspen, CO.....................................303-925-2224
DeHoff, RD/632 N Sheridan, Colorado Springs, CO.........................303-635-0263
DeLespinasse, Hank/2300 E Patrick Ln #21, Las Vegas, NV..............702-798-6693
DeMancznk, Phillip/5635 Riggins Ct #15, Reno, NV..........................702-826-5533
DeSciose, Nick/2700 Arapahoe St #2, Denver, CO..........................303-296-6386
DeVore, Nicholas III/1280 Ute, Aspen, CO......................................303-925-2317
Dickey, Marc/PO Box 4705, Denver, CO...303-449-6310
Douglass, Dirk/2755 S 300 W #D, Salt Lake City, UT........................801-485-5691
DuBois, F.E./The Bench, Fallon, NV..702-867-2551

EFG

Elder, Jim/PO Box 1600, Jackson Hole, WY....................................307-733-3555
Fader, Bob/14 Pearl St, Denver, CO...303-744-0711
Farace, Joe/14 Inverness #B104, Englewood, CO...........................303-799-6606
Feld, Stephen/9480 Union Sq #208, Sandy, UT...............................801-571-1752
Fisher, Gene/PO Box 3600, Lake Tahoe, NV...................................702-588-0323
Frazier, Van/2770 S Maryland Pkwy, Las Vegas, NV.........................702-735-1165
Gallian, Dirk/PO Box 4573, Aspen, CO...303-925-8268
Goetze, David/3215 Zuni, Denver, CO..303-458-5026
Gorfkle, Gregory D/16544 SE 28th St, Bellevue, WA........................206-746-3312
Graf, Gary/1870 S Ogden St, Denver, CO.......................................303-722-0547
Grannis, Peter/1553 Platte St #208, Denver, CO.............................303-433-6927

HJ

H B R Studios/3310 South Knox Court, Denver, CO..........................303-789-4307
Harris, Richard/935 South High, Denver, CO...................................303-778-6433
Havey, James/1836 Blake St #203, Denver, CO..............................303-296-7448
Hazen, Ryne/172 West 36th St, Ogden, UT.....................................801-621-6400
Heaton, Grant/156 W Utopia Ave, Salt Lake City, UT........................801-467-0101
Herridge, Brent/736 South 3rd West, Salt Lake City, UT....................801-363-0337
Hiser, David C/1280 Ute Ave, Aspen, CO..303-925-2317
Holdman, Floyd/1908 Main St, Orem, UT..801-224-9966
Hunt, Steven/2098 E 25 S, Layton, UT..701-544-4900
Huntress, Diane/3337 W 23rd Ave, Denver, CO...............................303-480-0219
Johnson, Jim Photo/16231 E Princeton Circle, Denver, CO...............303-680-0522
Johnson, Ron/2460 Eliot St, Denver, CO...303-458-0288

KL

**Kay, James W/PO Box 81042, Salt Lake City, UT
(P 299)** ..**801-583-7558**
Kelly, John P/PO Box 1550, Basalt, CO...303-927-4197
Kitzman, John/3060 22nd St, Boulder, CO......................................303-440-7623

Koropp, Robert/901 E 17th Ave, Denver, CO...................................303-830-6000
Krause, Ann/PO Box 4165, Boulder, CO...303-444-6798
Laidman, Allan/110 Free Circle Ct A102, Aspen, CO........................303-925-4791
Laszlo, Larry/420 E 11th Ave, Denver, CO......................................303-832-2299
Lee, Jess/6799 N Derek Ln, Idaho Falls, ID....................................208-529-4535
LeGoy, James M/PO Box 21004, Reno, NV.....................................702-322-0116
Levy, Patricia Barry/3389 W 29th Ave, Denver, CO.........................303-458-6692
Lichter, Michael/3300 14th St, Boulder, CO.....................................303-449-3906
Lissy, David/14472 Applewood Ridge Rd, Golden, CO......................303-277-0232
Lokey, David/PO Box 7, Vail, CO..303-949-5750
Lotz, Fred/4220 W 82nd Ave, Westminster, CO...............................303-427-2875

M

Mahaffey, Marcia/283 Columbine #135, Denver, CO........................303-778-6316
Mangelsen, Tom/POB 241185/ 8206 J St, Omaha, NE......................800-228-9686
Markus, Kurt/237 1/2 Main St, Kalispell, MT....................................406-756-9191
Marlow, David/421 AABC #J, Aspen, CO...303-925-8882
Martin, Hughes/1408 Willow Ln, Park City, UT.................................801-649-1471
Masamori, Ron/5051 Garrison St, Wheatridge, CO..........................303-423-8120
McDowell, Pat/PO Box 283, Park City, UT.......................................801-649-3403
McManemin, Jack/568 S 400 W, Salt Lake City, UT..........................801-359-3100
McRae, Michael/925 SW Temple, Salt Lake City, UT.........................801-328-3633
Messineo, John/PO Box 1636, Fort Collins, CO...............................303-482-9349
Miles, Kent/465 Ninth Ave, Salt Lake City, UT.................................801-364-5755
Milmoe, James O/14900 Cactus Cr, Golden, CO.............................303-279-4364
Milne, Lee/3615 W 49th Ave, Denver, CO.......................................303-458-1520
Mitchell, Paul/1517 S Grant, Denver, CO..303-722-8852

NOP

Neligh, Dave/PO Box 811, Denver, CO...303-534-9005
Ng, Ray/1855 Blake St, Denver, CO...303-292-0112
**Noble, Chris/8415 Kings Hill Dr, Salt Lake City, UT
(P 327)** ..**801-942-8335**
Oswald, Jan/921 Santa Fe, Denver, CO..303-893-8038
Outlaw, Rob/PO Box 1275, Bozeman, MT.......................................406-587-1482
Patryas, David/3200 Valmont Rd #1, Boulder, CO............................303-444-7372
Paul, Ken/1523 E Montane Dr E, Genesee, CO...............................303-526-1162
Peck, Michael/2046 Arapahoe St, Denver, CO.................................303-296-9427
Peregrine Studio/1541 Platte St, Denver, CO..................................303-455-6944
Perkin, Jan/428 L St, Salt Lake City, UT...801-355-0112
Phillips, Ron/6682 S Sherman St, Littleton, CO................................303-730-8567
Powell, Todd/PO Box 2279, Breckenridge, CO................................303-453-0469
Preston, Greg/3111 S Valley View A117, Las Vegas, NV...................702-873-0094
Purlington, Camille/8221 S Race St, Littleton, CO.............................303-797-6523

QR

**Quinney, David Jr/423 E Broadway, Salt Lake City,
UT (P 336)** ...**801-363-0434**
Radstone, Richard/456 S Cochran Ave #104, Los Angeles, CA...........213-460-2879
Rafkind, Andrew/1702 Fairview Ave, Boise, ID.................................208-344-9918
Ramsey, Steve/4800 N Washington St, Denver, CO..........................303-295-2135
Redding, Ken/PO Box 717, Vail, CO...303-476-2446
Rehn, Gary/860 Toedtli Dr, Boulder, CO...303-499-9550
Reynolds, Roger/3310 S Knox Ct, Englewood, CO...........................303-789-4307
Roberts, Michael Studio/One East Broadway, Salt Lake City, UT.........801-359-8232
Rosen, Barry/1 Middle Rd, Englewood, CO.....................................303-758-0648
Rosenberg, David/1545 Julian SE, Denver, CO................................303-893-0893
Rosenberger, Edward/2248 Emerson Ave, Salt Lake City, UT.............801-355-9007
Russell, John/PO Box 4739, Aspen, CO...303-920-1431

S

Saehlenou, Kevin/3478 W 32nd Ave, Denver, CO............................303-455-1611
Sallaz, William R/3512 W 96th St Circle, Westminster, CO.................406-466-7321
Saviers, Trent/2606 Rayma Ct, Reno, NV..702-747-2591
Schlack, Greg/1510 Lehigh St, Boulder, CO....................................303-499-3860
Schmiett, Skip/740 W 1700 S #10, Salt Lake City, UT.......................801-973-0642
Schoenfeld, Michael/PO Box 876, Salt Lake City, UT........................801-532-2006
Shattil, Wendy/PO Box 67422, Denver, CO.....................................303-721-1991
Shivdasani, Suresh/PO Box 2710, Sun Valley, ID.............................208-622-3494
Skousen, Nevin/Rte 3 Box 162, Springville, UT................................801-489-8212
Smith, David Scott/4904 Nez Perce Lookout, Billings, MT..................406-652-9424
Smith, Derek/568 South 400 West, Salt Lake City, UT.......................801-363-1061
Sokol, Howard/3006 Zuni St, Denver, CO.......................................303-433-3353
St John, Charles/1760 Lafayette St, Denver, CO..............................303-860-7300

Staver, Barry/5122 S Iris Way, Littleton, CO303-973-4414
Stewert, Sandy/26406 Columbine Glen, Golden, CO303-278-8039
Stoecklein, David/PO Box, Ketchum, ID208-726-5191
Sunlit Ltd/1523 E Montane Dr, Genesse, CO303-526-1162
Swartz, William/6801 S Emporia #103, Greenwood Village, CO...........303-790-4545

TVWY

Tanner, Scott/48 E Robert Ave, Salt Lake City, UT801-466-6884
Tejada, David X/1553 Platte St #205, Denver, CO303-458-1220
Tharp, Brenda/PO Box 1653, Ross, CA415-461-8522
Till, Tom/PO Box 337, Moab, UT (P 343)**801-259-5327**
Tobias, Philip/3614 Morrison Rd, Denver, CO303-936-1267
Travis, Tom/1219 S Pearl St, Denver, CO303-377-7422
Tregeagle, Steve/2994 S Richards St #C, Salt Lake City, UT.....801-484-1673
Trotto, John Photo Inc/4006 S 23rd St #10, Phoenix, AZ602-268-2020
Van Hemert, Martin/9837 Stonehaven, South Jordan, UT801-569-1847
Walker, Rod/PO Box 2418, Vail, CO303-926-3210
Wark, Jim/5 Bellita Dr, Pueblo, CO719-561-6622
Wayda, Steve/5725 Immigration Canyon, Salt Lake City, UT801-582-1787
Weeks, Michael/PO Box 6965, Colorado Springs, CO719-632-2996
Wellisch, Bill/2325 Clay St, Denver, CO303-455-8766
Welsh, Steve/1191 Grove St, Boise, ID208-336-5541
Wheeler, Geoffrey/721 Pearl St, Boulder, CO303-449-2137
White, Stuart/1812 3rd Ave N, Great Falls, MT406-761-6666
Yarborough, Carl/PO Box 4739, Aspen, CO303-920-1431

WEST COAST

A

Abecassis, Andree L/756 Neilson St, Berkeley, CA415-526-5099
Abraham, Russell/60 Federal St #303,
San Francisco, CA (P 272,273)**415-896-6400**
Abramowitz, Alan/PO Box 45121, Seattle, WA206-621-0710
Ackroyd, Hugh S/Box 10101, Portland, OR...........................503-227-5694
Adams, Michael/PO Box 4217, Mission Viejo, CA714-583-8651
Addor, Jean-Michel/1456 63rd St, Emeryville, CA415-653-1745
Adler, Bob/33 Ellert St, San Francisco, CA415-695-2867
Agee, Bill & Assoc/715 Larkspur Box 612, Corona Del Mar, CA714-760-6700
Aguilera-Hellweg, Max/1316 1/2 Westerley Terrace, LA, CA213-965-0899
Ahrend, Jay/1046 N Orange Dr, Hollywood, CA213-462-5256
Aldridge, Wayne/330 SE Union Ave, Portland, OR503-236-5517
All Sports Photo USA/6160 Fairmont Ave #H, San Diego, CA....319-280-3595
Allan, Larry/3503 Argonne St, San Diego, CA619-270-1850
Allen, Charles/537 S Raymond Ave, Pasadena, CA818-795-1053
Allen, Judson Photo/839 Emerson, Palo Alto, CA415-324-8177
Allison, Glen/1910 Griffith Park Blvd, Los Angeles, CA.............213-666-0883
Ambrosio, Joe/8230 Beverly Blvd #3, Los Angeles, CA213-655-1505
Amdal, Philip/916 W Raye, Seattle, WA206-282-8666
Andelotte, John/15747 East Valley Blvd, City of Industry, CA....818-961-2118
Andersen, Kurt/250 Newhall, San Francisco, CA415-641-4276
Anderson, Karen/1170 N Western Ave, Los Angeles, CA213-461-9100
Anderson, Rick/8871-B Balboa Ave, San Diego, CA619-268-1957
Ansa, Brian/2605 N Lake Ave, Altadena, CA818-797-2233
Apton, Bill/1060 Folsom St, San Francisco, CA415-861-1840
Arend, Christopher/5401 Cordova St, Anchorage, AK907-562-3173
Armas, Richard/6913 Melrose Ave, Los Angeles, CA213-931-7889
Arnold, Robert /1379 Natoma, San Francisco, CA415-621-6161
Arnone, Ken/3886 Ampudia St, San Diego, CA619-298-3141
Aron, Jeffrey/17801 Sky Park Cir #H, Irvine, CA.....................714-250-1555
Aronovsky, James/POB 83579, San Diego, CA619-232-5855
Arrabito, Jim/PO Box 916, Everett, WA206-339-3637
Arzola, Frank/4903 Morena Blvd #1201, San Diego, CA619-483-3810
Atherly, Robbin/1000 Brannan, San Francico, CA415-626-1100
Atiee, James/922 N Formosa Ave, Hollywood, CA213-850-6112
Atkinson Photo/4320 Viewridge Ave #C, San Diego, CA619-565-0672
Avery, Franklin/PO Box 15458, San Francisco, CA415-986-3701
Avery, Ron/11821 Mississippi Ave, Los Angeles, CA213-477-1632
Ayres, Robert Bruce/8609 Venice Blvd, Los Angeles, CA213-837-8190

B

Bacon, Garth/18576 Bucknall Rd, Saratoga, CA408-866-5858
Bagley, John/730 Clemintina, San Francisco, CA415-861-1062
Baker, Bill/265 29th St, Oakland, CA415-832-7685

Baker, Frank/21462 La Capilla, Mission Viejo, CA...................714-472-1163
Balderas, Michael/5837-B Mission Gorge Rd, San Diego, CA ...619-563-7077
Baldwin, Doug/216 S Central Ave, Glendale, CA.....................818-547-9268
Banko, Phil/1249 First Ave S, Seattle, WA206-621-7008
Banks, Ken/135 N Harper Ave, Los Angeles, CA213-930-2831
Bardin, James/111 Villa View Dr, Pacific Palisades, CA............213-689-4566
Bare, John/3001 Red Hill Ave #4-102, Costa Mesa, CA714-979-8712
Baris, Geoffrey/2715 Western Ave, Seattle, WA206-728-7137
Barkentin, Pamela/1218 N LaCienga, Los Angeles, CA213-854-1941
Barnhurst, Noel/34 Mountain Spring Ave,
San Francisco, CA (P 304,305)**415-731-9979**
Barros, Robert/1813 E Sprague Ave, Spokane, WA................509-535-6455
Barta, Patrick/1274 Folsom, San Francisco, CA415-626-6085
Bartay Studio/66 Retiro Way, San Francisco, CA415-563-0551
Bartholick, Robin/1050 W Nickerson #3A, Seattle, WA206-286-1001
Barton, Hugh G/33464 Bloomberg Rd, Eugene, OR503-747-8184
Bartone, Laurence/335 Fifth St, San Francisco, CA415-974-6010
Bartruff, Dave/PO Box 800, San Anselmo, CA415-457-1482
Basse, Cary Photographers/6927 Forbes Ave, Van Nuys, CA...818-781-4856
Bates, Frank/5158 Highland View Ave, Los Angeles, CA..........213-258-5272
Batista-Moon Studio/1620 Montgomery #300, San Francisco, CA415-777-5566
Bauer, Bob/1057 Winsor Ave, Oakland, CA415-763-4819
Bayer, Dennis/130 Ninth St, San Francisco, CA415-255-9467
Beals, Steven/807 N Russell St, Portland, OR503-288-0550
Bear, Brent/8659 Hayden Pl, Culver City, CA213-558-4471
Beebe, Morton/150 Lombard St #808, San Francisco, CA.......415-362-3530
Behrman, C H/8036 Kentwood, Los Angeles, CA213-216-6611
Belcher, Richard/2565 Third St #206, San Francisco, CA415-641-8912
Bell, Robert/1360 Logan Ave #105, Costa Mesa, CA714-957-0772
Benchmark Photo/1442 N Hundley, Anaheim, CA714-630-7965
Bencze, Louis/2442 NW Market St #86, Seattle, WA206-283-6314
Benet, Ben/333 Fifth St #A, San Francisco, CA415-974-5433
Benne, Dick/PO Box 7854, Vallejo, CA707-642-4044
Bennion, Chris/5234 36th Ave NE, Seattle, WA206-526-9981
Benson, Gary L/11110 34th Pl SW, Seattle, WA206-242-3232
Benson, Hank/653 Bryant St, San Francisco, CA415-543-8153
Benson, John/130 Ninth St #302, San Francisco, CA415-621-5247
Benton, Richard/4810 Pescadero, San Diego, CA619-224-0278
Berger, Robert/3857 Birch #144, Newport Beach, CA.............714-646-2867
Berman, Steve/7955 W 3rd, Los Angeles, CA213-933-9185
Bernson, Carol/, Los Angeles, CA818-501-5854
Bernstein, Andrew/1450 N Chester, Pasadena, CA818-797-3430
Bernstein, Gary/8735 Washington Blvd, Culver City, CA213-550-6891
Berry, Greg/PO Box 8426, Woodland, CA916-666-3342
Bertholomey, John/17962 Sky Park Cir #J, Irvine, CA714-261-0575
Berton, Laura/3461 Greenfield Ave, Los Angeles, CA.............213-842-7945
Betz, Ted R/527 Howard Top Fl, San Francisco, CA415-777-1260
Bez, Frank/71 Zaca Lane, San Luis Obispo, CA805-541-2878
Bielenberg, Paul/2447 Lanterman Terr, Los Angeles, CA.........213-669-1085
Big City Visual Prdctn/1039 Seventh Ave #12, San Diego, CA...619-232-3366
Biggs, Ken/1147 N Hudson Ave, Los Angeles, CA213-462-7739
Bilecky, John/5047 W Pico Blvd, Los Angeles, CA213-931-1610
Bilyell, Martin/643 SE 74th Ave, Portland, OR503-238-0349
Bishop, Bruce/1830 17th St, San Francisco, CA.....................415-552-4254
Bjoin, Henry/146 N La Brea Ave, Los Angeles, CA213-937-4097
Black, Laurie/22085 Salamo Rd, West Lynn, OR503-665-5939
Blair, Richard/2207 Fourth St, Berkeley, CA415-548-8350
Blakeley, Jim/1061 Folsom St, San Francisco, CA415-558-9300
Blakeman, Bob/710 S Santa Fe, Los Angeles, CA213-624-6662
Blattel, David/19730 Observation Dr, Topanga, CA818-848-1166
Blaustein, Alan/154 Harvard Ave, Mill Valley, CA415-383-1511
Blaustein, John/911 Euclid Ave, Berkeley, CA415-525-8133
Bleyer, Pete/807 N Sierra Bonita Ave, Los Angeles, CA..........213-653-6567
Bloch, Steven J/431 NW Flanders, Portland, OR503-224-8018
Bloch, Tom/30 S Salinas, Santa Barbara, CA805-965-1512
Blumensaadt, Mike/306 Edna, San Francisco, CA415-333-6178
Bobo/Alexander/206 First Ave S, Seattle, WA206-343-9426
Boghwell, Craig/262 Magnolia, Costa Mesa, CA714-642-9403
Bolanos, Edgar/PO Box 16328, San Francisco, CA415-585-7805
Bonini, Steve/615 SE Alder, Portland, OR503-239-5421
Bonneau, Beau/1915 Divisidero, San Francisco, CA415-563-9234
Boonisar, Peter/PO Box 2274, Atascadero, CA805-466-5577
Borges, Phil/4222 48th Ave S, Seattle, WA (P 306,307)....**206-284-2805**
Bossert, Bill/2009 Irvine Ave, Newport Beach,
CA (P 308) ...**714-531-7222**
Boudreau, Bernard/1015 N Cahuenga Blvd, Hollywood, CA213-467-2602
Boulger & Kanuit/503 S Catalina, Redondo Beach, CA...........213-540-6300
Boyd, Bill/201 E Haley St, Santa Barbara, CA805-962-9193

Boyd, Jack/2038 Calvert Ave, Costa Mesa, CA................714-556-8332
Boyer, Dale/PO Box 391535, Mountain View, CA................415-968-9656
Boyer, Neil/1416 Aviation Blvd, Redondo Beach, CA................213-374-0443
Boyer, Paul/225 Taylor St, Port Townsend, WA................206-385-4038
Braasch, Gary/PO Box 1465, Portland, OR................503-368-5091
Brabant, Patricia/245 S Van Ness 3rd Fl, San Francisco, CA................415-864-0591
Bracke, Vic/912 E 3rd St #106, Los Angeles, CA................213-625-1531
Bradley, Glenn/4618 W Jefferson, Los Angeles, CA................213-737-5156
Bradley, Leverett/Box 1793, Santa Monica, CA................213-394-0908
Brady Architectural Photo/3939 Turnagain Blvd E, Anchorage, AK................907-248-7500
Brandon, Randy/PO Box 1010, Girdwood, AK................907-563-3351
Braun, Kim/5555 Santa Fe St #L, San Diego, CA................619-483-2124
Brazil, Larry/41841 Albrae St, Freemont, CA................415-657-1311
Brenneis, Jon/2576 Shattuck, Berkeley, CA................415-845-3377
Brewer, Art/27324 Camino Capistrano #161, Laguna Nigel, CA................714-582-9085
Brewer, Bill/620 Moulton Ave #213, Los Angeles, CA................213-227-6861
Brewer, James/4649 Beverly Blvd #103, Los Angeles, CA................213-461-6241
Brian, Rick/555 S Alexandria Ave, Los Angeles, CA................213-387-3017
Brinegar, Scott/1088 Irvine Blvd #518, Tustin, CA................714-731-5630
Britt, Jim/3221 Hutchinson Ave, Los Angeles, CA................213-836-6317
Broaddus, Steve/6442 Santa Monica Blvd, Los Angeles, CA................213-466-9866
Brock, Donna and Ron/PO Box 820, Larkspur, CA................415-924-1131
Brod, Garry/6502 Santa Monica Blvd, Hollywood, CA................213-463-7887
Brookhause, Win/2316 Porter St #11, Los Angeles, CA................213-488-9143
Brown, Matt/PO Box 956, Anacortes, WA................206-293-3540
Browne, Rick/145 Shake Tree Ln, Scotts Valley, CA................408-438-3919
Browne, Turner/10546 Greenwood Ave N, Seattle, WA................206-367-3782
Brun, Kim/5555-L Santa Fe St, San Diego, CA................619-483-2124
Bubar, Julie/12559 Palero Rd, San Diego, CA................619-234-4020
Buchanan, Craig/1026 Folsom St, San Francisco,
CA (P 280,281)................**415-861-5566**
Buckley, Jim/1310 Kawaihao St, Honolulu, HI................808-538-6128
Burger, Harriet/117 S Main #401, Seattle, WA................206-628-9090
Burke, Kevin/1015 N Cahuenga Blvd, Los Angeles, CA................213-467-0266
Burke, Leslie/947 La Cienega, Los Angeles, CA................213-652-7011
Burke/Triolo/940 E 2nd St #2, LA, CA (P 291)................**213-687-4730**
Burkhart, Howard Photography/1783 S Holt Ave, Los Angeles, CA................213-836-9654
Burkholder, Jeff/Life Images/3984 Park Circle Lane, Carmichael, CA................916-944-2128
Burman & Steinheimer/2648 Fifth Ave, Sacramento, CA................916-457-1908
Burnside Photography/3839 44th Ave SW, Seattle, WA................206-935-8570
Burr, Bruce/2867 1/2 W 7th St, Los Angeles, CA................213-388-3361
Burr, Lawrence/76 Manzanita Rd, Fairfax, CA................415-456-9158
Burroughs, Robert/6713 Bardonia St, San Diego, CA................619-469-6922
Burt, Pat/1412 SE Stark, Portland, OR................503-284-9989
Burton, Irwin/4743 21st Ave NE, Seattle, WA................206-522-5263
Burton, Steve/PO Box 52092, Pacific Grove, CA................408-372-1610
Bush, Chan/PO Box 819, Montrose, CA................818-957-6558
Bush, Charles William/940 N Highland Ave, Los Angeles, CA................213-466-6630
Bush, Dave/2 St George Alley, San Francisco, CA................415-981-2874
Busher, Dick/7042 20th Place NE, Seattle, WA................206-523-1426
Butler, Erik/655 Bryant St, San Francisco, CA................415-777-1656
Bybee, Gerald Digital Studios/1811 Folsom St, San Francsico, CA................415-863-6346
Bydalek, Martin/PO Box 45848, Seattle, WA................206-587-2372

C

C & I Photography/275 Santa Ana Ct, Sunnyvale, CA................408-733-5855
Cable, Ron/17835 Skypark Cir #N, Irvine, CA................714-261-8910
Caccavo, James/1000 S Crescent Hts Blvd, Los Angeles, CA................213-939-9594
Cameron, Martin/2952 Naples St, Sacramento, CA................916-387-0711
Campbell Comm Photo/8586 Miramar Pl, San Diego, CA................619-587-0336
Campbell, Tom + Assoc/PO Box 1409, Topanga Canyon, CA................213-473-6054
Campbell, Willis Preston/1015 Cedar St, Santa Cruz, CA................408-425-5700
Campos, Michael/705 13th St, San Diego, CA................619-233-9914
Cannon, Bill/516 Yale Ave North, Seattle, WA................206-682-7031
Caplan, Stan/2224 Main St, Santa Monica, CA................213-464-6636
Capps, Alan/137 S La Peer Dr, Los Angeles, CA................213-276-3724
Capra, Robert/1256 Lindell Dr, Walnut Creek, CA................415-947-0323
Caputo, Tony/1040 N Las Palmas Ave, Los Angeles, CA................213-464-6636
Carey, Ed/438 Treat Ave, San Francisco, CA................415-621-2349
Carlson, Craig/266 J Street, Chula Vista, CA................619-422-4937
Carlson, Joe/901 El Centro, S Pasadena, CA................213-682-1020
Carofano, Ray/1011 1/4 W 190th St, Gardena, CA................213-515-0310
Carpenter, Brent Studio/19 Kala Moreya, Laguna Niguel, CA................312-787-1774
Carpenter, Mert/202 Granada Way, Los Gatos, CA................408-370-1663
Carroll, Bruce/517 Dexter Ave N, Seattle, WA................206-623-2119
Carroll, Tom/26712 Calle Los Alamos, Capistrano Beach, CA................714-493-2665
Carruth, Kerry/9428 Eton Ave #H, Chatsworth, CA................818-718-4014

Cartwright, Casey/434 9th St, San Francisco, CA................415-621-7393
Casado, John/1858 Fanning St, Los Angeles, CA................213-666-5123
Casilli, Mario/2366 N Lake Ave, Altadena, CA................213-681-4476
Casler, Christopher/1600 Viewmont Dr, Los Angeles, CA................213-854-7733
Cato, Eric/7224 Hillside Ave #38, Los Angeles, CA................213-851-5606
Caulfield, Andy/PO Box 41131, Los Angeles, CA................213-258-3070
Chamberlain, Paul/319 1/2 S Robertson Blvd, Beverly Hills, CA................213-659-4647
Chaney, Brad/1750 Army St #H, San Francisco, CA................415-826-2030
Charles, Cindy/631 Carolina St, San Francisco, CA
(P 309)................**415-821-4457**
Chase, Julie/400 Treat Ave #E, San Francisco, CA................415-863-4749
Chen, James/1917 Anacapa St, Santa Barbara, CA................805-569-1849
Chen, Ken/11622 Idaho Ave #6, Los Angeles, CA................213-826-8272
Chernus, Ken/9531 Washington Blvd, Culver City, CA................213-838-3116
Chesser, Mike/5290 W Washington Blvd, Los Angeles, CA................213-934-5211
Chester, Mark/PO Box 99501, San Francisco, CA................415-922-7512
Chin, K P/PO Box 421737, San Francisco, CA................415-282-3041
Chmielewski, David/230-C Polaris, Mountain View, CA................415-969-6639
Christmas, Michael/9863 Pacific Heights Blvd #A, San Diego, CA................619-554-0226
Chubb, Ralph/340 Tesconi Cicle #B, Santa Rosa, CA................707-579-9995
Chung, Ken-Lei/5200 Venice Blvd, Los Angeles, CA................213-938-9117
Ciskowski, Jim/2444 Wilshire Blvd #B100, Santa Monica, CA................213-829-7375
Clark, Richard/8305 Wilshire Blvd #672, Los Angeles, CA................213-933-7407
Clark, Tom/2042 1/2 N Highland, Hollywood, CA................213-851-1650
Clarke, Chandra/860 2nd St, San Francisco, CA................415-957-9393
Clayton, John/160 S Park, San Francisco, CA................415-821-2616
Clement, Michele/221 11th St, San Francisco, CA................415-558-9540
Clifton, Carr/PO Box 71, Taylorsville, CA................916-284-6205
Cluck, Elsie/PO Box 22271, Carmel, CA................408-659-1357
Cobb, Bruce/1537-A 4th St #102, San Rafael, CA................415-454-0619
Cobb, Rick/10 Liberty Ship Way, Sausalito, CA................415-332-8739
Coccia, Jim/PO Box 81313, Fairbanks, AK................907-479-4707
Cogen, Melinda/1112 N Beachwood Dr, Hollywood, CA................213-467-9414
Cohen, Hilda/6674 Maryland Dr, Los Angeles, CA................213-205-0922
Coit, Jim/1205 J St #A, San Diego, CA................619-234-2874
Cole, Steve/16710 Orange Ave #A-4, Paramount, CA................213-408-1008
Coleman, Arthur Photography/303 N Indian Ave, Palm Springs, CA................619-325-7015
Colladay, Charles/705 13th Ave, San Diego, CA................619-231-2920
Collison, James/6950 Havenurst, Van Nuys, CA................818-995-3171
Coluzzi, Tony Photo/897 Independence Ave #2B, Mountain View, CA................415-969-2955
Connell, John/4120 Birch St #108, Newport Beach, CA................714-995-3212
Conrad, Chris/333 Second Ave W, Seattle, WA................206-284-5663
Cook, Kathleen Norris/PO Box 2159, Laguna Hills,
CA (P 310)................**714-770-4619**
Corell, Volker/3797 Lavell Dr, Los Angeles, CA................213-255-3336
Corey, Carl/1503 Abbot Kinney Blvd, Venice, CA................213-399-3313
Cormier, Glenn/828 K St #305, San Diego, CA................619-237-5006
Cornfield, Jim/8609 Venice Blvd, Los Angeles, CA................213-204-5747
Cornwell, David/1311 Kalakaua Ave, Honolulu, HI................808-949-7000
Corwin, Jeff/CPC Assoc/1910 Weepah Way, Los Angeles, CA................213-656-7449
Courbet, Yves/6516 W 6th St, Los Angeles, CA................213-655-2181
Courtney, William/4524 Rutgers Way, Sacramento, CA................916-487-8501
Cowin, Morgin/5 Windsor Ave, San Rafael, CA................415-459-7722
Craft, Michael/621 W McGraw, Seattle, WA................206-282-7628
Crane, Wally/PO Box 81, Los Altos, CA................415-960-1990
Crepea, Nick/12137 Kristy Lane, Saratoga, CA................408-257-5704
Crosier, Dave/11435 37th Ave Sw, Seattle, WA................206-682-6445
Crowley, Eliot/3221 Benda Pl, Hollywood, CA (P 287)................**213-851-5110**
Cummings, Ian/2400 Kettner Blvd, San Diego, CA................619-231-1270
Cummins, Jim/1527 13th Ave, Seattle, WA................206-322-4944
Curtis, Jeff/1109 N 35th St, Seattle, WA................206-634-3707
Curtis, Mel Photography/2400 E Lynn St, Seattle,
WA (P 311)................**206-323-1230**

D

Dahlstrom Photography Inc/2312 NW Savier St, Portland, OR................503-222-4910
Dajani, Haas/2501 14th Ave W #23, Seattle, WA................206-282-7643
Daly, Michael Kevin/PO Box 36753, Eugene, OR................503-342-8337
Daniel, Jay/816 W Francisco Blvd, San Rafael, CA................415-459-1495
Daniels, Charles/905 N Cole Ave #2120, Hollywood, CA................213-463-7513
Dannehl, Dennis/3303 Beverly Blvd, Los Angeles, CA................213-388-3888
Davenport, Jim/PO Box 296, Chula Vista, CA................619-549-8733
David/Gayle Photo/3223-B 1st Ave S, Seattle, WA................206-624-5207
Davidson, Dave/25003 S Beeson Rd, Beavercreek, OR................503-228-1268
Davidson, Jerry/3923 W Jefferson Blvd, Los Angeles, CA................213-735-1552
Davis, Tim/PO Box 1278, Palo Alto, CA................415-327-4192
Day, Bob/3360 21st St, San Francisco, CA................415-387-0191

Dayton, Ted/1112 N Beachwood, Los Angeles, CA213-462-0712
DBS Photo/1088 Irvine Blvd #518, Tustin, CA714-731-5630
De Gennaro Assoc/902 South Norton Ave,
Los Angeles, CA (P 276,277)**213-935-5179**
DeCastro, Mike/2415 De La Cruz, Santa Clara, CA408-988-8696
DeCruyenaere, Howard/1825 E Albion Ave, Santa Ana, CA714-997-4446
DeGabriele, Dale/900 1st Ave S #305, Seattle, WA206-624-9928
Degler, Curtis/1050 Carolan Ave #311, Burlingame, CA415-342-7381
Del Re, Sal/211-E East Columbine Ave, Santa Ana, CA714-432-1333
Delzell, Bill/2325 3rd St #409, San Francisco, CA415-626-3467
Demerdjian, Jacob/3331 W Beverly Blvd, Montebello, CA213-724-9630
Denman, Frank B/1201 First Ave S, Seattle, WA206-325-9260
Denny, Michael/2631 Ariane Dr, San Diego, CA619-272-9104
Dent, Fritz/211 Taylor #18, Port Townsend, WA206-385-9645
DePaola, Mark/1560 Benedict Cnyn Dr, Beverly Hills, CA213-550-5910
Der Cruyenaere, Howard/1825 E Albion Ave, Santa Ana, CA714-997-4446
Der, Rick Photography/50 Mandell St #10, San Francisco, CA415-824-8580
Deras, Frank/342 N Ferndale Ave, Mill Valley, CA415-381-2324
Derhacopian, Ronald/3109 Beverly Blvd, Los Angeles, CA213-388-6724
DeSilva, Dennis/3449 San Pablo Dam Rd, El Sobrante, CA415-222-0385
Devol, Thomas/236 W First Ave, Chico, CA916-894-8277
DeVries, Nancy/2915 Redhill Ave A-202, Costa Mesa, CA213-874-2200
DeWilde, Roc/953 Mt View Dr #119, Lafayette, CA415-676-8190
DeYoung, Skip/1112 N Beachwood, Los Angeles, CA213-462-0712
Diaz, Armando/19 S Park, San Francisco, CA415-495-3552
Digital Art/3000 S Robertson Blvd #26, Los Angeles, CA213-836-7631
Dockery, Alan/4679 Hollywood Blvd, Los Angeles, CA213-662-8153
Doll, Tom/4186 Serranto Valley Blvd #J, San Diego, CA619-452-1683
Dominick/833 N LaBrea Ave, Los Angeles, CA213-934-3033
Donaldson, Peter/118 King St, San Francisco, CA415-957-1102
Dow, Curtis/642 7th St, San Francisco, CA415-431-3105
Dow, Larry/1537 W 8th St, Los Angeles, CA213-483-7970
Drake, Brian/1209 NE 126th St, Vancouver, WA206-574-6199
Dreiwitz, Herb/3906 Franklin Ave, Los Angeles, CA213-662-0622
Dresser, Rod/1620 Montgomery St, San Francisco, CA415-824-8448
Dressler, Rick/1322 Bell Ave #M, Tustin, CA714-730-9113
Driver, Wallace/2540 Clairemont Dr #305, San Diego, CA619-275-3159
Drobek, Carol/1260 Broadway #106, San Francisco, CA415-776-6188
Duff, Rodney/4901 Morena Blvd #323, San Diego, CA619-270-4082
Duffey, Robert/9691 Campus Dr, Anaheim, CA714-956-4731
Duka, Lonnie/919 Oriole Dr, Laguna Beach, CA714-494-7057
Dumentz, Barbara/39 E Walnut St, Pasadena, CA213-467-6397
Dunbar, Clark/1260-B Pear Ave, Mountain View, CA415-964-4225
Dunmire, Larry/PO Box 338, Balboa Island, CA714-673-4058
Dunn, Roger/544 Weddell Dr #3, Sunnyvale, CA408-730-1630
Durke, Vernon/842 Folsom St #128, San Francisco, CA415-648-1262
Dyer, Larry/1659 Waller St, San Francisco, CA415-668-8049

E

Eadon, Jack/150-31 Pkwy Loop #B, Tustin, CA714-259-1414
Ealy, Dwayne/2 McLaren #B, Irvine, Ca.714-951-5089
Earnest, Robert G/1625 Boyd St, Santa Ana, CA.714-259-9190
Eckert, Peter/2136 SE 7th Ave, Portland, OR503-234-2344
Edelman, Howard/4739 Hillsdale Dr, Los Angeles, CA213-221-0309
Edmunds, Dana/188 N King St, Honolulu, HI808-521-7711
Edwards, Grant P/1470 Rancho Encinitas Dr, Olivenhain, CA619-458-1999
Ehrlich, Seth/1046 N Orange Dr, Hollywood, CA213-462-5256
Elgin, John-Paul/20812 Vose St, Canoga Park, CA818-347-7719
Elias, Robert Studio/959 N Cole, Los Angeles, CA213-460-2988
Elk, John III/3163 Wisconsin, Oakland, CA415-531-7469
Emanuel, Manny/2257 Hollyridge Dr, Hollywood, CA213-465-0259
Emberly, Gordon/1479 Folsom, San Francisco, CA415-621-9714
English, Rick/1162 Bryant St, San Francisco, CA415-255-0751
Enkelis, Liane/764 Sutter Ave, Palo Alto, CA415-326-3253
Epstein, Rachel/PO Box 772, Ukiah, CA707-468-0514
Ergenbright, Ric/PO Box 1067, Bend, OR (P 289)**503-389-7662**
Ersland, Bill/PO Box 556, Stillwater, MN612-430-1878
Esgro, Dan/PO Box 38536, Los Angeles, CA213-932-1919
Eskenazy, Marcel/1231 24th St #4, Santa Monica, CA213-828-4464
Estel, Suzanne/2325 3rd St, San Francisco, CA415-864-3661
Evans, Douglas/111 S Lander St #304, Seattle, WA206-621-8549
Evans, Marty/6850-K Vineland Ave, N Hollywood, CA818-762-5400

F

Fabrick, Ken/1320 Venice Blvd #308, Venice, CA213-822-1030
Fahey, Michael/608 3rd St, San Raphael, CA415-459-8777

Falconer, Michael/610 22nd St, San Francisco, CA415-626-7774
Falk, Randolph/123 16th Ave, San Francisco, CA415-751-8800
Faries, Tom/8520 Ostrich Circle, Fountain Valley, CA714-968-6568
Farmer, Roscoe/PO Box 1909, San Francisco, CA415-474-8457
Farrell, Craig/80 Laurel Dr, Carmel Valley, CA408-659-4445
Faubel, Warren/627 S Highland Ave, Los Angeles, CA213-939-8822
Feldman, Marc/6442 Santa Monica Blvd, Hollywood, CA213-463-4829
Feller, Bob/Worldway Ctr #91435, Los Angeles, CA213-670-1177
Felt, Jim/1316 SE 12th Ave, Portland, OR503-238-1748
Felzman, Joe/4504 SW Corbett Ave #120, Portland, OR503-224-7983
Finnegan, Kristin/3045 NW Thurman St, Portland, OR503-241-2701
Firebaugh, Steve/6750 55th Ave S, Seattle, WA
(P 312,313)**206-721-5151**
Fischer, Curt/51 Stillman St, San Francisco, CA415-974-5568
Fischer, Hanna/1118 Drake Dr, Davis, CA916-756-0338
Fisher, Arthur Vining/271 Missouri St, San Francisco, CA415-626-5483
Fitch, Wanelle/1142 Manhattan Ave #333, Manhattan Beach, CA213-546-2490
Flavin, Frank/901 W 54th St, Anchorage, AK907-561-1606
Flood, Alan/206 14th Ave, San Mateo, CA415-572-0439
Fogg, Don/400 Treat St #E, San Francisco, CA415-974-5244
Foothorap, Robert/426 Bryant St, San Francisco, CA415-957-1447
Forsman, John/8696 Crescent Dr, Los Angeles, CA213-933-9339
Forster, Bruce/431 NW Flanders, Portland, OR503-222-5222
Fort, Daniel/PO Box 11324, Costa Mesa, CA714-546-5709
Fowler, Bradford/1522 Sanborn Ave, Los Angeles, CA213-464-5708
Fox, Charles/PO Box 60432, Palo Alto, CA415-327-3556
Frankel, Tracy/641 Bay St, Santa Monica, CA213-396-2766
Franklin, Charly/3352 20th St, San Francisco, CA415-543-5400
Franz-Moore, Paul/421 Tehama, San Francisco, CA415-495-6183
Franzen, David/746 Ilaniwai St #200, Honolulu, HI808-537-9921
Frazier, Jules/PO Box 84345, Seattle, WA206-283-3633
Frazier, Kim Andrew/PO Box 998, Lake Oswego, OR503-697-8798
Freed, Jack/749 N La Brea, Los Angeles, CA213-931-1015
Freedman, Holly/2312 Cheryl Pl, Los Angeles,
CA (P 303)**213-472-1715**
Freeman, Davis/365 Wheeler St, Seattle, WA206-284-1767
Freeman, Hunter/1123 S Park, San Francisco, CA415-495-1900
Freis, Jay/416 Richardson St, Sausalito, CA415-332-6709
French, Nancy/7421 Laurel Canyon Blvd #14, North Hollywood, CA818-982-5448
French, Peter/PO Box 100, Kamuela, HI808-889-6488
Fridge, Stephen/PO box 410413, San Francisco, CA415-550-6711
Fried, Robert/29 Aries Lane, Novato, CA415-898-6153
Friedlander, Ernie/275 Sixth St, San Francisco, CA415-777-3373
Friedman, Todd/PO Box 3737, Beverly Hills, CA213-474-6715
Friend, David/3886 Ampudia St, San Diego, CA619-260-1603
Frigge, Eric714-854-2985
Frisch, Stephen/ICB - Gate 5 Rd, Sausalito, CA415-332-4545
Frisella, Josef/340 S Clark Dr, Beverly Hills, CA213-659-7676
Fritz, Michael/PO Box 4386, San Diego, CA (P 315)**619-281-3297**
Fritz, Steve/3201 San Gabriel Ave, Glendale, CA213-629-8052
Fritze, Jack/2106 S Grand, Santa Ana, CA714-545-6466
Fruchtman, Jerry/8735 Washington Blvd, Culver City, CA213-839-7891
Fry, George B III/PO Box 2465, Menlo Park, CA415-323-7663
Fujioka, Robert/715 Stierlin Rd, Mt View, CA415-960-3010
Fukuda, Steve/454 Natoma, San Francisco, CA415-543-9339
Fukuhara, Richard Yutaka/1032-2 Taft Ave, Orange, CA714-998-8790
Fuller, George/4091 Lincoln Ave, Oakland, CA415-530-3814
Furon, Daniel/3435 Army #202, San Francisco, CA415-821-0919
Furuta, Carl/7360 Melrose Ave, Los Angeles, CA213-655-1911

G

Gage, Rob/789 Pearl St, Laguna Beach, CA714-494-7265
Gallagher, John/PO Box 4070, Seattle, WA206-937-2422
Galvan, Gary/4626 1/2 Hollywood Blvd, Los Angeles, CA213-667-1457
Garcia, Elma/2565 Third St #308, San Francisco, CA415-641-9992
Gardner, Robert/800 S Citrus Ave, Los Angeles, CA213-931-1108
Gasperini, Robert/PO Box 954, Folsom, CA916-985-6474
Gates, Valerie/1235 S Bedford St, Los Angeles, CA213-271-0979
Gelert, Rex/2660 S Grand Ave, Snata Ana, CA714-751-2727
Gelineau, Val/1265 S Cochran, Los Angeles, CA213-465-6149
Gendreau, Raymond/114 Alaskan Way S, Seattle,
WA (P 337)**206-543-2518**
Gerretsen, Charles/1714 N Wilton Pl, Los Angeles, CA213-462-6342
Gersten, Paul/1021 1/2 N La Brea, Los Angeles, CA213-850-6045
Gervais, Lois/923 E 3rd St, Los Angeles, CA213-617-3338
Gervase, Mark/PO Box 38573, Los Angeles, CA213-877-0928
Ghelerter, Michael/1020 41st St, Emeryville, CA415-547-8456

Giannetti Photography/730 Clementina St, San Francisco, CA	415-864-0270
Gick, Peter/659 W Dryden St #5, Glendale, CA	818-500-0880
Giefer, Sebastian/3132 Hollyridge Dr, Hollywood, CA	213-461-1122
Gilbert, Elliot/311 N Curson Ave, Los Angeles, CA	213-939-1846
Gillette, Richard/PO Box 1400, 6856 Lois Ln, Forestville, CA	707-887-1718
Gilley, Rob/PO Box 232367, Leucadia, CA	619-944-7873
Gilmore, Ed/54 Palm Ave, San Francisco, CA	415-861-7882
Giraud, Steve/2960 Airway Ave #B-103, Costa Mesa, CA	714-751-8191
Gleis, Nick/4040 Del Rey #7, Marina Del Rey, CA	213-823-4229
Glendinning, Edward/1001 East 1st St, Los Angeles, CA	213-617-1630
Glenn, Joel/439 Bryant St, San Francisco, CA	415-957-1273
Gnass, Jeff/PO Box 91490, Portland, OR	503-629-2020
Goavec, Pierre Yves/2335 3rd St #201, San Francisco, CA	415-552-7331
Goble, James/620 Moulton Ave #205, Los Angeles, CA	213-222-7661
Goble, Jeff/300 Second Ave W, Seattle, WA	206-285-8765
Godwin, Bob/1427 E 4th St #1, Los Angeles, CA	213-269-8001
Going, Michael/1117 N Wilcox Pl, Los Angeles, CA	213-465-6853
Goldman, Larry/23674 Stagg, West Hills, CA	818-347-6865
Goldner, David/833 Traction Ave, Los Angeles, CA	212-617-0761
Goodman, Todd/2412-B Bayview Dr, Manhattan Beach, CA	213-453-3621
Gordon, Jon/2052 Los Feliz Dr, Thousand Oaks, CA	805-496-1485
Gordon, Larry Dale/225 Crossroads #410, Carmel, CA	408-624-1313
Gorman, Greg/1351 Miller Dr, Los Angeles, CA	213-650-5540
Gottlieb, Mark/1915 University Ave, Palo Alto, CA	415-321-8761
Gowans, Edward/10316 NW Thompson Rd, Portland, OR	503-223-4573
Grady, Noel/277 Rodney Ave, Encinitas, CA	619-753-8630
Graham, Don/1545 Marlay Dr, Los Angeles, CA	213-656-7117
Graham, Ellen/614 N Hillcrest Rd, Beverly Hills, CA	213-275-6195
Graham, Jay/6 Bridge Ave #8, San Anselmo, CA	415-459-3839
Graves, Robert/30 NW 1st Ave #202, Portland, OR	503-226-0099
Graves, Tom/296 Randall St, San Francsico, CA	415-550-7241
Gray, Dennis/8705 W Washington Blvd, Culver City, CA	213-559-1711
Gray, Todd/1962 N Wilcox, Los Angeles, CA	213-466-6088
Greene, Jim Photo/PO Box 2150, Del Mar, CA	619-270-8121
Greenleigh, John/756 Natoma, San Francisco, CA	415-864-4147
Gregg, Barry/84 University #210, Seattle, WA (P 297)	**206-285-8695**
Grigg, Robert/1050 N Wilcox Ave, Hollywood, CA	213-469-6316
Grimm, Tom & Michelle/PO Box 83, Laguna Beach, CA	714-494-1336
Grison, Herve/4917 W Washington Blvd, Los Angeles, CA	213-464-5608
Griswold, Eric/1210 SE Gideon, Portland, OR	503-232-7010
Grodske, Kirk/19235-7 Hamlin St, Reseda, CA	818-344-5966
Groenekamp, Greg/3710 Dunn Dr #3, Los Angeles, CA	213-838-2466
Groutoge, Monty/2214 S Fairview Rd, Santa Ana, CA	714-751-8734
Gunn, Lorenzo/POB 13352, San Diego, CA	619-280-6010

H

Hadel, Gregg E/15431 Red Hill, Tustin, CA	714-259-9224
Hagopian, Jim/915 N Mansfield Ave, Hollywood, CA	213-856-0018
Hagyard, Dave/1205 E Pike, Seattle, WA	206-322-8419
Haislip, Kevin/PO Box 1862, Portland, OR	503-254-8859
Hale, Bruce H/421 Bryant St, San Francisco, CA	415-882-9695
Hall, Bill Photo/917 20th St, Sacramento, CA	916-443-3330
Hall, George/601 Minnesota St, San Francisco, CA	415-821-7373
Hall, Norman/55 New Montgomery St #807, San Francisco, CA	415-543-8070
Hall, Steven/645 N Eckhoff St #P, Orange, CA	714-634-1132
Hall, William/19881 Bushard St, Huntington Bch, CA	714-968-2473
Halle, Kevin/8165 Commerce Ave, San Diego, CA	619-549-8881
Hamilton, David W/455 S Eliseo Dr #10, Greenbrea, CA	415-461-5901
Hamman, Rich/3015 Shipway Ave, Long Beach, CA	213-421-5708
Hammid, Tino/6305 Yucca St #500, Los Angeles, CA	213-461-8017
Hammond, Paul/1200 Carlisle, San Mateo, CA	415-574-9192
Hampton, Wally/4190 Rockaway Beach, Bainbridge Isl, WA	206-842-9900
Hanauer, Mark/2228 21st St, Santa Monica, CA	213-462-2421
Hands, Bruce/PO Box 16186, Seattle, WA	206-938-8620
Hansen, Jim/2800 S Main St #1, Santa Ana, CA	714-545-1343
Hara/265 Prado Rd #4, San Luis Obispo, CA	805-543-6907
Harding, C B/660 N Thompson St, Portland, OR	503-281-9907
Harmel, Mark/714 N Westbourne, West Hollywood, CA	213-659-1633
Harrington, Kim/1420 45th St 326, Emeryville, CA	415-653-6554
Harrington, Marshall/2775 Kurtz St #2, San Diego, CA	619-291-2775
Harris, Paul/4601 Larkwood Ave, Woodland Hills, CA	818-347-8294
Hart, G K/780 Bryant St, San Francisco, CA	415-495-4278
Hart, Jerome/4612 NE Alameda, Portland, OR	503-224-3003
Hartman, Raiko/1060 N Lillian Way, Los Angeles, CA	213-278-4700
Harvey, Philip/1195 Oak St, San Francisco, CA	415-861-2091
Harvey, Stephen/7801 W Beverly Blvd, Los Angeles, CA	213-934-5817
Hastings, Ryan/309 S Cloverdale, Seattle, WA	206-762-8691

Hathaway, Steve/400 Treat Ave #F, San Francisco, CA	415-255-2100
Hawkes, William/5757 Venice Blvd, Los Angeles, CA	213-931-7777
Hawley, Larry/6502 Santa Monica Blvd, Hollywood, CA	213-466-5864
Haythorn, Tom/820 SE Sandy Blvd, Portland, OR	503-222-1990
Healy, Brian/333-A 7th St, San Francisco, CA	415-861-1008
Heffernan, Terry/352 6th St, San Francisco, CA	415-626-1999
Hellerman, Robert/920 N Citrus Ave, Los Angeles, CA	213-466-6030
Henderson, Tom/11722 Sorrento Vly Rd #A, San Diego, CA	619-481-7743
Hendrick, Howard/839 Bridge Rd, San Leandro, CA	415-483-1483
Herrin, Kelly/1623 South Boyd, Santa Ana, CA	714-261-1102
Herrmann, Karl/3165 S Barrington Ave #F, Los Angeles, CA	213-397-5917
Herron, Matt/PO Box 1860, Sausalito, CA	415-479-6994
Hershey, Bruce/4790 Irvine Blvd #105-220, Irvine, CA	714-248-5288
Hess, Geri/134 S Roxbury Dr, Beverly Hills, CA	213-276-3638
Hewett, Richard/5725 Buena Vista Terr, Los Angeles, CA	213-254-4577
Hicks, Alan/PO Box 4186, Portland, OR	503-226-6741
Hicks, Jeff/41 E Main St, Los Gatos, CA	408-395-2277
Higgins, Donald/201 San Vincente Blvd #14, Santa Monica, CA	213-393-8858
Highton, Scott/996 McCue Ave, San Carlos, CA	415-592-5277
Hightower Woodward Photo/504-Q W Chapman, Orange, CA	714-639-1276
Hildreth, Jim/2565 3rd St #220, San Francisco, CA	415-821-7398
Hill, Dennis/20 N Raymond Ave #14, Pasadena, CA	818-795-2589
Hiller, Geoff/44 Jersey St, San Francisco, CA	415-824-7020
Hines, Richard/734 E 3rd St, Los Angeles, CA	213-625-2333
Hirsch, Claudia/600 Moulton Ave #203, Los Angeles, CA	213-342-0226
Hirshew, Lloyd/750 Natoma, San Francisco, CA	415-861-3902
Hishi, James/612 S Victory Blvd, Burbank, CA	213-849-4871
Hixson, Richard/3330 Vincent Rd #1, Pleasant Hills, CA	415-621-0246
Hodes, Brian Black/812 S Robertson Blvd, Los Angeles, CA	213-282-0500
Hodges, Rose/2325 3rd St #401, San Francisco, CA	415-550-7612
Hodges, Walter/1605 Twelfth Ave #25, Seattle, WA	206-325-9550
Hoffman, Davy/1923 Colorado Ave, Santa Monica, CA	213-453-4661
Hoffman, Paul/4500 19th St, San Francisco, CA	415-863-3575
Hofmann, Mark/827 N Fairfax Ave, Los Angeles, CA	213-450-4236
Hogg, Peter/1221 S La Brea, Los Angeles, CA	213-937-0642
Holden, Andrew/17911 Sky Park Circle, Irvine, CA	714-553-9455
Holder, Leland/23311 Via Linda #6, Mission Viejo, CA	714-583-9215
Hollenbeck, Cliff/Box 4247 Pioneer Sq, Seattle, WA	206-682-6300
Holmes, Mark/PO Box 556, Mill Valley, CA	415-383-6783
Holmes, Robert/PO Box 556, Mill Valley, CA	415-383-6783
Holmes, Tim/217 NE 8th St, Portland, OR	503-230-0468
Holmgren, Robert/319 Central Ave, Menlo Park, CA	415-325-6837

**Holt, David/1624 Cotner Ave #B, Los Angeles,
CA (P 266,267)** .. **213-478-1188**

Honowitz, Ed/39 E Walnut St, Pasadena, CA	818-584-4050
Hopkins, Stew/2112 NE 137th St, Seattle, WA	206-362-1871
Horikawa, Michael/508 Kamakee St, Honolulu, HI	808-538-7378
Housel, James F/84 University St #409, Seattle, WA	206-682-6181
Howe, Christina/3652 Francis Ave N #201, Seattle, WA	206-869-9348
Hudetz, Larry/11135 SE Yamhill, Portland, OR	503-245-6001
Huling, Rod/84 University #207, Seattle, WA	206-622-8486
Hunt, Phillip/3435 Army St #206, San Francisco, CA	415-821-9879
Hunter, Jeff/4626 1/2 Hollywood Blvd, Los Angeles, CA	213-669-0468
Huss, W John/520 Murray Canyon Dr, Palm Springs, CA	619-325-3563
Hussey, Ron/229 Argonne #2, Long Beach, CA	213-439-4438
Hylen, Bo/1640 S LaCienega, Los Angeles, CA	213-271-6543
Hyun, Douglass/13601 Ventura Blvd #174, Sherman Oaks, CA	818-789-4729

IJ

Imagic/1545 N Wilcox Ave, Hollywood, CA (P 355) **213-461-7766**

Imstepf, Charles/620 Moulton Ave #216, Los Angeles, CA	213-222-8773
Ingham, Stephen/2717 NW St Helens Rd, Portland, OR	503-274-9788
Iri, Carl/5745 Scrivener, Long Beach, CA	213-658-5822

**Irion, Christopher/183 Shiply St, San Francisco,
CA (P 268,269)** .. **415-896-0752**

Irwin, Dennis/164 Park Ave, Palo Alto, CA	415-321-7959
Isaacs, Robert/1646 Mary Ave, Sunnyvale, CA	408-245-1690
Isola, Vincent/185 Moffatt Blvd, Mountain View, CA	415-967-2301
Iverson, Michele/1527 Princeton #2, Santa Monica, CA	213-829-5717
Iwaya, Hiroshi/1314 NW Irving St #703, Portland, OR	503-223-2385
Jacobs, Dan/1527 13th Ave, Seattle, WA	206-325-2975
Jacobs, Michael/646 N Cahuenga Blvd, Los Angeles, CA	213-461-0240
Jaffee, Robert/140 Nursery St, Ashland, OR	503-482-3808
Jang, Michael/587 9th Ave, San Francisco, CA	415-751-3431
Jansen, Peter/122 Martina St, Pt Richmond, CA	415-235-2958
Jarrett, Michael/16812 Red Hill, Irvine, CA	714-250-3377
Jenkin, Bruce/1305 E St/Gertrude Pl #D, Santa Ana, CA	714-546-2949

Jensen, John/449 Bryant St, San Francisco, CA......................415-957-9449
Johannesson Photography/1162 E Valencia Dr, Fullerton, CA714-738-1152
Johnson, Charles/2124 3rd Ave W, Seattle, WA......................206-284-6223
Johnson, Conrad/350 Sunset Ave, Venice, CA......................213-392-0541
Johnson, Edward/11823 Blythe St, N Hollywood, CA......................818-765-2890
Johnson, Geoffrey/PO Box 6186, Albany, CA......................415-528-9005
Johnson, Payne B/4650 Harvey Rd, San Diego, CA......................619-299-4567
Johnson, Ron Photo/2104 Valley Glen, Orange, CA......................714-637-1145
Johnson, Stuart/688 S Santa Fe Ave #301, Los Angeles, CA......................213-744-1844
Jones, William B/2171 India St #B, San Diego, CA......................619-235-8892

K

Kaake, Phillip/47 Lusk, San Francisco, CA......................415-546-4079
Kaehler, Wolfgang/13641 NE 42nd St, Bellevue, WA......................206-881-6581
Kaestner, Reed/2120 J Durante Blvd #4, Del Mar, CA......................619-755-1200
Kaldor, Curt W/1011 Grandview Dr, S San Francisco, CA......................415-583-8704
Kallewaard, Susan/4450 Enterprise #112, Fremont, CA......................415-651-7202
Kam, Henrick/2325 3rd St #408, San Francisco, CA......................415-861-7093
Kamens, Les/333-A 7th St, San Francisco, CA......................415-621-1888
Kamin, Bonnie/PO Box 745, Fairfax, CA......................415-456-5913
Kaplan, Fred/5618 Berkshire Dr, Los Angeles, CA......................213-227-8858
Kaplan, K B/302 Evergreen Ln, Mill Valley, CA......................415-389-8220
Karageorge, Jim/610 22nd St #309, San Francisco, CA......................415-648-3444
Karau, Timothy/4213 Collis Ave, Los Angeles, CA......................213-221-9749
Kasmier, Richard/441 E Columbine #I, Santa Ana, CA......................714-545-4022
Kasparowitz, Josef/PO Box 14408, San Luis Obispo, CA......................805-544-8209
Katano, Nicole/112 N Harper, Los Angeles, CA......................213-655-1717
Kato, Sig/940 East 2nd St #3, Los Angeles, CA......................213-617-0708
Katzenberger, George/211-D E Columbine St, Santa Ana, CA......................714-545-3055
Kauffman, Helen/9017 Rangeley Ave, Los Angeles, CA......................213-275-3569
Kaufman, Mitch/2244 Walnut Grove Ave/POB 194, Rosemead, CA818-302-7983
Kearney, Ken/8048 Soquel Dr, Aptos, CA......................408-688-4546
Keenan, Elaine Faris/421 Bryan St, San Francisco, CA......................415-546-9246
Keenan, Larry/421 Bryant St, San Francisco, CA......................415-495-6474
Kehl, Robert/769 22nd St, Oakland, CA......................415-452-0501
Keller, Greg/769 22nd St, Oakland, CA......................415-452-0501
Kelley, Tom/8525 Santa Monica Blvd, Los Angeles, CA......................213-657-1780
Kermani, Shahn/109 Minna St #210, San Francisco, CA......................415-567-6073
Kerns, Ben/1201 First Ave S, Seattle,
WA (P 270,271) **206-621-7636**
Kilberg, James/3371 Cahuenga Blvd W, Los Angeles, CA......................213-874-9514
Killian, Glen/1270 Rio Vista, Los Angeles, CA......................213-263-6567
Kim, James/5765 Thorwood Dr, Santa Barbara, CA......................805-964-1400
Kimball, Ron/1960 Colony, Mt View, CA......................415-948-2939
Kimball-Nanessence/PO Box 2408, Julian, CA......................619-762-0765
Kimoto, Hitoshi/1227 N Hoover #6, Los Angeles,
CA (P 28,29) **213-663-1267**
Kimura, Margaret/940 N Highland Ave, Los Angeles, CA......................213-467-1923
King, CR/2420 24th St, San Francisco, CA......................415-652-5112
King, Kathleen/1932 1st Ave, Seattle, WA......................206-443-2800
King, Nicholas/3102 Moore St, San Diego, CA......................619-296-8200
King, Taylor/620 Moulton Ave #210, Los Angeles, CA......................213-225-9722
Kious, Gary/9800 Sepulvada Blvd #304, Los Angeles, CA......................213-536-4880
Kirkland, Douglas/9060 Wonderland Park Ave, Los Angeles, CA........213-656-8511
Kirkpatrick, Mike/1115 Forest Way, Brookdale, CA......................408-395-1447
Klein, Karey/1513 NE 92nd St, Seattle, WA......................206-528-0691
Kleinman, Kathryn/3020 Bridgeway #315, Sausalito, CA......................415-331-5070
Kobayashi, Ken/1750-H Army St, San Francisco, CA......................415-826-4382
Koch, Jim/1360 Logan Ave #106, Costa Mesa, CA......................714-957-5719
Kodama & Moriarty Photo/4081 Glencoe Ave, Marina Del Rey, CA......213-306-7574
Koehler, Rick/1622 Edinger #A, Tustin, CA......................714-259-8787
Kohler, Heinz/125 Electric Dr, Pasadena, CA......................213-564-1130
Kolodny, Jeff/20335 Arminta, Canoga Park, CA......................818-718-9010
Koosh, Dan/PO Box 6038, Westlake Village, CA......................818-991-2105
Kopp, Pierre/PO Box 8337, Long Beach, CA......................213-430-8534
Kopriva, Greg/16150 NE 85th St #222, Redmond, WA......................206-292-1662
Korn, Steve/1818 Barry #208, Los Angeles, CA......................213-478-8560
Kosta, Jeffrey/2565 Third St #306, San Francisco, CA......................415-285-7001
Kramer, David/3109 1/2 Beverly Blvd, Los Angeles, CA......................213-388-6747
Krasner, Carin/3239 Helms Ave, Los Angeles, CA......................213-280-0082
Kredenser, Peter/2551 Angelo Dr, Los Angeles, CA......................213-278-6356
Krisel, Ron/1925 Pontius Ave, Los Angeles, CA......................213-477-5519
Krosnick, Alan/2800 20th St, San Francisco, CA......................415-285-1819
Krueger, Gary/PO Box 543, Montrose, CA......................818-249-1051
Krupp, Carl/PO Box 910, Merlin, OR......................503-479-6699
Kubly, Jon/604 Moulton, Los Angeles, CA......................213-224-8947
Kuhn, Chuck/206 Third Ave S, Seattle, WA......................206-624-4706

Kuhn, Robert/3022 Valevista Tr, Los Angeles, CA......................213-461-3656
Kumin, Jesse/2565 Third St #220, San Francisco, CA......................415-282-3935
Kunin, Claudia/2359 Loma Vista Pl, Los Angeles, CA......................213-661-0351
Kunkel, Larry/729 Minna Alley, San Francisco, CA......................415-621-0729
Kunstadt, Hilda/4450 La Barca Dr, Tarzana, CA......................818-342-0051
Kurihara, Ted/601 22nd St, San Francisco, CA......................415-285-3200
Kurisu, Kaz/819 1/2 N Fairfax, Los Angeles, CA......................213-655-7287
Kurtz, Steve/PO Box 625, Soquel, CA......................408-425-1090
Kurzweil, Gordon M/211 15th St, Santa Monica, CA......................213-395-0624

L

Lamb & Hall/7318 Melrose, Los Angeles, CA......................213-931-1775
Lammers, Bud/211-A East Columbine, Santa Ana, CA......................714-546-4441
Lamont, Dan/2227 13th Ave E, Seattle, WA......................206-324-7757
Lamotte, Michael/828 Mission St, San Francisco, CA......................415-777-1443
Lan, Graham/PO Box 211, San Anselmo, CA......................415-492-0308
Landau, Robert/7274 Sunset Blvd #3, Los Angeles, CA......................213-851-2995
Landecker, Tom/288 7th St, San Francisco, CA......................415-864-8888
Landreth, Doug/1940 124th Ave NE #A-108, Bellevue, WA......................206-453-0466
Lane, Bobbi/7213 Santa Monica Blvd, Los Angeles, CA......................213-874-0557
Langdon, Harry/8275 Beverly Blvd, Los Angeles, CA......................213-651-3212
Langston, Karen/905 N Cole Ave #2100, Los Angeles, CA......................213-463-7513
Lanker, Brian/1993 Kimberly Dr, Eugene, OR......................503-485-4011
Lanzer, Jack/16952 Dulca Ynez Lane, Pacific Palisades, CA......................213-459-1213
LaRocca, Jerry/3734 SE 21st Ave, Portland, OR......................503-232-5005
Larson, Dean/7668 Hollywood Blvd, Los Angeles, CA......................213-876-1033
LaTona, Kevin/159 Western Ave W #454, Seattle, WA......................206-285-5779
Lauderborn, Lawrence/301 8th St #213, San Francisco, CA......................415-863-1132
Law, Graham/PO Box 211, San Anselmo, CA......................415-898-5385
Lawder, John/2672 S Grand, Santa Ana, CA......................714-557-3657
Lawlor, John/723 N Cahuenga Blvd, Los Angeles, CA......................213-468-9050
Lawne, Judith/6863 Sunny Cove, Hollywood, CA......................213-874-3095
Lawson, Greg/PO Box 1680, Ramona, CA......................619-789-8878
Lea, Thomas/181 Alpine, San Francisco, CA......................415-864-5941
Leatart, Brian/520 N Western, Los Angeles, CA......................213-856-0121
LeBon, David/1148 2nd St, Manhattan Beach, CA......................213-375-4877
LeCoq, John Land/2527 Fillmore St, San Francisco, CA......................415-563-4724
Lee, Larry/PO Box 4688, North Hollywood, CA......................805-259-1226
Lee, Roger Allyn/601 Fourth St Loft 128, San Francisco, CA......................415-543-6463
Lee, Sherwood/632 Alta Vista Circle, Pasadena, CA......................213-255-1338
Legname, Rudi/389 Clementina St, San Francisco, CA......................415-777-9569
Lehman, Danny/6643 W 6th St, Los Angeles, CA......................213-652-1930
Leiber, Gregory/PO Box 985, Ashland, OR......................503-770-8006
Leighton, Ron/1360 Logan #105, Costa Mesa, CA......................714-641-5122
Leng, Brian/1021 1/2 N La Brea, Los Angeles, CA......................213-469-8624
LeNoue, Wayne/1441 Kearny St, San Francisco, CA......................415-981-1776
Levasheff, Michael/12001 Foothill Blvd #73, Lakeview Terrace, CA......213-946-2511
Levenson, Alan/1402 N Sierra Bonita Ave, Los Angeles, CA......................213-851-8863
Levy, Paul/2830 S Robertson Blvd, Los Angeles, CA......................213-838-2252
Levy, Richard J/1015 N Kings Rd #115, Los Angeles, CA......................213-654-0335
Levy, Ron/PO Box 3416, Soldotna, AK (P 319) **907-262-7899**
Lewin, Elyse/820 N Fairfax, Los Angeles, CA......................213-655-4214
Lewine, Rob/8929 Holly Pl, Los Angeles, CA......................213-654-0830
Lewis, Cindy/2554 Lincoln Blvd #1090, Marina Del Rey, CA......................213-301-1977
Lewis, Don/2350 Stanley Hills Dr, Los Angeles, CA......................213-656-2138
Lezo, Roman/14464-B Benefit St, Sherman Oaks, CA......................818-789-2700
Li, Jeff/8954 Ellis Ave, Los Angeles, CA......................213-837-5377
Lidz, Jane/33 Nordhoff St, San Francisco, CA......................415-587-3377
Liles, Harry/1060 N Lillian Way, Hollywood, CA......................213-466-1612
Lin, Martin/6502 Nagel Ave, Van Nuys, CA......................818-994-4876
Lindsey, Gordon/2311 Kettner Blvd, San Diego, CA......................619-234-4432
Lindstrom, Mel/63 Encina, Palo Alto, CA (P 320,321) ...**415-325-9677**
Linn, Alan/5121 Santa Fe St #B, San Diego, CA......................619-483-2122
Linna, Jim/900 1st Ave S #206, Seattle, WA......................206-624-7344
Livzey, John/1510 N Las Palmas, Hollywood, CA......................213-469-2992
Lockwood, Scott/2109 Stoner Ave, Los Angeles,
CA (P 322) **310-312-9923**
Loken, Blake/5809 Via Corona, Los Angeles, CA......................213-721-9029
London, Matthew/15326 Calle Juanito, San Diego, CA......................619-457-3251
Londoner, Hank/1921 N Hobart, Los Angeles, CA......................213-462-1707
Longwood, Marc/3045 65th St #6, Sacramento, CA......................916-731-5373
Lopez, Juan/3730 Vintor Ave #6, Los Angeles, CA......................213-836-9313
Lopez, S Peter/6306 Wilshire Blvd. #444, Beverly
Hills, CA (P 286) **213-650-7906**
Louie, Ming/14 Otis St, San Francisco, CA......................415-558-8663
Lovell, Buck/2145 W La Palma, Anaheim, CA......................714-635-9040
Lovell, Craig/80 Laurel Dr, Carmel Valley, CA......................408-659-4445

Lund, John M/860 Second St, San Francisco, CA415-957-1775
Lund, John William/741 Natoma St, San Francisco, CA415-552-7764
Lyon, Fred/237 Clara St, San Francisco, CA415-974-5645
Lyons, Marv/2865 W 7th St, Los Angeles, CA213-384-0732

M

MacDonald, James/14429 27th Dr SE, Mill Creek, WA.......................206-337-4658
Madden, Daniel J/PO Box 965, Los Alamitos, CA213-429-3621
Madison, David/2330 Old Middlefield Rd, Mountain View, CA...........415-961-6297
Magnuson, Mitchell D/23206 Normandie Ave #4, Torrance, CA........213-539-6355
Maharat, Chester/15622 California St, Tustin, CA714-832-6203
Maher, John/2406 NE 12th Ave, Portland, OR503-282-3815
Maloney, Jeff/265 Sobrante Way #D, Sunnyvale, CA..........................408-739-4030
Malphettes, Benoit/816 S Grand St, Los Angeles, CA213-629-9054
Mar, Tim/PO Box 3488, Seattle, WA...206-284-4484
Marcus, Ken/6916 Melrose Ave, Los Angeles, CA213-937-7214
Marenda, Frank/721 Hill St #105, Santa Monica, CA213-399-5206
Mareschal, Tom/5816 182nd Pl SW, Lynnwood, WA...........................206-771-6932
Margolies, Paul/22 Rosemont Pl, San Francisco, CA.........................415-621-3306
Markovich, Robert/7985 Maria Dr, Riverside, CA...............................714-681-0508
Marley, Stephen/1160 Industrial Way, San Carlos, CA415-966-8301
Marra, Ben/310 First Ave S #333, Seattle, WA...................................206-624-7344
Marriott, John/1830 McAllister, San Francisco, CA415-922-2920
Marsden, Dominic/3783 W Cahuenga Blvd, Studio City, CA..............818-508-5222
Marshall, Jim Photo/3622 16th St, San Francisco, CA415-864-3622
Marshall, John Lewis/2210 Wilshire Blvd #427, Santa Monica, CA......213-478-7464
Marshall, Kent/899 Pine St #1912, San Francisco, CA415-641-0932
Marshutz, Roger/1649 S La Cienega Blvd, Los Angeles, CA.............213-273-1610
Martin, Brent/37744 Thisbe Ct, Palmdale, CA....................................805-274-0967
Martin, Greg/700-D W 58th St, Anchorage, AK....................................907-563-6112
Martin, John F/118 King St, San Francisco, CA...................................415-957-1355
Mason, Don/80 S Jackson #306, Seattle, WA206-624-1668
Mason, Pablo/3026 North Park Way, San Diego, CA619-298-2200
Mastandrea, Michael/PO Box 68944, Seattle, WA206-244-6756
Masterson, Ed/11211-S Sorrento Val Rd, San Diego, CA.....................619-457-3251
Matsuda, Paul/920 Natoma St, San Francisco, CA.............................415-626-6146
Mauskopf, Norman/615 W California Blvd, Pasadena, CA818-578-1878
Maxwell, Craig/725 Clementina, San Francisco, CA...........................415-861-4131
May, P Warwick/PO Box 19308, Oakland, CA.....................................415-530-7319
McAfee, Lynn/12745 Moorpark #10, Studio City, CA...........................818-761-1317
McClain, Stan/39 E Walnut St, Pasadena, CA....................................818-795-8828
McClaran, Robby/PO Box 14573, Portland, OR..................................503-234-6588
McCormack, Mark/2707 Garnet, San Diego, CA619-581-5050
McCrary, Jim/211 S LaBrea Ave, Los Angeles, CA.............................213-936-5115
McCumsey, Robert/3535 E Coast Hwy, Corona Del Mar, CA714-720-1624
McDonald, Fred/650 9th St, San Francisco, CA..................................415-751-3565
McEvilley, John/1428 Havenhurst, Los Angeles, CA...........................213-656-7476
McGuire, Gary/1248 S Fairfax Ave, Los Angeles, CA..........................213-938-2481
McIntyre, Gerry/2100 Q Street, Sacramento, CA................................916-321-1278
McKinney, Andrew/1628 Folsom St, San Francisco, CA415-621-8415
McLane, Mark/214 Via Sevilla, Santa Barbara, CA..............................805-966-5783
McMahon, Steve/1164 S LaBrea, Los Angeles, CA............................213-937-3345
McNally, Brian/9937 Durant Dr, Beverly Hills, CA................................213-462-6565
McNeil, Larry/7107 Witchinghour Ct, Citrus Hts, CA...........................916-722-0302
McRae, Colin/1063 Folsom, San Francisco, CA415-863-0119
Mears, Jim/1471 Elliot Ave W, Seattle, WA ..206-284-0929
Mejia, Michael/244 9th St, San Francisco, CA415-621-7670
Melgar Photographers Inc/2971 Corvin Dr, Santa Clara, CA.................408-733-4500
Mendenhall, Jim/PO Box 4114, Fullerton, CA.....................................714-447-8555
Menuez, Doug/PO Box 2284, Sausalito, CA.......................................415-332-8154
Menzel, Peter J/180 Franklin St, Napa, CA...707-255-4720
Menzie, W Gordon/2311 Kettner Blvd, San Diego, CA.........................619-234-4431
Merfeld, Ken/3951 Higuera St, Culver City, CA...................................213-837-5300
Michels, Bob Photo/821 5th Ave N, Seattle, WA.................................206-282-6894
Migdale, Lawrence/6114 LaSalle Ave #433, Oakland, CA.....................415-482-4422
Miglaras, Yanis/525 1st St #104, Lake Oswego, OR............................503-635-5616
Mihulka, Chris/PO Box 1515, Springfield, OR......................................503-741-2289
Miles, Reid/1136 N Las Palmas, Hollywood, CA.................................213-462-6106
Milholland, Richard/911 N Kings Rd #113, Los Angeles, CA...............213-650-5458
Milkie Studio Inc/127 Boylston Ave E, Seattle, WA..............................206-324-3000
Miller, Bill/12429 Ventura Court, Studio City, CA.................................818-506-5112
Miller, Dennis/1467 12th St #C, Manhattan Beach, CA.......................213-546-3205
Miller, Donald/447 S Hewitt, Los Angeles, CA....................................213-680-1896
Miller, Earl/3212 Bonnie Hill Dr, Los Angeles, CA...............................213-851-4947
Miller, Jeff/300 Second Ave West, Seattle, WA...................................206-285-5975
Miller, Jim/1122 N Citrus Ave, Los Angeles, CA..................................213-466-9515
Miller, Jordan/506 S San Vicente Blvd, Los Angeles, CA.....................213-655-0408

Miller, Martin/5039 September St, San Diego, CA...............................619-276-4208
Miller, Peter Read/3413 Pine Ave, Manhattan Beach, CA....................213-545-7511
Miller, Ray/PO Box 450, Balboa Island, CA...714-675-0622
Miller, Robert/3826 Goodland , Studio City, CA..................................818-506-5678
Miller, Wynn/4083 Glencoe Ave, Marina Del Rey, CA.........................213-821-4948
Milliken, Brad/3341 Bryant St, Palo Alto, CA.......................................415-424-8211
Milne, Robbie/400 E Pine St, Seattle, WA...206-329-3757
Milroy/McAleer/711 W 17th St #G-7, Costa Mesa, CA
(P 323) ...**714-722-6402**
Mineau, Joe/8921 National Blvd, Los Angeles, CA.............................213-558-3878
Mishler, Clark/1238 G St, Anchorage, AK..907-279-0892
Mitchell, David Paul/564 Deodar lane, Bradbury, CA.........................415-540-6518
Mitchell, Josh/1984 N Main St #501, Los Angeles, CA.......................213-225-5674
Mitchell, Margaretta K/280 Hillcrest Rd, Berkeley, CA.........................415-655-4920
Mizono, Robert/650 Alabama St, San Francisco, CA415-648-3993
Mock, Dennis/13715 Sparren Ave, San Diego, CA.............................619-693-3201
Molenhouse, Craig/PO Box 7678, VAn Nuys, CA...............................818-901-9306
Molina, Jimi/6961 Havenhurst Ave, Van Nuys, CA.............................818-786-1566
Montague, Chuck/18005 Skypark Cir #E, Irvine, CA............................714-250-0254
Moore, Gary/1125 E Orange Ave, Monrovia, CA.................................818-359-9414
Moran, Edward/5264 Mount Alifan Dr, San Diego, CA.........................619-693-1041
Morduchowicz, Daniel/600 Moulton Ave #203, Los Angeles, CA..........213-223-1867
Morfit, Mason/897 Independence Ave #D, Mountain View, CA............415-969-2209
Morgan, J P/618 Moulton Ave #D, Los Angeles, CA...........................213-224-8288
Morgan, Mike/16252 E Construction, Irvine, CA..................................714-551-3391
Morgan, Scott/612-C Hampton Dr, Venice, CA...................................213-392-1863
Morrell, Paul/300 Brannan St #207, San Francisco, CA......................415-543-5887
Morris, Kevin/PO Box 4476, Seattle, WA...206-325-0664
Morris, Steve/PO Box 40261, Santa Barbara, CA...............................805-965-4859
Mosgrove, Will/85 Liberty Ship Way #110, Sausalito, CA....................415-331-1526
Moskowitz, Karen/1205 SE Pike, Seattle, WA....................................206-325-0142
Moss, Gary/1124 Oak Grove Dr, Los Angeles, CA..............................213-255-2404
Motil, Guy/253 W Canada, San Clemente, CA....................................714-492-1350
Muckley, Mike Photography/8057 Raytheon Rd #3, San Diego, CA.....619-565-6033
Mudford, Grant/5619 W 4th St #2, Los Angeles, CA...........................213-936-9145
Muench, David & Marc/PO Box 30500,
Santa Barbara, CA (P 284)...**805-967-4488**
Muna, R J/63 Encina Ave, Palo Alto, CA...415-328-1131
Murphy, Suzanne/2442 Third St, Santa Monica, CA...........................213-399-6652
Murray, Michael/15431 Redhill Ave #E, Tustin, CA..............................714-259-9222
Murray, William III/PO Box 2442, Redmond, WA.................................206-485-4011
Musilek, Stan/2141 3rd St, San Francisco, CA....................................415-621-5336
Mustafa, Bilal/5429 Russell NW, Seattle, WA......................................206-782-4164
Myer, Eric/2441 N Topanga Canyon Blvd, Topanga, CA213-455-1514

N

Nacca, Nick/6316 Riverdale St, San Diego, CA...................................619-280-9900
Nadler, Jeff/520 N Western Ave, Los Angeles, CA..............................213-467-2135
Nakashima, Les/600 Moulton Ave #101A, Los Angeles, CA................213-226-0506
Namaguchi, Charlene/17718 NE 160th Pl, Woodinville, WA................206-487-3498
Nance, Ancil/600 SW 10th St #530, Portland, OR...............................503-223-9534
Nation, Bill/937 N Cole #7, Los Angeles, CA......................................213-937-4888
Nease, Robert/441 E Columbine #E, Santa Ana, CA..........................714-545-6557
Nebeux, Michael/13450 S Western Ave, Gardena, CA.........................213-532-0949
Neil, Thomas/PO Box 901682, Palmdale, CA......................................213-202-0051
Neill, William/PO Box 162, Yosemite Nat Park,
CA (P 324)...**209-379-2841**
Nels/311 Avery St, Los Angeles, CA..213-680-2414
Nese, Robert/1215 E Colorado St #204, Glendale, CA818-247-2149
Neveux, Michael/13450 S Western Ave, Gardena,
CA (P 325)...**800-359-5143**
Newman, Greg/1356 Brampton Rd, Pasadena, CA213-257-6247
Nishihira, Robert/6150 Yarrow Dr #G, Carlsbad, CA............................619-438-0366
Nissing, Neil B/711 S Flower, Burbank, CA (P 326)**213-849-1811**
Noble, Richard/7618 Melrose Ave, Los Angeles, CA...........................213-655-4711
Nolton, Gary/107 NW Fifth Ave, Portland, OR (P 285)**503-228-0844**
Normark, Don/1622 Taylor Ave N, Seattle, WA...................................206-284-9393
Norwood, David/9023 Washington Blvd, Culver City, CA.....................213-204-3323
Nourok, Jonathan/2343 E 17th St #201, Long Beach, CA...................213-433-5600
Noyle, Ric/733 Auahi St, Honolulu, HI..808-524-8269
NTA Photo/600 Moulton Ave #101-A, Los Angeles, CA.......................213-226-0506
Nuding, Peter/2423 Old Middlefield Way #K, Mountain View, CA.........415-967-4854
Nyerges, Suzanne/413 S Fairfax, Los Angeles, CA.............................213-938-0151

O

O'Brien, Tom/450 S La Brea, Los Angeles, CA213-938-2008
O'Connor, Kelly/PO Box 2151, Los Gatos, CA408-378-5600
O'Hara, Yoshi/6341 Yucca St, Hollywood, CA213-466-8031
O'Rear, Chuck/PO Box 361, St Helena, CA....................................707-963-2663
Ochsner, Dennis/401 Second Ave S, Seattle, WA206-464-4033
Ogilvie, Peter/20 Millard Rd, Larkspur, CA415-924-5507
Ohno, Aki/940 E 2nd St #3, Los Angeles, CA213-617-1685
Oldenkamp, John/3331 Adams Ave, San Diego, CA619-283-0711
Olson, George/451 Vermont, San Francisco, CA415-864-8686
Olson, Jon/4045 32nd Ave SW, Seattle, WA206-932-7074
Olson, Rosanne W/5200 Latona Ave NE, Seattle,
WA (P 328,329) ..**206-633-3775**
Orazem, Scott/1150 1/2 Elm Dr, Los Angeles, CA213-277-7447
Orth, Geoffrey/PO Box 22, Ester, AK ...907-479-0014
Osbornem Bill/3118 196th Ave, Sumner, WA206-862-1977
Oshiro, Jeff/2534 W 7th St, Los Angeles, CA213-383-2774
Otto, Glenn/10625 Magnolia Blvd, North Hollywood, CA818-762-5724
Ounjian, Michael/612 N Myers St, Burbank, CA818-842-0880
Ovregaard, Keith/765 Clementina St, San Francisco, CA415-621-0687
Oyama, Rick/1265 S Cochran, Los Angeles, CA213-465-6149

P

Pacheco, Robert/11152 3/4 Morrison, N Hollywood, CA818-761-1320
Pacific Image/930 Alabama, San Francisco, CA415-282-2525
Pack, Bill/90 Natoma, San Francisco, CA......................................415-882-4460
Pack, Ross/175 Cohasset Rd #6, Chico, CA916-891-3442
Pacura, Tim/756 Natoma St, San Francisco, CA415-552-3512
Pagos, Terry/3622 Albion Pl N, Seattle, WA206-633-4616
Pan, Richard/722 N Hoover St, Los Angeles, CA213-661-6638
Panography/1514 Fruitvale, Oakland, CA415-261-3327
Papazian, David/618 NW Glisan, Portland, OR503-227-2930
Pape, Ross/1369 Lansing Ave, San Jose, CA415-595-4242
Parker, Douglas/1435 Gardena Ave #11, Glendale, CA213-660-6145
Parker, Suzanne/601 Minnesota, San Francisco, CA415-821-7373
Parks, Ayako/4572 Mariners Bay, Oceanside, CA714-240-8347
Parks, Jeff/12936 133rd Pl NE, Kirkland, WA206-821-5450
Parks, Peggy/21 Broadview Dr, San Rafael, CA415-457-5300
Parrish, Al/3501 Buena Vista Ave, Glendale, CA818-957-3726
Parry, Karl/8800 Venice Blvd, Los Angeles, CA213-558-4446
Parsons, Kimberly/2135 California St #10, San Francisco, CA415-346-4478
Pasley, Paul/418 Grande Ave, Davis, CA916-753-0501
Pasquali, Art/1061 Sunset Blvd, Los Angeles, CA213-250-0134
Patterson, Robert/915 N Mansfield Ave, Hollywood, CA213-462-4401
Paullus, Bill/PO Box 432, Pacific Grove, CA408-679-1624
Pavloff, Nick/PO Box 2339, San Francisco, CA415-452-2468
Peacock, Christian/930 Alabama St, San Francisco, CA..................415-641-8088
Pearlman, Andy Studios/4075 Glencoe Ave,
Marina Del Rey, CA (P 331) ..**310-306-9449**
Pearson, Lee/1746 North Ivar, Los Angeles, CA212-691-0122
Pedrick, Frank/PO Box 5541, Berkeley, CA415-849-2722
Peebles, Doug/445 Ilwahi Loop, Kailua, HI808-254-1082
Penoyar, Barbara/911 E Pike St #211, Seattle, WA206-324-5632
Percey, Roland/626 N Hoover, Los Angeles, CA213-660-7305
Perkins, Carl/PO Box 590, Moss Beach, CA415-726-7777
Perla, Dario/18 LaJacque Ct, Sacramento, CA916-555-1212
Perry, David/837 Traction Ave #104, Los Angeles, CA213-625-3567
Perry, David E/PO Box 4165 Pioneer Sq Sta,
Seattle, WA (P 332,333) ...**206-932-6614**
Peterson, Darrell/84 University #306, Seattle, WA...........................206-624-1762
Peterson, Richard/733 Auahi St, Honolulu, HI808-536-8222
Peterson, Richard Studio/711 8th Ave #A, San Diego, CA619-236-0284
Peterson, Scott/2565 3rd St #224, San Francisco, CA415-285-5112
Petrucelli, Tony/17522 Von Karman Ave, Irvine, CA714-458-6914
Pett, Laurence J/5907 Cahill Ave, Tarzana, CA818-344-9453
Petzke, Karl/610 22 St #305, San Francisco, CA415-626-5979
Pfleger, Mickey/PO Box 280727, San Francisco, CA415-355-1772
Pharoah, Rick/2830 Shoreview Circle, Westlake Village, CA805-496-7196
Phase Infinity/Ron Jones/6730 Lusk Blvd #F106, San Diego, CA619-546-0551
Philby, Donal/3102 Moore St, San Diego, CA619-692-0770
Phillips, Lee/4964 Norwich Place, Newark, CA415-794-7447
Photodesign LA/1020 N Cole Ave 2nd Fl, Hollywood, CA213-962-6350
Photography Northwest/1415 Elliot Ave W, Seattle, WA..................206-285-5249
Photogroup/3500 SE 22nd St/Bldg 41, Portland,
OR (P 334,335)...**503-233-4594**

Pinckney, Jim/PO Box 1149, Carmel Valley, CA..............................408-659-3002
Piper, Jim/922 SE Ankeny, Portland, OR (P 288)**503-231-9622**
Pisano, Robert/911 E Pike St #301, Seattle, WA206-324-6093
Piscitello/Svensson/11440 Chandler Blvd #1200, N Hollywood, CA818-769-2659
Pittman, Dustin ...213-655-0330
Pizur, Joe/194 Ohukai Rd, Kihie, Maui, HI808-879-6633
Place, Chuck/2940 Lomita Rd, Santa Barbara, CA..........................805-682-6089
Pleasant, Ralph B/8755 W Washington Blvd, Culver City, CA213-202-8997
Ploch, Thomas/30 S Salinas, Santa Barbara, CA805-965-1312
Plummer, Bill/963 Yorkshire Ct, Lafayette, CA415-284-1535
Plummer, Doug/501 N 36th St #409, Seattle, WA206-789-8174
Poppleton, Eric/1755 Correa Way, Los Angeles, CA213-471-2845
Porter, James/3955 Birch St #F, Newport Beach, CA714-852-8756
Poulsen, Chriss/104-A Industrial Center, Sausalito, CA415-331-3495
Powers, David/2699 18th St, San Francisco, CA415-641-7766
Powers, Lisa/1112 Beachwood, Los Angeles, CA213-465-5546
Powers, Michael/3045 65th St #7, Sacramento, CA916-451-5606
Prater, Yvonne/Box 940 Rt 1, Ellensburg, WA509-925-1774
Preuss, Karen/369 Eleventh Ave, San Francisco, CA415-752-7545
Pribble, Paul/911 Victoria Dr, Arcadia, CA213-262-8305
Price, Tony/PO Box 5216, Portland, OR ...503-239-4228
Pritchett, Bill/1771 Yale St, Chula Vista, CA619-421-6005
Pritzker, Burton/456 Denton Way, Santa Rosa, CA707-578-5461
Proehl, Steve/916 Rodney Dr, San Leandro, CA415-483-3683
Professional Photo/1011 Buenos Ave, San Diego, CA619-299-4410
Pronobus Photo/653 Commercial Rd, Palm Springs, CA619-320-8944
Pruitt, Brett/720 Iwilei Rd #260, Honolulu, HI808-521-1929

R

Rahn, Stephen/259 Clara St, San Francisco, CA415-495-3556
Ramey, Michael/2905 W Thurman, Seattle, WA206-329-6936
Rampy, Tom/PO Box 3980, Laguna Hills, CA714-850-4048
Ramsey, Gary/1412 Ritchey #A, Santa Ana, CA714-547-0782
Rand, Marvin/1310 W Washington Blvd, Venice, CA213-306-9779
Randall, Bob/1118 Mission St, S Pasadena, CA818-441-1003
Randlett, Mary/Box 10536, Bainbridge Island, WA206-842-3935
Randolph, Tom/324 Sunset Ave, Venice, CA..................................213-399-7058
Rantzman, Karen/2474-A Virginia St , Berkeley, CA........................415-841-6103
Rapoport, Aaron/3119 Beverly Blvd, Los Angeles, CA.....................213-738-7277
Rappaport, Rick/2725 NE 49th St, Portland, OR503-249-0705
Rausin, Chuck/4863 Maychelle, Anaheim, CA714-282-9173
Rawcliffe, David/7609 Beverly Blvd, Los Angeles, CA213-938-6287
Rayniak, J Bart/3510 N Arden Rd, Otis Orchards, WA509-924-0004
Reed, Bob/1816 N Vermont Ave, Los Angeles, CA213-662-9703
Reed, Joe/3401 W 5th St #120, Oxnard, CA800-888-5504
Reiff, Robert/4075 Glencoe Ave, Marina del Rey, CA213-306-3839
Reitzel, Bill/1001 Bridgeway #537, Sausalito, CA415-457-7385
Rhoney, Ann/2264 Green St, San Francisco, CA415-922-4775
Rich, Bill/109 Minna #459, San Francisco, CA415-775-8214
Rigelhof, John/527 Barrington Ave #16, Los Angeles, CA................213-471-6306
Riggs, Anthony/447 York Dr, Benencia, CA707-747-6948
Riggs, Robin/3785 Cahuenga W, N Hollywood, CA.........................818-506-7753
Ripley, John/470 Columbus #207, San Francisco, CA415-781-4940
Rish, Glenn/656 Orchid Ave, Montecito, CA805-969-9186
Ritts, Herb/7927 Hillside Ave, Los Angeles, CA213-876-6366
Robbins, Bill/7016 Santa Monica Blvd, Los Angeles, CA213-930-1382
Roberts, Chris J/84 University St #410, Portland, OR206-628-3643
Robin, David/818 Brannan St, San Francisco, CA415-863-8900
Rodal, Arney A/395 Winslow Way E, Bainbridge Island, CA206-842-4989
Rodney, Andrew/501 N Detroit St, Los Angeles, CA213-939-7427
Rogers, Art/PO Box 777, Point Reyes, CA415-495-4515
Rogers, Ken/PO Box 3187, Beverly Hills, CA213-553-5532
Rogers, Martin/1764 North Point, San Francisco, CA415-929-0999
Rogers, Peter/15621 Obsidian Ct, Chino Hills, CA714-597-4394
Rojas, Art/2465 N Batavia, Orange, CA ...714-921-1710
Rokeach, Barrie/499 Vermont Ave, Berkeley, CA415-527-5376
Rolston, Matthew/8259 Melrose Ave, Los Angeles, CA213-658-1151
Rose, Peter/2056 NW Pettygrove, Portland, OR..............................503-228-1288
Rosenberg, Alan/3024 Scott Blvd, Santa Clara, CA408-986-8484
Rosewood, Russell/PO Box 663, Truckee, CA916-587-3377
Ross, Alan C/202 Culper Ct, Hermosa Beach, CA213-379-2015
Ross, Dave/1619 Tustin Ave, Costa Mesa, CA714-642-0315
Ross, Herb/16072 Baker Canyon Rd, Canyon Country, CA818-501-6571
Ross, James Studio/2565 3rd St #220, San Francisco, CA408-725-1571
Rothman, Michael/1816 N Vermont Ave, Los Angeles, CA213-662-9703
Roundtree, Deborah/1316 Third St #3,
Santa Monica, CA (P 14)...**213-394-3088**

Rowan, Bob/209 Los Banos Ave, Walnut Creek, CA415-930-8687
Rowe, Wayne/567 North Beverly Glen, Los Angeles, CA213-475-7810
Rowell, Galen/1483-A Solano Ave, Albany, CA (P 359)**415-524-9343**
Rubin, Ken/4140 Arch Dr #209, Studio City, CA.........................818-508-9028
Rubins, Richard/3268 Motor Ave, Los Angeles, CA.....................213-287-0350
Ruppert, Michael/5086 W Pico, Los Angeles, CA.........................213-938-3779
Ruscha, Paul/940-F N Highland Ave, Los Angeles, CA..................213-465-3516
Russo, Michael/12100 Wilshire Blvd #1800, Los Angeles, CA213-442-1800
Ruthsatz, Richard/8735 Washington Blvd, Culver City, CA..............213-838-6312
Ryder Photo/136 14th St Apt B, Seal Beach, CA315-622-3499

S

Sabatini, Ken/915 1/2 N Mansfield Ave, Hollywood, CA213-462-7744
Sabella, Jill/2607 Ninth Ave W, Seattle, WA (P 290)**206-285-4794**
Sabransky, Cynthia/3331 Adams Ave, San Diego, CA619-283-0711
Sacks, Ron/PO Box 5532, Portland, OR.....................................503-641-4051
Sadlon, Jim/118 King St #530, San Francisco, CA415-541-0977
Safron, Marshal Studios Inc/1041 N McCadden Pl,
Los Angeles, CA (P 278,279)...**213-461-5676**
Sakai, Steve/724 S Stanley Ave #2, Los Angeles, CA213-460-4811
Saks, Stephen/807 Laurelwood Dr, San Mateo, CA415-574-4534
Salas, Michael/398 Flower St, Costa Mesa, CA714-722-9908
Saloutos, Pete/6851 Blue Sky Lane, Bainbridge Island, WA206-842-0832
Samerjan, Peter/743 N Fairfax, Los Angeles, CA........................213-653-2940
Sanchez, Kevin/1200 Indiana, San Francisco, CA........................415-285-1770
Sanders, Paul/7378 Beverly Blvd, Los Angeles, CA213-933-5791
Sanderson, Mark/2307 Laguna canyon Rd, Laguna Beach, CA714-497-4615
Sandison, Teri/8705 W Washington Blvd, Culver City, CA213-559-6446
Santos, Bill/5711 Florin Perkins Rd#1, Sacramento, CA916-383-7969
Santullo, Nancy/7213 Santa Monica Blvd, Los Angeles, CA213-874-1940
Sarpa, Jeff/11821 Mississippi Ave, Los Angeles, CA213-479-4988
Sasso, Gene/1285 Laurel Ave, Pomona, CA714-623-7424
Saunders, Paul/9272 Geronimo #111, Irvine, CA.........................714-768-4624
Scavo, Joe/1088 Irvine Blvd #518, Tustin, CA714-731-5630
Schaeffer, Steve (Schaf)/305 South Kalorama #1,
Ventura, CA (P 339) ..**805-652-1441**
Scharf, David/2100 Loma Vista Pl, Los Angeles, CA.....................213-666-8657
Schelling, Susan/244 Ninth St, San Francisco, CA415-621-2992
Schenck, Rocky/2210 N Beachwood Dr #10, Los Angeles, CA..........213-465-1547
Schenker, Larry/2830 S Robertson Blvd, Los Angeles, CA213-837-2020
Schermeister, Phil/472 22nd Ave, San Francisco, CA415-386-0218
Schiff, Darryll/8153 W Blackburn Ave, Los Angeles, CA213-658-6179
Schiffman, Bonnie/7515 Beverly Blvd, Los Angeles, CA213-965-0899
Schubert, John/11478 Burbank Blvd, N Hollywood, CA213-935-6044
Schultz, Jeff/PO Box 241452, Anchorage, AK907-561-5636
Schwager, Ron/PO Box 6157, Chico, CA916-891-6682
Schwartz, Stuart/301 8th St #204, San Francisco, CA415-863-8393
Schwob, Bill/5675-B Landragan, Emeryville, CA415-547-2232
Scinner, Peter/PO Box 652, Anacortes, WA206-293-5781
Scoffone, Craig/1169 Husted Ave, San Jose, CA408-723-7011
Scott, Mark/1208 S Genesee, Hollywood, CA213-931-9319
Sebastian Studios/5161-A Santa Fe St, San Diego, CA619-581-9111
Sedam, Mike/PO Box 1679, Bothell, WA206-488-9375
Segal, Susan Photography/11738 Moor Pk #B,
Studio City, CA (P 340,341) ...**818-763-7612**
Seidemann, Bob/1183 S Tremaine Ave, Los Angeles, CA...............213-938-2786
Selig, Jonathan/29206 Heathercliff Rd, Malibu, CA213-457-5856
Selland Photography/461 Bryant St, San Francisco, CA415-495-3633
Semple, Rick/1115 E Pike, Seattle, WA206-325-1400
Sessions, David/2210 Wilshire Blvd #205, Santa Monica, CA213-394-8379
Sexton, Richard/128 Laidley St, San Francisco, CA415-550-8345
Shaneff, Carl/1200 College Walk #105, Honolulu, HI808-533-3010
Sharp Image/Frank Short/828 K St #101, San Diego, CA619-531-0922
Sharpe, Dick/2475 Park Oak Dr, Los Angeles, CA.......................213-462-4597
Shaul, Wendy/7556 Rio Mondego Dr, Sacramento, CA..................916-429-0288
Shelton, Randy/10925 SW 108th St, Tigard, OR503-684-6271
Shirley, Ron/8755 W Washington, Culver City, CA213-204-2177
Sholik, Stan/1946 E Blair Ave, Santa Ana, CA............................714-250-9275
Short, Glenn/14641 La Maida, Sherman Oaks, CA.......................818-990-5599
Shorten, Chris/60 Federal St, San Francisco, CA415-543-4883
Shuman, Ronald/1 Menlo Pl, Berkeley, CA.................................415-527-7241
Shvartzman, Ed/31210 La Vaya Dr #212, Westlake Village, CA.........818-707-3227
Sibley, Scott/764 Bay, San Francisco, CA415-673-7468
Silk, Gary Photography/4164 Wanda Dr, Los Angeles, CA..............213-664-9639
Silva, Keith/771 Clementina Alley, San Francisco, CA415-863-5655
Silverek, Don/914 Ripley St, Santa Rosa, CA707-525-1155
Silverman, Jay Inc/920 N Citrus Ave, Hollywood, CA213-466-6030

Sim, Veronica/4961 W Sunset Blvd, Los Angeles, CA213-656-4816
Simon, Joel/729 College Ave, Menlo Park, CA............................415-321-8458
Simon, Wolfgang/PO Box 807, La Canada, CA...........................818-790-1605
Simpson, Stephen/701 Kettner Blvd #124, San Diego, CA619-239-6638
Sinick, Gary/3246 Ettie St, Oakland, CA415-655-4538
Sirota, Peggy/4391 Vanalden Ave, Tarzana, CA818-344-2020
Sjef's Fotographie/2311 NW Johnson St, Portland, OR503-223-1089
Sjoberg/742 N LaCienega, Los Angeles, CA..............................213-659-7158
Skirball, Aggie/9724 Lockford St, Los Angeles, CA213-837-9267
Skott, Michael/Rt 1/ Box 66D, East Sound, WA206-376-5284
Skrivan, Tom/1081 Beach Park Blvd #205, Foster City, CA415-574-4847
Slabeck, Bernard/2565 Third St #316, San Francisco, CA415-282-8202
Slatery, Chad/11869 Nebraska Ave, Los Angeles, CA213-820-6603
Slaughter, Paul D/771 El Medio Ave, Pacific Palisades, CA213-454-3694
Slenzak, Ron/7106 Waring Ave, Los Angeles, CA213-934-9088
Sloben, Marvin/7834 Nightingale Way, San Diego, CA619-239-2828
Slobodian, Scott/6519 Fountain Ave, Los Angeles, CA213-464-2341
Smith, Charles J/7163 Construction Crt, San Diego, CA619-271-6525
Smith, Don/1773 14th Ave S, Seattle, WA (P 298)**206-324-5748**
Smith, Elliott /PO Box 5268, Berkeley, CA.................................415-654-9235
Smith, Gary Photos/75 South Main #303, Seattle, WA206-343-7105
Smith, Gil/2865 W 7th St, Los Angeles, CA213-384-1016
Smith, Jean/4314 Campus Dr, San Diego, CA619-231-2855
Smith, Steve/228 Main St #E, Venice, CA213-392-4982
Smith, Todd/7316 Pyramid Dr, Hollywood, CA213-969-9832
Snook, Randy/3385-B Lanatt St , Sacramento, CA916-455-1360
Snyder, Mark/2415 Third St #265, San Francisco, CA415-861-7514
Sokol, Mark/6518 Wilkinson Ave, North Hollywood, CA818-506-4910
Sollecito, Tony/1120-B W Evelyn Ave, Sunnyvale, CA408-773-8118
Solomon, Marc/PO Box 480574, Los Angeles,
CA (P 294) ...**213-935-1771**
Spahn, Brian/2565 3rd St #339, San Francisco, CA415-282-6630
Spaulding, Kevin/21025 Lemarsh St #31, Chatsworth, CA.............818-998-6091
Speier, Brooks/6022 Haviland Ave, Whittier, CA.........................213-695-3552
Spellman, David/2345 Martin Ave #122, Los Angeles, CA213-257-6098
Spiker, Scott/824 S Logan, Moscow, ID....................................208-882-5102
Spradling, David/2515 Patricia Ave, Los Angeles, CA213-559-9870
Spring, Bob & Ira/18819 Olympic View Dr, Edmonds, WA206-776-4685
Springmann, Christopher/PO Box 745, Point Reyes, CA415-663-8428
St Jivago Desanges/PO Box 24AA2, Los Angeles, CA213-931-1984
Stahn, David/920 Natoma, San Francisco, CA............................415-864-1453
Stampfli, Eric/50 Mendell #10, San Francisco, CA415-824-2305
Stanley, Maria/2170 Chatsworth, San Diego, CA619-224-2848
Stanley, Paul/3911 Pacific Hwy #100, San Diego, CA619-293-3535
Starkman, Rick/1656 Freda Lane, Cardiff, CA619-943-1468
Starr, Ron Photo/PO Box 339, Santa Cruz, CA (P 293)**408-426-6634**
Stasenka, Don/2783 E 12th #A, Oakland, CA (P 292)**415-536-4811**
Steele, Melissa/PO Box 280727, San Francisco, CA415-355-1772
Stein, Robert/319 1/2 S Robertson Blvd, Beverly Hills, CA.............213-652-2030
Steinberg, Bruce/2128 18th St, San Francisco, CA415-864-0739
Steiner, Glenn Rakowsky/3102 Moore St, San Diego, CA619-299-0197
Steinke, Paula/830 NE 10th St, North Bend, WA206-746-7738
Stenjem, Scott/111 S Lander #103, Seattle, WA206-682-4260
Sterling, Doug/1827 Steiner St, San Francisco, CA415-441-2318
Stevens, Bob/608 Moulton Ave, Los Angeles, CA213-224-8082
Stillman, Richard/10 Shady Oak Ct, Danville, CA415-736-9600
Stinson, John/376 W 14th St, San Pedro, CA213-831-8495
Stock, Richard Photo/1205 Raintree Circle, Culver City, CA213-559-3344
Stockton, Michael/10660 Olive Grove Ave, Sunland, CA................818-352-3607
Stone, Pete/1410 NW Johnson, Portland, OR503-224-7125
Stormont, Bill/28279 Rainbow Valley Rd, Eugene, OR503-485-1684
Strandoo, Paul/1318 10th Ave, San Francisco, CA......................415-661-1650
Strathy, Donna R/PO Box 12575, Seattle, WA206-325-1837
Strauss, Andrew/6442 Santa Monica Blvd, Los Angeles, CA...........213-464-5394
Street-Porter, Tim/6938 Camrose Dr, Los Angeles, CA.................213-874-4278
Strickland, Steve/Box 3486, San Bernardino, CA........................714-883-4792
Studio AV/1201 1st Ave S #310, Seattle, WA.............................206-292-9931
Studio B/5121-B Santa Fe St, San Diego, CA619-483-2122
Su, Andrew/5733 Benner St, Los Angeles, CA213-256-0598
Sugar, James/45 Midway Ave, Mill Valley, CA............................415-388-3344
Sullivan, Jeremiah S/PO Box 7870, San Diego, CA619-236-0711
Sund, Harald/PO Box 16466, Seattle, WA.................................206-938-1080
Sutton, John/123 Townsend St #455, San Francisco, CA415-974-5452
Svendsen, Linda/3915 Bayview Circle, Concord, CA.....................415-676-8299
Svoboda, John/3211-B S Shannon, Santa Ana, CA......................714-979-8992
Swank & Newell/1551 Third Ave, Walnut Creek, CA.....................415-930-9229
Swanson, Scott/8937 Darrington Ave, W Hollywood, CA213-273-2645
Swarthout, Walter & Assoc/370 Fourth St, San Francisco, CA415-543-2525

Swartz, Fred/135 S LaBrea, Los Angeles, CA..................................213-939-2789
Swenson, John/4353 W 5th St #D, Los Angeles, CA213-384-1782

T

Taccone, Cristina/1442 Waller St, San Francisco, CA.......................415-626-3762
Tachibana, Kenji/1067 26th Ave E, Seattle, WA206-325-2121
Taggart, Fritz/1117 N Wilcox Pl, Los Angeles, CA213-469-8227
Tarleton, Gary/2589 NW 29th, Corvalis, OR503-752-3759
Taub, Doug/5800 Fox View Dr, Malibu, CA..213-457-8600
Tauber, Richard/4221 24th St, San Francisco, CA415-824-6837
Teeter, Jeff/1661 Forest Ave #133, Chico, CA916-895-3255
Teke/4338 Shady Glade Ave, Studio City, CA818-985-9066
Theis, Rocky/1457 Ridgeview Dr, San Diego, CA..............................619-527-0776
Thimmes, Timothy/8749 Washington Blvd, Culver City, CA...............213-204-6851
Thomas, Neil/PO Box 901682, Palmdale, CA.....................................213-202-0051
Thompson, Michael/7811 Alabama Ave #14, Canoga Park, CA..........818-883-7870
Thompson, Philip/1109 Longwood Ave, Los Angeles, CA213-939-6307
Thompson, William/PO Box 4460, Seattle, WA206-621-9069
Thomson, Sydney (Ms)/PO Box 1032, Keaau, HI808-966-8587
Thornton, Tyler/4706 Oakwood Ave, Los Angeles, CA213-465-0425
Tilger, Stewart/71 Columbia #206, Seattle,
WA (P 296)...**206-682-7818**
Tise, David/975 Folsom St, San Francisco, CA415-777-0669
Tomsett, Rafe/5380 Carol Way, Riverside, CA714-686-6638
Townsend, Jill Perry/117 Young Dr, Otis, OR....................................503-996-6289
Tracy, Tom/1 Maritime Plaza #1300, San Francisco, CA415-340-9811
Trafficanda, Gerald/1111 N Beachwood Dr, Los Angeles, CA213-466-1111
Trailer, Martin/8615 Commerce Ave, San Diego, CA.........................619-549-8881
Trierweiler, Tom/6316 Riverdale St, San Diego, CA619-280-0073
Trindl, Gene/14030 Sylvan St, Van Nuys, CA....................................213-877-4848
Trousdale, Mark/2849-A Fillmore St, San Francisco, CA...................415-391-0564
Tschoegel, Chris/600 Moulton Ave #101-A, Los Angeles, CA213-226-0506
Tucker, Doug/149 143rd Pl NE, Bellevue, WA206-643-7889
Tucker, Kim/2428 Canyon Dr, Los Angeles, CA.................................213-465-9233
Turk, Roger/PO Box 37, Southworth, WA...206-948-3587
Turner & DeVries/1200 College Walk #212, Honolulu, HI808-537-3115
Turner, John Terence/173 37th Ave E, Seattle, WA...........................206-325-9073
Turner, Richard P/Box 64205 Rancho Pk Sta, Los Angeles, CA.........213-279-2127
Tuschman, Mark/300 Santa Monica, Menlo Park, CA415-322-4157
Tussey, Ron/57 Sunshine Ave, Sausalito, CA....................................415-331-1427

UV

Ueda, Richard/618 Moulton Ave St E, Los Angeles, CA.....................213-224-8709
Ulrich, Larry/PO Box 178, Trinidad, CA (P 282,283)**707-677-3916**
Undheim, Timothy/1039 Seventh Ave, San Diego, CA619-232-3366
Unger, Trudy/PO Box 536, Mill Valley, CA...415-381-5683
Uniack/8933 National Blvd, Los Angeles, CA213-938-0287
Upton, Tom/1879 Woodland Ave, Palo Alto, CA.................................415-325-8120
Urie, Walter Photography/2204 N Ross St, Santa Ana, CA................714-835-0332
Vallance, Doug/4314 Campus Dr, San Diego, CA619-231-2855
Vallely, Dwight/2027 Charleen Circle, Carlsbad, CA619-434-3228
VanderHeiden, Terry/563 E Lewelling Blvd, San Lorenzo, CA415-278-2411
Vanderpoel, Fred/1118 Harrison, San Francisco, CA415-621-4405
Vanderschuit, Carl & Joan/627 8th Ave, San Diego, CA....................619-232-4332
VanSciver, Diane/3500 SE 22nd Ave, Portland, OR503-239-7817
Vega, Raul/3511 W 6th Tower Suite, Los Angeles, CA.......................213-387-2058
Veitch, Julie/5757 Venice Blvd, Los Angeles, CA..............................213-936-4231
Venera, Michael/527 Howard St, San Francisco, CA..........................415-543-3562
Venezia, Jay/1373 Edgecliffe Dr, Los Angeles, CA213-665-7382
Vento, Steve/109 N Capitol Way, Olympia, WA..................................206-786-1206
Vereen, Jackson/570 Bryant St, San Francisco, CA..........................415-777-5272
Viarnes, Alex/Studio 33/Clementina, San Francisco, CA415-543-1195
Viewfinders/3401 W 5th St #120, Oxnard, CA805-984-3117
Vignes, Michelle/654 28th St, San Francisco, CA..............................415-550-8039
Villaflor, Francisco/PO Box 883274,
San Francisco, CA (P 344,345).................................**415-921-4238**
Visually Speaking/3609 E Olympic Blvd, Los Angeles, CA213-269-9141
Vogt, Laurie/17522 Von Karman, Irvine, CA......................................714-497-1549
Vollenweider, Thom/3430 El Cajon Blvd, San Diego, CA....................619-280-3070
Vollick, Tom/5245 Melrose, Los Angeles, CA213-464-4415
Von Tragen, Fritz/2407 SE 10th Ave, Portland, OR............................503-236-2139

W

Wade, William/5608 E 2nd St, Long Beach, CA..................................213-439-6826
Wahlstrom, Richard/650 Alabama St 3rd Fl, San Francisco, CA415-550-1400

Wallace, Marlene/1624 S Cotner, Los Angeles, CA213-826-1027
Walters, Don/4886 Woodthrush Rd, Pleasanton, CA..........................415-462-1305
Warden, John/9201 Shorecrest Dr, Anchorage, AK............................907-243-1667
Warren Aerial Photography/1585 E Locust, Pasadena, CA.................818-899-5978
Wasserman, David/252 Caselli, San Francisco, CA415-552-4428
Watanabe, David/14355 132nd Ave NE, Kirkland, WA........................206-823-0692
Waterfall, William/1160-A Nuuanu, Honolulu, HI808-521-6863
Watson, Alan/710 13th St #300, San Diego, CA................................619-239-5555
Watson, Stuart/620 Moulton Ave, Los Angeles, CA...........................213-221-3886
Waz, Anthony/1115 S Trotwood Ave, San Pedro, CA.........................213-548-3758
Weaver, James/PO Box 2091, Manteca, CA209-823-6368
Weingart, Ken/836 N Fuller Ave #5, Hollywood, CA...........................213-933-2207
Weinkle, Mark/1213 Channing Way, Berkeley, CA415-540-6277
Weintraub, David/1728 Union St #105,
San Francisco, CA (P 346)..**415-931-7776**
Wells, Gary/2320 Marinship Way, Sausalito, CA................................415-491-8620
Werner, Jeffery R/4910 1/4 McConnell, Los Angeles, CA...................213-821-2384
Werngart, Ken/836 N Fuller #5, Hollywood, CA213-933-2207
Werts, Bill/732 N Highland, Los Angeles, CA.....................................213-464-2775
Wetzel, Kerry/330 SE Union, Portland, OR..503-233-3947
Wexler, Glen/736 N Highland, Los Angeles, CA.................................213-465-0268
Wheeler, Richard/1116 4th St, San Rafael, CA..................................415-457-6914
White, Barbara/712 Emerald Bay, Laguna Beach, CA714-494-2479
White, George/2125 NE 81st St, Seattle, WA206-525-1862
White, Lee/1172 S LaBrea Ave, Los Angeles, CA..............................213-934-5993
White, Randall/1514 Fruitvale, Oakland, CA.......................................415-261-3327
Whitfield, Brent/816 S Grand Ave #202, Los Angeles, CA.................213-624-7511
Whitmore, Ken/1038 N Kenter, Los Angeles, CA...............................213-472-4337
Whittaker, Steve/1155 Chess Dr/Bldg C, Foster City, CA..................415-574-5424
Wiener, Leigh/2600 Carman Crest Dr, Los Angeles, CA.....................213-876-0990
Wietstock, Wilfried/877 Valencia St, San Francisco, CA....................415-285-4221
Wildschut, Sjef/2311 NW Johnson, Portland, OR...............................503-223-1089
Wilhelm, Dave/2565 Third St #303, San Francisco, CA......................415-826-9399
Wilkings, Steve/Box 22810, Honolulu, HI...808-732-6288
Williams, Bill Photo/9601 Owensmouth #13, Chatsworth, CA.............818-341-9833
Williams, David Jordan/6122 W Colgate, Los Angeles, CA.................213-936-3170
Williams, Harold/705 Bayswater Ave, Burlingame, CA415-340-7017
Williams, Keith/PO Box 17891, Irvine, CA..714-259-9165
Williams, Sandra/PO Box 16130, San Diego, CA619-283-3100
Williams, Steven Burr/8260 Grandview, Los Angeles, CA...................213-650-7906
Williams, Waldon/2069 E 3rd St #11, Long Beach, CA213-434-1782
Williamson, Scott/1901 E Carnegie #1G, Santa Ana, CA...................714-261-2550
Wilson, Bruce/1022 1st Ave S, Seattle, WA.......................................206-621-9182
Wilson, Don/10754 2nd Ave NW, Seattle, WA....................................206-367-4075
Wilson, Douglas M/10133 NE 113th Pl, Kirkland, WA.........................206-822-8604
Wimberg, Mercier/8751 W Washington Blvd, Culver City, CA.............213-839-7521
Wimpey, Christopher/627 Eighth Ave, San Diego, CA........................619-232-3222
Windus, Scott/928 N Formosa Ave, Los Angeles, CA.........................213-874-3160
Wing, Frank/2325 Third, San Francisco, CA.......................................415-626-8066
Winholt, Bryan/PO Box 331, Sacramento, CA....................................916-969-1112
Winter, Nita Photography/176 Caselli Ave, San Francisco, CA...........415-626-6588
Witbeck, Sandra/581 Seaver Dr, Mill Valley, CA................................415-383-6834
Witmer, Keith/16203 George St, Los Gatos, CA.................................408-395-9618
Wittner, Dale/507 Third Ave #209, Seattle, WA.................................206-623-4545
Wolf, Bernard/3111 4th St #306, Santa Monica, CA...........................213-399-6803
Wolfe, Dan E/45 E Walnut, Pasadena, CA...213-681-3130
Wolman, Baron/PO Box 1959, Sebastopol, CA707-823-8123
Wong, Darrell/PO Box 10307, Honolulu, HI..808-737-5269
Wong, Ken/3431 Wesley St, Culver City, CA213-836-3118
Wood, Darrell/517 Aloha St, Seattle, WA...206-283-7900
Woodward, Jonathan/5121 Santa Fe St #A, San Diego, CA...............619-270-5501
Woolslair, James/17229 Newhope St #H, Fountain Valley, CA714-957-0349
Wortham, Robert/521 State St, Glendale, CA.....................................818-243-6400
Wright, Armand/4026 Blairmore Ct, San Jose, CA.............................408-629-0559
Wyatt, Tom Photography/PO Box 147, Vacaville, CA..........................415-543-2813

YZ

Yellin, Jan/PO Box 81, N Hollywood, CA ...818-508-5669
Young, Bill/PO Box 27344, Honolulu, HI ...808-595-7324
Young, Edward/PO Box 3802, Carmel, CA ...408-520-7035
Young, Irene/888 44th St, Oakland, CA..415-654-3846
Yudelman, Dale/1833 9th St, Santa Monica, CA213-452-5482
Zaboroskie, K Gypsy/5584 Mission, San Francisco, CA.....................415-239-4230
Zachary, Neil/4111 Lincoln Blvd #100, Marina Del Rey, CA213-399-5775
Zajack, Greg/1517 W Alton Ave, Santa Ana, CA................................714-432-8400
Zak, Ed/80 Tehama St, San Francisco, CA...415-781-1611
Zanzinger, David/2411 Main St, Santa Monica, CA213-399-8802

Zaruba, Jeff/911 E Pike #233, Seattle, WA206-328-9035
Zens, Michael/84 University St, Seattle, WA206-623-5249
Zimberoff, Tom/31 Wolfback Ridge Rd, Sausalito, CA415-331-3100
Zimmerman, Dick/8743 W Washington Blvd,
Los Angeles, CA (P 301) ...**213-204-2911**
Zimmerman, John/9135 Hazen Dr, Beverly Hills, CA.............213-273-2642
Zippel, Arthur/2110 E McFadden #D, Santa Ana, CA............714-835-8400
Zsarney, Chris/1932 Eastman #107, Ventura, CA805-644-5554
Zurek, Nikolay/276 Shipley St, San Francisco, CA.................415-777-9210
Zwart, Jeffrey R/1900-E East Warner, Santa Ana, CA...........714-261-5844
Zyber, Tom/1305 E St/Gertrude Pl #D, Santa Ana, CA...........714-546-2949

I N T E R N A T I O N A L

Arce, Francisco M/Rio San Lorenzo 511B, Garza Garcia, NL, MX...........83-567-696
Austen, David Robert/GPO Box 2480, Sydney, Australia612-957-2511
Bako, Andrew/3047 4th St SW, Calgary, AB.............................403-243-9789
Bierwagen, Ottmar/50 Woodycrest Ave, Toronto, ON..............416-463-6560
Bochsler, Tom/3514 Mainway, Burlington, ON.........................416-529-9011
Bruemmer, Fred/5170 Cumberland Ave, Montreal, QU514-482-5098
Carruthers, Alan/3605 Jeanne-Mamce, Montreal, QU............514-288-4333
Carter, Garry/179 Waverly, Ottawa, ON..................................613-233-3306
Chalifour, Benoit/1030 St Alexandre #812, Montreal, QU514-879-1869
Chin, Albert/1150 Homer St, Vancouver, BC............................604-685-2000
Clark, Harold/9 Lloyd Manor, Islington, ON416-236-2958
Cochrane, Jim/25 1/2 York St #1, Ottawa, ON........................613-234-3099
Cohen, Nancy/95 Atchison St, Crows Nest/NSW/Aust,02-929-7748
Cordero, Felix L/1259 Ponce De Leon #6-5, Santurce, PR809-725-3465
Cralle, Gary/83 Elm Ave #205, Toronto, ON416-923-2920
Cruz, Edgard/Parque de la Fuente, Bairoa Pk, Caguas, PR....809-746-0458
Dancs, Andras/518 Beatty St #603, Vancouver, BC................604-684-6760
Day, Michael/264 Seaton St, Toronto, ON...............................416-920-9135
Dee, Stuart/4725 W 6th Ave, Vancouver, BC604-224-3122
Dickson, Nigel/507 King St E #100, Toronto, ON416-366-4477
Dojc, Yuri/74 Bathurst St, Toronto, ON...................................416-366-8081
First Light Assoc/78 Rusholme Rd, Toronto, ON416-532-6108
Galvin, Kevin/Oblatterwallstr 44, 8900 Augsburg/GR,49821 156393
Gagnon, Francine/1981, Ave McGill Coll,bur 725, Montreal, QU514-762-4654
Gelabert, Bill/PO Box 3231, Old San Juan, PR.......................809-725-4696
Goldstein, Larry/21 E 5th St, Vancouver, BC...........................604-877-1117
Gual, Tomas/1916 Loiza St 2nd Fl, Santurce, PR....................809-728-6532
Harbron, Patrick/366 Adelaide St E #331, Toronto, ON...........416-462-0128
Harquail, John/67 Mowat Ave #40, Toronto, ON416-535-1620
Hayes, Eric/836 LeHave St, Bridgewtr, NS..............................902-543-0256
Henderson, Gordon/182 Gariepy Crescent, Edmonton, AB.................403-483-8049
Hines, Sherman/17 Prince Arthur Ave, Toronto, ON................416-967-4319
Hirsch, Alan/1259 Ponce de Leon #6C, San Juan, PR809-723-2224
Jarp, Leam/186 Brunswick Ave, Toronto, ON...........................416-696-7002
Joseph, Nabil/445 St Pierre St #402, Montreal, QU514-842-2444
Klotzek Studio/888 Dan Mills Rd #102, Dan Mills, ON............416-445-4426
Labelle, Lise/4282 A Rue Delorimier, Montreal, QU514-596-0010
LaCourciere, Mario/1 Rue Hamel, Quebec, QU.......................418-694-1744
Lacroix, Pat/25 Brant St, Toronto, ON.....................................416-864-1858
Loynd, Mel/208 Queen St S, Streetsville, ON416-821-0477
McCall, Stuart/518 Beatty St #603, Vancouver, BC.................604-684-6760
Merrithew, Jim/PO Box 1510, Almonte, ON.............................613-729-3862
Milne, Brian/78 Rusholme Rd, Toronto, ON.............................416-532-6108
Monk, Russell/443 King St W, Toronto, ON..............................416-599-8231
Moore, Marvin/5240 Blowers St, Halifax, NS902-420-1559
Morrison, John/99 Sudbury St Ste 2, Toronto, ON...................416-588-2746
Mullen, Kevin/71 Sunhurst Crescent SE, Calgary, AB.............403-256-5749
Murray, Derik/1128 Homer St, Vancouver, BC.........................604-669-7468
Nexus Productions/10-A Ashdale Ave, Toronto, ON416-463-5078
Olthuis, Stan/524 Queen St E, Toronto, ON............................416-860-0300
Outerbridge, Graeme/PO Box 182, Southampton 8,Bermuda,809-298-0888
Ramirez, George/303 Canals St, Santurce, PR........................809-724-5727
Ranson Photographers Ltd/26 Airport Rd, Edmonton, AB.....................403-454-9674
Reus-Breuer, Sandra/Cal Josefa Cabrera Final #3, Rio Piedras, PR809-767-1568
Rondel, Benjamin/2012-155 Marlee Ave, Toronto, ON.............416-785-8680
Rostron, Philip/489 Wellington St W, Toronto, ON...................416-596-6587
Semeniuk, Robert/78 Rusholme Rd, Toronto, ON416-532-6108
Share, Jed/Tokyo/Casa Ino 302/5-9-24 Inokashira, Tokyo, JP212-562-8931
Simhoni, George/33 Jefferson Ave, Toronto, ON......................416-535-1955
Staley, Bill/1160 21st St, W Vancouver, BC.............................604-922-6695
Stegel, Mark/9 Davis Ave #300, Toronto, ON416-462-3244
Strouss, Sandy/33 Jefferson Ave, Toronto, ON........................416-535-1955
Taback, Sidney/415 Eastern Ave, Toronto, ON.........................416-463-5718

Teschl, Josef/31 Brock Ave #203, Toronto, ON416-743-5146
Vogt, Jurgen/936 E 28th Ave, Vancouver, BC..........................604-876-5817
Von Baich, Paul/78 Rusholme Rd, Toronto, ON........................416-532-6108
Watts, Ron/78 Rusholme Rd, Toronto, ON................................416-532-6108
Whetstone, Wayne/149 W Seventh Ave, Vancouver, BC604-873-8471
Williamson, John/224 Palmerston Ave, Toronto, ON................416-530-4511
Zenuk, Alan/PO Box 3531, Vancouver,, BC..............................604-733-8271
Zimbel, George/1538 Sherbrooke W #813, Montreal, QU514-931-6387
Zoom Photo/427 Queen St West, Toronto, ON.........................416-593-0690

STOCK

NYC

American Heritage Picture Library/60 Fifth Ave212-206-5500
American Library Color Slide Co/121 W 27th St 8th Fl.................212-255-5356
Animals Animals/65 Bleecker St 9th Fl ..212-982-4442
Animals Unlimited/10 W 20th St ..212-633-0200
Archive Films/530 W 25th St ..212-620-3955
Arnold, Peter Stock/1181 Broadway 4th Fl......................................212-481-1190
Art Resource Inc/65 Bleecker St 9th Fl ...212-505-8700
Beck's Studio/37-44 82nd St, Jackson Heights.............................718-424-8751
Bettmann Archive/902 Broadway ...212-777-6200
Black Star/Stock/116 E 27th St 5th Fl ...212-679-3288
Camera Five Inc/6 W 20th St ..212-989-2004
Camp, Woodfin Assoc/116 E 27th St..212-481-6900
Coleman, Bruce Inc/381 Fifth Ave 2nd Fl ...212-683-5227
Comstock/30 Irving Pl ..212-889-9700
Contact Press Images/116 E 27th St 8th Fl212-481-6910
Cooke, Jerry/161 E 82nd St ...212-288-2045
Culver Pictures Inc/150 W 22nd St 3rd Fl ...212-645-1672
Design Conceptions/Elaine Abrams/112 Fourth Ave212-254-1688
DeWys, Leo Inc/1170 Broadway (P 354)212-689-5580
DMI Inc/341 First Ave ...212-777-8135
DPI Inc/19 W 21st St #901 ...212-627-4060
Ellis Wildlife Collection/69 Cranberry St, Brooklyn Hts718-935-9600
Ewing Galloway ...212-719-4720
Fashions In Stock/21-45 78th St, E Elmhurst718-721-1373
Flying Camera Inc/114 Fulton St ..212-619-0808
Focus on Sports/222 E 46th St ..212-661-6860
FPG International/32 Union Sq E 6th Fl (P 352,353).....212-777-4210
Fundamental Photographs/210 Forsythe St212-473-5770
Gamma-Liaison Photo Agency/11 E 26th St 17th fl..........................212-447-2515
The Granger Collection/1841 Broadway ...212-586-0971
Gross, Lee Assoc/366 Madison Ave ...212-682-5240
Heyl, Fran Assoc/230 Park Ave #2525 ...212-581-6470
Heyman, Ken/2 Charlton St ..212-366-5555
The Image Bank/111 Fifth Ave (P 9)212-529-6700
Image Resources/224 W 29th St ...212-736-2523
Images Press Service/22 E 17th St #226..212-675-3707
Index Stock International/126 Fifth Ave ...212-929-4644
International Stock Photos/113 E 31st St #1A212-696-4666
Keystone Press Agency Inc/202 E 42nd St ..212-924-8123
Lewis, Frederick Inc/134 W 29th St #1003 ..212-594-8816
Life Picture Service/Rm 28-58 Time-Life Bldg212-522-4800
London Features Int'l USA Ltd/215 W 84th St #406212-724-8780
Magnum Photos Inc/72 Spring St 12th Fl ..212-966-9200
Maisel, Jay/190 Bowery ..212-431-5013
MediChrome/232 Madison Ave ..212-679-8480
Memory Shop Inc/109 E 12th St ..212-473-2404
Monkmeyer Press Photo Agency/118 E 28th St #615......................212-689-2242
Nance Lee/215 W 84th St #406 ...212-724-8780
NBA Entertainment/38 E 32nd St ..212-532-6223
Omni Photo Communication/5 E 22nd St #6N212-995-0805
Onyx Enterprises/110 Greene St #804 ...212-925-5440
Outline/596 Broadway ..212-226-8790
Photo Files/1235 E 40th St, Brooklyn ...718-338-2245
Photo Researchers Inc/60 E 56th St ..212-758-3420
Photofest/47 W 13th St 2nd Fl..212-633-6330
Photography Bureau/400 Lafayette St #4G212-255-3333
Photonica/141 Fifth Ave #8S ..212-505-9000
Photoreporters/875 Ave of Americas #1003212-736-7602
Phototake/4523 Broadway #7G ...212-942-8185
Pictorial Parade/530 W 25th St ...212-840-2026
Rangefinder Corp/275 Seventh Ave ...212-689-1340
RDR Productions/351 W 54th St ..212-586-4432
Reese, Kay/225 Central Park West ...212-799-1133
Reference Pictures/900 Broadway #802 ..212-254-0008
Retna Ltd/36 W 56th St #3A ..212-489-1230
Robert Tod/Box 20058 ..212-765-1212
Roberts, H Armstrong/1181 Broadway..212-685-3870
Shashinka Photo/501 Fifth Ave #2108 ...212-490-2180
Sipa Press/30 W 21st St 6th Fl ...212-463-0150
Sochurek, Howard Inc/680 Fifth Ave ..212-582-1860
Sovfoto-Eastphoto Agency/225 W 34th St #1505212-564-5485

Sports Illustrated Pictures/Time-Life Bldg 20th Fl212-522-2803
Steinhauser, Art Ent/305 E 40th St ..212-953-1722
The Stock Market/360 Park Ave S 16th Fl...800-999-0800
The Stock Shop/232 Madison Ave...212-679-8480
Stockphotos Inc/373 Park Ave S 6th Fl ...212-686-1196
The Strobe Studio Inc/214 E 24th St #3D ..212-532-1977
Superstock/11 W 19th St 6th Fl ..212-633-0200
Sygma Photo News/225 W 57th St 7th Fl ..212-765-1820
Tamin Productions/440 West End Ave #4E ...212-807-6691
Telephoto/8 Thomas St ..212-406-2440
Time Picture Synd/Time & Life Bldg ..212-522-3866
Uncommon Stock/1181 Broadway 4th Fl ..212-481-1190
UPI/Bettmann Newsphotos/902 Broadway 5th Fl212-777-6200
Wheeler Pictures/Comstock/30 Irving Place212-564-5430
Wide World Photos Inc/50 Rockefeller Plaza212-621-1930
Winiker, Barry M/173 W 78th St ..212-580-0841

NORTHEAST

Allen, Beverly/Box 70, S Sterling, PA ..717-676-4145
Allen, John Inc/116 North Ave, Park Ridge, NJ201-391-3299
Anthro-Photo/33 Hurlbut St, Cambridge, MA617-497-7227
Aperture PhotoBank/180 Lincoln St, Boston, MA617-451-1973
Authenticated News Int'l/29 Katonah Ave, Katonah, NY..................914-232-7726
Bergman, LV & Assoc/East Mountain Rd S, Cold Spring, NY...........914-265-3656
Blizzard, William C/PO Box 659, Winfield, WV..................................304-755-0094
Camerique Stock Photography/45 Newbury St, Boston, MA.............617-267-6450
Camerique Stock Photography/1701 Skippack Pike, Blue Bell, PA215-272-4000
Camp, Woodfin Inc/2025 Penn Ave NW #1011, Washington, DC202-223-8442
Cape Scapes/542 Higgins Crowell Rd, West Yarmouth, MA.............508-362-8222
Chandoha, Walter/RD 1 PO Box 287, Annandale, NJ........................908-782-3666
Consolidated News Pictures/209 Penn Ave SE, Washington, DC202-543-3203
Cyr Color Photo/PO Box 2148, Norwalk, CT......................................203-838-8230
DCS Enterprises/12806 Gaffney Rd, Silver Spring, MD....................301-622-2323
DeRenzis, Philip/421 N 23rd St, Allentown, PA................................215-776-6465
Devaney Stock Photos/755 New York Ave #306, Huntington, NY516-673-4477
Earth Scenes/Animals Animals/17 Railroad Ave, Chatham, NY518-392-5500
Ewing Galloway/100 Merrick Rd, Rockville Centre, NY516-764-8620
F/Stop Pictures Inc/PO Box 359, Springfield, VT.............................802-885-5261
Folio/3417 1/2 M St NW, Washington, DC ...202-965-2410
Galloway, Ewing/100 Merrick Road, Rockville Center, NY516-764-8620
Garber, Bette S/3160 Walnut St, Thorndale, PA
(P 356) ..215-380-0342
Headhunters/2619 Lovegrove St, Baltimore, MD410-338-1820
Heilman, Grant/506 W Lincoln Ave, Lititz, PA717-626-0296
Image Photos/Main St, Stockbridge, MA ...413-298-5500
Image Specialists/12 Sharon St, Medford, MA617-483-1422
The Image Bank/, Boston, MA (P 9)617-267-8866
The Image Works Inc/PO Box 443, Woodstock, NY914-679-5603
Jones, G P - Stock/45 Newbury St, Boston, MA617-267-6450
Lambert, Harold M Studio/2801 W Cheltenham Ave, Philadelphia, PA.....215-224-1400
Light, Paul/1430 Massachusetts Ave, Cambridge, MA.....................617-628-1052
Lumiere/512 Adams St, Centerport, NY ...516-271-6133
Myers Studios/5575 Big Tree Rd, Orchard Park, NY716-662-6002
Natural Selection/177 St Paul St, Rochester, NY716-232-1502
New England Stock Photo/PO Box 815, Old Saybrook, CT203-388-1741
North Wind Picture Archives/RR 1 Box 172/Federal St, Alfred, ME207-490-1940
Photo/Nats/33 Aspen Ave, Auburndale, MA617-969-9531
The Picture Cube/89 Broad St, Boston, MA617-367-1532
Picture Group/830 Eddy St, Providence, RI401-461-9333
Positive Images/35 Main St #5, Wayland, MA508-653-7610
Rainbow/PO Box 573, Housatonic, MA ..413-274-6211
Reis,Jon/Photolink/141 The Commons, Ithica, NY607-272-0642
Roberts, H Armstrong/4203 Locust St, Philadelphia, PA215-386-6300
Rotman, Jeff/14 Cottage Ave, Somerville, MA...................................617-666-0874
Sandak/GK Hall/180 Harvard Ave, Stamford, CT203-348-3722
Seitz & Seitz/1006 N Second Ave #1A, Harrisburg, PA717-232-7944
Sequis Stock Photo/9 W 29th St, Baltimore, MD301-467-7300
Sickles Photo Reporting/PO Box 98, Maplewood, NJ201-763-6355
Signal Stock/54 Applecross, Chalfont, PA ..215-997-2311
SportsChrome/10 Brynkerhoff Ave 2nd Fl, Palisades Park, NJ201-568-1412
Starwood/PO Box 40503, Washington, DC ..202-362-7404
Stock Advantage/213 N 12th St, Allentown, PA215-776-7381
Stock Boston Inc/36 Gloucester St, Boston, MA617-266-2300
Sutton, Bug/6 Carpenter St, Salem, MA ..508-741-0806
Thomas, Bob Sports Photos/453 Brook St,
Framingham, MA (P 361)...508-877-8795

Undersea Systems/PO Box 29M, Bay Shore, NY................................516-666-3127
Uniphoto Picture Agency/3205 Grace St NW, Washington, DC..........202-333-0500
View Finder Stock Photo/2310 Penn Ave, Pittsburgh, PA................412-391-8720
Weidman, H Mark/2112 Goodwin Lane, North Wales, PA215-646-1745
Woppel, Carl/PO Box 199, Islip, NY...516-581-7762

SOUTHEAST

Arms, Jonathan/1517 Maurice Dr, Woodbridge, VA............................703-490-3810
Bryant, Doug/PO Box 80155, Baton Rouge, LA..............................504-387-1620
Camera MD Studios/8290 NW 26 Pl, Ft Lauderdale, FL......................305-741-5560
Fotoconcept/408 SE 11th Ct, Ft Lauderdale, FL305-463-1912
The Image Bank/, Naples, FL (P 9) **813-566-3444**
The Image Bank/3490 Piedmont Rd NE #1106,
Atlanta, GA (P 9) **404-233-9920**
Image File/526 11th Ave NE, St Petersburg, FL............................813-894-8433
Instock Inc/516 NE 13th St, Ft Lauderdale, FL..........................305-527-4111
Kutnyak, Catherine/644 S Third St #202, Louisville, KY502-589-5799
National Stock Network/8960 SW 114th St, Miami, FL.....................305-233-1703
Phelps, Catherine Stock Photo/2403 Dellwood Dr NW, Atlanta, GA.....404-264-0264
Philiba, Allan A/3501 Cherryhill Dr, Orlando, FL........................407-381-5000
Photo Options/1432 Linda Vista Dr, Birmingham, AL.......................205-979-8412
Photonet/2655 LeJeune Rd #1015, Miami, FL...............................305-444-0144
Photri(Photo Resrch Int'l)/3701 S George Mason Dr/Falls Church, VA..703-836-4439
Picturesque/1520 Brookside Dr #3, Raleigh, NC919-828-0023
Pinckney, Jim Photo/PO Box 22887, Lake Buena Vista, FL407-239-8855
Sandved, Kjell Photo/3871 Rodman St NW, Washington, DC202-244-5711
SharpShooters/4950 SW 72nd Ave #114, Miami, FL.........................305-666-1266
Silver Image Photo/5128 NW 58th Ct, Gainesville, FL.....................904-373-5771
Southern Stock Photo/3601 W Comm Blvd #33, Ft Lauderdale, FL......305-486-7117
Stills Inc/3288 Marjon Dr, Atlanta, GA....................................404-451-6749
Stock Options/851 French St, New Orleans, LA............................504-486-7700
Stockfile/2107 Park Ave, Richmond, VA804-358-6364
Taylor, Randy/555 NE 34th St #701, Miami, FL...........................305-573-5200
The Waterhouse/PO Box 2487, Key Largo, FL..............................305-451-3737

MIDWEST

A-Stock Photo Finder & Photogs/230 N Michigan #1100, Chicago, IL......312-645-0611
Artstreet/111 E Chestnut #12B, Chicago, IL...............................312-664-3049
Brooks & VanKirk/855 W Blackhawk St, Chicago, IL.......................312-642-7766
Bundt, Nancy/1908 Kenwood Pkw, Minneapolis, MN........................612-377-7773
Camerique Stock Photography/233 E Wacker Dr #4305, Chicago, IL..312-938-4466
Campbell Stock Photo/28000 Middlebelt Rd #260,
Farmington Hills, MI ..313-626-5233
Cowgirl Stock Photo/1526 N Halsted, Chicago, IL........................312-787-2778
Custom Medical Stock Photo/3819 N Southport Ave, Chicago, IL.......312-248-3200
Fay, Mark/7301 Ohms Ln #375, Edina, MN................................612-835-5447
Frozen Images/400 First Ave N #626, Minneapolis, MN612-339-3191
Gartman, Marilyn/510 N Dearborn, Chicago, IL...........................312-661-1656
Gibler, Mike/Rt 5 Zion Rd, Jefferson City, MO314-635-2450
Hedrich-Blessing/11 W Illinois St, Chicago, IL............................312-321-1151
Historical Picture Service/921 W Van Buren #201, Chicago, IL............312-346-0599
Ibid Inc/935 West Chestnut, Chicago, IL.................................312-733-8000
The Image Bank/822 Marquette Ave, Minneapolis,
MN (P 9) **612-332-8935**
The Image Bank/510 N Dearborn #930, Chicago,
IL (P 9) **312-329-1817**
Journalism Services Stock/118 E 2nd St, Rockport, IL.....................312-951-0269
Nawrocki Stock Photo/332 S Michigan Ave #1630, Chicago, IL312-427-8625
Panoramic Stock Images/230 N Michigan Ave, Chicago, IL...............312-236-8545
Photographic Resources/6633 Delmar St #200, St Louis, MO314-721-5838
The Photoletter/Pine Lake Farm, Osceola, WI............................715-248-3800
Pix International/300 N State #3926, Chicago, IL..........................312-321-9071
Schroeder, Loranelle/400 First Ave N #626, Minneapolis, MN.............612-339-3191
Sky King Stock Photo/RR 1 Box 45, Elroy, WI.............................608-462-8999
Stone, Tony Worldwide/233 East Ontario #1100,
Chicago, IL (P 350,351) **312-787-7880**
Studio B Stock/107 W Van Buren #211, Chicago, IL.......................312-939-4677
Thill, Nancy/537 South Dearborn, Chicago, IL............................312-939-7770
Third Coast Stock/PO Box 92397, Milwaukee, WI.........................414-765-9442
Zehrt, Jack/PO Box 122A Rt5, Pacific, MO314-458-3600

SOUTHWEST

Adstock Photos/6219 North 9th Place, Phoenix, AZ602-437-8772
Condroy, Scott/4810 S 40th St #3A, Phoenix, AZ..........................602-437-8772
Golfoto Inc/522-B South Jefferson, Enid, OK (P 357) 405-234-8284
The Image Bank/, Houston, TX (P 9) **713-668-0066**
The Image Bank/3500 Maple Ave #1150, Dallas,
TX (P 9) **214-528-3888**
Ives, Tom/2250 El Moraga, Tucson, AZ...................................602-743-0750
Lee, E Doris/5810 Star Lane, Houston, TX..............................713-977-1768
McLaughlin, Herb & Dorothy/2344 W Holly, Phoenix, AZ................602-258-6551
Photo Assoc of Texas/PO Box 887, Tomball, TX..........................713-351-5740
Photobank/313 E Thomas Rd #102, Phoenix, AZ..........................602-265-5591
Raphaele/Digital Transparencies Inc/616
Hawthorne, Houston, TX (P 348,349) **713-524-2211**
Running Productions/PO Box 1237, Flagstaff, AZ..........................602-774-2923
The Stock House Inc/9261 Kirby, Houston, TX............................713-796-8400
Visual Images West Inc/600 E Baseline Rd #B-6, Tempe, AZ602-820-5403

ROCKY MTN

Alpenstock/11831 Elkhead Range Rd, Littleton, CO303-978-1062
Ambrose, Paul /PO Box 8158, Durango, CO...............................303-259-5925
Aspen Stock Photo/PO Box 4063, Aspen, CO.............................303-925-8280
Bair, Royce & Assoc/6640 South 2200 West, Salt Lake City, UT801-569-1155
Cox, Daniel J/16595 Brackette Creek Rd, Bozeman, MT406-686-4448
Dannen, Kent & Donna/851 Peak View/Moraine Rte, Estes Park, CO...303-586-5794
F Stock/PO Box 3956, Ketchum, ID.......................................208-726-1378
Images of Nature/PO Box 241185/8206 J St, Omaha, NE..................800-228-9686
Miles, Kent/465 Ninth Ave, Salt Lake City, UT
(P 295) **801-364-5755**
Profiles West/PO Box 1199, Buena Vista, CO.............................719-395-8671
Stack, Tom & Assoc/3645 Jeannine Dr, Colorado Springs, CO............719-570-1000
The Stock Broker/450 Lincoln St #110, Denver, CO......................303-698-1734
Stock Imagery/711 Kalamath St, Denver, CO.............................303-592-1091
The Stock Solution/6640 South, 2200 West, Salt Lake City, UT801-569-1155
Williams, Hal/PO Box 10436, Aspen, CO.................................303-920-2802

WEST COAST

Adventure Photo/56 E Main St, Ventura, CA...............................805-643-7751
Alaska Pictorial Service/Drawer 6144, Anchorage, AK....................907-344-1370
All Sports Photo USA/320 Wilshire Blvd #200, Santa Monica, CA.........213-395-2955
Allstock/1530 Westlake Ave N, Seattle, WA...............................206-282-8116
Beebe, Morton & Assoc/150 Lombard St #808, San Francisco, CA415-362-3530
Big City Visual Prdctns/1039 Seventh Ave #12, San Diego, CA...........619-232-3366
Burr, Lawrence/76 Manzanita Rd, Fairfax, CA.............................415-456-9158
Camerique Stock Photo/6640 Sunset Blvd #100, Hollywood, CA213-469-3900
Catalyst/PO Box 689, Haines, AK...907-766-2670
Dae Flights/PO Box 1086, Newport Beach, CA............................714-676-3902
Dritsas, George/207 Miller Ave, Mill Valley, CA415-381-5485
Earth Images/PO Box 10352, Bainbridge Isl, WA.........................206-842-7793
Energy Prod/Schwartzberg & Co/12700 Ventura Blvd Studio City, CA...818-508-1444
Ergenbright, Ric Photo/PO Box 1067, Bend, OR..........................503-389-7662
Focus West/4112 Adams Ave, San Diego, CA.............................619-280-3595
Four by Five Inc/99 Osgood Place, San Francisco, CA....................415-781-4433
French, Peter/PO Box 100, Kamuela, HI..................................808-889-6488
Gibson, Mark/PO Box 14542, San Francisco, CA.........................415-524-8118
Great American Stock/7566 Trade St, San Diego, CA619-297-2205
Grubb, T D/5806 Deerhead Rd, Malibu, CA...............................213-457-5539
Havens, Carol/POB 662, Laguna Beach, CA..............................714-497-1908
The Image Bank/, San Francisco, CA (P 9) 415-788-2208
The Image Bank/4526 Wilshire Blvd, Los Angeles,
CA (P 9) **213-930-0797**
Imagic/5308 Vineland Ave, N Hollywood, CA (P 355) **818-753-0001**
Imagic/1545 N Wilcox, Hollywood, CA (P 355) **213-461-3901**
Jeton/513 Harrington Ave NE, Renton, WA...............................206-226-1408
Kimball, Ron Stock/1960 Colony, Mt View, CA............................415-
2939
Leeson, Tom & Pat/PO Box 2498, Vancouver, WA
(P 358) **206-256-0436**
Live Stock Photo/190 Parnassus Ave #5, San Francisco, CA..............415-753-6261
Long Photo Inc/57865 Rickenbacher Rd, Los Angeles, CA................213-888-9944
Madison, David/2330 Old Middlefield Rd, Mt View, CA...................415-961-6297
Motion Picture & TV Photo Archive/11821 Mississippi Ave, LA, CA......213-478-2379

Mountain Light Photography/1483-A Solano Ave, Albany, CA (P 359).................................**415-524-9343**
MPTV PhotoArchive/11821 Mississippi Ave, Los Angeles, CA..............213-478-2379
Muench, David Photo Inc/PO Box 30500, Santa Barbara, CA (P 284).................................**805-967-4488**
The New Image Inc/38 Quail Ct 200, Walnut Creek, CA.......................415-934-2405
NFL Photos/6701 Center Dr W #1111, Los Angeles, CA......................213-215-3813
Northern Light Studio/2407 SE 10th Ave, Portland, OR.......................503-236-2139
O'Hara, Pat/PO Box 955, Port Angeles, WA (P 300)**206-457-4212**
Pacific Stock/PO Box 90517, Honolulu, HI800-321-3239
Peebles, Douglas Photography/445 Iliwahi Loop, Kailua, HI................808-254-1082
Photo 20/20/PO Box 674, Berkeley, CA...415-526-0921
Photo File/110 Pacific Ave #102, San Francisco, CA...........................415-397-3040
Photo Network/1541 Parkway Loop #J, Tustin, CA714-259-1244
Photo Vault/1045 17th St, San Francisco, CA...................................415-552-9682
Photobank/CA/17952-B Skypark Circle, Irvine, CA...............................714-250-4480
Photophile/2311 Kettner Blvd, San Diego, CA619-234-4431
Shooting Star/PO Box 93368, Hollywood, CA213-876-2000
Simpson, Ed/PO Box 397, S Pasadena, CA......................................213-682-3131
Stock Editions/11026 Ventura Blvd #7, Studio City, CA818-762-0001
Stockworks/4445 Overland Ave, Culver City, CA..................................213-204-1774
Stone, Tony/After Image Inc/6100 Wilshire Blvd #240, Los Angeles, CA (P 350,351)**213-938-1700**
Terraphotographics/BPS/PO Box 490, Moss Beach, CA415-726-6244
TRW/9841 Airport Blvd #1414, Los Angeles, CA213-536-4880
Visual Impact/733 Auahi St, Honolulu, HI808-524-8269
Ward, Kennan/348 Fredrick St, Santa Cruz, CA...................................408-429-9533
West Stock/83 S King St #520, Seattle, WA..206-621-1611
Westlight/2223 S Carmelina Ave, Los Angeles, CA800-872-7872
Zephyr Pictures/2120 Jimmy Durante Blvd, Del Mar, CA619-755-1200

INTERNATIONAL

Alterimage/357 College St 3rd fl, Toronto, ON..416-968-0168
Code, Alan/PO Box 64, Churchill, MB ...204-675-2969
Hot Shots Stock/309 Lesmill Rd, Toronto, ON416-441-3281
The Image Bank/550 Queen St E #300, Toronto, ON (P 9).................................**416-362-6931**
Miller + Comstock/180 Bloor St W #1102, Toronto, ON416-925-4323
Popperfoto/Old Mill/Overstn Farm, Overstone, NH (P 360).................................**011-44-604-414144**
Stone, Tony Worldwide/116 Bayham St, London, EN (P 350,351).................................**071-267-8988**

LABS & RETOUCHERS

NYC

ACL Photolab/239 W 39th St..................................212-354-5280
ACS Studios/2 West 46th St..................................212-944-2622
Alchemy Color Ltd/239 W 39th St............................212-354-5280
American Blue Print Co Inc/7 E 47th St......................212-751-2240
American Photo Print Co/285 Madison Ave....................212-532-2424
American Photo Print Co/350 Fifth Ave......................212-736-2885
Apco-Apeda Photo Co/525 W 52nd St..........................212-586-5755
Appel, Albert/114 E 32nd St.................................212-779-3765
Arkin-Medo/30 E 33rd St.....................................212-685-1969
Arno Spectrum/230 E 44th St.................................212-687-3359
AT & S Retouching/230 E 44th St.............................212-986-0977
Atlantic Blue Print Co/575 Madison Ave......................212-755-3388
Aurora Retouching/10 W 19th St..............................212-255-0620
Authenticolor Labs Inc/227 E 45th St........................212-867-7905
Avekta Productions Inc/164 Madison Ave......................212-686-4550
Benjamin, Bernard/1763 Second Ave...........................212-722-7773
Berger, Jack/41 W 53rd St...................................212-245-5705
Berkey K & L/222 E 44th St..................................212-661-5600
Bishop Studio Inc/236 E 36th St.............................212-889-3525
Blae, Ken Studios/1501 Broadway.............................212-869-3488
Broderson, Charles Backdrops/873 Broadway #612.............212-925-9392
C & C Productions/445 E 80th St.............................212-472-3700
Carlson & Forino Studios/230 E 44th St......................212-697-7044
Chroma Copy/423 West 55th St................................212-399-2420
Color Masters Inc/143 E 27th St.............................212-889-7464
Color Perfect Inc/200 Park Ave S............................212-777-1210
Color Vision Photo Finishers/642 9th Avenue.................212-757-2787
Color Wheel Inc/227 E 45th St...............................212-697-2434
Colorama Labs/165 W 46th St.................................212-382-0233
Colorite Film Processing/115 E 31st St......................212-532-2116
Colotone Litho Separator/24 E 38th St #1B...................212-545-7155
Columbia Blue & Photoprint Co/14 E 39th St..................212-532-9424
Commerce Photo Print Co/106 Fulton..........................212-964-2256
Compo Photocolor/1290 Ave of Americas.......................212-758-1690
Copy-Line Corp/40 W 37th St.................................212-563-3535
Copycolor/8 W 30th St.......................................212-725-8252
Copytone Inc/115 W 46th St 8th fl...........................212-575-0235
Cordero, Felix/159 E 104th St...............................212-289-2861
Corona Color Studios Inc/10 W 33rd St.......................212-239-4990
Cortese, Phyllis/306 E 52nd St..............................212-421-4664
Crowell, Joyce/333 E 30th St................................212-683-3055
Crown Photo/165 W 46th St...................................212-382-0233
Dai Nippon Printing/2 Park Ave..............................212-397-1880
The Darkroom Inc/222 E 46th St..............................212-687-8920
Diamond Art Studio/11 E 36th St.............................212-685-6622
Diamond, Richard/155 E 42nd St..............................212-697-4720
DiPierro-Turiel/210 E 47th St...............................212-752-2260
Duggal Color Projects Inc/9 W 20th St.......................212-924-6363
EAD Color/29 W 38th St......................................212-869-9870
Egelston Retouching Services/333 Fifth Ave 3rd Fl...........212-213-9095
Exact Photo/247 W 30th St...................................212-564-2568
Farmakis, Andreas/835 Third Ave.............................212-758-5280
FCL/Colorspace/10 E 38th St.................................212-679-9064
Filmstat/520 Fifth Ave......................................212-840-1676
Finley Photographics Inc/509 Madison Ave....................212-751-3932
Flax, Sam Inc/39 W 19th St 9th fl...........................212-620-3000
Foto-Style Lab/5 W 20th St..................................212-242-0706
Fotos In Color/1 W 20th St..................................212-691-8360
Four Colors Photo Lab Inc/10 E 39th St......................212-889-3399
Frenchys Color Lab/10 E 38th St.............................212-889-7787
Frey, Louis Co Inc/902 Broadway.............................212-477-0300
Gilbert Studio/127 W 24th St................................212-255-7805
Giraldi, Bob Prodctns/581 Sixth Ave.........................212-691-9200
Graphic Images Ltd/119 W 23rd St............................212-727-9277
Grubb, Louis D/155 Riverside Dr.............................212-873-2561
GW Color Lab/36 E 23rd St...................................212-677-3800
H-Y Photo Service/16 E 52nd St..............................212-371-3018
Hadar, Eric/10 E 39th St....................................212-889-2092

Horvath Productions/335 W 12th St...........................212-924-8492
Hudson Reproductions Inc/601 W 26th St......................212-989-3400
Jaeger, Elliot/49 W 45th St.................................212-840-6278
Jellybean Photographics Inc/99 Madison Ave 14th Fl..........212-679-4888
Katz, David Studio/6 E 39th St..............................212-889-5038
KG Studios Inc/56 W 45th St.................................212-840-7930
King Camera/1165 Broadway...................................212-685-4784
Kurahara, Joan/225 Lafayette St.............................212-226-3628
LaFerla, Sandro/92 Vandam St................................212-620-0693
Larson Color Lab/123 Fifth Ave..............................212-674-0610
Lawrence Color Systems/250 W 40th St........................212-944-7039
Lieberman, Ken Laboratories/118 W 22nd St 4th Fl............212-633-0500
Loy-Taubman Inc/34 E 30th St................................212-685-6871
Lucas, Bob/10 E 38th St.....................................212-725-2090
Lukon Art Service Ltd/22 W 45th St #401.....................212-575-0474
Mann & Greene Color Inc/320 E 39th St.......................212-949-7575
Mann & Greene Quality Color/305 E 46th St...................212-753-2200
Marshall, Henry/2 W 45th St.................................212-944-7771
Martin, Tulio G Studio/234 W 56th St 4th fl.................212-245-6489
Martin/Arnold Color Systems/150 Fifth Ave #429..............212-675-7270
McCurdy & Cardinale Color Lab/65 W 36th St..................212-695-5140
McWilliams, Clyde/151 West 46th St..........................212-221-3644
Miller, Norm & Steve/17 E 48th St...........................212-752-4830
Modernage Photo Services/1150 Ave of Americas...............212-752-3993
Moser, Klaus T Ltd/127 E 15th St............................212-475-0038
Motal Custom Darkrooms/25 W 45th St 3rd Fl..................212-719-5454
Murray Hill Photo Print Inc/32 W 39th St....................212-921-4175
My Lab Inc/42 W 24th St.....................................212-255-3771
National Reprographics Co/44 W 18th St......................212-366-7000
New York Flash Rental/704 Broadway 10th fl..................212-353-0600
Olden Camera/1265 Broadway..................................212-725-1234
Ornaal Color Photos/24 W 25th St............................212-675-3850
Paccione, E S Inc/150 E 56th St.............................212-755-0965
Palevitz, Bob/333 E 30th St.................................212-684-6026
Photographic Color Specialists Inc./10-36 47th Rd, L I City.718-786-4770
Photographics Unlimited/17 W 17th St........................212-255-9678
Precision Chromes Inc/32 W 38th St..........................212-575-0120
Prussack, Phil/155 E 55th St................................212-755-2470
Rainbow Graphics & Chrome Services/49 W 45th St.............212-869-3232
Rasulo Graphics Service/36 E 31st St........................212-686-2861
Regal Velox/575 Eighth Ave..................................212-714-1500
Reiter Dulberg/250 W 54th St................................212-582-6871
Rivera and Schiff Assoc Inc/39 W 32nd St....................212-695-8546
Rogers Color Lab Corp/165 Madison Ave.......................212-683-6400
San Photo-Art Service/165 W 29th St.........................212-594-0850
Scala Fine Arts Publishers Inc/65 Bleecker St...............212-420-9160
Scope Assoc/56 W 22nd St....................................212-243-0032
Slide by Slide/445 E 80th St................................212-879-5091
Slide Shop Inc/220 E 23rd St................................212-725-5200
Spector, Hy Studios/47 W 34th St............................212-594-5766
Steinhauser, Art Retouching/305 E 40th St...................212-953-1722
Studio Chrome Lab Inc/36 W 25th St..........................212-989-6767
Studio Macbeth Inc/130 W 42nd St............................212-921-8922
Studio X/20 W 20th St.......................................212-989-9233
T R P Slavin Colour Services/37 W 26th St...................212-683-6100
Tanksley, John Studios Inc/210 E 47th St....................212-752-1150
Todd Photoprint Inc/1600 Broadway...........................212-245-2440
Trio Studio/65 W 55th St....................................212-247-6349
Twenty/Twenty Photographers Place/20 W 20th St..............212-675-2020
Ultimate Image/443 Park Ave S 7th Fl........................212-683-4838
Verilen Reproductions/350 W 51st St.........................212-971-4000
Vogue Wright Studios/423 West 55th St.......................212-977-3400
Wagner Photoprint Co/121 W 50th St..........................212-245-4796
Ward, Jack Color Service/220 E 23rd St 4th Fl...............212-725-5200
Way Color Inc/420 Lexington Ave.............................212-687-5610
Welbeck Studios Inc/39 W 38th St............................212-869-1660
Wolsk, Bernard/20 E 46th St.................................212-818-9024
Zazula, Hy Assoc/2 W 46th St................................212-819-0444

NORTHEAST

Able Art Service/8 Winter St, Boston, MA....................617-482-4558
Alfie Custom Color/155 N Dean St, Englewood, NJ.............201-569-2028
Alves Photo Service/14 Storrs Ave, Braintree, MA............617-843-5555
Artography Labs/2419 St Paul St, Baltimore, MD..............301-467-5575
Asman Custom Photo Service/926 Penn Ave SE, Washington, DC..202-547-7713
Blakeslee Lane Studio/916 N Charles St, Baltimore, MD.......301-727-8800

Blow-Up/2441 Maryland Ave, Baltimore, MD ..301-467-3636
Boris Color Lab/451 D St, Boston, MA ...617-439-3200
Boston Photo Service/112 State St, Boston, MA617-523-0508
Calverts Inc/938 Highland Ave, Needham Hts, MA617-444-8000
Campbell Photo & Printing/2601 Everts St NE, Washington, DC202-526-0385
Central Color/1 Prospect Ave, White Plains, NY914-681-0218
Chester Photo/398 Centrl Pk Ave/Grnvl Plz, Scarsdale, NY914-472-8088
Cinema Services/116 North Ave, Parkridge, NJ201-391-3463
Collett, Al Retouching/8 Covenger Dr, Medford, NJ609-953-9470
Color Film Corp/100 Maple St, Stoneham, MA617-279-0080
Color Services/120 Hampton Ave, Needham, MA617-444-5101
Colorlab/5708 Arundel Ave, Rockville, MD ...301-770-2128
Colortek/109 Beach St, Boston, MA ...617-451-0894
Colotone Litho Separator/260 Branford/PO Box 97, N Branford, CT203-481-6190
Complete Photo Service/703 Mt Auburn St, Cambridge, MA617-864-5954
Dunigan, John V/62 Minnehaha Blvd, PO Box 70, Oakland, NJ201-337-6656
Durkin, Joseph/5 Harwood Rd, Natick, MA ...508-653-7182
Eastman Kodak/343 State St, Rochester, NY716-724-4688
EPD Photo Service/67 Fulton Ave, Hempstead, NY516-486-5300
Five-Thousand K/281 Summer St, Boston, MA617-542-5995
Foto Fidelity Inc/35 Leon St, Boston, MA ...617-267-6487
G F I Printing & Photo Co/2 Highland St, Port Chester, NY914-937-2823
Graphic Accent/446 Main St PO Box 243, Wilmington, MA508-658-7602
Iderstine, Van/148 State Hwy 10, E Hanover, NJ201-887-7879
Image Inc/1919 Pennsylvania Ave, Washington, DC202-833-1550
K E W Color Labs/112 Main St, Norwalk, CT203-853-7888
Light-Works Inc/120 Pine St, Burlington, VT802-658-6815
Lighthaus/109 Broad St, Boston, MA ..617-426-5643
Marinelli, Jack/17 Willow St, Waterbury, CT203-597-1556
Medina Studios Inc/26 Milburn Ave, Springfield, NJ201-467-2141
Meyers, Tony/W 70 Century Rd, Paramus, NJ201-265-6000
Modern Mass Media/Box 950, Chatham, NJ201-635-6000
MotoPhoto/81 Closter Plaza, Closter, NJ ...201-784-0655
Musy, Mark/PO Box 755, Buckingham, PA ...215-794-8851
National Color Labs Inc/306 W 1st Ave, Roselle, NJ908-241-1010
National Photo Service/1475 Bergen Blvd, Fort Lee, NJ212-860-2324
Northeast Color Research/40 Cameron Ave, Somerville, MA617-666-1161
Ogunquit Photo School/PO Box 2234, Ogunquit, ME207-646-7055
Photo Dynamics/PO Box 731, 70 Jackson Dr, Cranford, NJ908-272-8880
Photo-Colortura/67 Brookside Ave, Boston, MA617-522-5132
Regester Photo Services Inc/50 Kane St, Baltimore, MD301-633-7600
Retouching Graphics/205 Roosevelt Ave, Massapequa Pk, NY516-541-2960
Riter, Warren/2291 Enfield, Pittsford, NY ...716-381-4368
Snyder, Jeffrey/915 E Street NW, Washington, DC202-347-5777
Starlab Photo/4727 Miller Ave, Washington, DC301-986-5300
STI Group/606 W Houstatonic St, Pittsfield, MA413-443-7900
STI Group Inc/326 Springside Ave, Pittsfield, MA413-443-7900
Stone Reprographics/44 Brattle St, Cambridge, MA617-495-0200
Subtractive Technology/338-B Newbury St, Boston, MA617-437-1887
Superior Photo Retouching Srvc/1955 Mass Ave, Cambridge, MA617-661-9094
Technical Photography Inc/1275 Bloomfield Ave, Fairfield, NJ201-227-4646
Visual Horizons/180 Metropark, Rochester, NY716-424-5300
Wilson, Paul/25 Huntington Ave, Boston, MA617-437-1236

S O U T H E A S T

A Printers Film Service/904-D Norwalk, Greensboro, NC919-852-1275
AAA Blue Print Co/3649 Piedmont Rd, Atlanta, GA404-261-1580
Alderman Co/325 Model Farm Rd, High Point, NC919-889-6121
Allen Photo/2800 Shirlington Rd, Arlington, VA703-524-7121
Associated Photographers/19 SW 6th St, Miami, FL305-373-4774
Atlanta Blue Print/1052 W Peachtree St N E, Atlanta, GA404-873-5911
Atlanta Blue-Print & Graphics Co/1052 W Peachtree St, Atlanta, GA ..404-873-5976
Barral, Yolanda/100 Florida Blvd, Miami, FL305-261-4767
Bristow Photo Service/2018 Wilson St, Hollywood, FL305-920-1377
Chromatics/625 Fogg St, Nashville, TN ..615-254-0063
Color Copy Inc/520 Whaley, Columbia, SC ...803-256-0225
Color Image-Atlanta/478 Armour Circle, Atlanta, GA404-876-0209
The Color Lab/111 NE 21st St, Miami, FL ...305-576-3207
E-Six Lab/678 Tenth St NW, Atlanta, GA ..404-885-1293
Eagle Photographics/3612 Swann Ave, Tampa, FL813-870-2495
Florida Photo Inc/781 NE 125th St, N Miami, FL305-891-6616
Florida Precision Graphics/5745 Columbia Cir, W Palm Beach, FL407-842-9500
Fordyce Photography/4873 NW 36th St, Miami, FL305-885-3406
Gables Blueprint Co/4075 Ponce De Leone Blvd, Coral Gables, FL305-443-7146
General Color Corporation/604 Brevard Ave, Cocoa, FL407-631-1602
Infinite Color/2 East Glebe Rd, Alexandria, VA703-549-2242

Janousek & Assoc Inc/3097 Colonial Way #O, Atlanta, GA404-458-8989
Laser Color Labs/Fairfield Dr, W Palm Beach, FL407-848-2000
Mid-South Color Laboratories/496 Emmet, Jackson, TN901-422-6691
Northside Blueprint Co/5141 New Peachtree Rd, Atlanta, GA404-458-8411
Par Excellence/2900 Youree Dr, Shreveport, LA318-869-2533
Photo-Pros/635 A Pressley Rd, Charlotte, NC704-525-0551
Qualex Illustrated/1200 N Dixie Hwy, Hollywood, FL305-927-8411
Reynolds, Charles/1715 Kirby Pkwy, Memphis, TN901-754-2411
Rich, Bob Video/12495 NE 6th Ave, Miami, FL305-893-6137
Rothor Color Labs/1251 King St, Jacksonville, FL904-388-7717
S & S Pro Color Inc/2719 S MacDill Ave, Tampa, FL813-831-1811
Sheffield & Board/18 E Main St, Richmond, VA804-649-8870
Taffae, Syd/3550 N Bayhomes Dr, Miami, FL305-667-5252
Thomson Photo Lab/4210 Ponce De Leon Blvd, Coral Gables, FL305-443-0669
World Color Inc/1281 US #1 North, Ormond Beach, FL904-677-1332

M I D W E S T

A-1 Photo Service/105 W Madison St #907, Chicago, IL312-346-2248
AC Color Lab Inc/2310 Superior, Cleveland, OH216-621-4575
Ad Photo/2056 E 4th St, Cleveland, OH ..216-621-9360
Advantage Printers/1307 S Wabash, Chicago, IL312-663-0933
Amato Photo Color/818 S 75th St, Omaha, NE402-393-8380
Anderson Graphics/521 N 8th St, Milwaukee, WI414-276-4445
Andre's Foto Lab/160 E Illinois St, Chicago, IL312-321-0900
Arrow Photo Copy/523 S Plymouth Ct, Chicago, IL312-427-9515
Artstreet/111 E Chestnut #12B, Chicago, IL312-664-3049
Astra Photo Service/6 E Lake, Chicago, IL ...312-372-4366
Astro Color Labs/61 W Erie St, Chicago, IL ..312-280-5500
Boulevard Photo/333 N Michigan Ave, Chicago, IL312-263-3508
Buffalo Photo Co/430 W Erie, Chicago, IL ...312-787-6476
Carriage Barn Studio/2360 Riverside Dr, Beloit, WI608-365-2405
Chroma Studios/2300 Maryland Ln, Columbus, OH614-471-1191
Color Central/612 N Michigan Ave, Chicago, IL312-321-1696
Color Concept/566 W Adams, Chicago, IL ..312-939-3397
Color Darkroom Corp/3320 W Vliet St, Milwaukee, WI414-344-3377
Color Detroit Inc/310 Livernois, Ferndale, MI313-546-1800
Color International Labs/593 N York St, Elmhurst, IL708-279-6632
Color Perfect Inc/7450 Woodward, Detroit, MI313-872-5115
Color Systems/5719 N Milwaukee Ave, Chicago, IL312-763-6664
Commercial Colorlab Service/41 S Stolp, Aurora, IL708-892-9330
Copy-Matics/6324 W Fond du Lac Ave, Milwaukee, WI414-462-2250
Cutler-Graves/10 E Ontario, Chicago, IL ...312-988-9393
Diamond Graphics/6324 W Fond du Lac Ave, Milwaukee, WI414-462-2250
Drake, Brady Copy Center/1113 Orive St, St Louis, MO314-421-1311
Dzuroff Studios/1020 Huron Rd E, Cleveland, OH216-696-0120
Emulsion Stripping Ltd/4 N Eighth Ave, Maywood, IL708-344-8100
Fotis Photo/270B Merchandise Mart, Chicago, IL312-337-7300
Fromex/188 W Washington, Chicago, IL ..312-853-0067
Gamma Photo Lab Inc/314 W Superior St, Chicago, IL312-337-0022
Graphic Lab Inc/124 E Third St, Dayton, OH513-461-3774
Graphic Spectrum/523 S Plymouth Ct, Chicago, IL312-427-9515
Grossman Knowling Co/7350 John C Lodge, Detroit, MI813-871-0690
Hill, Vince Studio/119 W Hubbard, Chicago, IL312-644-6690
J D H Inc/2206 Superior Viaduct, Cleveland, OH216-771-0346
Jahn & Ollier Engraving/817 W Washington Blvd, Chicago, IL312-666-7080
Janusz, Robert E Studios/1020 Huron Rd, Cleveland, OH216-621-9845
John, Harvey Studio/823 N 2nd St, Milwaukee, WI414-271-7170
K & S Photographics/1155 Handley Industrial Ct, St Louis, MO314-962-7050
K & S Photographics/222 N Canal, Chicago, IL312-207-1212
Kai-Hsi Studio/160 E Illinois St, Chicago, IL ..312-642-9853
Kier Photo Service/1627 E 40th St, Cleveland, OH216-431-4670
Kolorstat Studios/415 N Dearborn St, Chicago, IL312-644-3729
LaDriere Studios/1565 W Woodward Ave, Bloomfield Hills, MI313-644-3932
Lim, Luis Retouching/405 N Wabash, Chicago, IL312-645-0746
Lubeck, Larry & Assoc/405 N Wabash Ave, Chicago, IL312-726-5580
Merrill-David Inc/3420 Prospect Ave, Cleveland, OH216-391-0988
Meteor Photo /1099 Chicago Rd, Troy, MI ..313-583-3090
Multiprint Co Inc/5555 W Howard, Skokie, IL708-677-7770
Munder Color/2771 Galilee Ave, Zion, IL ..312-764-4435
National Photo Service/114 W Illinois St, Chicago, IL312-644-5211
NCL Graphics/1970 Estes Ave, Elk Grove Village, IL708-593-2610
Noral Color Corp/5560 N Northwest Hwy, Chicago, IL312-775-0991
Norman Sigele Studios/270 Merchandise Mart, Chicago, IL312-642-1757
O'Brien's Agency Inc/924 Terminal Rd, Lansing, MI517-321-0188
Pallas Photo Labs/207 E Buffalo, Milwaukee, WI414-272-2525
Pallas Photo Labs/319 W Erie St, Chicago, IL312-787-4600

Parkway Photo Lab/57 W Grand Ave, Chicago, IL312-467-1711
Photocopy Inc/104 E Mason St, Milwaukee, WI414-272-1255
Photographic Specialties/1718 Washington Ave N, Minneapolis, MN ..612-332-6303
Photomatic Corp/59 E Illinois St, Chicago, IL312-527-2929
Precision Photo Lab/5758 N Webster St, Dayton, OH513-898-7450
Pro-Color/909 Hennepin Ave, Minneapolis, MN612-332-7721
Professional Photo Colour Service/126 W Kinzie, Chicago, IL312-644-0888
Quantity Photo Co/119 W Hubbard St, Chicago, IL312-644-8288
Race Frog Stats/62 N Water, Milwaukee, WI414-276-7828
Reichart, Jim Studio/2301 W Mill Rd, Milwaukee, WI414-228-9089
Reliable Photo Service/415 N Dearborn, Chicago, IL312-644-3723
Repro Inc/912 W Washington Blvd, Chicago, IL312-666-3800
Rhoden Photo & Press Service/7833 S Cottage Grove, Chicago, IL.....312-488-4815
Robin Color Labs/2106 Central Parkway, Cincinnati, OH513-381-5116
Ross-Ehlert/225 W Illinois, Chicago, IL312-644-0244
Schellhorn Photo Techniques/3916 N Elston Ave, Chicago, IL.............312-267-5141
Scott Studios Inc/500 N Mannheim/Unit 1, Hillsdale, IL708-449-3800
Standard Studios Inc/270 Merchandise Mart, Chicago, IL312-944-5330
The Stat Center/668 Euclid Ave #817, Cleveland, OH216-861-5467
Trans Fx/362 W Erie, Chicago, IL312-943-2664
Transparency Duplicating Service/113 N May St, Chicago, IL312-733-4464
UC Color Lab/3936 N Pulaski Rd, Chicago, IL.................................312-545-9641

S O U T H W E S T

A-1 Blue Print Co Inc/2220 W Alabama, Houston, TX.................................713-526-3111
Alamo Photolabs/3814 Broadway, San Antonio, TX512-828-9079
Allied & WBS/6305 N O'Connor #111, Irving, TX214-869-0100
Burns, Floyd & Lloyd Ind/4223 Richmond Ave #2D, Houston, TX.........713-622-8255
BWC/4930 Maple Ave, Dallas, TX214-528-4200
Casey Color Inc/2115 S Harvard Ave, Tulsa, OK918-744-5004
Century Copi-Technics Inc/2008 Jackson St, Dallas, TX214-521-1991
Color Mark Laboratories/2202 E McDowell Rd, Phoenix, AZ.................602-273-1253
The Color Place/2927 Morton St, Fort Worth, TX.................................817-335-3515
The Color Place/1330 Conant St, Dallas, TX214-631-7174
Custom Photographic Labs/601 W ML King Blvd, Austin, TX512-474-1177
Dallas Photolab/3942 Irving Blvd, Dallas, TX214-630-4351
Five-P Photo Processing/2122 E Governor's Circle, Houston, TX.........713-688-4488
H & H Blueprint & Supply Co/5042 N 8th St, Phoenix, AZ602-279-5701
Hot Flash Photographics/5933 Bellaire Blvd #114, Houston, TX...........713-666-9510
Kolor Print Inc/PO Box 747, Little Rock, AR.................................501-375-5581
Magna Professional Color Lab/2601 N 32nd St, Phoenix, AZ602-955-0700
Master Printing Co Inc/220 Creath St, Jonesboro, AR501-932-4491
Meisel Photographic Corp/9645 Wedge Chapel, Dallas, TX214-350-6666
National Photographic Labs/1926 W Gray, Houston, TX713-527-9300
Photographic Works Lab/3550 E Grant Rd, Tucson, AZ602-327-7291
PhotoGraphics/1700 S Lamar #104, Austin, TX.................................512-447-0963
Pounds Photo Lab Inc/2507 Manor Way, Dallas, TX214-350-5671
Pro Photo Lab Inc/2700 N Portland, Oklahoma City, OK405-942-3743
Raphaele/Digital Transparencies Inc/616
Hawthorne, Houston, TX (P 349)**713-524-2211**
River City Silver/906 Basse Rd, San Antonio, TX512-734-2020
Spectro Photo Labs Inc/3111 Canton St, Dallas, TX214-748-3151
Steffan Studio/1905 Skillman, Dallas, TX214-827-6128
Texas World Entrtnmnt/8133 Chadbourne Rd, Dallas, TX214-351-6103
Total Color Inc/2242 Monitor St, Dallas, TX.................................214-634-1484
True Color Photo Inc/710 W Sheridan Ave, Oklahoma City, OK405-232-6441

R O C K Y M T N

Cies/Sexton Photo Lab/275 S Hazel Ct, Denver, CO303-935-3535
Pallas Photo Labs/700 Kalamath, Denver, CO303-893-0101

W E S T C O A S T

A & I Color Lab/933 N Highland, Los Angeles, CA.................................213-464-8361
Alan's Custom Lab/1545 Wilcox, Hollywood, CA213-461-1975
ASA Prodctns/Darkrooms/905 N Cole Ave, Hollywood, CA.................213-463-7513
Atkinson-Stedco Color Film Svc/7610 Melrose Ave, LA, CA.................213-655-1255
Baker, Bill Photography/265 29th St, Oakland, CA415-832-7685
Chromeworks Color Processing/425 Bryant St, San Francisco, CA......415-957-9481
Color Etcetera/740 Cahuenga Blvd, Los Angeles, CA213-461-4591
Color Lab Inc/742 Cahuenga Blvd, Los Angeles, CA.................................213-461-2916
Custom Photo Lab/123 Powell St, San Francisco, CA415-956-2374
The Darkroom/9227 Reseda Blvd, Northridge, CA.................................818-885-1153

Darkroom B&W Lab/897-2B Independence Ave, Mtn View, CA415-969-2955
Faulkner Color Lab/1200 Folsom St, San Francisco, CA.................415-861-2800
Focus Foto Finishers/138 S La Brea Ave, Los Angeles, CA213-934-0013
Frosh, R L & Sons Studio/4114 Sunset Blvd, Los Angeles, CA.............213-662-1134
Gamma Photographic Labs/351 9th St, San Francisco, CA.................415-864-8155
Gibbons Color Lab/606 N Almont Dr, Los Angeles, CA.................213-275-6806
Gornick Film Production/4200 Camino Real, Los Angeles, CA213-223-8914
GP Color Inc/201 S Oxford Ave, Los Angeles, CA.................213-386-7901
Graphic Process Co/979 N LaBrea, Los Angeles, CA.................213-850-6222
Hecht Custom Photo/Graphics/1711 N Orange Dr, Hollywood, CA......213-466-7106
Hollywood Fotolab/6413 Willoughby Ave, Hollywood, CA.................213-469-5421
Imagic/5308 Vineland Ave, N Hollywood, CA (P 355)...818-753-0001
Imagic/1545 N Wilcox, Hollywood, CA (P 355)213-461-3901
Imperial Color Lab/965 Howard St, San Francisco, CA415-777-4020
Ivey-Seright/424 8th Ave North, Seattle, WA.................206-623-8113
Jacobs, Ed/937 S Spaulding, Los Angeles, CA.................213-935-1064
Jacobs, Robert Retouching/6010 Wilshire #505, Los Angeles, CA.......213-931-3751
Kinney, Paul Productions/1990 Third St, Sacramento, CA.................916-447-8868
Landry, Carol/7926 Convoy Ct, San Diego, CA.................619-560-1778
Lee Film Processing/8584 Venice Blvd, Los Angeles, CA.................213-559-0296
M P S Photo Services/17406 Mt Cliffwood Cir, Fountain Valley, CA.......714-540-9515
Maddocks, J H/4766 Melrose Ave, Los Angeles, CA.................213-660-1321
Marin Color Lab/41 Belvedere St, San Rafael, CA.................415-456-8093
Modern Photo Studio/5625 N Figueroa, Los Angeles, CA.................213-255-1527
Modernage/470 E Third St, Los Angeles, CA.................213-628-8194
Newell Color Lab/630 Third St, San Francisco, CA.................415-974-6870
Pacific Production & Location/424 Nahua St, Honolulu, HI.................808-924-2513
Paragon Photo/731 1/2 N LaBrea, Los Angeles, CA.................213-933-5865
Petron Corp/5443 Fountain Ave, Los Angeles, CA.................213-461-4626
Pevehouse, Jerry Studio/3409 Tweedy Blvd, South Gate, CA.................213-564-1336
Photoking Lab/6612 W Sunset Blvd, Los Angeles, CA.................213-466-2977
Prisma Color Inc/5623 Washington Blvd, Los Angeles, CA.................213-728-7151
Professional Color Labs/96 Jessie, San Francisco, CA.................415-397-5057
Quantity Photos Inc/5432 Hollywood Blvd, Los Angeles, CA.................213-467-6178
Rapid Color Inc/1236 S Central Ave, Glendale, CA.................213-245-9211
Retouching Chemicals/5478 Wilshire Blvd, Los Angeles, CA.................213-935-9452
Revilo Color/4650 W Washington Blvd, Los Angeles, CA.................213-936-8681
RGB Lab Inc/816 N Highland, Los Angeles, CA.................213-469-1959
Snyder, Len/238 Hall Dr, Orinda, CA.................415-254-8687
Stat House/8126 Beverly Blvd, Los Angeles, CA.................213-653-8200
Still Photo Lab/1210 N LaBrea, Los Angeles, CA.................213-465-6106
Studio Photo Service/6920 Melrose Ave, Hollywood, CA.................213-935-1223
Timars/918 N Formosa, Los Angeles, CA.................213-876-0175
Tom's Chroma Lab/514 No LaBrea, Los Angeles, CA.................213-933-5637
Vloeberghs, Jerome/333 Kearny St, San Francisco, CA.................415-982-1287
Waters Art Studio/1820 E Garry St #207, Santa Ana, CA.................714-250-4466
Wild Studio/1311 N Wilcox Ave, Hollywood, CA.................213-463-8369
Williams, Alan & Assoc Inc/4370 Tujunga Ave, Los Angeles, CA.........213-653-2243
Wolf Color Lab/1616 Cahuenga Blvd, Los Angeles, CA.................213-463-0766
Zammit, Paul/5478 Wilshire Blvd #300, Los Angeles, CA.................213-933-8563
Ziba Photographics/591 Howard St, San Francisco, CA.................415-543-6221

I N T E R N A T I O N A L

Absolute Color Slides/197 Dundas E, Toronto, ON416-868-0413
Assoc Photo Labs/1820 Gilford, Montreal, QU514-523-1139
Benjamin Film Labs/287 Richmond St, Toronto, ON416-863-1166
BGM Color Labs/497 King St E, Toronto, ON416-947-1325
Bonaventure Color Labs/425 Guy St, Montreal, QU514-989-9551
Color Studio Labs/1553 Dupont, Toronto, ON.................416-531-1177
Corley D & S Ltd/3610 Nashua Dr #7, Mississaugua, ON416-675-3511
Gallery Color Lab/620 W Richmond St, Toronto, ON416-367-9770
Gourdon, Claude Photo Lab/60 Sir Louis VI, St Lambert, QU514-671-4604
Jones & Morris Ltd/24 Carlaw Ave, Toronto, ON416-465-5466
SE Graphics Ltd/795 E Kings St, Hamilton, ON416-545-8484
Transparency Processing Service/324 W Richmond St, Toronto, ON ...416-593-0434
Uniphoto Color/1120 Ashford Ave, Condado, PR809-722-3653

438

LIGHTING

NYC

Altman Stage Lighting Co Inc/57 Alexander, Yonkers...........................212-569-7777
Artistic Neon by Gasper/75-49 61st St, Glendale718-821-1550
Balcar Lighting Systems/38 Greene St 3rd fl...212-219-3501
Barbizon Electric Co Inc/426 W 55th St..212-586-1620
Bernhard Link Theatrical Inc/320 W 37th St..212-629-3522
Big Apple Lights Corp/533 Canal St..212-226-0925
Camera Mart/456 W 55th St..212-757-6977
Electra Displays/133 W 25th St..212-255-0438
Feature Systems Inc/512 W 36th St..212-736-0447
Ferco/601 W 50th St..212-245-4800
Fiorentino, Imero Assoc Inc/33 W 60th St..212-246-0600
Litelab Theatrical & Disco Equip/76 Ninth Ave.......................................212-675-4357
Lowel Light Mfg Inc/140 58th St, Brooklyn ...718-921-0600
Movie Lights Ltd/207 E 15th St ..212-673-5522
Paris Film Productions Ltd/31-00 47th Ave, Long Island City718-482-7633
Production Arts Lighting/636 Eleventh Ave...212-489-0312
Stage Lighting Discount Corp/318 W 47th St...212-489-1370
Stroblite Co Inc/430 W 14th St #507...212-929-3778

NORTHEAST

Barbizon Light of New England/3 Draper St, Woburn, MA...................617-935-3920
Capron Lighting & Sound/278 West St, Needham, MA617-444-8850
Cestare, Thomas Inc/188 Herricks Rd, Mineola, NY..............................516-742-5550
Filmtrucks, Inc/311 Washington St, Jersey City, NJ201-432-9140
Heller, Brian/200 Olney St, Providence, RI ..401-751-1381
Kliegl Bros Universal/5 Aerial Way, Syosset, NY516-937-3900
Lighting Products, GTE Sylvania/Lighting Center, Danvers, MA508-777-1900
Limelight Productions/Route 102, Lee, MA ...413-298-3771
Lycian Stage Lighting/PO Box D, Sugar Loaf, NY914-469-2285
Martarano, Sal Jr/9B West 1st St, Freeport, NY......................................516-378-5815
McManus Enterprises/111 Union Ave, Bala Cynwyd, PA215-664-8600
Packaged Lighting Systems/29-41 Grant, PO Box 285, Walden, NY....914-778-3515
R & R Lighting Co/813 Silver Spring Ave, Silver Spring, MD301-589-4997
Ren Rose Locations/4 Sandalwood Dr, Livingston, NJ201-992-4264

SOUTHEAST

Aztec Stage Lighting/1370 4th St, Sarasota, FL.....................................813-366-8848
Kupersmith, Tony/320 Highland Ave NE, Atlanta, GA............................404-577-5319

MIDWEST

Duncan, Victor Inc/23801 Ind Park Dr #100, Farmington Hls, MI..........313-471-1600
Grand Stage Lighting Co/630 W Lake, Chicago, IL.................................312-332-5611
S & A Studio Lighting/1345 W Argyle St, Chicago, IL.............................312-989-8808

SOUTHWEST

ABC Theatrical Rental & Sales/825 N 7th St, Phoenix, AZ....................602-258-5265
Astro Audio-Visual/1336 W Clay, Houston, TX..713-528-7119
Duncan, Victor Inc/6305 N O'Connor/Bldg 4, Irving, TX214-869-0200
FPS Inc/6309 N O'Connor Rd #200, Irving, TX..214-869-9535

WESTCOAST

Adaboy Rental Service/806 Rancho Rd, Thousand Oaks, CA..............805-495-8606
American Mobile Power Co/3218 W Burbank Blvd, Burbank, CA........818-845-5474
Astro Generator Rentals/2835 Bedford St, Los Angeles, CA................213-838-3958
Castex Rentals/1044 N Cole Ave, Los Angeles, CA...............................213-462-1468
Cine Turkey/2624 Reppert Ct, Los Angeles, CA.....................................213-654-6495
Cineworks Superstage/1119 N Hudson Ave, Hollywood, CA.................213-464-0296
Cool Light Co Inc/5723 Auckland Ave, North Hollywood, CA818-761-6116
Fiorentino, Imero/7060 Hollywood Blvd #1000, Hollywood, CA.............213-467-4020
Hollywood Mobile Systems/7021 Hayvenhurst St, Van Nuys, CA818-782-6558
Leoinetti Co/5609 Sunset Blvd, Hollywood, CA......................................213-469-2987

Mole Richardson/937 N Sycamore Ave, Hollywood, CA.......................213-851-0111
Raleigh Studios/5300 Melrose Ave, Hollywood, CA...............................213-466-3111

STUDIO RENTALS

NYC

All Mobile Video/221 W 26th St..212-675-2211
American Museum of the Moving Image/30 Fifth Ave
@ 36th St, Astoria, NY ...718-784-4520
Antonio/Stephen Ad Photo/5 W 30th St 4th Fl.......................................212-629-9542
Boken Inc/513 W 54th St...212-581-5507
C & C Visual/1500 Broadway 4th fl...212-869-4900
Camera Mart Inc/456 W 55th St...212-757-6977
Cine Studio/241 W 54th St...212-581-1916
Codalight Rental Studios/151 W 19th St...212-206-9333
Contact Studios/165 W 47th St ...212-354-6400
DeFilippo/215 E 37th St...212-986-5444
Devlin Videoservice/1501 Broadway #408 ..212-391-1313
Duggal Color Projects/9 W 20th St ...212-242-7000
Farkas Films Inc/385 Third Ave ..212-679-8212
Horvath & Assoc Studios/95 Charles St..212-741-0300
Mothers Sound Stages/210 E 5th St..212-260-2050
National Video Industries/15 W 17th St...212-691-1300
New York Flash Rental/704 Broadway 10th fl ..212-353-0600
North Light Studios/122 W 26th St ..212-989-5498
Osonitsch, Robert/112 Fourth Ave..212-533-1920
Phoenix State Ltd/537 W 59th St..212-581-7721
Professional Photo Supply/141 W 20th St...212-924-1200
Reeves Entertainment/708 Third Ave ..212-573-8888
Rotem Studio/259 W 30th St ...212-947-9455
Schnoodle Studios/54 Bleecker St ..212-431-7788
Silva-Cone Studios/260 W 36th St ...212-279-0900
Studio 2B/1200 Broadway ...212-679-5537
Yellow Dot/47 E 34th St ...212-532-4010

NORTHEAST

Bay State Film Productions Inc/35 Springfield St, Agawam, MA...........413-786-4454
Color Leasing Studio/330 Rt 46 East, Fairfield, NJ................................201-575-1118
Editel/651 Beacon St, Boston, MA...617-267-6400
Impact Studios/1084 N Delaware Ave, Philadelphia, PA215-426-3988
Ren Rose Locations/4 Sandalwood Dr, Livingston, NJ201-992-4264
September Productions Inc/1 Appleton St, Boston, MA617-482-9900
Ultra Photo Works/468 Commercial Ave, Palisades Pk, NJ201-592-7730
Videocom Inc/502 Sprague St, Dedham, MA ...617-329-4080
WGGB-TV/PO Box 40, Springfield, MA ...413-733-4040
WLNE-TV/430 County St, New Bedford, MA ...508-992-6666

SOUTHEAST

The Great Southern Stage/15221 NE 21st Ave, N. Miami Bch, FL305-947-0430
Wien/Murray Studio/2480 West 82nd St #8, Hialeah, FL.......................305-828-7400

MIDWEST

Lewis, Tom/2511 Brumley Dr, Flossmoor, IL ..708-799-1156
Mike Jones Film Corp/5250 W 74, Minneapolis, MN..............................612-835-4490
Rainey, Pat/4031 N Hamlin Ave, Chicago, IL ...312-463-0281
Sosin, Bill/415 W Superior St, Chicago, IL..312-751-0974

SOUTHWEST

AIE Studios/3905 Braxton, Houston, TX ...713-781-2110
Arizona Cine Equipment/2125 E 20th St, Tucson, AZ602-623-8268
Hayes, Bill Film & Video/11500 Braesview #2405, San Antonio, TX......512-493-3551
Pearlman Productions Inc/2401 W Belfort, Houston, TX........................713-668-3601
Stokes, Bill Assoc/5642 Dyer, Dallas, TX..214-363-0161

WEST COAST

ASA Productions/Studio/905 Cole Ave #2100, Hollywood, CA..............213-463-7513
Blakeman, Bob Studios/710 S Santa Fe, Los Angeles, CA213-624-6662
Carthay Studio/5907 W Pico Blvd, Los Angeles, CA213-938-2101
Cine-Rent West Inc/991 Tennessee St, San Francisco, CA...................415-864-4644
Cine-Video/948 N Cahuenga Blvd, Los Angeles, CA213-464-6200
Columbia Pictures/Columbia Plaza, Burbank, CA.................................818-954-6000
Disney, Walt Productions/500 S Buena Vista St, Burbank, CA..............818-560-1000
Dominick/833 N LaBrea Ave, Los Angeles, CA.....................................213-934-3033
Eliot, Josh Studio/706 W Pico Blvd, Los Angeles, CA...........................213-742-0367
Hollywood National Studios/6605 Eleanor Ave, Hollywood, CA213-467-6272
Hollywood Stage/6650 Santa Monica Blvd, Los Angeles, CA...............213-466-4393
KCLP TV/915 N LaBrea, Los Angeles, CA ...213-850-2236
Kelley, Tom Studios/8525 Santa Monica Blvd, Los Angeles, CA..........213-657-1780
Kings Point Corporation/8599 Venice Blvd, Los Angeles, CA...............213-559-4925
Liles, Harry Productions Inc/1060 N Lillian Way, Los Angeles, CA........213-466-1612
MGM Studios/10000 W Washington, Culver City, CA213-280-6000
Norwood, David/9023 Washington Blvd, Culver City, CA213-204-3323
Omega Studio Rentals/5755 Santa Monica Blvd, Hollywood, CA........213-466-8201
Paramount/5555 Melrose, Los Angeles, CA..213-468-5000
Raleigh Studios/5300 Melrose Ave, Hollywood, CA...............................213-466-3111
Studio Center CBS/4024 Radford Ave, Studio City, CA818-760-5000
Studio Resources/1915 University Ave, Palo Alto, CA415-321-8763
Sunset/Gower Studio/1438 N Gower, Los Angeles, CA.........................213-467-1001
Superstage/1119 N Hudson, Hollywood, CA ...213-464-0296
Trans-American Video/1541 Vine St, Los Angeles, CA..........................213-466-2141
Twentieth Century Fox/10201 W Pico Blvd, Los Angeles, CA213-277-2211
Universal City Studios/Universal Studios, Universal City, CA818-777-1000
Warner Brothers/4000 Warner Blvd, Burbank, CA818-954-6000

ANIMATORS

NYC

A P A/230 W 10th St...212-929-9436
ALZ Productions/11 Waverly Pl #1J...212-473-7620
Animated Productions Inc/1600 Broadway ...212-265-2942
Animation Services Inc/221 W 57th St 11th Fl...212-333-5656
Animus Films/2 W 47th St...212-391-8716
Avekta Productions Inc/164 Madison Ave..212-686-4550
Beckerman, Howard/35-38 169th St, Flushing..212-869-0595
Blechman, R O/2 W 47th St...212-869-1630
Broadcast Arts Inc/632 Broadway ..212-254-5400
Charisma Communications/32 E 57th St...212-832-3020
Charlex Inc/2 W 45th St 7th Fl..212-719-4600
Cinema Concepts/321 W 44th St...212-541-9220
Clark, Ian/229 E 96th St...212-289-0998
Dale Cameragraphics Inc/12 W 27th St..212-696-9440
Darino Films/222 Park Ave S...212-228-4024
Devlin Productions Inc/1501 Broadway #408 ...212-391-1313
Doros Animation Inc/156 Fifth Ave..212-627-7220
The Fantastic Animation Machine/12 E 46th St ..212-697-2525
Feigenbaum Productions Inc/5 W 37th St 3rd fl..212-704-9670
Film Opticals/144 E 44th St...212-697-4744
Gati, John/154 W 57th St #832 ...212-582-9060
Grossman, Robert/19 Crosby St..212-925-1965
ICON Communications/717 Lexington Ave...212-688-5155
International Production Center/514 W 57th St ...212-582-6530
Kimmelman, Phil & Assoc Inc/9 E 37th St 10th fl ...212-679-8400
Lieberman, Jerry/76 Laight St..212-431-3452
Locomo Productions/875 West End Ave ..212-222-4833
Marz Productions Inc/118 E 25th St...212-477-3900
Metropolis Graphics/28 E 4th St ...212-677-0630
Motion Picker Studio/416 Ocean Ave, Brooklyn, NY..718-856-2763
Musicvision, Inc/185 E 85th St...212-860-4420
Omnibus Computer Graphics/508 W 57th St..212-975-9050
Ovation Films/81 Irving Pl..212-529-4111
Rembrandt Films/59 E 54th St ...212-758-1024
Shadow Light Prod, Inc/163 W 23rd St 5th fl...212-689-7511
Stark, Philip/245 W 29th St 15th Fl..212-868-5555
Today Video, Inc/45 W 45th St ..212-391-1020
Videart Inc/39 W 38th St..212-840-2163
Video Works/24 W 40th St..212-869-2500

NORTHEAST

Aviation Simulations International Inc/Box 358, Huntington, NY516-271-6476
Computer Graphics Lab/100 Glen Cove Ave, Glen Cove, NY516-484-1944
Consolidated Visual Center/2529 Kenilworth Ave, Tuxedo, MD...........301-772-7300
Hughes, Gary Inc/PO Box 426, Glen Echo, MD...................................301-229-1100
Pansophic/1825 Q St NW, Washington, DC ...202-232-7733
Penpoint Prod Svc/331 Newbury St, Boston, MA.................................617-266-1331
Pilgrim Film Service/2504 50th Ave, Hyattsville, MD301-773-7072

SOUTHEAST

Cinetron Computer Systems Inc/6700 IH 85 North, Norcross, GA........404-448-9463

MIDWEST

AGS & R Studios/314 W Superior, Chicago, IL312-649-4500
Ball, John & Assoc/203 N Wabash, Chicago, IL312-332-6041
Boyer Studio/1324 Greenleaf, Evanston, IL...708-491-6363
Filmack Studios /1327 S Wabash Ave, Chicago, IL312-427-3395
Freese & Friends Inc/1429 N Wells, Chicago, IL..................................312-642-4475
Goldsholl Assoc/420 Frontage Rd, Northfield, IL..................................708-446-8300
Kinetics/444 N Wabash, Chicago, IL ..312-644-2767
Mike Jones Film Corp/5250 W 74, Minneapolis, MN.............................612-835-4490
Pilot Prod/2821 Central St, Evanston, IL..708-328-3700
Quicksilver Assoc Inc/16 W Ontario, Chicago, IL.................................312-943-7622
Simott & Associates/676 N La Salle, Chicago, IL.................................312-440-1875

WEST COAST

Bass/Yeager Associates/7039 Sunset Blvd, Hollywood, CA213-466-9701
Bosustow Entertainment/3000 Olympic Blvd, Santa Monica, CA..........213-315-4888
Cinema Research Corp/6860 Lexington Ave, Hollywood, CA...............213-460-4111
Clampett, Bob Prod/729 Seward St, Hollywood, CA............................213-466-0264
Duck Soup Productions Inc/1026 Montana Ave, Santa Monica, CA213-451-0771
Energy Productions/12700 Ventura Blvd 4th Fl, Studio City, CA...........818-508-1444
Filmcore/849 N Seward, Hollywood, CA...213-464-7303
Filmfair/10900 Ventura Blvd, Studio City, CA.......................................213-877-3191
Kurtz & Friends/2312 W Olive Ave, Burbank, CA.................................213-461-8188
Littlejohn, William Prod Inc/23425 Malibu Colony Dr, Malibu, CA.........213-456-8620
Lumeni Productions/1727 N Ivar, Hollywood, CA..................................213-462-2110
Melendez, Bill Prod Inc/439 N Larchmont Blvd, Los Angeles, CA213-463-4101
Murakami Wolf Swenson Films/4222 W Burbank Blvd, Burbank, CA818-846-0611
New Hollywood Inc/1302 N Cahuenga Blvd, Hollywood, CA...............213-466-3686
R & B EFX/1806 Victory Blvd, Glendale, CA818-956-8406
Raintree Productions Ltd/666 N Robertson Blvd, Hollywood, CA213-652-8330
Spungbuggy Works Inc/948 N Fairfax, Hollywood, CA213-657-8070
Title House/738 Cahuenga Blvd, Los Angeles, CA...............................213-469-8171
U P A Pictures Inc/14101 Valley Heart Dr #200, Sherman Oaks, CA....818-990-3800

MODELS & TALENT

NYC

Abrams Artists/420 Madison Ave ...212-935-8980
Adams, Bret/448 W 44th St..212-765-5630
Agency for Performing Arts/888 Seventh Ave...212-582-1500
Agents for the Arts/1650 Broadway..212-247-3220
Amato, Michael Theatrical Entrps/1650 Broadway ..212-247-4456
American Intl Talent/303 W 42nd St..212-245-8888
Anderson, Beverly/1501 Broadway...212-944-7773
Associated Booking/1995 Broadway...212-874-2400
Astor, Richard/1697 Broadway ...212-581-1970
Avenue Models/295 Madison Ave 46th Fl...212-972-5495
Barbizon Agency of Rego Park/95-20 63rd Rd..718-275-2100
Barry Agency/165 W 46th St...212-869-9310
Bauman & Hiller/250 W 57th St..212-757-0098
Beilin, Peter/230 Park Ave..212-949-9119

Bloom, J Michael/233 Park Ave S ...212-529-5800
Buchwald, Don & Assoc Inc/10 E 44th St212-867-1070
Carson-Adler/250 W 57th St ...212-307-1882
Cataldi, Richard Agency/180 Seventh Ave212-741-7450
Celebrity Look-Alikes/2067 Broadway212-532-7676
Click Model Management/881 Seventh Ave #1013212-315-2200
Coleman-Rosenberg/210 E 58th St212-838-0734
Columbia Artists/165 W 57th St212-397-6900
DeVore, Ophelia/350 Fifth Ave #1816212-629-6400
Eisen, Dulcina Assoc/154 E 61st St212-355-6617
Fields, Marje/165 W 46th St ...212-764-5740
Focus Model Management/611 Broadway #523212-677-1200
Ford Models Inc/344 E 59th St212-753-6500
Funny Face/440 E 62nd St ..212-752-6090
Gage Group Inc/315 W 57th St #4H212-541-5250
Greco, Maria & Assoc/1261 Broadway212-213-5500
Hadley, Peggy Ent/250 W 57th St212-246-2166
Harter-Manning & Assoc/111 E 22nd St 4th Fl212-529-4555
Harth, Ellen Inc/149 Madison Ave.212-686-5600
Hartig, Michael Agency Ltd/114 E 28th St212-684-0010
Henderson-Hogan/405 W 44th St212-765-5190
HV Models/18 E 53rd St ..212-751-3005
International Creative Management/40 W 57th St212-556-5600
Jacobsen Wilder Kesten/419 Park Ave So212-686-6100
Jan J Agency/213 E 38th St 3rd fl212-682-0202
Jordan, Joe Talent Agency/156 Fifth Ave212-463-8455
Kahn, Jerry Inc/853 Seventh Ave212-245-7317
KMA Associates/211 W 56th St #17D212-581-4610
Kolmar-Luth Entertainment Inc/165 W 46th St #1202212-921-8989
Kroll, Lucy/390 West End Ave ..212-877-0556
L B H Assoc/1 Lincoln Plaza ..212-787-2609
Larner, Lionel Ltd/130 W 57th St212-246-3105
Leigh, Sanford Entrprs Ltd/440 E 62nd St212-752-4450
Leighton, Jan/205 W 57th St ...212-757-5242
Lewis, Lester Assoc/400 E 52nd St212-758-2480
Mannequin Fashion Models Inc/150 E 58th St 35th Fl212-755-1456
Martinelli Attractions/888 Eighth Ave212-586-0963
McDermott Enterprises/216 E 39th St212-889-1583
McDonald/ Richards/156 Fifth Ave212-627-3100
Models Service Agency/1457 Broadway212-944-8896
Models Talent Int'l/1457 Broadway212-302-8450
Morris, William Agency/1350 Sixth Ave212-586-5100
Mystique Models/928 Broadway #704212-228-7807
Oppenheim-Christie/13 E 37th St212-213-4330
Oscard, Fifi/19 W 44th St #1500212-764-1100
Our Agency/112 E 23rd St PH ...212-982-5626
Packwood, Harry Talent Ltd/250 W 57th St212-586-8900
Palmer, Dorothy/235 W 56th St212-765-4280
Petite Model Management/123 E 54th St #9A212-759-9304
Phoenix Artists/311 W 43rd St...212-586-9110
Plus Models/49 W 37th St ...212-997-1785
Prelly People & Co/296 Fifth Ave212-714-2060
Premier Talent Assoc/3 E 54th St212-758-4900
Rogers-Lerman/37 E 28th St #506...................................212-889-8233
Roos, Gilla Ltd/16 W 22nd St ..212-727-7820
Ryan, Charles Agency/1841 Broadway............................212-245-2225
Schuller, William Agency/1276 Fifth Ave.........................212-532-6005
Select Artists Reps/337 W 43rd St #1B212-586-4300
Silver Kass Massetti/East Ltd/145 W 45th St212-391-4545
Smith, Susan Ltd/192 Lexington Ave212-545-0500
The Starkman Agency/1501 Broadway212-921-9191
Stars/303 E 60th St ..212-758-3545
STE Representation/888 Seventh Ave212-246-1030
Stroud Management/119 W 57th St212-688-0226
Talent Reps Inc/20 E 53rd St...212-752-1835
Theater Now Inc/1515 Broadway212-840-4400
Thomas, Michael Agency/305 Madison212-867-0303
Total Look/10 Bay St Landing #A4L, St George SI...........718-816-1532
Tranum Robertson Hughes Inc/2 Dag Hammarskjold Plaza212-371-7500
Triad Artists/888 Seventh Ave ...212-489-8100
Universal Attractions/225 W 57th St.................................212-582-7575
Van Der Veer People Inc/401 E 57th St212-688-2880
Wilhelmina Models/9 E 37th St..212-532-6800
Wright, Ann Assoc/136 E 57th St212-832-0110
Zoli/3 W 18th St ...212-758-7336

N O R T H E A S T

Cameo Models/437 Boylston St, Boston, MA.................617-536-6004
Conover, Joyce Agency/33 Gallowae, Westfield, NJ908-232-0908
Copley 7 Models & Talent/142 Berkeley St, Boston, MA617-267-4444
The Ford Model Mgmt/297 Newbury St, Boston, MA.......617-266-6939
Leach, Dennis/585 Dartmouth St, Westbury, NY............516-334-3084
Models Unlimited/4475 S Clinton Ave #7, South Plainfield, NJ...........908-769-8959
National Talent Assoc/40 Railroad Ave, Valley Stream, NY516-825-8707
Somers, Jo/142 Berkeley St, Boston, MA.......................617-267-4444

S O U T H E A S T

A del Corral Model & Talent/5830 Argonne Blvd, New Orleans, LA504-288-8963
Act 1 Casting Agency/1220 Collins Ave #200, Miami Beach, FL305-672-0200
Amaro Agency/661 Blanding Blvd, Orange Park, FL.......904-276-3408
Atlanta Models & Talent Inc/3030 Peachtree Rd NW, Atlanta, GA........404-261-9627
Brown, Bob Puppet Prod/1415 S Queen St, Arlington, VA...............703-920-1040
Burns, Dot Model & Talent Agcy/478 Severn Ave, Tampa, FL.........813-251-5882
Carolina Talent/220 East Blvd #C, Charlotte, NC704-332-3218
Cassandra Models Agency/513 W Colonial Dr #6, Orlando, FL407-423-7872
The Casting Directors Inc/1524 NE 147th St, North Miami, FL...........305-944-8559
Central Casting of FL/PO Box 7154, Ft Lauderdale, FL....305-379-7526
Directions Talent Agency/338 N Elm St, Greensboro, NC919-373-0955
Falcon, Travis Modeling Agency/17070 Collins Ave, Miami, FL305-947-7957
Flair Models/PO Box 17372, Nashville, TN.....................615-361-3737
Irene Marie Models/728 Ocean Dr, Miami Beach, FL......305-672-2929
JTA Talent/820 East Blvd, Charlotte, NC.........................704-377-5987
Lewis, Millie Modeling/1228 S Pleasanturg Dr, Greenville, SC.........803-299-1101
Lewis, Millie Modeling School/10 Calendar Ct #A, Forest Acres, SC803-782-7338
Mar Bea Talent Agency/6100 Hollywood Blvd, Hollywood, FL.........305-964-7401
Marilyn's Modeling Agency/601 Norwalk St, Greensboro, NC............919-292-5950
Polan, Marian Talent Agency/PO Box 7154, Ft Lauderdale, FL.........305-525-8351
Pommier, Michele/1200 Anastasia/Biltmore, Coral Gables, FL.........305-667-8710
Powers, John Robert School/828 SE 4th St, Fort Lauderdale, FL.........305-467-2838
Professional Models Guild & Wkshp/1819 Charlotte Dr, Charlotte, NC704-377-9299
Serendipity/2989 Piedmont Rd NE, Atlanta, GA.............404-237-4040
Steinhart-Norton Talent/2940 N Lynnhaven Rd, Virginia Bch, VA804-486-5550
Talent & Model Land, Inc/1501 12th Ave S, Nashville, TN....615-385-2723
Ted Schmidt/2149 NE 63rd St, Ft Lauderdale, FL212-751-7070
Theatrics Etcetera/PO Box 11862, Memphis, TN.............901-278-7454
Top Billing Inc/PO Box 121089, Nashville, TN.................615-327-1133
Wellington Models & Talent/823 E Las Olas Blvd, Ft Lauderdale, FL....305-728-8003

M I D W E S T

A-Plus Talent Agency Corp/680 N Lakeshore Dr, Chicago, IL..............312-642-8151
Actors Etc Ltd/5102 Leavenworth, Omaha, NB...............402-558-9750
Affiliated Talent & Casting Service/1680 Crook, Troy, MI...............313-244-8770
Creative Casting Inc/860 Lumber Exch/10 S 5th, Minneapolis, MN612-375-0525
David & Lee Model Management/70 W Hubbard, Chicago, IL............312-661-0500
IDC Services Inc/303 E Ohio St, Chicago, IL....................312-943-7500
Limelight Assoc Inc/3460 Davis Lane, Cincinnati, OH......513-651-2121
Moore, Eleanor Agency/1610 W Lake St, Minneapolis, MN612-827-3823
National Talent Assoc/6326 N Lincoln Ave, Chicago, IL....312-539-8575
New Faces Models & Talent Inc/5217 Wayzata Blvd #210,
Minneapolis, MN...612-544-8668
Pastiche Models Inc/1514 Wealthy #280, Grand Rapids, MI616-451-2181
Powers, John Robert/5900 Roche Dr, Columbus, OH614-846-1047
Schucart, Norman Ent/1417 Green Bay Rd, Highland Park, IL708-433-1113
Sharkey Career Schools Inc/1299-H Lyons Rd, Centerville, OH513-434-4461
SR Talent Pool/206 S 44th St, Omaha, NE.....................402-553-1164
Station 12-Producers Exp/1759 Woodgrove Ln, Bloomfield Hills, MI....313-855-1188
Verblen, Carol Casting Svc/2408 N Burling, Chicago, IL...312-348-0047

S O U T H W E S T

Actors Clearinghouse/501 N IH 35, Austin, TX................512-476-3412
ARCA/ Freelance Talent/PO Box 5686, Little Rock, AR.....501-224-1111
Ball, Bobby Agency/808 E Osborn, Phoenix, AZ..............602-468-1292
Barbizon School & Agency/1619 W Bethany Home Rd, Phoenix, AZ......602-249-2950
Blair, Tanya Agency/4528 McKinney #107, Dallas, TX......214-522-9750
Creme de la Creme/5804 N Grand, Oklahoma City, OK.....405-840-4419
Dawson, Kim Agency/PO Box 585060, Dallas, TX............214-638-2414

Ferguson Modeling Agency/1100 W 34th St, Little Rock, AR..............501-375-3519
Flair-Career Fashion & Modeling/8900 Menaul Rd, Albuquerque, NM.....505-296-5571
Fosi's Talent Agency/2777 N Campbell Ave #209, Tucson, AZ.............602-795-3534
Fullerton, Jo Ann/923 W Britton Rd, Oklahoma City, OK......................405-848-4839
Hall, K Agency/503 W 15th St, Austin, TX.......................................512-476-7523
Harrison-Gers Agency/1707 Wilshire Blvd NW, Oklahoma City, OK.....405-840-4515
Layman, Linda Agency/3546 E 51st St, Tulsa, OK..............................918-744-0888
The Mad Hatter/10101 Harwin Rd, Houston, TX.................................713-988-3900
Mannequin Modeling Agency/204 E Oakview, San Antonio, TX..........512-231-4540
Models of Houston/7887 San Felipe, Houston, TX..............................713-789-4973
Norton Agency/3900 Lemon Ave, Dallas, TX....................................214-528-9960
Parks, Page Model Reps/3131 McKinney #430, Dallas, TX.................214-871-9003
Southern Arizona Casting/2777 N Campbell Ave #209, Tucson, AZ.....602-795-3534
Taylor, Peggy Talent Inc/4300 N Central Exprswy #110, Dallas, TX.....214-826-7884
Wyse, Joy Agency/2600 Stemmons, Dallas, TX.................................214-638-8999

ROCKY MTN

Morris, Bobby Agency/1629 E Sahara Ave, Las Vegas, NV.................702-733-7575

WEST COAST

Adrian, William Agency/1021 E Walnut, Pasadena, CA.......................213-681-5750
American Talent Inc/10850 Wilshire Blvd #530, Los Angeles, CA.........213-470-4550
Anthony's , Tom Precision Driving/3418 N Knoll Dr, Hollywood, CA......213-466-8889
Artists Management Agency/835 Fifth Ave #411, San Diego, CA........619-233-6655
Barbizon Modeling Agy/15477 Ventura Blvd, Sherman Oaks, CA.......818-995-8238
Barbizon Modeling/452 Fashion Valley East, San Diego, CA...............619-296-6366
Blanchard, Nina/957 Cole Ave, Los Angeles, CA..............................213-462-7274
Celebrity Look-Alikes/7060 Hollywood Blvd #1215, Hollywood, CA.....213-272-2006
Commercials Unlimited/7461 Beverly Blvd, Los Angeles, CA...............213-937-2220
Cunningham, William D/261 S Robertson, Beverly Hills, CA.................213-855-0200
Frazer Agency/4300 Stevens Creek Blvd, San Jose, CA.....................408-554-1055
Garrick, Dale Internt'l Agency/8831 Sunset Blvd #402, LA, CA............213-657-2661
Grimme Agency/207 Powell St 6th fl, San Francisco, CA....................415-392-9175
Heldfond, Joseph & Rix/1717 N Highland #414, Los Angeles, CA.......213-466-9111
International Creative Mngement/8899 Beverly Blvd, LA, CA................213-550-4000
Leonetti, Ltd/6526 Sunset Blvd, Los Angeles, CA.............................213-462-2345
Media Talent Center/4440 SW Corbet, Portland, OR.........................503-226-7131
Model Management Inc/1400 Castro St, San Francisco, CA................415-282-8855
Pacific Artists, Ltd/515 N La Cienaga, Los Angeles, CA.....................213-657-5990
Playboy Model Agency/8560 Sunset Blvd, Los Angeles, CA...............213-659-4080
Schwartz, Don Agency/8749 Sunset Blvd, Los Angeles, CA...............213-657-8910
Seattle Models Guild/1809 7th Ave #303, Seattle, WA......................206-622-1406
Smith's, Ron Celebrity Look-Alikes/7060 Hollywood Blvd, LA, CA.......213-272-2006
Sohbi's Talent Agency/1750 Kalakaua Ave #116, Honolulu, HI............808-946-6614
Stern, Charles Agency/11755 Wilshire Blvd, Los Angeles, CA............213-479-1788
Studio Seven/304 E San Bernardino, Covina, CA..............................818-331-6351
Stunts Unlimited/3518 Cahuenga Blvd W, Los Angeles, CA...............213-874-0050
Talent Management/935 NW 19th Ave, Portland, OR.........................503-223-1931
Tannen, Herb & Assoc/1800 N Vine St #120, Los Angeles, CA...........213-466-6191

CASTING

NYC

Brinker, Jane/51 W 16th St...212-924-3322
Brown, Deborah Casting/250 W 57th St.......................................212-581-0404
Burton, Kate/39 W 19th St 12th fl..212-243-6114
C & C Productions/445 E 80th St...212-472-3700
Carter, Kit & Assoc/160 W 95th St..212-864-3147
Cast Away Casting Service/14 Sutton Pl S....................................212-755-0960
Central Casting Corp of NY/200 W 54th St....................................212-582-4933
Claire Casting/333 Park Ave S...212-673-7373
Complete Casting/350 W 50th St...212-265-7460
Contemporary Casting Ltd/41 E 57th St.......................................212-838-1818
Davidson/Frank Photo-Stylists/209 W 86th St #701.......................212-799-2651
DeSeta, Donna Casting/525 Broadway...212-274-9696
Digiaimo, Lou/513 W 54th St...212-691-6073
Fay, Sylvia/71 Park Ave..212-889-2626
Greco, Maria Casting/1261 Broadway..212-213-5500
Herman & Lipson Casting, Inc/24 W 25th St..................................212-807-7706
Howard, Stewart Assoc/22 W 27th St 10th fl.................................212-725-7770

Hughes/Moss Assoc/311 W 43rd St..212-307-6690
Jacobs, Judith/336 E 81st St..212-744-3758
Johnson/Liff/1501 Broadway...212-391-2680
Kressel, Lynn Casting/445 Park Ave 7th fl....................................212-605-9122
Navarro-Bertoni Casting Ltd/101 W 31st St...................................212-736-9272
Reed/Sweeney/Reed Inc/1780 Broadway.....................................212-265-8541
Schneider Studio/119 W 57th St..212-265-1223
Shapiro, Barbara Casting/111 W 57th St.......................................212-582-8228
Todd, Joy/37 E 28th St #700...212-685-3537
Weber, Joy Casting/250 W 57th St #1925.....................................212-245-5220
Wollin, Marji/233 E 69th St..212-472-2528

NORTHEAST

Belajac, Donna & Co/1 Bigelow Sq #1924, Pittsburgh, PA................412-391-1005
Central Casting/623 Pennsylvania Ave SE, Washington, DC..............202-547-6300
Lawrence, Joanna Agency/82 Patrick Rd, Westport, CT...................203-226-7239
Producers Audition Hotline/18156 Darnell Dr, Olney, MD..................301-924-4327

SOUTHEAST

Central Casting/PO Box 7154, Ft Lauderdale, FL.............................305-379-7526
DiPrima, Barbara Casting/3390 Mary St, Coconut Grove, FL..............305-445-7630
Lancaster Models/785 Crossover, Memphis, TN.............................901-761-1046
Taylor Royal Casting/2308 South Rd, Baltimore, MD.........................301-466-5959

MIDWEST

Station 12 Producers Exp/1759 Woodgrove Ln, Bloomfield Hills, MI.......313-855-1188

SOUTHWEST

Austin Actors Clearinghouse/501 North 1H 35, Austin, TX.................512-476-3412
Blair, Tanya Agency/Artists Mngrs/4528 McKinney #107, Dallas, TX....214-522-9750
KD Studio/2600 Stemons #117, Dallas, TX.....................................214-638-0484
New Visions/Box 372, Prescott, AZ...602-445-3382

WEST COAST

Abrams-Rubaloff & Lawrence/8075 W 3rd #303, Los Angeles, CA......213-935-1700
Associated Talent International/9744 Wilshire Blvd, Los Angeles, CA..213-271-4662
BCI Casting/6565 Sunset Blvd #412, Los Angeles, CA......................213-466-3400
C H N International/7428 Santa Monica Blvd, Los Angeles, CA...........213-874-8252
Celebrity Look-Alikes/7060 Hollywood Blvd #1215, Hollywood, CA.....213-272-2006
Commercials Unlimited/7461 Beverly Blvd, Los Angeles, CA..............213-937-2220
Creative Artists Agency Inc/9830 Wilshire Blvd, Beverly Hills, CA.......213-277-4545
Cunningham, William/261 S Robertson Blvd, Beverly Hills, CA...........213-855-0200
Davis, Mary Webb/515 N LaCienega, Los Angeles, CA......................213-652-6850
Garrick, Dale Agency/8831 Sunset Blvd #402, Los Angeles, CA........213-657-2661
Hecht, Beverly Agency/8949 Sunset Blvd #203, Los Angeles, CA.......213-278-3544
Heldfond, Joseph & Rix/1717 N Highland #414, Los Angeles, CA.......213-466-9111
Lien, Michael Casting/7461 Beverly Blvd, Los Angeles, CA................213-937-0411
Loo, Bessi Agency/8235 Santa Monica, W Hollywood, CA.................213-650-1300
Mangum, Joan Agency/9250 Wilshire Blvd #206, Beverly Hills, CA.....213-274-6622
Morris, William Agency/151 El Camino Dr, Beverly Hills, CA...............213-274-7451
Pacific Artists Limited/515 N LaCienega Blvd, Los Angeles, CA..........213-657-5990
Payment Management/935 NW 19th Ave, Portland, OR......................503-223-1931
Rose, Jack/7080 Hollywood Blvd #201, Los Angeles, CA...................213-463-7300
Schaeffer, Peggy Agency/10850 Riverside Dr, North Hollywood, CA..818-985-5547
Schwartz, Don & Assoc/8749 Sunset Blvd, Los Angeles, CA.............213-657-8910
Stern, Charles H Agency/11755 Wilshire Blvd #2320, LA, CA.............213-479-1788
Tannen, Herb & Assoc/1800 N Vine St #120, Los Angeles, CA...........213-466-6191
Wilhelmina/West/8383 Wilshire Blvd #954, Beverly Hills, CA..............213-653-5700

A N I M A L S

N Y C

All Tame Animals/250 W 57th St ...212-245-6740
Animals for Advertising/310 W 55th St ..212-245-2590
Cap Haggerty's Theatrical Dogs/222 Seaman Ave212-220-7771
Captain Haggerty's Theatrical Dogs/1748 First Ave212-410-7400
Chateau Stables/608 W 48th St ..212-246-0520
Claremont Riding Academy/175 W 89th St212-724-5100
Dawn Animal Agency/750 Eighth Ave ..212-575-9396

N O R T H E A S T

Animal Actors Inc/Box 221, RD 3, Washington, NJ908-689-7539
Long Island Game Farm & Zoo/Chapman Blvd, Manorville, NY516-878-6644

S O U T H E A S T

Dog Training by Bob Maida/7605 Old Centerville Rd, Manassas, VA...703-631-2125

S O U T H W E S T

Dallas Zoo in Marsalis Park/621 E Clarendon, Dallas, TX.....................214-670-6825
Estes, Bob Rodeos/138 E 6th St, Baird, TX915-854-1037
Fort Worth Zoological Park/2727 Zoological Park Dr., Fort Worth, TX ...817-870-7065
International Wildlife Park/601 Wildlife Parkway, Grand Prairie, TX214-263-2203
Scott, Kelly Buggy & Wagon Rentals/Box 442, Bandera, TX................512-796-4943
Y O Ranch/Dept AS, Mountain Home, TX512-640-3222

W E S T C O A S T

The American Mongrel/PO Box 2406, Lancaster, CA805-942-7550
Animal Action/PO Box 824, Arleta, CA ...818-767-3003
Animal Actors of Hollywood/864 Carlisle Rd, Thousand Oaks, CA.....805-495-2122
Birds and Animals/25191 Rivendell Dr, El Toro, CA714-830-7845
Casa De Pets/13323 Ventura Blvd, Sherman Oaks, CA818-986-2660
Di Sesso's, Moe Trained Wildlife/24233 Old Road, Newhall, CA805-255-7969
Frank Inn Inc/30227 Hasley Canyon Rd, Castaic, CA805-295-1205
Griffin, Gus/11281 Sheldon St, Sun Valley, CA818-767-6647
Martin, Steve Working Wildlife/PO Box 65, Acton, CA805-268-0788
Pyramid Bird/1407 W Magnolia, Burbank, CA818-843-5505
Schumacher Animal Rentals/14453 Cavette Pl, Baldwin Park, CA818-338-4614
The Stansbury Company/9304 Santa Monica Blvd, Beverly Hills, CA ..213-273-1138

H A I R & M A K E - U P

N Y C

Abrams, Ron/126 W 75th St..212-580-0705
Imre, Edith Beauty Salon/33 E 65th St212-772-3351
Jenrette, Pamela/300 Mercer St...212-673-4748
Laber, Honey Jeanne/235 W 102nd St #10D212-662-3199
Legrand, Jean Yves/41 W 84th St #4..212-724-5981
Narvaez, Robin/360 E 55th St...212-371-6378
Weithorn, Rochelle/431 E 73rd St ...212-472-8668

S O U T H E A S T

Irene Marie Models/728 Ocean Dr, Miami Beach, FL305-672-2929
Parker, Julie Hill/PO Box 5412, Miami Lakes, FL.............................305-362-5397

M I D W E S T

Camylle/112 E Oak, Chicago, IL..312-943-1120

Cheveux/908 W Armitage, Chicago, IL ...312-935-5212
International Guild of Make-Up/6970 N Sheridan, Chicago, IL.............312-761-8500
Kalagian, Maureen/Media Hair/Makeup Grp, Chicago, IL....................312-472-6550
Okains Costume & Theater/2713 W Jefferson, Joliet, IL815-741-9303
Sguardo, Che/716 N Wells St, Chicago, IL....................................312-440-1616
Simmons, Sid Inc/2 E Oak, Chicago, IL..312-943-2333

S O U T H W E S T

Dawson, Kim Agency/PO Box 585060, Dallas, TX............................214-638-2414

W E S T C O A S T

Gavilan/139 S Kings Rd, Los Angeles, CA......................................213-655-4452
Hamilton, Bryan J/197 Larrabee St, Los Angeles, CA213-657-6066
Johns, Arthur Adjectives/901 Westbourne Dr, W Hollywood, CA213-855-0225
Studio Seven/304 E San Bernardino, Covina, CA818-331-6351
Total You Salon/1647 Los Angeles Ave, Simi, CA805-526-4189

H A I R

N Y C

Benjamin Salon/104 Washington Pl..212-255-3330
Daines, David Salon Hair Styling/833 Madison Ave...........................212-535-1563
George V Hair Stylist/501 Fifth Ave...212-687-9097
Monsieur Marc Inc/Carlyle/981 Madison212-861-0700

N O R T H E A S T

Brocklebank, Tom/249 Emily Ave, Elmont, NY516-775-5356

S O U T H E A S T

Yellow Strawberry/107 E Las Olas Blvd, Ft Lauderdale, FL305-463-4343

M I D W E S T

Kalagian, Maureen/Media Hair/Makeup Grp, Chicago, IL......................312-472-6550

S O U T H W E S T

Southern Hair Designs/3563 Far West Blvd, Austin, TX.......................512-346-1734

R O C K Y M T N

Luezano Andrez Int Salon/2845 Wyandote, Denver, CO303-458-0131

W E S T C O A S T

Anatra Haircutters/530 N LaCienega, Los Angeles, CA213-657-1495
Barronson Hair/11908 Ventura, Studio City, CA818-763-4337
Edwards, Allen/345 N Camden, Beverly Hills, CA213-274-8575
John, Michael Salon/414 N Camden Dr, Beverly Hills, CA213-278-8333
Lorenz, Barbara..213-657-0028
Menage a Trois/8822 Burton Way, Beverly Hills, CA213-278-4431
Phillips, Marilyn..213-923-6996
Trainoff, Linda/11830 B Moorpark, Studio City, CA818-769-0373

M A K E - U P

N Y C

Groves, Teri..818-562-1668

Lane, Judy/444 E 82nd St..212-861-7225
Make-Up Center Ltd/1013 Third Ave..............................212-751-2001
Make-Up Center Ltd/150 W 55th St.................................212-977-9494
Oakley, Sara...212-749-5912
Ross, Rose Cosmetics/16 W 55th St................................212-586-2590
Sartin, Janet of Park Ave Ltd/480 Park Ave.....................212-751-5858

N O R T H E A S T

Douglas, Rodney N/473 Avon Ave #3, Newark, NJ...............201-375-2979
Gilmore, Robert Assoc Inc/990 Washington St, Dedham, MA.............617-329-6633

S O U T H E A S T

Lajoan, Brenda/236 Sandalwood Trail, Winter Park, FL.........407-645-2434
Something Special/1805 S Oakland St, Arlington, VA.............703-892-0551
Star Styled of Miami/475 NW 42nd Ave, Miami, FL...............305-541-2424

M I D W E S T

Kalagian, Maureen/Media Hair/Makeup Grp, Chicago, IL...............312-472-6550

S O U T H W E S T

ABC Theatrical Rental & Sales/825 N 7th St, Phoenix, AZ...............602-258-5265
Corey, Irene/4147 Herschel Ave, Dallas, TX.......................214-821-9633
Dobes, Pat/1826 Nocturne, Houston, TX...........................713-465-8102
Schakosky, Laurie/17735 Windflower Way #10, Dallas, TX.............214-250-1019
Stamm, Louis M/721 Edgehill Dr, Hurst, TX.......................817-268-5037

R O C K Y M T N

Moon Sun Emporium/Pearl Street Mall, Boulder, CO.............303-443-6851

W E S T C O A S T

Anderson, Dorian Blackman/12751 Addison, N Hollywood, CA............818-761-2177
Blackman, Charles F/12751 Addison, N Hollywood, CA.............818-761-2177
Blackman, Gloria/12751 Addison, N Hollywood, CA...............818-761-2177
Copeland, Christine..213-938-8414
Cosmetic Connection/421 N Rodeo Dr, Beverly Hills, CA.............213-550-6242
D'Ifray, T J/468 N Bedford Dr, Beverly Hills, CA..................213-274-6776
Fradkin, Joanne c/o Pigments/8822 Burton Way, Beverly Hills, CA......213-858-7038
Henrriksen, Ole/8601 W Sunset Blvd, Los Angeles, CA.............213-854-7700
Logan, Kathryn...818-988-7038
Menage a Trois/8822 Burton Way, Beverly Hills, CA..............213-278-4431
Nadia...213-465-2009
Natasha/4221 1/2 Avocado St, Los Angeles, CA..................213-663-1477
Romero, Bob/4085 Benedict Canyon Dr, Sherman Oaks, CA.............818-981-3338
Tuttle, William/325 Aderno Way, Pacific Palisades, CA............213-454-2355
Westmore, Michael..818-763-3158
Westmore, Monty...818-762-2094
Wolf, Barbara..213-466-4660

S T Y L I S T S

N Y C

Benner, Dyne (Food)/311 E 60th St..................................212-688-7571
Berman, Benicia/399 E 72nd St.......................................212-737-9627
Cheverton, Linda/150 9th Avenue....................................212-475-6450
Chin, Fay/67 Vestry St..212-219-8770
Davidson/Frank Photo-Stylists/209 W 86th St #701.............212-799-2651
George, Georgia A/404 E 55th St....................................212-759-4131
Goldberg, Hal/40 E 9th St...212-353-9622
Hammond, Claire/440 E 57th St......................................212-838-0712
Haynie, Cecille/105 W 13th St #7C..................................212-929-3690
Laber, Honey Jeanne/235 W 102nd St #10D........................212-662-3199
Manetti, Palmer/336 E 53rd St.......................................212-758-3859

McCabe, Christine/200 E 16th St #8B................................212-995-8175
McCracken, Laura/73 Atlantic Ave, Brooklyn......................718-643-9206
Meshejian, Zabel/125 Washington Pl................................212-242-2459
Sampson, Linda/431 W Broadway.....................................212-925-6821
Scherman, Joan/450 W 24th St.......................................212-620-0475
Schoenberg, Marv/878 West End Ave #10A.........................212-663-1418
Sheffy, Nina..212-982-0454
Sinclair, Joanna/Food Stylist..212-679-7575
Smith, Rose/400 E 56th St #19D.....................................212-758-8711
Specht, Meredith/411 West End Ave.................................212-877-8333
Weithorn, Rochelle/431 E 73rd St...................................212-472-8668
West, Susan/59 E 7th St...212-982-8228

N O R T H E A S T

Maggio, Marlene - Aura Prdtns/55 Waterview Circle, Rochester, NY....716-381-8053
Rosemary's Cakes Inc/299 Rutland Ave, Teaneck, NJ.............201-833-2417

S O U T H E A S T

Foodworks/1541 Colonial Ter, Arlington, VA.......................703-524-2606
Kupersmith, Tony/320 Highland Ave NE, Atlanta, GA.............404-577-5319
Reelistic Productions/6467 SW 48th St, Miami, FL...............305-284-9989
Sampson, Linda/827 Ursulines, New Orleans, LA..................503-523-3085
Torres, Martha/933 Third St, New Orleans, LA....................504-899-6873

M I D W E S T

Carlson, Susan/255 Linden Park Pl, Highland Park, IL.............708-433-2466
Cheveux/908 W Armitage, Chicago, IL...............................312-935-5212
Erickson, Emily/3224 N Southport, Chicago, IL....................312-281-4899
Marx, Wendy/4034 N Sawyer Ave, Chicago, IL....................312-509-9292
Pace, Leslie/6342 N Sheridan, Chicago, IL.........................312-761-2480
Passman, Elizabeth/927 Noyes St, Evanston, IL...................708-869-3484
The Set-up & Co/1049 E Michigan St, Indianapolis, IN..........317-635-2323

S O U T H W E S T

Riley, Kim Manske/10707 Sandpiper, Houston, TX................713-777-9416

W E S T C O A S T

Alaimo, Doris/8800 Wonderland Ave, Los Angeles, CA.............213-654-1544
Corwin, Aleka/2383 Silver Ridge Ave, Los Angeles, CA............213-665-7953
Davis, Rommie/4414 La Venta Dr, West Lake Village, CA..........818-906-1455
Frank, Tobi/1269 N Hayworth, Los Angeles, CA....................213-552-7921
Granas, Marilyn/220 S Palm Dr, Beverly Hills, CA.................213-278-3773
Griswald, Sandra/963 North Point, San Francisco, CA............415-775-4272
Hamilton, Bryan J/197 Larrabee St, Los Angeles, CA..............213-657-6066
Miller, Freyda/1412 Warner Ave, Los Angeles, CA.................213-474-5034
Minot, Abby/61101 Thornhill Dr, Oakland, CA.....................415-339-9600
Olsen, Eileen/1619 N Beverly Dr, Beverly Hills, CA...............213-273-4496
Russo, Leslie/327 10th, Santa Monica, CA.........................213-395-8461
Shatsy/9008 Harratt St, Hollywood, CA.............................213-652-2288
Skinner, Jeanette/15431 Redhill Ave #E, Tustin, CA..............714-259-9224
Stillman, Denise/PO Box 7692, Laguna Niguel, CA................714-496-4841
Thomas, Lisa/9029 Rangely Ave, W Hollywood, CA..............213-858-6903

C O S T U M E S

N Y C

Academy Clothes Inc/1703 Broadway...............................212-765-1440
Austin Ltd/140 E 55th St...212-752-7903
Capezio Dance Theater Shop/1650 Broadway......................212-245-2130
Chenko Studio/130 W 47th St...212-944-0215
David's Outfitters Inc/36 W 20th St.................................212-691-7388
Eaves-Brookes Costume/21-07 41st Ave, L I City.................718-729-1010
Grace Costumes Inc/244 W 54th St..................................212-586-0260
Ian's Boutique Inc/1151-A Second Ave..............................212-838-3969

Kulyk/72 E 7th St212-674-0414
Martin, Alice Manougian/239 E 58th St.................212-688-0117
Michael-Jon Costumes Inc/39 W 19th St................212-741-3440
New York City Ballet Costume Shop/16 W 61st St........212-247-3341
Purcell, Elizabeth/225 Lafayette St..................212-925-1962
Rubie's Costume Co/1 Rubie Plaza, Richmond Hill.......718-846-1008
Stivanello Costume Co Inc/66-38 Clinton Ave, Maspeth, NY....718-651-7715
Tint, Francine/1 University Pl #PHB..................212-475-3366
Universal Costume Co Inc/535 Eighth Ave212-239-3222
Weiss & Mahoney Inc/142 Fifth Ave212-675-1915
Winston, Mary Ellen/11 E 68th St...................212-879-0766
Ynocencio, Jo/302 E 88th St.......................212-348-5332

N O R T H E A S T

At-A-Glance Rentals/712 Main, Boonton, NJ201-335-1488
Costume Armour Inc/PO Box 85/2 Mill St, Cornwall, NY..914-534-9120
Douglas, Rodney N/473 Avon Ave #3, Newark, NJ........201-375-2979
Ren Rose Locations/4 Sandalwood Dr, Livingston, NJ....201-992-4264
Strutters/11 Paul Sullivan Way, Boston, MA...........617-423-9299
Westchester Costume Rentals/540 Nepperhan Ave, Yonkers, NY....914-963-1333

S O U T H E A S T

ABC Costume/185 NE 59th St, Miami, FL...............305-757-3492
Atlantic Costume Co/2089 Monroe Dr, Atlanta, GA......404-874-7511
Star Styled/475 NW 42nd Ave, Miami, FL..............305-649-3030

M I D W E S T

Advance Theatrical Co/1900 N Narragansett, Chicago, IL312-889-7700
Broadway Costumes Inc/954 W Washington, Chicago, IL312-829-6400
Center Stage/Fox Valley Shopping Cntr, Aurora, IL....708-851-9191
Chicago Costume Co Inc/1120 W Fullerton, Chicago, IL....312-528-1264
Ennis, Susan/3045 N Southport, Chicago, IL..........312-525-7483
Kaufman Costumes/5065 N Lincoln, Chicago, IL........312-561-7529
Magical Mystery Tour, Ltd/6010 Dempster, Morton Grove, IL....708-966-5090
Okains Costume & Theater/2713 W Jefferson, Joliet, IL....815-741-9303
The Set-up & Co/1049 E Michigan St, Indianapolis, IN....317-635-2323

S O U T H W E S T

ABC Theatrical Rental & Sales/825 N 7th St, Phoenix, AZ....602-258-5265
Anykind-A Costumes/210 Hancock Shpng Ctr, Austin, TX....512-454-1610
Campioni, Frederick/1920 Broken Oak, San Antonio, TX512-342-7780
Corey, Irene/4147 Herschel Ave, Dallas, TX..........214-821-9633
Incredible Productions/3327 Wylie Dr, Dallas, TX.....214-350-3633
Lucy Greer & Assoc. Casting/600 Shadywood Ln, Richardson, TX....214-231-2086
Old Time Teenies Vintage Clothing/1126 W 6th St, Austin, TX512-477-2022
Second Childhood/1116 W 6th St, Austin, TX..........512-472-9696
Starline Costume Products/1286 Bandera Rd, San Antonio, TX....512-435-3535
Thomas, Joan S/6904 Spanky Branch Court, Dallas, TX....214-931-1900

R O C K Y M T N

And Sew On-Jila/2035 Broadway, Boulder, CO303-442-0130
Raggedy A Clothing & Costume/1213 E Evans Ave, Denver, CO....303-733-7937

W E S T C O A S T

Adele's of Hollywood/5034 Hollywood Blvd, Hollywood, CA....213-663-2231
Burbank Studios Wardrobe Dept/4000 Warner Blvd, Burbank, CA....818-954-1218
California Surplus Mart/6263 Santa Monica Blvd, Los Angeles, CA213-465-5525
Capezio Dancewear/1777 Vine St, Hollywood, CA.......213-465-3744
CBS Wardrobe Dept/7800 Beverly Blvd, Los Angeles, CA213-852-2345
Courtney, Elizabeth/8636 Melrose Ave, Los Angeles, CA213-657-4361
E C 2 Costumes/431 S Fairfax, Los Angeles, CA.......213-934-1131
Fantasy Costume/4649 1/2 San Fernando Rd, Glendale, CA213-245-7367
International Costume Co/1423 Marcellina, Torrance, CA....213-320-6392
Kings Western Wear/6455 Van Nuys Blvd, Van Nuys, CA....818-785-2586
LA Uniform Exchange/5239 Melrose Ave, Los Angeles, CA213-469-3965
MGM/UA Studios Wardrobe Dept./10000 W Washington Blvd,

Culver City, CA213-558-5600
Minot, Abby/61101 Thornhill Dr, Oakland, CA.........415-339-9600
Nudies Rodeo Tailor/5015 Lanskershim Blvd, N Hollywood, CA....818-762-3105
Palace Costume/835 N Fairfax, Los Angeles, CA.......213-651-5458
Paramount Studios Wardrobet/5555 Melrose Ave, Hollywood, CA213-468-5288
Tuxedo Center/7360 Sunset Blvd, Los Angeles, CA.....213-874-4200
United American Costume Co/12980 Raymer, N Hollywood, CA....818-764-2239
Valu Shoe Mart/5637 Santa Monica Blvd, Los Angeles, CA213-469-8560
Western Costume Co/11041 Van Allen, N Hollywood, CA....213-469-1451

P R O P S
N Y C

Abet Rent-A-Fur/231 W 29th St #304.................212-268-6225
Abstracta Structures Inc/347 Fifth Ave..............212-532-3710
Ace Galleries/67 E 11th St.........................212-991-4536
Adirondack Direct/300 E 44th St....................212-687-8555
Adorn Accessory Resource/28 W 25th St 11th Fl........212-242-6278
Alice's Antiques/505 Columbus Ave..................212-874-3400
Alpha-Pavia Bookbinding Co Inc/601 W 26th St/2nd Mezz....212-929-5430
Artistic Neon by Gasper/75-49 61st St, Glendale......718-821-1550
Baird, Bill Marionettes/139 W 17th St #3A...........212-989-9840
Bill's Flower Mart/816 Ave of the Americas..........212-889-8154
Brandon Memorabilia/PO Box 20165...................212-691-9776
Breitrose Seltzer Stages/383 W 12th St..............212-877-5085
Brooklyn Model Works/60 Washington Ave, Brooklyn.....718-834-1944
Carroll Musical Instrument Svc/351 W 41st St.........212-868-4120
Chateau Stables Inc/608 W 48th St..................212-246-0520
Constructive Display/525 W 26th St..................212-643-0086
Doherty Studios/2255 Broadway212-877-5085
Eclectic Encore Props/620 W 26th St 4th fl..........212-645-8880
Furs, Valerie/150 W 30th St........................212-947-2020
Golden Equipment Co Inc/574 Fifth Ave...............212-719-5121
Gordon Novelty Co/933 Broadway212-254-8616
Harrison/Erickson Puppets/66 Pierrepont, Brooklyn212-929-5700
Jeffers, Kathy-Modelmaking/151 W 19th St #3F.........212-255-5196
Kaplan, Howard/820 Broadway212-674-1000
Karpen, Ben/212 E 51st St..........................212-755-3450
Kempler, George J/160 Fifth Ave....................212-989-1180
Kenmore Furniture Co Inc/352 Park Ave S.............212-683-1888
Manhattan Model Shop/40 Great Jones St..............212-473-6312
Maniatis, Michael Inc/48 W 22nd St.................212-620-0398
Mason's Tennis Mart/911 Seventh Ave................212-757-5374
Matty's Studio Sales/2368 12th Ave.................212-491-7070
Mendez, Raymond A/220 W 98th St #12B...............212-864-4689
Messmore & Damon Inc/530 W 28th St.................212-594-8070
Metro Scenic Studio Inc/129-02 Northern Blvd, Corona718-844-2835
Modern Miltex Corp/130-25 180th St, Springfield Gardens....718-525-6000
Newell Art Galleries Inc/425 E 53rd St..............212-758-1970
Paul De Pass Inc/220 W 71st St.....................212-362-2648
The Place for Antiques/993 Second Ave...............212-308-4066
Plant Specialists Inc/42-25 Vernon Blvd, Long Island City212-839-9414
Plastic Works!/2107 Broadway @ 73rd................212-362-1000
Plexability Ltd/200 Lexington Ave..................212-679-7826
The Prop House Inc/653 11th Ave @ 47th..............212-713-0760
The Prop Shop/26 College Pl, Brooklyn Heights........718-522-4606
Props and Displays/132 W 18th St...................212-620-3840
Props for Today/121 W 19th St......................212-206-0330
Ray Beauty Supply Co Inc/721 Eighth Ave212-757-0175
Ridge, John Russell................................212-929-3410
Say It In Neon/319 Third Ave, Brooklyn..............718-625-1481
Smith & Watson/305 E 63rd St.......................212-355-5615
Solco Plumbing & Baths/209 W 18th St...............212-243-2569
Starbuck Studio - Acrylic props/162 W 21st St212-807-7299
Theater Technology Inc/37 W 20th St................212-929-5380
Times Square Theatrical & Studio/318 W 47th St.......212-245-4155
Uncle Sam's Umbrella/161 W 57th St.................212-247-7163
Whole Art Inc/580 Eighth Ave 19th fl...............212-719-0620

N O R T H E A S T

Atlas Scenic Studios Ltd/46 Brookfield Ave, Bridgeport, CT203-334-2130
Bestek Theatrical Productions/218 W Hoffman, Lindenhurst, NY....516-225-0707

Geiger, Ed/12 Church St, Middletown, NJ.............................908-671-1707
Hart Scenic Studio/35-41 Dempsey Ave, Edgewater, NJ....................212-947-7264
Rindner, Jack N Assoc/112 Water St, Tinton Falls, NJ...................908-542-3548
Stewart, Chas H Co/69 Norman St, Everett, MA..........................617-625-2407
Strutters/11 Paul Sullivan Way, Boston, MA............................617-423-9299
Zeller International/Main St/POB Z, Downsville, NY.....................212-627-7676

SOUTHEAST

Arawak Marine/PO Box 7362, St Thomas, VI..............................809-775-6500
Dunwright Productions/15281 NE 21st Ave, N Miami Beach, FL.........305-944-2464
Kupersmith, Tony/320 Highland Ave NE, Atlanta, GA.....................404-577-5319
Reelistic Productions/6467 SW 48th St, Miami, FL......................305-284-9989
Sunshine Scenic Studios/1370 4th St, Sarasota, FL.....................813-366-8848

MIDWEST

Advance Theatrical/1900 N Narragansett, Chicago, IL...................312-889-7700
Becker Studios Inc/2824 W Taylor, Chicago, IL.........................312-722-4040
Bregstone Assoc/500 S Wabash, Chicago, IL.............................312-939-5130
Cadillac Plastic and Chemical Co/953 N Larch Ave, Elmhurst, IL........312-342-9200
Center Stage/Fox Valley Shopping Cntr, Aurora, IL.....................708-851-9191
Chanco Ltd/3131 West Grand Ave, Chicago, IL...........................312-638-0363
Chicago Scenic Studios Inc/1711 W Fullerton, Chicago, IL..............312-348-0115
Gard, Ron/2600 N Racine, Chicago, IL..................................312-975-6523
Hartman Furniture & Carpet Co/220 W Kinzie, Chicago, IL...............312-664-2800
Hollywood Stage Lighting/5850 N Broadway, Chicago, IL.................708-869-3340
House of Drane/410 N Ashland Ave, Chicago, IL.........................312-829-8686
The Model Shop/345 Canal St, Chicago, IL..............................312-454-9618
Okains Costume & Theater/2713 W Jefferson, Joliet, IL.................815-741-9303
Scroungers Inc/351 Lyndale Ave S, Minneapolis, MN.....................612-823-2346
The Set-up & Co/1049 E Michigan St, Indianapolis, IN..................317-635-2323
Starr, Steve Studios/2654 N Clark St, Chicago, IL.....................312-525-6530
Studio Specialties/606 N Houston, Chicago, IL.........................312-337-5131

SOUTHWEST

Creative Video Productions/5933 Bellaire Blvd #110, Houston, TX.......713-661-0478
Doerr, Dean/11321 Greystone, Oklahoma City, OK........................405-751-0313
Eats/PO Box 52, Tempe, AZ...602-966-7459
Marty, Jack/2225 South First, Garland, TX.............................214-840-8708
Riley, Kim Manske/10707 Sandpiper, Houston, TX........................713-777-9416
Southern Importers/4825 San Jacinto, Houston, TX......................713-524-8236

WEST COAST

Abbe Rents/1001 La Brea, Los Angeles, CA..............................213-466-9582
Aldik Artificial Flowers Co/7651 Sepulveda Blvd, Van Nuys, CA.........818-988-5970
Allen, Walter Plant Rentals/4996 Melrose Ave, Hollywood, CA...........213-469-3621
Antiquarian Traders/650 LaPerre, West Hollywood, CA...................213-289-0345
Antiquarian Traders/4851 S Alameda, Los Angeles, CA...................213-627-2144
Arnelle Sales Co Prop House/7926 Beverly Blvd, Los Angeles, CA........213-930-2900
Asia Plant Rentals/1215 225th St, Torrance, CA........................213-775-1811
Astrovision, Inc/7240 Valjean Ave, Van Nuys, CA.......................818-989-5222
Backings, c/o 20th Century Fox/10201 W Pico Blvd, Los Angeles, CA.....213-277-0522
Baronian Manufacturing Co/1865 Farm Bureau Rd, Concord, CA............415-671-7199
Barris Kustom Inc/10811 Riverside Dr, N Hollywood, CA.................213-877-2352
Barton Surrey Svc/518 Fairview Ave, Arcadia, CA.......................818-447-6693
Bischoff's/449 S San Fernando Blvd, Burbank, CA.......................818-843-7561
Brown, MelCruises/Berth 76W-33 Ports O'Call, San Pedro, CA............213-548-1085
Burbank Studios Prop Dept/4000 Warner Blvd, Burbank, CA...............818-954-6000
Carpenter, Brent Studio/19 Kala Moreya, Laguna Niguel, CA.............714-363-0825
Custom Neon/2210 S LaBrea, Los Angeles, CA............................213-937-6366
D'Andrea Glass Etchings/3671 Tacoma Ave, Los Angeles, CA..............213-223-7940
Decorative Paper Products/2481 Lilyvale Ave, Los Angeles, CA..........213-223-2676
Deutsch/Rattan/8611 Hayden Pl, Culver City, CA........................213-559-4949
Ellis Mercantile Co/169 N LaBrea Ave, Los Angeles, CA.................213-933-7334
Featherock Inc/20219 Bohama St, Chatsworth, CA........................818-882-3888
Flower Fashions/9960 Santa Monica Blvd, Beverly Hills, CA.............213-272-6063
Grand American Fare/3110 Main St 3rd fl, Santa Monica, CA.............213-450-4900
The Hand Prop Room/5700 Venice Blvd, Los Angeles, CA..................213-931-1534
Hollywood Toys/6562 Hollywood Blvd, Los Angeles, CA...................213-465-3119
House of Props Inc/1117 N Gower St, Hollywood, CA.....................213-463-3166
Hume, Alex R/1024 W Burbank Blvd, Burbank, CA.........................213-849-1614

Malibu Florists/23823 Malibu Rd #300, Malibu, CA......................213-456-1858
Marvin, Lennie Entrprs Ltd/1105 N Hollywood Way, Burbank, CA..........818-841-5882
MGM Studios Prop Dept/10000 W Washington Blvd, Culver City, CA.........213-280-6000
Mole-Richardson/937 N Sycamore Ave, Hollywood, CA.....................213-851-0111
Moskatels/733 S San Julian St, Los Angeles, CA........................213-689-4830
Motion Picture Marine/616 Venice Blvd, Marina del Rey, CA.............213-822-1100
Music Center/5616 Santa Monica Blvd, Hollywood, CA....................213-469-8143
Omega Cinema Props/5857 Santa Monica Blvd, Los Angeles, CA............213-466-8201
Paramount Studios Prop Dept/5555 Melrose Ave, Los Angeles, CA.........213-468-5000
Post, Don Studios/8211 Lankershim Blvd, N Hollywood, CA...............818-768-0811
Prop Service West/915 N Citrus Ave, Los Angeles, CA...................213-461-3371
Scale Model Co/4613 W Rosecrans Ave, Hawthorne, CA....................213-679-1436
School Days Equipment Co/2525 Medford St, Los Angeles, CA.............213-223-3474
Silvestri Studios/1733 W Cordova St, Los Angeles, CA..................213-735-1481
Special Effects Unlimited/752 N Cahuenga Blvd, Hollywood, CA..........213-466-3361
Spellman Desk Co/6159 Santa Monica Blvd, Hollywood, CA................213-467-0628
Studio Specialties/3013 Gilroy St, Los Angeles, CA....................213-662-3031
Stunts Unlimited/3518 Cahuenga Blvd W, Los Angeles, CA................213-874-0050
Tropizon Plant Rentals/1401 Pebble Vale, Monterey Park, CA............213-269-2010
Western Costume Company/11041 Van Allen, N Hollywood, CA..............213-469-1451

LOCATIONS

NYC

A Perfect Space/PO Box 1669...212-941-0262
C & C Productions/445 E 80th St.......................................212-472-3700
Cinema Galleries/517 W 35th St 1st Fl.................................212-627-1222
Davidson/Frank Photo-Stylists/209 W 86th St #701......................212-799-2651
Florentine Films, Inc/136 E 56th St #4C...............................212-486-0580
Great Locations/350 Hudson St 6th Fl..................................212-691-1761
Howell, T J Interiors/301 E 38th St...................................212-532-6267
Joy of Movement/400 Lafayette St......................................212-260-0459
Leach, Ed Inc/585 Dartmouth, Westbury.................................516-334-3084
Location Locators/225 E 63rd St.......................................212-685-6363
Loft Locations/50 White St..212-966-6408
Marks, Arthur/24 Fifth Ave #829.......................................212-673-0477
Myriad Communications, Inc/208 W 30th St..............................212-564-4340
Wolfson, Paula/227 W 10th St..212-741-3048

NORTHEAST

Betty Rankin/Location Unlimited/24 Briarcliff, Tenafly, NJ............201-567-2809
Forma, Belle/32 Vine Rd, Larchmont, NY................................914-834-5554
Gilmore, Robert Assoc Inc/990 Washington St, Dedham, MA...............617-329-6633
Lehman, Patty/78 Flaggy Hole Rd, E Hampton, NY........................516-324-4788
Maine State Development Office/193 State St, Augusta, ME..............207-289-2656
Maryland Film Commission/217 Redwood/9th fl, Baltimore, MD............301-333-6631
Massachusetts Film Off/10 Park Plaza #2310, Boston, MA................617-973-8800
New Hampshire Vacation Travel/PO Box 856, Concord, NH.................603-271-2666
NJ State Motion Pic Dev/1 Gateway Ctr, Newark, NJ.....................201-648-6279
Pennsylvania Film Bureau/455 Forum Bldg, Harrisburg, PA...............717-787-5333
Proteus Location Services/9217 Baltimore Blvd, College Park, MD.......301-441-2928
Ren Rose Locations/4 Sandalwood Dr, Livingston, NJ....................201-992-4264
Rhode Island State Tourist Div/7 Jackson Walkway, Providence, RI......401-277-2601
Telesis Production/277 Alexander St #600, Rochester, NY...............716-546-5417
Terry, Karen/131 Boxwood Dr, Kings Park, NY...........................516-724-3964
Verange, Joe - Century III/545 Boylston St, Boston, MA................617-267-9800
Vermont State Travel Division/134 State, Montpelier, VT...............802-828-3236
Video One/100 Massachusetts Ave, Boston, MA...........................617-266-2200
WV Film Commission/1900 Washington St E, Charleston, WV...............800-225-5982

SOUTHEAST

Alabama State Film Office/340 N Hull St, Montgomery, AL...............800-633-5898
Bruns, Ken & Gayle/7810 SW 48th Court, Miami, FL......................305-666-2928
Darracott, David/2299 Sandford Rd, Decatur, GA........................404-872-0219
Florida Film Bureau/107 W Gaines St, Tallahassee, FL..................904-487-1100
Georgia State Film Office/PO Box 1776, Atlanta, GA....................404-656-3591
Harris, George/2875 Mabry Lane NE, Atlanta, GA........................404-231-0116
Irene Marie/728 Ocean Dr, Miami Beach, FL.............................305-672-2929
Kentucky Film Office/Berry Hill Mansion/Louisville, Frankfort, KY.....502-564-3456
Kupersmith, Tony/320 Highland Ave NE, Atlanta, GA.....................404-577-5319

Locations Extraordinaire/6794 Giralda Cir, Boca Raton, FL 407-487-5050
McDonald, Stew/6905 N Coolidge Ave, Tampa, FL 813-886-3773
Mississippi State Film Office/PO Box 849, Jackson, MS 601-359-3449
Natchez Convention Bureau/Liberty Pk Hwy, Hwy 16, Natchez, MS 601-446-6345
North Carolina Film Office/430 N Salisbury St, Raleigh, NC 919-733-9900
TN State Econ & Comm Dev/320 6th Ave N/8th fl, Nashville, TN 615-741-1888
Virginia Division of Tourism/1021 E Cary St, Richmond, VA 804-786-2051

M I D W E S T

A-Stock Photo Finder/230 N Michigan #1100, Chicago, IL 312-645-0611
Carlson, Susan/255 Linden Park Pl, Highland Park, IL 708-433-2466
Illinois State Film Office/100 W Randolph #3-400, Chicago, IL 312-793-3600
Indiana State Tourism Development/1 N Capital, Indianapolis, IN 317-232-8860
Iowa Film Office/200 E Grand Ave, Des Moines, IA 800-779-3456
Kansas State Film Office/503 Kansas Ave, Topeka, KS 913-296-4927
Michigan St Trvl & Film Bureau/PO Box 30226, Lansing, MI 517-373-0670
Minnesota State Tourism Division/375 Jackson St, St Paul, MN 612-296-5029
Missouri State Tourism Comm/301 W High St, Jefferson City, MO 314-751-3051
ND State Business & Industrial/604 E Blvd Ave, Bismarck, ND 701-224-2810
Ohio Film Bureau/77 S High St, Columbus, OH 614-466-2284

S O U T H W E S T

Alamo Village/PO Box 528, Brackettville, TX 512-563-2580
Arizona Land Co/PO Box 63441, Phoenix, AZ 602-265-0108
Arkansas State Film Office/#1 Capital Mall, Little Rock, AR 501-682-7676
Blair, Tanya Agency/4528 McKinney #107, Dallas, TX 214-522-9750
Dawson, Kim Agency/PO Box 585060, Dallas, TX 214-638-2414
Epic Film Productions/7630 Wood Hollow #237, Austin, TX 512-345-2563
Greenblatt, Linda/5150 Willis, Dallas, TX ... 214-361-7320
Kessel, Mark/2429 Hibernia, Dallas, TX ... 214-520-8686
MacLean, John/10017 Woodgrove, Dallas, TX 214-343-0181
OK State Tourism-Rec Dept/500 Will Rogers Bldg, Ok City, OK 405-521-3981
Oklahoma Film Comm/PO Box 26980, Oklahoma City, OK 405-843-9770
Ranchland - Circle R/5901 Cross Timbers Rd, Flower Mound, TX 817-430-1561
Ray, Al/2304 Houston Street, San Angelo, TX 915-949-2716
Ray, Rudolph/2231 Freeland Avenue, San Angelo, TX 915-949-6784
San Antonio Zoo & Aquar/3903 N St Marys, San Antonio, TX 512-734-7184
Senn, Loyd C/PO Box 6060, Lubbock, TX ... 806-792-2000
Summers, Judy/3914 Law, Houston, TX ... 713-661-1440
Taylor, Peggy Talent/4300 N Central Exprswy #110, Dallas, TX 214-826-7884
Texas World Entrtnmnt/8133 Chadbourne Road, Dallas, TX 214-351-6103
Tucson Film Office/Box 27210, Tucson, AZ 602-791-4000

R O C K Y M T N

Wyoming Film Comm/IH 25 & College Dr, Cheyenne, WY 307-777-7851

W E S T C O A S T

California Film Comm/6922 Hollywood Blvd, Hollywood, CA 213-736-2465
Daniels, Karil2477 Folsom St, San Francisco, CA 415-821-0435
Excor Travel/1750 Kalakaua Ave #116, Honolulu, HI 808-946-6614
Film Permits Unlimited/8058 Allott Ave, Van Nuys, CA 818-997-6197
Juckes, Geoff/1568 Loma Vista St, Pasadena, CA 818-791-3484
The Location Co/8646 Wilshire Blvd, Beverly Hills, CA 213-820-7770
Location Enterprises Inc/6725 Sunset Blvd, Los Angeles, CA 213-469-3141
Mindseye/767 Northpoint, San Francisco, CA 415-441-4578
Minot, Abby/61101 Thornhill Dr, Oakland, CA 415-339-9600
Newhall Ranch/23823 Valencia, Valencia, CA 818-362-1515
San Francisco Conv/Visitors Bur/900 Market St, San Francisco, CA415-974-6900

S E T S

N Y C

Abstracta Structures/347 Fifth Ave ... 212-532-3710
Alcamo Marble Works/541 W 22nd St ... 212-255-5224
Baker, Alex/30 W 69th St ... 212-799-2069
Golden Office Interiors/574 Fifth Ave .. 212-719-5150

LaFerla, Sandro/92 Vandam St ... 212-620-0693
Lincoln Scenic Studio/560 W 34th St .. 212-244-2700
Nelson, Jane/21 Howard St .. 212-431-4642
Oliphant, Sarah/20 W 20th St 6th fl .. 212-741-1233
Plexability Ltd/200 Lexington Ave ... 212-679-7826
Theater Technology Inc/37 W 20th St .. 212-929-5380
Unique Surfaces/244 Mulberry ... 212-941-1866
Variety Scenic Studio/25-19 Borden Ave, Long Island City 718-392-4747
Yurkiw, Mark/568 Broadway ... 212-226-6338

N O R T H E A S T

Davidson, Peter/9R Conant St, Acton, MA 508-635-9780
Foothills Theater Company/074 Worcester Ctr, Worcester, MA 508-754-3314
Ren Rose Locations/4 Sandalwood Dr, Livingston, NJ 201-992-4264
The Focarino Studio/718 Fireplace Rd, East Hampton, NY 516-324-7637
Videocom, Inc/502 Sprague St, Dedham, MA 617-329-4080

S O U T H E A S T

The Great Southern Stage/15221 NE 21 Ave, N Miami Beach, FL 305-947-0430
Kupersmith, Tony/320 Highland Ave NE, Atlanta, GA 404-577-5319

M I D W E S T

Backdrop Solution/311 N Desplaines Ave #607, Chicago, IL 312-993-0494
Becker Studio/2824 W Taylor, Chicago, IL 312-722-4040
Centerwood Cabinets/3700 Main St NE, Blaine, MN 612-786-2094
Chicago Canvas & Supply/3719 W Lawrence Ave, Chicago, IL 312-478-5700
Gard, Ron/2600 N Racine, Chicago, IL .. 312-975-6523
Grand Stage Lighting Co/630 W Lake, Chicago, IL 312-332-5611
The Set-up & Co/1049 E Michigan St, Indianapolis, IN 317-635-2323

S O U T H W E S T

Dallas Stage Lighting & Equipment/1818 Chestnut, Dallas, TX 214-428-1818
Dallas Stage Scenery Co, Inc/3917 Willow St, Dallas, TX 214-821-0002
Dunn, Glenn E/7412 Sherwood Rd, Austin, TX 512-441-0377
Freeman Exhibit Co/8301 Ambassador Row, Dallas, TX 214-638-8800
Reed, Bill Decorations/333 First Ave, Dallas, TX 214-823-3154
Texas Scenic Co Inc/5423 Jackwood Dr, San Antonio, TX 512-684-0091
Texas Set Design/3103 Oak Lane, Dallas, TX 214-426-5511

W E S T C O A S T

American Scenery/18555 Eddy St, Northridge, CA 818-886-1585
Backings, J C/10201 W Pico Blvd, Los Angeles, CA 213-277-0522
Carthay Set Services/5300 Melrose, Hollywood, CA 213-871-4400
CBS Special Effects/7800 Beverly Blvd, Los Angeles, CA 213-852-2345
Erecter Set Inc/1150 S LaBrea, Los Angeles, CA 213-938-4762
Grosh, RL & Sons/4114 Sunset Blvd, Los Angeles, CA 213-662-1134
Hollywood Stage/6650 Santa Monica Blvd, Los Angeles, CA 213-466-4393
Pacific Studios/8315 Melrose Ave, Los Angeles, CA 213-653-3093
Superstage/1119 N Hudson, Los Angeles, CA 213-464-0296
Triangle Scenery/1215 Bates Ave, Los Angeles, CA 213-662-8129